Inside the Spiral

Inside
the Spiral

The Passions of
Robert Smithson

SUZAAN BOETTGER

 University of Minnesota Press
Minneapolis
London

Publication of this book has been aided by a grant
from the Millard Meiss Publication Fund of CAA.

Published by the University of Minnesota Press
111 Third Avenue South, Suite 290
Minneapolis, MN 55401-2520
http://www.upress.umn.edu

ISBN 978-1-5179- 1353–3 (hc)
ISBN 978-1-5179-1354-0 (pb)

A Cataloging-in-Publication record for this book is available
from the Library of Congress.

Printed in the United States of America on acid-free paper

The University of Minnesota is an equal-opportunity educator and employer.

30 29 28 27 26 25 24 23 10 9 8 7 6 5 4 3 2 1

ROBERT SMITHSON: Since I can't believe in objects and I can't believe in totems, what do I believe in? Fiction. Now let's get to the integrity of the fiction.

DENNIS WHEELER: Oh God.

ROBERT SMITHSON: Right. That gets a little closer to what I am talking about.

—Interview by Dennis Wheeler, 1969–70
Robert Smithson and Nancy Holt Papers
Archives of American Art, Smithsonian Institution

Contents

Note to Readers

Chapter epigraphs are repeated within the chapter,
and the citation is given at the location in chapter text.
Unless otherwise identified, epigraphs are quotations
from Robert Smithson.

Quotations of handwritten texts by Smithson retain
his capitalization and spelling. Unless otherwise noted,
quotations from books in Smithson's library are from the
editions he owned.

In the Notes, the first reference to a reprinted article
also provides the name and date of the original publication.
Texts by Smithson unpublished in his lifetime are so
indicated.

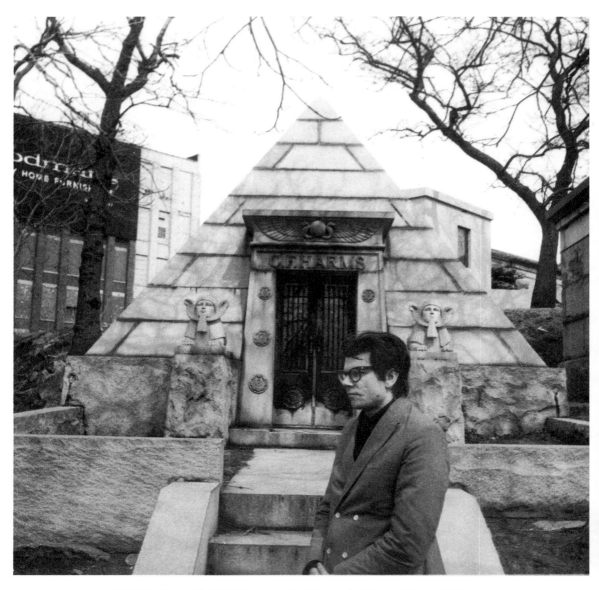

FIGURE P.1. Nancy Holt, Untitled portrait of Robert Smithson at Flower Hill Cemetery, North Bergen, New Jersey (1968). Courtesy Holt/Smithson Foundation and Nancy Holt Estate Records, Archives of American Art, Smithsonian Institution. Copyright Holt/Smithson Foundation / Licensed by Artists Rights Society, New York.

Portrait of the artist in Harms way: Nancy Holt's 1968 photograph of Robert Smithson at the mausoleum of C. F. Harms, a stranger to him but not the sentiment. Above the door is a carving of the ancient Egyptian Winged Sun symbolizing divinity, royalty, and protection. Years earlier Smithson had depicted those spread wings in at least one painting and many drawings; years later, the sun disk is the first image in his film *Spiral Jetty.* Here it is held aloft by upright cobras, the uraeus personification of power. Snakes appear in his own early images and are evoked in his last two earthworks. Smithson appreciated symbols and employed them. Flower Hill Cemetery, North Bergen, New Jersey.

Prologue and Background

"Red."

The first word Robert Smithson chose for his essay on his colossal whorl of rock and soil at an edge of the Great Salt Lake, *Spiral Jetty,* insinuates the hue's priority in its creation:

> Red is the most joyful and dreadful thing in the physical universe; it is the fiercest note, it is the highest light, it is the place where the walls of this world of ours wear the thinnest and something beyond burns through.

Smithson's placement of G. K. Chesterton's ecstatic declaration above his own words can be taken as referring to the site's bizarre hue (Plate 1). Due to its intense salinity and immensity, the Great Salt Lake in the western state of Utah has been called North America's "Dead Sea." But it isn't. Smithson chose a site where bacteria and algae thrive. They induce a carmine radiance reflected in the name of the point below the cove which it is located—*Rozel.*

Chesterton was not just describing the passionate connotations of the color and neither was Smithson. The mid-twentieth-century artist was literary, but he didn't imagine the roseate water as Homer's "wine dark sea"— rather, it was a fluid more primal. Through the British essayist's words, he augured that the red seascape was not only otherworldly but also called up a corporeal inscape. Smithson elaborated in his own hallucinatory reverie:

> On the slopes of Rozel Point I closed my eyes and the sun burned crimson through the lids. I opened them and the Great Salt Lake was bleeding scarlet streaks. My sight was saturated by the color of red algae circulating in the heart of the lake, pumping into ruby currents, no they were veins and arteries sucking up the obscure sediments. My eyes became combustion chambers churning orbs of blood. . . . Surely, the storm clouds massing would turn into a rain of blood.[1]

In this dialogue of sanguinary fantasias, Smithson did not quote Chesterton's next sentence:

> For it marks the sacredness of red in nature, that it is secret even when it is ubiquitous, like blood in the human body, which is omnipresent, yet invisible. As long as blood lives it is hidden; it is only dead blood that we see.[2]

"Blood" "hidden" "dead." The first and last appear often in Smithson's writing and speech, directly and figured. His secret yet ubiquitously alluded to life history hid inside the other two: "blood" and "death." Or as in a favorite verb, it *lurked*. When an interviewer surmised that his connection to religion was unusual among his peers, Smithson made it sound like professional research: "I was interested I guess in a kind of iconic imagery that I felt was lurking or buried under a lot of abstractions at the time."[3] It was exactly the only "partially buried"—as he suggestively titled an earthwork made a few months before *Spiral Jetty*—that lurked beneath his stylistic innovations, "omnipresent yet invisible."

Among the pentimenti to *Spiral Jetty* are Smithson's paintings. Prefiguring its crusty carapace that following years of submersion in the saline lake blanketed the basalt spiral in white, a decade earlier he brushed swirls of white blocks on a ruddy field, painting *Eye of Blood* (1960; Plate 2). In the next year or so he produced variations on the devotional image of Man of Sorrows, the nude torso of Christ displaying his wounds (Plate 5). At the same time, he wrote what he called "incantations," which, yes, sound like witches' chants calling up cosmic forces hypnotizing the coven (Figure P.2).

Zigzags of neon reflected against red walls in *The Eliminator* (Plate 24), the mirrored construction with which in 1965 he debuted his identity as sculptor, evoke spurting veins. Toward the end of the decade he likened his travel through the Yucatán to a "ride on a knife covered in solar blood."[4] He built *Jetty* in a long-sought red sea, raved that sections of his film of it shot through a red filter "brought forth a blood-drenched atmosphere," and was excited to carve *Amarillo Ramp* from red earth (Plate 29).[5] What inspired all these rhapsodies in red?

Spiral Jetty became a cultural disrupter, breaking out of art world acclaim to cross over to an audience enthralled by its majesty, mysticism, remoteness, and strangeness. The earthwork is not an *objet d'art*, or even just an environment, but a challenging destination that, once arrived at, offers immersive wonder. Snapshots of those exulting while posed atop *Spiral Jetty*

To The Flayed Angels

Blood, Blood, Precious Blood, Blood, Blood.
Flesh, Flesh, Sacred Flesh, Flesh, Flesh.
Christ, Christ, Jesus Christ, Christ, Christ.
Bleeding Angels of Jesus Christ have mercy on us.
Lord, have Mercy.
Christ, have Mercy.
Lord, have mercy.
Word of Flesh with amputated wings.
Mercy on us.

FIGURE P.2. Robert Smithson's handwritten opening lines of his first incantation, "To the Flayed Angels," 1961. See those *Flayed Angels'* amputated wings in Figure 2.4.

Robert Smithson and Nancy Holt Papers, 1905–1987, bulk 1952–1987. Archives of American Art, Smithsonian Institution. Copyright Holt/Smithson Foundation / Licensed by Artists Rights Society, New York.

and posted on social media offer enthralled selfies as trophy evidence that the contemporary art world's primary pilgrimage site had been reached, the hybrid pre- and postmodern enchanted labyrinth personally trekked. As a work of art, *Spiral Jetty*'s solitary ambiguity has stimulated not only scholars' analyses of the *Jetty* but visual artists', poets', and novelists' accounts of traveling to, locating, and becoming absorbed by the spiral, walking it almost ritualistically as Smithson did in his autobiographical film— "Following our spiral steps, we return to our origins."[6] The extent to which people groove with *Jetty* indicates not only that the artist expressed something significant of himself in it, but also that it expresses something viewers find significant in themselves.

At the time, Smithson was the alpha artist of a group of "macho" cowboy-boot and Stetson-hat-wearing earthworkers, all Caucasian males (reflecting the most populous component of ambitious New York sculptors, the values of their private patrons, the social convention then of privileging that gender and race, and the popularity of Westerns as film and television entertainment). They moved sculpture's innovation of arraying units as site-specific interior spatial environments to the outdoors, at remote expanses, and vastly enlarged them, working in earth hacked and mounded. Even before that, following the influential *Primary Structures* exhibition of reductive geometric boxes and planks at the Jewish Museum in spring 1966, in France the art historian/critic Jean Clay could with impunity title an article on kinetic sculpture "La peinture est fini."[7] In his sculpture and

conceptual art Smithson pioneered the transition to working with raw geological matter, first bringing it into the gallery, filling low bins whose shape corresponded to that of maps of the locale from which the rocks or sand had been taken. He was free-ranging: in upstate New York, beheading a tree and planting the trunk upturned so its gnarled roots formed a wiry crown; pouring a gush of asphalt down an Italian hillside; engulfing a cabin in Ohio in soil; designing a ramp in Texas that turned out to have the form of an ancient symbol of eternal return. And he was a switch-hitter, simultaneously publishing extravagantly imaginative essays in the art world herald *Artforum* that at once spoke to public concerns and both camouflaged and slyly conveyed personal issues.

As an influencer of conceptions of what art could be and do, this visual artist's impact on succeeding generations derives more from his ideas conveyed through his writing and statements, which for artists, as Peter Halley wrote, "have had an almost talismanic value."[8] Smithson is quoted for his skeptical outward-directed perceptions advocating an encompassing perception of art in the world, profoundly mediated—seen not only through media but also through language, history, memory, and by implication, private concerns both personal and existential. His encapsulation of a sculpture's standing segmented spiral (see Figure 9.3) exemplifies his rejection of the prevailing restriction of the analysis of a work of art to its visual form: "*Gyrostasis* is relational and should not be considered an isolated object."[9]

Correspondingly, Smithson's subversive combination of sober discourse, veering from science to science fiction, documentation of journeys, and fantastic conjuring, shows a close attention to words—that is, *their* nuanced meaning and how *they* work relationally. One of his most penetrating images is verbal: "We are lost between the abyss within us and the boundless horizon outside us."[10] Like a poet or novelist, Smithson knew enough of words' power to be able to play with them: "The best writing by artists doesn't set out to explain or discover, instead it might offer tautologies, slow-witted jests, pseudo-exactitudes, languid problems, and contentless word facades. The meaning of single words, phrases, sentences may be emptied, reversed, damaged, changed by the use of an odd syntax."[11] Smithson's synthesizing merged dichotomies of object and environment, center and periphery, nature and culture, and most distinctively for his own practice, making and writing. His artistic mediums were so interwoven that critic Craig Owens declared "the reciprocity of Smithson's visual and verbal practices" as a characteristic anticipating Postmodernism's profound intermingling of forms.[12]

Less recognized are the inner-directed implications of his amalgams that are evident when his work is embedded in the personal: juxtapositions of secular and sacred subjects; scientific and occult systems; heterosexual

and homosexual eroticism; professional and private identities; a wounded self and constructed persona. The mix presents a complicated person experiencing what he described regarding Michelangelo's homosexuality and plausibly felt himself, a "quagmire of confounded passion." Understanding them must encompass his puns, allusions, and frequent references to both subterfuge and catastrophe: "Each landscape, no matter how calm and lovely, conceals substrata of disaster."[13] Perceiving Smithson's complexity demands both an expansive purview and a close perusal of what he wrote and made. Recognizing and deciphering his religious and esoteric references, alert to misery, and contextualizing it in individual and family history, reveal much about the emotional frequencies of this artist's visual and verbal utterances that resonate with so many others.

Attending to these elements shows that Smithson's erudite references are exceeded by his recurring metaphors of mortality. The titles of early paintings—*Purgatory* (1959; Plate 8), *Death Taking Life* (1961; Plate 23), *My House Is a Decayed House* (1962; Plate 17)—rarely shown and hardly analyzed, foreshadow his future essays' dolorous allusions. He replied to a questionnaire about the state of current art by envisioning arrays of minimalist boxes as headstones—an "Avant-garde of cemeteries."[14] He likened galleries' "vacant white rooms" to asylums of "esthetic convalescence" housing works of art "looked upon as so many inanimate invalids, waiting for critics to pronounce them curable or incurable."[15] He intellectualized his affiliation with death by promoting the concept of entropy, physicists' concept for an object's loss of energy within a closed system. But what was inexorable for him personally was that "the mind of this death, however, is unrelentingly awake."[16] Those barely latent laments in clever analogies—"One is always crossing the horizon, yet it always remains distant"—expressed with a writerly sensitivity and poetic imagination, brought to discussions of art both the metaphysical and the mournful.[17]

Smithson's wry pessimism—"Rust is the fundamental property of steel"—has been interpreted as "skepticism about the optimistic technology of twentieth-century modernists, such as David Smith."[18] It is that, as well as part of what Herbert Marcuse famously called the Great Refusal, anticapitalist, antiestablishment, and uninhibited social attitudes by the burgeoning youth culture. As Gene Youngblood wrote in his influential *Expanded Cinema* (1970), "The current generation is engaged in an unprecedented questioning of all that has been held essential."[19]

The decade of the 1960s is known for its fracturing of social cohesion around personal values and the Vietnam War, the expansion of racial consciousness, and the onset of an environmentalist conscience. Morbidity appeared in earthen sculptures such as Claes Oldenburg's *Placid Civic Monument*, also referred to as *Hole* (1967), dug grave size; in Robert Morris's

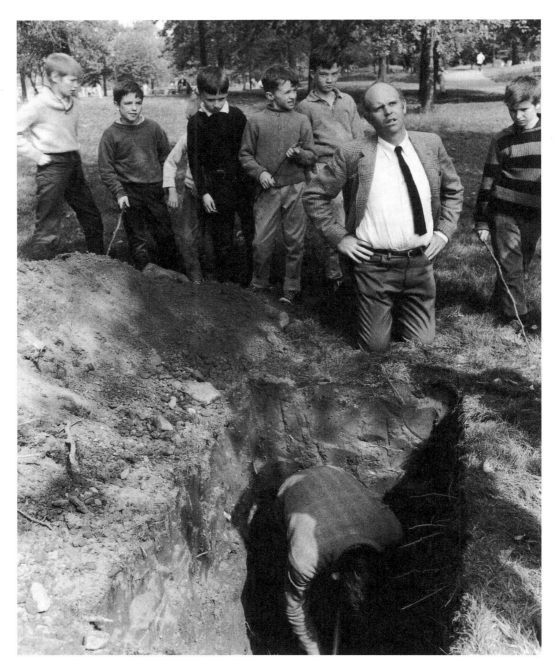

FIGURE P.3. Smithson made his "Tour of the Monuments of Passaic" the day before the well-publicized and innovative New York City–wide outdoor exhibition *Sculpture in Environment* opened on Sunday, October 1, 1967. On that morning, as boys playing nearby gathered around, Claes Oldenburg oversaw a cemetery worker digging a grave-size excavation in Central Park for the work he titled *Placid Civic Monument.* Within three hours it was filled in. Courtesy Oldenburg Studio, Pace Gallery, and New York City Parks Department. Photographer: Daniel McPartlin, NYC Parks Photo Archive.

chaotic pile of soil, grease, waste rubber, and metal, *Earthwork*, spilled in 1968 on the Dwan Gallery's carpet; in Dennis Oppenheim's *Branded Mountain* and *Cancelled Crop* (both 1969), each marked with huge Xs as if eliminating terrain, its harvest, and a source of life; and Michael Heizer's repetitions of his open trough *Depressions* (1968) and *Displaced/Replaced Mass* (1969), an irregular boulder nested in a recessed rectangular box like a body encased in an open casket. These primordial forms manifested the bruised social body buffeted by murders of civil rights workers; violent assassinations of beloved leaders; a virulent war and antiwar activism—all of it on the nightly TV news programs of the three network channels families gathered around to watch, coalescing audiences into community. Consistent with his masculinist "intellectual" art world contemporaries, attention to Vietnam, civil rights, or race does not appear in Smithson's interviews and essays. But his expression of art world conflicts in doleful poetics spoke to political and social ruptures.

Beyond topical social crises, if death is inevitable and common to everyone, why did Smithson make so many more references—both visual and verbal—than did his contemporaries to precariousness, where "planning and chance almost seem to be the same thing"?[20] Decades ago, that question sparked my study of Smithson. OK, it was fashionable in the 1960s to disdain institutions and to liken museums to tombs. But the consistency of Smithson's bleak implications suggests reactions more personal than counterculture skepticism, hip irony, or political pessimism. He may have found justification in Carl Jung's frequent reiteration across the six volumes of his essays he owned that in contrast to the Abrahamic religions' antinomy of God as purely good and Satan as absolutely evil, in human wholeness the "self" must assimilate both affirmations and the darkness of its "shadow. . . . [The self] represents in every respect thesis and antithesis, and at the same time, synthesis. . . . The artist's unity is postulated as the absolute condition for the completion of the work."

That statement is from Jung's *Psychology and Alchemy*, a volume to which Smithson's imagery and statements show he closely attended. In medieval alchemy the "work"—the *opus*, or philosopher's *lapis*—is not the historically late debasement as a materialistic goal of turning lead into gold and is more than the cliché of transforming the profane into the sacred. Rather, it is a mystical aspiration to experimentally alter base substances to release the spirit imprisoned in matter that will engender psychic development and transcendence from the mundane. Jung conceptualized the aim as holistic individuation, and "point[ed] to active imagination as the thing that sets the process really going."[21] Commensurately, the intensity of Smithson's productivity and his incorporation of occult motifs cannot be construed as simply careerist ambition or akin to hippies' adoption of

archaic emblems such as the spiral. Rather, he channeled the alchemist's desire for, and symbolization of, transformation and paralleled the process. Just as one does not find recipes in alchemists' treatises but only suggestions and hints, Smithson was a master of occult systems and canny innuendo.

Jung's advocacy of personal synthesis of light and shadow may have been meaningful to Smithson precisely because his temperament's dominant drumbeat was the downbeat. Discussing art in public places, he remarked, "In regard to the origin of parks in this country it's interesting to note that they really started as graveyards."[22] Poet and *Village Voice* art critic John Perreault observed, "Smithson was both an intellectual and an artist. A hard thing to pull off. Both aspects of him were informed by a dialectic of irony and despair."[23] Long before the punk scene dressed in goth black, he was known for wearing the hue that in daytime attire was associated with outlaws and mourning. His pal as artist-as-writer, Mel Bochner, described him as "a great conversationalist, well-read, witty and sarcastic, with a deeply diabolical streak."[24] His close friend and fellow ambitious sculptor from the later 1960s, Richard Serra, recalled that he had "a great critical voice, always pestering and mocking. He was ironic and humorous in a nasty sort of way. I loved playing off his intelligence; it was perverse, diverse, broad, and serious."[25] Tony Shafrazi, a friend who spent what turned out to be the last days of Smithson's life with him, emphasized his perceptiveness but also recalled an aspect as "perverse." This is the word with which fellow artist and friend Les Levine also described him; Levine continued by saying that Smithson was "morbid, and very connected to the negative."[26] Smithson accounted for that propensity: "All the 'fancy junk' of science cannot hide the void. I am sick of 'lighting candles,' I want to know what the 'darkness' *is*, I don't 'curse' it or praise it, but I know it is there."[27]

Smithson was not a stranger to the dark. What is the implication of a collage titled *Alive in the Grave of Machines* (Plate 11)? What was the appeal of excursions to cemeteries? In 1968, his life partner, Nancy Holt, photographed him in front of a pyramid mausoleum in North Bergen, New Jersey, not the only time they visited (see Figure P.1). What is notable is not just his ghoulish attraction to cemeteries but also that in two visits in which he was photographed there, he chose as the setting the pyramidal tomb of one C. F. Harms: the punmaster pictured "in Harms way." There he stood between symbols of inscrutability, sphinxes.

Art critic Douglas Davis observed of Smithson, "He had the kind of mind that saw analogies and metaphors everywhere."[28] But for others, affective themes implied in his visual and verbal imagery have hardly been

seen, let alone deciphered. Valentin Tatransky, the first cataloguer of Smithson's posthumous library, mentioned "death, a recurring topic in his writings" only in his overview's final words, without elaboration.[29] In 1985, when George Lester, Smithson's former gallerist and patron, flung onto the marketplace his accumulation of Smithson paintings, all of them were unknown. As a well-known earthworker, Smithson had misrepresented and disparaged them, successfully discouraging attention to them. Halley—the essayist for *Robert Smithson: The Early Work, 1959–1963* at the Diane Brown Gallery, SoHo/New York City—became the first analyst of Smithson's work to link Smithson's paintings and his analogies about the site of *Spiral Jetty* as "an obsession with blood, and with the color red."[30] And J. G. Ballard, the science fiction novelist with whom Smithson felt an affinity, years later returned that sense of affiliation, describing Smithson's work as his own has been interpreted, as manifestations of emotional issues. Ballard insightfully construed Smithson's earthworks as "*psychological* edifices that will one day erect themselves"—that is, after his audiences are able to recognize and receive them—"and whose shadows we can already see from the corners of our eyes."[31]

One source of the sparse discernment of those shadows was the elimination of Smithson's presculptural work from early assessments. "Robert Smithson's Development," written by curator and critic Lawrence Alloway with Smithson's input, begins the artist's trajectory in 1966 when Smithson was twenty-eight—as if his sculpture and writing sprang from Zeus's forehead fully formed. That set his career's parameters, posthumously maintained by his estate through its ownership of both works of art and copyright regarding illustrations and quotations, influencing his career-defining survey exhibitions and scholarship. *Robert Smithson: Drawings*, curated by Susan Ginsburg at the New York Cultural Center in 1974, was presented over the next three years at six museums in the United States, four in the United Kingdom, and three in Europe. In 1980, *Robert Smithson: Sculpture*, organized by Robert Hobbs at Cornell University, traveled to five U.S. museums and served as the U.S. representative in the 1982 Venice Biennial before being hosted by another six museums from Helsinki to Belgrade.[32] These venues' numerousness and diverse locales evince Smithson's appeal, the widespread sense of loss following his death at thirty-five in 1973, and the collective desire to honor him.

Those two survey exhibitions, along with *The Writings of Robert Smithson* (1979), edited by Holt, established a canonical narrative of Smithson's artistic identity, one that commenced with art and writing produced in 1964. *Robert Smithson: The Collected Writings* (1996), edited by Jack Flam and reprinting Holt's edited versions of Smithson's essays and interviews

plus additional others, includes texts unpublished in Smithson's lifetime from 1961 to 1962, but no contemporaneous illustrations of paintings or drawings.

In doing so, none chose to independently bring into art historical dialogue his prior seven-year career as a painter and drawer of emotionally "hot" topics such as those so provocatively described in a 1961 article:

> [Smithson's] studio is a large high-ceilinged dark room crammed with images. . . . A life-size painted devil and a large spider web of wires and painted blocks hang from a bat-painted ceiling. Larger than life canvases, mainly depictions of Christ, in blatantly colored conceptions stand against the walls. Drawings displaying a profusion of demonic torments and temptations are everywhere—pinned around the room's edges, piled on the floor, and falling out of portfolios. . . . A bookshelf [holds] Kierkegaard, Graham Greene, interpretations of early symbolism, Michelangelo's works, the Bible.[33]

In his review of the 1985 Diane Brown exhibition, poet and critic Ted Castle called Smithson's paintings "surprises. These are all works that were suppressed on the occasion of the Smithson Retrospective which toured the world a few years ago, presumably because they have nothing to do with 'Earth Art' of which Smithson was a demigod." That's one rationale. In the *New York Times,* Grace Glueck declared that Smithson's "early work comes as a bit of a shock. . . . The work, so out of sync with Smithson's Minimal image, has been buried."[34] The exhuming was brief and rare. Eugenie Tsai was the first scholar to examine Smithson's early work for her doctoral dissertation and the Columbia University exhibition and catalogue, *Smithson Unearthed: Drawings, Collages, Writings* (1991). The relegation of the exposure of early work to those media was both revelatory about his work in those forms and accommodated the estate's desire that the paintings not be noticed (Tsai informatively discussed and provided images of a few).

After Castle got past his own "shock" at seeing this unknown aspect of Smithson, he was "highly pleased that the paintings look wonderful today. They have a sureness and an anguish that distinguishes first rate art of all periods."[35] Indeed, the exhibition revealed the paintings' correspondence to the then-rising Neo-Expressionism. Nevertheless, that show, which traveled to London and Lucerne, was the first and last substantial exhibition of Smithson's paintings, as a result of which they are rarer in public collections than Vermeers (although Castle reported, "I was informed that there are about that many more [as on view, forty] in the same genre still in hiding," making the sum of his paintings greatly exceed that of his post-1964 sculptures and earthworks).[36] Subsequently, a small number of paintings

and early drawings have been integrated into Smithson survey exhibitions in the United States, more in European ones.[37] They indicate that his prominence as an innovative sculptor did not need bolstering by confinement of his oeuvre to it. Thanks to the ecumenical perspective of the Holt/Smithson Foundation, many of the illustrations in this volume are being published for the first time ever or are the first to be included in a U.S. publication.

While those two elemental exhibitions restricted their presentation to the known Smithson, in their catalogues' chronologies, Holt displayed her recognition of the importance of biography by placing notice of a family loss that unlocks a view into the art historically unknown Smithson. She put it there because she understood the explanatory force of the fact's significance in her late husband's early history. In my first meeting with her more than thirty years ago she called my attention to it. But the time was not right, both for the field and for my own curiosity about the social and art historical sources of earthworks, to assimilate it. The situation Holt identified, described here in chapters to come, opens a realm to understanding this complicated artist who had more depths than the ones for which he has been acclaimed.

Smithson did not discuss the impact of the situation Holt inserted in the chronological accounts of his life—it is evident in his writing and art—and the tenor of the times regarding the artist's persona provided intellectual cover. Both his own self-representation and then his art historical reception were confined by what art historian Anna C. Chave incisively described as "critical paradigms entailing the diminishment or outright erasure of considerations of artistic subjectivity." Late modernist art theory prominently rejected the historical perception of the artist as a unique and charismatic "creator," called out by feminists as a "male genius," a stereotype at once reductive and sanctified. Emphasizing linguistic fundamentals and shared cultural/social conditions, critical theory dismissed the "premise," as Chave put it, "that art and experience must be linked, that artistic as well as critical practices and positions, interests, and privileges are invariably colored by personal factors that may reward examination."[38]

In his introduction to a retrospective anthology on relations between art and biography, Charles Salas explained, "The trend in criticism toward depersonalization accelerated in the sixties and seventies, fueled by the popularity of theory. . . . In certain circles in the 1960s, the idea that the work was in some emotional sense a surrogate for the artist fell into disrepute. American art at this time, says [Rosalind] Krauss 'staked everything on the accuracy of a model of meaning severed from the legitimizing claims of a private self.' "[39] Krauss herself argued for viewing environmental "sculpture in the expanded field" not as the handling of material to make socially or historically bound form, nor as an expression of individual subjectivity, but

as operations between types of impersonal—that is, public and linguistic—configurations: architecture, landscape, site, and place.[40] She extended her argument against the originality of the avant-garde and other modernist myths in a book of that title advocating Structuralist methodology in which meaning was not taken to be intrinsic to an object, determined by its own distinctive elements, but external and relational, deriving from correspondences and differences between objects in a categorical field.

Thus, Krauss shunned, as she stated, "whole realms of inquiry—aesthetic intention, biographical context, psychological models of creativity, or the possible existence of private worlds of allusion [which] call for an interpretive model based on the analogy between the work and its maker." In ridiculing a methodology she described as "an aesthetics of autobiography," "the restricted profile of a merely private life," and "a contraction of sense to the simple task of painting, or labeling to the act of unequivocal reference . . . thereby fixing and limiting the play of meaning," Krauss set up a straw ogre easy for her to torch.[41] Yet for ambitious scholars in the humanities, she and her cohort (several who had been her graduate students, a.k.a. "Rozicrucians" or "Kraussettes") were influential, foreclosing attention to personal sources of individuality that differentiated them within shared structures.

Ironically, Krauss's description that Ferdinand de Saussure's analysis of a linguistic or artistic sign "stresses that status of the sign as substitute, proxy, stand-in, for an absent referent" absolutely applies to a biographical and psychological analysis of the common use of artmaking as a not-necessarily-intentional stand-in, compensation, or working through the effect of an "absent referent," Smithson's process. And that relates to another reason the dolorous affect of Smithson's writing has not been attended to: his evocations of the experience of loss are difficult to bear. "Loss is the precondition of interpretation," literary scholar Richard Stamelman has observed. That is, writing about art is an urge to speak for, to speak to, and to complete the communicative arc that works of art project, and the absences on which their productive ambiguities are based, for which creations serve on one level as compensation. "But," Stamelman continues, "much writing represses that truth, and the will of much interpretation is a will to forget loss."[42]

Decades later, after that critical edifice ruptured, art historian Eve Meltzer addressed how "Krauss began to celebrate the notion that the human locus of production (author, artist, what have you) was 'dead.'" Meltzer's perceptive critique of Krauss's "expansion" of methodology identified its constriction, "an occlusion of depths, as it were, an effort to repress [a work of art's] discursive resonances and historical specificity."[43]

Yet even before the prominence of that advanced critical methodology,

its incipient attitudes facilitated Smithson's radical alteration of his public artistic and authorial identity. After his so-called "religious" images were professionally rebuffed, like the subterranean landscapes he subsequently painted with sanctuary cavities midst dense foliage and teeming creatures, as in Plate 18, aspects of his self went underground. In his visual art, he relegated his wrestling with personal torments to clandestine drawings not exhibited in his lifetime and rarely thereafter. His early writings are anguished grievances of professional and personal alienation that served as private laments. When published decades later, in the absence of biographical context they were taken to be art criticism. "The word 'color' means at its origin to 'cover' or 'hide.' "[44] That act was familiar to him; in his new persona his afflicted self was no longer overtly apparent as it had been in his paintings, but coded in less obvious surrogates and implied in figures of speech. Thus, in his first public talk, at Yale in 1966, he declared, "The self is a fiction which many imagine to be real."[45] Appearing on the cusp of Minimalism to fashionably reject personal subjectivity, he gave us an autobiographical cue to his own public presence.

Consistent with his era's ethos of the artist as a circumspect constructor, when interviewers who were dimly aware of his presculptural work inquired about it, Smithson made himself appear to denigrate biographical expressivity in favor of emphasizing shared social structures. "Dialectics could be viewed as the relationship between the shell and the ocean. Art critics and artists have for a long time considered the shell without the context of the ocean."[46] Taking this commentary as intellectual analysis, it can be reasonably understood as advocating an expansive contextualization—"the dialogue" as he put it, "between, let's say, the circumference and the middle and how those two things operated together."[47] Anticipating historians' turn to Poststructuralism and a new historicism, Smithson's statement corresponds to the shift in focus from viewing artists as internally driven individuals to analyzing them as professionals working from historical sequences of form and investigating their media's material possibilities. As Jennifer L. Roberts has written, "[Smithson's] entire career can be understood as a continuing, and constantly renegotiated, engagement with the practice and philosophy of history."[48]

Pertinently to this study, Michael Ann Holly asserted that " 'art' can never be attenuated to what we reductively call 'history.' "[49] Replace Roberts's "history" with "autobiography," and so many additional "engagements" can be seen, particularly in *Spiral Jetty* but of course within every other work. The Smithson who withheld his personal self and spoke to interviewers from behind a professional persona had previously titled a painting after a line in T. S. Eliot's poem "Gerontion," another line of which states, "History has many cunning passages, contrived corridors." Like

Eliot, Smithson's references to history—and to Christ's Passion, circles, mirrors, nonsites, entropy, ruins—so often metaphorize biographically relevant issues that it appears he contrived cunning passages to simultaneously disguise and disclose *personal* corridors. And it wasn't just his life history but his life's prehistory, a family crisis that preceded his birth and had a profound impact on his understanding of himself in the world—and that thus needs to be incorporated to an understanding of him and his work.

How do we know this? He told us, albeit indirectly. As Mel Bochner observed, "[His] work was really very literary. . . . The metaphysics . . . were always very close to the surface."[50] Diving below, in a detailed analysis of his visual and verbal creations, particularly those made before he transmuted himself around 1964, and an equally receptive reading of the books he owned, especially beyond the snippets that through his epigraphs he directed readers' attention, reveal buried treasures. And he told us the procedure: "One must learn to see the mud through the grid and create a new sense of scale."[51] Taken literally, he spoke to contemporaneous sculpture's emphasis on materiality and spatiality. But beyond positivism, his statement applies to seeing a distinctive artist's muck surging through conventions—historical, social, stylistic—to create both a new sense of art and a new comprehension of self, within the wider scale of biography-meets-history.

Taking Smithson's shell/ocean analogy as one of his double entendres with disguised information turns around its meaning. Despite his averring otherwise, he continually implied that art should be understood as personal. "Critics, by focusing on the 'art object,' deprive the artist of any existence in the world of both mind and matter. The mental process of the artist which takes place in time is disowned, so that a commodity value can be maintained by a system independent of the artist."[52] In 1973, after creating two major earthworks and with the confidence of having established himself as prominent artist, he divulged to intimates Holt and writer Lucy Lippard, "I've always been a kind of a psychoanalytic type. . . . I think decisions are made based on one's physio-psychological needs."[53] The "context of the ocean"—Smithson's "always been" that he felt had been insufficiently considered—can also be analogized to the "oceanic experience" that begins in the womb, the milieu in which the shell/person is formed. And this particular shell has secrets curled within it to which an analyst must listen with a receptive inner ear. When attending to his poetical references as tangential autobiography—"The infirmity of [Michelangelo's] melancholia seems infinite and unending"—the reader can hear its conflation with the personal.[54]

It was Smithson's sensibility that drove him to bind the historical, social, *and* personal in the material, as he explained in one of his rare direct statements of artistic intention: "There's this kind of trying to make things

out of the senseless situations, I guess, a kind of continuity. But there is a preoccupation—in other worlds, you develop mental structures. I was trying, I guess, to develop a reflection in the physical world, so that these two things would coincide, the mental and the material would in a sense inform each other."[55] With characteristic self-awareness, he acknowledged that his artistic wrestling with materials was also a form of psychological grappling, the art both reflecting and illuminating for him interior states.

In analyzing this, a combination of methodological paradigms is needed: psychological interpretation to resist the diminution of art to form, intellect, or displays of social/political identity and to perceive suggestive evocations in images, symbols, and figures of speech, and historical/ stylistic contextualization to inhibit the psychoanalytic tendency to reduce images to emotion, pathology, or personal history. Restoring lacunae to this protean personality makes his figurative images comprehensible and resolves deliberately encoded works—the most monumental in every sense being *Spiral Jetty*—into meaningful focus. It makes significant associations, not only between earliest and late works, increasingly recognized by art historians such as Thomas Crow, who writes that "far from abandoning his first preoccupations, [in his two-year hiatus from the art world in 1963–64] Smithson was instead departing on a quest to find a way back to them."[56]

Integration of biography does connect a beginning and end as Smithson's circular *Amarillo Ramp* almost does (Plate 29). But it also allows recurring marks to be perceived along the arc of his visual and verbal creations. Whereas semiotic and social history theorists advocated a decentered self in favor of shared practices and historical contexts, this study centers subjectivity as a major source of Smithson's ideas and creativity, one that rewards examination and reveals his art as substantially *expressive*. These methodologies are not mutually exclusive. My integration of circumstances of Smithson's biography is not to prevail over but to augment analyses of him as a cerebral innovator. His public intellectuality has been examined extensively; his early history, not at all. But as writer Guido Piovene has urged:

> The prolonged debate—particularly in the field of journalism—with regard to the distinction between inner man and social man is a theme that we have to move away from: subjectivity projects itself into social man and sociality is interiorised within subjectivity, in a continuous movement. I would go so far as to say that a pure and abstract subjectivity does not exist, and could not exist.[57]

Rather than viewing Smithson as unitary or sequential—the wounded son, the struggling painter, the devout Roman Catholic, the artist incorporating

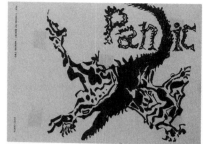

FIGURE P.4. Covers Smithson designed for Alan Brilliant's poetry journal *Pan*, numbers 1 and 2, 1958. Photograph: Daniel Root / The Root Group. Private collection, New York City. Copyright Holt/ Smithson Foundation / Licensed by Artists Rights Society, New York.

arcana of astrology, numerology, alchemy, or science, the ambitious interloper, the cerebral conceptualist, the postmodern theorist, the fantastical writer, the social critic, the innovative stylist, the frustrated designer of reclaimed environments—a useful model is provided by psychoanalyst/philosopher Félix Guattari's attestation that "subjectivity is in fact plural and polyphonic."[58] As do most of us, Smithson more often than not manifested more than one of these identities. Asked to design covers for the poetry journal *Pan*, a word that calls up associations of the ancient bestial god of lust and literature, for the second issue Smithson extended the title into "Panic," and planned on doing future covers as "Panting" and "Pandemonium."

Let us begin. From the shore, the spiral of Smithson's *Jetty* curves left, counterclockwise, as if toward the past. That's the direction in which the intrigued viewer must turn to understand the arc of Smithson's lifeline sited in a sea of blood. It circles back to when his artistic medium was not soil but pigment and his subject matter was Christ's Passion. There we will revive what a commentator described as "paintings [that have] been lying dormant in the dark annals of history."[59] And so much more.

On the first page of his *Principles of Art History*, Heinrich Wölfflin pungently acknowledged the underlying counterpart of those historical precepts: passions: "It has long been realized that every painter paints 'with his blood.'" For Smithson, especially so, and he knew it. In an incantation, he invoked, "From a ruptured / Blood vessel / Comes a prayer." Let us extend that devotion by drawing inspiration from Simone Weil, who famously wrote, "Attention, taken to its highest degree, is the same thing as prayer."[60] Here we will honor Smithson's forms of prayer with hers: by giving them, in ways they have not previously received, close attention.

Prehistory
and
Early Painting

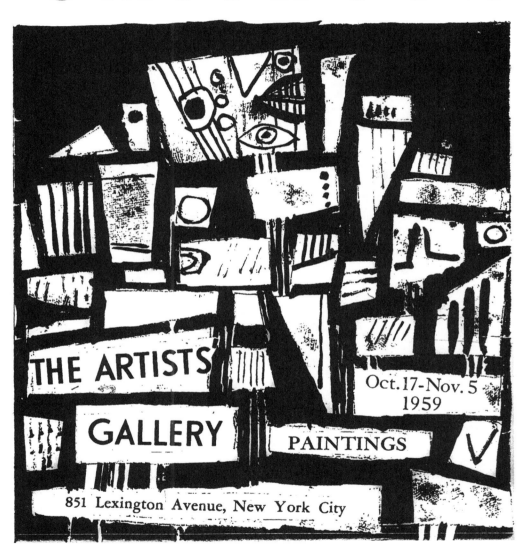

FIGURE 1.1. Robert Smithson's poster for his solo exhibition, The Artists' Gallery, 1959.

1

Man of Sorrow

These paintings are not for arty-chatter
but for the lacerated soul.

In the early '60s I met a similar alien mind, Robert Smithson."[1] Artist and moviegoing companion Peter Hutchinson's characterization, tinged by their mutual attraction to science fiction, suggests his friend's . . . distinctiveness. It is intimates' common characterization. At the other end of the decade, Willoughby Sharp, a freelance curator and with Liza Bear founder of the journal *Avalanche* (1970–76), saw him regularly:

> Smithson was obviously someone you didn't take lightly. He was very tall, six feet, two inches, and looked taller. Very gaunt, pocked, acne-marked face, heavy, nerdy black glasses, which he later exchanged for aviator frames, and rough clothes. Rough and ready. And he was rough and ready around town at the watering holes that counted at that particular time, the most important of which was Max's Kansas City. . . . He was a kind of *eminence gris*. Not as an older guy, but a kind of gray cloud hanging over the scene. And the *eminence gris* of the young, up-and-coming people. He was imposing, argumentative, and had vehement opinions.[2]

And Nancy Holt, recalling Smithson's invitation when they were both twenty-one to come down from Boston, where she was a university student,

to attend the reception for his first solo show in a professional gallery, re-marked, "I didn't go. I thought he was, you know, kind of strange."[3] Three and a half years later she married him, having converted to Roman Cathol-icism to do so. What was his alien mind, his gray eminence, his kind of strangeness that many found so appealing?

We'll begin as customary at what was—but in an important way actually *wasn't*—his beginning. Robert Irving Smithson was born on January 2, 1938, at Passaic General Hospital, New Jersey. Contrary to legend about his mythologized arrival, Smithson was not brought into this world by William Carlos Williams, but as the latter was that hospital's chief of pediatrics, the boy could have been, as he later claimed, the poet's patient.

During his freshman and sophomore years at Clifton High School, Smithson took classes in drawing—winning first prize in an American Le-gion Auxiliary poster contest depicting its commemorative poppy—and in his junior year in advertising design. The fierceness of his ambition to dif-ferentiate himself from suburban New Jersey is indicated by his initiation of art school instruction while a junior in high school. Having clipped a magazine advertisement for the Art Students League, he sent the informa-tion required for admission, including several drawings, omitting his age and was accepted.[4] That entailed the sixteen-year-old's commuting Friday afternoons from Clifton, New Jersey, to Manhattan (by bus, a little over an hour) for evening classes in life drawing and in cartooning at the vener-ated school. He took a seat where Abstract Expressionist painters Barnett Newman and Jackson Pollock had studied and among the many others who became part of the art historical pantheon, Pollock's teacher, the idealist of rural life Thomas Hart Benton. His instructor was illustrator John Groth (1908–1988), who had taught at the League since 1942 after achieving rec-ognition for dynamic visual and lively text anecdotes of his adventures as a correspondent during World War II, published in the *Chicago Sun*, *Parade*, and *American Legion Magazine*. Groth's evaluation acclaimed Smithson as "one of three students of my ten years at the League whose work and talent give real promise of future success."[5]

The severity of Smithson's self-image can be seen in his self-portrait at seventeen beside a series of expressionist black-and-red woodcuts on a sheet 146 inches long with explanatory designations: "Boys Looking at a Hot Book," one of them appearing to clasp another's crotch; "Speaker at High School Assembly," with a young man looking away, bored (his alter ego); and "Teenagers and Beggar on 42nd Street." Under his name, his seri-ous expression has cat eyes and half his face and neck are in black shadows,

FIGURE 1.2. Robert Smithson, *Teenagers and Beggar on 42nd Street,* 1955. Woodcuts, 136¼ × 145⅝ inches (346.1 × 369.9 cm). Collection Richard Castellane, Munnsville, New York. Courtesy Munson-Williams-Proctor-Arts Institute, Utica, New York. Copyright Holt/Smithson Foundation / Licensed by Artists Rights Society, New York.

Both Smithson's age when he made this series of woodcuts (seventeen) and his subject matter are notable, indicating he wasn't your ordinary 1950s suburban New Jersey adolescent.

the duality reflecting his temperament's flips between the manic and the melancholic. Two years later, when he more directly made the self-portrait in Plate 3, he maintained the expressionist style and sharply angular facial structure, something like early twentieth-century German Ernst Kirchner meets mid-twentieth-century French Bernard Buffet. The mood shares their grimness.

The woodcut anecdotes, dated October 1955, indicate that Smithson was already familiar with the rough life along that Manhattan crosstown boulevard then known for its movie theaters and prostitutes, Forty-Second Street, often in the companionship of his Clifton High School best friend, Danny Donahue, also an aspiring artist, to whom he dedicated it. Its date indicates that he produced it around the time of his award, on October 3, 1955, from the Art Students League, of an Elizabeth Carstairs Scholarship in the Merit Scholarship Competition. The jurors were artists Arnold Blanch, Thomas Fogarty, and Philip Guston. Receiving the scholarship intensified his academic disengagement and garnered him permission during his senior year to leave Clifton High at noon to take classes at the League, academically and parentally justified as job training as an illustrator. Four nights a week he took life drawing and painting composition classes from painter and illustrator Richard Bove (1920–2020), who also taught at Pratt Institute.

The Manhattan extracurricular ventures served Smithson not only as art instruction but also as escape, he recalled, from a "stifling suburban atmosphere . . . where there was just nothing."[6] The contrast between where he was coming from and where he was going parallels an observation by

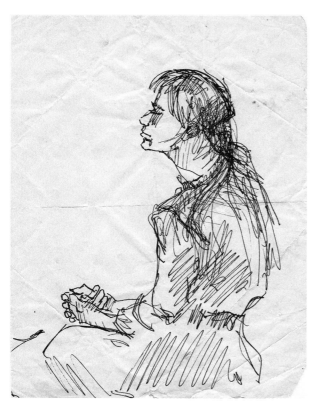

FIGURE 1.3. Robert Smithson, *Sketch of Kathy MacDonald,* 1955. Pen/paper, 10 × 7½ inches (25.4 × 19.5 cm).

Courtesy Kathryn MacDonald. Copyright Holt/Smithson Foundation / Licensed by Artists Rights Society, New York.

art historian Gavin Butts about the composer Ned Rorem and artist Jasper Johns: "The powerful drive to become an artist was founded upon an equally potent disidentificaiton with the reality of the culture in which they found themselves."[7]

Smithson and fellow League attendee Jonathan Levin, then known as Jo, later self-renamed as Eli (the name used here) a student at New York City's High School of Music and Art, became friends poring over art books, going down Fifty-Seventh Street to the Horn & Hardart Automat at Sixth Avenue, where no one objected to their hours of sitting and talking. Here he honed his sharp voice, perhaps absorbing the acerbic critiques in his copy of *The Satirical Letters of Saint Jerome,* who, for example, complained, "With his usual effrontery, Calphurnius, surnamed Lanarius, has sent me his execrable writings."[8] And he and pals evaded their under-legal-age status to drink at artists' hangouts like the Cedar Tavern, the White Horse Tavern, and the Five Spot, which Levin described as "that artists' bar where de Kooning and all his gang hang out, and has jazz, live. They hang pictures and have gallery programs. It's good, cheap, and honest."[9]

In the fall semester of 1955, Smithson also attended a weekly three-hour Saturday afternoon class in painting and drawing specifically for high school students given at the Brooklyn Museum Art School, taught by the well-regarded American figurative painter Isaac Soyer (1902–1981). Levin invited Smithson, who brought Donahue, to join the weekly sketching sessions hosted by Soyer's son Avron held in his father's studio. There they met and became friends with Levin's Music and Art High School classmates, artists Mimi Gross, Charles Haseloff, and Kathryn MacDonald.

In January 1956, the beginning of his final semester of high school, Levin invited Smithson to join him and Gross, then a couple, and others at an informal Friday night art seminar in Manhattan led by Columbia University professor of art Gilbert "Bert" Carpenter, in his home on Madison

Avenue and Ninety-Fourth Street. During the week attendees would view a designated gallery show, then gather to discuss it. In that postwar period, American Abstract Expressionism in nonobjective and figurative painting and welded sculpture was receiving increasing art world attention. Whereas before the war artists in New York City had been in the shadow of the dominant historical legacy of Paris, after it, as part of the United States' pride in its impact in concluding the war, they felt themselves to be in the center of a dynamic art scene.

The idea of forming a discussion group was Alan Brilliant's, Carpenter's undergraduate art student at Columbia College. Brilliant had also attended high school in New Jersey, at the southern end in Camden. Smithson was drawn to Brilliant's gallery-going companionship, his literary sophistication and knowledge of art, and his expansive personal library (which on a smaller but still substantial scale Smithson would emulate). Brilliant became a mentoring friend, lending books and paying for their meals and drinks together. He recalled the younger artist as

> tall, intense, hunched over, face covered with acne, walked with hands buried in his coat jacket pockets and his head bowed, but eyes roaming everywhere. Picture a gaunt giant insect with hands plunged down keep into jacket pockets, a frown on his face, always *peering* as if for predators, a predator itself. He always had a sardonic grin on his puss, loved the grotesque, had a hideous laugh and was smart as a whip.[10]

One week after high school graduation Smithson joined three pals—Donahue, Haseloff, and Levin—in signing up at the United States Army Reserves to serve their military obligation. Donahue was rejected because of a heart murmur, Levin for asthma. Their friend from Music and Art Miles Kreuger, who had a "passion for musicals, steered him toward the Special Services, the entertainment branch of the U.S. military," which he himself was joining.[11] Smithson and Haseloff were accepted and assigned to Fort Knox, Kentucky, for six months of active-duty training. Its Armored Replacement Training Center, which had been placed on inactive status in 1947, had been reactivated the year before, in 1955, for preparedness in relation to the Cold War with the Soviet Union and China. Along with Kreuger, the future film director and actor John Cassavetes was part of their Special Services group.

That summer, while Smithson was away at the Reserves, and Levin and Donahue were on a hitchhiking and sketching trip in Mexico, they and three others participated in an exhibition north of New York City in Armonk. Levin's father, Meyer, in his newspaper column "I Cover Culture," lauded it as a "historic first exhibition in Breezemont Park," skirting the

site's identity since 1936 as Breezemont Day Camp. then owned and run by Beatrice Gelbaum Laurain, a nurse and musician, and her husband, Jean Laurain, a French athlete. Ambitiously titled *The Coming Generation*, it was Smithson's very first public exhibition, albeit to an audience chiefly of youngsters. As some of the artists may have attended or worked at the children's summer camp, they likely initiated and organized it.

Meyer Levin was well known as an author of novels and nonfiction with a modest knowledge of art and great eagerness to promote his son and his son's pals. Although admitting to nepotistic attention, he praised Donahue's nude self-portrait as the "strongest painting in the show" and described Smithson's unnamed abstraction as "violent, tortured orange and black forms that look like pieces of jagged bone and rusty metal."[12]

One wonders if that painting's anguished mood expressed Smithson's own, exacerbated by being in the Reserves. In September, on "Special Services / The Armored Center, Fort Knox, Kentucky" letterhead, Smithson wrote MacDonald:

> I reached under my blanket and found a letter, as I did so, I discovered that something had been done to my bunk. The vultures that I have been forced to live with for the last 3-½ months had played a practical joke on me. They took all the springs from my bed and replaced them with string, so that I would fall through and land down on Charley who slept in the lower bunk. My heart beat at a terrible pulse. From there I went into the latrine and tryed to read my letter. But it was useless to attempt such a thing. I went back to my bunk and I stood next to it. The tensions and frustrations of my whole existence here began to well up inside of me. The loveless atmosphere, the triumph of pettiness, the social perversion. I could go on for ever relating one hellish aspect after another. Actually its not these things themselves . . .[13]

His bunkmate Haseloff recalled that men in their platoon "had it in for us, because I had a German accent, and Bob and I both used the Fort's library and read books."[14] Smithson was soon transferred from his initial assignment as clerk typist to being an artist-in-residence for the base, making posters and watercolors of scenes at the base for the mess hall. After being released from his six-month stint, he hitchhiked around the United States and Mexico with Donahue and Levin and, rather than returning to the family home, moved to Manhattan.[15]

He lived for a while in Brilliant's apartment on Park Avenue between Ninety-Seventh and Ninety-Eighth Streets, then Spanish Harlem and known as the El Barrio area. For the four-flights-up railroad flat, Brilliant

paid thirty-nine dollars per month. From there they could walk to a church (location unremembered) to view in the nave copious cherubim and seraphim carved by Smithson's great-grandfather Charles Smithson. After training in England as a plasterer and carver, Charles had emigrated in 1891 from Manchester with his wife and seven children, settling in the Bronx. He had distinguished himself sufficiently to merit a newspaper profile as a sculptor of decorative figures in churches, the Waldorf Astoria hotel, the Museum of Natural History, and the Metropolitan Museum of Art.[16] Charles's son Samuel, Smithson's grandfather, had as a young person worked alongside his father on the first New York City subway line, the Interborough Rapid Transit Company, particularly the Seventy-Second Street stop on Broadway.

Brilliant graduated from Columbia and became manager of Greenwich Village's popular Eighth Street Bookshop (one among many independent bookstores then in the area). Both wanting to see Smithson's art career move forward, they stripped bare the main rooms of Brilliant's apartment, painted them white, and made it into what they called the "Park Avenue Art Gallery." In December 1957 Smithson exhibited drawings, pastels, and gouache paintings on paper. Among the forty-five who attended the opening were their discussion organizer Professor Gilbert Carpenter, later director of the Witherspoon Art Gallery; Cecil Hemley, who had founded Noonday Press, which became part of Farrar, Straus and Giroux, and whose poems were in the first issue of *Pan*; the poet and founder of New Directions Publishing James Laughlin; literary critic Susan Sontag; the Eighth Street Bookshop co-owner Ted (Theodore) Wilentz, "and many other New York luminaries and ordinary citizens."[17]

To aid Smithson getting his own place, Brilliant told Wilentz that Smithson would be able to afford renting an apartment if he had a part-time job. Wilentz was so impressed with the artwork he saw that he bought a few paintings (*Untitled [Crucifixion]*; Plate 12, among several Smithsons they gave to the Hirshhorn Museum) and "invented a part-time job for Bob." He became the bookstore's "package wrapper, including lugging the packages to the post office . . . a position invented to 'subsidize' Smithson."[18] Brilliant commissioned covers from him for poetry collections he titled *Pan*. While the name calls up the ancient Greek half-goat god of wild nature and rustic music, Brilliant took it from his earlier mimeographed magazine published when he was in Mexico, *Pan* being the Spanish word for "bread." Smithson designed the covers for issues number 1, Winter 1958, containing poems Brilliant selected by a dozen writers, and number 2, "4 Issues of Poetry," also 1958, edited by Canadian poet Irving Layton with a large number of fellow Canadians, including the young Leonard Cohen. As noted, Smithson characteristically extended the title of the second issue to "Panic" and

intended to design covers for the following two—not published—as "Pant-ing" and "Pandemonium" (see Figure P.4).

Another benefit of the apartment gallery show may have been its inspi-ration of Meyer Levin to devote one of his columns to Smithson. In it, he re-counted that the young artist "asked me to recommend him for a grant from a foundation," suggesting Smithson's confidence that the well-regarded writer viewed his painting favorably. Indeed, titling his essay "How Can You Spot an Artist-To-Be?" Meyer answered, regarding Smithson:

> He has tremendous concentration and absorption in art. He has the rebellious and experimental bent necessary to young artists. He has a powerful sense of form and the ability to communicate through images, whether abstract or representational. . . He's a gawky, Lin-colnesque lad with intense eyes. An artist, sure enough, whether he makes fame or not. I'd say he's a good bet to come through, one day, with work of individual power.[19]

Smithson must have been gratified to receive his friend's father's pane-gyric, especially as it was his first professional affirmation in print. But he never mentioned it; rather, he recounted that as a high school student he had been "very much encouraged by Federica Beer-Monti who ran nonprofit The Artists' Gallery when I was sixteen or seventeen. She was an Austrian woman of the circle of Kokoschka and that crowd."[20] Even so, his first exhi-bition there was not until three or four years later, at twenty, when he par-ticipated in the Artists' Gallery's 1958 show, *New Talent*. The gallery's mis-sion statement made its booster function explicit: "Supported by voluntary contributions to exhibit the work of mature contemporary artists so that their work may be seen by the public and taken under the sponsorship of commercial galleries."[21] The Artists' Gallery's affirmation by including him in exhibitions in 1958, 1959, and 1960 would catapult him into exhibitions at commercial galleries. Crucial to that leap was his solo show there in 1959.

A few weeks before the October opening, Smithson wrote his child-hood chum with whom he had recently reconnected, Holt, who was then a senior majoring in biology at Jackson College for Women, a coordinate college of Tufts University with shared coed classes. Smithson described the neighborhood where until recently he had shared a loft above a syn-agogue at 27 Montgomery Street on the Lower East Side with Brilliant's best friend from high school, Phil Israel, and also for a time, Levin. "'Mur-der Mile' says the tabloids . . . on the pavement was a big sign that said DRAGONS 'The Blacks and Spics are wiping out the Jews.'" (Neverthe-less, when Smithson and Israel moved out, that did not deter the Jewish-identified artist Sol LeWitt from snapping up the loft. LeWitt recalled, "I

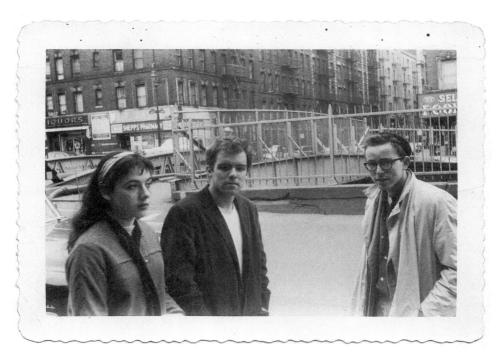

FIGURE 1.4. Smithson snapped this picture in 1958 of friends outside Alan Brilliant's apartment building on Park Avenue just north of Ninety-Seventh Street, Manhattan. The woman on the left has not been identified; Eli Levin is in the middle; Brilliant is on the right, wearing an artist's beret. Courtesy Holt/Smithson Foundation and Nancy Holt Estate Records, Archives of American Art, Smithsonian Institution. Copyright Holt/Smithson Foundation / Licensed by Artists Rights Society, New York.

gave him $100 [as a finder's fee and/or for residential improvements], rent was $23.50/month.")[22] After describing broken windows and "furniture always burning in the street," Smithson summarized to Holt, "So goes life in the lower depths. My paintings are Posters from Hell." His punning adoption of the title of Maxim Gorky's play about impoverished desperation conjures a life both downtown and downtrodden.

The infernal "posters" also served as postcards from his personal netherworld. Describing "N.Y.C. in the summer" as "curious and deadly" and saying that it was his "first season without a vacation"—sounding like the indulged only child he was—he continued, "Nothing but hanging around fitting pieces together both Psychic and Otherwise. I pulled many paintings out of that caved-in atmosphere."[23]

Of his 1959 solo show's sixteen paintings, titles suggest figuration and coalesce around the dismal, confirmed by extant photographs of a few: *Blue Dinosaur* (a sad—blue—extinct beast whose wide-open mouth and thrusting tongue threaten to devour); *Flesh Eater* (likewise, a geometrically collaged head baring arcs of teeth and a tongue broad and forked); the triptych *Walls of Dis* (the name of the capital city of the three lowest circles of hell in

FIGURE 1.5. New Jersey classmate and friend Lorraine Harner took this picture during a visit to Robert Smithson's studio, spring 1960.

Courtesy Lorraine Harner.

Dante's *Inferno*); and an assortment of creatures dangerous—*The Assassin, Shark Man, The Spider Lady*—and crazy—*Portrait of a Lunatic*. Others evoke desolation: *The Absence, Living Extinction, The Ruins, The Victim*. In *Arts*, reviewer Margaret Breuning reported the show as a bunch of gratuitous oddities exemplifying "the old game of 'shocking the bourgeois.' . . . If some system of sorcery or necromancy is to be inferred from the trivia of detail . . . it is certainly not one that is widely recognized."[24] She got that right, regarding both the references and their obscurity. In *Art News*, critic Irving Sandler historicized Smithson's band of outsiders as "These monsters, whelped by Surrealism and primitive art, are reared by frenzied Action Painting. *Walls of Dis*, with its crude totemic creatures, would have looked well in the temple of some savage cult."[25]

Unmentioned was an anomalous nonfigurative abstraction on a theme that would have been considered perverse, *Portrait of a Transvestite*. Its image, known only through a black-and-white photograph, will be described later; for now, we can discern another version of it in his studio the next year in Figure 1.5, on the wall back, left.[26]

Yet it wasn't the primitive, the provocative, or the privations that propelled Smithson's career but the more ambiguously perilous *Quicksand* (1959; Plate 4). "Fundamentally abstract" is how he would later downplay it, as "sort of olives and yellows and pieces of paper stapled onto it; it had a kind of incoherent landscape look to it."[27] That format rendered it akin

to contemporaneous densely collaged and mixed-media paintings by Robert Rauschenberg, such as *Collection* and *Charlene* (both 1954), conglomerations exemplifying artists' working their way out from under the dominant painting style then, the dramatic vivacity of Abstract Expressionism's solely painted, often thickly impastoed, surfaces. But Smithson's description didn't account for his choice of depicting a terrain with treacherous sucking. *Quicksand*'s timely technique and quasi-representational, semiabstract straddling spoke to George Lester, who in the fall of 1960 saw it in the window of the Alan Gallery and purchased it for $200 (the price stated on the Alan Gallery label on the back) or less. Owner Charles Alan took advantage of the Artists' Gallery's energetic routine of visiting studios of unaffiliated artists to canvass for new talent and picked up some to sell under consignment and display under the Alan's commercial canopy at Madison Avenue and Sixty-Sixth Street.

Lester (1914–1997), a graduate of Cambridge University (1936) and Harvard Law School (1939), and former U.S. vice-consul to Italy based in Milan, had resigned his position and moved his family south to found his eponymous gallery of modern art in Rome.[28] Scouting art in Manhattan for gallery artists, he was intrigued by Smithson's *Quicksand* and arranged to visit what Smithson had described to Holt as his "newly renovated studio—doesn't that sound Chic . . . new white pure white walls + ceiling—on 6 ave + 23 St. It's sort of in the hinterlands between the Garment district and the Village."[29]

The nascent dealer, age forty-six, tall, slender, reserved in demeanor, was drawn to Smithson's intensity and decided to represent the twenty-two-year-old artist. Lester offered him an advance against sales of seven hundred and fifty dollars, a monthly stipend of seventy-five dollars—more than sufficient for rent and expenses—and a three-week solo show for the middle of the following summer of 1961 with an illustrated catalogue.

The international distance between them and, as it turned out, Lester's and Smithson's differing views of appropriate inclusions, sparked extensive negotiations by mail. But just as much, Smithson's more than twenty

GEORGE BACON LESTER
B.A. Cambridge Univ. 1936
17 Dunster St.—Phone: Eli 9242
Powell

Villa King San Reno, Italy

FIGURE 1.6. George Lester, Harvard Law School yearbook, 1939, the year he graduated. Courtesy Harvard Law School Library.

handwritten letters—Lester's to him appear to be lost—read like a confidential epistolary tête-à-tête providing an intimate reckoning of the young man's longings prior to becoming a famous art world figure known for his rhetorical bite. In the first, Smithson made a point of stating his bond with Lester: "Since I met you, you have displayed such a remarkable enthusiasm, I feel I can trust you as a friend." His declaration of affiliation blatantly conveys overcoming a hesitancy of trust, as well as a premature perception of business support as personal alliance. Writing the former diplomat, the artist is by turns deferential ("I believe in your venture"), defensive ("I only hope all transactions can be taken care of gracefully"), conspiratorial ("With that in mind, you can count on my support, to help make your gallery the Best in Rome"), and grandiloquent ("I expect this show to be a turning point, toward a new realm of art. Avenues that people never thought existed will be opened; avenues Forgotten will be revised").[30]

That was a lot to expect from a three-week show in Rome opening in the sweltering mid-summer on Saturday, July 15, when even as tourists continued to arrive Romans were departing for holidays. Smithson had noted to Lester that "the art world in New York shuts down in mid-June" for summer hiatus in eastern Long Island, and he urged an early June publication of the "catalogue" (April 7, #4). The actuality of that is shown in Lester's quarter-page text-only advertisement in the June 1961 issue of *Art in America* listing summer exhibitions by Claudio Olivieri and Enrico Della Torre, painters of nonfigurative abstractions, preceding Smithson. On the opposite page, the well-regarded uptown Manhattan Staempfli Gallery announced a group show of a few midcareer figurative painters from the San Francisco Bay Area and midlevel New Yorkers and stated that the gallery would be closed July 22 to September 8. But Smithson made no reference to dealers' practice of displaying during summer months such work of lesser stature or group shows on flimsy themes.

Smithson's sweeping prophecy of his show's impact displays his personal ambitions. It also voiced the social mood of upbeat optimism after a strong economic recovery from the privations of World War II and emanating from the recent election of the youngest man ever to become president of the United States. In his inaugural address, John F. Kennedy had announced, "Let the word go forth from this time and place, to friend and foe alike, that the torch has been passed to a new generation of Americans, born in this century." That fervent desire for change, as well as attention to literary suavity, is evident in the younger Catholic, Smithson's, own writing.

Between procedural pragmatics and descriptions of paintings in process, Smithson shared with his patron his evolving creative aspirations. Although he had not attended college, his reading and self-reflection

stimulated a strong sense of who he was and what he wanted. His descriptive detail indicate that these were not simply the emotional outpourings they first appear, but a mixture of self-analysis and obsession: "Each stroke of paint contains grace. Granted, not the 'discipline' of Giotto, but the 'discipline' of those martyrs hacked and sliced in the Circus of Diocletian. Not *Aesthetic* discipline but *Ascetic* discipline" (undated [June 1961], #12). His distinction between asceticism and aesthetic form is strikingly similar to the thrust of Hans Sedlmayr's *Art in Crisis: The Lost Center* (Germany 1948; Smithson owned the U.S. 1958 edition in English). The Austrian art historian believed that following the French Revolution, art had descended into a "chaos of total decay." Years later, Smithson will gain attention as a contentious objector to critic Clement Greenberg's narrow, late modernist aesthetic formalism. That reigning interpretive approach valued art for its attention to visual and stylistic form, preferably abstract, over subject matter, without integrating environmental factors and social contexts. But Sedlmayr was Smithson's first source of his repudiation of that attitude:

> The fact is that art cannot be assessed by a measure that is purely artistic and nothing else. Indeed such a purely artistic measure . . . would be merely an aesthetic one, and actually the application of purely aesthetic standards is one of the peculiarly inhuman features of the age.[31]

The terms of Sedlmayr's criticism of early twentieth-century abstraction and Surrealism recall the Nazis' 1937 exhibition that denounced modernist art and artists, *Degenerate Art*, which he may have viewed. But he "diagnoses" (a medical analogy that in his own critiques Smithson will frequently employ) from an explicitly religious perspective, "from the facts of art that the disrupted relationship with God is at the heart of the disturbance."[32] Regarding the "lost center," Sedlmayr, a devout Roman Catholic, advocated artistic attention "not to the wheel of history, but [to] the axle about which it revolves." That is, a spiritual life that will "flower . . . in the soil of knowledge, the knowledge that we are creatures of God."[33]

Smithson displayed that spiritual devotion himself and extended it to a belief about the direction of current painting. Writing Lester early in 1961, he stated that he would submit work to a Museum of Modern Art competition called "Recent Painting U.S.A.: The Figure. . . . This will give you an idea which way the trend is going." In his negotiation with Lester about which of his paintings would be exhibited, he presented MoMA's focus on figuration as evidence of its art world currency. His polarizing rationale viewed figuration as opposite to Lester's preference for abstraction. But at the time, until Pop Art swept aside loose painterliness around

1962, figuration commonly took the form of expressive gesturalism akin to Willem de Kooning's *Woman* series, Larry Rivers's portraits, and Grace Hartigan's urban scenes, blurring distinctions between abstraction and representation. Smithson used that stylistic categorization of "figuration" to justify his own way: "I have a . . . Man of Sorrow series that I want them to see" (undated [Jan./Feb. 1961], #2). His paintings were not included in the MoMA show that spring and summer.[34]

A few months later in his letter of May 1, Smithson identified these as *Man of Sorrow (The Passionate)*, *Man of Sorrow (The Forsaken)*, *Triptych*, and *Man of Sorrow (The Doubted)*, each oil on canvas. The first two are extant and dated on the front 1960; the last is missing. All are rendered in the visual language of expressionism, with rough, gestural red and black brushstrokes over white against black backgrounds (which may, as in the nonfigurative *Dies Irae*, refer to the darkened sky at the time of the crucifixion, according to Luke 23:45). The forms are distorted both in abbreviated shape and spatial flatness.

The Passionate is an over-life-size frontal view of a nearly nude, bearded Jesus with a sober expression and large eyes stiffly staring at the viewer akin to Byzantine portraits. Behind both his head and halo and his lower body are three narrow horizontal lines; their irregularity in white against black calls up the similar, obviously handmade stripes in those colors in Frank Stella's radically reductive paintings that generated so much attention in the Museum of Modern Art exhibition *Sixteen Americans* (December 1959 to February 1960). Most of Smithson's lines have a fringe of black paint drips demonstrating his affiliation with Abstract Expressionism as did mixed-media paintings in the 1950s by Robert Rauschenberg and paintings by Alex Katz, Andy Warhol, and others.

Smithson's *Man of Sorrow (The Passionate)* stands with his hands raised to shoulder level, exposing the wounds in his palms. The large halo behind Jesus's head is a quadrated circle—that is, it is overlaid with a cross of equal-length arms, the head at the center point. This motif is the sun wheel—the whole disk of the circle etymologically relates to the concept of being holy, but with horizontal and vertical spokes, it is also called an encircled cross. This combination of circle and cross is an ancient symbol of divinity sacrificed and is akin to the labyrinth on the floor pavement of the nave at Chartres Cathedral. In *The Self in Psychotic Process: Its Symbolization in Schizophrenia* (in Smithson's library), psychiatrist John Weir Perry explains that when Jesus began to be depicted as crucified on the cross in the eleventh century, his head was placed at the intersection of the arms of the cross, supplanting the prior ancient symbolization of Christ's sacrifice that pictured a lamb at the center of a sun wheel.[35]

Another he listed in the series, *Man of Sorrow (The Forsaken)*, *Triptych*,

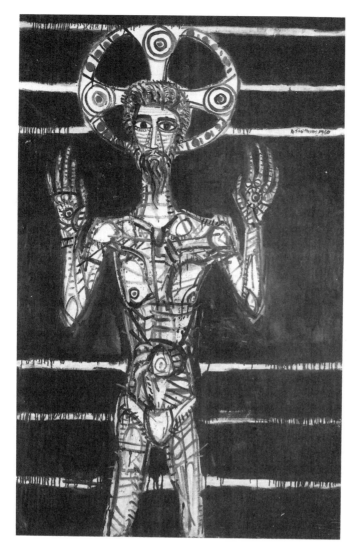

FIGURE 1.7. Robert Smithson, *Man of Sorrow (The Passionate)*, 1960.
Oil/canvas, 77½ × 47½ inches (197.3 × 120.6 cm). Collection of
Ikeda Gallery, Japan. Copyright Holt/Smithson Foundation / Licensed by Artists
Rights Society, New York.

seems to refer to paintings that have been separated. Currently, one known
by that title is of a frontal close-up of the face of Jesus wearing the crown
of thorns, the sixth act of persecution among the fourteen Stations of the
Cross in the torturous Passion of Christ leading to his death and entomb-
ment. Another set known by that title must have framed it as the triptych's
wings. They depict close-up views of hands, palms out, displaying a prom-
inent wound in the center with strokes from it. Plate 5 pictorially reunites
them.

The gesture of the raised hand, palm outward—originally to show to

an aggressor that one is unarmed—is by custom the act before testifying, taking an oath to speak the truth. So, the big bloody hands in Smithson's painting, with lines of a pinwheel around a dark center in each palm, are as if confronting a doubting interlocutor with corporeal evidence. That act confuses its possible subject with the third painting in the series, *The Doubted*, but they are a different size than Smithson listed in letters for it.

The mood of these *Man of Sorrow* images is anguished. Smithson's aim was not the concurrent modernist investigation of what can be done with the medium or with non-illusionistic space, prominent then in critics' discourse about nonrepresentational Abstract Expressionism. Believing his figural series of the agonies of Christ to be on trend and potentially appealing to MoMA curators, he alerted the distant dealer to the sensibility of paintings forthcoming for his Rome exhibition.

The Bible's Old Testament prophecy of Isaias (Isaiah 53:3) is taken to be about Christ's Passion: "Despised, and the most abject of men, a man of sorrows, and acquainted with infirmity: and his look was as it were hidden and despised, whereupon we esteemed him not."[36] Smithson's use of the singular—*sorrow*—is significant. The "Man of Sorrows" is the religious and art historical term for the devotional image of Christ post-crucifixion displaying his wounds. Smithson's usage of the singular was not a slip; in that letter he wrote it that way four times. Rather, a "man of sorrow" sounds like a characterological description of a person "acquainted with infirmity" and suffering from chronic mourning. That is an attribute of melancholia, the subject of what in the future he identified to artist friend Dan Graham as his favorite work of art, Albrecht Dürer's engraving *Melancholia* (1514).[37] The trait is extensively discussed in Robert Burton's famous seventeenth-century essayistic medical textbook *The Anatomy of Melancholy*. Smithson's good friends' description of his temperament suggests that his ownership of an edition of Burton published in 1955 was likely due to his identification with that mood. His own oft-professed fatalistic attitude displays affinities to what Burton summarized as "a commotion of the mind . . . perpetual anguish of the soul, fastened on one thing, without an ague [fit of fever or chills] . . . *Fear* and *Sorrow*."[38] With his *Man of Sorrow* series, Smithson conflated the mood's reference to Christ and to himself.

Sometimes Smithson's writing to Lester surrounds a drawing. His letter of April 7 shows "the first version of *Death Taking Life*." Within a rectangle he drew a male head in profile, intricately marked with black lines, biting onto another person's forearm inserted into his wide-open mouth, and gripping it with his left hand. It's an elaboration of the teeth-baring open jaws of his *Blue Dinosaur* and *Flesh Eater* in his 1959 solo show, and a 1960 *Untitled* in the Utah Museum of Fine Arts, with the addition of a victim's limb in the mouth. The famous precedent of a male chomping on another's

FIGURE 1.8. Robert Smithson letters to George B. Lester, 1960–1963. Archives of American Art, Smithsonian Institution. Copyright Holt/Smithson Foundation / Licensed by Artists Rights Society, New York.

In the first lines of his letter to George Lester, April 7, 1961, page four, Robert Smithson sketched the gouache in Plate 6. Both have that big fearful mouth familiar in his early paintings of monsters.

arm is Francisco Goya's painting of an unhinged *Saturn Devouring His Son* (1820–23). Smithson's schematic head reduces and flattens Goya's broadly brushed volumetric nude seen squatting and deliriously gripping the youth whose arm he gnaws.

Above the drawing Smithson wrote, "Remember this?" The *Death Taking Life* sketched in the letter is of a collage-and-opaque watercolor on board (Plate 6). It had been purchased the previous year by Raymond Saroff, who had seen Smithson's work at the Artists' Gallery and visited his studio near him in Chelsea to see more. Saroff recalled that 1960 visit:

> At the time I knew little of art, but my [life] partner [Howard Rose, who worked at the Alan Gallery] suggested I check out the shows at the Artists' Gallery. I wasn't interested in Smithson's religious subjects, the crucifixions, that I saw at the gallery and plenty in his studio. But I liked what he was doing—the artistic brain behind them. The images' grotesqueness appealed to me.[39]

Around this time Smithson was photographed with a large oil version of that cannibalistic scene depicting both of the eater's hands.[40] In March 1961 the Alan Gallery exhibited that subsequent *Death Taking Life*. The

35

checklist identifies it as fifty-seven inches high, the same height as Goya's painting, and at thirty-six inches wide just three inches more than the Goya. The similarities suggest that Smithson's painting was inspired by, if not an homage to, the monumentally horrific image from Goya's late series known as his Black Paintings, which depicted Christian rituals, witchcraft, and, in *Saturn Devouring*, parental depravity. The fear of being swallowed up by a parent is a familial manifestation of the terror of being submerged in quicksand's unstable ground—both are apprehensions of being devoured by an overwhelming environment.

Below that letter's drawing Smithson reverted to imaginative metaphor. "The Chaos was beginning to reveal its face. The collage turned in[to] an IKON [his spelling adopting that of early Christianity]. For the most part I have abandoned the shattered image . . . the distorted image." Again, Smithson sounds like Sedlmayr. In a chapter titled "Chaos Unleashed: The Revolution in Painting," the art historian declared Goya to be "one of the great pulverizing destructive forces that bring a new age into being. . . . The new element ["the demonic"] in his art has no connection with the public sphere, but derives from a completely subjective province of experience, from the dream."[41] Sedlmayr believed Modernism's painterly distortions and receptivity to the unconscious to be "man's error [that] really does represent an attempt to arrive at a . . . truer picture of the First Person of the Godhead. The attempt naturally fails and the suppression of this spiritual need has led to deep and terrible experiences of death, chaos and of the demoniac."[42]

Following Sedlmayr, when Smithson got "all the chaotic demons in their place," he abandoned the "shattered image" and his painted figures became more recognizably human (April 7, 1961, #4). To Lester, Smithson acknowledged that the subject matter of his paintings was out of sync with his time, but he insisted that the time—that is, the art world—would come around. He differentiated his imagery into two groups. "My patrons here in N.Y.C. are concerned not with my 'modern' works but with my more spiritual works. In fact, I sold more spiritual works than modern this year" (May 17, 1961, #7). Smithson's bifurcation of "modern" as nonfigurative abstraction and "spiritual" as figurative was broadly accurate, both historically and as understood at the time. The consensus of the avant-garde New York art world, articulated in 1954 by Greenberg and included in the critic's influential *Art and Culture*, published a few months before Smithson's own statement, was that "representational painting and sculpture have rarely achieved more than minor quality in recent years, and that major quality gravitates more and more toward the nonrepresentational."[43] The models most available of religious art were representational.[44]

In the mid- to later 1950s, the National Council of Churches' Commission on Art began to merge what Smithson antinomized as "modern" and "spiritual" by advocating that Protestant churches incorporate modern art into church decor and religious representations. Strongly influenced by nonobjective Abstract Expressionism, a working paper stated, "When it is recognized that genuine art is not didactic, moralistic, propagandistic, inspirational—and in this connection, not representational—then its proper universality and cultural relevancy are reestablished." Of course, as a Catholic, Smithson would not have experienced modern art in Protestant churches.

In 1959, the exhibition catalogue for the Museum of Modern Art's *New Images of Man* included a preface by Lutheran theologian and existentialist philosopher Paul Tillich, who lauded the artists' depictions of faces (none Christological) as possessed by "demonic forces," although curator Peter Selz described the shared sentiments as existential dread, which also would have appealed to Smithson.[45] As an expressionist then leaning toward figurative work, Smithson undoubtedly saw *New Images of Man* and could have considered it an affirmation of his own production of anguished, if more explicitly religious, figuration. Tillich's remarks may have even been a distant source of his comment to Lester about getting his own "chaotic demons" under control. In either case, whether historical paintings were of biblical subject matter or modern spiritual evocations, they were figurative, so Smithson associated his "religious" work with that side of his binary.

The simplistic opposition of advanced art as nonrepresentational and not religious, versus religious art as figurative, correspond to what historian Sally M. Promey has critiqued as "the secularization theory of modernism."[46] It ignores or is uninformed of Wassily Kandinsky's *On the Spiritual in Art* (1912) and his, Paul Klee's, Kasimir Malevich's, and Piet Mondrian's, as well as Arthur Dove's, Marsden Hartley's, Georgia O'Keeffe's, and other Americans' use of abstraction for spiritual aims (in addition to the more recently recognized Swedish artist and mystic Hilma af Klint and Swiss artist Emma Kunz). All, and many more, were inspired by reading about the late nineteenth-century, early twentieth-century fusion of ancient and modern, Western and Eastern, spiritual traditions, Theosophy.

But before modernist art historians became receptive to those abstractionists' devotion to esoteric spirituality, Smithson also had to fight the disparagement of religion in art on account of its association with both establishment tradition and populist sentimentality. Explicit religious imagery was characterized by the bland piety and representational conventions of the hugely popular *Head of Christ* (1940) and *Christ at Heart's Door* (1942) by the Chicago painter, illustrator, and ad man Warner Sallman, whose religious denomination was Evangelical Covenant. Those images continue

to be widely reproduced in formats from printed canvases to prayer cards and have been given art historical credibility through analyses by major scholars. Art historian David Morgan identified nineteenth-century British and German sources and described the appeal of Sallman's *Christ at Heart's Door* (Plate 7):

> Viewers appreciate the unambiguous legibility of Sallman's picture. . . . The barely concealed [shape of a] heart produced by the luminous Christ and the frame of the doorway conveys the savior's call to the soul ensnared in the thistles of sin and the darkness of ignorance and willfulness. . . . The image offered assurance of Christ's benevolent yet persistent love.[47]

That is not the sentiment evoked by Smithson's tense "Christ series." And one has only to compare Sallman's gauzy illusionism of Christ in shafts of golden light to the fervor of Smithson's *Man of Sorrow* pictures to recognize the extent of the abstraction of Smithson's figurative religious works.

Smithson's benefactor in Rome had been drawn to his abstract *Quicksand*. It corresponded to the current incorporation of collage and to Lester's taste for expressive surrealist or nonobjective forms prominent in his own youth. But Smithson made it clear that "at that time I really wasn't interested in doing abstractions. . . . I was always interested in origins and primordial beginnings, the archetypal nature of things. And I guess this was always haunting me all the way until about 1959 and 1960 when I got interested in Catholicism."[48] The chronology is confirmed by Smithson's paintings with Christian themes dated 1959 (earlier ones are lost). His friend Kathryn Mac-Donald recalled, "In the early 60's Smithson fell in love with God and the Catholic church. When I suggested that the search for God might be more direct through a simpler form of faith, less pomp and ritualistic, he insisted that the grand ritual was the whole point."[49]

However, their accounts of his awakening to Catholicism is complicated by prior situations. He had been baptized, received First Communion, and confirmed in his childhood at the appropriate ages. Levin wrote in his 1958 diary, when both were twenty, "Bob painted another St. Anthony, the largest ptg he's done, loose and good in parts. Six foot long."[50] Saint Anthony is the patron saint of lost things. A few years before his statement to MacDonald, Smithson gave her a copy of Nathanael West's novella *Miss Lonelyhearts*, on the pages of which he had drawn and painted; he did that also in another copy given to Brilliant and had a copy in his own library as well. His strong connection to the book suggests that he identified with the title's implication of disconsolation, the protagonist's double gender

associations—being a male newspaper journalist writing the personals advice column "Miss Lonelyhearts" as if it were by a female respondent—and who was a Roman Catholic ridiculed for his avid beliefs. West wrote that Miss Lonelyhearts thought to himself, "As far as he could discover, there were no signs of spring. The decay that covered the surface of the mottled ground was not the kind which life generates." A companion remarks, "You're morbid, my friend, morbid. Forget the crucifixion, remember the Renaissance. There were no brooders then."[51] Smithson himself preferred the more morbid Gothic period and in the future would promote consciousness of decay as "entropy." By giving his personalized hand-illustrated *Miss Lonelyhearts* to these two good friends, he may have been tacitly telling them about himself.

Smithson justified his engagement with Christological imagery professionally by asserting that abstraction was not the direction perspicacious influencers in the then capital of the art world were going: "Collectors, who have been buying the most 'advanced' nonobjective work, are now interested in absolutes" (undated [May 1961], #8). Again, his stylistic distinction between "modern" and "spiritual" does not pertain. He was either unaware of or ignoring the convergence of nonobjective Abstract Expressionism and the purity of "absolutes." As Barnett Newman had written in his 1948 polemic, "The Sublime Is Now," "We are reasserting men's natural desire for the exalted, for a concern with our relationship to the absolute emotions."[52] Greenberg described the goal of advanced art as

> the expression of an absolute in which all relativities and contradictions would be either resolved or beside the point. . . . It has been in search of the absolute that the avant-garde has arrived at "abstract" or "nonobjective" art. . . . Content is to be dissolved so completely into form that the work of art or literature cannot be reduced in whole or in part to anything not itself.[53]

Smithson seemed to think that the approach to "absolutes" should be expressionistically figurative and imply narrative. He was clearly deliberate about the anguish in his crucifixion pictures. His recognition that "the spirit of my art is being drawn from a Pre-Renaissance mood. Nature has all but evaporated. Divine Suffering has taken the place of Nature" (April 7, 1961, #4) parallels Sedlmayr's statements "The forerunners of modern art appear in movements and in areas that are spiritually antagonistic to the Renaissance" and "Art must not be judged by some supposed faithfulness to nature, some imaginary correctness of representation."[54] In mood, it is Gothic. Smithson's priority of conveying corporeal pain corresponds

to that described in the editor's preface to *The Cloud of Unknowing*, the fourteenth-century mystical guide to contemplative prayer by an anonymous British priest or Carthusian monk, published in 1961 and trending among New York intellectuals:

> We can recognize in medieval Christianity a gradual movement towards more personal and passionate kinds of religious devotion. . . . The conception of Christ as a warrior [who] defeated the Devil and thus released human souls from his tyranny, which was dominant in earlier religious writings, was . . . from the eleventh century onwards . . . outshone by one of Christ as a wounded and suffering man, sent by his Father to arouse compassionate love in his fellow human beings and thus draw them back to God.[55]

This description correlates to the emphasis of Smithson's "Pre-Renaissance" spirituality on Christ's human woundedness. Alienated from the Renaissance's classical serenity, Smithson found appealing the fervent styles bracketing it, first the preceding Medieval and, later, Mannerism.

Smithson had sources of his own woundedness, current and historical, that both drove him to Christ and sparked what he described to Lester as "my spiritual crisis. A crisis born out of an inner pain, a pain that has overwhelmed my entire nervous system." He continued that letter to Lester, "When I painted *Purgatory* [Plate 8] and *The Walls of Dis* [both 1959], I painted in a thick despairing way" (May 1, 1961, #5). One source of his sense of desolation in 1959 must have been the sudden death that year in a motorcycle crash of his intimate buddy, Danny Donahue.

Smithson had illustrated his agony with images of imprisonment—in purgatory, where souls are purged of sins, or in Dis, the city of the lowest three circles of hell in Dante's *Inferno*, which confined the most malevolent sinners such as the violent and bestial, fraudulent, hypocrites, and betrayers, guarded by fallen angels.[56] Both feature a shallow expanse crossed by an irregular black grid as if by a chain link fence. In *Purgatory*, behind the grid are barely discernible grimacing faces. He eliminated them in *Walls of Dis*. Both show a multitude of circles with centered dots; the lattices not only enclose the swarm but serve to contain emotions. He continued to Lester:

> From that despair emerged the absolute ikons of Life and Death, [single linear figures, in torment] ikons infused with the feelings of

the Aztec human sacrifice; the visions of the Spanish mystics; and the Martyrdoms of the Early Church. Against backgrounds of *dead space* and *no-time* [literally, the solid black backgrounds of his *Man of Sorrow* series], I painted ikons bleeding from every stroke, without mechanical distortions, unlike the dispassionate distortions of cubism, each stroke becomes a raw nerve. . . . I am modern artist dying of Modernism. (May 1, 1961, #5)

One source of his despair was professional estrangement. Advanced art's prohibition against representation of the personal in favor of experimentation with form was obstructing his renderings of sacrifice and mortality. His characterization of his malaise corresponds to Sedlmayr's anti-Modernism, for example, "Cubism lays the emphasis on deadness."[57]

Elaborating in that May 1 letter, Smithson declared, "Those without souls can continue seeing 'truth' in targets." His zinger toward Jasper Johns's iconic target paintings—deliberately banal object, obscure juxtapositions, absence of drama—particularly pertains to the version owned by the Museum of Modern Art. Over the bright bull's-eye, its row of identical cast faces is covered by a continuous plank above their noses, preventing sight either by or into those windows to the soul. MoMA's *Target with Four Faces* (1955) and three other *Target* paintings by Johns had been prominently showcased in the exhibition *Sixteen Americans*. The show was heralded as displaying modes beyond the dominant Abstract Expressionism; curator Dorothy C. Miller described the sixteen artists as demonstrating "an unusually fresh, richly varied, vigorous and youthful character."[58]

With his swipe, Smithson distanced himself from this "fresh" turn most prominently by Johns and Robert Rauschenberg, who led toward pop, and by Ellsworth Kelly and Frank Stella, precedents of Minimalism, all in the show. In the MoMA catalogue, Carl Andre's statement on behalf of Stella displayed the current deflation of Abstract Expressionism's rhetoric of emotion and existential self-absorption. "Frank Stella is not interested in expression or sensitivity. He is interested in the necessities of painting."[59] The persona of the artist had become an emotionally detached professional. On the cusp of the shift from spontaneously emotive to deliberately conceptional art, the compositional constraints and incisive title of one of Stella's paintings in *Sixteen Americans* signaled the direction forward: *The Marriage of Reason and Squalor*. "Reasoned" painting and sculpture—geometric abstraction and representations of ready-made commercial and cultural icons, both without tactile evidence of the hand of the artist—will soon prevail. Smithson, on the contrary, still affiliated himself with the gesturally and subjectively messy "necessities" of absolutes.

FIGURE 1.9. Julia Duke and Robert Smithson, possibly on the occasion of his confirmation rite as a Roman Catholic, May 22, 1949, which clearly made his devout aunt very proud. Photographer unknown.
Courtesy Holt/Smithson Foundation and Nancy Holt Estate Records, Archives of American Art, Smithsonian Institution.

But Smithson's more immediate experience of the act of dying and being a "Man of Sorrow" was that about which he began that May 1 letter to Lester. "This week someone very close to me died. She was like a second mother to me. This lost has upset me very much." "Lost"? The customary euphemism is "loss." The substitution hints that the death of his "second mother" had become his personal "lost center." Exactly one week later Smithson requested that Lester print a dedication in the catalogue "FOR JULIA DUKE" to "make me feel better." His aunt, who lived with his family and had not been ill, had had a fatal heart attack. His mother's elder sister, Julia was fifty-seven and unmarried; she had left school after the eighth grade and at the time of her death had been a stenographer in the office of the Waldrich Bleachery, a local textile manufacturer, for thirty years. As it was the convention of the day for unmarried adults to not live on their own, Julia had resided with her elder married sister Mary Dvorschak and her husband, Joseph, an accountant, and their two daughters prior to moving to the Smithson household around the time of Smithson's birth. Julia encouraged Smithson's practice of Catholicism, the Duke family religion, and took him with her to museums and musicals.

Julia Duke's death exacerbated his spiritual crisis. Yet in 1961 neither his grieving nor his religiousness can be thought of as more than intensifiers of Smithson's preexisting condition of being a devout Roman Catholic drawn to Christ's suffering. He had previously exhibited a *Man of Sorrow* image in an Artists' Gallery group show, *New Painting 1960*, and painted those grimacing faces, some males with big red lips, behind bars in *Purgatory* in 1959. Smithson's disconsolate references in images and texts both preceded and continued after her death.

Smithson declared to Lester, "The over all effect of the show + catalog should convey a 'Dark Night of the Soul.'" Today that description of nocturnal despair may be familiar from its use by several popular culture

musicians and novelists, or from its quotation or allusion by Paul Valéry, T.S. Eliot, and F. Scott Fitzgerald. But Smithson's source appears to be more direct, the untitled poem and discourse elaborating it written by the sixteenth-century Spanish member of the order of the ascetic Carmelites, Saint John of the Cross, the originator of the metaphor of the "dark night." He owned a new translation of Saint John's treatise *Ascent of Mount Carmel* published in 1958 by a Christian imprint. In it the literary mystic describes darkness as a period not only of confusion and challenges on the path toward spiritual development, but also of being unable to visualize the Godhead in "this dark night, through which the soul passes in order to attain to the Divine light of the perfect union of the love of God."[60] The process of purification is the first of several spiritual/psychological journeys Smithson will evoke in the course of his life's literary peregrinations.

To Lester, Smithson concluded, "The paintings should make people mortified and fill their eyes with suffering. These paintings are not for arty-chatter but for the lacerated soul" (May 1, 1961, #5). His assertion echoes a remarkably similar one in *The Cloud of Unknowing*: "I do not desire that this book should be seen by worldly chatterers, public self-praisers or fault-finders, newsmongers, gossips or scandalmongers, or detractors of any kind, for it was never my intention to write of such matters for them."[61] With these successive sentences Smithson linked Saint John's sixteenth-century mysticism to the unknown fourteenth-century monk's, mimicking their historical connection as both texts are considered influenced by the sixth-century thinking of Pseudo-Dionysius the Areopagite, who emphasizes divine silence, darkness, and unknowing as demanding the necessity of faith.

Smithson's efforts to persuade indicates Lester's reluctance. In his eagerness to convince his dealer and professional father figure to accept his religious images, Smithson pleaded in a six-page letter, "Don't be afraid of the word 'religion.' The most sophisticated people in Manhattan are very much concerned with it" (May 17, 1961, #7). His assertion is confounding. Eleven years earlier *Partisan Review* had devoted an issue to "religion and the intellectuals," seeking responses from twenty-nine of them (two women) to an editorial statement that began: "One of the most significant tendencies of our times, especially in this decade, has been the new turn toward religion among intellectuals. . . . At present many thinkers sound an insistent note of warning that Western civilization cannot hope to survive without the re-animation of religious values."[62] But their responses to the postwar social mentality did not present an affirmative consensus, and Smithson was twelve when it was published; he could have read it later, although his collection of issues of *Partisan Review* begins in 1964. His use of the nebulous adjective "concerned" might imply Manhattanites' personal

practice of religion. If so, his claim contradicts the customary convention that urban culture in the 1960s was increasingly secular. More than a decade later Paul Cummings, taking Smithson's oral history for the Archives of American Art, expressed that view when replying to Smithson's explanation that during his visit to Rome he sought to learn "how religion had influenced art" by remarking, "I find that interesting in the context of the people you knew, because [religion] wasn't generally something they were all that interested in."[63]

Christian religious imagery was rare among ambitious midcentury artists, and none was as graphically conveyed as Smithson's. The Abstract Expressionist artist Jackson Pollock painted a gouache *Untitled (Crucifixion)* in 1939–40; Mark Rothko painted *Gethsemane* in 1944 and *Entombment* in 1946; Willem de Kooning, a line drawing of a crucifixion in 1966; Milton Avery painted an emotionally detached *Crucifixion* in 1945; in the 1950s and '60s Robert De Niro Sr. produced numerous gestural scenes of the crucifixion, seen distantly, generalized and surrounded by crowds of followers.[64] As previously noted, the catalogue for MoMA's 1959 exhibition *New Images of Man* included a testimonial by Tillich. Smithson owned Marvin Halverson's *Great Religious Paintings,* an oversize folio with a dozen tipped-in color reproductions, its pages edged in gold (1954). Halverson was executive director of the Department of Worship and the Arts, National Council of the Churches of Christ in the U.S.A., and with Tillich and Alfred Barr, then director of collections for the Museum of Modern Art, would found in October 1961 the Society for the Arts, Religion and Contemporary Culture.[65]

Concurrently, William Rubin, who in a few years became a curator at MoMA, published his doctoral research as *Modern Sacred Art and the Church of Assy* (in Smithson's library) on the French Alps church's interior decor by Marc Chagall, Pierre Bonnard, Henri Matisse, Georges Rouault, and others in the years after World War II. Other than Barr and Rubin (then teaching at Hunter College), however, the "sophisticates" of the art world maintained the separation between religious imagery and secular abstraction; contrary to Smithson's contention, they gave no evidence of being "concerned with religion" at all. The words "religion" and "religious" do not appear in the catalogues of *Sixteen Americans* or *The Art of Assemblage* or in feature articles in contemporaneous art periodicals.

Zen Buddhism had a presence in the art world from the 1940s in the music of John Cage, who practiced Buddhism and threw I Ching coins to compose and perform scores. In the mid- to late 1950s and through the next couple of decades, Alan Watts, a former Episcopal priest, became increasingly popular among the Beats and those identifying with the counterculture for his promotion of Zen Buddhism. As writer and artist Grégoire Müller explained, "In the counter-culture that developed [in the 1960s], oriental

philosophies lost their exoticism and became widely vulgarized as a valid alternative to a Judeo-Christianism shaken by its blatant hypocrisies."[66] That is another reason Smithson's affiliation with Catholicism would raise eyebrows, and after the Lester show he would be reluctant to make his religious affiliation known. Thus his belief in the centrality of religious subject matter among the New York intelligentsia suggests his desire for it to be so.

But if we remove both art and the practice of religion from the equation, Smithson was broadly correct about religion as a hot topic of the time. Not only the Manhattan elite but also the public at large were "very much concerned" with religious issues because in immediately prior months the political campaign and election of the first Roman Catholic president, John F. Kennedy, had brought the relation of church and state into public debate. As a Catholic making his religious affiliation known through his art, Smithson may have felt some vulnerability of scrutiny by association. And Catholicism was in the news just two days before Smithson proclaimed its importance to Lester. Released on May 15, 1961, Pope John XXIII's "great social encyclical *Mater et Magistra*" (Mother and teacher) argued for the Church's leadership in those roles toward ensuring individual freedoms and social justice.[67]

Ultimately, despite Smithson's ardent negotiations with Lester, both pleading and defiant, among the twenty-four works the dealer put on view none is from the *Man of Sorrow* series and only one depicts Christ. It is titled—ironically or appropriately—*Jesus Mocked*, an experience with which Smithson could identify. In contrast to the Byzantine stiffness of the *Man of Sorrow* series, it is painted with a fervor that seems demonic; Lester could construe it as akin to New York school Action Painting. Seven others refer to religious subject matter: *Blind Angel*, *Dies Irae*, the diptych *Flayed Angels* (Figure 2.4), *Green Chimera with Stigmata*, *Purgatory* (Plate 8), *Man of Ashes*, and *Walls of Dis*. Galleria George Lester, located in a city of museums and churches with reverential biblical scenes, was two minutes' walk from the Spanish Steps, where tourists congregated. Lester thought Smithson's religious imagery would not appeal to Italians or visitors to Rome; he was not affiliated with any religion.[68]

Smithson's *Man of Sorrow* series was not exhibited by anyone in his lifetime and rarely thereafter as separate canvases unrecognized as part of a series. Titles of the other paintings in the show indicate that in accommodating Lester's resistance, Smithson had turned his morbid perspective onto the malevolence of nature (*Black Grass*, *Deadwood*, *Dull Space Rises*, *Sign of the Dog*, *Venomous Fern*, *Vile Flower*), of mechanization (*Alive in the Grave of Machines*, *Dry Wheels*), or architecture (*Grey Tower*, *Monolith of Desolation*). Religious or not, it appears only one sold; and that was to another quasi patron, Charles Alan himself, the gallerist whose window display had

inspired Lester to seek out Smithson and who that spring had put Smithson in the four-person show. He went to Rome to see Smithson's show at Lester's gallery. Smithson sent a postcard to his Manhattan apartment-mate Philip Israel on which he reported that "C.A." had purchased his *Tired Fetish* "for a song" and another to his mother announcing that he had sold "$200 worth of art," presumably Alan's payment.[69] But Smithson wouldn't collect that money, as before the show opened he had offered to presell to Lester "20 [circled for emphasis] major" paintings for $650 and $100 as reimbursement for shipping. The rest of the works in the show, plus others Smithson had brought over, remained in Lester's possession.[70] Twenty-four years later, when Lester consigned some of his Smithson paintings to the Diane Brown Gallery in SoHo, New York, to exhibit as *Robert Smithson: The Early Work, 1959–1962*, the twenty-four on Lester's 1961 checklist comprised the first twenty-four of the forty on Brown's checklist, sequenced exactly the same as if the earlier group had remained intact; *Tired Fetish* was "not in exhibition."[71] Smithson had predicted to Lester that his exhibition in Rome would be a "turning point toward a new realm of art" (undated [June 1961], #13). That would be true for him—but not in the direction he anticipated.

It had been crucial to Smithson that what he called the "echo" of his exhibition in Rome, the "catalogue," adequately transmit his ideas back to the New York art world. He requested that Lester include "at least 5 reproductions so that those in this country shouldn't loose sight of what I am doing." But he declined to provide a descriptive biography. "I feel it would not be in the Best of Taste to publish such material. Better to print a photo of me. Of course, I will send a short history of Facts for your files" (April 7, 1961, #4, 1961, #7). On the contrary, discussing personal sources of one's art was not socially prohibited in the art world at that time as it would soon be. In the September 1961 *Art News*, the painter Philip Pearlstein addressed the issue of an artist's "Private Myth" (a term associated with critic Harold Rosenberg's influential 1952 *Art News* article "American Action Painters") by introducing a dozen painters' and sculptors' reflections on their creative processes. But Smithson's longtime friend Levin, publishing under the guise of his well-known father's column and putatively as an exhibition review, had sorely betrayed Smithson with a nasty account of his background, paintings, and intimate revelations of his mood (to be discussed). So, the Lester brochure's bio provided a minimum of biographical facts.

Thus began Smithson's half-hearted evasion of describing his personal history in professional contexts: ambivalent, because as much as he refused, he divulged decipherable clues if not, as here, outright data. In the sparse list he provided Lester for publication, Smithson included as noteworthy a

life event between his birth and high school graduation: his confirmation ceremony formalizing him as a practicing Roman Catholic when he was an adolescent. He identified it as occurring in 1950 (April 7, 1961, #4). And thus started his loose recounting of his own personal history; his confirmation as a Roman Catholic at Saint Andrew's Church in Clifton, when he was eleven, was on May 22, 1949.[72]

The terse bio in the brochure that Lester printed for Smithson's show states only his birth year and lists two of his prior six exhibitions. The omission of identifying Smithson's Roman Catholic affiliation for an exhibition located less than two miles from the Vatican Museums, thronged with tourists drawn to that holy site, thus offered viewers and readers of the brochure no clue as to the artist's personal relation to titles on view such as *Dies Irae*, *Jesus Mocked*, and *Purgatory*. So also began art world accounts that disregard biographical information as irrelevant, confining the artist to a professional identity.

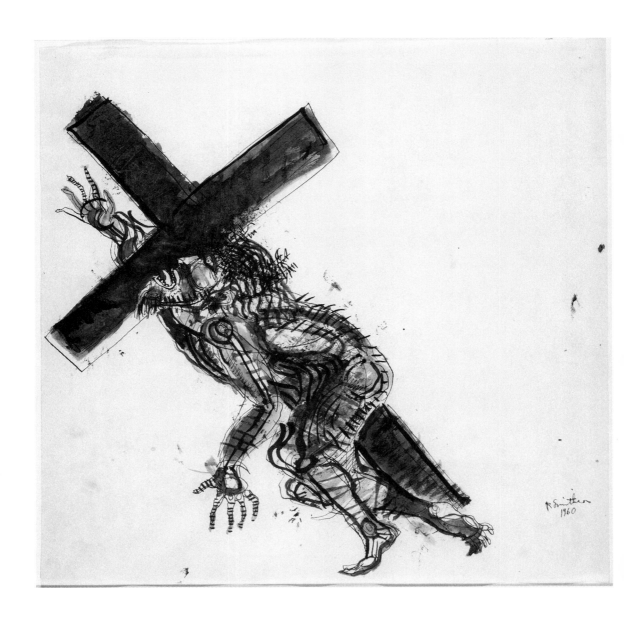

FIGURE 2.1. Robert Smithson, *Christ Series: Christ Carrying the Cross,* 1960. Ink and gouache on paper, 18 × 18⅛ inches (45.7 × 46 cm). Photographer: Paul Hester. Courtesy Menil Collection, Houston. Copyright Holt/Smithson Foundation / Licensed by Artists Rights Society, New York.

2

Brother's Keeper

The voice of thy brother's blood crieth to me from the earth.

—*Genesis 4:10*

Smithson's extant figurative paintings from 1959 to 1961, on canvas or paper, are substantially Christological. But in differentiating his paintings' subjects and corresponding styles as "modern" and "spiritual," he dodged the designation that Lester felt uneasy about exhibiting, "religious." But then, all those terms suppress the particularity of his dramatized content and the peculiarity of its rendering. Do his images connote the spiritual, evoking a sense of the sacred? No. Are they reverential? Absolutely not.

Regarding subject matter, Christological themes common in Western historical painting (the Nativity, the Flight into Egypt, the Baptism, Preaching with Apostles, the Temptation in the Wilderness, the Last Supper, the Deposition, Christ in Majesty, the Holy Trinity) would have conveyed his bond with Jesus. They are absent from what has been most narrowly described as Smithson's "Christ series." It is not even accurate to say that he depicted the Savior solely in death, as there is neither a Pietà, the lifeless adult Jesus being cradled by Mary, nor images akin to biblical themes of the mystical Resurrection and rapturous Ascension.

Rather, Smithson chose to paint Jesus Christ almost exclusively as displaying his wounds or in the process of dying, phases of what is known as his Passion. The focus is on Christ's body or parts of it, bloodied. The

grisly naturalism of *Crucifixion*, by the German Renaissance painter Matthias Grünewald, is an art historical precedent epitomizing painful sacrifice (Plate 9). Commissioned by the Brothers of Saint Anthony, patron saint of skin diseases, for their hospital in Isenheim (in the Alsace region of France), Grünewald's exacting renderings accentuate gruesome sores like those peasants then suffered after consuming infected rye grain, in sympathy for whom the painting displayed Christ's own afflictions.[1] Smithson had a strong connection to Grünewald and owned books about his Isenheim Altarpiece and other pictures. Like Grünewald's nocturnal crucifixion, Smithson's *Man of Sorrow* paintings have black backgrounds. But his own expressionistic renderings do not attempt physical verisimilitude, and he does not depict the crucifixion in situ, with the customary mourners the Virgin Mary and Saint John the Evangelist pictured on either side of the cross and sometimes the mountaintop setting with the two criminals' crucifixions nearby. Smithson's visceral roughness prompts the question of whether his primary emotional impetus was devotional. As he wrote Lester, his *Man of Sorrow* depictions dwell on "human sacrifice," mystical visions, and "martyrdoms," rife with wounds (May 1, 1961, #5). Smithson's paintings on paper, *Christ Carrying the Cross*, *Fallen Christ*, *Feet of Christ*, *Veronica's Veil*, *Untitled* (crucifixion), many drawings, and his lost painting on canvas *Consummatum Est* ("It is finished," Christ's last words as he was dying on the cross, according to the Latin Vulgate, discussed in Jung's *Psyche & Symbol*; Smithson owned a copy), all 1960, and *Untitled (INRI—Christ on Crucifix)*, 1961, also display torture. It's a perverse kind of worship, not reverence for Christ's divinity but identification with his agony.

Rather than offering consolation, Smithson's Passion pictures analogize a sacrifice his parents had personally experienced. The Bible describes, "For God so loved the world, as to give his only begotten Son; that whosoever believeth in him, may not perish, but may have life everlasting" (John 3:16). Similarly, Irving and Susan Smithson had given up their own first begotten son, Harold, to an excruciating death, which then prompted Smithson's own life—everlasting in art history.

His father, Irving Joseph Smithson, had been born in The Bronx in 1905. Irving was a first-generation American; his own father, Samuel Smithson, born in Manchester, England, in 1881, had at the age of ten immigrated with his father, Charles Smithson, his mother, and six siblings to the Bronx, New York. After leaving school when he finished the eighth grade, Samuel worked in various construction trades as an electrician. In 1904, at age twenty-three, he married Bronx-born Lillian Albertina De Veaux, who was twenty-one; their sons, Irving and Harold, were born in 1905 and 1907, respectively.

Smithson's mother, Susan, also a first-generation American, was born in 1908 in Clifton, New Jersey. Her father, Alexander Duke (1861–1909), and mother, Mary Miller Duke (1863–1925), who were both born in the Austro-Hungarian Empire and identified their native language as Slovak, emigrated from Vienna in 1880. They arrived with son Michael, and in New Jersey George, Mary, Julia, and Susan were born. Alexander Duke died when Susan was in her infancy, sending the family into poverty; Holt recalls hearing that Susan's childhood home "was near a pond in Rutherford and had a thatched roof and mud floors."[2] Susan left school at fifteen after the ninth grade (her sisters had each left after the eighth); her mother died when she was seventeen. At that age, on April 5, 1926, in Manhattan, she married Irving Smithson, twenty, who had completed two years of high school and at the time identified himself as working in the electrical battery business.

Six and a half months after their wedding, their first child was born, on October 24, 1926. They named him for his father's sole sibling, his brother, Harold Samuel, honoring their closeness and extending his identity to the next generation. That year Irving was employed as a carpenter; he and Susan lived with his parents at least four more years until they were twenty-five and twenty-two and Harold was four. Customary for married women at the time, Susan did not work outside the home.

FIGURE 2.2. Susan and Harold Smithson, circa 1935. Photographer unknown. Courtesy Holt/Smithson Foundation and Nancy Holt Estate Records, Archives of American Art, Smithsonian Institution.

This may have been the photograph permanently displayed in the Smithson dining room.

Irving had been raised Baptist, Susan was a practicing Catholic, but they did not follow religious urging to procreate and multiply. In March 1936, the family triad's bond ruptured when Harold, afflicted with leukemia, then without curative treatment, died at the age of nine. That is the noteworthy biographical circumstance preceding Smithson's birth that Nancy Holt considered significant to understanding her late husband and included in his posthumous exhibition chronologies.

The oncologist and essayist Siddhartha Mukherjee described leukemia

as "cancer in one of its most explosive, violent incarnations."[3] In Smithson's book collection, Isaac Asimov's *The Bloodstream: River of Life*, explains that in healthy blood, "there are many fewer white cells than there are red . . . so that the white cells are outnumbered six hundred and fifty to one." In leukemia, uncontrolled growth of white cells "crowd[s] into the bloodstream, reaching a count 15 to 150 times the normal count. The other formed elements decrease in numbers correspondingly so that there is anemia and an increased tendency to bleed."[4] Bleeding to death, the organs and tissues were starved of oxygen the blood wasn't delivering.

Renowned hematologist and oncologist Emil Freireich (1927–2021), who was old enough to have professionally witnessed childhood leukemia before effective treatments, declared that at the time, "the diagnosis was a death sentence."[5] Medical care was solely palliative. One might reasonably expect this cancer of the blood to manifest internally, in the bloodstream and organs, with visual evidence of it, as with any illness, in an overall appearance of depletion. But leukemia lacks the platelets that clot blood; it goes haywire. The Greek root for blood is *hemo.* Hemorrhage literally means "blood bursting forth." And that's what happened before treatment for this blood cancer started to be developed between the late 1940s and the late 1950s. Interviewed at the time of his inclusion in a Ken Burns documentary on cancer, Dr. Freireich described his experience of leukemia prior to medical treatment. "Kids with all manner of lumps, bruises, headaches, infections, fevers and, most of all, bleeding, made the hospital unit 'look like a butcher shop' ":

> "You cannot imagine how horrible it was," says Freireich, 88, nearing his fiftieth anniversary at M. D. Anderson Cancer Center [in 2015]. "These were 3-, 4-, 5-year-old kids bleeding to death, *bleeding out of their ears, eyes, nose, skin and bowels, bleeding internally, vomiting blood.* It was a parent's greatest horror."[6]

When he kindly answered my questions, Dr. Freireich, then ninety, memorably described the sign of leukemia as "bleeding out of every orifice."[7] For me, that called up Smithson's "I painted ikons bleeding from every stroke" (to Lester, May 1, 1961, #5).

A developer in the late 1950s of the treatment of combination chemotherapy, Dr. Freireich reported prior research on leukemia showing that "for over six hundred patients studied between 1943 and 1952, the median survival was approximately six weeks, and ninety-five percent of the patients were dead by twelve months after diagnosis."[8] In his personal experience, "When they came to the hospital, ninety percent of the kids would

be dead in six weeks. They would bleed to death. If you're bleeding in your mouth and nose, then you can't eat. . . . You get diarrhea from blood in the stools. So you starve to death. Or you get an infection, and then you get pneumonia, and then you get fever, and then you get convulsions."[9] Some of his description is too ghastly to quote. These accounts indicate that in 1936 the span of Harold's morbidity between diagnosis and death had to have been swift.

Another typical symptom of leukemia described to me by Dr. Freireich is an abundance of petechiae—minute, round, nonraised hemorrhages of small vessels visible under the skin. They give the body an overall bruised appearance and could account for Smithson's depiction of the body of Christ as awash with blood.

This was the abomination Smithson conjured of his family's experience: tortured male bodies and body parts, bloody. His statement more than a decade later—"The entire history of the West was swallowed up in a preoccupation with notions of prehistory and the great prehistoric epics"—can be understood as covertly analogizing his family's absorption with their own epic battle with illness in their family's "prehistory" before Smithson's birth began a new phase of family life.[10] And it suggests his sensitivity to being constricted by his parents' responses to that "prehistory," a subject he will express great interest in without divulging the continuing presence of his own.

Smithson's *Man of Sorrow* images parallel Carl Jung's description (in *Psyche & Symbol*) of God's offering of himself as "a voluntary act of love, but the actual sacrifice was an agonizing and bloody death."[11] From the perspective of the survivors, Harold's grisly premature dying can likewise be thought of as sacrificial, as engendering Smithson's birth. By conflating the religious crucifixion and his family's crisis, Smithson both honored Jesus's harrowing Passion and reanimated Harold's hemorrhagic one. The vehement visual and verbal imagery in which he depicted the Crucifixion enabled him to wrestle with conflicts about his personal history and identity.

Smithson's articulation of Christ's face, torso, and limbs in black lines over washes of red also parallels the dark red lines against pink showing the interior networks of veins and arteries in a male body on the cover of Asimov's *Bloodstream*. That anatomical transparency appears in Smithson's diptych *Flayed Angels* (1961). Each of the two tall (sixty-by-thirty-inch) paintings features a slim winged figure (hardly sexually differentiated by anatomy although *Number One* appears to have breast orbs and *Number Two* a penis), reddened as if by leukemia's petechial bruising and

FIGURE 2.3. Isaac Asimov, *The Bloodstream* (Collier Books, 1961). The title page includes the subtitle *River of Life*.

with stigmata. The figures of the bloody couple, their facial expressions befuddled, are clumsy, their pointed toes suggest levitating bodies although the short wing-like ribbons flowing from each shoulder would hardly keep them aloft. Smithson's distorted figuration was not for lack of skill at anatomical rendering—he had studied the basics at art schools and for reference owned Charles Singer's *A Short History of Anatomy from the Greeks to Harvey* (1957). And it wasn't from ignorance of aesthetic precedents; he had a copy of art historian Kenneth Clark's history-spanning *The Nude: A Study in Ideal Form* and in the future would draw idealized nudes of both sexes.

The barbarism of *Flayed Angels* is without reference in the Bible. Their nude bloodiness resembles Smithson's crucifixion images and offers

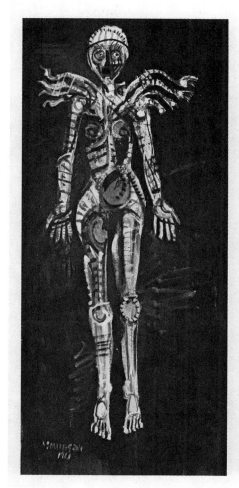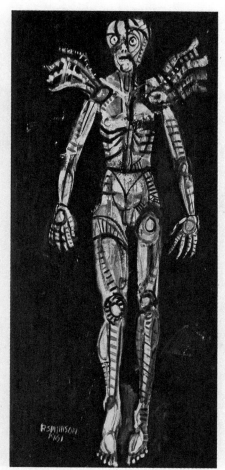

FIGURE 2.4. Robert Smithson, *The Flayed Angels,* 1961. Diptych, oil/canvas, each 59⅞ × 26 inches (152 × 66 cm). See the beginning of his corresponding handwritten meditation/incantation "To the Flayed Angels" at Figure P.2. Collection of Ikeda Gallery, Japan. Copyright Holt/ Smithson Foundation / Licensed by Artists Rights Society, New York.

another opportunity to conjure terminal blood loss. His accompanying verse, "Meditation on the Flayed Angels," describes "Word of Flesh with amputated wings." Corresponding to those painterly depictions, Smithson wrote it to serve as the introduction to his Lester show and be printed in the brochure. It reads as a supplicant group's fevered chant:

Blood, Blood, Precious Blood, Blood, Blood.
Flesh, Flesh, Sacred Flesh, Flesh, Flesh.
Christ, Christ, Jesus Christ, Christ, Christ.
Bleeding Angels of Jesus Christ have mercy on us.

And

Here is the everlasting funeral.
Here is the soul turned inside out.
Here is the angel of God burning with blood. (May 1, 1961, #5)

Another conjunction of the Christological and the Smithson family's devastation at the loss of their leukemic son are the lines "Here is the angel of God burning with blood" and "A voice from the whirlpool of Blood / Is crying out for vengeance." We can imagine the renewed family triad—Irving, Susan, and Bob, as he was known—as the petitioners repeating three times, "Impossible Martyrdom / Grant us peace."[12]

The fact that Smithson thought it was reasonable to expect a little-known artist's verse of seventy-eight lines, including "A voice from the whirlpool of Blood / Is crying out for vengeance," would be included in an exhibition brochure published by a recently established gallery of modern art in Rome displays his faith in his own desires and devotions. And he believed the inclusion of "To the Flayed Angels" would benefit him professionally. He wrote to Lester, "I know the NYC art world inside out. And I know that the work I have sent you will have a great effect here, if only there is no slip-ups. So, from the depths of my heart I ask to publish the catalog exactly as I requested." He offered evidence of professional validation. The editor in chief of Sheed & Ward, "a very powerful avant-garde Catholic publishing house," was "very very impressed" with Smithson's idea to publish a book of his incantations and related paintings and asked him to write about twenty-five more. "Now, this Kind of publicity can not be bought" (May 17, 1961, #7). He wrote ten more that, like "To the Flayed Angels," were titled with the words "To the . . ." ("Blind Angel," "Dead Angel," Eye of Blood," etc.) and ten with titles that begin with "From the/a . . ." ("Broken Ark," "Dream," Walls of Dis," etc.), for a total of twenty-one.

In another of his verses, "To the Stigmata," Smithson wrote five times, "Holy fount / Spouting thy Blood / Into a crimson cloud"; in "To the Unknown Martyr," a poignant designation for the brother he never knew. He declared, "With the Red fever / In the Red night / Small portions of martyrs / Rained Red / Upon our sleep," evoking tumult and nightmares.[13]

Although Smithson initially referred to his verse as a meditation (April 7, 1961, #4), he subsequently identified his verses as incantations. He may have adopted that unusual literary term from T.S. Eliot's poem *Choruses from "The Rock,"* verses of which he quoted in a letter dated May 8, 1961 (#6) and in the following lines from an undated letter ([May 1961], #8):

Out of the slimy mud of words, out of the sleet and hail of verbal
imprecisions,
Approximate thoughts and feelings, words that have take the
place of thoughts and feelings
there spring the perfect order of speech, and the beauty of
incantation.

His own verses do not display poetry's "perfect order" in word usage: mea-
sured meter, deliberate word choice, and precise diction. Neither are they con-
crete poetry or free verse. Yet Smithson's posthumous *Collected Writings* des-
ignate the four it includes as poems, a term secularizing and formalizing their
devotional expressivity into literary construction. That categorization also
suggests an ongoing engagement with writing poetry, whereas among his
extensive writings, published and not, his early diaristic "The Lamentations
of the Paroxysmal Artist," to be discussed, is his only other piece in verse.

Smithson had a deep appreciation for literature, the most numerous
genre in his library, and owned thirteen books of poems published in 1961
or earlier—from Virgil to Merton. He knew the art of poetry well, and it
wasn't out of modesty that he didn't refer to his own verses as that. Rather,
lines from Smithson's incantations call up the voice of urgent supplication
in Eliot's *Ash Wednesday*: "And pray to God to have mercy upon us" and
"Pray for us sinners now and at the hour of our death."

In form, spirit, and intention, the twenty-one are exactly what he
termed them: "incantations," invocations of atavistic and ritualistic mani-
festations of religious experience, intended to be chanted or sung to conjure
hallucinatory rapture. Their percussive repetitions, giving maximum hyp-
notic effect—as much magicians' invocations of spirits as priests' appeals to
divinities—call up archaic rites by groups of believers in the thrall of orgias-
tic abandon. Discussing the "fusion or confusion of magic with religion" in
The Golden Bough (in Smithson's library), Sir James George Frazer's analysis
notes that in the development of civilization, belief in magic preceded that
of faith in deities with higher powers:

The functions of priest and sorcerer were often combined or, to
speak perhaps more correctly, were not yet differentiated from each
other. . . . [The leader] performed religious and magical rites simul-
taneously; he uttered prayers and incantations almost in the same
breath.[14]

Similarly, Smithson could have read in his copy of E. M. Butler's *Ritual
Magic*, published two years before he wrote his incantations, "There would

appear to be no religion without some magic at its foundation, and certainly there is no magic in any significant sense without deep roots in religion."[15] In Smithson's incantations, the convergence of allusions to paranormal phenomena and nascent practices of Christianity is consistent with several of the books in his library on astrology and alchemy that have a Christian or specifically Catholic orientation.

The propulsive structure of Smithson's incantations mirrors the chants found on papyri and potsherds described in a book he owned, *Early Christian Prayers,* published the year he wrote them, 1961. As in those devotions, Smithson's several insertions in Latin display his connection to Catholic liturgy. Most of his are from the Mass; one, "*Regnans per omne saeculum*" (shall live and reign eternally), is from a venerable seventh-century hymn of Saint Ambrose for vespers at the close of the day.[16]

Smithson's incantations also echo the voice of early Christian prayers in which "the personal element becomes more prominent, especially in petitions for forgiveness."[17] It's not only the personalization of the petitioner that is emphasized; but Christ himself is intensely humanized. Both Smithson's paintings and his incantations emulate the Medieval tradition of devotions stressing not the exceptionality of Christ's divinity but extreme human corporeal pain. Yet in contrast to his paintings' unruly expressionism, his incantations, like their historical precedents, are methodically structured by simple, repeated phrases. The staccato phrasing both conveys Christ's suffering aurally and serves to restrain outpourings of grief in prescribed performative expressions to be uttered by a group in unison. Literary scholar Robert Pogue Harrison discussed twentieth-century Italian philosopher Ernesto De Martino's analysis of ritualistic lamentations, so akin to Smithson's incantations in both structure and spirit:

> Ritual lament helps assure that the psychic crisis engendered by loss, especially in its initial stages, will not plunge the mourner into sheer delirium or catalepsy. . . . The primary purpose of ritual lament is not to honor the dead, nor to mechanically discharge emotion, but to master grief by submitting its potentially destructive impulse to objective symbolization.[18]

With their imaginative form, passionate language, and occult affinities, Smithson's incantations demonstrate psychoanalyst Melanie Klein's recognition that as part of a mourning process, grief can promote creativity, "suffering can become productive . . . painful experiences of all kinds sometimes stimulate sublimations, or even bring out quite new gifts in some people."[19]

In urging the inclusion of his "Incantation for Flayed Angels" in his exhibition catalogue in lieu of an artist's statement, Smithson implied that it

GALLERIA GEORGE LESTER

R. SMITHSON

dal 15 luglio al 4 agosto 1961
via Mario dei Fiori 59a · Roma · tel. 67.09.09

FIGURE 2.5. Cover of the brochure for Smithson's exhibition at Galleria George Lester, Rome, summer 1961. 9 × 6.5 inches (22.9 × 16.5 cm). The design of solid blocks and only the initial of the artist's first name was Lester's format for all exhibitions. Courtesy Kathryn MacDonald.

would serve as his biographical proxy. In the way that Harold's red death is a pentimento beneath Smithson's Christ paintings, Harold hovers between the lines of its incantation verses such as "Blood, Blood, Precious Blood, Blood . . . Impossible Martyrdom . . . Here is the eye that cracks into rivers of blood." Despite the collective voice in which Smithson wrote these incantations, both their subject matter and his usage of them evoke intimate laments.

After all his impassioned negotiation, when he arrived in Rome Smithson found that Lester had not included the incantation. The "catalogue" turned out to be a brochure modest in both size and length, six pages, with three black-and-white illustrations, a checklist, and a brief biography.

No incantation was published in his lifetime. Nevertheless, in expressing the emotional impact of Harold's death and his family's anguish, Smithson's pictorial and literary images of loss served as not only an expression

of feelings of loss but also repositories for them, functioning as emotional reliquaries, preserving a relationship. Like a saintly figure who died long before one was born and is represented by a fragment of bone, hair, or garment in a decorated container that one prayed in front of, for Smithson, Harold lived on through such imagistic devotions. And in performing them, Smithson became for his family his brother's keeper. This is an aspect of the experience of what psychologists term the "replacement child."[20]

Historically, families were large, as the mortality rates of infants and children elicited grief yet not utter surprise. With the knowledge that not all those born to the family would survive to contribute labor, economic resources, and companionship, there was good reason to bear large numbers of children conceived in close succession. Poverty increased vulnerability, but wealth was no absolute shield. Before the development of effective medicine and the establishment of common practices of sanitary hygiene, "children of the élite died just as often and just as early as those of the poor," as is illustrated in *Queen Marie Antoinette and Her Children*, painted in 1789 (Plate 10).[21] The French queen commissioned Marie Louise Élisabeth Vigée Le Brun, portraitist of the prerevolutionary haut monde, to humanize Her Highness's arrogance. In sumptuous velvet and plumed hat, Marie-Antoinette is majestic, but her red gown recedes behind the baby squirming on her lap and daughter nuzzling her shoulder. At her other side, *le dauphin* Louis lifts a blanket from the shrouded cradle to expose its emptiness and the queen's loss, shared in common with her subjects after an infant's death.

From the late nineteenth century, improvements in medical care dramatically lessened rates of infant and child mortality. Progress in public health allowed modern parents to reasonably expect their children to reach maturity. With the decreased need for child labor as well as urban economic pressures prompting smaller families, parental love was invested in fewer offspring and more freely given. The death of a child, then, left a larger gap and was more keenly felt.

The general chronological parameters for the replacement child phenomenon are the decades between the late nineteenth century, when families started having fewer children, and the mid-twentieth century, when medical advances began to thwart childhood diseases: vaccinations and new treatments made once-fatal diseases increasingly exceptional. Today psychologists and psychiatrists, historians and biographers, the lay public, and thus even those who were born into a family tragedy of the prior death of a child may not know it as a psychological syndrome with substantial clinical literature on the particular effects on both parents and the

subsequent child. The existential triad of bereft parents + memory of dead child + presence of next child makes for complex circumstances in which each is awash in ambivalent regard for themselves and each other.

Until 1964 the constellation of emotions in this situation for both parents and the successor child was unrecognized in clinical literature. That year, psychologist Albert C. Cain and social worker Barbara S. Cain analyzed their experiences with the emotional lives of parents who lost a child and with the deliberately conceived subsequent child and introduced the concept of the "replacement child."[22] One might think the trauma of a child's death would be chiefly the parents', but the successor child is born into a milieu of grief that their arrival only partially mitigates and is given a conflicted identity that becomes fundamental to their being.

Parents of children who have died at a relatively young age and who are themselves still young enough to start over with child-rearing are often "compelled," as literary scholar Gabriele Schwab has written, "to try to undo for themselves and their affective life what should not be."[23] They attempt to recover from the pain of the loss and to divert from their sorrow by seeking comfort in having another child as soon as possible who will fill the unbearable hole left by the one gone. And they want to make up for their own perceived mistakes in parenting by having another chance at being good parents. The child arrives not only to joyous love but also with obligations—however unstated or even unconscious on everyone's part—to compensate. And inevitably, to compete—with a predecessor who, being dead, can do no wrong.

Being thirty-one and twenty-eight years old, Irving and Susan were young enough to start over in creating a family. He was working as an electrician and served as a volunteer fireman for the Rutherford Fire Company; in a couple of years, he began extended employment with Electric Autolite, which manufactured electrical car parts such as spark plugs and ignition systems. Approximately one week after the first anniversary of Harold's death, March 19, 1936, they conceived again.[24] Two days after the start of the new year—auspiciously promising a new beginning—their new baby was born on January 2, 1938, regenerating their family trio. With the birth of Robert Irving they again had an only child, a son, and their family's broken circle was restored. Given his father's name for his middle name, Robert and his predecessor, Harold, were named for the previous generation of brothers (and to be exact, were both given first names with two syllables and six letters). Despite Susan and Irving's own youth, Irving's steady and improving employment, and Susan's practice of Catholicism, they had not had a second child during Harold's nine years, and neither did they bear another after Robert was born.

Typically, in replacement child scenarios the lost child remains in the

family as a "ghost in the nursery."[25] Several biographers have considered the impact on Vincent van Gogh of the ghost of the first Vincent van Gogh, whose stillbirth/death was exactly one year to the day before the artist's birth, who was then given his predecessor's name. His family lived around the corner from the graveyard of the church where his father was pastor, and as a child he regularly viewed the tombstone marking the death of "Vincent van Gogh." None of Van Gogh's statements refer to his predecessor directly, but one bears an uncanny parallelism to his birth circumstances. Writing to his sister, Van Gogh remarked, "We just spoke of the hour of fatality which seems sad to us. . . . And what do we care whether there is a resurrection or not, as long as we see a living man arise immediately in the place of the dead man? Let us take up the same cause again, continuing the same work, living the same life, dying the same death."[26]

The most famous and perhaps the only self-identified replacement child in art history is Salvador Dalí, born just a little over nine months after the death of his predecessor, whose first name, like that of Van Gogh's, was the source of his own. The emotional linkage that this chronological proximity and nominal repetition impressed upon Dalí is apparent in both his auto-biographies and his art and provides an illuminating parallel to Smithson's intense but less explicitly stated response. Dalí wrote, "[My brother's] death plunged my father and mother into the depths of despair; they found conso-lation only upon my arrival into the world."[27]

Smithson himself merged Harold's identities as family martyr and ghost in his incantation "To the Dead Angel":

> We bring
> The martyr Palm
> To this martyred Ghost . . .
> Miserable and unworthy
> Sinners that we are
> We implore Thy grace
> In this hour of horror.[28]

Nancy Holt also used the "ghost" analogy to conjecture the effect on Smithson's having been a replacement child, tacitly reflecting her own ex-perience as an only child:

> I think probably there was an impact on his upbringing. If you have
> a son who dies at the age of nine and then you replace that son with
> another son, it must have an effect. . . . The attitude of the parents
> must have been unique. First of all, he was an only child of parents
> who already knew how to take care of a child. With only children

their parents are usually learning for the first time [reflecting her own upbringing as an only child]. And then there's probably always the ghost of that other child around. There must be a feeling of a missing person, wouldn't you think? I mean, here's this brother who died before you were born, and you know that he existed and was around these two parents for nine years and you probably are being compared with him.[29]

Commonly the identity of the successor child within the family constellation is forever linked to that of the deceased. Diana, Princess of Wales, recalled about her childhood: "I couldn't understand why I was perhaps a nuisance to have around which, in later years, I've perceived as being part of the [whole question of the] son, the child who died before me was a son and both [parents] were crazy to have a son and heir and here comes a third daughter."[30] Gertrude Stein realized: "Leo and then I came, two died in babyhood or else I would not have come nor my brother just two years older and we never talked about this after we had heard of it that they never intended to have more than five children [there were three older] it made us feel funny." Stein generalized it as, "Let us talk not about disease but about death. If nobody had to die how would there be room enough for any of us who now live to have lived. We never could have been if all the others had not died. There would have been no room." Paralleling Stein's comment, in a complaint about environmentalists Smithson remarked to an interviewer, "Someone who gives up eating meat [does so] because he is afraid that eating it will cut down the life of the earth; but you have to eat, so that death depends on life and life depends on death."[31] For all of these successors, their very existence not only resulted from a prior death but was forever linked to it.

Surviving one's child is such an inversion of the natural order that psychologists consider it to be the most severe interpersonal loss an adult may face. Comparing the extent of grief upon the loss of different intimates, psychologist Catherine M. Sanders found that parents' bereavement produces the most despair.[32] Two factors magnified the difficulty of the Smithsons' integration of their second son into the family. Their nine years and five months with Harold was unusually long for predecessors of replacement children; more commonly, children die in their early years. In comparison to losing a child who is in the first years of life, death after a child has developed a personality and been part of the family dynamic for several years sharpens the loss.

But the intensity of grief is relative not only to the survivor's history

with the deceased but also to the extent of that person's past personal losses of intimates and response to them. The death of Susan Smithson's first child repeated disappearances she experienced in her early years and youth with the fatalities of her parents—her father, at forty-eight, when she was eight months old, and her mother, at sixty-three, when she was seventeen.[33] In his foundational study *Loss: Sadness and Depression* (1980), psychoanalyst John Bowlby has shown that such early losses of parents cause developmental and emotional disturbances. The child's mourning both for the lost parent and for him- or herself, feeling abandoned and a sense of loss of control over existence, can leave a lifelong wound of sadness. She may have felt self-reproach for not being "good enough" to ensure her parents' survival, a misplaced perception but one that is not uncommon among children who have lost parents. Likewise, she could have felt guilt again as a parent who was unable to save her child from death. For Susan Smithson, Harold's early death undoubtedly reopened a familiar abyss. If melancholia inhibited her emotional availability to Harold, regret following his death may have in turn further constrained her connection to Robert.

In replacement child situations, the urge to restore the family structure must be weighed against the time needed for full expression of mourning and the resolution of natural self-recrimination and guilt. (Robert was born twenty-one months after Harold's death.) If it is not worked through, that depressive state will constrict the affective flow between parent and child necessary to the infant's developmental needs. For parents in replacement child situations, often there is an "oscillation between parenting and grieving."[34] As Schwab notes, "Commonly, parents are supposed to function as protective shields against trauma for their children. Traumatized parents instead tend to pass their trauma on to their children."[35]

Recall, Smithson wrote Lester that his aunt Julia, who had lived with the Smithsons since sometime between Harold's illness and Smithson's birth, was "like a second mother to me" (May 1, 1961, #5). Susan was a young stay-at-home mom with only one child, yet it appears she needed Julia's backup in acts of mothering. Kathryn MacDonald, Smithson's friend in the late 1950s and 1960s who visited the family home with him several times, never saw his welcoming mother smile. Alan Brilliant recalls her as "a suffering, overworked burdened woman with a furrowed brow, an apron, worry on her face, work all around her . . . a typical mother in those days!" Holt believed that Susan had been treated for depression.[36] Given the losses she had suffered starting early in life, that would be an understandable response. Perhaps Julia was not only her nephew's second mother but continued to be her sister's. Susan's history exemplifies that described by the foundational replacement child researchers Cain and Cain, who found

a prominent factor contributing to associated emotional difficulties being "the guilt-ridden, generally depressive, phobic, or compulsive premorbid personalities of the mothers, who themselves had suffered a surprising number of family losses in their own childhood."[37]

Irving had also lost an intimate. His brother Harold, only fifteen months younger and who for a few years had lived with his own family just a half block from the Smithsons, died at sea in 1943 while serving in the Merchant Marines. Robert was five when the elder Harold Smithson died, and Harold's death date, March 16, was just three days before that of his uncle's namesake nephew seven years earlier. Smithson grew up in a family that experienced multiple successive deaths.

Incised at the top of Harold's gravestone in Rutherford, New Jersey, is "Sonny." That endearing designation and Smithson's characteristic demeanor could not be more incongruous. Responding to the complicated conditions prompting his existence, and determinedly distinguishing himself from his brother, the Smithsons' second son displayed not the winsome sunniness their first son's nickname calls up but something like an excess of the black bile medieval alchemists believed that, if predominant among the four humors (the others being blood, phlegm, and yellow bile), would produce gloominess. Carl Andre, who knew nothing of Smithson's early biography, painting, and incantations, described him as "akin to William Blake—with an apocalyptic temperament. He was melancholic—Transylvanian," an uncanny allusion to the homeland of the blood-obsessed Dracula.[38]

Knowledge of Smithson's family history indicates that his emphasis on the agonies of Christ in his paintings and incantations was not simply a believer's mourning of Jesus's suffering. The bloodiness of his expressionistic rendering and ideation indicates that Jesus and the flayed angels resonated as surrogates for Harold's hemorrhagic leukemia. The numerousness of these images suggests that Harold's death had not been psychically accepted by the Smithsons, worked through, and the mourning resolved. As he had not experienced the loss himself, his obsession with bloody dying suggests that Smithson had internalized his parents' grief, making it into what he described in his "Flayed Angels" incantation as an ongoing "everlasting funeral."[39] Through him, Harold was—typically, as Schwab explains—being kept "psychically alive. . . . While we can foreclose mourning by burying the dead in our psyche, those dead will return as ghosts."[40]

The violent tenor of Smithson's images and incantations suggests that he viewed his ghost brother with distinct ambivalence. Traditionally,

works of art depicting a deceased convey subdued melancholy and in mood are categorized as elegiac. But Smithson's Passion imagery is not tenderly melancholic. The bloodiness with which he rendered the crucifixion and the violence implied by the torsos or limbs' striated linearity or agitated brushwork do not evoke heroic bodily mortification promising redemption. As previously noted, Smithson recognized this, writing to Lester, "Divine Suffering has taken the place of Nature" (April 7, 1961, #4). But it is not just suffering by the Divine, or the family's deceased, but also by the artist himself. In doing so, he performed what literary scholar Tammy Clewell has identified as "the creation of a new practice of mourning, one that steadfastly resists consolation, scorns recovery and transcendence, and gives voice to criticism of the dead as well as to self-criticism."[41]

"Blessed are they that mourn: for they shall be comforted" (Matthew 5:4). Grieving is the process of healing. "After the work of mourning is completed, [one] 'can remember, but not relive, and concentrate on the difficult task of being.'"[42] But as is evident, Smithson's images of Christ's Passion are not comforting. Rather, seeing those lacerated torsos, one recoils—or if one is visually analytical—detaches to observe techniques of painterly exaggeration. The visceral excess of Smithson's crucifixion pictures is not about the relief of death but rather about active suffering. And not just by the depicted sufferer. They convey not sorrow but rage. While he was in Rome for his show at Galleria George Lester Smithson read *Naked Lunch* by William Burroughs, whose "grotesque massive accumulation of all kinds of rejective rituals" he appreciated, as well as "the way Burroughs sort of brings in a kind of savage Mayan–Aztec kind of imagery to that."[43] Those early nations in precolonial Mexico were known for their sanguinary sacrifices, not unlike the crucifixions Smithson had been painting and pleading for Lester to show. They exemplify literary scholar Jahan Ramazani's contention that "the elegy flourishes in the modern period by becoming anti-elegiac (in generic terms) and melancholic (in psychological terms)." As such it is a resonant yet credible vocabulary for grief in our time—elegies that erupt with all the violence and irresolution, all the guilt and ambivalence of modern mourning:

> I propose the psychology of melancholia or melancholic mourning, arguing that the modern elegist tends not to achieve but to resist consolation, not to override but to sustain anger, not to heal but to reopen the wounds of loss. To explore the paradoxically *melancholic* emphasis within modern poems of *mourning,* I recast the

classical distinction between mourning and melancholia, shading it as a difference between modes of mourning: the normative (i.e., restitutive, idealizing) and the melancholic (violent, recalcitrant).[44]

Ramazani's analysis of modern poetry of mourning precisely applies to Smithson's Christological images. Smithson himself declared that his art failed to assuage grieving: "The absence of consolation in art produces desolation."[45] Making art and writing poetic flights of fatalism seemed to be his attempts toward resolution. But his brutal depictions of the bloody deaths of Christ and the flayed angels call up the common mixture of grief, gratitude, guilt, and grudge for the predecessor sibling's sacrifice.[46] Smithson's affiliation with mortality, conflicted feelings about Harold as represented in his paintings of crucified and flayed, bloody torsos, and general pessimism about outcomes are common among those who were replacement children.

But those inhibitory inclinations seem to have been countered by an almost manic blast of both energetic productivity and of aggression toward the lost one. Both fuel his art. The duality calls up Melanie Klein's description of mourning as commonly including regressive feelings of anger and aggression. Klein identified the continuous struggle within mourning between the desire for restoration and destructive aggressions, what Ramazani described as the conflict "between pining for the lost object and the sadomasochistic rage that complicates this affection. [Klein] argues that, like melancholia, mourning moves in waves, alternating between mania and depression, between fantasies of omnipotence and annihilation."[47] Those mood swings are evident in Smithson's letters to Lester, and the aggression is obvious in his brash renderings of crucifixions.

They are also illuminated by Bowlby's studies on loss that reevaluate postmortem "anger, directed at third parties, the self, and sometimes at the person lost, and disbelief that the loss has occurred (misleadingly termed denial)."[48] Rather than being reverential, Smithson is not only identifying Christ's Passion with Harold's bloody process of dying but also expressing family grief in an act of mourning. At the same time, he is identifying with both Christ *and* Harold. Feeling himself to be persecuted, the victim of having to serve as a replacement, he could rightly resent what Harold's death and his parents' idealized memory of his brother put him through. His "religious" images radiate fury at being his brother's keeper.

FIGURE 3.1. Robert Smithson, *Untitled*, 1957. Pencil, 9 × 11¾ inches (23 × 30 cm).

Archives of the Unicorn Press, Brown University Library. Copyright Holt/Smithson Foundation /
Licensed by Artists Rights Society, New York.

3

Drunk on Blood

Let me be wounded with his wounds,

Let me be inebriated by the cross and your Son's blood.

—"Stabat Mater," thirteenth century

What happened was I was born in Passaic and lived there for a short time."[1] In his numerous interviews, Smithson spoke of the circumstances of his birth only once, providing a terse account for the Archives of American Art's oral history program. His description sounds like an event that befell him rather than a process in which he participated, even if no one actually remembers the shock of being pulled from the womb. That is much like "Beckett's antihero . . . one to whom things bafflingly happen," as literary critic Wylie Sypher observed in a 1964 book in Smithson's collection.[2] But that is exactly a replacement child's experience: his or her initial identity is more than usually predestined. Smithson appeared to recognize this when he stated in 1969, "The future is always going backwards."[3] That is, the past determines the future; free will is limited. His fashionable sardonicism camouflaged the profound dissatisfaction with his childhood that in an early unpublished essay he explicitly lamented as "a terrible yearning for Innocence [that] stares back over Original Sin into some impossible paradise."[4] In either voice, at both ends of the decade, one can sense his longing to break free from the particular "original sin" of the circumstances of his birth.

When in his oral history he was asked how his parents felt about his high school involvement with art, Smithson replied bluntly, "They didn't

like it." For an artist, not only is income unstable, but in the intensely homophobic 1950s calling a male "artistic" could insinuate an identity as gay. (More on that later.) But they visited his solo show at the Artists' Gallery in 1959, when he was twenty-one, "and tried to understand what their son was getting into. They've always been sympathetic."[5] That parental ambivalence is illustrated in one of Smithson's earliest extant drawings, made in an expressive realism when he was just a year out of high school. It shows three adults in profile, a couple on the left, the male seemingly musing on the male ahead with his back to them, and between them is a shorter male somewhat in the background. Easily construed as the Smithson family triad, the division suggests alienation between parents who had left high school after their first and second years and their son who at sixteen had started adding to high school classes study at the Art Students League in the Big City, and their bond with Harold, a specter haunting the family.

Smithson continued, "I mean they're really pretty good to me. I had a brother who died before I was born, and then being an only child—" He broke off that train of thought and finished with "and my father did take me on trips," as if volunteering a compensatory generosity.[6] (In 1953, when he was fifteen, the *Herald-News* in Passaic reported that the Smithsons had returned from a two-weeks southern tour during which they stopped at Mount Mitchell, Virginia, Asheville, North Carolina, Florida's Lido Beach in Sarasota and Sanibel Island.)[7] "When he was about seven, his father paneled and finished the basement and the attic of the family home," so his son would have his own natural history museum and laboratory.[8] Speaking of it to *New Yorker* writer Calvin Tomkins, Smithson noted, "I was always on the lookout for fossils. . . . It was sort of a private world that kept me going."[9]

What was thwarting him? In the Archives of American Art oral history, Smithson circled back to circumstances of his birth to interject background information tangential to his interviewer's direction of inquiry about parental responses to his becoming an artist. His introduction of Harold into the family structure displays his awareness of his missing brother's importance to his and his parents' lives. The cause-and-effect sequence of Smithson's sentences suggests that his parents were "really pretty good" to him *because* he had a brother who died before he was born. And Smithson's emphasis that his parents were *really* pretty good to him leans toward persuasion, as if trying to overcome his own ambivalence. Smithson's conversational associations between his art, his parents' loss of their first child, their response to his art, and their response to him in the context

of a discussion of his position as an artist make apparent the entwinement of his art and his lost brother.

He said a second time "my father did take me on trips" and continued, "My first major trip was when I was eight years old and my father and mother took me around the entire United States."[10] His attribution of the trips to his father's initiation (he was allowed to plan the itinerary) suggests a preferential closeness to him. But also, the parents' instigation of vacation travel would have been a special event for all of them to assuage familial anxiety about having him survive past Harold's age at death, nine. Smithson's reiteration of his age, as in his "first major trip when I was eight years old" and "I was eight years old and it made a big impression on me," is significant. Typically for the replacement child, the predecessor's age of death would have been a "feared anniversary age with increasing awareness and growing comprehension of the reality of death. Nevertheless, until the child passes that anniversary there is a historical real child to identify with as well as the distorted and idealized parental memory."[11]

FIGURE 3.2. Irving and Robert Smithson on a boat with other tourists at Ross Allen's Alligator Institute, Silver Springs, Florida, 1952 or 1953. Detail of snapshot. Photographer unknown. Courtesy Holt/Smithson Foundation and Nancy Holt Estate Records, Archives of American Art, Smithsonian Institution.

In his oral history recollections, Smithson associated two memorable events with being nine years old. "We lived there [in Rutherford, New Jersey] until I was about nine and then we moved to Clifton, New Jersey, to a section called Allwood."[12] Smithson's geographical specification implied, accurately, that Allwood is a particularly nice residential area. Relieved that Robert had surpassed Harold's age at death and confident about the future, the Smithsons moved up.

Describing potential responses of a replacement child in reference to the American philosopher John Dewey, who was named for and apparently conceived immediately upon the accidental death of his parents' second son (he was born just forty weeks later), biographer Jay Martin observed, "If his temperament is sunny and optimistic [as was Dewey's] . . . after he lives past the age at which his sibling perished, he may feel invulnerable, the darling of fate."[13] But that inclination cannot be said to have been Smithson's.

Surviving beyond the age of the brother who caused his existence seemed to have prompted not an identification with luck but guilt and resentment for owing his life to another, as is invoked in Smithson's incantation:

> Let the birth of our day
> Be moved.
> Let the conception of our night
> Be moved.
> *On cai me on*
> O tiresome concern![14]

Here he demonstrates that he was well aware that his focus on identity and mortality derived from the particular timing of his conception and birth. He felt the burden of that relentless "tiresome concern" and wanted it "moved," so he would be freed of its association. Despite that urge, "being" and particularly "not being" would be his life's "concern."

In the Archives of American Art oral history, Smithson then immediately recalled another significant conjunction with his age of nine: "I guess around that time I had an inclination toward being an artist."[15] He made large drawings and paper constructions of dinosaurs, sharing a common boyhood fascination with monsters who threaten to devour. But his renderings would continue into adulthood (such as his 1963 drawing *King Kong and John the Baptist* and his 1970 filming of dinosaur skeletons in the American Museum of Natural History for his *Spiral Jetty* film) as if rehearsing self-protection against feeling aggressively overwhelmed.

He described his high school art instruction as "Everything was kind of restricted."[16] Apparently that "everything" was not just at school. We can surmise that his mother's successive early losses of father, mother, son, and brother-in-law, and his father's of brother then son, led them to be averse to perceived risk and to place phobic restrictions on Smithson's behavior. Pediatric psychiatrists term babies born subsequent to the loss of a child or fetus to be considered by the parents a "precious child," watched over anxiously, alternately indulged and confined in expressions of gratitude and grief. Holt described her father-in-law as "a serious,

FIGURE 3.3. From 1948 to 1956, the Smithson family lived in the Allwood section of Clifton, New Jersey; between 1950 and 1952 they moved from 68 Harvey Road to 74 Harvey Road (pictured). Photographer unknown.
Courtesy Holt/Smithson Foundation and Nancy Holt Estate Records, Archives of American Art, Smithsonian Institution.

sober, practical man, who had disapproved wholeheartedly of his son's decision to be an artist."[17] She recalled her mother-in-law:

> She was really cautious. If Bob got a cold or something . . . he got to stay home from school, and he *loved* being sick and staying home from school. I'm sure he sensed that he could get away with that little bit more than normal. He used to talk about that a lot [and said] that he just loved those times when he was home from school.[18]

For his mother, keeping her son home would have had the double benefit of protecting his health while also indulging him. "A key factor contributing to the ambivalent feelings of specialness in replacement children," according to researchers, "is the overprotectiveness often displayed by their parents, who hold themselves responsible for the deaths of their previous offspring."[19] Cary Grant recalled experiencing that. Born four years after his parents lost their one-year-old to tuberculous meningitis, he had a difficult relationship with his mother. In his unpublished autobiography, quoted in the documentary film *Becoming Cary Grant* (2017), Grant recalled that his mother blamed herself for her first son's death "for the rest of her life," had a "will to control," and "Mother tried to smother me with her care."[20]

The flip side of the coddling mother is the demanding, fearful one. Replacement children are often analogized to children of Holocaust survivors, born after parental trauma. In both, even though those "born after their parents' liberation from concentration camps were not directly exposed to Nazi persecution," they perceived the world as a place of the strong presence of dangers and death.[21] The child, captive to parental anxieties of a threatening world and held tightly close to them, can feel as if swallowed by quicksand. Smithson displayed particular resistance to prying eyes, writing to Holt from Rome, "My paintings are on display across the street, exposed like the private parts of butterflies against the walls of ice cubes. . . . Each specimen can be seen in all its stunning glory; all this exposure causes me to feel a bit perturbed . . . alas, People want to stare with aggressive eagerness."[22]

Any creator can relate to that preference for a viewer's serious receptivity to their works' glories. But the thrust of Smithson's statement is resentment; thinking of himself on the verge of molting from lowly caterpillar to successful butterfly, he didn't want his "private parts . . . exposed" to intrusive observation. This sounds like a plaint from an adolescent who has suffered too much nosy curiosity. In relating to his parents, it appears that Smithson both kept his distance and accommodated—if not shared—their anxiety. In the five weeks he was in Europe for his exhibition, the twenty-three-year-old's nine air mail postcards to his parents frequently included

the assuring refrain "Everything fine" as well as "Glad to hear that everything is okay" and "Everything in the gallery going alright."[23] Earlier, writing to Lester before departing for Rome, he projected parental anxiety onto him. "I will bring a roll of 20 [circled for emphasis] or more paintings not religious done in many different colors. . . . I am sure you will approve of these. . . . They are smaller, they relate to that blue painting you liked, don't worry" (undated [June 1961], #10).

Responding both to Lester's resistance to exhibiting his "religious" figures and the prominence of collage and visual playfulness in galleries (and perhaps aware of the upcoming Museum of Modern Art fall 1961 survey *The Art of Assemblage*), Smithson began incorporating collages into his paintings, two of which Lester exhibited. In his melodramatically titled *Alive in the Grave of Machines* (1961), Christ's cross is small and relegated to the upper right as if in the distance (Plate 11). A jumble of magazine photographs and automobile industry advertisements of wheels and cars' underside chassis all over the surface debases the sober piety associated with a crucifix. The subject of these clippings links them to his father, who was employed for decades in the auto industry and was the family driver. Augmenting that intimate association, on the upper left, is a "Ford four door sedan" with whitewall tires—that is, a midrange family vehicle, connecting the composition with the domestic. Those associations give the fact that Smithson never learned to drive—an unnecessary skill in New York City and New Jersey but definitely needed beyond them—a whiff of rejection of his father.

The title's "grave of machines" could refer to a dump yard for wrecked vehicles. But who is alive there? In the bottom of the claustrophobic scene a rectangle framing a frontal half figure is collaged onto the painting, compositionally and materially separated as if from a different world. He is boyish, covered with wavy lines, half-submerged in water. The figure may be akin to the person Jung, in *Psychology and Alchemy*, describes as "the King's Son [who] lies in the dark depths of the sea as though dead, but yet lives and calls from the deep."[24] The youth could be taken to represent the King's (Smithson's father's) first son, who lives in the dark depths of the sea (the unconscious), dead, but yet lives (in submerged memory) and calls from the deep. Or just as likely, it could describe feelings of his father's second son, Smithson himself, confused, confined, almost drowning in the family's remorse. *Alive in the Grave*'s impacted tensions are consistent with psychologists' descriptions of a replacement child's sense of the world as a place fraught with "constant unpredictable dangers," where "fate and chance govern life."[25]

As in many of Smithson's images made both before and after his *Man*

of Sorrow paintings, numerous dotted circles appear in the composition of *Alive in the Grave of Machines.* Several others contain dense all-over scatterings of circles and circular blobs containing a dot in the center. These may be understood as obsessive space-fillers, or perceived as eyes with pupils, which is plausible in the context of the penal scenes of souls' confinement. But on the top center of *Purgatory* (Plate 8), Smithson painted a horizontal ovoid with a dot in it, a naturalistic shape of a human eye. In comparison, the profusion consists of distinct circles with center spots, a shape he also painted on each of the palms of his *Man of Sorrow (The Forsaken)* (Plate 5) and *(The Passionate)* (see Figure 1.7), and the top of his *Feet of Christ.* Since the theme of these paintings is a bloody death and the places a soul goes after dying (*Purgatory, Dis*), and his characteristic subject is mortality, those dotted circles are more likely associated with death. Smithson's incantation "From the Walls of Dis," "Walls throb / With Death" (the walls enclosing Dante's infernal city of Dis), puns with the motility of cell walls.

Red cells carry oxygenated blood and are reddened, as blood itself is, by hemoglobin. Their shape can be likened to bean bag chairs or circular pillows with an indentation in the middle, except that they are "biconcave. . . . Both faces of the disc have shallow bowl-like indentations."[26] Leukemia is characterized by the overproduction of white blood cells. Smithson could have read in Isaac Asimov's *Bloodstream* that "unlike the red cells, the white cells . . . possess a nucleus." Smithson's circles and blobs with a dot in the center seem to be a reference to the plethora of white blood cells in leukemia, Harold's cause of death. Regarding their color, "Leukocyte is a word that is derived from Greek words meaning *white cell* and that, indeed, is a common alternative name for them. They are the ordinary color of cells and are called 'white.' "[27] Leukocytes are transparent, so Smithson renders these cells without their own color, merely outlined and with a center dot representing the nucleus. In *Alive in the Grave of Machines,* many circular forms merge the dotted hematology reference with automobile tires and hubcaps. On the top right, a large encircled dot at the intersection of arms of a Christian cross condenses Christ's bloody torso to a single leukemia cell. Thus, the boy in that image not only is "alive in the grave of machines," but also is within a flurry of leukemic cells, calling from the grave.

While he was preparing works for his summer 1961 exhibition at Galleria George Lester, Smithson participated in a four-person show, *New Work by New Artists* in March at the Alan Gallery, the place where Lester had encountered Smithson's *Quicksand* (1959). The other three artists were Ay-O, Rodger LaPelle, and Claes Oldenburg, represented by small wood reliefs of flags. Continuing his negotiations with Lester, Smithson later wrote, "Re-

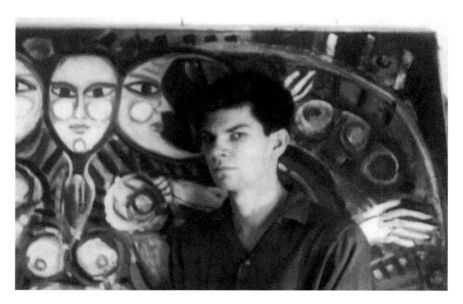

FIGURE 3.4. Robert Smithson with a painting he identified as *Hecate Turning the Moon to Blood*, 1961. Photographer unknown. Courtesy Lorraine Harner.

member, the Alan gallery exhibited not my 'modern' work, but my spiritual works, all four paintings were religious" (May 17, 1961, #7). His designation indicates the slippage between those terms. Of the four paintings by Smithson on view (all from 1961), three could be called religious if pre-Christian belief is included, but none is reverently spiritual. He showed the Goyaesque grotesque in *Death Taking Life*, a male biting another's arm (discussed in chapter 1), which has no reference to divinity.

The exhibition brochure identifies another painting as *Trimorph Turning the Moon to Blood*; it is lost, known only through a photograph showing a female with two crescent moon faces on either side of her own, multiple waving arms, and other appendages. On the reverse of the above snapshot of Smithson standing next to the seventy-nine-inch-high painting, the subject's head powerfully above his (Figure 3.4), he wrote, "The painting in the back is called Hecate Turning the Moon to Blood." (Presumably for the exhibition he decided not to title it in reference to a pre-Christian idol but used the more descriptive *Trimorph*.) As in his image, Hecate, an archaic goddess of magic and spells, is known for having three faces, one on each side facing sideways, enabling her to look in all directions at once. She is also the force that moves the moon in its twenty-eight-day cycles, determining the bleeding periods of menstruation. Painted during his developing relationship with Holt, it suggests his curiosity about a subject he was still intrigued by a decade or so later when he acquired the book *Woman's Mysteries, Ancient and Modern: A Psychological Interpretation of the Feminine Principle as*

Portrayed in Myth, Story and Dreams, by M. Esther Harding, published by the Jung Foundation for Analytical Psychology in 1971.

That spring Smithson wrote to Lester, "Art today is in a transformation state" (undated [late May 1961], #8). Comparing identically titled images from that year illustrates the direction of change in Smithson and the Manhattan art world vanguard (Plates 12 and 13). *Creeping Jesus,* in the Alan show, also displays Smithson's evolving approach to both exposing his Christianity and his rendering of it. He referred to *Creeping Jesus* a couple of months later when writing Lester: "I am very good friends with the owner of the Eighth St. Book Shop. Manhattan's most influential Book Stop as far as Art + Writing goes. [Smithson was co-owner Ted Wilentz's former employee.] He just bought one of the Creeping Jesus I am doing. I sent you the second version of Creeping Jesus" (May 17, 1961, #7). The *Creeping Jesus* on paper depicts Jesus in the center on a cross with short arms, almost more of a post, his wrists tied together above his head. The pose is like that of Saint Sebastian sometimes used in the Renaissance (Agostino Carracci, Marcantonio Raimondi, and Guido Reni) to depict the early Christian believer whom Roman emperor Diocletian ordered to be executed by military archers. Smithson's dark green, gray, and black surface is heavily collaged and densely painted with repeated black strokes forming patterns of lines and circles, including many instances of the dotted circle suggesting a leukemic cell. The style and tenor are expressionistic, and Jesus's unblinking eyes look dazed.

"Creeping Jesus" is an obsolete epithet disparaging a Roman Catholic who overdramatizes his faith. Considering the difficulty Smithson was having getting professional affirmation for his crucifixion imagery, the term suggests self-accusatory discomfort at exposing his own religious intensity. The *Creeping Jesus* in the Alan Gallery show (later sent to Lester) disrupts devotion to the crucifixion by collaging around it a collage of women's and automotive magazines and a grocery circular. It mockingly undercuts reverence by illustrating inappropriate religious display in two ways. The large crucifix is embedded within clippings from modern quotidian commerce. Second, the pose is again that associated with Saint Sebastian, a historical figure persecuted for his faith who in the early to mid-twentieth century had particular appeal to gay writers and artists who, like Sebastian, had been subjected to hostility because of their affiliation, thus identity.[28] Smithson contemporizes that connection by strapping Jesus's nude torso with bands that call up the black leather associated with sadomasochistic allure.

Collaged below the crucifix are three haloed, glamorous women in disparate European historical costumes. Among Smithson's extant paintings, images of females are rare. Two of the *Creeping Jesus* trio hold household appliances, associating them with domesticity and motherhood. In relation

to the crucifixion, the three women conflate two biblical stories: the Virgin standing at the foot of the cross, sometimes with a distraught Mary Magdalene; and the three Marys (those two plus Mary of Bethany) at the sepulcher. The three also could be stand-ins for the Duke sisters: Susan, mother of Harold and Smithson and, like the Virgin Mary in relation to her first son, the primary mourner; her elder sister and Smithson family housemate Julia; and the oldest sibling, Mary, who lived in nearby Rutherford with her family.

Closely on the right of Jesus's torso, the clipping of a sedan with family passengers calls up his father's employment in an automobile parts company and the family's several driving vacations. Right of the car, a portion of an advertisement with the word *YOUR* above a large number 36 identifies the reason for the sisters' mourning; *their* loss of Harold, who died in 1936. Also, in numerology, the sum of three plus six is nine, his age at death; we'll see more of Smithson's use of numerology and nine as a recurring number.

At the bottom right, three blurred photographs of a man's hand grasping the handle of a bell suggest motion and its plangent ringing. In the Catholic Mass, a bell is rung to alert the congregation to the calling down of the Holy Spirit and prepare them for the consecration that immediately follows. The bell is rung again at the elevation (the showing) of both the Eucharistic bread and the chalice to signal to the faithful that transubstantiation has taken place and that the Body and Blood of the Lord are present on the altar. In a picture conflating references to Jesus's sacrifice and Harold's, the bell tolls for their entwined mortalities.

The last of his works in the Alan show ends an arc displayed across the four from pre-Christian mythology and mosaic-like patterns to sober lament for the crucifixion to Pop Art levity around it. Like the first two, it is lost; this one is only known from its small black-and-white illustration accompanying the exhibition's *Art News* review. "*Ecce homo*" are the words from John 19:5 with which Pontius Pilate presented the thorn-crowned Christ to his accusers: "Behold the man!" Again, this is a subject he had previously depicted. His 1960 watercolor *Death as Ecce Homo* in the Utah Museum of Fine Arts depicts a grimacing seated figure with a skeletal head and sunken eyes, draped in a shroud. The pose is identical to a line drawing in the oldest book in Smithson's collection, *Christian Iconography* (1891).[29] The large oil of that title dated 1960 on the Alan Gallery checklist is so different in style and mood from his contemporaneous *Man of Sorrow* images that its date is hard to accept. This *Ecce Homo* appears to present not death but leisure, as if satirizing the religious theme. It shows Christ against a wide, blocky, and striped cross, but as his arms are bent at the elbows to show nail wounds, he is not affixed to it. Rather this bony body in bikini briefs

appears to be supine against a fringed beach towel. Behind the cross is a loose grid of photographed head shots. Indeed, less sacred than sacrilegious, it and *Creeping Jesus*, collaged with clippings from mainstream illustrated magazines, align his images with nascent Pop Art.

The conjunction appears to have baffled the reviewer:

> Robert Smithson's *Ecce Homo*, an oil of the Crucifixion emerging from a weltering collage of newspaper photos —faces grinning, giddy, "having a ball"—is immediately and ironically ambiguous; one cannot say whether the human images mock and revile the Redemption, or the Redemption makes a tragic point about the distance of natural man.[30]

Another review of the show, "A Nightmare World," was written by his former classmate, barhopping companion, hitchhiking partner, and friend of several years, Eli Levin. Although he introduced it as a discussion of "four young avant-garde artists," Levin didn't state the other artists' names or describe their works, but singled out Smithson for his "little formal art education" in "commercial illustration" (both had studied at the League with the well-known illustrator John Groth) and focused attention on his paintings, which "stand out like sore thumbs," a projection of the pain caused by Levin's own hammering:

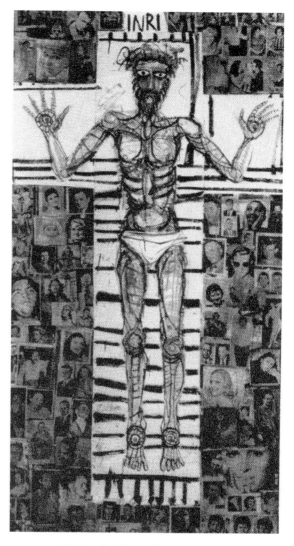

FIGURE 3.5. Robert Smithson, *Ecce Homo*, 1960. Oil and collage/canvas, 95 × 47 inches (24.3 × 119.7 cm).

Courtesy Art Department, New York Public Library. Copyright Holt/ Smithson Foundation / Licensed by Artists Rights Society, New York.

This work is known only from its illustration alongside a brief review in the April 1961 issue of *Art News*.

> Like all of today's young artists, Smithson soon began to direct all his efforts to become more modern than Picasso.... All these paintings looked very much alike. While they were in many ways confused, they did have some strength, being infused with a dynamic

all-over hatred. Their ugliness attracted the attention to an art world cult—semi-existential aestheticians who like the accidental, the extreme, and the perverse.

He obviously didn't examine Smithson's works closely, since rather than being "very much alike," the four could have been legitimately critiqued for their stylistic and thematic disparities.

As Levin quoted the only oral statement by Smithson from the early 1960s that has been published, Smithson's comment needs to be reckoned with:

> I had sunk deeper and deeper into society's sickness, searching for truth in the meaninglessness. Faith was the only hope, Faith in the supreme man—Jesus Christ—a reason to go on. That's when I painted *Creeping Jesus*, Jesus the man, swamped with the ugly meaninglessness of our civilization.[31]

The blunt language, simplistic argument, and repeated use of the word "meaninglessness" are inconsistent with Smithson's vocabulary, syntax, and sophisticated allusions. Perhaps Levin was recalling frank thoughts spoken casually to an intimate, but he did not capture them faithfully. His ad hominem malevolence also attempted to undermine Smithson's show in Rome, mentioned as upcoming.

This ostensible exhibition review written for the *Philadelphia Inquirer* was undoubtedly published because of the stature of his coauthor, Meyer Levin, who was still writing a regular column. However, Meyer's more mature literary voice, his strong praise for Smithson three years earlier, and the fact that Eli wrote columns as a substitute for his father makes it doubtful that Meyer had anything to do with this one.

The column was syndicated to other suburban newspapers by the Gannett newspaper group, and it was read by Smithson's parents in what Eli described as the "modern but cheap settlement area of New Jersey," words that caused great anguish to Smithson's mother especially, as MacDonald learned from him.[32] Perhaps it was a thrust in an ongoing rivalry. When both were high school seniors, Levin had written in his journal, "Bob is becoming a great artist. He has understood Abstract Expressionism. I am becoming a Flop."[33] To Lester, Smithson contrasted himself as getting "all the chaotic demons in their place . . . [while] Levin is still in the natural stew." (Levin painted portraits and still lifes in the style of academic naturalism.)

In that letter, written just a few days after the two reviews were published, Smithson told Lester, "The show at the Allan Gallery has created much comment. People are either, absolutely for me, or deadly against me.

... The critic for Art News made a good observation" (April 7, 1961, #4). But the latter comment was hardly an accolade and was actually quite ambivalent. The experience calls up the aggressions in Smithson's contemporaneous painting *Jesus Mocked* (1961), which shows arms crossed protectively over the bloodied chest as faces on either side spew slander, as well as the final lines of his "To the Mockery" incantation: "Never before has derision / Raged, / As it rages now."[34] Here, he conflated Christ's mortifications, public skepticism about the church and religion, and his own professional impediments. His personal history and professional challenges converged to justify his identification with both sacrifice and victimization (Plate 14).

Undaunted and determined, Smithson declared to Lester, "After my visit to Rome, and when I return everybody in New York art circles will know about the George Lester Gallery and Robert Smithson. I don't have to appeal to the art world here; they will follow. Believe me" (May 17, 1961, #7). As Thomas Crow astutely surmised, "This implausible pronouncement that a summer show in Rome was going to shake the New York art world might represent overcompensation for some other, unstated motive."[35] Indeed, in imagining antecedents as successors, Smithson conjured a reversal of his own fortune. Yet although his prediction of fame—"everyone ... will know about [me]"—is grandiose, his emphatic addition of the urging—"Believe me"—indicates that he himself was not convinced.

Working through the resistance he was experiencing to his fervent expression of Christ's death and his own doubt about the trends being promoted in museums and galleries, Smithson thrashed about for over a year or so in a thirteen-page collage of scrambled references to current exhibitions, artists, scientists, and familiar forms of "visual mortification" that amounted to, as he termed it, an "Iconography of Desolation." The structure of its title mimics Robert Burton's famous *Anatomy of Melancholy*, while also echoing Hans Sedlmayr's "A new ethos of desolation has come into being," ensuing from the cultural chaos of its "lost center" of devotion to God.[36] After exhibition reviewers' hostile response to his emotionally wrought figuration and Lester's undermining of his display of religious feeling and refusal to print the incantation, Smithson's losses were more in the area of confidence in his professional future. His religious affiliation is one thing he hadn't lost: in a year or so he and Holt would have a *very* Catholic wedding. But his "Desolation" essay indicates that he also hadn't let go of family remorse. References in the essay continue his incantations' bitter allusions to a cancer of the blood: "Which brings to mind Grünewald's incarnations of the Black Plague that say, 'Where were you, good Jesus, where were you? And why did you not come and heal my wounds?' In the same inflamed atmo-

sphere is Jackson Pollock's last painting *Scent*—astounding tumors on a Divine Blood Cell." And it includes resentment at the failure of a divine intervention: "A Dead God speaks out of the soul through the depths of disease, playing wounded tricks on Improvement."[37]

Smithson's references to a mother in his art and writing are to the Catholic primary maternal figure, the Madonna or Virgin Mary. Like the life of Jesus, biblical accounts tell many stories of Mary's life: her Immaculate Conception, the Annunciation, her adoration of her infant at the Nativity and afterward, her presence at her son's miracles, her Ascension and Enthronement as Queen of Heaven. But with one small exception: in Smithson's work there is no devotional reverence for "Hail Mary, full of grace, the Lord is with thee," as in the Catholic prayer. Yet even in his schematic ink drawing *Virgin of Guadalupe* (1961), a triangular mother in a long robe cradling an infant depicts Jesus's mother as she is venerated at the major pilgrimage site on the Hill of Tepeyac in Mexico City, where she is believed to have appeared in 1531; the magenta background calls up blood.

Smithson consistently attributes to Mary a single affect. Corresponding to his focus in his renderings of Jesus on the cross, his depictions of her (all from the early 1960s) are almost entirely of her role as her dead son's chief mourner. Twice he veers off from discussions of art to invoke the Virgin Mary, first referring to her as "*Maria Desolata,*" the Latin term for Mary's persona as Our Lady of Sorrows.[38] Historically, as part of services on Good Friday evening, the Church offers special devotions to the mourning mother, *Maria Desolata.*

Later in his "Desolation" essay, he proclaimed, "A wolf-man (geniuses know where he lives) howls on a fire escape in Chelsea," making the essay's autobiographical aspect explicit while implicitly echoing Allen Ginsberg's (in)famous poem *Howl.*[39] He had previously painted *Wolf Man of Chelsea* (1961), the neighborhood of his Sixth Avenue apartment, the two works suggesting identification with a feral spirit.[40] What does the wolf man howl on his fire escape at 725 Sixth Avenue—and in his studio, and at his writing desk? His next sentence is stated in the Latin of the Roman Church, "*Fac me plagis vulnerari.*"[41] Inserted without translation, the reference is immediately dropped as if it were a self-explanatory aside. But it is more like a hot potato—too inflammatory to touch, or explain, so he made it difficult to do so. His prior use of the Latin designation for the mourning Mary, *Desolata,* would have been familiar to a churchgoing Catholic; services did not begin to be said in English until late August 1964. This hymn line is obscure, thwarting a reader's recognition of his allusion.

"*Fac me plagis vulnerari*" is from the thirteenth-century hymn to Mary, "Stabat Mater," titled for its first words, "Stabat Mater dolorosa": "the sorrowful mother was standing." That is, the mourning Mary stood at the foot

of the cross on which her son was crucified, a presence familiar in historical European altarpieces and paintings (Plate 9), as are depictions focusing on the teary *Mater Dolorosa* herself, just as the *Pietà* image of a mournful mother cradling the crucified body of her adult son is central to Gothic and Renaissance sculpture. The intricate rhyming structure of the twenty-stanza "Stabat Mater" has been set to music by hundreds of composers. The phrase Smithson quotes is from the verse

> *Fac me plagis vulnerari, Cruce hac inebriari, Ob amorem Filii*
> [Let me be wounded with his wounds, inebriated by the cross
> because of love for the Son]
> *Fac me plagis vulnerari, fac me Cruce inebriari et cruore Filii*
> [Let me be wounded with his wounds, let me be inebriated by the
> cross and your Son's blood]

"Let me." "Let me." Following his howl, the Latin quotation indicates what provoked it: the sorrowful mother and her and the petitioner's mutual blood-drunkenness. The supplicant's plea to be wounded like the bloodily deceased son Jesus was to offer to take her place, essentially to get drunk on his blood. That corresponds to parents' common expectation that the replacement child will serve as a surrogate for what they lost, as reparation for themselves. The successor child adopts that desire to heal his parents' woe and his own survivor's guilt by fantasizing about switching places with the wounded prior-born, thus undoing the loss of the mourned one.

Those hopes of restitution by parents and successor children, even if unconscious, parallel the "child-of-survivor complex," extensively discussed in literature on the psychoanalytic effects of the Holocaust and which has been applied to understand relations between parents and replacement children.[42] Both engage in "missions for redemption which they anticipate would magically undo, or at least partially compensate for, the unendurable losses of the parents' generation."[43] In recounting the impact of being a replacement, poet Louise Glück illustrated this theme about her own experience as a replacement:

> Her death let me be born. I saw myself as her substitute, which produced in me a profound obligation toward my mother, and a frantic desire to remedy her every distress. I took it all personally: every shadow that crossed her face proved my insufficiency. . . . I took on the guilty responsibility of the survivor.[44]

The Smithson family's catastrophic loss (for Susan, losses) occurred before he was born. He did not directly experience his brother's life or, upon his

death, his absence. Similarly, artist Christian Boltanski's breakthrough mixed-media installations were stimulated by Hitler's genocide of the Jews and losses in World War II, which he did not personally experience. Born in Paris shortly after its liberation from the Nazis (from whom his Jewish father hid beneath floorboards), Boltanski seems to have identified not with the relief of emancipation but the anticipation of a threat—a sense of the world as a place with a strong presence of death and degradation. His work is pervaded by affecting melancholy. Like Smithson's fatalistic tenor, both derive from family communication, spoken and nonverbal, with those who had directly experienced others' deaths. They exemplify the transgenerational transmission of trauma, when the elder impresses psychic tattoos upon the younger—stated or unconscious and inadvertent—in what is called "deposited self-representation. Then in his interactions with the child, the adult sends 'messages' so that now it becomes the child's task to deal with the traumatized self- representation of the older person."[45]

As an adult Smithson experienced contemporaneous social, that is, public and shared, instances promoting contemplation of mortality (e.g., civil rights violence, Vietnam War carnage, and antiwar clashes). But he came to them from a home life that promoted receptivity to depressive ideation. His parents, especially his mother, had several causes for ongoing states of residual sadness. Smithson's fatalism was learned.

But his sensitivity to loss was also earned. Psychologists have noted the existentially ambiguous position of being a replacement. On one hand, their "fate is to have been permitted to live in the place where someone else has died. But . . . if to be a replacement child involves a sense of having been chosen, it also involves a sense of burden."[46] The successor child often experiences both the conflicts of receiving indulgences due someone "special" and the expectation of being the savior of the broken family. So there is resentment for getting the feeling, as Smithson stated in the context of architectural historicism but which could very well have been inspired by his own experience, that "repetition not originality is the object."[47] Not being identical in personality, interests, and skills in comparison to the inevitably idealized missing person, replacement children are commonly afflicted with guilt for not being able to step into the shoes of their predecessor so as to restore their parents' losses.

These are sources of what Gabriele Schwab has termed "the identity problems of replacement children . . . assigned a role in parental fantasies intimately tied to traumatic loss."[48] The child absorbs the distress of the family and continues its psychic grief work, making it additionally difficult—besides the inevitable comparisons, however unverbalized—for the successor to separate from the deceased. Smithson's obsession with blood,

mourning, and death—events that preceded his existence—suggests that in his family, the crisis around those was not resolved.

That process illuminates Smithson's sensitivity to issues of mortality, transience, identity, and everyday confidence in the ways of the world, as well as his ambivalence about the family role assigned to him. His emphasis of the Madonna as a Lady of Sorrows parallels his own identification as "Man of Sorrow"; his designation of her as "Desolata" echoes the title of his "Desolation" essay, which begins with an epigraph from Lewis Carroll: "I wish I hadn't cried so much!" All link mother's and son's melancholia as if it were a shared sensibility. It demonstrates how those born after their parents suffer psychological injury that has been insufficiently emotionally integrated, whether that injury hasn't been discussed by the parents or it has been repressed by their unconscious denial or refusal to accept the loss, can adopt their attitudes of unresolved melancholy or sensitivity to loss. As Smithson wrote, "One apprehends what is around one's eyes and ears, no matter how unstable or fugitive."[49] And his understanding became a source of his skepticism about control over one's future. He wrote, "But of course, today and yesterday may always be reversed," and spoke about confronting "the area of death" in his art "or the swinging back and forth between life and death."[50]

Smithson made the fragility of existence directly autobiographical when he wrote in a press release for a Dwan Gallery summer 1967 show on language, "Books entomb words in a synthetic rigor mortis, perhaps that is why 'print' is thought to have entered obsolescence. The mind of this death, however, is unrelentingly awake."[51] By signing it with the pen name "Eton Corrasable"—referring to a trademarked brand of translucent "onion skin"–like coated paper that allowed for the easy erasure of typed words—Smithson evoked the grip of this "mind of death" on himself, his awareness of the fragility of existence, and how he felt he could simply be erased.

Perhaps it was his independence from his family after high school that allowed him to eventually confront the family crisis of Harold's death and by the late 1950s start to work through it in his imagery. Literary scholar Richard Stamelman describes an emotional impetus: "Like a moth circling a flame in an arc of fatal fascination, the image moves in a frenetic, always circular, self-representing pattern around the event of the past it wishes to carry back into the present." Works of art representing loss—carrying them into the present—are supposed to function psychologically to contain overwhelming emotions, controlling and assimilating them. Such catharsis provides an experience of release and optimally a resolution of conflicts. So

why did Smithson express emotional distress, and when not that, dispassionate affiliation with mortality, so frequently and intensely? Stamelman has a relevant explanation:

> The relentless attempts at recuperation multiply the forms and meanings it expresses. This quest to repossess the past produces a proliferation of signs and an excess of meaning that seek to compensate for the inadequacy of the representational process. The image is always impoverished when compared to the loss it is trying to signify.[52]

The fantasy is that perhaps one more picture will capture the feeling and release one from it. It drives one, creativity, but does it heal one, psychologically? Metaphorizing his conflicts in ever inventive and imaginative forms. Smithson kept trying.

Clandestine
Fantasies
1962–1964

FIGURE 4.1. Robert and Nancy Smithson (as she was known then), 1963. What is that newlywed thinking as she looks at the camera with a wry smile, the arm of her husband of six months flung across her shoulder yet not clasping her? He looks away, perhaps refusing to accommodate a parent's desire for a smile and sign of their unity. As her parents were gone, this Christmas snapshot of them nicely dressed was probably taken at his parents' home. Courtesy Holt/Smithson Foundation and Nancy Holt Estate Records, Archives of American Art, Smithsonian Institution.

4

Burying the Angel

Let the Bloody Dove go down.

Far below a ragged mountain horizon, at the lowest level of an underground cross-section of a jumble of gray marks, cryptic letters, and words and series of numbers, a nude male's articulated physique suggests a schematic rendering of the swelling musculature of a classical Adonis. Although the painting is titled *Buried Angel* (1962), the male does not appear to be inert; his enormous wingspan is tautly erect. Confined within one of the overcrowded undergrounds of Smithson's post-Christological paintings, he is another who Carl Jung describes as "in the dark depths . . . as though dead, but yet lives and calls from the deep."[1] He signals in symbols and smoke. From a mountain's phallic channel, a plume scatters into the darkening sky, spurting pink (Plate 15).

Coinciding with and following Smithson's representations of Jesus's Passion, his even more numerous renderings of angels—at least among easily stored extant drawings—served as additional surrogates for Harold. The ancient Greek guide of souls to the underworld, Hermes, and his Roman counterpart, Mercury, had wings on their heels, the better to speed their travel. Latinate alchemists called him Mercurius; in *Psychology and Alchemy* he is likewise illustrated nude and winged and described by Jung as "stand[ing] at the beginning and end of the work; he is the *prima materia*."[2] For Smithson the angel *was* a *prima materia* of another sort. In

historical visual representations of the apotheosis of both Roman emperors and Christian souls, winged figures bear them heavenward. Smithson merged the deceased and the angelic messengers. His youthful males, winged, literalize the common vernacular of consoling bereaved parents by speaking of a dead child as having become an angel in heaven. According to Luke 20:36, "Neither can they die any more: for they are equal to the angels, and are the children of God, being the children of the resurrection."[3]

Before traveling to Rome, Smithson wrote Lester that he had "a special concern in the frescos in the church of Santa Cecilia in Trastevere, done by Pietro Cavallini" (undated [June 1961], #12). Displaying his attraction to what he called the Pre-Renaissance, the decoration in the late thirteenth-century basilica shows God seated in a Last Judgment pose wreathed by effulgently feathered angels. Smithson displayed that Gothic conjunction associating angelicness and mortality in his own work. Historically, angels are supernatural beings epitomizing goodness, beauty, and purity, messengers of God with wings enabling ascendance to the empyrean. But not in Smithson's pantheon. In contrast to Cavallini's glorious angels, Smithson's at Galleria Lester, a half-hour walk away, were horrifically skinned young adults, bloodied, roughly marked, with clipped wings that castrate levitation, as in *Ash Wednesday* by Smithson's favorite poet, T.S. Eliot: "Because these wings are no longer wings to fly."

While in Rome, in a letter to Nancy Holt he identified himself as

> From the keeper of Derangement himself, now vacationing in the Eternal City in order to walk in the path of the Vandals and the Saints, and to concoct flaming rhapsodies for a crippled God. The Nero from New Jersey watches the fire on top of a Lucky Strike.

In the margin, he drew cute putti, writing, "Don't mind these cherubs. They are always around, bothering me."[4] The disguised double entendre is characteristic. Cherubs, the Christian second order of angels as winged babies representing love, had another significance for Smithson.

A grown-up *Untitled (Angel without Wings)* (1961), now in the Menil Collection, has repeated red lines and zigzagging black ones surrounding the hollow-eyed figure, the intensity evoking electrocution or psychosis. *Jaundiced Angel* (1962) suggests another symptom Harold may have experienced. In his private drawings angels took the form of lithe winged young men à la the ambiguously sexed sylphs by the nineteenth-century English illustrator Aubrey Beardsley. In 1963–64 drawings, discussion to come, their torsos became less boyish than "built," less angelic than erotic.

In his incantations Smithson directly linked Harold with angels. His

plaint "Why must the angel / Eat Broken glass in such a land of plenty?" evokes both internal bleeding and the injustice of an advanced country (albeit 1936, the year of Harold's death, one that was in the midst of the Great Depression) being unable to devise a cure.[5] That question is posed in an incantation titled "From a Dream," suggesting Smithson's own sleep disturbance. His "To the Dead Angel" conflates images of ghost, martyr, and angel and declares, "The gates of paradise run red with an Angel's Blood" and acknowledges the personal significance of his angelic martyr: "Blessed be the Dead Angel for He is our Life."[6]

No replacement for a departed angel can compete against its perfection. Being dead, he is fixed in memory, he can do no wrong. Being a paragon, his ideal is ever present. This one's glorification by the family must have been intensified by having been victimized by untreatable mortifications of the flesh. The impossibility of the successor's measuring up to what his predecessor represents constrains his own wings. As Smithson had noted about high school, "There was no comprehension of any kind" as if of his own distinctive way of being angelic.[7]

And the successor child's differences from the person whose achievements and personality the parents unconsciously want him to duplicate make him born into a situation promoting rivalry. Conceived as a substitute, he finds that the lost predecessor is actually revered as a prototype, with whom he is both confused and driven to exceed. That is what we see in Smithson, whose family structure manifests both in a succession of artistic references to Harold and metaphors for his relation to him and propel Smithson to seek recognition as an original.

That tacit rivalry seems to have stimulated Smithson to reject a range of authority figures' expectations. He attributed his estrangement from high school to its academic environment, recalling it as "hostile and cramped, and it just alienated me more and more." With his wide-ranging intellectual interests (publication dates of books in his collection indicate that he may have started amassing them in high school or earlier), and his artistic and sexual proclivities rubbing up against the oppressive emphasis on conformity in the 1950s, the alienation must have gone both ways. He stated emphatically, "In a very, very definite way I wanted nothing to do with high school, and I had no intention of going to college."[8] Instead of suffering through high school as many bright outliers do with the aim of finding cohorts in the more sophisticated milieu of college, he opted out.

That academic disaffection may have prevented Smithson from becoming a zoologist, the profession that interested him the most according to a sheet of "My Favorites" (dated 1952), at the age of fourteen.[9] That corresponds to his Clifton High School records, where at the end of his freshman

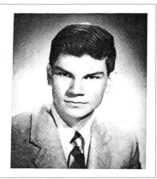

ROBERT SMITHSON
74 Harvey Road
GENERAL

FIGURE 4.2. Robert Smithson in the Clifton High School Class of 1956 yearbook. Those flaring eyebrows suggest a source of Alice Neel's description of the artist whose portrait she painted (Plate 16) as "wolf boy." Courtesy Clifton High School Library.

year he designated his "Ambition" as zoologist. By the end of his sophomore year, he identified it as art. Two years later, in the Class of 1956 Clifton yearbook, next to his formal photograph in which he glares from under sharply arched brows, is just one word: "General." That is, *not* college preparatory. A classmate from elementary, middle, and high school, Judi Den Herder, recalls him as distinctly "quiet."[10]

Given Smithson's account of the situation, we might take that to mean withdrawn, chafing against institutional authority and refusing to engage in another arena of competition beyond the one he had been born into. His classmate in middle and high school, Nancy Holt, was blunter, recalling him during those years as

> one of the ten students to watch in high school, because he might commit suicide or go crazy or something or like that. He was not a normal person. Which is why they allowed him to go to art school half a day, the last two years of high school. A principal in high school allowing that to happen? I think he thought that if he didn't, Bob would commit suicide, or do something weird.
>
> Then he met people in art school who were going to the High School of Music and Art. People he could connect with, and that made all the difference.[11]

At graduation from Clifton High, Smithson had been absent thirty of the academic year's 180 school days and his average grade was 78 percent (C+).[12] A decade later he still castigated formal art education, seeing it as restraining: "Art is 'humanized' in all our schools under the censor called 'The Humanities.' Humanism confuses and subverts all consciousness of art by opposing 'life' to 'art.' . . . The 'studio' and the 'class room' are artistic prisons."[13] It wasn't that he was against study of the humanities. At the time he potentially owned about two hundred and thirty-nine books in the dominant field of the humanities, literature—those published in 1966 or earlier. But, sensitive to suppression, he railed against the authority of institutional education. Among the influences evident from his reading of Wylie Sypher's 1964 collection of essays, *Loss of the Self in Modern Literature and*

Art, he undoubtedly felt an affinity for that Middlebury College professor's assertion that "if one is an artist, one does not need schooling to respond to the turn of our interests."[14] Sypher had earned four degrees (including a master's and a doctorate from Harvard University) but voiced the romance of the artistic persona as self-sufficient creator before its mid-1960s transformation into a cerebral professional.

Smithson's big NO to potentially constraining conventions expanded from formal education and secular abstract painting to "warden-curators" and museums' "oppressive" "walls of confinement," as well as a belief that "artists who try to get into museums or who want to show on white walls are really like convicts trying to break into prison."[15] He wanted to know the art world "apparatus" that he considered himself being "threaded through."[16] In June 1968—that violent spring with the assassinations of Martin Luther King Jr. and Robert Kennedy, the national student strike and general strike in France—Smithson wrote, "The Establishment is a nightmare from which I am trying to awake."[17] James Joyce's protagonist Stephen Dedalus in *Ulysses* says, "History is a nightmare from which I am trying to awake." Smithson's adaptation voices the ethos of the postwar baby boomers then in their teenage years who considered government, institutions, and elders as the "robots of The Establishment" running "The Museum of Leftover Ideologies." (Notably, one establishment Smithson did not critique was the Vatican.) Young people's maxim was "Don't trust anyone over thirty." Smithson was exactly that age, and in this essay demonstrated that he was still on the side of youth.

Posthumously, he would be lauded as a proleptic artist anticipating attitudes such as the postmodern conception of the "decentered self"—identity not from a unique sensibility but from shared and motile social/historical conditions. A strong source of Smithson's intellectual acumen was his insight into his own emotional life. His *own* identity had been "decentered" since birth, in that he had been given an identity that was intensely relational with both predecessor and parents. Knowing his background, it's easy to discern personal issues galvanizing the social ones. The discomfort of a child constricted by fearful, overbearing parents eager to contain risk and prevent the loss of yet another family member corresponds to his resistance to confinement in adulthood, as in his published rant against "thought-control" exercised by a "nightmarish system [that] catalogues every known physical thing according to the 'science' of totalitarian propaganda." The diatribe was part of a short essay for the New York alternative paper *Metro* linking the "Establishment" to "a deadly utopia or invisible system that inspires an almost mythical sense of dread—it is a 'bad dream' that has somehow consumed the [or at least his] world." Smithson's words, written in 1968, recall those claustrophobic underworlds of the 1959 penal

FIGURE 4.3. Very young marrieds? Her long white dress, corsage, and bouquet, his dark tie, blazer, and boutonnière, their formal yet entwined pose and expressions of delight evoke that ceremony. Lorraine Harner took this picture of classmates Nancy Holt and Robert Smithson possibly on the occasion of their graduation from middle school in 1952, when all were fourteen. Courtesy and copyright Lorraine Harner.

Purgatory (Plate 8) and *Walls of Dis*, or of a single figure in a cross-section of an underground sometimes within a cavity, but not a corpse. See, for example, *Alive in the Grave of Machines* (Plate 11) and *Scorpion Palace* (Plate 18) (both 1961) and *Buried Angel* (1962) (Plate 15).[18] (Many other instances of confinement are in paintings not illustrated here.) Years later, he expressed his sensitivity to being controlled by distinguishing between spatial "openness" and its pictorial representation, disparaging the latter's unconvincingness as "One might as well tell a prisoner facing a life sentence that he is free."[19]

Compare that adamantine insistence on autonomy to the experience of his classmate in middle and high school and future wife, Nancy Holt. Her paternal grandparents, Samuel Holt and Mary Ellen Crowther, had emigrated from a rural area around Manchester, England, to New Bedford, Massachusetts, where following the births of his sisters Ethel and Elizabeth her father, Ernest Milton Holt (1910–1962), was born. Her maternal grandfather, Joseph Gottlieb Jehlicka, had emigrated from Mainz, Germany, to Barre, Massachusetts, outside Worcester. His surname is a Czech and Slovak (Jedlička) nickname for a tall, well-built man (from a diminutive of *jedle*, "spruce, fir"); on some documents it is anglicized to Jelicoe. Her maternal grandmother, Etta May Robbins, was born in New Bedford, Massachusetts. Joseph and Etta had two daughters: the first, Etta Louise (1913–1962), born in Barre, was known by her middle name, Louise. Her sister was Dorothie Adele (1919–1999).

Ernest Holt and E. Louise Jehlicka married in Leominster, Massachusetts, in 1935, when he was twenty-five and she twenty-two. Unlike Smithson's parents, both had completed high school. Ernest went on to graduate from the Worcester Polytechnic Institute with a degree in chemistry. Within a year he was a chemical engineer for the DuPont Company, his employer throughout his lifetime. When Ernest was twenty-seven and Louise twenty-five, Nancy was born in Worcester, Massachusetts, in 1938 (three months after Smithson). As her mother had been, Nancy was given

her mother's name, Louise, as her middle name; she was raised as a Presbyterian. Dupont transferred Ernest to New Jersey when she was three. After a short period in Bloomfield, they moved to Clifton.

Holt and Smithson grew up a few blocks from each other in the Allwood section of Clifton and attended the same local schools. Both were only children, second-generation Americans of mixed English and Slavic descent, and had a paternal grandfather named Samuel. An undated snapshot shows them posing together as a couple, dressed up, most likely on the occasion of their eighth-grade graduation in 1952 (Figure 4.3). That August Holt sent Smithson a postcard from Cape Cod, where her family vacationed every summer until her high school years: "Dear Bob, Having a wonderful time here. The water is grand. Seeing you in a week. Nancy PS. Write to Dennisport P.O., Dennisport, Cape Cod, Mass."[20]

At Clifton High they both took drawing as freshmen and art history in their junior and senior years; she earned a grade of eighty-eight percent each year, he seventy-six percent and seventy-seven percent. Their Class of 1956 numbered 463 students; they weren't necessarily in a class's same section. Their paths diverged and their early teen closeness dissipated; they saw little of each other in high school. While Holt pursued her Honor Society membership, majorette status, and duties as the junior year Fiesta Queen, Smithson, the renegade from public education, chased buses to the Art Students League in the city.

At the time of their graduation his house was a compact bungalow with metal siding. Eli Levin demeaned it as a "lower-middle-class tract house furnished, I thought, without taste."[21] Irving Smithson had left Electric Autolite to be a real estate salesman. Holt had grown up in a tall brick pseudo-Tudor, albeit rented, as although by 1950 Ernest Holt had been promoted to management of DuPont's plastic material manufacturing, he and Louise continually hoped that DuPont would imminently restore them to their native Massachusetts, so they put down few social and property roots in New Jersey until years later. Holt's smiling photograph in their Class of 1956 yearbook identifies her academic program as "College Preparatory." She graduated with an overall grade average of 90 percent and the rank of seventeenth in their graduating class of 463; his rank was 227.

FIGURE 4.4. Nancy Holt, photographed by Lorraine Harner on her own family's front step, Clifton, New Jersey, circa 1955–56, when they were seventeen or eighteen. Courtesy Lorraine Harner.

NANCY HOLT
20 Windsor Road
COLLEGE PREPARATORY
Majorette; National Honor Society;
Le Cercle Francais; G.A.A.; Senior
Representative; Swimming Club;
Bowling Club

FIGURE 4.5. Nancy Holt in the Clifton High School Class of 1956 yearbook. Courtesy Clifton High School Library.

Note, however, that era's priority in listing her activities next to her yearbook picture: "Majorette" is first, as if the most significant position she had achieved was being a baton twirler in front of a marching band. In the fall of 1956 she enrolled in the women-only Jackson College, part of Tufts University in Boston, returning to the state where she had been born and that her family considered home for generations, Massachusetts.

A couple of years later, Harner, then attending Barnard College, ran into Smithson on the bus from Allwood to Manhattan and renewed their friendship. Another year or so later, she connected the alienated alumnus with her good friend and his former chum, Holt. In late summer 1959, Smithson wrote, "My Dear Nancy, Looking forward to seeing you down here, for my opening [of his Artists' Gallery solo show] and party." As noted, she didn't go. Nevertheless, in a letter soon thereafter Smithson gave travel details about visiting her in Boston, signing it "Bobbie," the name by which she knew him as an early teen and an affectionate reference to their history together.[22]

Following graduation from Tufts in 1960, Holt spent the summer in Europe with Harner and two of Harner's college friends, then moved to Manhattan and worked for Lederle Laboratories in Pearl River, New York (just north of the New Jersey state line; in 1948 Lederle had developed the first broad-spectrum antibiotic).[23]

Harner reflected on friends since childhood whom she had reunited:

> I think Nancy saw someone who had an inner core of strength. Someone who moved in a circle of people, who understood that circle of people, someone who could talk rings around any sort of idea, someone who was actually committed to doing something with his life and wasn't actually flailing around with useless undergraduate degrees like we were.[24]

Holt's college major in biology was aligned with Smithson's interest in natural science. Despite the disparities in their parents' educations and income, like Smithson, she stated, "I didn't come from a family where art was appreciated or encouraged."[25] They were both only children, and Holt, too, had had a family history marked by loss:

I had a difficult family life, really. I lived in a nuclear family, where I was the only child. There were no other adults. I mean, we had no relatives. My parents had very few friends. They were thorough New Englanders, and only moved to New Jersey because my father ... was transferred there. He was told it was only going to be there for a couple of years, which he was very happy about. So they never bought a house. They rented for many, many years, thinking that we were about to move. And I was taught that living in New Jersey wasn't, like, real life. Like, real life happens somewhere else—in New England. . . . And so that was my world, these two people.

Holt's ambivalence about her mother echoes Smithson's characterization of a maternal figure as a lady of sorrows:

My mother—she sort of had a lot of emotional problems, and she was also very ill with a lot of different things. So she wasn't really a role model for me. . . . So I looked at my father and I thought, "Well, he's somebody who is out in the world." . . . And that meant that—he was a scientist, so I decided that that interested me.[26]

Years later in a conversation with critic Lucy Lippard about artist Eva Hesse, Smithson and Holt both referred to motherhood. Recalling seeing Hesse's *Ishtar* on his first visit to her studio, he remarked, "That's the one that remains in my mind" and "That was the piece I used in my article."[27] Hesse's *Ishtar*, a vertical panel with ten rows of two hemispheres, depicts the multiple stacked breasts of the ancient goddess also known as Artemis of Ephesus (illustrated in Jung's *Symbols of Transformation*, which he owned). Smithson confirmed that that's the one he meant by referring to "extension of the nipple region." In Hesse's *Ishtar*, hanging from the center of each breast is a black cord, as if toxic milk is dripping from the nipple. Smithson's connection to this image of poisonous motherhood—"I've thought about [*Ishtar*] the most"—is reinforced by the bookmark,

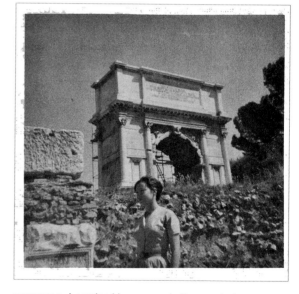

FIGURE 4.6. Lorraine Harner was in Europe during Smithson's Lester Galleria show in summer 1961 and came down to visit. They took pictures of each other in the Roman Forum, this one near the Arch of Titus. Courtesy Lorraine Harner. Copyright Holt/Smithson Foundation / Licensed by Artists Rights Society, New York.

FIGURE 4.7. Eva Hesse, *Ishtar,* December 1965. Acrylic, cord, papier-mâché, wood, plastic, 42½ × 7½ × 2½ inches (108 × 19.1 × 6.4 cm). Private collection, Switzerland.

Copyright the Estate of Eva Hesse. Courtesy Hauser & Wirth.

Photograph courtesy Doris Ammann Fine Arts.

a cash register receipt for $1.57 dated Feb. 10, 1956, that he placed between pages 122 and 123 in his copy of *The Self in Psychotic Process: Its Symbolization in Schizophrenia*. The author states, "These myths exemplify the prevalent association of the mother goddess with *death*. In the Babylonian Gilgamesh Epic, the hero enumerates the murderous crimes of the goddess Ishtar, who is also responsible for the mass destruction of the deluge."[28]

In that conversation with Lippard and Holt, Smithson continued, "[Hesse's] consciousness was the most interesting thing about her. Her consciousness of what she was and what she's been through and what she's making." (As a very young child in Nazi Germany, Hesse and her sister were briefly separated from their parents during their escape. Reunited, they emigrated to New York City. Hesse's mother left the family and, when Hesse was ten, committed suicide.) His sensitivity to her losses suggests his feeling of affinity with Hesse regarding both introspective sources of their art and disturbed relations with what Holt described to them about the rendering of the breasts as "desire for the mother." Later in that conversation, Holt spoke collectively: "Many of us had to reject our own mothers; our fathers were usually the strong ones who were doing things and going places."[29]

Another emotional connection between Smithson and Holt was that they both experienced multiple deaths of family intimates. Smithson's paternal grandmother, Lillian, wife of Samuel, died at seventy-seven in November 1960. Julia Duke, his aunt, died in April 1961; soon Holt's mother was diagnosed with colon cancer and died at forty-nine, within a week of the first anniversary of Julia's death in April 1962. Three months later, Holt's father, fifty-one, died the way Julia had, of a fatal heart attack. Holt was twenty-four and her immediate family, isolated in New Jersey, was

gone. No wonder she identified his appeal as "Bob was always eager to see me . . . and he knew everybody."[30]

Despite her parents' early deaths, Holt, unlike Smithson, seems to have absorbed her losses and ceased grieving. Her works of art and writings about them do not display an affiliation with mortality. Rather, she shared Smithson's sensitivity to confinement. When she became a sculptor, her constructions' constricted perception repeated her childhood family's narrow focus. Holt's small-diameter lensless pipes as viewing tubes in *Locator (Cracked Window)* (1971), the ground-level recessed pipes filled with water of *Hydra's Head* (1971), and the circumscribed environmental perception offered in her land art *Sun Tunnels* (1973–76), *Stone Enclosure: Rock Rings* (1977–78), and *Dark Star Park* (1995) direct and focus views. But unlike telescoping lenses, which bring distant and expansive entities close and make viewing intimate, Holt's pipes and tunnels constrict perception of things that remain distant. The containment evokes her lonely family experience, restricted from visiting the glittering but dangerous city across the Hudson River and being endlessly putative transients in New Jersey while her father anticipated the corporate return transfer that would restore them to their paradisiacal Massachusetts homeland, which never came.

The contrast between Smithson's senior year grades of 77 percent in American history, 75 percent in English, and 83 percent in music appreciation and his copious library suggests this bookworm's mixture of a love of learning, a desire for self-improvement, and an almost obsessive act of overcompensation for the lack of formal education, his own and his parents'. Richard Serra, Smithson's fellow dauntless sculptor and good-friend-cumrival from the end of the 1960s, who earned a BA in 1961 from the University of California, Santa Barbara and an MFA from the prestigious graduate studio art program at Yale University, recalled that Smithson frequently brought up that he had not attended college although he never offered a reason.[31] At his death at thirty-five Smithson's personal library numbered more than eleven hundred volumes. If Smithson's period of book buying is considered the twenty years from the age of fifteen to his death, that amounted to retaining on average more than fifty-six books annually. His middling grades in high school cannot be attributed to a lack of aptitude but rather insufficient engagement or a refusal to perform according to parental and societal expectations.

Smithson's desire for distinction had led him to grandiosely proclaim to Lester that after his Rome show he would be known as an influencer. That did happen, but it took a detour and over a decade to reconfigure his artistic persona before he integrated personal concerns into the topical medium, sculpture, and form, minimalist, yet new material, earth. In the early

1960s, Smithson's identification with morbid sacrifice expressionistically conveyed made him an outlier. In the year of his Lester show, 1961, an exhibition that captured the momentum and became historically influential was, in the spring, the extroverted *Environments, Situations, Spaces* at the Martha Jackson Gallery, for which "Happenings" originator Allan Kaprow famously filled its courtyard with a dense jumble of automobile tires he titled *Yard*. In the fall the Museum of Modern Art's international survey *The Art of Assemblage* also served toward breaking painting's dominance. Both of these opened after Smithson shipped his paintings to Lester, but they were inspired by tendencies that had accrued in the galleries over time, particularly the free-form, mixed-media Happenings and Jasper Johns's and Rauschenberg's hybrids of painting and sculpture. The explosion of Pop Art was igniting; in March 1961, Smithson had exhibited alongside Claes Oldenburg at the Alan Gallery, and in December Oldenburg would display cheap foodstuffs and tacky muumuus made of loosely painted plaster in his faux "Store" on East Second Street.

His "Iconography of Desolation" howl from his fire escape conveys Smithson's scorn for the new styles—the text peppered with synonyms for experiences of destruction: decay, void, devastation, mortification, calamity, ruins, mortal, agony, despair, catastrophe, dirge, diseased, wounds. This essay's convoluted structure seems to have been spurred by a frenzy of free association. Specific references to exhibitions and periodicals—from MoMA's *New Images of Man* exhibition in fall 1959 to a *Life* magazine article on Grandma Moses in the September 19, 1960, issue to a *New York Times* front page report on nuclear testing in the South Pacific on April 10, 1962— suggest that it was spit out over months as a personal jeremiad.

Elaborating to Lester about personal conflicts, Smithson's disdain for Modernism, paralleling Sedlmayr, mixes with the misery evident in his images of crucifixion and earthen decay. Lamenting the absence of what he called the sense of the "sacred," he lambasted both the impersonal detachment he attributed to nonrepresentational abstraction—"After many secular ambushes, iconography is oriented into the snares of mediocrity called OBJECTIVITY—declassic and deromantic—which in time and space break down into NON-OBJECTIVITY"—and Pop Art, initially known as "New Realism." He complained of "the mundane mania for the neo found-object chock full of 'banal' mystery," where "economic vices are openly anti-glory and rip down anything that looks other-worldly," as seen in the bold constructions of common commercial objects and mass media news images by Arman, Johns, Edward Kienholz, Rauschenberg, and others promoted in MoMA's *Assemblage* exhibition. That tendency was amplified by the increasing presence in galleries of artists' incorporation of comics, news photos and prosaic goods. Smithson described the predominant art world

options as "'pop' art and Clement Greenberg's visual Puritanism" (edge-to-edge planes of saturated color, fulfilling the critic's modernist dogma to reject volumetric illusionism and appear flat). "Dehumanized voices put off intensity while claiming humanity. Paradox reverberates against paradox, till the Ghost is given up."[32]

By his criticism of the 1960s art world's emerging representation of the quotidian and its relentless desire for stylistic revolutions, Smithson conveyed nostalgia for the expressionism that reigned when he first started studying art. "Action painting shows no non-objectivity." Stylistically, it actually was predominately nonobjective abstraction, that is, nonrepresentational, but he seemed to be distinguishing that from critics' late Modernist restriction of visual analysis to impersonal form. "Rather [Action Painting] reveals unformed incarnations from a primordial animism lurking in sacramental substance. . . . Art was never objectified during the Ages of Faith; art was an 'act' of worship."[33] Here he refers to critic Harold Rosenberg's famous description of the canvas as "an arena in which to act": "What matters always is the revelation contained in the act," and significantly, "a painting that is an act is inseparable from the biography of the artist."[34] His identification with Rosenberg's assertions indicates that he viewed his own painting as an expression of his emotional life, but also that his emotional life was about "worship."

Here is a statement of belief that is not just Christian but aesthetic, one Smithson will reiterate throughout his career. In declaring, "This invisible world is just as actual as the space-time continuum, just as death is as sure as life," he is affirming the centrality of imaginative sources of art, and yet that art should be about eternal truths. He argued, "If icons are seen as *sense-objects*, they are dead to the world."[35] His images will manifest this "invisible world,' which as he ended both sentences' declarations with reference to death, again, are intimately entwined with mortality. The dead are invisible, as are memories, and is the Holy Ghost—both the member of the Trinity and the absent angel of the original Smithson family trinity. With his assertion of the "actuality" of these entities that are unavailable to sight—what in the future he will term "nonsites"—he believes that art should express spirit, memory, and endogenous states, those that come from personal reflection.

"Iconography of Desolation" is Smithson's earliest extant essay. His careful crossing out, writing over, and addition of phrases in the thirteen-page typescript suggests that he was preparing it for close reading and potential publication. But no communication with or about a potential publisher exists. While during his lifetime it remained his private howl, he made that easy to hear by bookending his overwrought rant with two intelligible quotations. The epigraph is from Lewis Carroll. "'I wish I hadn't

cried so much!' said Alice as she swam about, trying to find her way out." It is the first of his epigraphs to his essays by authors with multiple identities; Carroll was the nom de plume of the Reverend Charles Dodgson, a professional mathematician and symbolic logician, a writer of "nonsense," and a photographer, mainly of provocatively posed prepubescent girls.[36]

But more resonant than the epigraph's author is the sentiment Smithson chose to highlight, being lost and crying. Tears flowed from his conflict between desires for spiritual devotion and "for professional recognition. He's aware that, as he wrote, "Sensible ways of looking at art works are lost in the abandonment of the Holy Ghost." But that loss is exactly what he is about to conjure—make it appear so—through transforming his artistic persona. He is uncertain: "Not knowing if such . . . vision[s are] right or wrong," yet he has decided, "the artist returns to earth where everything is always wrong." He hesitates yet sees what he must do: "Paradox reverberates against paradox, till the Ghost is given up."[37] He must abandon the appearance of affiliation with the Holy Ghost and its family double, angels, in the art he shares with the public.

To seal his resolution, Smithson concluded his "Desolation" essay with translated lines from a religious song, "O Day of Wrath! O Day of Mourning." The thirteenth-century Oremus Hymnal reinforces his path forward, moving away from direct depiction of religious subjects in his art:

> Worthless are my prayers and sighing.
> Yet, good Lord, in grace complying,
> Rescue me from Fires undying.

The mental energy displayed in Smithson's long "Iconography of Desolation" essay careens between the manic (howling) and the mournful (*Maria Dolorosa*). Journalist Howard Junker, who in the mid- to late sixties socialized with Smithson and joined him on New Jersey jaunts, recalled, "Bob was always a depressive character . . . he was very dark and brooding and haunted."[38] Smithson could be said to typify what the Renaissance attributed to artists, a saturnine temperament. As art historians Margot Wittkower and Rudolf Wittkower explained in *Born under Saturn: The Character and Conduct of Artists*, in Smithson's library:

> Aristotle . . . first postulated a connection between the melancholic humour [of the four humors or substances that the Greeks believed characterized individual human temperaments] and outstanding talent in the arts and sciences. . . . [In] the late fifteenth century . . . Aristotle's position [was] newly and fully endorsed. . . . Marsilio Ficino . . . maintained that the melancholy of great men was simply

a metonymy for Plato's divine *mania*. The Renaissance accepted Ficino's conclusion: only the melancholic temperament was capable of Plato's creative enthusiasm.[39]

Smithson may have been intrigued by this explanation for precedent artists' temperament. Or maybe it was more personal, as he himself had been born under Saturn, the planet associated with his astrological sun sign for his birthdate, Capricorn. Despite all the frustration Smithson expressed in his "Iconography of Desolation," writing it seemed to rescue him from going "down the rabbit hole into Desolation" and into the "Fires undying" of hellish banishment by the art world.[40] It helped him accept the need to relinquish his representation of what he punningly referred to as the Holy Ghost in favor of what he satirized as "sensible ways of looking at art." By that, he didn't mean analytically sound judgment but mundane analysis of visual form. He will "comply" with the art world's taste for the "secular ambush of iconography" by excelling at its preference for material innovation.

He needn't have made such a complete break in his art with religion. At the time, Barnett Newman was working on his fourteen *Stations of the Cross* (1958–66), which in 1966 would be exhibited at the Guggenheim Museum; Newman's use of Jewish sacred Jewish texts such as the Kabbalah as sources for other compositions would be revealed in Thomas Hess's catalogue for the Museum of Modern Art's posthumous Newman show in 1971. But Newman's evocations of Jesus's passions in nonrepresentational color field abstractions, without iconography, did not correspond to Smithson's conception of religious imagery as figurative. In actuality, what Smithson eliminated in his art was not symbolization but figuration, what he later identified as anthropomorphism. While his art will appear in more fashionable forms, his beliefs and conflicts will be configured in symbolic systems more esoteric than Christianity.

With the last text he wrote in verse Smithson strengthened his resolve. His autobiographical title, "Lamentations of the Paroxysmal Artist," reiterates Ficino's description of a great man as a mixture of melancholy (subject to lamentations) and mania (a "paroxysm" is a fit of violent action or emotion). But his choice of those two words so perfectly encapsulates the moods of his art and writing that it also indicates how perceptively he observed himself. And it articulates his artistic orientation's segue from hymnal lamentations to secular paroxysms.

In calling himself "paroxysmal," Smithson acknowledged the frenetic energy that carried him across his personal Rubicon of eccentricity to reach the mainstream art world. And "paroxysmal" sounds so much more

romantically tortured than mundane "mania." But the latter describes a level of activity in the first five months of 1961 that was extreme even for him: the creation of about fifty paintings for Lester to choose from for Rome and twenty-one incantations to submit to the Catholic publishing house while reading his twenty-year annual average acquisition rate of fifty-six books (and we can assume more from friends, the public library, or read and passed on), keeping up with exhibitions, and on frequent late nights showing up where there would always be artists to engage and dispute—at the Cedar Tavern, and a few years later, Max's Kansas City restaurant and bar.[41] As Alan Brilliant recalled, "I can see now that Bob was attracted by my mania about art (and spirituality), how intensely serious I was and I found in him the only person who was willing to go on about art, art history, everything to do with art, *endlessly*."[42] Years later curator Jan van der Marck recalled Smithson's hyperkinetic volubility. "He was argumentative, he went on endlessly on subjects, so that at two o'clock in the morning I literally had to fight sleep, but he went on. He was monomaniacal."[43]

Soon after returning from abroad, Smithson wrote Lester, "For the most part this past month I've been working on a new series [of paintings]; I've completed about ten." That number indicates the intensity of his activity, reflected in his packed imagery. But for him, it's as if that rate of production is his quotidian routine, which he characterized by adapting the tormented Macbeth, "And so life creeps at its petty pace, but without any sound or Fury" (September 22, 1961, #15). He was—as he put it in his title for a painting with red and black stripes akin to those of his crucifixion torsos, here secularized into a stack of irregular rectangles—*Busy Busy Busy* (1961).

Holt recalled: "Bob's energy level was like ten times the normal person. I used to say that he had the metabolism of a hummingbird."[44] More likely, the maniacal "paroxysmal" so perfectly complements the melancholia in his "Desolation" essay that the successive texts can be thought of as displaying a "bipolar" mentality. Smithson used that word (also spelling it "bi-polar") four times in the interviews and texts in his *Collected Writings*, as in "So that dialectic can be thought of that way: as a bipolar rhythm between mind and matter. You can't say it's all earth and you can't say it's all concept. It's both. Everything is two things that converge."[45]

Unsurprisingly, he seemed aware of its applicability to his own behavior. Smithson's "Lamentations" intersperses paragraphs and single lines to again convey a supplicant's chant, but now voiced by a skeptic:

The Word came unto me looking like a silly mess. Take it away! Take me away! . . . Cut my eyes out before I see Death. Too much Hemophilia. Too much Honey [used historically to mummify cadavers]. . . .

Degod me! The faster the better. Spare my dying puddle. Unamen
 ["Amen" as at the end of a prayer, but not-amen: unamen].
Good-by Mary. It was nice knowing you. Give my best to Dad
 [so he is the son of the sorrowful Mary; "Dad" is Jesus].
Let the Bloody Dove go down.[46]

With that symbol he reconfigured the bloody *Flayed Angel* as the Christian avian symbol of the Holy Ghost or Spirit, one of the sacred Trinity. Saying farewell to *Maria Desolata* and her "inebriation by the cross and her Son's blood," per the *Stabat Mater*, and hopefully thereby to his own desolation, he seeks release from her blood drunkenness and the family's hemophilia, which in this case is not the disease of failure for blood to clot but a pun suggesting an intimate bond (*-philia*, "love") with blood. He urges the mother to detach from the family's Holy Spirit and his "everlasting funeral," a line from his "Flayed Angels" incantation that presents the eulogistic obsequies as inexorable, and wants to "Cut my eyes out before I see Death," a violent metaphor of his personal connection alluded to in his 1960 painting *Eye of Blood*.[47]

His desire to distance himself from identification with Harold and the family's obsession with his bloody demise, and Lester's resistance to his own religious iconography, seem to have stimulated him to explore religious doubts. Among the seventy-six books on religious subjects in his library published through 1961, when he was avidly painting Christological subjects, one of the fourteen published that year is Richard Hinton's *Arsenal for Skeptics*. Absent dated notes on Smithson's part, it is impossible to know when he read it, but this volume's contents and publication date coincide with the date and sentiments of "Lamentations." *Arsenal for Skeptics* is a compendium of historians', investigators,' and scientists' commentaries on inconsistencies, superstitions, and outdated beliefs concerning church fathers, saints, and Bible writers intending to show readers "the theological delusion." Among the "freethought literature" pertinent to Smithson is Hinton's incredulity about martyrs' "ardor and fanaticism," summarizing a section from Edward Gibbon's *Decline and Fall of the Roman Empire*. Following that, in a section titled "Their Martyrdom Proves Nothing," Hinton quotes from H. L. Mencken's translation of Nietzsche's *The Antichrist*: "Blood is the worst of all testimonies to the truth; blood poisoneth even the purest teaching and turneth it into madness and hatred in the heart."[48]

Smithson's "Lamentations" is undated, but its epigraph indicates both a source of his cries and their time period: "All of 'em have fun but me / from a song as sung by Dion." In 1961 the teen idol wailed those lines in the song "Somebody Nobody Wants." The 45 RPM single was played frequently on AM radio stations featuring the Top 40. (Carl Andre later remarked, "[Bob]

was eminently a man of his time—the top forty were much more important to him than Bach or Beethoven and he had an almost mediumistic sensitivity to the cryptanalysis of pop culture.")[49]

Dion complained, "Why why why must I be / Just another somebody nobody wants." It was not a major hit but must have struck a nerve with Smithson. As in one of his own incantations, Dion's self-pity ends with a thrice-repeated refrain, "Nobody wants me." The conclusion of the "Lamentations" is in a more parodic voice:

Glory! Glory! Glory!
Bingo. Bingo.
IBM

The acronym for International Business Machines is Smithson's mocking substitute for the Christogram IHS, the abbreviation of Jesus's name in Greek, ΙΗΣΟΥΣ. He's ventriloquizing Pop. Because of that, in contrast to the alignment of "The Iconography of Desolation" with Abstract Expressionism, and even more because of the sentiments Smithson expresses about changing direction for his artistic future, it appears that he wrote it in late 1962 or 1963.

With Smithson, as with so many strivers, the distinction between self-revelation and self-invention is always in play. Yet the correspondences of his self-pitying plaints in "Desolation" and "Lamentations" to his life, career, and beliefs about art display his wrestling at that time with changing his artistic persona. His increased reticence about exposing his feelings is evident in the portrait Alice Neel made of him in 1962 (Plate 16). Sitting for her, Smithson's pose of left ankle atop right knee blocks entry, and his turned head—unusual among Neel's customary frontal orientations or profile portraits—refuses engagement with the viewer. Whether the pose was determined by the subject or the artist, it has the advantage for Neel of featuring not the front but the side of his face. Neel used especially vigorous brushwork to emphasize his scarred and reddened cheek and heightened that by contrasting the red to its color wheel complement, green, applied to his face, his raised hand, and behind his head. Speaking with those who knew Smithson, the first thing mentioned by many is his prominent visual characteristic of pitted complexion from scratched acne. Like Edvard Munch's 1886 self-portrait at almost the same age emphasizing his own scarred face, both could be considered forms of stigmata, signs of suffering. Without explanation, Neel described Smithson as "wolf boy." While that could refer to Smithson's flaring eyebrows, high cheekbones, and angular

lower face that he himself emphasized in his self-portrait (Plate 3), more likely she was responding to his intense dark eyes, at times fierce expression, and judgmental harshness. Alan Brilliant recalled, "He had such a severe, penetrating look that it frightened a lot of people."[50]

By early 1962 Smithson was professionally "wanted" by art dealer Richard Castellane: "I vaguely remember a critic recommending Smithson to me, and Smithson came to my gallery. My first impression on seeing his work or photos of it was that he was a very unique individual.... It was his imaginative abilities that made him intriguing to me."[51] Castellane gave him a solo show at his eponymous gallery at 19 East Seventy-Sixth Street in Manhattan. Opening a week after Ash Wednesday, its title, *Exhibition of Paintings and Drawings for Lent*, responds to the Christian observation that begins

FIGURE 4.8. Poster for "R. Smithson Exhibition of Paintings and Drawings for Lent," Richard Castellane Gallery, 1962. 24 × 18 inches (61 × 46 cm). Copyright Holt/Smithson Foundation / Licensed by Artists Rights Society, New York.

on Ash Wednesday and concludes forty days later, following which Christ's resurrection is celebrated on Easter. It provided a theme with which Smithson could continue his visual affiliation with Christianity yet distance himself from illustration of Christ's Passion.[52]

A gouache, ink, and collage painting on paper recalled by Castellane as having been in the show (he owned it until 2017) illustrates Smithson's approach to imagery following the Lester debacle over religion.[53] As in other post-Rome images, the horizon is high and the terrain dense with markings. But this composition's elements are more directly representational. Horizontal striations call up terraces and steps around a domed Baroque church with fragments of architectural carving. It is a cityscape with a crowded hillside of aged, dusky buildings like ones Smithson would have seen in Rome. The vertical jumble of vaguely arched and rectangular forms within the shadowy blue-gray scene and three towers jutting into the violet sky also call up the obscure complexity of Piranesi's imaginary prison.

In that urban context, his title *My House Is a Decayed House* (1962; Plate 17) could be taken as a critique of the Roman Catholic Church, whose seat, Vatican City, is in Rome, or of the aged city itself. The theme is one in a chain of representations of degraded architecture. An early drawing, *Untitled (Ruined Building)*, 1955, produced when Smithson was seventeen, shows a dilapidated fence and askew entryway before a multistory construction site (see Figure 11.3). His incantation "From the Broken Ark" speaks of a fractured home in which "cargos of travail flow through our heart."[54] His 1969 proposal for the Los Angeles County Museum of Art *Art and Technology* exhibition to build and demolish a concrete building and exhibit the dispersed material on the museum grounds was not accepted. In 1970 he drew piled building fragments mired in mounds of earth. The trajectory of architectural ruination culminated that year in *Partially Buried Woodshed* at Kent State University, where he asked a backhoe driver to dump twenty loads of dirt on the roof of a campus storage cabin, an arbitrary number that must have been symbolic: numerologically, twenty (two plus zero) sums to two, suggesting the second broken house he experienced. The repetition of structural disintegration in relation to buildings that could be construed as homes and the last submergence in earth—*Quicksand* resurgent—present an attunement to brokenness and engulfment that even when he was thirty-two was, as he perceptively indicated, only "partially buried."

Smithson took the title *My House Is a Decayed House* from a complaint midst caustic retrospection in a poem by T. S. Eliot, "Gerontion." The image's disordered composition and overall gray look of obscurity align with Eliot's rueful line "History has many cunning passages, contrived corridors." Eliot mixed social and personal history; *gerontion* is Greek for "little old man."[55] At twenty-two, Smithson was too young to identify directly with the "old

man" narrating the poem, nor is he "A
dull head among windy spaces." But
when Eliot published this in 1920 he
was only a decade older, thirty-two.
They shared a sense of alienation
and concern about debilitation, par-
ticularly of the carnal: "old man in a
dry month." In *My House Is a Decayed
House* that took perceivable form in
an overall grayness. The collages of
angels that alighted throughout con-
tinued his private metaphor; the an-
gel above the church's dome clasps a
cross as would a martyr. Another, a
winged statue atop a pedestal to the
left of the lower arched double door,
as well as others, resembles Berni-
ni's marble angels in dynamic poses
and billowing drapery on the Ponte
Sant'Angelo over the Tiber River. An-
other personal code related to decay
is the irregular cell-like forms with
that leukemic nucleus in the center
scattered around the cityscape.

FIGURE 4.9. Karel Plicka, *House at the Golden Well (18th
Century)*, late 1930s. Gelatin silver print. Smithson
incorporated the lower half of an illustration of Plicka's print
into his painting *My House Is a Decayed House* (Plate 17).

In the painting, to the left of the
tall arched double doors is a collaged
photograph of what appears to be a
small squat building with an arched
doorway bracketed by niches, like a basilica. It is a Prague landmark built
in the fourteenth century on the corner of Karlova and Seminárská Streets,
the last reconstruction of the exterior that in 1769 added a decorated
Baroque-style facade. The building is known historically as the house at
the golden well, as by legend its basement had a well whose glinting water
was thought to reflect the presence of gold coins. A housemaid searching for
them fell in and drowned; because the death happened during a plague, af-
ter removing the corpse the owner was required to drain and clean the well
and found the coins behind a wall. The maid's ghost haunted the residents.

The photograph of the building and street scene was made in the late
1930s by the Czech artist Karel Plicka. Smithson must have cut the picture
from one of the many volumes of Plicka's photographs in which it is illus-
trated. In the building's twentieth-century use, over the entryway, "Jos.
Sucky Drogerie" and the advertisement in the display case to the right of

the entrance for Nivea cream announce it as a drugstore.[56] Above them are stucco reliefs by J. U. Mayer (1701) of patron saints thought to protect from the plague.[57] The nexus of references to infirmity reflects Smithson's sensitivity to that subject and his cry in an incantation as if referring to a plague: "When shall this scourge pass?"[58]

The ghost of the family's maid calls up the Smithsons' own ghost, Harold. Moreover, in a linkage akin to that in his "Desolation" essay, the image's source in what was then Czechoslovakia connects the theme of illness to his mother, as he believed her family to be of "Middle European of diverse origins, I suppose mainly Slavic."[59] That ancestry is confirmed by U.S. census reports in which his mother identified her family's native language as Slovak. At the time that would have been the state of Czechoslovakia, whose capital was Prague.

Smithson's inclusion in his composition of Plicka's Drogerie accentuates, in the slight disguise of a foreign language, that his house's decay is not architectural but rather, like Eliot's, corporeal and emotional. That is confirmed by an analysis of "Gerontion" in a book Smithson owned by Eliot scholar George Williamson, *Reader's Guide to T. S. Eliot*: "The final separated lines [Tenants of the house, / Thoughts of a dry brain in a dry season] again collapse man and house. . . . Thus 'house' and 'head' present the physical and mental aspects of one comprehensive symbol."[60] Williamson, whose *Reader's Guide to T. S. Eliot* demonstrates Smithson's close study of the poet he quoted so frequently, declared about "Gerontion": "In this poem Eliot opened a vein of feeling and imagery that he was not to exhaust for some time to come."[61] Smithson had already been bleeding that vein but not with as blunt a first-person assertion as *My House Is a Decayed House*. And unlike Eliot's claim in "Gerontion," "I have no ghosts," Smithson's won't go away.

During the Castellane show, Smithson sent Lester a drawing, describing it as "one of a series of 40–50 called *The Days of Atrophy—A Preparation for Annihilation*" (undated [March/April 1962], #17). The large number suggests a fixation on end-stage terrors akin to his crucifixion theme but now one that is an anticipated future. *Annihilation* thematically coincides with another series that year. The four large pen drawings as well as a painting titled *From the Valley of Suicides*, all 1962, illustrate Canto XIII of the *Inferno*, in which Dante wrote of the "spirits of the damned," those who had been "Violent Against Themselves," and who were confined to and "slinking" within trees, their foliage "nearly black."[62] Smithson's arboreal apparitions show sinewy figures as trees, their torsos twisted trunks, attenuated arms leafing and legs branching into roots. In Dante, harpies (in classical mythology, a

ravenous monster having a woman's head and a bird's body) continually tear at and feed on them; only when their wounds bleed do they have voice. Like them, the Smithson family's history with blood had given him a creative voice to analogize it to Christ's Passion.

Annihilation and *Valley of the Suicides* imagery intensified his familiar theme of mortality. His rate of artistic productivity suggests that his ideation of destructiveness was not inhibitory depression or about vulnerability to bodily self-harm but that his abandonment of Christological subjects could be a kind of spiritual suicide. Yet putting down an obsession with the "bloody dove" in art was not the same as putting aside his Catholicism. Lorraine Harner recalled visiting him in Rome while still in Europe following her travel with Holt and their other two companions and his taking her around to churches, catacombs, and art sites. And the next summer, back in New York City, both being Catholic, "Bob and I tried various churches in the [Greenwich] Village for Sunday mass. In warm weather, he knew which had the best fans!"

Early in 1963 Smithson and Holt moved in together at 799 Greenwich Street and that spring, on June 8, they were married at Eglise Saint Jean Baptiste on Lexington Avenue at East Seventy-Sixth Street.[63] The imposing Italian Neo-Baroque church has richly veined marble columns, paintings of biblical subjects, a cupola over the altar, and towers atop the facade. If they just wanted to be legally wed, Smithson and Holt could have gone to city hall. If they wanted a Roman Catholic ceremony in a church with Old World architectural grandeur, it could have been performed at one of many in the historically dominantly Catholic Greenwich Village.[64] But Saint Jean Baptiste, a member of the Societas Sanctissimi Sacramenti, was one of two churches in Manhattan administered by the Congregation of the Blessed Sacrament. Its mission focuses on the veneration of the Eucharist, in which Christ's body and blood are held to be present.

Equally pertinent is the Congregation's special mission to perform outreach and instruction about the Catholic religion. Holt had been raised Protestant. At the time of their religious union the Church viewed a Catholic's marriage to a non-Catholic as a "mixed marriage"; such couples could be married in a church but not with the sacrament of marriage bestowed by a Nuptial Mass. Holt took religious instruction from Father Adrian Hebert; her baptism at Saint Jean Baptiste on May 23 formalized her conversion to Roman Catholicism. In preparing for this process, Smithson and Holt may have consulted the latest publication from a strongly Catholic-identified author three of whose books he owned. G. K. Chesterton's *The Catholic Church and Conversion* describes how the Catholic Church's teachings led to his conversion to it; the book's 1961 publication date overlapped with the development of their relationship. Smithson and Holt were then eligible to

be married in a Nuptial Mass performed by Father Hebert sixteen days later, on June 8, 1963.[65]

Perhaps Smithson was thinking of his participation in the conversion process when he explained in his oral history how he occupied himself after his late 1962 show at Castellane: "I got married, actually, and that took up a lot of my time."[66] But they didn't have a big wedding and reception to plan. No one presently alive who is mentioned in this study attended the wedding except Harner, who was Holt's maid of honor. Smithson's best man was Charles Bongiorno, another classmate from Clifton High; neither was part of Smithson's Manhattan art crowd.

Their two attendants and legal witnesses, both Roman Catholic as required by the Church, present a notable contrast as friends standing up for the bride and groom. Harner, born, as Smithson was, in Passaic, had graduated from Barnard in English, completed her master's degree in early childhood education at New York University, and would get a PhD in developmental psychology at Columbia Teachers' College. Bongiorno, born in Clifton, was three years older than the others. He had been on Clifton High's football team for four years but apparently did not graduate as he appears in no yearbook as a senior; perhaps he left to enlist in the U.S. Army, where for three years he served a paratrooper. Holt described him as a close friend; in Smithson's exhibition catalogue chronologies he is identified as having died in 1963, but she gave the Archives of American Art three letters from him written from prison in the summer of 1964. In one he referred to his prior use of recreational drugs, to his boyfriend, and his status and prospects:

> I shall go down in history as the first person to be indicted on three counts of Robbery, two counts of Grand Larceny—facing a minimum of 7 ½ to 15 years, and to receive as a sentence the Half-way House! [in Staten Island] Most humbly do I ejaculate all over the Supreme Court Bench.

No wonder Holt recalled, "Bob thought of Charlie as his Genet"; the transgressive novelist and poet Jean Genet had been imprisoned for petty crimes.[67] But Bongiorno's letters do not indicate literary interests, and as of this writing (he died in 2011) nothing has been published under that authorial name. Thereafter, he seems to have disappeared from their lives; Harner continued as a friend.

In both Smithson's and her own professional chronologies, Holt withheld information of their marriage ceremony's month and day, city and church, and the fact of her religious conversion, seemingly a major life decision. (In the 2010 publication of the book accompanying her own exhibition

survey, she divulged solely the year and city in which they married.)[68] That lack of disclosure reflects more than just personal privacy; in the mores of the liberatory 1960s, poet John Giorno recalled, "In New York at that time, being religious was worse than being a fag."[69] Still, as equally intriguing as the conversion is its secrecy, which Holt maintained personally and professionally.

Holt's conversion and their marriage in a Nuptial Mass demonstrates strong commitments, hers to him and his to her and to Roman Catholic orthodoxy and its prohibition of homosexuality. Smithson's own "art in crisis" prompted him to relinquish that "centre" advocated by Sedlmayr in his art, but he didn't lose it in his life. Years later, friends from the art world of the mid- to late 1960s identified Smithson with Catholicism. Critic John Perreault described his "dark vision" as "Catholic and perverse," Junker related him to a "poisonous . . . '50s Catholicism," and Serra was aware of Smithson's Catholic affiliation. Smithson maintained communication with Father Hebert through 1970 until the priest's illness.[70]

Guidance for an ambitious artist practicing a religion passé in the art world may have been provided by a statement in the prologue of a then-fashionable anonymous book of fourteenth-century mystical meditations Smithson owned, *The Cloud of Unknowing*: "These matters have nothing to do even with people who lead truly good active lives, except for those who, though their outwardly manner of existence belong to the active life, are nevertheless inwardly and secretly stirred by the Spirit of God."[71] Stirred secretly? For Smithson, increasingly so. He had ambition, energy, and creativity, and for inspiration could look back to his own writing in the incantation "From the Broken Ark." His place of refuge, his ark/home/self, may be troubled but, he declared, "Tongues cut out / must keep speaking." He will find ways of doing so, sometimes by speaking in tongues.

FIGURE 5.1. Robert Smithson, *Untitled*, 1962. Ink/paper, 24 × 18 inches (61 × 45.7 cm). Collection Rainer Ganahl, New York City. Copyright Holt/Smithson Foundation / Licensed by Artists Rights Society, New York.

The cryptic series of numbers and dates on the angel's wing had to mean something. I turned to Will Shortz, crossword Puzzlemaster of the *New York Times,* who referred me to the American Cryptogram Association, which in five minutes found a big clue that led me to a book that, sure enough, was in Smithson's collection and is illustrated in Plate 19.

5

Secret Partner

Art works in mysterious ways.

C ooling his expressive affect in response to resistance
to his religious imagery and the art world's emphasis
on ratiocination, Smithson recoiled into symbolic
languages even more covert. Christ went below, as
in his *Christ in Limbo* (1961), and then, as in *My House Is a Decayed House*
(1962), disappeared entirely, his face supplanted by a church facade. Smithson
himself was in professional limbo, no longer a novice but not receiving
attention as an "emerging" artist.

In paintings produced post-Rome, late 1961 through 1963, he imagined
fantasy terrains with high horizon lines. Most are cutaways of deep under-
ground earth crammed with convoluted roots or teeming with quivering
mini creatures; a few have single underground figures. The profusion of
markings could be viewed as a defense against horror vacui, but the anxiety
appears to be not about open spaces but rather an expression of febrile ur-
gency or obsessive thoughts, suggesting efforts to gain control over sensory
bombardment. Overall, the paintings' subterranean spaces evoke a sanctu-
ary sheltered from surveillance from above.

After returning from Rome, Smithson explained to Lester:

The figures in this new series live in a world without nature. Nature
cannot touch these figures, because the figures are not real. . . .

Animals, plants, + minerals unlike animals, plants, + minerals far from the boring [is that tedious, or bearing down?] eyes of nature. Transformations within transformations. . . . The way up is the way down!" (September 22, 1961, #15)

His adaptation of Heraclitus's "The way up and the way down are one and the same" meant the way forward was to move his personal self underground. In that sense they are reminiscent of his naturalist laboratory in the family basement, which he described as "a private world that kept me going.' "[1]

Scorpion Palace (1961) exemplifies his dive to a secular subterrane with a confined figure (Plate 18). In an underground busy with decorative flourishes, the nominal "palace," customarily a mansion for the exalted, is here an embedded cavity. With pincers at head level, as in *Man of Sorrow (The Passionate)* (see Figure 1.7), and its eight legs extending perpendicular to its torso as in the standard crucifixion configuration of arms extended along a crossbeam (as in a Smithson untitled drawing), the crucifixion pose has been displaced onto an arachnid. It is a significant yet unsurprising choice, segueing Christ as a surrogate sufferer for Harold into the astrological symbol, Scorpio, associated with the position of the sun on the Zodiac at the time of Harold's birth. Coincidentally, in numerological symbolism the number of the scorpion's legs is associated with the eighth letter of the Romance languages' alphabet, *H.* Smithson's designation of the scorpion's domain as palatial suggests that even in the grave Harold is king.

Smithson's interest in astrology coincided with the appeal to the 1950s' Beat generation's practices of astrological divination, I Ching coin tossing, tarot card reading, and other esoteric systems. That swelled in the baby boomer population's liberatory counterculture movement in the 1960s. In 1967, those occult affiliations would be celebrated as "The dawning of the Age of Aquarius, of harmony and understanding," when the downtown Public Theater presented the tribal rock musical *Hair,* which soon transferred to Broadway. The degree of astrology's saturation of common culture in those years was indicated by an observation published in 1967, even if in the partisan *The Black Arts*:

[Two thousand] newspapers and magazines carry regular astrology columns. . . . There seems to be greater public acceptance of astrology at the present time than it has enjoyed since the seventeenth century, when it was thrown on to the rubbish heap with much of the rest of medieval science and philosophy. . . . Astrology offers a comprehensible explanation of human behaviour which, if its basic assumptions are granted, is attractively logical and orderly.[2]

Smithson's acquisition of *The Black Arts* in 1967 or later (and additional others such as *The Origin of the Zodiac,* published in 1969) evinces an engagement contrary to the dominant rationalist approach in which by that time he was designing sculpture, practiced by artists with whom he sought to be associated. By then, the hippie values and hedonistic practices celebrated ebulliently in *Hair* were disdained by artists invested in rejecting mainstream burlesques of countering culture and asserting their own sober professionalism. Yet six years later, Paul Cummings's first question when taking an Archives of American Art oral history from Claes Oldenburg was, "You're an Aquarian, right?" to which Oldenburg (born January 28) assented.[3]

FIGURE 5.2. The cover of *The Black Arts,* by Richard Cavendish (1967), the edition Smithson owned, published by Capricorn Books—which he was, astrologically, per his birth's sun sign.

In his post–Lester show transitional period of late 1961 through 1964, Smithson expressed his most personal conflicts mainly in drawings. Dense with bodies, many of them include winged male nudes and/or scrawled, repeated verbal phrases. These are radically dissimilar from the consumer and media imagery of Pop; the geometric abstraction increasingly dominant in sculpture and painting; or painters' photorealist verisimilitude. Rather, Smithson's expressive imagery adopted another representational strategy, that of thwarting easy comprehension by using alchemical, astrological, numerical, and cryptological systems of signification. Only exhibited once in his lifetime in his 1962 *Lent* show for Castellane and rarely thereafter, his withdrawal into symbolism produced many inventive puzzles. The hermeticism of their subject matter, the equivocality of their sexual address, and the rarity of their exhibition in his lifetime—and continuing thereafter—evidences their private, even diaristic, function. He did not title them (his estate would assign them descriptive titles; the Holt/Smithson Foundation removed those and designates every one *Untitled*), but Smithson did sign and date many, acknowledging their creation and establishing their authenticity.

Stylistically, the drawings can be sorted into three groups. The earliest, from 1960, are conglomerations of nude figures, disembodied heads, and congested architectural towers, crammed together as if stimulated in a controlled frenzy—the forms legible, even if an overall theme is indiscernible. Some are like those shown on the poster for Smithson's first solo show with

Richard Castellane in March 1962 (see Figure 4.8). In some, their density and the hybrid human/animal figures call up Pieter Bruegel's scenes of a multitude of allegorical figures, but without the cohesion of his illustrations of Dutch proverbs. Were these produced while he was intoxicated? Holt believed that Smithson's body had its own supply of biochemical "hallucinogens" (that is, energy both maniacal and phantasmagorical) and that he took "peyote only four or five times."[4]

Another group are sheets made in 1961–62 containing incongruous juxtapositions of loosely drawn figures and verbal phrases. Also not resolved deliberate compositions, these pages appear to be sites of rapid free association. The tightly compressed but seemingly impromptu profusion of writings and curlicues, with single words and phrases repeated many times as if in incantation, evoke mania. Yet he inserted into some of them images and numbers so specific and detailed that they could only have been carefully planned, with references deliberately and cleverly disguised. These aspects suggest that these sheets were for playing with images, discharging excess energy, and working through personal concerns; they were not meant for critical scrutiny.

For example, one *Untitled*, 1962, depicts two identical muscular nude males lounging adjacent to each other, each with large wings on one of which is written "CLIMAX" and on the other "Violet Ice 223." Below the two nudes, Smithson wrote a paragraph that begins, "Bob Henderson ran down to the shore resort . . ." Beneath he wrote the word "ocean," as to give a clue to the uncited source. He copied it from page forty-five of *Betty Gordon at Ocean Park, or Gay Days at the Boardwalk* by children's book author Alice B. Emerson, published in New York in 1923. Those numbers 223 on the wings then signal that publication: "twenty-three" as the publication year and since at the time the association of "gay" with homosexuality was becoming prevalent, the two twos could suggest same-sex frivolity at the beach (achieving "climax"?).

"Violet Ice," also written on the sheet, is the name of a purple flowering ground cover, but at least since Oscar Wilde's late nineteenth-century designation of his pleasures with male prostitutes as "purple hours," purple, violet, and its tint, lavender, have in male attire and design, and often in public disparagement, connoted homosexuality. Historically, owing to purple dye's first source in copious amounts of the mucus of a rare species of sea snail, purple signified wealth, royalty, luxury, and then indulgence. The book *Lavender Culture* (1979) gives a more prosaic conjecture: the lavender hue has "been associated with homosexuals for many decades [because] the

color is implicitly androgynous, a combination of the male principle (blue) and the female principle (pink), which society has sanctified in its segregationist choice of baby blankets." The association is so common that in the 1950s, when the U.S. State Department sought to purge its ranks of "perverts" (because their illicit sex was considered vulnerable to blackmail by Communists and other enemies of the state), "While members of Congress held hearings to determine how to 'eradicate this menace,' jokes circulated about the 'lavender lads' in the State Department."[5]

So rather than a ground cover, the phrase "violet ice" on Smithson's drawing suggests homoerotic coitus "on ice" due to its illegality, Catholic or social homophobia, or his forthcoming marriage to Holt. At the bottom right, the outlined capital letters of the word "ice," the largest on the page, emphasize coldness in relation to the men's "violet" liaisons.

In Smithson's paintings, shades of violet to lavender are prominent in *Alive in the Grave of Machines*, *Burnt Out and Glad*, *Creeping Jesus*, *Death Taking Life*, *Dull Space Rises*, *My House is a Decayed House*, *Petrified Wood*, and *Reinforcement from the Rear* (all 1961), and in *Acorn Worm* and *Mermaid with Unknown Illness* (both 1962). He wrote Holt from Rome that rather than showing his work in a bright gallery he preferred to exhibit his in a "room faintly lit by violet lights," and eleven years later described the surface of the lake where he would build *Spiral Jetty* as "an impassive faint violet sheet held captive in a stony matrix."[6]

In another untitled 1962 drawing, two slender muscular nude young men again lie face up on the same line in identical recumbent poses, this time with their spines arched upward, as if during sexual climax. "LUNAR PARALLEL" are the largest words, and in all capitals on the page, daring us to make something of them. Literally, "lunar parallel" is a geographical term for an imagined line around the moon parallel to its equator to determine latitude. Perhaps the parallel postures of the men occur under moonlight.

Those are simple conjectures. To begin to decrypt Smithson's images, one must recognize them as intricately encoded, and apply a process articulated by an author he read a lot of, the science fiction novelist J. G. Ballard:

> I feel that the writer of fantasy has a marked tendency to select images and ideas which directly reflect the internal landscapes of his mind, and the reader of fantasy must interpret them on this level, distinguishing between the manifest content, which may seem obscure, meaningless or nightmarish, and the latent content, the private vocabulary of symbols drawn by the narrative from the writer's mind.[7]

FIGURE 5.3. Robert Smithson, *Untitled*, 1962. Ink/paper, 18 × 24 inches (45.7 × 61 cm).

Conventionally, especially Smithson's drawings of the early 1960s can appear obscure, if not outright incoherent, as was demonstrated when this drawing was displayed at the Metropolitan Museum's Met Breuer in the fall of 2017 in its exhibition *Delirious: Art at the Limits of Reason, 1950–1980*. The wall text, listing its "incongruous array . . . a prayer written in ecclesiastical Latin . . . and a few indecipherable scribbles," perceptively likens the drawing's contents to both "infantile babble" and "ritual incantation," but does not realize that the "babble" could have been used intentionally to distract from significant elements related to his own earlier "ritual incantations."

The drawing's surface is almost entirely covered with blocks of handwritten text: a column of the word "candy" on the left, two columns of the word "flesh" on the right, and at the edge a column of doughnut shapes resembling leukemic cells. "Hippocamps" probably refers to hippocampus, the part of the brain significantly associated with making memories permanent.

But in the center of this page's feverish script is a legible disk with two concentric circles. It could be dismissed as a wagon wheel, but it is divided into twelve wedges, in which Smithson inserted numbers and astrological

symbols. That indicates it is a zodiac circle of a horoscope chart, marking the location of planets within the twelve astrological signs at the place and exact time of a person's birth. In the segment at the top of the disk Smithson drew the sign for the planet Jupiter, and above it, in the band between the two circles, he made two parallel serpentine lines, the symbol for Aquarius. By now we can guess whose natal chart it is. Yes! Their birth times on Smithson's and Harold's birth certificates indicate that those are features of Harold's horoscope. At the moment he was born, Jupiter was in Aquarius, and Smithson drew the sign for his ascendant, the degree of the zodiac that was rising over the eastern horizon at the moment of his brother's birth.[8] The "40.10" that Smithson inserted is a sloppy, or disguised, reference to forty degrees point ten, the degrees that Venus, in the sign of Libra, was then trine to Aquarius.

In the wedge that has Pisces, he wrote "9345," too large a number to indicate a planet's placement (each of the twelve signs spanning the 360-degree zodiac is only 30 degrees). That number or the individual digits could be personally significant to him and encrypted, facilitated by reading his copy of *Cryptanalysis: A Study of Ciphers and Their Solution*. Numerical decryption requires a key indicating the word or symbol represented by each number; Smithson's key, if it exists, is not part of his papers in the Archives of American Art or has not been made available to scholars.[9]

The hub of the zodiac disk names the person whose astrological birth data it presents; Smithson placed a boldly drawn number four. Applying numerology provides a straightforward identification. In numerology's system, the letters in "Harold" are represented by the numbers eight one nine six three four, which sum to thirty-one, which sums to four.[10] Harold's numerological ID is at the center of his natal horoscope, just as Smithson's drawing of it is at the sheet's center. By figuring the location of planets at the moment Harold was born to construct his natal chart, an intricate and challenging project (and especially so before computers), and then consulting books about the location of planets in the twelve "houses" and their relation to each other, Smithson attempted to learn more about the family member he had dedicated an incantation to as an "unknown martyr."

In ten identical rows below the disk, Smithson scrawled "*oblatio occisi ad cultum Dei.*" He and other Catholics would have heard it in the offertory during Mass (until 1965 or so, given in Latin). Carl Jung, in "The Work of Redemption" (*Psychology and Alchemy*), discusses that phrase and translates it as "the offering up of the slain to the service of God" when the consecration of the host "brings about transubstantiation."[11] The juxtaposition of Harold's horoscope and this phrase reinforces Smithson's linkage around the issue of sacrifice.

In front of each of the ten lines of "*oblatio occisi ad cultum Dei*" is the

number two five three. The sum of those digits is also ten; Smithson seems to be incorporating the symbolic associations of ten, which in decimal systems was considered to exemplify perfection and a return to unity.[12] But to consider another meaning of two five three, since the phrase it fronts is in Jung, let's see what is on page two hundred fifty-three in *Psychology and Alchemy.* It is an illustration from the sixteenth-century manuscript *Splendor Solis: Alchemical Treatises of Solomon Trismosin* with the caption, "Saturn or *Mercurius senex* being cooked in the bath until the spirit or white dove ascends." Sure enough, in Harold's natal horoscope chart, the planets Saturn and Mercury are united, corresponding to the number ten's symbolism of unity, by being conjunct (close together) and on the chart parallel within the astrological sign of Scorpio, Harold's sign presenting another disguised reference.

Another deliberate instance of Smithson's speaking in tongues in a drawing, *Untitled* (1962), reiterates the extent of his emotional connection to his lost brother and its concealment through the use of occult systems (Figure 5.1). In a column of large, slanting, liquid-looking Art Nouveau-ish font that foreshadows psychedelic posters for rock concerts in the mid-1960s, Smithson wrote five times, "First National City Bank," dominating the page.[13] The words may have been an act of artistic loosening up or discharging energy, or their specificity could refer to an incident in his life or to looming financial concerns (Holt had an inheritance; his income was sparse and unstable). Another benefit to the words' prominence, and that of the adjacent list of bank branches and their area codes next to it, is their effectiveness as distractions from more telling elements on the page.

Below those words is another youthful nude male, with well-developed musculature and, as on so many of them across these drawings, abundant wings and a prancing, balletic arabesque. Written on the young man's broad wing are what looks to be a baffling series of dates, symbols, and numbers. First the dates as written: "DEC. 19, 1917; JAN. 19, 1918; FEB. 19, 1918; MAR. 19, 1918." Below the year of each date, on the right column. are the numbers "27.11, 28.21, 29.31, 0.41." On the first, second, and third lines of the second set of numbers are small scribbles that could be easily missed or dismissed by the viewer frustrated by trying to make sense of the opaque sequences not deciphered by applying numerology. I had to appeal to the famous "Puzzlemaster" Will Shortz for help with this one, but its form isn't within his domain and he generously referred me to the American Cryptogram Association.[14] Recognizing that the first of the three marks is the astrological sign for Cancer, and the last is for Leo, returns us to the realm of the zodiac. The source of the whole series is *The Message of the Stars: An Esoteric Exposition of Natal and Medical Astrology Explaining the Arts of*

Reading the Horoscope and Diagnosing Disease, owned by Smithson (Plate 19). It presents another link between astrology and Christianity. Max Heindel, the author, with his wife, Augusta Foss Heindel, was an elder of the Rosicrucian Fellowship, an association of Christian mystics that in Smithson's book *The Sun in Art* is relevantly described as a "near-morbid mass movement in the Baroque era."[15]

The chart Smithson copied from it is in a section on medical astrology within instructions on creating a progression of the horoscope. That is, while a natal chart shows the location of planets at the time of a person's birth, an astrological progression locates their positions at a later date— say, when as an adult one seeks information about a current quandary. The planetary locations are difficult to calculate but necessary to know because, as the Heindels put it, "The progressed horoscope indicates when previous indulgence of harmful habits is scheduled to bring sorrow or sickness; it tells truthfully when crises culminate."[16] The example Smithson chose to reproduce in his drawing is that of a horoscope of an unnamed "young man" who "died of hemorrhages."[17] The numbers Smithson copied onto the angel's wings are the Heindels' computation for six dates and degrees of the moon's location up to the young man's death. Smithson stopped his listing with the fourth, its month and day the same as that of Harold's death date, March 19, who himself died of hemorrhage. The sign on the three lines above that is the astrological one of Cancer, a crab, which in Harold's natal horoscope is in his fifth and sixth houses, and was also Harold's diagnosis, a cancer of the blood.[18]

Smithson did not divulge in any text or interview his interest in astrology, but his library indicates that esoteric systems had an early and strong appeal for him. In addition to five books on astrology published through 1961, the date of many works in which he utilized it, relevant others published by then include three on esoteric forms of magic, two on witchcraft, two by Jung on symbolism, and six on mysticism. At his death he owned twenty-three books on occult subjects, including *The Black Arts*, a compendium covering black magic, numerology, the "Cabala," alchemy, astrology, ritual magic, and "worship of the Devil." These display his receptivity to these alternative, or alogical, systems of knowledge.

Smithson's use of these esoteric signs facilitated a relationship with Harold, making him not just his predecessor but an ongoing presence. They did so by enabling concealment, allowing him to resist surveillance and thwart others' perception of private concerns. But his adoption of historically codified systems—astrology, numerology, alchemy—also permits anyone interested enough in him to apply them to learn about him (except for encrypted numbers for which he did not supply the code). In this game

JUL 62

FIGURE 5.4. Between Smithson's spring and fall solo shows at Castellane Gallery in 1962, in July he and Holt visited Richard Castellane in Provincetown, Massachusetts, where he also had a gallery. They were likely coming from Barre, Massachusetts, where in July they buried her father. Compared to Castellane, vital in swim trunks, and Holt, alluring in a swimsuit, Smithson, fully covered and standing nearer to him than her in a closed pose suggesting discomfort, looks like the odd man out. Courtesy and copyright Anna Wiberg, the photographer and Castellane's friend.

of hiding, he did not make the seeking too difficult, suggesting that on some level he wanted to be seen.

In the fall of 1962 Castellane relocated his gallery six blocks north to 1078 Madison Avenue and in November gave Smithson a second solo show that year. And his artist moved stylistically, making a swerve from the Lenten theme of his spring show with Castellane, and his drawings' private occult signage, to the cult of scientism. With its awkward listing-as-title *Bio-Icons Specimens Chemicals Diagrams* the show strived to cover the territory between an affiliation with the objectivity of science to its visual manifestation as disembodied—diagrammatic—conceptual art. But the leopard didn't lose his spots; he camouflaged them—just barely.

Drawing on his reading from science and science fiction, and his childhood hobby as a naturalist, Smithson's Castellane mishmash of science and art (made further cockeyed by his misspellings) presented a fiction of science. Little documentation of the exhibition remains, but photographer Fred McDarrah's extended caption under his picture published in the downtown weekly the *Village Voice* indicates Smithson's synthesis of the quasi-serious and satirical:

The exhibition contains works which the artist calls snake diagram; rare receptacle for chewing gum; embryo chart of hog, calf, rabbit and man; imitation sponges; ammonia hydroxide bottled; and jars of sponges and other artificial specimens with such labels as "Acutiffrons Papillae UX-93" and "Protolotos Terebellidea UX-92."[19]

"Protolotus" is a plant genus name, used for what was thought to be an early ("proto") evolutionary lineage of the lotus flower. The final sets of terms refer to an "acutifrons" species of a "terrebellid" marine worm.[20] The

biological arcana may have been aided by Holt's knowledge of biology and her college textbooks. But "terebellidea" also sounds like a playful homonym for both "terrible idea" and, in the art context, for *terribilità*, an artist's state of emotional intensity of conception and execution of a work of art, first attributed to Michelangelo. Putting the allusions together, *proto lotus terribilità* suggests a feverish productivity or anxiety experienced before eating lotus fruit, which in antiquity Homer described as producing a state of dreamy idleness or even euphoria but which in modernity could refer to consuming any intoxicating beverage or drug.

More significantly, the use of this arcane gibberish is another signal that Smithson was encoding his speech, this time whimsically. McDarrah tempered the show's eccentric pseudoscience by headlining his extended blurb "Harmless Horror," topically linking the artist's intentions with the exhibition's propinquity to Halloween and the emerging guileless amusements of Pop Art.

Exhibition of

BIO-ICONS SPECIMENS CHEMICALS DIAGRAMS

November 1 to November 23
Preview: October 31 5-7 P.M. Wednesday
Castellane Gallery 1078 Madison Avenue
(Near 81st)

R. SMITHSON

FIGURE 5.5. Poster for Smithson's exhibition at Castellane Gallery, November 1962. 11 × 8½ inches (27.9 × 21.6 cm). Note the different design in comparison to the poster for his show eight months earlier (see Figure 4.8).
Courtesy Kathryn MacDonald.

The opening of *Bio-Icons* was celebrated with a reception on Halloween evening. The day is popularly thought of as the feast day of witches, as discussed in *Witchcraft Today* and *God of the Witches*, as an ancient pre-Christian religious practice (both owned by Smithson). In his "Desolation" essay Smithson had declared, "Penitential fires are built on Halloween in the dim regions of the suburbs, burning inside the rotting Jack-o'-Lantern with glowing hollow eyes, nose and mouth. . . . A face that risks Gothic dread on a million crabgrass-ridden lawns."[21] But he undoubtedly knew, and perhaps read in James George Frazer's *The Golden Bough: A Study in Magic and Religion*, also in his collection, that Halloween precedes the Feast of All Souls on the first of November (his show's opening day), which the famous Scottish anthropologist described:

A thin Christian cloak conceals an ancient pagan festival of the dead. . . . Hallowe'en, the night which marks the transition from

autumn to winter, seems to have been of old the time of year when the souls of the departed were supposed to revisit their old homes in order to warm themselves by the fire and to comfort themselves with the good cheer provided for them in the kitchen or the parlour by their affectionate kinsfolk.[22]

The timing of both that show and his previous Castellane "Lent" exhibition coincided with Christian holidays associated with mortality. Neither Mc-Darrah nor Smithson mentioned that religious connection, and there seems to be nothing sacred about the wacky science on view. Thus, Smithson's interjection of the topic of religion into his commentary about his exhibition is both irrelevant and indicates it was on his mind:

> "I'm trying to achieve a sublime nausea by using the debris of science and make it superstitious," says artist Smithson. "Religion is getting so rational that I moved into science because it seems to be the only thing left that's superstitious. It's not that I'm for science," he says, "or anything like that. I just want to be completely uninvolved. All of this is a metamorphosis from religious iconology which I found a rather atrophied realm."[23]

His statement contradicted his actual practices in at least two ways, providing a condensation of persona construction. In rejecting iconology, he distanced himself from art historians' methodology of incorporating the cultural, social, and historical background of themes and subjects, the very contextualization necessary to understand his own art. In the future he will denounce its opposite, formalist restriction of analysis to the object itself. He may have meant to imply that he rejected *iconography*, symbol systems, but again, he was expert at employing arcane systems of signification. Secondly, in the next few months he and Holt will move their religious observance uptown to the ornate church where she will undergo conversion instruction and they will receive the sacrament of marriage; he was completely *involved* with both. So, it appears that he interjected the subject of religion for the purpose of denying his involvement with it, using the *Voice* platform and Castellane Gallery to publicly present his new, ostensibly post-devout identity.

For this Halloween/Day of the Dead occasion, Smithson dressed his concerns in a "Bio-Icons" costume. A 1962 painting with collaged pictures of marine animals and list of chemical data corresponds to the show's scientistic theme (Plate 20). A verso sticker placed by the Castellane Gallery sug-

gests its inclusion, more appropriate than to the gallery's prior Smithson show's theme of Lent; exhibition checklists do not exist for either show. Smithson tauntingly titled it *Self-Less Portrait*, a conundrum begging to be examined. Characteristically, his allusions go beyond punning to paradox. The act of considering the "self" suggests introspection; eight books in Smithson's library have "self" in their title. But the two published before the date of *Self-Less Portrait* indicate a disturbed self-image: *The Self in Psychotic Process: Its Symbolization in Schizophrenia*, by John Weir Perry (1953), and R. D. Laing, *The Divided Self: An Existential Study in Sanity and Madness* (1959). Jung's *Psychology and Alchemy* and *Psyche & Symbol*, both published in the 1950s and owned by Smithson, treat the idea of the self and its mental/spiritual development extensively, distinguishing it from the conscious ego and calling it "the total personality, which, though present, cannot be fully known."[24]

An artist's act of making a self-portrait implies self-absorption and potentially narcissistic self-regard. But this *Portrait* is *Self-Less*, suggesting an absence. The description of being "self-less" conventionally describes a person who sets aside self-interest in favor of humility or self-abnegation. Art historically, it calls up the bony penitent draped in a rope-tied habit of rough cloth as seen in Giovanni Bellini's *St. Francis in the Desert*, accessible to Smithson at the Frick Collection. But in his *Self-Less Portrait*, the void within the profile's concentric black lines suggests not humility but vacancy. That is akin to his *Butter Mummy*'s head and shoulders in an unarticulated vaporous yellow, within a belowground cavity, also from 1962. "Self-Less" could refer to a vacuum regarding his art world identity as he searches for a replacement identity for "expressionist painter."

Examination of the composition's specific details reveals them to be both manifestly enigmatic and latently decipherable. The process of synthesizing concealed allusions into a coherent theme can be analogized to what Smithson described in an incantation with a phrase found in Jung's *Psychology and Alchemy*, "*Ignotum per ignotius*"—explanations more obscure than the thing to be explained.[25]

The format of *Self-Less*'s black-bound head is in profile, facing left. Contrasted to the rightward direction of analog clocks and when reading texts in English and the Romance languages, that implies looking backward, a "retrospective effect."[26] Haloing the ghostly head are discrete images, painted or collaged. There are fourteen, the number of the Stations of the Cross, commonly images or relief plaques hung clockwise around Christian churches' naves as prompts to contemplate the Passion of Christ. Customarily, they mark successive incidents in Jesus Christ's last days from his fatal condemnation through his tortures while carrying the cross along the Via Dolorosa, also known as the Way of Sorrows, to his crucifixion on

Mount Calvary and entombment. Parishioners sequentially offer prayers before each station, symbolically making their own spiritual pilgrimage, a devotion primarily undertaken on the day Christ died, Good Friday.

Smithson's fourteen units haloing the head do not correspond to incidents suffered by Christ as recorded in the Stations of the Cross. Rather, as a group they symbolically repeat his identification with the crucified Christ while individually functioning like attributes in historical portrait painting signifying aspects of the sitter's identity. More literally, a faint dotted line from each to the head mimics links in cartoons to speech balloons, serving as prompts toward understanding Smithson's thoughts.

Beginning *Self-Less Portrait*'s interpretive arc as a parishioner in a church would, at lower left and moving clockwise, the first is a daub of paint within a distinct parallelogram: the departure point in this journey around the head signals parallels. Above it a continuous outline forms symmetrical upper and lower ovoids, extending the parallelism to doubleness. It could be a two-dimensional rendering of a Möbius strip, a continuous one-sided looped ribbon, symbol variously of infinity, unity, and the permeability of mental and physical planes of existence. At the same time it resembles the number eight, which as noted in numerology represents the eighth letter in English, *H*. That calls up Harold, and its red hue evokes his cause of death, blood. This condensation of references initiates the journey around the head. Above it, a white, square, quasi-parallelogram with a four-leaf clover and the collaged word FROM suggests that it was his luck to have been born from Harold's demise.

Then, a newspaper clipping with cutoff words, "chiopod laid open to show internal structure, more like . . . lives in deep water on the west coast" refers to "brachiopods—marine animals that, upon first glance, look like clams. They are actually quite different from clams in their anatomy, and they are not closely related to the mollusks."[27] So, it is an entity from the depths that is not what it appears to be.

After a clipping with the partial words "for ra," which could refer to a forra, a ravine or gorge, and the word "and" which moves us upward, we see a painted clamshell with two crescent-like forms on it. Beside it, a white square, probably a filler, and above them a picture of two tomato- or onion-like spheres, joined together in another sign of doubleness. Right of it, directly above the profile's head, a clipping with the largest font among them serves as a marquee for the composition. But Smithson positioned the text upside down, thwarting easy comprehension and accentuating his procedures, challenging the viewer's interpretation. Its clipped headline at the pinnacle of the halo enacts what it states, "Lie Hidden / . . . Mountain of / -cal Appliances."

After another blank white rectangle—perhaps to make fourteen images,

FIGURE 5.6. Detail of Robert Smithson, *Self-Less Portrait,* 1962 (Plate 20).

Courtesy The National Museum of Art, Architecture, and Design, Oslo. Photographer: Børre Høstland.

Copyright Holt/Smithson Foundation / Licensed by Artists Rights Society, New York.

The newspaper photograph's caption states, "The finishing touch to the reconstruction of the nameless corpse. Mrs. Curry carefully dusts her creation with a fine powder that she herself..."

or maybe a suggestion that sometimes one's mind is blank, the impetus of his mountain of mechanical—automatic, obsessive—hidden meanings is more directly stated. In the upper-right corner, the largest collaged item is a newspaper photograph of a woman brushing the face of a mannequin, also known as a dummy, another vacant bust. The caption states, "The finishing touch to the reconstruction of the nameless corpse. Mrs. Curry carefully dusts her creation with a fine powder that she herself . . ." The dotted line from this clipping leads to the central vacant bust's brain, as if the "nameless corpse" is what is on "Self-Less portrait's" mind. That illustrates the assertion by the researchers inaugurating replacement child studies, Cain and Cain, that "the image of the dead child casts its shadow upon his replacement."[28] The verbal parallel also suggests that the subject is "Self-Less" *because* the corpse is "nameless," insufficiently known or discussed, so their respective identities are nebulous or merged.

This portrait of the artist as a brachiopod/pseudo clam tells the alert observer that he isn't what he appears to be. He clams up about what is hidden, living below in deep water. But in his *Self-Less Portrait* Smithson

both covertly communicates and attempts to distract from decoding the elements of his own cross by placing along the lower right a long, clearly legible column listing minerals and chemical compounds. The word "calcium" is obvious and is linked by the dotted line to the spine (i.e., bone), soliciting the literal linkage: "The artist is interested in science!" But the artist is also interested in astrology, and Capricorn, his sun sign, is ruled by the planet Saturn, which in turn is "largely concerned with the crystallisations of the Mineral Kingdom Saturn governs the bony structure in man and his concrete or scientific mind."[29] The line in the painting from calcium to the profile reiterates that this is *his* self-portrait.

And as the artist is also engaged with the transformative processes and symbols of alchemy, the list of chemicals can also refer to the historically late, crude understanding of alchemists as early chemists experimenting in transforming lead into gold. Specifically, as chemist Gary Porter has observed, "He has chosen an interesting portion of a chemical catalog: Bismuth, Calcium, Cadmium to Chromium. All of these elements would produce visible colors when burned in a hot flame."[30] To this reference to fire, we can cycle back through the fourteen "stations" and find air or wind made by brushing powder on the bust; earth, where the vegetable spheres or bulbs would have grown; and water, where the pseudo clams hid—alchemy's four classical elements.

Smithson didn't claim this work as a self-portrait, just as he didn't identify his early unpublished essays as autobiography. He didn't need to. To a receptive viewer, the parallels between the biography of the person and the metaphors of his persona are inescapable. *Self-Less* more than hints at Smithson's inner world being not at all a void, but rather, as in his underground landscapes, teeming—here with conflicts, confused identity, issues of mortality, and subterfuge. It maps psychic concerns as would his later attention to geographical maps do so more obliquely. Around the figure's blank bust, its thick outer edge projects perpendicular lines as if instruments of malevolence, a combatant's spikes or porcupine's quills, warning others to keep their distance as well as calling up the torturous thorns on Jesus's Via Dolorosa crown. Those thick boundaries to the supposedly vacant self illustrate his emphatic self-containment, his concealment of his psyche's issues in signs that appear deliberately cryptic.

Here again Smithson is channeling Jung, who wrote in *Psychology and Alchemy*, "The real mystery does not act mysteriously or secretively; it speaks a secret language, it suggests itself by a variety of images which all indicate its true nature."[31] Smithson assembled those signs, sequenced them meaningfully, produced this painting, and gave it to Castellane to exhibit, a self-portrait offering abundant cues to his self-regard not so difficultly deciphered.

. . .

The most developed figuration and deliberate compositions of Smithson's early drawings are his 1963–64 series of mash-ups of polymorphous sexiness of nudes exaggerated in musculature or tumescence, sometimes racing on motorcycles or riding in hot rod cars. He appended to the shoulders of many figures voluminous wings. Rare in the history of art, these figures are Erotes (Greek) or adult versions of Cupid (Roman) or cherubs, winged gods associated with sexuality and desire. In Smithson, they have become angelic hunks fusing eroticism and sacred immortality, as in his *Buried Angel* living in his emotional underground. In between his copies of commercial seducers Smithson placed serpentine and dripping shapes as if signaling sexual tension and release.

All are rendered in crisply outlined academic idealization with some fill-in and shading with soft colored pencil. They decoratively frolic around a rectangular pattern that sometimes obscures a published illustration beneath it of classical statuary. Smithson likened such central, spatially flattened rectangles to "cartouches."[32] A cartouche is an architectural ornament simulating an unrolled scroll or tablet, often a stone panel with incised text, surrounded by Baroque flourishes. While he might have learned of that term from books on architecture, it is just as likely that he adopted it, as well as his appreciation for the Baroque itself, from J.G. Ballard's likening of the prismatic forest in his *The Crystal World* to Baroque art, its "intricate crests and cartouches . . . so seemed to contain a greater ambient time, providing that unmistakable premonition of immortality sensed within St. Peter's."[33]

In a characteristic cartouche drawing, nudes around a 1950s-style pink faux-pearlized geological pattern cut from adhesive shelf liner mix sexes, sex, and menace. The upper-left corner of *Untitled* (1964) shows a sitting male with spread legs displaying his genitals and demonstrating a response by licking a lollipop. Art historian Jason Goldman discovered this figure to be a direct tracing of a published drawing by the illustrator known as Etienne, "the pseudonym of Dom Orejudos [1933–1991], an artist based in Chicago":

> The image Smithson chose was titled "Hard Candy" and consists of two scantily clad beefcakes lounging in what appears to be a back alley. Looking out toward the viewer, the men display their chiseled bodies while seductively mouthing phallic lollipops. . . . At once titillating and campy, the drawing exemplifies the thinly veiled homoeroticism typical of mid-century American physique magazines. Brimming with photographs of muscled men and artwork along the lines of "Hard Candy," these small publications constituted a pre-Stonewall, semi-illicit form of soft-core gay erotica.[34]

HARD CANDY, is a fine example of the well-planned compositional construction which is inherent in every one of Etienne's works. Notice how the eye is continuously led back to the central area by the use of the interlocking circular motif. Noteworthy also is the play of the hard vertical lines against the fluid rounded forms of the archway, and how the arch is repeated in the center subject's legs, and the lower figure's chest.

12

FIGURE 5.7 (*left*). Robert Smithson, *Untitled,* 1964. Collage, colored pencil, and pen and ink on paper, 30⅛ × 22 inches (76.5 × 55.9 cm). Copyright Holt/Smithson Foundation / Licensed by Artists Rights Society, New York.

FIGURE 5.8 (*right*). Dom Orejudos's drawing *Hard Candy,* made under his pen name Etienne, is the source of the upper-left drawing in Robert Smithson's *Untitled*. It was published in December 1964 in the January 1965 issue of the magazine named after the god of the Roman military, *Mars,* where male erotica served as putative instruction in two-dimensional artistic composition. Art historian Jason Goldman found it as Smithson's source. Courtesy of Estate of Dom Orejudos and Leather Archives and Museum, Chicago.

Ostensibly intended to illustrate the rippling musculature produced by weightlifting, the illustrations and photographs of such magazines appealed to aspirational body builders and even more, if covertly, to homoerotic desire for hypermasculinist male bodies.

On the other side of Smithson's pink center, a "beefcake" wearing solely a militaristic cap, sunglasses, and boots urinates toward a lower male whose pose is that of Benvenuto Cellini's or Antonio Canova's statues of Perseus, in his outstretched left arm victoriously displaying the head of Medusa. Here he holds aloft a golden cup of urine. This and other cartouche

compositions include buxom babes in pinup poses of 1940s "girlie" magazines for men; in *Untitled* a winged cowgirl rides a horse (a nickname for a penis) and another reclines on explosive spikes, a cartoon signal for excitement.

In another drawing, the cartouche is a photograph of the head of Michelangelo's marble *Dying Slave* (1513–16) as illustrated in Ludwig Goldscheider's *Michelangelo: Paintings, Sculptures, Architecture,* a book he owned. Smithson's positioning of that delicately handsome face at the center of his composition, albeit behind translucent yellow, green, and red stripes, links allusions to a male figure's bondage (as a slave) in relation to another androgynous physical beauty, and to mortality, as it and Michelangelo's companion sculpture *Rebellious Slave* had been carved for the tomb of Pope Julius II. This type of feminized and passive male beauty contrasts to the aggressions seen in drawings around another cartouche, an illustration of the first-century BCE statue *Venus de Medici* in her "venus pudica" pose of modestly covering her breasts and genitals (thus gesturing to them), the picture obscured by rippling red and yellow stripes. A winged, muscular male wears only a leather jacket and boots, two others are astride their hog motorcycles, and a couple of nude men wrestle.

The drawing in the cartouche series derives from tracing illustrations and making them volumetric, akin to traditional academic naturalism, the shapes filled in with the pure values of basic Crayola colors, the signs for expressive emotion akin to those abbreviations in comics. These thematic and formal aspects and media references align these works with Pop Art's style, which was sweeping culture's attention during these years of 1962–64, as well as its wit. In the familiar characterization of Smithson as the master of irony they could be taken as caricatures of provocative displays of aroused figures or those seeking to stimulate. Viewed as impersonal, they can appear to satirize the fetish for extreme body building, belligerent biker culture, and raunchy sex—the sort of amusements found in the sleazy movie theaters and pulp magazine joints then dominating Times Square, whose southern edge is the Forty-Second Street Smithson referenced in his 1955 woodcut (see Figure 1.2). Recall, Carl Andre praised Smithson's "mediumistic sensitivity to the cryptanalysis of pop culture."[35]

The inclusion of the stereotyped female sexpots could demonstrate parodic commentary by Smithson on lowbrow titillation, or the flamboyant dames that drag queens preferred to emulate; an expansive queer sensibility in advance of the twenty-first century's adoption of it as a positive attribute of sexual fluidity, his own bisexual inclinations, or all of these. But the "hunks" dominate in presence, distinctive attributes, agency, and associated emotional charge. And the number of drawings he produced in this format—at least twenty, probably more—is too many to be taken simply as

exaggerations of the Pop sensibility or emotionally detached social commentary; one or two would have made that point.

Goldman astutely observes of Smithson's cartouche images: "At a time when homosexuality was widely treated as a perversion, a social problem, a curable disorder, and a criminal tendency, physique magazines performed a unique and audacious function: they distilled male homoerotism into a pleasurable image and a consumable commodity."[36] Likewise, they exuded not just pleasure for the gay eye but gaiety itself. One might think his renderings of gamboling babes and hunks illustrate artist Dan Graham's observation about him: "There was a sense of being a bad boy, like D. H. Lawrence . . . playing that role."[37] But these were Smithson's private drawings, not revealed until long after he died, and then sparsely. More likely these sly juxtapositions of classical figuration, collage, comic book patterns, and sex illicit for a husband in a heterosexual marriage were a sanctuary where he was safe to *not* play a role, to let it all hang out. The motley crews he depicted evoke a self piqued—pleasured—by all sorts of expressions of sexuality. His prominent pink center played with and against the appeal of male bondage, the effeminate male, the fearsome He-Man and, yes, the buxom bimbo. These compilations illustrate a polymorphous eroticism, encompassing bisexuality (between and within figures), exemplifying our current conception of queerness as an expansion of sexual affiliations, while showing that Smithson can also swing both ways as an artist, juxtaposing abstraction and figuration.

One especially provocative cartouche drawing evokes the act of "doubling" in many forms (*Untitled*, 1963; Plate 21). The male nude about to throw a basketball and the opposite female with a large red heart covering her genitals are both grandly winged but otherwise unremarkable stereotypes of heterosexual sexiness in popular culture: the muscular athlete and the voluptuous babe. The two winged nudes filling a sports car's tank represent more lithe males, but the scene is all about power: gigantically disproportionate wings, nude bodies, a sports car's *varoom*. At the bottom left, a horned, burly nude is bound by a thick snake nuzzling its penis. It is a copy of Michelangelo's figure of Midas from the Sistine Ceiling with enhanced breasts and nipples doubling his sexual identity. The largest figure at the bottom of this sheet, with both penis and fulsome breasts, plus what appears to be cosmetic eye shadow and lipstick, lounges as an intersex odalisque. Uncharacteristic of nineteenth-century exotic courtesans' coy allure—or even Édouard Manet's confrontational *Olympia* (1963), who covers her pudenda—this one's torso faces the viewer to fully expose itself. It is a provocative image, full disclosure of mixed identity and doubled desire. This prominent lower-center image could also represent the fusion of those pictured above, what Jung described as

the hermaphrodite that was in the beginning, that splits into the traditional brother-sister duality and is reunited in the *coniunctio* to appear once again at the end in the radiant form of the *lumen novum*, the stone [the Work, lapis, creation, as well as its aim, the developed Self]. He is metallic yet liquid, matter yet spirit, cold yet fiery, poison and yet healing draught—a symbol uniting all opposites.[38]

Demonstrating that, this crowd's relaxed, even playful figures in soft graphite with Pop Art–like spiky explosions around them amounts to a paean to panoramic expressions of eroticism.

The thrusting center "cartouche" image itself suggests a darker sexual ambiguity. The clipping, of a "Second-Stage Injector," illustrates a mold-making apparatus; it is most likely from an automobile parts catalogue obtained from his father's employment. The structure consists of two rods connected by a flange entering a third, in the act of injecting. No matter what sexual position or orifice this penetration metaphorizes, it evokes hard and emotionally detached ("mechanical") if not rough sex. Is that the next "stage" of sexuality? A few years later Smithson will disparage the ostensible duplicity of "something like the homosexual who acts like a Nazi," as if gays are characteristically effete, but again, contrary to his declarations, his art suggests a taste for exactly what he critiqued—what writer Michel Leiris's memoir published that year and in Smithson's collection of books on sexuality of all sorts called "the fierce order of virility."[39] Douglas Chrismas recalls that in the late 1960s he saw early drawings in Smithson's home and wanted to purchase or exhibit them in his Vancouver and Los Angeles galleries; Smithson refused, saying, "They were not for the art world."[40] In the binary and dominantly masculine model of intellectual heterosexuality that had evolved from the Abstract Expressionists' macho virility, his drawings' plethora of genders and eroticisms would have prompted confusion and marked him as much more deviant than did his Christological paintings. But because of their modest size he didn't need to destroy them; he could keep them out of sight in a drawer but available for private savoring.

Smithson also incorporated photographic sexualized images into two assemblages of machine parts that specifically represent heterosexual coitus. *Machine Taking a Wife* and *Honeymoon Machine* (both 1964) could be his sardonic riffs on Marcel Duchamp's *The Bride Stripped Bare by Her Bachelors, Even* (1917–23). Duchamp's arcane construction in two registers with machine-like images separates the woman at the top and the men

at the bottom as frustrated supplicants. Smithson owned three books on this radically inventive artist and theorist of anti-optical (ideational) art. But it would be uncharacteristic for his work not to latently express the personal.

Both of these wall pieces consist of vertically stacked panels with a documentary photograph of an indeterminate bulky machine and actual parts of machines above a cheesecake photograph of a nude female in a seductive pose. That spatial relation is akin to the conventional heterosexual one during coitus of the male on top, and in *Machine Taking a Wife* the phallic glass tube points at the woman. In each image, wires extend from the machine to the nipples of the well-endowed woman, whose pictures might have been clipped from a men's "girlie" magazine (Plate 22).

Dr. Porter observed, "Those devices [the machine parts] do not generate electricity. They ordinarily require electrical energy to function. The wiring suggests the energy is coming from the women to the mechanical devices. Where the connection is made on the women supports this. The mammary gland's purpose is to supply sustenance."[41] That is both a traditional female role and may suggest Holt's support of Smithson and their bond. Alternatively, the machines could be otherwise electrically powered and stimulating the woman.

In either case, the copulation is mechanical, customarily connoting rote behavior and emotional disengagement. Could a source of that be that the phallic tube's pink field feminizes it? (The voluptuous torso is blue, coding it as male.) Their contact generates electrical lightning or explosive zigzags rendered cartoonishly simplified, signaling humor or wit. These mixed-media burlesques of coitus can be read as detached satires of fake(d) ecstasy. But made the year following Smithson and Holt's wedding, one wonders how amusing their evocations of alienated or alternate copulation were to both of the young marrieds.

Smithson's associations of sex with mechanical injection also suggests the erotic pleasure that some experience from the infliction or endurance of corporeal pain. It is described in a licentious novel Smithson owned, by Jean de Berg, *The Image* (1966):

> We were aware, all three of us, that the tortures scheduled for the evening were by no means imaginary. The thought that they would, in a moment, wrench from this tender young girl the most voluptuous spasm of pain gave her flesh, which was desirable anyway, an incomparable allure. I made her come closer so I could run my fingers over the curves and hollows which we were about to wound, with abandon, as long as it seemed entertaining.[42]

That such tortured sexuality—physical or emotional—was a concern to Smithson is demonstrated in his library: Marquis de Sade, *Justine, Philosophy in the Bedroom, and Other Writings* (1966), and *Marquis de Sade: His Life and Works* (1948), by Iwan Bloch; Frances Winwar's *Oscar Wilde and the Yellow 'Nineties* (1941); and novels of female heterosexual sadomasochism by Pauline Reage, *The Story of O*, (1967), *Return to the Château, Preceded by a Girl in Love* (1971), and by Joan Ayres, *Lady Susan's Cruel Lover* (1967).[43] Howard Junker, the journalist and Smithson's friend, described him as a "midnight cowboy, given to black outfits and leather bars," which they frequented together. Chrismas, who met him in the late 1960s, recalls that when they went drinking, whatever city they were in—New York City, Vancouver, Los Angeles—Smithson wanted to go to leather bars.[44] Holt countered such associations with the statement, "When Bob went to leather bars, he was a voyeur, going four or five times in his life." The detachment she implied is mitigated twice: Viewing as a "voyeur" calls up sexual gratification by looking at a sexual object or acts, and she recounts his having observed homosexuals interacting in illicit enclaves multiple times. (Gay relations would remain surreptitious in New York State until 1980, when laws against private same-sex conduct between consenting adults were abolished.) On another occasion, she noted, "Bob liked being out at night. During the day he worked, then at night he liked to go to openings, to Max's—I couldn't keep up with all that. So my knowledge is limited to what he told me the next day, you know, told me who he saw and what he did."[45] Hmm.

Friends of Smithson's from the late 1950s recall his strong attraction to, relations with and friendships with women, such that he claimed that his design for the cover of the second issue of *Pan* (see Figure P.4) depicts the genitals of one of them (what was the motivation for *that* assertion?). A pal of a decade later who would know, but does not want to be identified, is certain that Smithson had sexual liaisons with men as well as with women. In at least two interviews Graham, who knew him from 1964, identified Smithson as gay, asserting that he came "out of kind of a gay background."[46] Among Smithson's paintings, the image in *Reinforcements from the Rear* (1961) could be taken as referencing anal penetration. His *Portrait of a Transvestite* (1959) enacts a disguise by abstraction. It is lost; a black-and-white photograph of it shows a big tangle of curly paint strokes framing a smaller rectangle of geometric areas—the classic and classical representation of the female by soft and organic forms, here the outside, and the male by the inside hard shapes. Another version of it is seen on the wall, back left, in Figure 1.5.

These sources suggest that Smithson's sexual curiosity, desires, or

actualized identity, whether during specific phases or across the span of his adult life, can be best characterized as fluid—the term "bisexual" is too dimorphic—or queer, as in expansive. Yet other paintings' titles indicate that behavior's constraint, by intimating the social and spiritual dangers he would have felt as a person acting on other-than-heterosexual desire. He gave his painting of serpentine roots, an erect thick stem, and explosively radiating petals against a passionate red field an ambivalently feminized title, *Vile Flower* (1961), conveying vacillating disgust and desire.

Homosexuality was a prominent social fear; historian Vicki Lynn Eaklor reports, "The postwar era produced what was likely the most intense homophobia of the century." Queers were thought of as "mentally and morally unstable. By definition, then, 'perverts' were a threat to the government and the nation":

> Congress passed the Immigration and Nationality Act (McCarran-Walter Act) in 1952, banning homosexual immigrants, and the next year President Eisenhower issued Executive Order 10450, making homosexuality grounds for dismissal from federal employment. In effect, that Order further institutionalized homophobia in American society, and it was used as a basis for government hiring and firing until the 1970s.[47]

The 1950s was an oppressive climate for nonconformists. But in the uninhibited cultural idyll of 1960s and '70s sexual liberation pre-HIV, coitus could be brief, anonymous liaisons in bars, and in Manhattan, in Lower East Side Eastern European public bathhouses and otherwise abandoned Hudson River piers.

Smithson owned John Rechy's novel about gay male hustlers, *City of Night*, and its follow-up, *Numbers*; Gore Vidal's satirical *Myra Breckinridge* about machismo, transsexuality, and gender forms then considered deviant; and two anthologies from *Olympia*, the magazine of literary erotica. But other titles he owned suggest sexuality was an issue to be explored because it troubled him, for example, *Auto-Erotism: A Psychiatric Study of Onanism and Neurosis* (1950), by Wilhelm Stekel, and psychoanalyst Theodor Reik's *Psychology of Sex Relations* (1961). The surrealist poet Michel Leiris's autobiographical *Manhood: A Journey from Childhood into the Fierce Order of Virility*, written when the author was a self-abnegating young man, and the anthology *The Problem of Homosexuality in Modern Society* were both published the year of his marriage, 1963.

The latter title was echoed at the end of that year when the *New York Times* reported, "The problem of homosexuality in New York became the focus yesterday of increased attention by the State Liquor Authority and

the Police Department." Two "homosexual haunts" had their liquor licenses revoked for serving and allowing same-sex "deviates" to dance together. The city with "probably the greatest concentration of sexual inverts in the world" draws them there for the community enclaves, where "they have to fear only the law which punishes homosexual conduct variously as a crime or a misdemeanor." A monsignor of the Roman Catholic Archdiocese of New York was quoted: "Parish priests are advised under our pastoral counseling program to urge homosexuals to seek psychiatric help."[48] In a few years, the archdiocese would "mount a fierce and successful battle to retain statutes making both adultery and homosexuality criminal acts in New York State."[49]

The art world, generally more accepting of diverse expressions of identity than the mainstream, shared its prejudice. An artist and good friend of Smithson, responding to my question if in the early to mid-1960s Smithson was aware he was gay, replied indignantly, "NOBODY knew I was gay; I would be labeled and my sales would have evaporated."[50] Almost a decade later, that belief still held. John Giorno wrote in his "Vitamin G" (gossip) column that the couple "John Perreault [the poet and critic] and Ira Joel Haber [the artist] were chosen [by Giorno] as true-romance Culture Heroes of the Month, but Ira Joel said 'You can write about my work, but you can't write about my personal life, it would ruin my career as an artist.' "[51] Dan Flavin, who had been schooled in a Roman Catholic seminary, made numerous gratuitous "derogatory comments on gay men [in the mid-1960s], which focus on how they can be spotted or made visible." Moreover, as art historian David Getsy also observes, "It is important to remember that such comments on homosexuality by Flavin were not made only in private. Rather, they were published in . . . such magazines as *Artforum* and were anthologized along with the rest of his writings in 1973."[52] Smithson read the periodicals in which Flavin stated those remarks, participated in many of the same exhibitions as Flavin, and they socialized together. He was certainly aware of Flavin's—and others'—antipathy for homosexuals, an attitude that his own remarks give the impression he shared.

Like Flavin's, Smithson's references to homosexuality were made in print, that is, publicly and openly as if corresponding to conventionally accepted views (although unlike in Flavin's collected writings, Holt deleted the most blatant from Smithson's). In his essays and interviews, Smithson initiated reference to homosexuality through insertions as extraneous asides. In his dismissal of a discussion of the "apocalypse of ecology," Smithson noted that the announcer had a "gay-sounding voice," and in an interview he introduced another irrelevant reference to homosexuality only to disparage it, scorning Walter De Maria's gallery sculpture as "neo-symbolist theatricality, very swish, I think. So I discount him."[53] The epithet

PECCATUM MUTUM
alias
SODOMY
—

scholarly book by a noted
ecclesiastic authority on
this unspeakable crime.

Contents include:
Sodomy - The Mute Sin ,
The Practice of Sodomy,
etc.

Collection
"Le Ballet de Muses"
PARIS

FIGURE 5.9. The off-register text on the cheap paper cover of *Peccatum Mutum alias Sodomy*, a seventeenth-century tract by a Roman Catholic friar published in English in 1958 (the edition Smithson owned), suggests both the imprecision of the publisher and that it is an underground text about an act it considered morally askew, transgressive to both civil and sacred communities.

was applied to gay men who appropriated and exaggerated mannerisms traditionally associated with the female to express their own sexual identity—as do many of Smithson's own drawings of epicene angels. He recounted William Carlos Williams's recalling "Hart Crane inviting him over to New York for all his fairy parties."[54] Whether he was echoing Williams or originating the description to distinguish his masculinity from that of poets belittled as sissies, the gibe was gratuitous. And it is hypocritical from one in whose *Buried Angel* (Plate 15) the underground bulbous scrotum-like lower end of the erect channel spews pink—a smoke signal as feminized phallus.

In the midst of his published tour of Passaic, New Jersey, in 1967, he likened an architectural structure to homosexual coitus —"It was as though the pipe was secretly sodomizing some hidden technological orifice, and causing a monstrous sexual organ (the fountain) to have an orgasm. A psychoanalyst might say that the landscape displayed 'homosexual tendencies,' but I will not draw such a crass anthropomorphic conclusion."[55] His analogy so swerves from that section's deadpan discourse that anyone attuned to latent feelings "might say" that the function of his conjured image of sodomy was to enable him to simultaneously declare his distance from it and, like his imagery described here, hint at his knowledge of that must-be-secret act.

As a reader, Smithson wasn't detached from that sexual—or secret—act, as he owned a 1958 edition of the seventeenth-century Catholic tract *Peccatum Mutum: The Mute* [or *Secret*] *Sin*, that is, the unspoken of and considered unspeakable act of sodomy. The author is Ludovico Maria Sinistrari, a surname calling up the Italian *sinistra* or sinister, too perfect for his subject matter and denunciatory tone not to be an assumed name. But Sinistrari was apparently a Franciscan priest (obviously a deviation *himself* from an order known for humility and kindness) and an expert on demonology and what since early canonical codes had been considered not only an abomination, but so much so that one only approached it with great reticence

(hence, the "mute sin"). To moderns, *Peccatum Mutum*'s opening line presents a confusing imbalance: "After *pollution*, under the genus of *vice against nature*, there comes, still more grievous, SODOMY." But you might guess, here pollution results from masturbation. That's considered bad, but not as grievous in this accounting of sinful acts as anal penetration. "This crime is exceedingly heinous . . . because the engendering of man is prevented, so long as the seed is poured out in a barren place, where it can have no chance to grow." Sinistrari speaks of sodomy less as an ecclesiastical sin than a civil crime. The punishment for indictment for sodomy is torture by fire (that is, in this world, not Hell). After ninety-three pages of ecclesiastical dicta, he concludes, "This is enough on this most foul inquiry."[56] So Smithson knew what he was up against, or up for on Judgment Day, should he commit that spiritual sin and civil crime. And the medical profession confirmed society's view of homosexuality as a sickness; until 1973 the American Psychological Association listed it among its diagnoses as a pathology. No wonder Smithson read both nonfiction and fiction about tortured selves—and male bodies—and had painted them.

His article about Frederick Law Olmsted's design of Central Park veers to describe types of people known to typically frequent an area called "The Ramble," an "urban jungle" where "lurking in its thickets are 'hoods, hobos, hustlers, homosexuals,' and other estranged creatures of the city (see John Rechy, *The City of Night*)."[57] He must have felt like one of those "estranged creatures," being "other" than those comfortable with fidelity to marital heterosexuality. Seeming to establish his difference from homosexuality, these statements indicate his ambivalence—engaged with it enough to irrelevantly insert attention to it, but only to malign its practice and practitioners. The frequency of his disparagements suggests an aim less to convince his readers of his heterosexuality than to disavow an identification he had already made himself, perhaps deriving from internalized homophobia.[58]

This context gives a plausible context to Graham's otherwise incredible assertion that Smithson's "hero was Andy Warhol."[59] Artistically, their work and their conception of the artist's relation to audience are disparate, the structure of their careers, not so. As art historian Bradford Collins has described:

> Warhol had two separate careers: one as a commercial illustrator, 1949–ca. 1964, and one as a Pop artist, 1960–1987. The shift, a true metamorphosis, was characterized by an absence of apparent continuity. The cool, industrial character of his '60s art was antithetical to the warmly personal quality of both his advertising and artistic production of the preceding years.

The radical dissimilarity of Warhol's two-step career is also characteristic of Smithson's sequentially bifurcated trajectory. But another observation by Collins about Warhol also applies to Smithson: "Two distinct personal agenda generated Warhol's first Pop production: ostensibly it was designed to satisfy his social ambitions; less apparently, it was intended to cope with a nexus of psychological problems." And also, Collins separately notes, Warhol, "homosexual and Catholic . . . masked strong feelings and convictions behind a trifling and insouciant cool."[60] Smithson also masked personal passions, was of indeterminate or mixed sexuality and equally because of that, difficultly Catholic. And both commanded tables at Max's. Smithson could be considered Warhol's darker counterpart, one who only partly disguised his obsession with mortality behind intellectuality, his demeanor hardly detached, more direct, including his disavowals of homosexuality.

A painting Smithson made in 1961 accentuates sexual conflict (Plate 23). In the sky a black-and-red winged specter converges associations of bloodsucking bats and the small airborne angels hovering over the dead in Gothic elegies such as Giotto's *Lamentation* (Arena Chapel, Padua, 1304–6) and Buonamico Buffalmacco, *The Triumph of Death* (Camposanto, Pisa, 1338–39). Below, the writhing terrain fuses stony cliffs and urban cityscape—structures entirely gray, black, and seemingly infertile. A columnar form that resembles a medieval Italian tower but looks just as much like a stylized phallus shoots out of the bleak landscape into the lavender cosmos, the hue signaling homosexuality.

Acting on homosexual urges, especially by one as affiliated with a religion denouncing it as was Smithson, could elicit shame, guilt, and fear of spiritual—not to mention social and professional—retribution. That gives another perspective on Smithson as a "man of sorrow" being "paralyzed in a divine agony, unable to explode into some cheap ism" (which sounds like a dive bar where in dark corners duos anonymously copulated). And it provides another source of his disguise as a sculptor, of his personal conflicts and attraction to religion, the occult, and psychological self-reflection. "This creates an almost unbearable tension," he continued to Lester (May 1, 1961, #5). Perhaps that struggle was a source of his choice to depict Christian places of afterlife as sites of punishment: *Purgatory* and—of all the regions within of Dante's *Inferno—Dis*, the penal confinement assigned to the violent and bestial, hypocrites, and betrayers.

And yet—in that painting's confrontation, the phallus reaches the same height in the sky as the angel of death, as if they are having a standoff. Here Smithson resists deadness with *elan vital*, that is, in this case, potent sexuality, while fearing—or defying—the consequences identified in the painting's title: *Death Taking Life*.

. . .

Structurally related to his cartouche-collaged drawings and encompassing his equivocalities is a profusion of enigmas in a 1963 drawing, *Untitled*. This modest-size sheet gathers an assortment typical of his pencil drawings of the time signaling sexuality and aggression. In the lower-right corner two dinosaurs brawl, a larger one lunging over the smaller. An anachronistic plane flies overhead, suggesting that they are actually not prehistoric creatures but live in modern times. (This, of course, predates *Jurassic Park* by decades.) Above it at the top right is a girlie "pinup" posing on one leg on a plinth near a torch, nude except for 1940s-style garter belt, stockings, and heels. The center top hot rod with racing stripes links sexuality and racing motors driven by men in movies of the time. The number five on its side adopts Charles Demuth's number in his *I Saw Number Five in Gold* (1928), and is possibly a nod to Demuth's openly gay identity. At top left is Saint Sebastian, in a pose of hands behind his back, head turned, and right knee forward depicted by Andrea Mantegna in mid-fifteenth-century paintings in the Louvre and the Kunsthistorisches Museum, Vienna, on a pedestal, haloed, nude except for loin cloth, and characteristically pierced by many arrows. As previously noted regarding *Creeping Jesus,* the saint represents another sort of allure. For his combination of statuesque physique, the experience of the rapture of penetration, and persecution for his identity (as a Christian), Sebastian had historical appeal to modern gay writers and artists. In that postwar period of rabid homophobia, for those who risked being personally and professionally martyred for their own attributes and inclinations Sebastian was an exemplar of both tortured male beauty and fortitude to which men with gay, queer, or fluid sexual inclinations could especially relate.

Toward the center of the sheet, Smithson regendered a sphinx. In classical mythology and its nineteenth-century adoptions, the sphinx was depicted with the head and breast of a woman and the body of a lion. Smithson reversed and merged the sexual orientation; his sphinx's distinctly masculine facial profile wears a Native American chief's headdress and sunglasses with the round frames with which earlier modern artists (Mondrian, Le Corbusier) signaled their intellectuality. As a sphinx, he's mum, but the tumescent breasts squirt onto the men below so propulsively as to evoke not lactation but urination. The hooded welder ignores the stream; his focus is on a hunky male's crotch, from which radiates signs of explosive energy. Or excitement.

The center cartouche is a black-and-white photograph of the head of a man seen from the back with another holding a gun to his ear. The unidentified film still is a scene from the 1961 British thriller *The Secret Partner* about doubled threats, or a kind of twinship: the protagonist is being

FIGURE 5.10. Robert Smithson, *Untitled,* 1963. 24 × 18 inches (61 × 46 cm).

blackmailed by a villain who himself is being threatened by a mysterious man.

Yet throughout his cartouche series as well as his pen-and-ink drawings of sexualized angels, other issues pertain. Smithson's intimate relation to Holt seemed to have stimulated intense reflections on his part, through reading and making art, on the topic of sexuality, that is, his own. *Untitled (Fighting Dinosaurs)*'s diverse group presents a riddle: in this year, in the middle of which he and the converted Catholic married in a Nuptial Mass, any one of the figures—the dinosaur, the babe, the saint, the intersex sphinx, the hunk, the thug, his unknown victim—could potentially be Smithson's "secret partner." It is a "quagmire of confounded passion," Smithson's description in a few years of "a tidal wave of infinite carnality" by Michelangelo, who "wrote a Dionysian love poem to Cavalieri."[61] And

yet all of these are probably side issues—as they are, in fact, in the composition—to his dominant one, and the central photograph of a man threatened with death, whose face cannot be seen.

Smithson has taken up his family's ghost who seemingly could not be addressed or discussed by displacing him onto the crucified Christ, leukemic dots, a martyred ghost, the Holy Ghost, an angel, a scorpion, astrological symbols and numbers, and an anonymous man on death's doorstep. Scholar Richard Stamelman offers a compelling understanding of rationales for repeated representations of loss:

> We try to overcome loss by naming it, by representing it, and by finding new forms and images through which to retell, recall, remember and resuscitate what has disappeared. . . . Surrogate objects that, standing in the place of what has disappeared, simultaneously memorialize its significance and mourn its loss.

That helps explain the continuity of Smithson's creative "'presentification' of absence."[62] His profusion of verbal metaphors and succession of visual ones simultaneously mourn the absence and call up the presence of that which has been lost. Memorializing mourning and vitalistic remembering are entwined. Inverting the identity of Harold as an intrusive ghost, all of these references also serve a desire to hold on to that figure, for the successor to know and have a relationship with the lost (br)other. To let him go from memory, obsession, and representation would be to lose Harold more absolutely.

"Art works in mysterious ways." Smithson's alteration of the line from a popular eighteenth-century English hymn written by William Cowper, "God moves in a mysterious way" characteristically implies a double entendre.[63] To the viewer, his allusions to the esoteric were mysterious—their source unknown and unacknowledged. But to himself, Smithson's creative process corresponded to Jung's analysis of alchemists' behavior: "I am not speaking of a secret personally guarded by someone, with a content known to its possessor, but of a mystery, a matter or circumstance which is 'secret,' i.e., known only through vague hints but essentially unknown."[64] That is the deeper unknowable, both the lurking subject of his art—the identity of his fraternal predecessor and prompter of his existence—and the direction his art will take. His transition from *Man of Sorrow* to *Secret Partner* performed his own act of self-replacement. From an incantation chanter painting "in a thick despairing way," Smithson became an artist of forms deliberately mysterious.

Mutation
of
Artistic Persona
1965–1968

FIGURE 6.1. Robert Smithson, *Quick Millions,* 1965. Plexiglas and corrugated acrylic, 54 × 56 inches (137.2 × 142.2 cm). Collection Centre Pompidou. Copyright Holt/Smithson Foundation / Licensed by Artists Rights Society, New York.

6

A Better Entrance

He always knew that you didn't get anywhere
by being busy and doing positive things.

—*Nancy Holt*

Whether Smithson was "not wanted" by art deal-
ers, as he rued in his private "Lamentations"
essay, or "completely uninvolved," as he preten-
tiously declared in the *Village Voice* at the time of
his *Bio-Icons* at Castellane Gallery, when that show closed on November 23,
1962, both statements were more true than anyone might have recognized:
he had no future exhibitions scheduled. Over the next twenty-eight months
he devised a new persona and delved into an unfamiliar artistic medium.
His process could be analogized to one described by a favorite science fic-
tion novelist, J. G. Ballard: "This growing isolation and self-containment . . .
reminded Kerans of the slackening metabolism and biological withdrawal
of all animal forms about to undergo a major metamorphosis."[1]

At the end of the decade, Smithson would still be complaining about
arbitrary sources of meaning: "As soon as you name something, then you
destroy its reality. So that as soon as you're, like, named at birth, you're
already, like, wiped out."[2] Yet to the extent the replacement child situation
imposes an identity on the successor and a sensitivity to constraints, for
the rebellious and ambitious like Smithson, it also galvanizes a desire to
perform his own replacement scenario, shedding that position of existen-
tial double toward reparative recognition as radically original. This was his
process of transmutation.

In March 1965, Smithson debuted his professional identity as a sculptor in Philadelphia's Institute of Contemporary Art's exhibition *Current Art*. His *The Eliminator* consists of two rectangular mirrors hinged along a vertical edge open at a forty-five-degree angle (Plate 24). Between the mirrors, spanning a steel frame's twenty-eight-inch height, columns of loosely zigzagging neon regularly pulse light, their reflections multiplying them into thickets of febrile energy. His use of the glass tube signage material links the sculpture to the commercial sources and economic optimism of Pop Art. Those artists rejected Action Painting's thick brushstrokes, what artist Robert Indiana denigrated as "impasto as visual indigestion." Not being "burdened with that self-consciousness of Abstract Expressionism," Pop artists, as Roy Lichtenstein put it in the same article, "look out into the world." Pop Art is "anti-contemplative . . . anti-mystery . . . and anti-Zen."[3] The next year, Howard Junker provided an apt condensation:

> In a world bewildered by variety and complexity, Pop assured us neither existed. . . . Pop believed in culture by take-over. That is, the fine arts embraced the commercial, comic, and billboard arts. . . . Pop provided us . . . a chance to seize the day, the Brillo box and the giant hamburger . . . to assault our senses with trivia.[4]

Joining that turn to audacious extroversion, Smithson's irregular zigzags evoke propulsive thrusts as in lightning strikes, or muscular bolts from a cartoon victor knocking out opponents. A review in the *Philadelphia Daily News* titled "'Pop Art' at Penn has a Neon Glow" described *The Eliminator*'s frenzied lines as "reminiscent of a disemboweled toaster."[5] Yet prevailing over a victim or violently excising the guts of an appliance is not that far from the stabbing and wounding associated with Christ's crucifixion. All those mirrored marks of pulsing, reflecting red walls, can also be seen as propulsive surges of blood, the tempo of flashes as if a heartbeat. Significantly, in the dark room, and with the mirrors angled, viewers can't see themselves in the mirror; only the allusion to streaming blood is doubled. Christ and Harold redux.

In his accompanying statement, his first text available to the public, Smithson explained, "*The Eliminator* overloads the eye whenever the red neon flashes on and in so doing diminishes the viewer's memory dependencies or traces. Memory vanishes, while looking at *The Eliminator*. . . . [It] is a clock that doesn't keep time but loses it." Despite his participation in producing witty hijinks then considered a relief from ponderous painterliness, his creations continued incorporating barely disguised references to his private life. So his aim that the strong presence of this tabletop piece would "overload the eye" apparently to overwhelm and subjugate "memory,

[which] vanishes while looking at *The Eliminator*," had a distinctly personal benefit. As a fulcrum work between past and future artistic selves, the construction's aggressive sensory overload suggests not just a fantasy of vaporizing personal memories. Rather, Smithson was for the first time exhibiting a *sculpture* and expected *The Eliminator* to serve as he described, as a "clock that doesn't keep [his artistic past] time [in mind] but loses it." And it was to perform as titled—that is, as instructed—erasing his identity as a painter in the art world's memory, and particularly of those who four years earlier had read Eli Levin's character assassination in the *Philadelphia Inquirer*. Smithson had risen again, as a sculptor.

The double mirror structure he used in *Eliminator* is illustrated in a book he owned, *The Ambidextrous Universe* (1964). In the first chapter, "Mirrors," author Martin Gardner describes how, unlike viewing anything in a single mirror parallel to itself that produces a laterally reversed reflection, this double mirror produces "a true, *unreversed* image. For the first time you are seeing yourself in a mirror *exactly* as others see you!"[6] And that was the point: Smithson wanted others to see him exactly and solely as he was then representing himself—as a sculptor.

Smithson's absence from exhibitions in 1963 and 1964 had given him the gap years that he could withdraw into and undergo his transmutation. During his hiatus, he expelled figuration and replaced his artistic persona as a creator of painterly morbidity with one who materialized innovation in three dimensions. Several years later he would attribute his transition to an intellectual and professional quest: "Out of the defunct, I think, class culture of Europe I developed something that was intrinsically my own and rooted to my own experience in America."[7] It is another of his reasonings that sound a lot like Barnett Newman, who wrote, "I believe that here in America, some of us, free from the weight of European culture, are finding the answer."[8] In Smithson's case, speaking as an earthworker, that could be taken as finding inspiration in his experience of the United States' expansive uninhabited terrains, so foreign to Europe.

But in 1965 the greater impetus was personal—"intrinsically my own . . . rooted" in his individual experience. His artistic transition away from anguished imagery had been incited by skeptical reviews of his Artists' Gallery solo show and pushed by Lester's refusal to represent his incantation and *Man of Sorrow* series in the Rome show. It was further propelled by his own careful study of new forms in the galleries and in art magazines. He wrote to Lester during this period: "I've discovered a great deal about the economics and the politics in the art world . . . art cartels, politics blocs in the international market, power plays and other avant-garde tactics. It takes much personal observation to understand such things" (February 22, 1963, #19). Holt put it another way: "He always knew that you didn't get

anywhere by being busy and doing positive things. That it was all about being receptive to inner intuitions. So he was a very interesting combination of forceful drive and extreme receptivity."[9]

Toward that end, three books he owned potentially offered guidance concerning his changing relationship with both religion and the art world. By its very title, *The Hidden God: A Study of Tragic Vision in the Pensées of Pascal and the Tragedies of Racine* (1964) would seem to speak to Smithson's conjunction of conflicts about displaying his religious feelings and the melancholic tenor of his writings. French scholar Lucien Goldmann describes a seventeenth-century "turning-point" that paralleled Smithson's transformation of his art into the reductive masses and plain surfaces of what would be called "primary structures":

> The nature of the tragic mind in seventeenth-century France can be characterised by two factors: the complete and exact understanding of the new world created by rationalistic individualism, together with all the invaluable and scientifically valid acquisitions which this offered to the human intellect; and, at the same time, the complete refusal to accept this world as the only one in which man could live, move, and have his being.[10]

Hence, for Blaise Pascal and Jean Racine, allusions to the divine were disguised, offering a model for Smithson.

Secondly, Mesoamericanist and architectural historian George Kubler's book *The Shape of Time: Remarks on the History of Things* (1962) provides the procedure. Kubler critiqued historians' excessive attribution of artistic success to biography. "In the long view, biographers and catalogues are only way stations where it is easy to overlook the continuous nature of artistic traditions . . . [to mistakenly emphasize] congenital disposition as an inborn difference of kind among men, instead of [seeing it] as a fortuitous keying together of disposition and situation into an exceptionally efficient entity."[11] Actually, both of these were strong factors in Smithson's success. His energy, inclinations toward personal growth by reading and observation, and response to his family experience as a replacement, drove him forward. And his fatalistic "disposition" and soon, identification with the process of entropy, spoke of and to issues in the social and cultural "situation" that under the stress of the Vietnam War, antiwar and civil rights protests, and emerging awareness of environmental threats produced a general sense of precariousness. In a few years, his earthworks' boldness and their shapes' mystical symbols will convey both the postwar period's residue of economic optimism and the sixties' openness to Medieval, alchemical, and non-Western symbolic forms.

Kubler's alternative explanation for success, against the reductiveness of singular "genius," was the "union of temperamental endowments with specific positions." That is, ideas and goals specific to a historical time and place. That provided a playbook on utilizing personal attributes for personal success: "When a specific temperament interlocks with a favorable position, the fortunate individual can extract from the situation a wealth of previously unimagined consequences."[12] Smithson connected to Kubler's ideas, citing passages from *The Shape of Time*, for example, in his 1967 essay "Ultramoderne" on the Art Deco facades of 1930s' apartment buildings: "The 'history of art,' according to Kubler, resembles 'a broken but much repaired chain made of string and wire' that connects 'occasional jeweled links.'"[13] He did not include the rest of Kubler's sentence: "surviving as physical evidences of the invisible original sequence of prime objects." For him, the prime object in his family sequence, invisible, was Harold, as he made clear in his next sentence: "To understand this 'chain' would be like trying to retrace the pattern of ones footsteps from the day of ones birth to the present. The prime monuments are as enigmatic as the prime numbers."[14]

Seeking to become such a "jeweled link" himself, Smithson likely attended to Kubler's statements on the following page addressing "the phenomenon of climactic *entrance*" (Kubler's emphasis) for its personal relevancy:

> Such entrances occur at moments when the combinations and permutations of a game are all in evidence to the artist; at a moment when enough of the game has been played for him to behold its full potential; at a moment before he is constrained by the exhaustion of the possibilities of the game to adopt any of its extreme terminal positions.

The latter had been Smithson's position as latecomer painter of figurative abstraction. His letters to Lester indicate the extent of his scrutiny of the art world's combinations and permutations. Kubler provides a way to gain access:

> To the usual coordinates fixing the individual's position—his temperament and his training—there is also the moment of his *entrance*, this being the moment in the tradition—early, middle, or late—with which his biological opportunity coincides. Of course, one person can and does shift traditions, especially in the modern world, in order to find better entrance. Without a good entrance, he is in danger of wasting his time as a copyist regardless of temperament and training.[15]

In switching his artistic identity from painter to sculptor, Smithson was in effect shifting to a less developed realm where he could "find a better entrance." As I discussed in my history of earthworks within the stylistic and social upheavals of the 1960s:

> The arena of the art world where that sense of expansive possibilities so endemic to the sixties particularly became manifest was that of sculpture. Whereas in the hierarchy of artistic media sculpture has traditionally been ranked, as Charles Baudelaire noted, as "nothing else but a *complementary* art . . . a humble associate of painting and architecture . . . serving their intentions," in the 1960s sculpture became the most fertile medium, dominating art production as never before in the modern period. "The Sculptor Nowadays Is the Favorite Son," headlined John Canaday in a November 1964 issue of the *New York Times* Sunday Arts & Leisure section. In praising sculpture, Canaday all but buried painting. . . . The *Times* chief art critic described the current status of painting as "living in an iron lung . . . a rather pretty patient"—contrasting the clear hedonistic expanses of Color Field painting to the prior sober tensions of Abstract Expressionism—"but the artificiality of its existence must be recognized," he asserted. "For every painter who succumbs to 'the exhaustion all around us,' there is a sculptor who finds new vigor."[16]

Indeed, the new medium gave Smithson a new life. And as well as being artistically talented, articulate, and intellectually curious, he had what Kubler called the "temperamental endowments" to make use of the stylistic opening of new possibilities: ambition, diligence, conversational skills, and a sociable wife.

Dan Graham recounted the benefit to Smithson of Holt's graciousness and their regular hosting of "dinner-salon type meetings": "Nancy was essential to Bob's well-being, as an optimistic and cheerful person. We all adored her as fun and sexy."[17] (Holt did not start actively exhibiting as an artist, and to be known as such, until 1972.) In their short video *East Coast/ West Coast* (1969), filmed by artist Peter Campus in artist Joan Jonas's SoHo loft, Holt and Smithson conversed in the format of 1950s' television sketch comedy, satirizing opposite artistic mentalities by exaggeration. On the one hand, the parts they played, Holt the intellectual conceptualist and Smithson the intuitive romantic, countered both gendered stereotypes and their own presentational personae. Holt had a light feminine voice, was friendly if guarded, and spoke with descriptions and self-reflective self-corrections. Smithson, tall and masculine, was confident, declarative, and judgmental.

But the roles they played corresponded to authentic characterological tendencies. Holt was very detail oriented, administering their finances and household, keeping a calendar of his professional activities and their social engagements. Smithson couldn't type (so Holt said, despite his initial army assignment as a clerk/typist) or drive. She did both for him; served as the first editor of his texts; photographed him for posterity; and assisted with his earthworks projects and their documentation. She was present during his interviews, sometimes interjecting dates of his history that he didn't recall, even ones before they reunited as young adults. Her partnership was absolutely crucial to his success. After his death she collected, edited (expurgated), and published his writings; her management of his papers, works of art, and copyrights was fundamental to how his fame was represented by scholars, curators, gallerists, and journalists.

In their video, she wears a crisp white shirt and performed the disciplined, analytical East Coast artist advocating an "ordered approach" of "making diagrams, within a system." In the late 1960s Holt applied her biology degree toward studying to become a nurse, a course of study she apparently did not complete.[18] From the mid-1970s she would construct *Sun Tunnels* and various multi-part public sculptures precisely aligned with astronomical positions.

Smithson, in a loose black sweater reminiscent of a Beat poet's attire, burlesqued a northeasterner's view of an anarchical Californian who declared, "I really just, like, spin out on acid. I have my thing going. I don't care about the system. . . . I am out there doing it, I'm doing it!" Holt, reaching for commonality, construes his behavior as akin to hers by attributing to it a systematic character: "Well, you know, that's a philosophy too." Her response to him articulates the span of his inclinations: "You're some kind of mystical pragmatist."

Smithson's parody of pseudo–New Age mindlessness exaggerated his familiar issue of resistance against convention and authority. In the video he defended his position in period lingo, asserting, "Definitions are for really uptight types. . . . Don't lay that on me, man." Consistent with that, he more soberly told interviewer Dennis Wheeler, "Everyone who invents a system and then swears by it, that system will eventually turn on the person and wipe him out."[19] As a writer who never met him retrospectively ventured about this video, "The character Smithson assumes appears so close to his natural persona as to be almost indistinguishable."[20]

Thirdly, a novel he owned provides a model of characters successfully inhabiting new roles. *Cards of Identity* (1960), by British author Nigel Dennis, was prescient in its recognition, popular in cultural politics three decades later, that "identity is the answer to everything. There is nothing that can't be seen in terms of identity." The narrative's entrepreneurial

FIGURE 6.2. The jacket cover of the cloth edition of
Nigel Dennis, *Cards of Identity* (1960), designed by
Lucian Freud.

psychologists and psychoanalysts, members of the (fictitious) private club
Cards of Identity, were "proud to know that we are in the very van[guard]
of modern development, that we can transform any unknown quantity into
a fixed self, and that we need never fall back on the hypocrisy of pretend-
ing that we are mere uncoverers."[21] Temporarily squatting in an unoccupied
English country house to organize their conference, the group leader, "Cap-
tain," applies authoritative suggestion mixed with warm appreciation to
successfully convince villagers that they have always held specific staff po-
sitions. Each character, grateful to be so ardently wanted, disappears into
his or her appointed role. Captain reflects on the well-organized household:

> Formerly . . . an artist took real people and transformed them into
> painted ones: how much finer and more satisfying is the mod-
> ern method of assuming that people are not real at all, only self-
> painted, and of proceeding to make them real by giving them new

selves based on the best-available theories of human nature. . . .
It is incredible to think how well the open ear responds to a little
love and chronological falsification [of their personal histories].[22]

As a postwar novel published during a vogue for Freudian analysis
among educated urbanites, *Cards of Identity* was acclaimed for satirizing
Nazi and Communist techniques of indoctrination and present-day mental
health practitioners. Its cover art, by Freud's grandson Lucian Freud, em-
phasizes the fragility of identity, as if it were an unstable arrangement of
playing cards.

The novel's exaggerated view of the malleability of the self by others is
dubious, but it provides a fantasy model of how a new identity can be as-
sumed if one chooses to thoroughly inhabit it. In his interviews Smithson
did not initiate discussion of his art or art career prior to 1964, and when his
interviewer did, he disparaged his presculptural work, discouraging fur-
ther discussion. But until the 1970s it was common for sculptors to begin
their artistic careers as painters, traditionally the primary medium of vi-
sual fine art, and thus of art practice education. Smithson's friend Kathryn
MacDonald recalls that in 1956, at the time she graduated from New York
City's High School of Music and Art, it did not teach sculpture; she then
talked her way into a spot in the studio of the Sculpture Center on East
Sixty-Ninth Street.[23] Predecessor sculptors David Smith and George Segal
and peers Ronald Bladen, Donald Judd, Sol LeWitt, and Robert Morris be-
gan their careers as painters. Those artists didn't denigrate and suppress
knowledge of their initial artistic efforts as did Smithson. In his extensive
conversations with Dennis Wheeler, 1969–70, Smithson mischaracterized
his paintings as "somewhat like Dubuffet and de Kooning." His composi-
tions were neither faux-naïf figuration as Jean Dubuffet's images, nor as
painterly and abstract as Willem de Kooning's figurative paintings. Asked
by Wheeler, "Have those all been bought or sold?" Smithson replied, "No."
That was true: some remained in his possession. But in not mentioning
George Lester, Smithson renounced both his own history as a painter and
affiliation with the patron who had extended substantial support and who
at the time probably owned more than eighty works by him on canvas and
paper to be potentially viewed.

To Wheeler, Smithson continued: "I destroyed a lot of them. Those are
really like talented early work that I grew dissatisfied with."[24] It is com-
mon to feel one's youthful creations compare unfavorably to later work, but
Smithson must have been more than dissatisfied, as "destroyed" sounds
brutal. If his twenty-one incantations each correspond to a painting, only
ten can be linked to extant works, and studio visitors recalled seeing many

more Passion-theme paintings than are known. To Lester, he described an exemplar: "I like Botticelli, because he burnt so many of his vain works after hearing the terrifying prophecies of Savonarela" (undated [June 1961], #12). But similarly, he acted as iconoclast of his own religious images, self-regulating what of his work would exist and controlling what of it—and him—would be known, in the way that art historian Richard Meyer has described as "to withhold or destroy works of art as a preemptive strike against external acts of censorship."[25] Smithson must have feared "terrifying prophecies" from peers or art reviewers.

The timing of Smithson's "moment of his entrance" for a Kublerian "union of [his] temperamental endowments" interlocking with a "specific position" was enormously advantageous. It enabled his professional transformation to be propelled by the mid-1960s surge of attention to young American artists. In January 1965, critic Harold Rosenberg declared:

> The American Art Establishment is in the process of construction. Much of it is still unfinished. Key posts are occupied by squatters. Permanent positions in it have not yet been assigned. One reason for its condition is that this Establishment is the newest among America's cultural-economic edifices; in its present form it dates no farther back than the five or six years since money began streaming into American art and art education. . . . The big question for the Establishment is: Has the time come to unload and take on something new? . . . Owing to its condition of unremitting anxiety, the Art Establishment is easily swayed (as no established Establishment would be) by aggressively stated opinions, attention-getting stunts . . . [or] sheer brass (Warhol's imitation Brillo boxes).[26]

Smithson's process would encompass the first, bold statements, and the last, audacious upturns in conceptualizing sculpture.

Not being represented by a gallery in the spring of 1965 served Smithson well, as it rendered him eligible for inclusion in the pointedly titled *Lesser Known and Unknown Painters* at the 1964–65 World's Fair held in Flushing Meadows, Queens, New York. American Express needed to boost its attendance at its World's Fair pavilion, so for the second year of the fair it devised a timely presentation, *Art '65*. The fact that the corporation believed these exhibitions would draw spectators to its pavilion presumes great interest on the public's part in little-known artists and shows the period's broad receptivity to new art. The corporation turned to Brian O'Doherty, former art critic for the *New York Times*, to travel the country and select thirty-five artists for *Lesser Known and Unknown Painters*. Among them, Peter Hutchinson, Robert Ryman, Leo Valledor, and Jamie Wyeth were also pre-fame.

MIT professor Wayne Andersen organized a parallel show, *Young American Sculpture—East to West*. The United States' vibrant economy, the period's openness to cultural innovation, and societal sexism were all on display in O'Doherty's exhibition catalogue essay. " 'Lesser known painters?' said a curator at the Modern Museum, 'They don't exist any more. They're discovered so fast you can't find them.' He has a point. Nowadays an artist can expect professional success quicker than any other professional man—if he's good enough."[27]

Blurring the material distinctions between painting and sculpture in American Express's exhibitions, a trend merging categories of fine art media had begun a decade earlier with inventive acts of juxtaposition (Robert Rauschenberg's *Combines*), assemblage (Jasper Johns), and shaped canvases (Frank Stella). Paintings often became volumetric constructions hung like sculptural reliefs. This convergence of categories makes it less paradoxical that the work by which Smithson was represented as a "less known" painter was a simple arrangement of bright, plastic, geometric panels: two large diagonal parallelograms in reddish-brown acrylic sheeting as wings of a vertical panel of corrugated blue acrylic. Within *Art '65*'s media binarism, it is closer to the domain of sculpture, but like painting, it hung parallel to the wall.

Smithson wasn't just replacing, or mixing, the media with which he was engaged. He changed his personal and artistic style and his art's medium, appearance, and mood. In the history of modern art, personal self-transformation of one's artistic or public persona is not so unusual. Among modern artists, Paul Gauguin epitomizes the self-made artistic persona. Initially a bourgeois Parisian stockbroker, when he turned to painting full-time he went to the deliberately quaint historical village and tourist destination of Pont-Aven in Brittany and then to the French colony of Polynesia to assimilate what he imagined to be the pure mentality of an artistic savage. Through his promotion of his own self-mythology Gauguin became the paradigm of artistic primitivism. Marcel Duchamp turned from being a painter of Cubist/Futurist figuration to a mystical/conceptual sculptor. The Armenian refugee Vostanik Manoug Adoian identified with the Greek warrior Achilles and falsely claimed the Russian writer Maxim Gorky as a relative and, as the American Surrealist/Abstract Expressionist painter Arshile Gorky, became famous. Bronx-born Yitzroch Loiza Grossberg became the Manhattan/Hamptons musician-painter-character Larry Rivers. When Robert Indiana, who had been adopted as a replacement for a deceased child, sought to assert his own distinctiveness he replaced his adopters' surname, Clark, with the name of his state, distinguishing his midwestern affiliation among New Yorkers. Judith Cohen became Judith Gerowitz when she married, but after her husband's death and as her art career began to be

recognized she changed her name to Judy Chicago, a self-actualizing act that became synonymous with the initiation of the radical Feminist Art movement.

Smithson's transfiguration aligned him with the new emphasis on art as rational investigation of space and materiality. It conformed to the broad shift of interest by the New York art world away from the expressionism that dominated art after World War II toward what in 1962 LeWitt heralded in a fifty-inch-square "painting" consisting of a five-by-five grid of recessed boxes almost ten inches deep containing the capitalized letters of its title: *OBJECTIVITY*. The result of Smithson's extended "personal observation to understand such things" is evident in his description in the same letter to Lester of his "new series of paintings, which are primarily concerned with light and color, without any trace of expressionism, impressionism, or cubism" (February 22, 1963, #19). His flatly painted *High Sierra* (1964) has five sharp-edged vertical jagged bands, something like a two-dimensional version of *The Eliminator*, in blue. Both could have been made to appeal to Museum of Modern Art curator William Seitz for inclusion in his 1965 exhibition *The Responsive Eye*, but Seitz's eye did not view them favorably.[28]

Nothing in his construction's angular planes reflects its title *Quick Millions* (1965; Figure 6.1). But that description of easy affluence did connect it to the spectacle just outside the American Express Pavilion, a twenty-four-and-one-half-foot-high, golden *International Money Tree*. The corporation had commissioned Samuel Gallo to produce the monumental sculpture for its entrance near that of the fairgrounds as a whole. Fluttering above its sturdy flanged metal trunk was foliage made of a multitude of small reflective palettes to which more than a million dollars in international paper currency and Travelers Cheques had been laminated. Dramatizing its value, the tree's sparkling boughs were caged. American Express announced that "the 'money tree' was meant to symbolize the international economic and cultural forces binding the world's peoples together." A photo caption proclaimed, "Now—money does grow on trees!"[29] The display of the vast amount of cash served as a beacon to visitors' economic aspirations.

While the title of Smithson's *Quick Millions* gave it topical relevance, nothing in the composition evokes money. Rather, the design resembles a shape that would have been recognized by Catholics who like Smithson regularly attended Mass. The two diagonally downward-oriented wings on either side of the vertical panel of corrugated plastic resemble the configuration of a priest's chasuble (a cape-like decorated robe with, on the back, a centered vertical tapestry panel). Viewed that way, *Quick Millions* becomes a coded reference to spiritualism and retort to American Express's glittering display of materialism, an opposition Smithson had articulated to Lester in one of his futile pleas of receptivity to religious imagery: "I will leave

it up to your conscience as to what should come first. Will it be business or will it be the spirit?" (May 8, 1961, #6).

Describing *Quick Millions* in the exhibition brochure, his first published text, Smithson referenced neither its title's riffing on the pavilion's *Money Tree* fluttering with a million bucks or its shape's resemblance to a priest's robe. Rather, his statement amounts to a series of negatives, here italicized for emphasis. "For me, *Quick Millions* comes out of a world of *remote* possibilities, held together by *incomprehensible* motives. The work is named after a movie I have *never seen*. . . . One could also say it has a '*non-content*.'"[30] He would like us to think it is nonobjective abstraction, without referential subject matter.

But as a film buff whose datebooks indicate that he viewed films regularly not just in commercial theaters but at the Museum of Modern Art, and who at the time of his death owned thirty-four books of film history and criticism, Smithson did not need to have seen the film *Quick Millions* to know of it. O'Doherty recounts frequently going with Smithson and others to see "all sorts of movies in the many theaters then along West 42nd Street," and Richard Serra recalled the many times they saw second-tier, genre, and bad movies together.[31]

Like the still from *Secret Partner* so central to that 1963 drawing, Smithson's adoption of the title *Quick Millions* for his own work's title *and* his naming of it in his statement indicate the extent of his connection to film, and that this one clearly meant something to him. Again, as with *Secret Partner*, Smithson chose a film that is about murder, that is, death.

The well-known early gangster movie *Quick Millions*, director Rowland Brown's debut in 1931, features a youthfully brazen Spencer Tracy in his first substantial role as a small-time truck driver become thug attempting to crowd out big-city racketeers. (The film is also famous for George Raft's impromptu solo dance of intricate steps and kicks at a cocktail party.) In its final scene, two tough guys chauffeuring the now-boss (Tracy) to a wedding murder him and toss his top hat out the car window at the foot of the bride's lacy bridal train as she ascends the church steps. In its notorious punch line, the driver exclaims admiringly, "Don't those society people have big weddings?" His buddy retorts, "Yeah, but us hoodlums have swell funerals."

In this Depression-era film's bluntly bifurcated class system, it is not the "society people" with whom Smithson would have identified. Rather, Irving Smithson's employment history as a carpenter, electrician, volunteer fireman for the Rutherford Fire Company, employee of Electric AutoLite, which manufactured electrical car parts such as spark plugs and ignition systems, suggests affinities with blue-collar laborers and a traditional close-knit family.[32] We're revisiting the subject matter of his painting *Alive in the Grave of Machines*, that is, a family that experienced so many

funerals—swell or not—that it appears to be a machine of graves. Smithson reinforces the latter by describing his *Quick Millions* as "a terminal work: sealed, impenetrable, unrevealing—forever hidden," which also applies to the focal point of a funeral, the casket.[33] Smithson appeared to be ruminating on generic or universal mortality. But his claim that he named his construction "after a movie I have never seen" sounds like a displacement of his own life conceived after a brother he never saw.

He may have additionally referenced Harold by visually alluding to the other animal symbolizing his astrological sun sign: brown downward parallelograms on either side of the blue vertical of *Quick Millions* evoke wings. Harold's sun sign, Scorpio, is represented in its lower phase, a scorpion or snake, but also by its transmuted opposite, the soaring eagle of regeneration.[34]

Concluding his series of negatives in his *Quick Millions* statement, Smithson declared in his new voice of artist as machine: "All kinds of engineering fascinates me, I'm for the automated artist."[35] He had already voiced that withdrawal of emotion when he explained to Fred McDarrah regarding his *Bio-Icons* show, "I just want to be completely uninvolved." But by the time he echoed that wish in 1965, the artistic stance of mechanized detachment had become fashionable. It was strongly associated with Andy Warhol, who in the intervening time had famously stated, "The reason I'm painting this way is that I want to be a machine, and I feel that whatever I do and do machine-like is what I want to do." That is, as Bradford Collins recognized, Warhol "was not only expressing his commitment to American industry, he was revealing what had given that commitment its singular shape: the honest desire to be freed from the troublesome baggage of the human heart."[36] Independently, Smithson's move toward impersonal procedures and mechanized forms also served to desensitize his art from its emotional and personal sources. And in announcing his identification with machines in the context of a group show of thirty-five artists selected by the prominent O'Doherty, Smithson reiterated his new, fashionably cool persona.

In the future Smithson will hint at his process: "Contrary to affirmations of [an identifiable] nature, art is inclined to semblances and masks, it flourishes on discrepancy."[37] Just as when speaking to McDarrah about his Castellane show that opened on All Saints' Day he had introduced the topic of religion only to state that he had moved away from it, he had identified the film after which he had titled his construction but denied having viewed it. In doing so, he drew the reader's attention to the film but defended against the convergence of its concluding wisecrack about funerals and his own funereal allusions. The contradictions suggest ambivalence

about being known on an intimate level—he indirectly states his issues in enticing "semblances and masks," hinting at conflicts so as to potentially receive consolation, but defensively denies the meaningfulness of his utterance, like his work, seeking to remain "impenetrable, unrevealing—forever hidden." Despite, or maybe because of, the discrepancy, his art will flourish.

The month before American Express's *Art '65* opened, Smithson's "struggle to get into another realm" as he later put it in his oral history, was eased by Dan Graham's inclusion of him—along with established artists like Arman and the up-and-coming Charles Ginnever, Judd, and others—in Graham's timely group show, *Plastics*.[38] In his pre-artist identity, Graham was the director of the John Daniels Gallery on Madison at Sixty-Fourth Street. Smithson presented a wall-hung construction of plastic panels on wood edged in aluminum. Similar to *Quick Millions*, it consists of a central vertical corrugated panel, this one chartreuse, bordered by vertical teal bands and jade-green left- and right-angle scalene triangles.

Two years earlier Smithson had written to Lester of his new paintings, "in plastic paint (acrylic polymer emulsion) which give stunning surface, some of the titles are *Flash, Blaze, Avalanche, Aries* (3 panels)." (Holt's astrological sun sign is Aries.) "They have an optical effect that is at once dazzling and remote" (February 22, 1962, #19). That is, the material conveyed both sensory spectacle and the emotional containment Lester preferred. His subsequent constructions of plastic sheeting intensified both of those qualities: the bright-green corrugation screamed Pop vivacity, while the lack of evidence of the artist's touch and the aluminum stripping that framed it muted it toward Minimalism. They exemplify a description of Kenneth Anger's film *Scorpio Rising* that Smithson will quote the next year: "the ultimate reduction of ultimate experience to brilliant chromatic surface; Thanatos in chrome—artificial death."[39]

For his debut with young New York sculptors ahead of him professionally, his attitude was insinuated. Not only did he color his piece green, a hue idiomatically associated with being a novice, envy, or fertility, but he titled it *Fling* (1965), intimating an unrestrained pursuit of desires or a trial escapade (Plate 25). The extent to which Smithson was successful in concealing his expressionistic/religious history from vanguard downtown artists was evidenced years later by Graham's belief that Smithson "came out of Pop art. . . . It seemed to me then that he was trying to do everybody. . . . It was also his personality, which was of somebody who was trying too hard."[40] Nevertheless, his seduction worked: *Fling* enticed Graham to give Smithson a date for a solo show at John Daniels in the fall, which was canceled

when the gallery ceased operations in early summer. In return, in the future Smithson introduced Graham to Mel Bochner and to Dale McConathy, an editor they both wrote for at *Harper's Bazaar.*

In *Plastics,* Smithson showed with LeWitt and connected with Judd, both then in nascent stature as artists of reductive geometries. Each would be instrumental to Smithson's professional growth, and in lesser ways he would be helpful to theirs. Judd additionally published exhibition reviews in the art magazines, giving him an edge in recognition among art world connections and modeling a route for Smithson. Opportunity came a few months later when Judd asked Smithson to write on his work for a brochure accompanying Judd's participation in *7 Sculptors* at the Institute of Contemporary Art, Philadelphia, the same place where Smithson had exhibited *The Eliminator* concurrent with *Plastics.*

Like him, Judd had spent his high school years in New Jersey and studied at the Art Students League. But Judd was senior to him by a decade and had earned a BA from Columbia College (1952)—in philosophy. The importance to Smithson of this very first writing commission, and his difficulty organizing his thoughts, are indicated by the number of handwritten and typed drafts of his essay among his papers in the Archives of American Art. In microfilm it spans ninety-eight frames (pages or portions of pages, and how many others were discarded in the writing process?) for an essay ultimately consisting of eight paragraphs. In it, Smithson provided deadpan analyses of Judd's fabrication procedures and spatial form interspersed with suave flights of associations in which his personal attitudes break through his "automated" artist persona:

> Instead of bringing Christ down from the cross, the way the painters of the Renaissance, Baroque and Mannerist periods did in their many versions of The Deposition, Judd has brought space down into an abstract world of mineral forms. He is involved in what could be called, "The Deposition of Infinite Space." Time has many anthropomorphic representations, such as Father Time, but space has none. . . . Space is *nothing,* yet we all have a kind of vague faith in it. What seems so solid and final in Judd's work is at the same time elusive and brittle.

The conventional function of an exhibition catalogue essay is to provide not only the reader with background information but the artist with acclamation. Smithson's account of Judd's work is intellectually clever but so ambivalent—holding only a "kind of vague faith" in Judd's desacralization of "infinite space" to the banal materiality and profane materialism of "pink plexiglas"—that he verges on revealing himself as an infidel of

Modernism.[41] His own conflicts about transitioning from personal expressiveness to materialist abstraction are evident. *He* has brought Christ down from the many crucifixes he painted him on. For his career, he banished him underground (*Christ in Limbo*, 1961), then depicted him not at all. "An abstract world of mineral forms" is exactly where he himself is heading with his own sculpture, which he seems to fear will be, like Judd's, emotionally "brittle."

"With Judd," Smithson declared, "there is no confusion between the anthropomorphic and the abstract. . . . The 'unconscious' has no place in his art. His crystalline state of mind is far removed from the organic floods of 'action painting.' "[42] Damning with faint praise, Smithson appears to be lauding the purity of Judd's work but implies that the clarity derives from rigidity, without productive ambiguities between figuration and abstraction or the stimulation of emotional flooding.

His distinction between solidity and flow is an acerbic application of that made in *Crystals: Their Role in Nature and Science*, which he owned, between "two types of solid substance, the crystalline and the amorphous ('without form') characteristic of glass. . . . Glass has the kind of internal structure found in liquids, in which the particles are disordered."[43] As Smithson noted, this "confusion" did not pertain to Judd. His prior work was not beset by uninhibited expressiveness; his "specific objects"—the title of Judd's influential 1965 essay that described an androgyne art form that was "neither painting nor sculpture"—were both formally and emotionally astringent.[44] It was Smithson himself whose turn to plastic planarity, and soon to crystal-like configurations of cubes, served the double goal of being on trend and suppressing the emotional floods that formerly had surged into his painting.

Previously, he had described that conflict as an issue of "proportion." Shortly before going to Rome, he wrote Lester: "Many artists are so infested with demons their souls are all or almost atomized into abstract hells. They refuse to seek for the invisible *proportions* and so they fall into the pit of despair." In contrast to "breakdown or distortion," he wrote, the " 'Fearful symmetry' that Blake speaks about in his poem *Tyger* is what I mean by *proportion*" (undated [June 1961], #12). And more than a decade later the struggle continued; in late 1971 or 1972 he wrote, "Between violence and calm is lucid understanding and perception. What goes on between the raging flood and the peaceful pond? I hope to make that an aspect of the film on *Broken Circle* and *Spiral Hill*."[45]

Smithson's acts of attribution to Judd of his own issues exemplify what Carl Jung described as a projection of one's own "shadow" or "dark aspects of the personality" that, beneath conscious control, "changes the world into the replica of one's own unknown face."[46] For him, the symmetry he

sought was the mental equilibrium between hyperproductivity and inhibitory withdrawal into rumination and depression. Smithson's attribution to Judd of proportion as an act of emotional containment was a projection of his own use of it as an antidote to his apprehension, as he put it, of "falling into the pit of despair." Balance—"proportion"—remained elusive.

Also, by describing the roseate hue of Judd's translucent Plexiglas box as "pink," he associated it with girliness, emasculating the plastic's rectilinearity (and Judd's testosterone self-presentation). But his drawing with the pseudo-geologically faceted pink plastic center (1964) displays his own center as a feminized plastic rectangle, and erupting from the chthonic recesses of his own *Buried Angel* (1962) is pink effluent. As he titled another 1962 painting, of a nude male above a string of as-yet-undeciphered pink letters, *he* was *Master of the Pink Word*[47] (Figure 6.7; plate 15). He must have been conscious that his own imagery exposes his ambiguous sexuality, and wanted that aspect of himself to be known, just as we would all like our authentic selves to be seen and loved.

A few months later Smithson produced a spinoff of the Judd essay for *Harper's Bazaar*. For an artist seeking to be considered kindred to the recondite sculptors he was then concurrently exhibiting with in *Primary Structures* at the Jewish Museum, Manhattan, his affiliation with a legacy fashion magazine was quirky. In doing so, he accepted the publishing opportunity, remuneration, and large circulation offered by Holt's boss in her position as part-time assistant to Dale McConathy, a poet who was the fashion magazine's literary editor. It suggests both a willingness to take a professional risk of frivolousness and an ambition to play his art career both ways: to seek to be one of the guys producing the austere constructions that would come to be known as Minimalism—few women did so—and yet to distinguish himself as a writer who mixed intellectuality and populism.

Adopting a casual voice, Smithson recounted anecdotally how he, Judd, and their "wives," Nancy—not identified as magazine staff—and Julie (a future *Harper's Bazaar* employee), had ventured to New Jersey quarries, a story presumably appealing to fashionista rockhounds. Describing their excursion to the "mineral-rich quarries of the First Watchung Mountain," Smithson noted the nearby "highways [that] crisscross through the towns and become man-made geological networks of concrete. . . . The entire landscape has a mineral presence."[48]

For his article's title "The Crystal Land," Smithson tacitly—he did not mention J. G. Ballard—adapted that of the acclaimed New Wave science fiction author's then-recent publication of his fourth and breakthrough novel,

FIGURE 6.3. The jacket of the cloth edition of J. G. Ballard, *The Crystal World* (1966), shows a detail of Max Ernst, *The Eye of Silence* (1943–44). Courtesy Rick McGrath.

The Crystal World (1966). It would establish Ballard's reputation as a writer of extraordinary powers of imagination and description. But at the time Ballard wasn't yet well known. For the few who got the connection, Smithson displayed an unconventional taste in literature. One of art dealer John Weber's strongest memories of him is that they would "hang out together and go to many, many, many science fiction movies in [the then very, very, very tawdry] Times Square."[49] In the future, Smithson would promote his connection to science fiction through quotations prominently placed in epigraphs of articles and commentary. His books relating to science fiction numbered a little over a third of the those associated with religion. But due to his prominent references in his essay's epigraphs and quotations, he has been much more associated with the former, stimulating critical analysis of his relation to that genre of literature. His attraction to what in the 1960s was considered a cheap thrill—tales easily available in racks of slender

paperbacks that fit into a purse or the back pocket of jeans—mixed in his essays an outré edge of popular diversion with references to literary and scientific titans to swing both high and low.

For everyone else, altering Ballard's title to "The Crystal Land" emphasized Smithson's professional affiliation with crystalline form then on view in *Primary Structures* in his sculpture *Cryosphere*. And the essay insinuated a shift in his interests from the structure of discrete *crystals* to that of the disorder of desolate *land*. His description of the "Crystal Land's" "moon"-like quarry where, "On the top of a promontory stood a motionless rock drill against the blank which was the sky" in turn foreshadows his essay statement, "Pumps coated with black stickiness rusted in the corrosive salt air," when he described the site of what would become his *Spiral Jetty* (1970).[50]

Those enticed to read Ballard's *The Crystal World* will find a physician of unstated nationality who specializes in the treatment of leprosy narrating a visit to friends working in a small outpost in the interior of Africa. As the roadways are blocked, he takes a boat upriver and discovers a strange forest where a leprosy-like virus is progressively crystallizing the entire environment. Flora, fauna, objects, buildings, and nonmoving humans are immobilized in an exoskeleton of gloriously hued prismatic facets.

Smithson's description of the New Jersey quarry also emphasizes a rich geological apocalypse, but his response is less wondrous than dolorous:

> Cracked, broken, shattered, the walls [of the quarry] threatened to come crashing down. Fragmentation, corrosion, decomposition, disintegration, rock creep, debris slides, mud flow, avalanche were everywhere in evidence. . . . Fractures and faults spilled forth sediment, crushed conglomerates, eroded debris and sandstone. It was an arid region, bleached and dry.[51]

His sensory vividness displays his inspiration by more than Ballard's title, as the British novelist's writing is characteristically crystalline in its literary precision yet imagistically lush. As scholar Haim Finkelstein astutely observed, "Similarly to Smithson, Ballard too conceives the external landscape as a 'mental map' of psychic reality. The mechanism involved is not that of projection but the perception of a quality of the landscape that appears connected with a certain innate quality of his character's mind."[52]

As Smithson had already applied the metaphor of the crystal when discussing Judd's work the prior year, before *Crystal World* was published, it is likely that his crystal reference derived from Ballard's preceding story published two years earlier. Ballard had elaborated it into *Crystal World* by adding a few tangential characters, a couple of romantic liaisons, more

scientific/mystical description, and a different ending. Otherwise, the plot and many descriptions are quite similar: in the earlier version, while investigating a phantasmagoric mutation sweeping over the Florida Everglades, the narrator found shards of crystalline glass accruing to roadways, cars, and houses, entombing every nonmoving object into chromoluminescent stasis. He "entered an enchanted world, the Spanish moss investing the great oaks with brilliant jeweled trellises" and encountered—and became for a time himself—the story title's "Illuminated Man."[53]

Crystallization was a clever if imprecise analogy to Judd's angular sculptures. Ballard's narrative of immobilization by crystallization applies more directly to Smithson's containment of "organic" fervor in faceted constructions in the exhibitions curated by Graham and O'Doherty. Some of the planes are reflective like mirrors akin to Ballard's prismatic reflected light. But an efficient account of the numerous correspondences between Ballard's "Illuminated Man" and Smithson's life and work requires that they be itemized:

- The story's references to the "Andromeda spiral," a body of water's "curious roseate sheen," and "bars of livid yellow and carmine light [that] bled away across the surface of the water" prefigure Smithson's siting of *Spiral Jetty* at the Great Salt Lake's Rozel Point, below which the cove's microscopic algae and bacteria tint the water roseate.
- Ballard's "a brilliant glow of light poured down upon the altar" would be adapted in Smithson's account of the site of his *Spiral Jetty* as "the sun poured down its crushing light."
- Ballard's "hanging mirrors of the Spanish moss" precede the mirrors Smithson hung between boughs of his *Dead Tree* for the exhibition *Prospect '69* at the Düsseldorf Kunsthalle.
- Ballard's "double constellations" and "Hubble bubble, double trouble" foreshadow Smithson's future play with duality as "sites" and "nonsites" and with mirrors.

Smithson's appropriations of science fiction varied between the explicit, bolstering public appreciation of his sculpture, and the allusive, insinuating private issues. When in another essay he noted that "the idea of the 'megalith' appears in several of Ballard's science-fiction stories," he was embellishing the reductive geometric structures, including his own, in *Primary Structures* with an eccentric literary analogy.[54] Likewise, he quoted from Ballard's story "The Terminal Beach" (1964) regarding a labyrinth of two thousand "concrete monsters . . . each a perfect cube fifteen feet in height, regularly spaced at ten-yard intervals."[55] Ballard's description remarkably paralleled the format of arrays of Minimalist cubes that one would walk

between and around, experientially comprehending their size and mass in relation to one's own and the immediate environment. He noted that in "'The Waiting Grounds,' we find many references to codes that are 'chiselled' onto the 'five stone rectangles.'"[56] Undoubtedly, just as appealing as the codes was the act of encoding; Smithson himself was using astrological, numerological, and alchemical ones. His references to Ballard serve equally as a cue to readers about himself.

In Ballard's *Crystal World* is a town with "more than a passing resemblance to purgatory," the zone of sorrowful atonement that Smithson pictured in his 1959 painting *Purgatory* (Plate 8) and that sounds like the "typical abysses" and "abandoned set of futures" he will later attribute to his hometown, Passaic. For both Ballard and Smithson, the attraction of geological brokenness seemed to be akin to the Romantic one of the power of ruins to call up melancholic reverie. In *The Crystal World* the "spectacle" of terrestrial fragmentation

> turned the keys of memory, and a thousand images of childhood, forgotten for nearly forty years, filled his mind, recalling the paradisal world when everything seemed illuminated by that prismatic light described so exactly by Wordsworth in his recollections of childhood. The magical shore in front of him seemed to glow like that brief spring.[57]

So beyond the echoing descriptions between "The Illuminated Man" and Smithson's imagery, the more significant resounding is "the organ reverberating among the trees." Lost in the bewitched forest, the protagonist found his way out after entering

> a small church in a clearing, its gilt spire fused to the surrounding trees . . . above me, refracted by the stained glass windows, a brilliant glow of light poured down upon the altar. . . . Prismatic colors pouring through the stained glass windows whose original scriptural scenes had been transformed into painting of bewildering abstract beauty. . . . [The priest stated] "The body of Christ is with us everywhere here—in each prism and rainbow, in the ten thousand faces of the sun. . . . So you see, I fear that the church, like its symbol"—here he pointed to the cross—"may have outlived its function."[58]

The priest's assessment could apply to Smithson, for whom the crucifixion, personally resonant, had "outlived" its potential to get him art world traction. He turned to the dominant format of the day, secular abstract

sculpture. In his interview years later for the Archives of American Art, Smithson described that process: "The real breakthrough came once I was able to overcome, I would say, this lurking pagan religious anthropomorphism. I was able to get into crystalline structures in terms of structures of matter and that sort of thing."[59]

Yet that opposition is not in the Ballard stories and neither it is in Smithson's work. The priest does not declare an abandonment of a sense of the sacred, but expresses doubt that the cross can symbolize it. Instead, the priest displaces reverence onto nature. The crystal world remains a Christological universe. The forest church is the source of the narrator's salvation. In *The Crystal World*, clutching its altar's heavily jeweled cross that the priest had "pressed" into his arms, the protagonist ventured forth to exit the forest. As he leaned toward the "gold cross set with rubies and emeralds, immediately the sheath [of crystals constricting his body] slipped and dissolved like a melting sleeve of ice."[60] (In both stories, gemstones, described as made of extreme concentrations of light, serve to dissolve crystallization.) By this, he was released from the carapace of rationality into a mystical radiance.

The revelation was compensation, *The Illuminated Man* divulges: "Since the death of my wife and three-year-old daughter in a car accident ten years earlier I had deliberately repressed such feelings, and the vivid magical shore before us seemed to glow like the brief spring in my marriage."[61] Ballard's wife had died the year of its publication, 1964, leaving him to raise their three children. Of the Ballard stories Smithson cited, in "Terminal Beach" Ballard's bereaved protagonist, alone on an atoll, recurrently sees "the spectres of his wife and [six-year-old] son [both had been killed in a motor accident] standing on the opposite bank [and] was sure they were beckoning to him." He finds a photograph of an unknown six-year-old girl (an amalgam of the two) and "pinned the page to the wall and for days gazed at it through his reveries."[62] Later, he discovers a corpse who states, "That son you mourn . . . every parent in the world mourns the lost sons and daughters of their past childhoods. . . . Your son and my nieces are fixed in our minds forever, their identities as certain as the stars."[63] On his way to finding safe haven, *Crystal World*'s protagonist held the bejeweled cross over a crystallized child, bringing it back to life. If only Smithson's crystalline constructions could do that.

Both Ballard and Smithson were mavericks attracted to paradox. In Ballard's stories of terrestrial crystallization, Smithson found an obsession with an absent deceased that uncannily paralleled his own. Like Ballard, drawn to "auroral gloom" and "mournful wrecks," Smithson believed "wreckage is often more interesting than structure."[64] Ballard was another guide toward Smithson's better entrance.

FIGURE 7.1. Artist Rosemarie Castoro took this time-delay Polaroid picture of herself and fellow artists gathered at her SoHo loft on January 31, 1969. They are, from left, Lawrence Weiner, Richard Long, Alice Weiner, Rosemarie Castoro, Sol LeWitt, Robert Smithson, Carl Andre (Castoro's husband), Jan Dibbets, Susan Weiner, Mary Valentine, David Novros, and two unidentified friends. Long was in town from England and Dibbets from the Netherlands. Along with Smithson, LeWitt, and others they were on the way to Ithaca to make work on site for the Cornell University *Earth Art* show organized by Willoughby Sharp. Courtesy and copyright the Estate of Rosemarie Castoro and Thaddaeus Ropac London/Paris/Salzburg/Seoul.

7

Locked Within

Language "covers" rather than "discovers"
its sites and situations.

W hen I had my first solo show, in 1966," recalled Brian O'Doherty, the curator of the American Express World's Fair pavilion, a critic, and an artist, "Bob called me up and said that my *Portrait of Duchamp*, which was an electrocardiogram, was a demonstration of entropy. I just said, 'Yes, Bob, whatever you say.' He was a fierce debater, and I wouldn't engage with him, so he just hung up." O'Doherty dodged Smithson's bite. But while he didn't want to wrestle with him himself, he invited Smithson to speak on the panel discussion he was moderating in June 1966 for the Yale University's School of Art and Architecture Alumni Day Convocation.

At twenty-eight, Smithson had not had a solo exhibition for three and a half years, a long lack in an ambitious young artist's career. Nor at the time of the invitations, either for spring 1966 exhibitions or to speak at Yale, had he yet published in an art magazine; the *Artforum* piece on entropy appeared in June. So why did O'Doherty ask him to participate on the upcoming Yale University panel discussion titled "Shaping the Environment: The Artist and the City"? "Bob always had a great rap, a utopian, sci-fi rap. Felt that lots was at stake. [On the panel] his major theme was entropy, akin to his article then out."[1] Smithson distinguished himself by freewheeling

references swinging between science and science fiction, the humanities and popular culture, the high and the low.

Smithson's verbal adroitness brought fortuitous networking; relationships propel a career's—a life's—turns (forward and backward). As longtime friend Lorraine Harner recalled:

> He talked to me about seeing this person, going to openings, the structure of art world, who got into what galleries. He went to parties and gave parties. He understood at that point that it was a social world and that you had to be in it if you wanted to be successful. That was very important, so he had a variety of different relationships with people, gallery owners, artists. . . . It wasn't just all about whatever creative ideas were in his mind. He understood that art in New York flourished within that community. You might not like all in the community, but you had to move within that community in certain ways in order to be recognized and continue your art. It became clear to me that the social world was quite significant to becoming successful.[2]

In the early 1960s, Smithson had been friendly with Edward Avedisian; Alice Neel recalled the two artists' constant presence together at her gallery openings, resulting in her request to depict Smithson, her "wolf boy" (Plate 16).[3] Avedisian, whom he met through the gallerist Richard Bellamy, introduced Smithson to his summer next-door neighbor at Provincetown, Peter Hutchinson. In Manhattan, Hutchinson and Smithson frequented movie theaters together and became good friends; later, Hutchinson wrote that Smithson's "strong personality" was the model for protagonist Darwin Smith in his story "The Art Dictator."[4] Hutchinson brought Smithson to the attention of O'Doherty. In his role as gallerist, Dan Graham recalled, "It took me a while to be convinced [of Smithson's work]. Bob had somebody on his side; if I remember, it was Brian O'Doherty."[5] That connection got Smithson included in Graham's *Plastics* show at the John Daniels Gallery in spring 1965. O'Doherty invited both Hutchinson and Smithson to participate in the *Less Known and Unknown Painters* exhibition he organized for the American Express Pavilion at the World's Fair, for spring through early fall 1965.

In the Yale audience on June 17, 1966, was alumnus (BFA, 1933) Walter Prokosch (1911–1991), an architect with Tippetts–Abbett–McCarthy–Stratton (hereafter TAMS). The architectural and engineering firm was well regarded for its work on airports; Prokosch had designed the Pan-American

Terminal at Idlewild Airport (renamed John F. Kennedy International Airport in 1963). Smithson recalled "discussing the whole city in terms of crystalline network."[6] That corresponded to ideas that TAMS architects and engineers were developing for an airport design of modular segments that could be duplicated and added on to like a Tinkertoy (or now, Lego) set.[7] The firm was planning to apply that concept in their proposed design for the Dallas Fort Worth Airport, which was to encompass the largest land area of any commercial airport in the United States to date.

In going outside its own disciplines of architecture and engineering or the relevant one of landscape architecture for a consultant drawn from contemporary art, TAMS was remarkably progressive. This arrangement began a year before the founding of the National Endowment for the Arts Art in Public Places program in the spring of 1967, which would eventually encourage early incorporation of an artist's participation in overall design and site planning. And the interest of TAMS in Smithson was uncannily apt. Smithson's study of geology, his thinking about "new monuments" and "art and the city," his appreciation for the futuristic explorations of science fiction, and his ability to imagine wide-ranging connections among these, made him an ideal contributor to the project's development. Eleven days later Prokosch visited Smithson and asked if he could, in Smithson's words, "supply some of the same kind of speculations about an airport that he was involved in planning."[8] He could: Smithson's fantastical imagination, typifying the "great rap" that O'Doherty noted and the "rhetoric" that art historian Irving Sandler recounted of him as "at times zany, but always brilliant and passionate," made him an appealing conversationalist, writer, and consultant.[9]

Smithson's own understanding of himself was that from his youth, "I had a good oral sense; I liked to talk."[10] Recall that his high school classmate Judi Den Herder remembered Smithson as "quiet."[11] That divergence may have been because, as he put it about school, "I grew rather hostile to the whole public school situation."[12] A decade later, he had things to say: an armature of wide reading provided both ideas to speak about and models of fluent verbalization. President Kennedy's use of reversed figures of speech, as in the chiasmus of his iconic inaugural declaration, "Ask not what your country can do for you—ask what you can do for your country," modeled for Smithson his own nimble tossing of provocative inversions such as his description of "primary structures" as "They are not built for the ages, but rather against the ages" and his declarations, "There is nothing more tentative than established order" and "Nothing is more corruptible than truth."[13] A book he owned, *Dark Conceit: The Making of Allegory*, may have offered tips on verbal impact: "In satire, irony is the chief instrument of the writer's critical aims; and these are continually being brought to the surface in

FIGURE 7.2. Max's Kansas City, 213 Park Avenue South, circa summer 1972, and, on his way in, Ronald Bladen. Bladen's three ten-foot slanting boxes, *Untitled* (1965–66), were illustrated above Smithson's "Entropy and the New Monuments" *Artforum* text and in 1969 were acquired by the Museum of Modern Art. Courtesy Loretta Howard Gallery for the Ronald Bladen Estate.

a figure of speech or an inversion of terms that emphasizes by deliberate distortion."[14]

Smithson performed his acerbic provocations most regularly in alcohol-fueled debates at Max's Kansas City at Park Avenue South and East Eighteenth Street. Max's opened in December 1965 just as Smithson's second career was lifting off, and it quickly became a hub of overlapping spheres of those now dubbed "creatives." Brice Marden, nine months younger than Smithson, stated, "I can't emphasize enough how important Max's was to an artist's development and the formation of the art scene. John Chamberlain [eleven years older, and part of an earlier generation of established artists] would talk with you." That is, conversation at the bar crossed ages and styles. "And Micky Ruskin [the owner] let you trade art for meals!"[15]

Artist Chuck Close recounted that Max's had

one of the great jukeboxes of all time. Essentially depending upon your faction of this pluralist art world located where you sat at Max's. The back room underneath the [Dan] Flavin sculpture, which cast an eerie green glow [was where] Warhol and those people held court. . . . The front tables and the banquettes near the bar

with the big Chamberlain [sculpture]—Richard Serra, and Robert Smithson, and Mel Bochner, and Dorothea Rockburne and a few other people would regularly hold court up front. There were some wonderful, passionate arguments essentially calling into question every aspect of someone's work. It was in a way a kind of extension of the kind of thing that went on in graduate school in which you were forced to defend your position.[16]

"Last Call at Max's," a history of this hangout popular among downtown artists, models, photographers, musicians, and their cohorts, recounts that "almost every night from eleven or twelve o'clock until closing," a particular table was

> Robert Smithson's territory. . . . LeWitt remembers, "Smithson was the real catalyst. He had a way of provoking people, of provoking discussion. It was very important because it forced people to defend themselves and to qualify their own ideas." Apparently, [Carl] Andre and Smithson disagreed about almost everything, sometimes loudly, but their discussions effected the sharpening of ideas and were never dull or stupid, two things Smithson could never forgive.[17]

Smithson himself seems to have not been forgiven by another regular observer at Max's, server Cathy Drew: "I didn't judge people by their art, I judged them as people, and Smithson was always difficult to wait on, never left a decent tip, and was usually morose."[18]

Smithson and Serra were very close, seeing each other and talking several times a week. They pushed each other, with a rivalrous bond nourishing to both. To others invited to their table the friendliness could turn fearsome.[19] Critic Peter Schjeldahl divulged:

> Smithson in person intimidated me, and I resented it. I would see him at his front table in Max's and reflect defensively that there was something seedy and dubious—something reminiscent of the guys in high school who carried slide rules—about him, with his bad skin, glasses, and nervous smirk. He would be talking and talking, and I never went near enough to hear the words.[20]

A regular at Smithson's table, Mel Bochner, recalled:

> Bob was a formidable debater. An autodidact and polymath, he was in command of a prodigious range of sources. Wickedly, brutally,

bitterly, laugh-out-loud funny, he could turn any situation, any discussion, upside down with a withering aside, punctuating it one of his darkly perverse chuckles.[21]

But for Virginia Dwan, who recounted his frequent visits to the gallery to chat, "His oceanic [speaking] style could set one adrift in his sea of ruminations."[22]

One subject these artists, mostly sculptors and mainly men, seemed averse to discussing as a source of their art was personal feelings. Such introspective admissions do not appear in interviews with artists in the 1960s and '70s, presumably not having been elicited by the interviewer, volunteered by the interviewee, or remaining after editing, as if—in any case—considered irrelevant to the work and the artist's increasingly professionalized art world position.[23] In his published interviews, Smithson only referred to his brother, and then in passing, in his 1972 interview with the Archives of American Art. The disparity between the number of his coded references to Harold in his visual and verbal creations and his sparse acknowledgment to others of Harold's importance to him parallels a pivotal statement in a story by an author well represented in his book collection, Jorge Luis Borges. A character in "The Garden of Forking Paths" asks, " 'In a guessing game to which the answer is chess, which word is the only one prohibited?' I thought for a moment and then replied: 'The word is *chess*.' 'Precisely.' " The manuscript after which Borges's story is titled is described as a kind of literary labyrinth,

> an enormous guessing game, or parable, in which the subject is time. The rules of the game forbid the use of the word itself. To eliminate a word completely, to refer to it by means of inept phrases and obvious paraphrases, is perhaps the best way of drawing attention to it. . . . I can state categorically that not once has the word *time* been used in the whole book.[24]

The maneuver appears more recently in the Harry Potter novels, where characters refuse to utter the name of the archvillain Voldemort, referring to him as "He Who Must Not Be Named." Nor, in Smithson's interviews and writings does Smithson name the huge influence on his life, Harold, but refers to him by tantalizing allusion.

Smithson's inhibition about sharing biographical information derived from two sources. One was personal: the numerousness of his coded references to Harold's death suggests that during his upbringing the family's

FIGURE 7.3. "Locked in." The first eleven lines of Smithson's fifty-five-line incantation "From the Walls of Dis," 1961. Robert Smithson and Nancy Holt Papers, 1905–1987, bulk 1952–1987. Archives of American Art, Smithsonian Institution. Copyright Holt/Smithson Foundation / Licensed by Artists Rights Society, New York.

loss had not been openly acknowledged, sufficiently discussed, psychically integrated, and put to rest. His incantation "From the Walls of Dis" (1961) indicates this. From that lowest region of hell, *Dis*, the region where the violent and bestial, hypocrites, and betrayers are confined, the speaker is "Trapped in death . . . Locked within . . . Mortar of perpetual woe."[25] The "woe" was so innate that a decade later he repeated himself, remarking, "No matter how irregular we think we are or how free and infinite we think we are, we end up locked in."[26] Precisely because it was suppressed, it was "perpetual."

Unresolved by his parents—his sole references to a maternal figure as Maria Dolorosa and Maria Desolata suggest his mother's ongoing melancholy—through intergenerational transmission of trauma, her "desolata" became his ("Iconography of") "desolation." He pictured that self in *Monolith of Desolation* (1961). A monolith has a uniform, massive, or inflexible quality; it is impenetrable. This one, erect and broad against a black background, is gray with gray markings: hatch marks, encircled dots, curving lines, squiggles. Yet its top section, with the suggestion of an eye, has a gaping mouth like that in two versions of his devouring *Death Taking Life*

FIGURE 7.4. Robert Smithson, *Monolith of Desolation,* 1961. Oil/canvas, 61⅜ × 34⅛ inches (156 × 94.4 cm).

Collection of Ikeda Gallery, Japan. Copyright Holt/Smithson Foundation / Licensed by Artists Rights Society, New York.

(Plate 6) here as if a formidable but impenetrable character.

The lack of resolution of the family's loss not only prompted Smithson to take that on; it also provided a model of reticence about it. Eli Levin recalled that during their high school years Smithson invited him to visit his family home during his parents' absence and confided that they had had a child prior to Smithson's birth "whose namesake Bob was." Levin's misremembering of the predecessor's name suggests that Smithson otherwise implied a close affiliation with the lost brother. Their friend and fellow artist Kathryn MacDonald recalls Smithson telling her about having had a brother who died before he was born, but very tersely, as if it was both something as a good friend she would need to know about him, a very important aspect of his being, but at the same time not something he could or wanted to talk about.[27] In an essay of private musing unpublished in his lifetime Smithson powerfully metaphorized constructions such as his *Mirrored Ziggurat*: "The 'visual' memories of something terrible are buried under pressure in my tiers of glass sheet."[28] It is as if the gravity on that pyramidal stack—the pressure of family burying "something terrible" in the act of mirroring—produced tears.

Concurrently, Smithson's avoidance of discussing personal issues was "buried under [the] pressure" of changing social ethos in the worlds of art and culture. In his influential 1952 assessment, "The American Action Painters," Harold Rosenberg had proclaimed, "A painting that is an act is inseparable from the biography of the artist."[29] The self-mythologizing urge was epitomized by Jackson Pollock's famously blunt retort to the venerable Hans Hofmann's advocacy in the mid-1940s to paint from nature, declaring of himself, "*I* am nature." By the late 1950s among advanced artists in

FIGURE 7.5. Robert Smithson, *Sketch for Mirrored Ziggurat,* circa 1966. Ink/paper, 11 × 8¼ inches (28 × 21 cm). Robert Smithson and Nancy Holt Papers, 1905–1987. Archives of American Art, Smithsonian Institution. Copyright Holt/Smithson Foundation / Licensed by Artists Rights Society, New York.

New York City, a reaction in the general culture against the embrace in the 1950s of Freudian ideas and psychoanalysis was underway. In the art world, younger artists differentiated themselves from both the social realism of the 1930s and the Surrealist-inspired wartime generation, inverting the image of the artist as an expressive visionary inspired by one's preconscious into a coolly professional constructor following a more positivist ethos. Both personal introspection, either as a source of works of art or shared in conversation, and poetic ambiguity, were scorned.

Advanced culture's rejection of what came to be caricatured as a kind of disinhibited expressivity and exclusive focus on the creator's emotional state had been articulated early in the 1960s by the inventive composer and Zen practitioner John Cage. In the 1950s, during stints at Black Mountain College in North Carolina and other interactions, Cage influenced the development of young innovators such as Robert Rauschenberg and Jasper Johns. Pointedly titling his 1961 book *Silence,* Cage wrote:

> Those involved with the composition of experimental music find ways and means to remove themselves from the activities of the sounds they make. Some employ chance operations derived from sources. Or, analogous to the Rorschach tests of personality, the

interpretation of imperfections in the paper upon which one is writing may provide a music free from one's memory and imagination.[30]

Two years later, a paper analyzing the avant-garde's change to "radical empiricism" approvingly quoted Cage as an inspiration: "'Man is no longer to be the measure of all things, the center of the universe.' 'Art cannot be a form of communication.' The new aesthetic employs random, indeterminate procedures; 'like nature, art should simply present.'"[31]

By the mid-1960s the model of the advanced artist had shifted to what could serve as the iconic statement of the evacuation of interiority—in addition to Warhol's identification with the machine—Johns's assertion, "I am interested in things that suggest the world rather than suggest personality."[32] Retrospectively, the art historian Alexander Alberro emphasized "[Donald] Judd's antitranscendental skepticism and neopositivism. . . . His elimination of all poetic recourse, of drama, of transcendental investment from the work of art was an important step in the process toward the dismantling of subjectivity from the world itself."[33] The artist's intentionality, consciousness, or subconscious—sources of personal subjectivity, as well as biographical history—had lost credibility as a determinant of art forms. Medium-specific experimentation was emphasized, such as regarding sculpture, unadorned form, the materials as unprocessed matter, their handling, outsize scale, and the contingencies of site where the work was experienced.

Thus, in contrast to the autobiographical expressiveness of Smithson's overwrought crucifixion imagery and his anguished "Iconography of Desolation" and "Lamentations of a Paroxysmal Artist," his outline for his 1966 Yale symposium talk conveys disdain for what was considered the self-indulgence of emotive, improvisational, and self-revelatory procedures: "Any kind of expressionism involves the pathetic remains of the self." His statement "The self is a fiction which many imagine to be real" echoes the psychologist's boast in Nigel Dennis's novel *Cards of Identity* about remaking character. Smithson's "There is at present a new esthetic emerging that does not have its origin in history or in the self-centered notions" corresponds to Wylie Sypher's analysis in *Loss of the Self in Modern Literature and Art*:

The importance of recent painting and literature is [that] both suggest that we must no longer confuse humanism with romantic individuality or with an anthropomorphic view that put the self at the center of things. . . . Any surviving humanism must be based upon a negative view of the self, if not a cancellation of the self.[34]

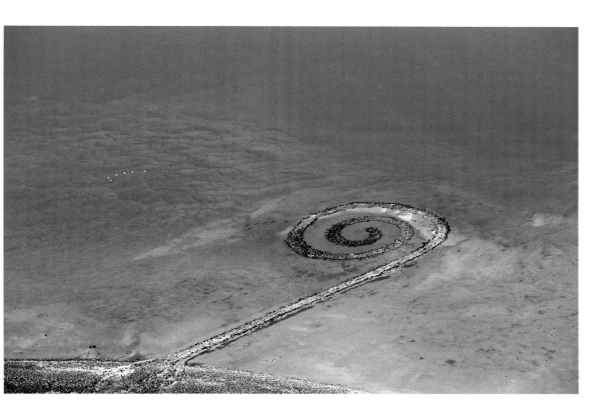

PLATE 1. Robert Smithson, *Spiral Jetty,* 1970. Great Salt Lake, Utah. 1,500 ft. (457.2 m) long and 15 ft. (4.6 m) wide. Photograph courtesy and copyright Steve Durtschi. Collection Dia Art Foundation. Artwork copyright Holt/Smithson Foundation and Dia Art Foundation / Licensed by Artists Rights Society, New York.

Steve Durtschi, Utah pilot and geologist, captured rapturous beauty in *The Spiral Jetty from the Air* in May 2011. Note the shadow of the arc of pelicans to the left of the spiral. In 1996 Durtschi founded the Utah Back Country Pilots Association, dedicated to preserving Utah's remote recreation landing strips.

PLATE 2. Robert Smithson, *Eye of Blood*, 1960.
Collage and tempera on cardboard, 33 × 24 inches
(83.8 × 61 cm). Copyright Holt/Smithson Foundation /
Licensed by Artists Rights Society, New York.

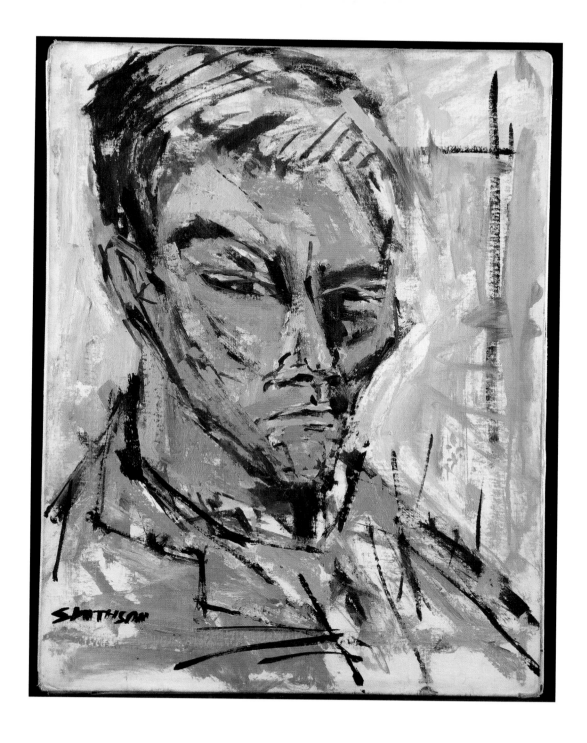

PLATE 3. Robert Smithson, *Self Portrait,* circa 1958. Oil/canvas, 24 × 18⅛ inches (61 × 46 cm).

Collection of the Utah Museum of Fine Arts at the University of Utah. Purchased with funds from the Phyllis Cannon Wattis Endowment Fund and the Paul L. and Phyllis C. Wattis Fund, conserved with funds from the Ann K. Stewart Docent and Volunteer Conservation Fund. Copyright Holt/Smithson Foundation / Licensed by Artists Rights Society, New York.

Smithson gave this grim portrait to friend Kathryn MacDonald, who more recently observed: "He was not kind to himself in it. He was much, much nicer looking" (conversation, August 26, 2021). The resemblance to Harold Smithson at the age of eight is notable (see Figure 2.2).

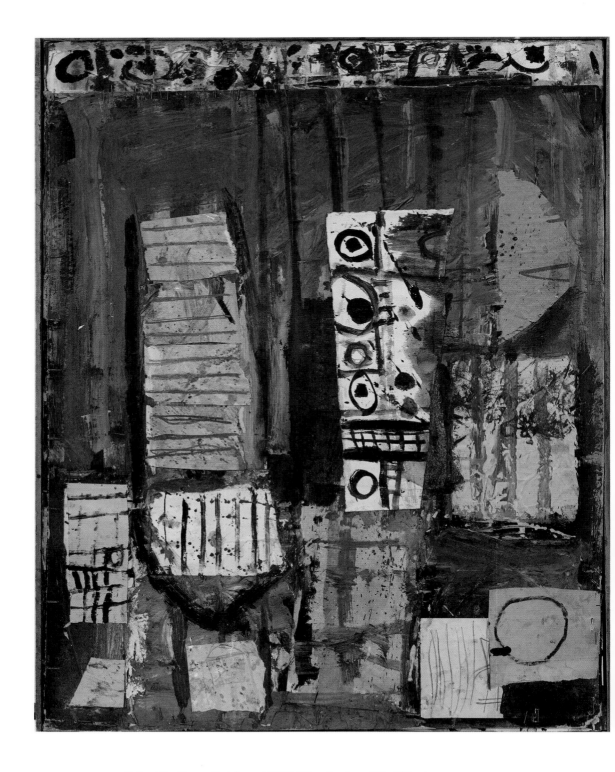

PLATE 4. Robert Smithson, *Quicksand,* 1959. Oil and collage, 28 × 22 inches (71.1 × 55.9 cm). Courtesy private collection, Devon, United Kingdom. Copyright Holt/Smithson Foundation / Licensed by Artists Rights Society, New York.

This is the painting that piqued George Lester's interest and sparked Smithson's development as a painter, even if in resistance to Lester's preference for nonfigurative abstraction.

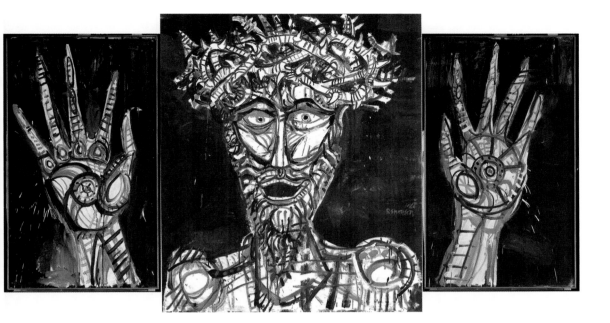

PLATE 5. Robert Smithson, *Man of Sorrow (The Forsaken)*.
Oil/canvas. The hands (1961) are each 45¼ × 25⅝ inches
(133.5 × 144 cm); the head (1960) is 52¾ × 45 inches
(133.7 × 114.2 cm). Courtesy photographer Daniel Root/The Root
Group. Hands: private collection, Devon, United Kingdom. Head:
Collection Ikeda Gallery, Japan. Copyright Holt/Smithson Foundation /
Licensed by Artists Rights Society, New York.

This illustration reunites panels that Smithson identified
in a letter to George Lester as a triptych and Lester later
sold separately.

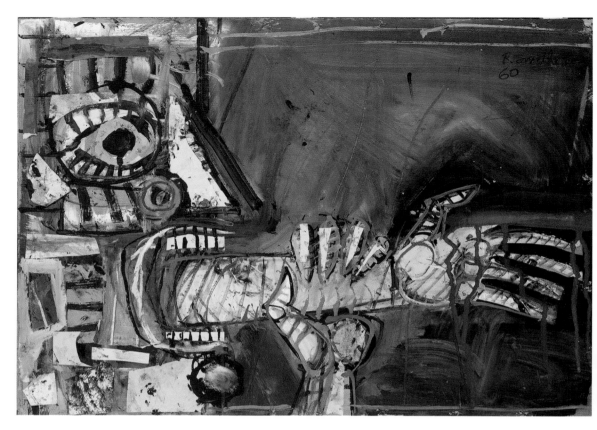

PLATE 6. Robert Smithson, *Untitled,* 1960. Collage and opaque watercolor/board, 21 × 29⅝ inches (53.3 × 74.6 cm). Whitney Museum of American Art, partial gift of Raymond Saroff and purchase, with funds from the Drawing Committee. Copyright Holt/Smithson Foundation / Licensed by Artists Rights Society, New York.

In his April 7, 1961, letter to George Lester, Smithson drew this work and identified it as *Death Taking Life* (see Figure 1.8). When it entered the collection of the Whitney Museum of American Art in 2006 it became, and remains to date, the only painting by Smithson in a New York City museum, albeit on paper.

PLATE 7. Warner Sallman, *Christ at Heart's Door,* 1942. Oil/canvas, 40 × 30 inches (101.6 × 76.2 cm). Jessie C. Wilson Galleries, Anderson University, South Carolina. Copyright Warner Christian Resources.

PLATE 8. Robert Smithson, *Purgatory,* 1959. Oil/canvas, 61⅝ × 67⁵⁄₁₆ inches (156.5 × 171 cm). Collection JPMorgan Chase. Copyright Holt/Smithson Foundation / Licensed by Artists Rights Society, New York.

PLATE 9. Matthias Grünewald, *Crucifixion,*
a panel from the *Isenheim Altarpiece,* circa 1515.
Limewood, 102⅜ × 255⅞ inches (260 × 650 cm)
Photograph: Erich Lessing/Art Resource, NY.

PLATE 10. Louise Élisabeth Vigée Le Brun,
Queen Marie Antoinette and Her Children, 1787.
Oil/canvas, 108¼ × 84⅝ inches (275 × 215 cm).
Especially before sanitary practices became
established, wealth did not shield infant
mortality. Musée national des Châteaux de Versailles
et de Trianon (MV 4520).

PLATE 11. Robert Smithson, *Alive in the Grave
of Machines,* 1961. Collage and tempera/paper,
23¾ × 13¾ inches (60.325 × 34.925 cm).
Private collection, New York. Photograph by Brandon
Wickenkamp; courtesy Andrea Rosen Gallery, New York.
Copyright Holt/Smithson Foundation / Licensed by Artists
Rights Society, New York.

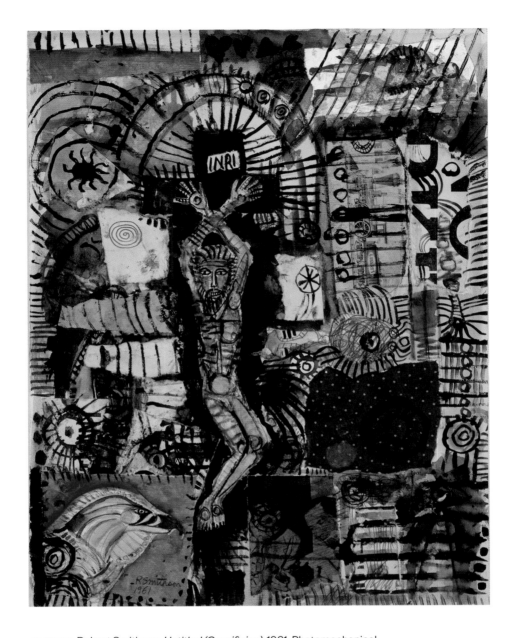

PLATE 12. Robert Smithson, *Untitled (Crucifixion)*, 1961. Photomechanical reproductions, watercolor, and ink/paper, 17¹³⁄₁₆ × 12¹¹⁄₁₆ inches (45.2 × 32.2 cm). Collection of the Hirshhorn Museum and Sculpture Garden, Smithsonian Institution. Gift of Theodore and Joan Wilentz, 2000. Photograph by Lee Stalsworth. Copyright Holt/Smithson Foundation / Licensed by Artists Rights Society, New York.

In his letter to George Lester of May 17, 1961, Smithson identified this as the first version of his *Creeping Jesus* (Plate 13). With its dense pattern of repeated lines, circled dots, oversized bird/monster head, crucifixion, scorpion, collage, spiral, and antique train, this image encompasses his work then and to come.

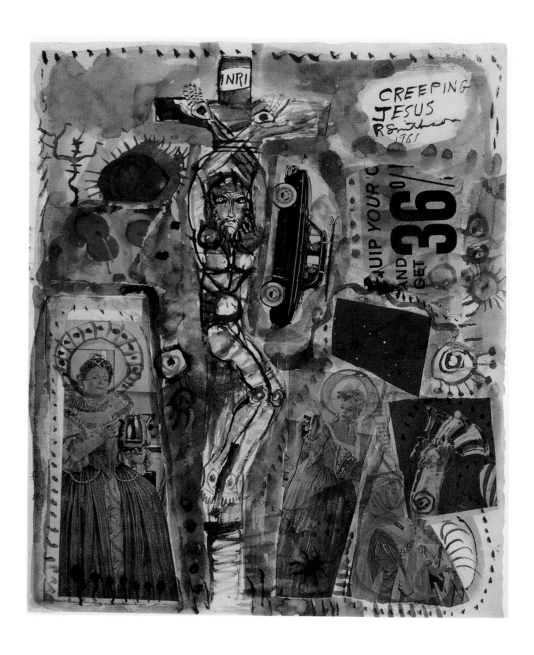

PLATE 13. Robert Smithson, *Creeping Jesus,* 1961.
Photo collage and gouache, 18 × 14 inches (45.7 × 35.6 cm).

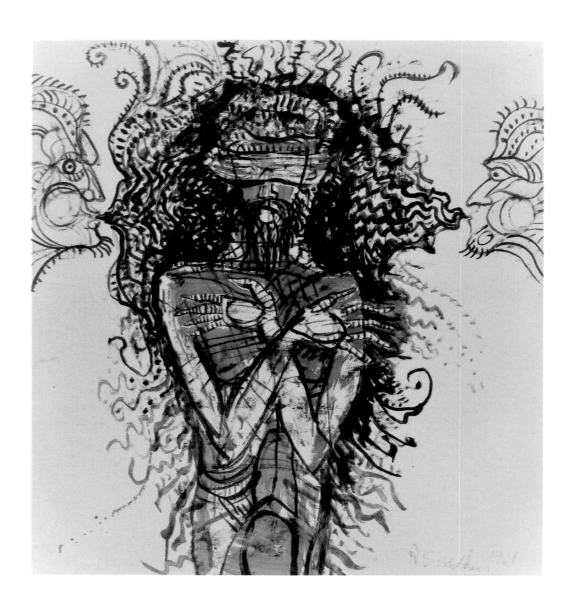

PLATE 14. Robert Smithson, *Jesus Mocked,* 1961. Oil/paper,
37½ × 35 inches (95.3 × 88.9 cm). Copyright Holt/Smithson
Foundation / Licensed by Artists Rights Society, New York.

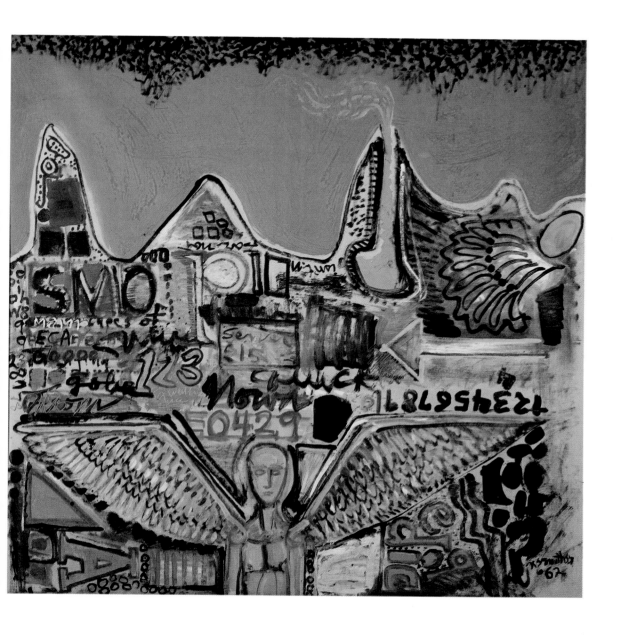

PLATE 15. Robert Smithson, *Buried Angel,* 1962.
Oil/canvas, 49¼ × 49¼ inches (125.1 × 125.1 cm).

Courtesy Collection of the Utah Museum of Fine Arts at the
University of Utah. Purchased with funds from The Phyllis Cannon
Wattis Endowment Fund. UMFA2008.11.1. Copyright Holt/Smithson
Foundation / Licensed by Artists Rights Society, New York.

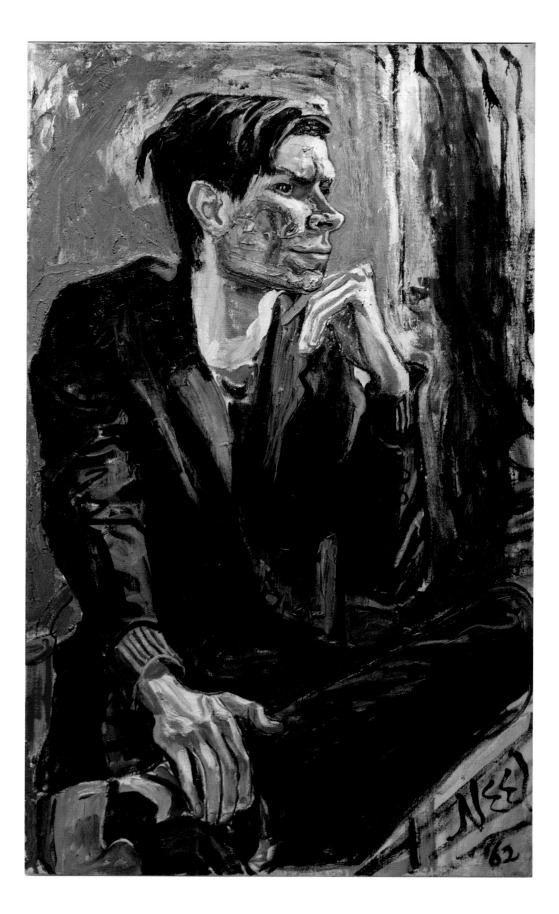

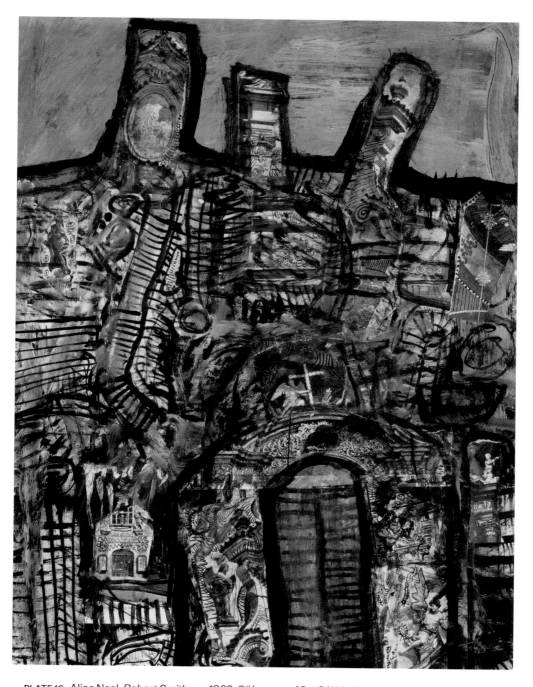

PLATE 16. Alice Neel, *Robert Smithson,* 1962. Oil/canvas, 40 × 24¼ inches
(101.6 × 61.6 cm). Smithson objected to her emphatic rendering of his acned cheek.

The Locks Foundation, Philadelphia. Copyright The Estate of Alice Neel. Courtesy The Estate of Alice Neel,
David Zwirner, and The Locks Foundation.

PLATE 17. Robert Smithson, *My House Is a Decayed House,* 1962. Gouache, ink, and
printed paper collage/paper, 24 × 18 inches (61 × 45.7 cm). Drawing Matter Collections,
Somerset, United Kingdom. Copyright Holt/Smithson Foundation / Licensed by Artists Rights Society, New York.

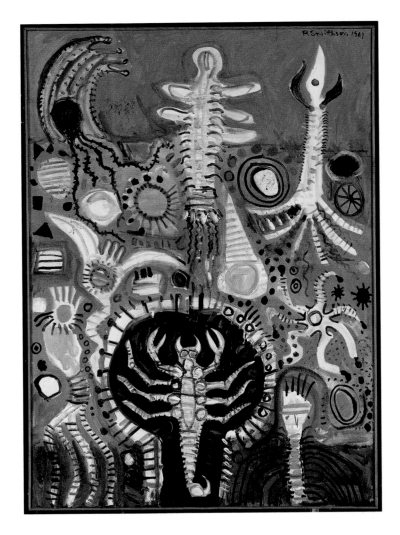

PLATE 18. Robert Smithson, *Scorpion Palace,* 1961. Oil/canvas, 52 × 37 inches (132.1 × 94 cm). Who is it that lives in this palatial underground? Courtesy Christie's Images Limited. Copyright Holt/Smithson Foundation / Licensed by Artists Rights Society, New York.

PLATE 19. On the cover of *The Message of the Stars,* by Max Heindel and Augusta Foss Heindel, a book instructing medical astrology first published in 1918, the Roman cross garlanded with roses and with trefoils at the ends of the post and arms is a Rosicrucian insignia, indicating the religious orientation of the book and its publisher, the Rosicrucian Fellowship. It exemplifies the frequent overlap in Smithson's book collection between astrology and Christianity.

PLATE 20. Robert Smithson, *Self-Less Portrait,* 1962.
Oil and paper collage/canvas, 30 × 25 inches (76.5 × 63.5 cm).
Count the number of items haloing this profile; the sum is
significant to Christianity. Copyright The National Museum of Art,
Architecture, and Design, Oslo. Photograph by Børre Høstland. Copyright
Holt/Smithson Foundation / Licensed by Artists Rights Society, New York.

PLATE 21. Robert Smithson, *Untitled,* 1963.
Collage, crayon, gouache/paper, 17¾ × 14 inches
(45.1 × 35.6 cm). Copyright Holt/Smithson Foundation /
Licensed by Artists Rights Society, New York.

PLATE 22. Robert Smithson, *The Machine Taking a Wife,*
1964. Plexiglas, machine parts, and photograph, 11 ×
40 × 4 inches (27.9 × 101.6 × 10.2 cm). Smithson made
this construction about a year after he wed. Copyright Holt/
Smithson Foundation / Licensed by Artists Rights Society, New York.

PLATE 23. Robert Smithson, *Death Taking Life,* 1961.
Oil/canvas, 37 × 58 inches (94 × 147.3 cm). Photograph by
Daniel Root / The Root Group. Private collection, New York. Copyright
Holt/Smithson Foundation / Licensed by Artists Rights Society, New York.

This is the third painting given this title by Smithson.

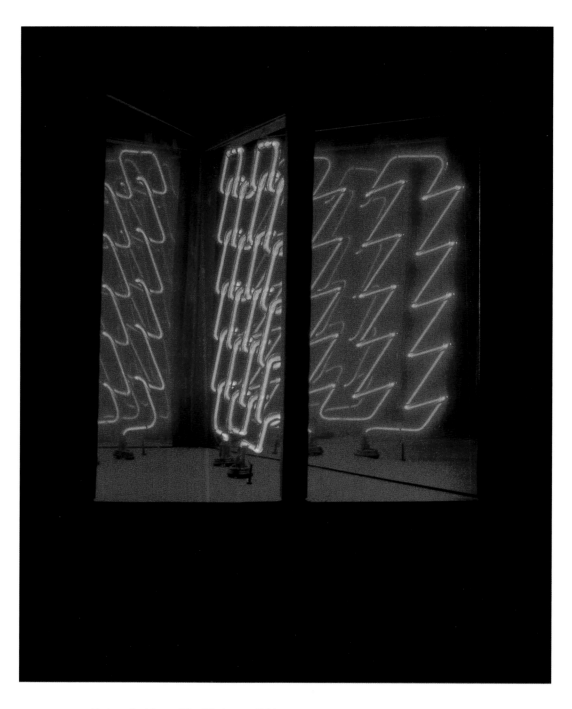

PLATE 24. Robert Smithson, *The Eliminator,* 1964 (possibly 1965). Steel, mirror, and neon, 20 × 20 × 28 inches (50.8 × 50.8 × 71.1 cm). Copyright Holt/Smithson Foundation / Licensed by Artists Rights Society, New York.

This photograph of the exhibition copy was made in 2004; the original, in the collection of Sylvio Perlstein, is too fragile to travel. In his statement regarding this work, Smithson described the neon as red not yellow; perhaps it faded, or the copy duplicated the discolored original.

PLATE 25. Robert Smithson, *Fling,* 1965. Plastic
panels/wood, aluminum stripping, 48 × 42 inches
(121.9 × 106.7 cm). As a sculptor, Smithson was
"green" when he made this, but his upward *Fling*
propelled him. Copyright Holt/Smithson Foundation /
Licensed by Artists Rights Society, New York.

PLATE 26. Robert Smithson, *Rocks and Mirror Square II,*
1971. Basalt rocks and mirrors, 14³⁄₁₆ × 86⅝ × 86⅝
inches (36 × 220 × 220 cm). National Gallery of Australia,
Canberra. Copyright Holt/Smithson Foundation / Licensed by Artists
Rights Society, New York.

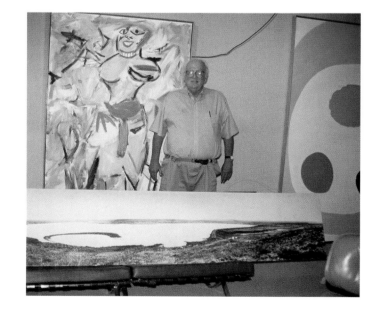

PLATE 27. Still from Robert Smithson, *Spiral Jetty,* 1970. 16 mm film, color, sound, duration 35 minutes. Copyright Holt/Smithson Foundation / Licensed by Artists Rights Society, New York. Distributed by Electronic Arts Intermix, New York.

Gorgosaurus at the American Museum of Natural History as photographed through a red filter.

PLATE 28. Stanley Marsh in his office, Amarillo, Texas, June 13, 2003. In front of him is a panoramic photograph by Wyatt McSpadden (photographer of Figure 14.4). Behind him are loose approximations of Willem de Kooning's *Woman with Bicycle* (1953) and Jules Olitski's *Ino Delight* (1962), which, he told me, he commissioned locally and passed off to visitors as originals (except to a visiting art historian). If you can't own it, fake it! Photograph by Suzaan Boettger.

PLATE 29. Robert Smithson, *Amarillo Ramp,* 1973. Tecovas Lake, Amarillo, Texas. Diameter 140 ft. (42.7 m). Height: Ground level to 15 ft. (4.6 m). Image courtesy and copyright Bryan Brumley. Earthwork copyright Holt/Smithson Foundation / Licensed by Artists Rights Society, New York.

Bryan Brumley, *Ramp from High,* 2016. This beautiful image showing the serpentine form of *Amarillo Ramp* was taken in September 2016 via drone from approximately 350 feet.

PLATE 30. Matthias Merian, Emblem XIV, "This is the dragon which devours its own tail" in Michael Maier, *Atalanta Fugiens* [*Atalanta Fleeing*], 1617, Oppenheim (Germany). Courtesy Lloyd Library, Cincinnati, Ohio.

Yet Smithson's writing is engaging because he cannot resist playing things both ways: going with the flow intellectually, but cunningly diverting it to his personal tributary. The conclusion of his outline for his Yale talk is characteristically ambiguous: "The problem is, that there is no problem."[35] He echoed philosopher Ludwig Wittgenstein's epigram 149: "The solution to the problem of life is seen in the vanishing of the problem."[36] Smithson appeared to corroborate the dominant attitude, paraphrased as: "the issue is, there is no interest in problematic personal conflicts." Yet his statement can also be taken as articulating a problem that is metaphysically paradoxical. It actually could be a problem that no conflict or difficulty could be worked out in art, because it reduces the art to being about itself or its relation to the material environment. That impersonality cuts off sources in conflicts either intimate or public and prevents viewers from knowing the artist more deeply as well as themselves for the issues it calls up. That is contrary to Smithson's way of working, dealing with issues by projecting them into coded imagery.

Promotion of an impersonal approach to making art prominently reached the art world audience in two influential essays by the literary critics Susan Sontag and Roland Barthes published in *Aspen*. Smithson would have attended to that Fall/Winter 1967 issue not only because that journal of advanced culture published authors he read, such as Samuel Beckett, William Burroughs, George Kubler, and Alain Robbe-Grillet. He personally knew the guest editor, Brian O'Doherty. And he would have been sensitive to that issue's publication because O'Doherty had deliberately omitted him from its contributors. He explained, "I did not include Bob in my *Aspen* issue because he had not included me in the two language shows he put together as Dwan summer exhibitions. He acknowledged that he understood that."[37] Well!

FIGURE 7.6. The self-effacing sobriety with which the artistic enterprise was viewed in New York in the mid-1960s is reflected in the manner in which *Aspen*'s Fall/Winter 1967 issue was presented. This boxed collection of commissioned projects includes Sol LeWitt's first artist book, an assemble-it-yourself sculptural multiple in miniature of *Smoke*, by Tony Smith; a recording of William S. Burroughs reading an excerpt from *Nova Express*; and texts by Roland Barthes, Samuel Beckett, George Kubler, Max Neuhaus, Alain Robbe-Grillet, Susan Sontag, and others, in all, nineteen printed components, one film reel, and five flexi-discs, with illustrations in black and white.

In O'Doherty's issue of *Aspen*, Sontag's "The Aesthetics of Silence" articulated the new spirit of emotional containment and scientistic investigation of space. That attitude had been coalescing around constructions such as Frank Stella's bright stripes forcing out illusionism by mimicking the irregular perimeter of shaped canvases and Carl Andre's and Robert Morris's emphasis on site- and experience-specific phenomenological understanding. Rejecting what she set up as "the leading myth about art, that of the 'absoluteness' of the artist's activity," Sontag advocated

> denying that art is mere expression . . . the newer myth, ours, derived from a post-psychological conception of consciousness. . . . As the activity of the mystic must end in a via negative, a theology of God's absence, a craving for the cloud of unknowingness [a play on *The Cloud of Unknowingness*] . . . so art must tend toward anti-art, the elimination of the "subject" (the "object," the "image") . . . and the pursuit of silence.

Written at the height of Minimalism in visual art and the early years of its musical manifestations by composers Terry Riley, Steve Reich, and Philip Glass, Sontag's heralding of the act "to construct 'minimal' forms which seem to lack emotional resonance" as "vigorous, often tonic choices" positions it as a purgative of the perceived messy emotionality of the preceding Abstract Expressionism: "Behind the appeals for silence lies the wish for a perceptual and cultural clean slate." Beyond the evolution in artistic style, the desire was also born of the widespread craving in the 1960s for eradicating the old and promoting innovation. "Though no longer a confession, art is more than ever a deliverance, an exercise in asceticism . . . for confronting the art work in a more conscious, conceptual way. . . . Art is certainly now, mainly, a form of thinking."[38]

In the same issue of *Aspen*, Barthes exaggerated that diminution of the artistic persona by provocatively titling his own essay "Death of the Author." Like Sontag, he opposed an overemphasis in interpretation on the creator's personal subjectivity. "Though the sway of the Author remains powerful . . . in France, Mallarme was doubtless the first to see . . . the necessity to substitute language itself for the person who until then had been supposed to be its owner."[39] The "person"—and personal—aspects of the author were "decentered" in favor of reading his or her text through—and as a manifestation of—language, its words and forms of which are contingent upon layered historical, social, and economic exigencies. Smithson spoke through historical forms most directly in his figurative expressionistic paintings and his incantations' adoption of early Christian prayer and song chants. But in all his work, he utilized predecessors' formats to convey

distinctive subjects derived from his *personal* history. The blanket emphasis on the driver of history as social—that is, shared—experience obscured the recognition of individuality, not to mention idiosyncrasy.

By 1972, artist and author Grégoire Müller summarized the attitude of "the new avant-garde": "Individual-centered philosophies became outdated and the intellectuals started to favor more analytical sciences such as anthropology, ethnology, or linguistics" and "Warhol has shown an almost heroic ambition by completely disconnecting the artist's inner feelings from the finished work."[40] A few years later, the art historian and critic Robert Pincus-Witten incisively encapsulated this position as the 1960s' and '70s' "high formalist cult of impersonality" in which "all personal reference, exposed personal reference that is, was covert in this machine of closed judgment. Privileged biographical details were omitted. This tone prevailed not only because formalist critics imposed apersonal, hermetic values on their writing, but because artists also insisted upon it."[41]

This attitude explains Smithson's many interviewers' absence of discussion of his personal connection to his metaphors of entropy as mortality and his own constraint in volunteering that information. To do otherwise would be to violate the code of behavior consistent with ambitious, scientistically conceptual artists and systematizing critics who were determined to reject in themselves what they viewed as the prior dominant style's effusive emotionalism and self-aggrandizing stance of heroic self-revelation. Instead, in 1971 when established as an earthworker and being interviewed by critic Kenneth Baker, Smithson echoed Johns by saying, "I don't subscribe to Surrealism because I'm concerned with a phenomenon that doesn't originate in my head, it originates in the world":

> Surrealism originates in the head, in dreams and nightmares and the subconscious. But I'm concerned with the physical remains of the actual world, and I draw my motives from that rather than from an interior kind of introverted exploration of internalized fantasy. The whole investigation is external; I'm not interested in dredging up my personal psychological situations.[42]

But even in these demurrals, his concern with "physical remains" displays that his "personal psychological situation" doesn't need dredging to bring up a cadaver.

Smithson's oral history taken by Paul Cummings for the Archives of American Art in July 1972 was the sole interview to seek a longitudinal inquiry into Smithson's life and work, thus to ask about his family history. In chapter 3, I considered Smithson's account of his childhood in that interview. In comparison to implied references to it in his art and writing,

his oral account demonstrates that he internalized those two sorts of constraints against psychological reflection: his family's and the art world's.

Regarding his professional trajectory, Smithson revised his point of entry, stating, "I began to function as a conscious artist around 1964–65. I think I started doing works then that were mature. I would say that prior to the 1964–65 period I was in a kind of groping, investigating period."[43] Designating his artistic career as beginning with his work as an intellectualizing sculptor, he swept away his more than eight years of professional activities—nine shows, five solo—between his 1956 group show in Armonk and the second at Castellane in 1962 and paintings and drawings through 1964, about which his letters to Lester make clear his deliberate desire to make a name for himself in the art world. In actuality, he was a more experienced painter in 1963 than he was a nascent sculptor in 1964, "groping" neon, mirrors, and Plexiglas to find a new artistic position.

Although he emphatically repeated twice the date of his professional origin, 1964–65, when interviewed the previous year he had given an even later start date: "The origins of my own consciousness go back to the site/nonsite situation which in a sense finds its synthesis in the Spiral Jetty."[44] He was so successful suppressing his first career as a painter that in his first posthumous major survey even Lucy Lippard, who knew him both professionally and personally, characterized his presence as "during the last eight years or so that he was in the art world."[45] That would be from 1965 forward.

Smithson dated his affiliation with "the whole New York School of painting" to something "I felt very much at home with . . . when I was in my late teens," consigning it to juvenilia.[46] Yet his 1962 "Iconography of Desolation" essay, completed when he was twenty-four, praised "Action painting" for its "unformed incarnations from a primordial animism lurking in a sacramental substance" and Pollock for having "restored something of the ritual life of art."[47] He described his 1959 show at the Artists' Gallery (he said he was nineteen; he was twenty-one) as growing out of Barnett Newman and Pollock's *She-Wolf* (both artists interested in primitivism but expressing it disparately) as if adopting Irving Sandler's assessment of his work as "monsters whelped by Surrealism and primitive art."[48] He explained his attraction to Pollock et al. as, "I was interested in this kind of archetypal gut situation that was based on kind of primordial needs and unconscious depths."[49] Emotional depths? The charged subjects and style of his paintings and drawings definitely evoke such sources. But his description of himself as a kind of Pollock manqué working out of his unconscious slights Pollock's thinking and is implausible for Smithson. His myriad pictorial and verbal metaphors contain too many biographical references for this extremely analytical artist not to be aware of the emotional issues implied by his figures of speech and images.

The interviewer, speaking for future researchers looking to this oral history for information, might have asked, what did his works of art depicting "primordial needs and unconscious depths" look like? Confronted with his subject's vaulting of ideas in abstruse verbiage, this timid interlocutor, perhaps reluctant to appear either clueless or pushy, did not ask him to restate that clearly or to describe the images literally. Smithson then discouraged elaboration with another diversion: "And the real breakthrough came once I was able to overcome this lurking pagan religious anthropomorphism."[50] His quartet of vivid descriptors—a precious example of obfuscation masked as intellectualizing—calls for exegesis of each of these terms.

Lurking? Hardly. His bloody Christs boldly revealed themselves.

Pagan? His introduction of that term served to throw his examiner off the scent of Christianity, which since the Counter-Reformation has shunned association with occult paganism. But here again Smithson swung both ways—being Christian, but also reading the occult, primarily alchemy and astrology. The latter might be associated with pagan polytheism, but in his case the books he owned confirmed his connection to Christianity. It is strongly interwoven in Jung's *Psyche & Symbol* and *Psychology and Alchemy*. E.M. Butler's *Ritual Magic* describes procedures invoking both spirits of the deceased and the spirit of God.[51] On the cover of *Message of the Stars*, the source of the horoscope data that Smithson copied about the young man's hemorrhagic death, between a lamp of knowledge and a Sacred Heart is a Rosicrucian-style budded Roman cross (Plate 19). That is, at the ends of the cross's post and arms are trefoils; their intersection is encircled by a garland of roses, one of the flowers associated with the Virgin (their redness signifies her Son's bloodened crucifixion). In the introduction to *Meditations on the Signs of the Zodiac*, which he owned, Beredene Jocelyn explained "the divinity of the Zodiac": "We need an enlarged—a cosmic—concept of the Christ, [who] became the Spirit of the Earth and the Lord of all the heavenly forces upon the Earth."[52]

Following his professional (re)birth when this chameleon supposedly shed such metaphysical affiliations, Smithson's interest in the occult did not cease. By their publication dates, Smithson had to have acquired *Meditations on the Signs of the Zodiac* (1966), *The Morning of the Magicians* (1968), and *The Origin of the Zodiac* (1969) years after his early putative purging of the pagan, during the period in which he was known as a highly conceptual sculptor, then earthworker. Actually, Smithson's affiliation with the pagan didn't *begin* until he published his 1969 account of visiting Mexico's Yucatán Peninsula, where the Mayan gods Tezcatlipoca, Itzpapalotl, Chalchiuhtlicue, and Coatlicue hardly had to lurk because Smithson ventriloquized them into life.

Religious? His practices, communication with the priest years after he

had instructed Holt and married them, his friends' knowledge of his Catholic affiliation, and the High Requiem Mass that Holt arranged for him upon his death, suggest he never ceased being a believer. But contrary to that, and to Lorraine Harner's, Eli Levin's, Kathryn MacDonald's, Alice Neel's, and Raymond Saroff's descriptions of having observed plentiful images of Christ in Smithson's studio, the word "Christ" does not appear in this oral history either as a subject of devotion or art.

Explaining his historical connection to Catholicism, Smithson noted, "I was very skeptical even through high school. In high school they thought I was a Communist and an atheist, which I was actually."[53] He also stated that at the time he painted *Quicksand*, 1959, at twenty-one, "I was actually interested in religion, you know, and archetypal things. . . . I guess I was always interested in origins and primordial beginnings, you know, the archetypal nature of things. And I guess this was always haunting me all the way through until about 1959 and 1960 when I got interested in Catholicism through T. S. Eliot and through that range of thinking."[54] His linkage of "origins," "haunting" and "Catholicism" is a significant nexus, implying the impetus for his crucifixion paintings as a haunting by his own origins. This is the high school "atheist" who in an incantation quoted part of the Mass, *"Ad deum qui laetificat juventutem meam"* ("To the God who gives joy to my youth").[55] And who had urged Lester, "Don't be afraid of the word 'religion.' The most sophisticated people in Manhattan are very much concerned with it" (May 17, 1961, #7). His statements in 1972 suggest his apprehension about revealing the actual extent of his affiliation with it. Yet when he described his letters to mining companies as "brass tacks instructions" that "have to make sense to people who don't know anything about art," he referred to them as "epistles," as if they were writings by a holy man sent to heathens.[56]

Of the more than one hundred books owned at the time of his death on the subject of religion or written from a distinctly Roman Catholic viewpoint, twenty-seven were published on or before the year of his 1956 high school graduation. And twenty-three were published in 1964 or later; *The Sources of the Doctrines of the Fall and Original Sin*, which he owned, came out in the politically, and for him professionally, pivotal year of 1968. We don't know when he read them, but it couldn't have been earlier than those publication years.

And his fourth descriptor of what he wants us to think he got beyond, anthropomorphism? His denigration of it corresponds to Sypher's use of the term for the attitude "of recent painting and literature . . . that we must no longer confuse humanism with romantic individuality or with an anthropomorphic view that put the self at the center of things."[57] Smithson's statements about anthropomorphism—"I had completely gotten rid of that problem" and "I got that out of my system, you might say"—are so absolute,

without mitigation, that they call up the process of defensive denial of any implication that his art expressed anthropomorphic—human—feelings.[58]

When Cummings asked about Smithson's interest in ritual, Smithson assented, and Holt—who was present throughout—interjected for the first and only time: "Also psychology, psychoanalysis."[59] That prompted Cummings's further inquiry, to which Smithson concurred with a terse "Yes" that he read the writings of Jung and Freud, then replied to Cummings's query that he had never gone into psychoanalysis. Smithson's repetitions of autobiographical/emotional issues in his creations, and projection of those onto others in his writing (Donald Judd) or commentary (Walter De Maria) suggest that he had not experienced psychotherapy's consciousness-raising. Cummings inquired, "Did they [Freud and Jung] answer questions for you?" Deftly deflecting this line of inquiry, Smithson turned his engagement with psychoanalysis from a desire for self-understanding to an intellectual investigation: "I think I got to understand, let's say, the mainspring, you know [long pause] of what European art was rooted in prior to the growth of Modernism."[60]

Thus refused personal disclosures, Cummings turned to asking about the Galleria George Lester exhibition. Smithson compressed his two dozen works on view to two exemplars painted two years before the show and broadened the subject matter with a literary gloss: "I did three paintings that I think were probably the best. They were sort of semi-abstractions based on a rough grid and roughly based on—one was called *The Inferno*, another was called *Purgatory*, another was called *Paradise*."[61] He had exhibited *Walls of Dis*, a site within *Inferno*, two years prior at the Artists' Gallery; it and *Purgatory* appeared on Lester's checklist. But not on any list or among known Smithson works is one relating to *Paradise*, which for him would be thematically aberrant, as demonstrated by his later remark to Cummings: "I never really could believe in any kind of redemptive situation."[62]

Customarily assumed to be the product of a collaboration between interlocutor and subject with the mutual goal of accurately representing a personal past, such research interviews are generally received as candid and credible. So Smithson's misrepresentations, inconsistencies, and inaccuracies about the previous fifteen years of his life, both explanatory and chronological, further itemized in this accompanying endnote, are confounding.[63] Here is an artist, seemingly in good health and analyzed art historically as being deeply engaged with history, who at thirty-four can't remember his own. Smithson disparaged "History [as] a facsimile of events held together by flimsy biographical information," which his own account of himself did little to buttress.[64] For someone who has jettisoned early works, masked his

professional history, and created a new artistic persona, this occasion seems to have given Smithson the opportunity to devise a normative but provocative autobiography for art historical consumption. Cummings aided him by repeatedly failing to seek clarification of Smithson's bewildering locutions, completing his sentences with words Smithson had to correct, cutting off his hesitant speech regarding emotionally sensitive topics, and nervously diverting the conversation to impersonal art world issues.[65]

This interview's chronological disparities and gnomic pronouncements make it less informative as an artist's chronology and thinking than as a performance of persona construction—and of the interviewer reduced to being his amanuensis. Or perhaps Smithson's recounting of, for example, implausible twists in his relationship to religion, should be enjoyed as tour de farce. He had already displayed an ability at parody by performing a dreamy New Age artist in the satirical 1969 video *East Coast/West Coast*, made in dialogue with Holt. His Archives of American Art interview served him not just as an opportunity to shape his art historical legacy but as a sly example of "institutional critique" *avant la lettre* of the subsequently popular exposure by artists of socially prejudicial institutional practices.

In actuality, Smithson's engagement with understanding and developing himself did not cease when it became unfashionable to project it into works of art or mention it to an interviewer. Consider how Smithson talked about the creative process in a conversation with Lippard and Holt less than a year after the Cummings interview. He knew it was being recorded, but as research for Lippard's book on their deceased mutual friend, Eva Hesse. So he did not expect that their dialogue would be published as information about him and spoke frankly. Of Hesse, Smithson stated, "I saw her as a very interior kind of person. I saw her really as making psychic models." That displays his awareness of artworks as condensations of psychological states and sensitive to projection, even though he didn't always appear aware of his own. He observed, "I think all perception is tainted with a kind of psychoanalytic reading. In other words, somebody who's having Oedipal problems, it's going to come out in the perception, or it's going to come out in the making, the kind of work they choose to do. I got into a sort of psychoanalysis of landscape perceptions in that Olmsted piece" (on Frederick Law Olmsted, the nineteenth-century landscape architect, journalist, and social critic).

Among these intimates and speaking with the confidence of a by-then established major artist, Smithson was self-revelatory, acknowledging what a close reading of his art's and writing's latent content indicates and contradicting his fashionable denials in the late sixties: "I've always been a kind of a psychoanalytic type. I don't think one can exclude that from the

actuality. In other words, I think decisions are made based on one's physio-psychological needs."[66]

Also, Smithson made his affiliation with Carl Jung's ideas clear. In his "entropy" essay, he promoted Jung as "providing many clues" about the *materia prima* and the "16th-century alchemist-philosopher-artist."[67] In *Psychology and Alchemy*, Jung stated the justification and the procedure for Smithson's evasions and implications:

> The alchemist is quite aware that he writes obscurely. He admits that he veils his meaning on purpose. . . . He makes a virtue of necessity by maintaining either that mystification is forced on him for one reason or another, or that he really wants to make the truth as plain as possible, but that he cannot proclaim aloud just what the [mystical/metaphysical goal of the] *prima materia* or the *lapis* is.[68]

This suggests that to explain the plethora of psychological allusions in his art and writing a distinction is needed between Smithson's disinclination to "dredge up" his personal psychology for others and his mining of them for his own self-understanding. In his library, volumes by the psychiatrists Sigmund Freud (three), Otto Rank (two), one each by Ludwig Binswanger and Rollo May, and titles such as *The Self in Psychotic Process: Its Symbolization in Schizophrenia* (John Weir Perry), *The Divided Self: An Existential Study in Sanity and Madness* (R. D. Laing), and *Psychology of Sex Relations* (Theodor Reik) display his extensive interest in the psyche and identity. His books on astrology show not only engagement with the nominal subject but a desire for self-knowledge. The full title of A. F. Seward's *The Zodiac and Its Mysteries* is *A Study of Planetary Influences upon the Physical, Mental, and Moral Nature of Mankind*. Walter Sampson's book is *The Zodiac: A Life Epitome, Being a Comparison of the Zodiacal Elements with Life-Principles; Cosmic, Anthropologic and Psychologic*.

In his memoir, Irving Sandler recalled Smithson's 1959 Artists' Gallery exhibition: "I reviewed his first show of extravagant expressionist pictures favorably. The centerpiece was a bizarre crucifixion [tactfully, Sandler had not mentioned it]. Bob would soon turn one-hundred-and-eighty degrees from that painting to a reductivist extreme." Then, parrying Smithson's claim to Cummings by then available in his *Collected Writings* of having expelled such impulses, Sandler noted, "Bob rejected Catholicism but never seemed to get it out of his system."[69] He tried. Or actually, he tried to make it appear so while telling us one of his maneuvers: "Language 'covers' rather than 'discovers' its sites and situations."[70]

FIGURE 8.1. Smithson in animated conversation on the Park Avenue penthouse terrace of art collectors and convivial hosts Barbara and Eugene Schwartz in July 1967.

Polaroid photograph by Barbara Schwartz. Courtesy and copyright Barbara Schwartz.

8

Transmuted

Rigid Paroxysms Set in a Row.

That spring of 1966, Smithson completed his transition to his professional identity as a cerebral sculptor with verbal agility. That year he and Holt began maintaining a calendar recording their commingling with figures in the art world famous (Robert Rauschenberg; Ad Reinhardt, Alfonso Ossorio), subsequently famous (almost everyone else, like them), or famous-adjacent and locally well known, such as the collectors Barbara and Eugene Schwartz, at whose Park Avenue penthouse Smithson and Holt attended dinner parties and viewed their collection of art by major postwar and soon-to-be major artists, including himself. That year Smithson displayed his renovated art form of multi-part geometric structures in influential exhibitions highlighting the new prominence of sculpture. And he spurred that ascendancy with provocative essays in the then-oracle of the art intelligentsia, *Artforum*. His previous years of creating art, viewing it, writing and conversing about it had prepared him to write for the "big time." Between 1964 and 1973 he would produce sixty-seven texts, thirty of which he saw published.[1] That number is remarkable for any writer, let alone one whose focus was devising art forms in a three-dimensional medium unfamiliar to him made in materials new to him fabricated by nonartists under his direction, while also prodigiously reading and making the scene in bars.

In his voluminous library, 1966 is the year of the greatest number of publications. That amplitude may be a chronological fluke or a bonanza year for book publishers; undoubtedly, he purchased some in ensuing years. Even so, the mass of books in his collection published in 1966, eighty-three—twelve more than published the previous year and four more than the next, sums much greater than the thirty-nine published in 1959 or the twenty-eight in 1972—suggests a parallel acceleration between professional ambition and book acquisition. He demanded of himself to be intellectually current and historically informed. Notable volumes he owned published in 1966 are Rudolf Arnheim, *Art and Visual Perception: A Psychology of the Creative Eye*; Gregory Battcock, *The New Art: A Critical Anthology*; György Kepes, *Module, Proportion, Symmetry, Rhythm*; Matila Ghyka, *The Geometry of Art and Life*, from the Catholic publishers Sheed & Ward; John Jocelyn's *Meditations on the Signs of the Zodiac*; Thomas Hess, *The Grand Eccentrics: Five Centuries of Artists Outside the Main Currents of Art History*; and Willard and Marguerite Beecher, *Beyond Success and Failure: Ways to Self-Reliance and Maturity*.

The title with the most strikingly Smithsonesque tenor published that year—or perhaps of any year among those in his collection—is *Nil: Episodes in the Literary Conquest of Void during the Nineteenth Century*. Scholar Robert Martin Adams offered the consoling impetus to creativity that "the experience of (physical) Nothing is the only path to the delights of an (imaginative) Everything." Smithson had indeed experienced the former, both in the professional void of the twenty-eight months without exhibitions and, before that, the personal sense suggested by the vacant profile of his *Selfless Portrait*. His evolving professional persona might have also been guided by Adams's analysis of the "rich repertoire of screens, masks, guises, and indirections" of novelists. But even more uncannily relevant is Adams's assertion that

> a first step in seizing the elusive and prickly spirit of [Edgar Allan] Poe is to distinguish that element of his mind which is ideological and *philosophe*, which asserts pugnacious dominion over the practical world, from that which is called "morbid" and "decadent" because it is impelled toward a darkness one major aspect of which is Nothingness.[2]

While the echo is not exact, Poe's mix of contentiousness, morbidity, and being "fascinated with death"—what Adams aptly terms "the last enigma"—calls up Smithson. For him, such rumination was productive; he recommended the reader "look up 'dirge' in the dictionary, it will give you

lots of ideas."[3] His paintings and incantations demonstrate that fundamental to his creativity was a lament for the dead; his art is expressive. Thus, his attraction to Adam's *Nil*.

Also, Adams's discussion of Poe's "fabrication of pseudo-scientific devices and procedures to overcome death" applies to Smithson's own 1961 paintings *Device for Removing the Death Rattle from Radios* and *Device for Removing the Death Rattle from Typewriters*. Adams's statement that Poe's "horizon is the very lip of the grave" applies to Smithson's numerous paintings of convoluted creatures, and often an encased figure, below high horizon lines. Adams's observation "A remarkable number of Poe's stories deal with the experience of falling or drowning or being buried" calls up Smithson's *Buried Angel* (1962), *Partially Buried Woodshed* (1970), and numerous self-reflexive references such as his description of "'characters' . . . not developed but rather buried under countless disguises."[4] *Nil* serves as a literary mirror of not just Poe but also Smithson.

Despite his scant history of exhibiting sculpture, in April and May Smithson was included in three topical group shows in Manhattan encompassing the art scene: *Primary Structures: Younger American and British Sculptors,* part of the then avant-garde exhibition program at the Jewish Museum; *Art in Process*, at the academic Finch College Museum; and *New Dimensions*, at the commercial A. M. Sachs Gallery. These, especially his participation in the Jewish Museum's survey of recent reductive geometrics, demonstrate his stylistic currentness. In that show, the form of his steel *Cryosphere* conformed with the plain geometric units presented by Carl Andre, Dan Flavin, Donald Judd, Sol LeWitt, Robert Morris, and Tony Smith. Their systems of oppositions—open and closed objects, cubic and vacant spaces—made them akin to linguistic Structuralism and elicited their initial designation as Structuralists. Their temperate containment of the emotive passions of the preceding "Action Painting" exemplified the direction Susan Sontag had recognized in 1964: "A great deal of today's art may be understood as motivated by a flight from interpretation."[5]

These sculptors were soon known as Minimalists, and their impersonal and increasingly anonymous industrially fabricated constructions shifted the source of meaning. Moving away from an artist's subjectivity projected into improvisational painting, the focus of Abstract Expressionism, the emphasis became an array of neutralized units and the viewer's mobile interaction around or within them, altering perceptions of the objects, one's own form, and ambient space. The change of attention outward, to the object's—and one's own body's—relation to the immediate

FIGURE 8.2. Robert Smithson, *The Cryosphere,* 1966 (right). Painted steel with chrome inserts, six units, each 17 × 17 inches (43.2 × 43.2 cm). Photograph: The Jewish Museum, New York / Art Resource, NY. Copyright Holt/Smithson Foundation / Licensed by Artists Rights Society, New York.

On the far wall: Judy Chicago (Gerowitz), Rainbow Pickett, *1965.*

environment, was described by Judd in what became a paradigmatic statement of the new form as "neither painting nor sculpture."[6] It was object plus site. Describing the new work as "specific objects," after which the article was titled, Judd declared, "The newest thing about it is its broad scale," and he described its form as "that which is open and extended, more or less environmental," that is, *spatially* environmental, physically extended, encompassing.[7]

Smithson's sculpture in *Primary Structures, Cryosphere,* consists of six identical metal units a uniform aqua blue hung parallel to the wall and spaced at eye level. Each is a thick hexagonal platform supporting six bars radiating from an open center; their square ends at both center and

circumference are mirrors. His title *Cryosphere* is the term for those portions of earth's surface where water is in solid form: glaciers, sea ice, ice caps. The work's hexagonal shape is that of water molecules lined up to form is a single crystal of ice. Yet the bulky structure resembles not so much a lacy snowflake as a wagon wheel. In effect, this work enacts what Smithson read in J.G. Ballard and attributed to Judd: immobilization by crystalline structure.

This structure's appearance of repressive constriction is intensified by the design's additional resemblance to the eighteenth-century panopticon, a penal structure conceived by the English social theorist Jeremy Bentham to enable a single watchman at the center to observe all inmates housed in radiating wings.[8] The rigorous geometricity and geological title of *Cryosphere* reiterated the message of Smithson's *Bio-Icons* and *Quick Millions* statements that his artistic persona was scientistic.

Displaying that, his text about *Cryosphere* in the exhibition catalogue is an explanation as list, at once mathematically straightforward and obliquely heretical. First, he listed a string of ones and zeros, relating to early computer programming, as the sequence for the placement of the modules: the number ones are visible modules, the single zeros on the ends are spaces, and the six double zeros in between represent what he considered invisible modules. Then, the sum of the surfaces on each visible module that are mirrored (one at each end of the six spokes, so twelve), multiplied by the number of modules, six, yields a total of seventy-two. Then the multiplication of each invisible module's mirrored surfaces, twelve, by the number of invisible modules, twelve, gave one hundred and forty-four. All this may appear to be a pointless emphasis on data, but there will be a point: the next assertion that "66⅔% of the entire work is invisible."[9] That could be taken simply as factual, accounting for all those "invisible" modules. Or it could be interpreted as likening this geometricized molecule of an ice crystal to the glaciers to which its title refers, whose structures from a terrestrial viewpoint are mostly below the water's surface, inaccessible to sight. But that also applies to the Freudian latent content of dreams, not directly perceptible, disguised.

The denouement is his penultimate statement before a final flat attribution of the company that made the paint—a swerve to a cheery exhortation: "Invent your sight as you look. Allow your eyes to become an invention." Contra Minimalists' empiricism, Smithson states that what is meaningful to this work is more than what is available to optical perception. And what is invisible to this work?

- In magical systems, six is considered a perfect number, as it is equal to the sum of its divisors (one plus two plus three).

- *Cryosphere*'s six radiants multiplied by six units equal thirty-six, Harold's death year, and which per numerology, the digits (three plus six) add to nine, Harold's age at death.

Returning to Smithson's list on his statement for this work, also totaling nine are:

- The sum of the digits of Smithson's seventy-two visible mirror surfaces (seven plus two);
- The one hundred and forty-four mirror surfaces he identified as invisible (one plus four plus four); and
- The six visible modules and twelve invisible ones (six plus one plus two).

Years later in his oral history, Smithson noted, "I guess I was always interested in origins and primordial beginnings, you know, the archetypal nature of things." That parallels what C.G. Jung called "primordial experience" (facilitated by alchemy, astrology, and religion) expressed covertly through mystical symbols developed among esoteric groups over centuries.[10] Smithson concluded that oral history statement with what could serve as an analysis of *Cryosphere*: "I was sort of interested I guess in a kind of iconic imagery that I felt was lurking or buried under a lot of abstractions at the time."[11] He both participated in and opened up the style or approach known as Minimalism.

His attention to the subliminal suggests that understanding *Cryosphere* requires more than one kind of crystal gazing. The crystal, Smithson would have known from his copy of E.M. Butler's *Ritual Magic*, is "the magical medium *par excellence*" and "the hypnotic effect of crystal-gazing is notorious." It is used by skryers (crystal gazers) for crystallomancy (divination by crystal gazing) along with "some short though fervent prayers"—his own incantations gave him a good supply along with the Catholic missal. Butler recounts sixteenth-century reports of seers crystal gazing to call up and see "spiritual creatures and hear their voices," enabling them to engage in "Diabolical questioning of the dead."[12]

Speaking of which, another underlying significance of crystals is provided in Charles Bunn's description of them in *Crystals: Their Role in Nature and Science* as enantiomorphic. One side mirrors the shape of the other, like a person's two hands. Yet also, Bunn notes, "the sort of symmetry found in crystals is more austere—more 'dead,' if you like—than the symmetry of a flower or a tree. . . . 'Dead' matter should show a cruder, more rigid type of symmetry than living organisms." In the crystal lurks a sign of mortality. Bunn notes that "the complete list of [crystals'] symmetry types consists of

six *systems*, whose names are based on the shape and symmetry of the *unit cell*." That may be another source of *Cryosphere*'s design of six spokes on each of the six units. Bunn continues: "The symphony of crystal shapes is in six movements, one of which . . . is really two movements telescoped into one."[13] Uncannily, that sounds like a replacement child's fears of parental expectations of a convergence of identities of prior and present child.

Beyond the rotaries' engineered rigidity, the rays of *Cryosphere*'s units call up a sundial, a wheel, and a circle. Smithson owned two books published the same year as his *Cryosphere* that focus on the circle. Bruno Munari's *Discovery of a Circle*, illustrating cross-cultural and -chronological examples, begins, "Since ancient times a simple circle has represented eternity, for it has neither beginning nor end."[14] The other book Smithson enthused about to Dennis Wheeler:

> I might recommend a very good book called the *Metamorphosis of the Circle* by Georges Poulet [essays on references to the circle in European literature from the Renaissance to the early twentieth century], which I find is very fascinating in terms of the idea of expansion and contraction; he traces a kind of structure running through practically all that.[15]

Circles are frequent in Smithson's paintings and collages, whether crucifixion wounds, leukemic encircled dots, automobile tires, or hubcaps. The following year, in his "Ultramoderne" essay, he will illustrate another circular mirrored disk. He could have read further about the form's symbolic meaning in Jung's *Psychology and Alchemy*:

> It is to be noted that the wheel is a favourite symbol in alchemy for the circulating process, the *circulatio*. By this is meant firstly the *ascensus* and *descensus* (God's descent to man and man's ascent to God), and secondly the rotation of the universe as a model for the [alchemical, spiritual] work, and hence the cycling of the year in which the work takes place. . . . The *opus* [the alchemist's mystical work] was often called *circulare* (circular) or else *rota* (the wheel). . . . The transforming substance is an analogy of the revolving universe, of the macrocosm, or a reflection of it imprinted in the heart of matter. Psychologically, it is a question of the revolving heavens being reflected in the unconscious, an *imago mundi* that was projected by the alchemist into his own *prima materia*.[16]

Such a suggestion of revolving transformation was exactly what Smithson was undergoing—literally, a disguised, under-the-radar-of-the-art-world

FIGURE 8.3. Mel Bochner, *Portrait of Robert Smithson,* 1966. Pen and ink on graph paper, 7⅝ × 6¾ inches (19.4 × 17.1 cm). In 2001, Bochner enacted "repetition" by duplicating this design in charcoal and pencil and larger, 31½ × 26 inches (80.5 × 66.5 cm).

Private collection. Courtesy Peter Freeman Inc.

process of transmutation, altering not his *prima materia* or artistic vocation but his professional appearance or persona.

Cryosphere's light-turquoise hue—his statement gave its commercial name, "surf green"—calls up summer garments and beach fun, a provocative contrast to the sober neutralities of the show's other works in metal, bricks, and plywood painted gray. The oddity of the aqua was probably understood as the color of the water—aquamarine—from which snowflakes are made. Reframing this structure as alchemically inflected, its color becomes a pun on *aqua permanens,* eternal water, one of the quaternity of elements, described in *Psychology and Alchemy* as "extracted from the stone [astrologer's

lapis, a materialization of the spiritual work]."[17] The aqua wheel becomes a symbol of an elemental transformation.

All of these sources of Smithson's choice of an ice crystal for his representative "primary structure" in the exhibition of that name could validate, for a follower of astrology, the influence of a sun sign's ruling planet. Smithson, a Capricorn, was born under Saturn, a planet believed to be "largely concerned with the crystallisations of the Mineral Kingdom."[18]

Cryosphere's layered associations, like alchemists' hermetic symbols and coded experimental procedures, are both aspects of its 66⅔% invisible sources of meaning, far outside the concerns of orthodox Minimalism. But with a friend's help (probably unintentional), Smithson convincingly made it appear that the intellectual coolness connoted by *Cryosphere*'s association with snow was his own mentality. The first page of Mel Bochner's review of the *Primary Structures* exhibition illustrated six views of one of the six units of Smithson's *Cryosphere*. Below, the epigraph by Alain Robbe-Grillet declared, "There is nothing behind these surfaces, no inside, no secret, no hidden motive."[19] Their juxtaposition makes Robbe-Grillet's assertion into a caption for Smithson's *Cryosphere*. Or more than that, a testimonial that Smithson was absolutely in tune with the new art's turn away from personal subjectivity.

Smithson may have provided Bochner with Robbe-Grillet's statement, as that spring he wrote an article, "The Pathetic Fallacy in Esthetics," in which he expressed affiliation with Robbe-Grillet's and Judd's "attacks" on what he called "the empathetic esthetic." His reductive antinomies—"Abstract art does not appeal to the emotions but to the mind. All expressive art is representational. . . . Abstract art is not a self-projection, it is indifferent to the self"—reversed his previous position to Lester advocating representational spiritual art over abstraction.[20] Similarly, Bochner describes the "primary structures" as "a provocative art . . . distant from the humanistic stammering of Abstract Expressionism."[21]

Bochner's review concludes with the statement that this New Art (capitalized) "deals with the surface of matter and avoids its 'heart.'" The description strikingly applies to Smithson's change of artistic procedure: ceasing his highly emotional former painting—from the heart—and stopping the heart's fluid, blood, in his work; displacing the heart of his subject matter, loss, onto works that appear bloodless—and yet eliciting examination by noting that "66⅔% of the entire work" is not accessible through observation. Then examination reveals that despite appearances, the subject matter was not at all heartless.

Peter Schjeldahl later observed about Smithson, "The spare, measured, nonsensuous style of his sculptures struck one as arbitrary in the face of the richness and quirky poetry of his ideas."[22] Smithson's consistent use

of metaphysical symbols evinces a much more complicated, conflicted, and richer subjectivity than would be admitted by a perspective girded by Minimalism and conceptualism. But they were not acknowledged by him or recognized by critics. That year, 1966, probably after his June "Primary Structures" article, Bochner made a *Portrait of Robert Smithson*. On graph paper, Bochner printed "repetition" across the top and below wrote synonyms or related meanings of that word seventy-seven times in two columns, duplicating or triplicating words seven times. He could be referring to the minimalist practice of serial constructions, but that wasn't particularly associated with Smithson; it was a characteristic of Minimalism as a whole. Rather, his theme appears to echo Dan Graham's account of Smithson's "personality, which was of someone trying too hard" and that he was "trying to do everybody," that is, his work was derivative.[23]

But there is another, undoubtedly unintended, allusion in Bochner's *Portrait*: six (the number so frequent in Smithson's *Cryosphere* of that year) lines span the two vertical blocks of text, forming a capital *H*. That, of course, is the first letter of the name of the person with whom Smithson had the ambiguous relation with concerning issues of repetition. As Bochner refused to speak with me about his *Portrait*, we'll set this conundrum aside.

In the same month that Bochner's piece was published, June 1966, Smithson debuted as both an author and a sculptor in *Artforum*. His "Entropy and the New Monuments" was illustrated with installation shots from *Primary Structures*, implying that his article was a response to it. But a month before the show opened, Smithson had sent it, unbidden, to editor in chief Philip Leider, who replied in a letter, "Your article got here this morning; I like it very much—it's full of so many impudent ideas. . . . If there is some chance of getting it into the June issue I will."[24] Smithson didn't discuss his own work in the show (his *Cryosphere* was illustrated); he didn't need to, as it headlined Bochner's article. Rather, by writing about the show in which he was exhibiting virtually the first three-dimensional minimalist sculpture he had made, he strongly inserted himself into that group of sculptors while demonstrating his professional ambidexterity.

As he had in his "Desolation" and "Lamentations" pieces, Smithson fronted his "Entropy" essay with a suggestive quotation. Smithson's epigraphs are particularly sly, embellishing the texts with implications. Readers who attend to them, and who are sufficiently beguiled to go to the cited source, discover that they offer uncanny cues to him and his life. (Notably, none quote women authors.)

FIGURE 8.4. Philip Leider, editor of *Artforum* from 1962 to 1971, in the office of *Artforum,* Los Angeles, 1967. In March 1966 Leider welcomed Smithson's article submission and edited it and four more. Courtesy Philip Leider.

For "Entropy," Smithson took from *The Time Stream,* a book he owned by John Taine, the pseudonym of the academic mathematician and science fiction author Eric Temple Bell:

> On rising to my feet, and peering across the green glow of the Desert, I perceived that the monument against which I had slept was but one of thousands. Before me stretched long parallel avenues, clear to the far horizon of similar broad, low pillars.

The series of shafts bear an obvious similarity to sculptures, particularly Ronald Bladen's tall boxes (leaning on a diagonal), *Untitled,* illustrated in *Artforum* just above the epigraph. The parallel between sculpture and science fiction displayed Smithson's literary cleverness. But nothing Smithson proffered is that transparently straightforward. The "illimitable wilderness of desolation" that Taine's characters experience when they are intermittently sucked into the stream that sweeps them backward in time parallels Smithson's own "iconography of desolation." In the paragraph following the one he quoted, a protagonist exclaims the joy of deciphering "the structure of that dead language in which the inscriptions were written [on the pillars]." Another character observes, "It's so much more interesting

to tease out other men's secret motives than it is to manufacture riddles whose answers one knows in advance."[25] That is what we're doing here! Both appreciations align with the appeal for Smithson of keeping motives secret, encryption, and understanding the dead. And just as the stories by Ballard that Smithson referred to mourned the loss of a child, in Taine's *Time Stream*, the son of a character was born following the first child's absorption into the time stream without return, becoming—as was Smithson himself—a successor.

All of those autobiographical affinities between Smithson and the story from which he chose to excerpt an epigraph are covert. In the essay itself, Smithson spoke in his new persona, a sober authorial voice ventriloquizing ascendant Minimalism's dispassion. At the same time, he distinguished himself by contrariness. Unlike conventional assessments, Smithson ascribed the new sculpture style's radical simplification to the format of boxes, planks, tiles, or bricks and not to an absence of the artist's touch and lack of referentiality, but to a positive "nullification." He didn't mention Adams's *Nil* but compared the sculptures to painter Kazimir Malevich's "non-objective world." The Russian Suprematist's Theosophy-inspired spiritual aspirations were little known then; Smithson applied the conventional reductive empirical/formalist spin as pure opticality:

> There are no more "likenesses of reality, no idealistic images" . . . a "City of the Future" . . . [which] is brought into focus by a strict condition of perception, rather than by any expressive or emotive means. . . . As action decreases, the clarity of such surface-structures increases. This is evident in art when all representations of action pass into oblivion.[26]

Years later Leider quoted those last sentences and condensed the period's attitude: "It is a world, in short, that is the shambles of the Cedar Street Bar [actually, "Tavern," Greenwich Village saloon and salon of the Abstract Expressionists], one in which 'action' painting is a kind of naive idiocy."[27] Articulating emerging artists' dismissal of emotive expressionism, Smithson did not acknowledge that that had been his own artistic language. Instead, he positioned himself as a serious analyst, likening the sculptures' look of hulking inertness to "what the physicist calls 'entropy' or 'energy drain'":

> In a rather roundabout way, many of the artists have provided a visible analog for the Second Law of Thermodynamics, which extrapolates the range of entropy by telling us energy is more easily

lost than obtained, and that in the ultimate future the whole universe will burn out and be transformed into an all-encompassing sameness.[28]

The second law of thermodynamics states that over time, things within closed systems lose energy and degrade to simpler states of inertness and uniformity. For example, when an antique grandfather clock is not wound, in the closed system of its cabinet its swinging pendulum will lose momentum and come to rest at the midpoint, exemplifying static equilibrium. Displaying the force of entropy, it loses organization and no longer keeps time. As Richard Schlegel explains in *The Voices of Time: A Cooperative Survey of Man's Views of Time as Expressed by the Sciences and by the Humanities*, owned by Smithson and published that year, "Changes in any isolated system always occur in a way such that the entropy of the system increases or, at the least, remains constant."[29]

Smithson's extrapolation of the effect to the "whole universe" derived not from scientific sources but from a book of humanities criticism he owned that had been published four years earlier. Without identifying the source as *Loss of the Self in Modern Literature and Art*, a title that was both too existential for current discourse and cut too close to Smithson's personal issues, he referred to "Wylie Sypher's insight that 'Entropy is evolution in reverse.'"[30] Sypher's own text prefaced that statement:

> In effect entropy is the tendency of an ordered universe to go over into a state of disorder. This is another way of saying that the behavior of things tends to become increasingly random, and in any system tending toward the random there is a loss of direction. . . . Entropy is a drift toward an unstructured state of equilibrium that is total.[31]

However, Sypher's projection of "unstructured state of equilibrium that is total" and then Smithson's "in the ultimate future the whole universe will . . . be transformed into an all-encompassing sameness" are conceptual exaggerations. Consider again the grandfather clock. If not regularly wound, the pendulum will stop swinging and will come to rest. But will the cessation of timekeeping bring the whole parlor into squalor? Rather, as above, scientists restricted the parameters of the process of entropy to *isolated*— that is, closed—systems. Delimited entities lack the contagion to generate "evolution in reverse." Sypher, and following him Smithson, asserted an extension that seemed reasonable at the time to nonscientists. But properly understood, thermodynamics applies to discrete systems but not to the

universe as a whole. As physicist Lee Smolin stated, "The law of increasing entropy does not apply to the biosphere, which is not an isolated system."[32]

Sypher claimed that "during the course of time entropy increases."[33] But Smolin notes:

> Look around. Either with the naked eye or through the most powerful telescope, we see a universe that is highly structured and complex. . . . Early on it was filled with a plasma in equilibrium; from that simplest of beginnings, it has evolved enormous complexity over a wide range of scales, from clusters of galaxies to biological molecules.[34]

In effect, the universe is experiencing reverse entropy, that is, negentropy. But as early as 1970 in a book Smithson owned Gene Youngblood recognized that "the phenomenon of man, or of biological life on earth taken as a process, is negentropic because its subsystems feed energy back into one another and thus are self-enriching, regenerative."[35] For example, the digestive process of converting food into energy is negentropic because foodstuffs have less order than the organs and tissues they feed—even as individuals' overall corporeal biosystems inevitably slow down and succumb to entropic decay. In the twenty-first century, increasing digital connectivity through diverse networked platforms has made our quotidian experience of life more complicated: more opportunities for communication, knowledge, and mobility, thus more stimulation, sources of distraction, bureaucratic administration, and surveillance—making time feel as if it is accelerating and our balancing of sources of information a demanding process.

Smithson's presentation of entropy as wholesale degradation not only exaggerated its effect; it also contradicted the social and cultural vitality of the United States in the early to mid-1960s: its low unemployment rate, absence of inflation, booming economy and bipartisan support for social programs, all of which facilitated the radicalization of youth culture; rapid proliferation of new forms of music, art, theater, dance, and fashion; and the flourishing of the civil rights and antiwar movements. Lucy Lippard reflected on the decade's optimistic social mood: "There was a *sense of possibility,* of rebellion against the looming authorities and institutions of the recent past, a desire for a kind of *tabula rasa* that would allow not just a new art style or movement, but new ways of conceiving of, experiencing, and distributing art."[36]

By contrast, Smithson's assertion that "instead of causing us to remember the past like the old monuments [as memorials], the new monuments seem to cause us to forget the future" bespeaks his characteristic fatalism.

His statement "Both past and future are placed into an objective present. This kind of time has little or no space; it is stationary and without movement, it is going nowhere" suggests that the past's presence overwhelms experience of the present, which is immobilized, akin to the frozen monumentality of *Cryosphere* in the show he was discussing.[37] Despite—or because of—those disjunctions, by prominently applying the esoteric scientific concept of entropy to an unquestioning—gullible—art audience, Smithson garnered intellectual cachet. His poetic wryness made him a fashionable contrarian, a coolly skeptical primary voice of "primary structures'" refusals of Pop Art culture's hedonism and of the social complacency such as that promoted the next year by the pop psychologist Thomas Anthony Harris in the wildly popular book *I'm OK—You're OK*.

Entropy became Smithson's signature intellectual trope—so much so that in 1968, when they traded works of art, artist Joseph Kosuth made for him a large photostat of its dictionary definition. It was hanging behind his and Holt's dining room table (adjacent to their living room with the mirrored ceiling) when John Perreault visited and Smithson ambiguously divulged, "The word entropy . . . is a mask for a lot of other issues . . . a mask that conceals a whole set of complete breakdowns and fractures." Typically for the period, the critic did not elaborate for readers the breakdowns to which Smithson referred, having probably not inquired himself. But without noting the parallels, Perreault observed another kind of masking by Smithson:

> Bob Smithson in person, as opposed to Robert Smithson in print, is a related but somewhat different person. In the essays . . . [he] comes across as youthfully polemical, learned and even slightly arrogant. His writing has been dense, controversial. . . . In person, Smithson is studious, considerate, shy—"a nice guy."[38]

By the late 1960s, the concept of entropy spoke to a wide audience, appealingly metaphorizing perceptions of both nature under threat by pollution and, on the social level, a culture that was undergoing disruption. Then entropy's idea of increasing disorder in a system could serve as a macrocosmic explanation for the sense that, under the stress of the Vietnam War, of civil rights protests, and the broad rejection of tradition and convention in all forms of art and social mores destabilizing familiar conventionality, "entropy" became shorthand for the precarity that Smithson encapsulated as "As rockets go to the moon the darkness around the Earth grows deeper and darker."[39] In his sole direct political statement, for a Museum of Modern Art symposium, "The Artist and Politics," Smithson described his "position"

as "one of sinking into an awareness of global squalor and futility," that is, the foulness of the political system and futility of artists' protests against it, which he likened to "trying to pick poison out of boiling stew."[40]

But Smithson's intellectual fascination with entropy had a counterpart in personal obsession. The chapter of Sypher's *Loss of the Self* in which Smithson read "entropy is evolution in reverse" is titled "Existence and Entropy," a duality just a step away from the dyad of life and death. Entropy is, after all, about loss, and not just of energy—the ultimate stasis follows the loss of the heartbeat. The mortality entwined with Smithson's birth makes understandable the appeal for him of entropy as an explanatory force in a worldview; basic to psychoanalytic research about those born as replacement children is that they commonly display great interest in the topic of death and in naturally occurring catastrophes. Holt recalled, "Entropy—Bob really understood that as a state of being."[41] The appeal to him of the dystopian was apparent to his editor and Holt's boss at *Harper's Bazaar*, Dale McConathy, who became a friend and later wrote about him. "For Smithson, the *speculum mundi* was the discarded, the decayed, the disused."[42] That is exactly how Smithson described his own proclivity. Contrasting the "classical idea of making a piece of sculpture" as "the idea is to take a block of marble and then chip away until you find this form or structure within there," he distinguished his own preference: "Well I'm more interested in the chips, the things that are disposed of."[43] As a surrogate for corporeal degradation, it was another instance of his "fascination with the coming and going of things" in which *he* was the thing that came after.[44] Entropy's process of decreasing order clearly spoke to Smithson as a physical state that metaphorized an existential or emotional one, an alignment between the material and the mental he described as his artistic goal. His professed professional affiliation with entropy enabled him to take agency over an unspoken personal anxiety.

With its rapid proliferation of art styles—Happenings, Pop, Op, Minimalism, Conceptual Art, new music and non-narrative abstract dance—the art world in 1966 was vibrant. In March, Sol LeWitt sent Virginia Dwan photographs of Smithson's work with an offer to take her to his studio; they visited on the afternoon of April 7. In his letter to her, LeWitt described Smithson's work as "somewhat akin to mine, not so much visually but in theory and direction."[45] This would have been very appealing to Dwan, who has recounted her unusually immediate enthusiasm for LeWitt's work upon her first visit to his studio.[46] In turn, "Because of LeWitt," Dwan has written, "I viewed this enigmatic person with interest." She described Smithson

FIGURE 8.5. Virginia Dwan was Robert Smithson's art dealer/gallerist, patron, friend, and occasional traveling companion. They chatted on the roof of the Dakota apartment building in New York, one of her residences, circa 1969. Photograph by Roger Prigent. Courtesy Virginia Dwan.

as "lean, gaunt. Stooped. Black boots, black trench coat, black trousers, and black hair shaped a dark frame for a Saturnine face suggesting a strange intelligence."[47]

Just five months earlier Dwan had extended her Los Angeles gallery operation to New York at 29 West Fifty-Seventh Street and was then assembling her roster of New York artists; the timing of Smithson's connection was fortuitous. Dwan began representing his art, which not only ensconced him in a gallery that with his contributions became increasingly avant-garde but also garnered him a monthly stipend against future sales. As a person of inherited means, Dwan could take risks in exhibiting advanced forms of art without being financially dependent on sales. Smithson and a few other male sculptors benefited from the unusual situation of Dwan serving as both their art dealer and their patron. For the next five years, Dwan became the second heiress to support him—fiscally and otherwise—after Holt; Dwan would exhibit and promote his gallery work and fund his earth projects.

Smithson made his Dwan Gallery debut in an October 1966 group exhibition of reductive geometric abstraction seen in both painting and sculpture that he himself organized along with Robert Morris and the

FIGURE 8.6. Robert Smithson, *Alogon #1,* 1966. Painted stainless steel, seven units, overall 35½ × 73 × 35½ inches (91.2 × 185.4 × 91.2 cm). Whitney Museum of American Art, New York; purchase, with funds from the Howard and Jean Lipman Foundation, Inc. Copyright Holt/Smithson Foundation / Licensed by Artists Rights Society, New York.

distinguished painter Ad Reinhardt. With it, Smithson expanded his repertoire into curating and positioned his sculpture within a group of well-regarded peers.[48] Its literalist exhibition title, *10,* indicated the number of artists in the show.[49]

Even as Smithson assimilated Minimalist strategies of designing modular units of pared-down geometricized hollow forms made of welded steel, commercially fabricated and painted a solid color, his progressions were more complex and less inert than others'. His wall piece, *Alogon #1,* consists of seven stainless steel black modules. Each is a thin hollow box in the shape of a right triangle with the vertical edge attached to the wall and the horizontal edge at the top, perpendicular to the wall. The diagonal between the two arms forms six equal steps. The seven units in identical configuration are in sequential sizes ranging from about eighteen to thirty-six inches on a side. The structure is similar to an illustration of a "stack of tiny rhombohedral units" in Bunn's book on crystals.

The sculpture's title, *Alogon*, is a Pythagorean term meaning *alogos*, or without logic, which Smithson explained as "[coming] from the Greek which refers to the unnameable, an irrational number."[50] The art historical use of *alogon* is associated most strongly with Russian Suprematist Malevich's quest to supplant positivist rationality with a "supremacy of pure feeling in creative art."[51] (The "feeling" is "pure" because it is not conveyed through an intermediary image of a figure or scene but solely by planes of saturated color against white space.) The sentiment wasn't illogical but sidestepped deductive logic in favor of the inductive and intuitive, which Malevich and others of his time called the alogical.

With his use of *Alogon* as his title, Smithson wasn't reducing Malevich to a formalist as he had in "Entropy and the New Monuments" but incorporating his ideas about "transrational" feelings inexpressible in reasoned logic and incommensurable to verbal language. That also connects to Samuel Beckett's sensibility and his novel *The Unnamable* about an experience being ineffable, too overwhelming to convey in language. As Smithson put it, "It's just that reality doesn't seem to be knowable. It seems unnameable."[52]

The black hue of *Alogon* may also refer to Malevich, whose most famous Suprematist painting is *Black Square* (1915). But in Smithson's symbolist orientation, it also connotes mystery, foreboding, and mourning.

A month after *10* closed, Smithson's first solo show of sculpture and his first at the Dwan Gallery went on view.[53] Chronologically and stylistically, the five sculptures have been categorized as Minimalism. But their shapes, titles, and hues idiosyncratically transgress the neutral forms' typical non-referentiality and maintained his characteristic ominous tenor. Contrary to artists' common practice of withholding associations by designating a work "Untitled," Smithson's suggestive titles display his desire, however ambivalent and indirect, to convey personal subjectivity. *Four-Sided Vortex*, *Plunge*, *Terminal*, *Mirage*, *Shift*, as art historian Caroline A. Jones recognized, "suggest precipitous, liminal, and ephemeral states."[54]

Plunge consists of black units of identically arranged offset stacks of four progressively larger cubes, each arrangement sequentially increasing from 14.5 to 19 inches in height and spaced along a twenty-eight-foot floor span. There are ten units, the number symbolizing completion and astrologically associated with Capricorn, Smithson's sun sign, the tenth sign of the Zodiac. The tapering perspective, foreshortening or enlarging depending on the end from which they are viewed, evokes *Plunge*'s allusion to plummeting, as if into darkness, water, the cosmos, or a time stream. By their very essence of disciplined geometricity in ratios, such cubic arrangements exemplify the experience Smithson had long sought of "proportion" as a barricade against falling into what he had so pungently described to Lester as a "pit of despair" (undated [June 1961], #12). At the same time, that

FIGURE 8.7. In his first solo show with the Dwan Gallery in December 1966, Smithson exhibited (from left) *Plunge* (acquired by the Denver Art Museum), *Alogon #2* (Museum of Modern Art), *Doubles* (on the wall; location unknown), *Terminal* (Des Moines Art Center), and *Mirrored Ziggurat* (not visible; Metropolitan Museum of Art) (see Figure 7.5). Courtesy Virginia Dwan; artworks copyright Holt/Smithson Foundation / Licensed by Artists Rights Society, New York.

very deficit in equilibrium that Smithson sought so rigorously to contain inevitably vented in the poetic artistry that—aside from subverting Minimalist coolness—made his work so compelling.

Like *Plunge*, other works in the solo show—*Alogon #2*, *Doubles*, *Terminal*, *Mirrored Ziggurat*—are in steel or mirrored. *Alogon #2* is a three-dimensional representation of an isometric projection illustrated in Ronald G. Carraher and Jacqueline B. Thurston's *Optical Illusions and the Visual Arts* (1966). All are composed of elements that structurally mirror each other or that are composed in sequential arrays of identical cubic forms in progressive scales that incrementally increase or decrease in size (depending on one's viewpoint). The printed invitation to the show emphasized this by having each letter in Smithson's last name progressively decrease in size from about 7½ inches to ½ inch. The announcement also highlighted the scientistic demeanor of the work by illustrating annotated charts indicating the relative sizes and positions of sculptures' elements.

Characteristically, Smithson undercut the potentially dull sobriety of Minimalism by applying droll metaphysics in a list of ten "Constants Exalted into the Null-Dimension." They included "4. Agreement between

acedia and splendor; . . . 7. Quadripartitioning of futility; and 8. Rigid paroxysms set in a row."[55] In vividly sensory language, he has indicated how the "paroxysmal artist's" lamentations have solidified yet retain intimations of those eruptions.

In his oral history, Smithson described how he "work[ed] out of that preoccupation . . . a kind of savage splendor" by "gradually. . . recogniz[ing] an area of abstraction that was really rooted in crystal structure."[56] The crystalline enabled him to pivot to a new position. To Lester, he had written, "I am modern artist dying of Modernism" (May 1, 1961, #5). When he abandoned the practice of painting, transmuted himself, and started exhibiting alongside sculptors of advanced geometric abstraction, his professional estrangement from current art ceased. But his pessimism did not. In disguised symbols, entropy, and references to ruins he found ways to emblematize his own truths.

At the end of the year, less than three months after the Whitney Museum of American Art moved from a former townhouse in midtown to a Brutalist hulk designed by Marcel Breuer on Madison Avenue at Seventy-Fifth Street, Smithson was included in a Whitney show for the first time in the first of its prestigious "annual" exhibitions held there, *Contemporary Sculpture and Prints*. As a bonus, the piece he exhibited, *Alogon #1* (1966), was purchased by the foundation of Howard and Jean Lipman, with whom he socialized, and given to the Whitney, the first work by him to enter its collection.[57] He was on his way up.

FIGURE 9.1. Robert Smithson, *The Monuments of Passaic* (*The Sand-Box Monument,* also known as *The Desert*), 1967 (one of the six photographs originally published in Robert Smithson, "The Monuments of Passaic," *Artforum* 6, no. 4, December, 1967)

9

From the Ground, Upward

A sort of rhythm between containment and suffering

"I worked with these architects from the ground up," Smithson recalled of his experience with Tippetts-Abbett-McCarthy-Stratton (TAMS). His connection to the architects and engineers developing their proposal for the Dallas–Fort Worth Airport appeared at the right moment to galvanize his creativity. "As a result I found myself surrounded by all this material that I didn't know anything about—like aerial photographs, maps, large-scale systems, so in a sense I sort of treated the airport as a great complex, and out of that came a proposal that would involve low-level ground systems that would be placed at fringes of the airport, sculpture that you would see from the air."[1] His abundant energy and increasing confidence propelled speculative drawings. Placed at a distance from the terminal in what were called "clear zones" (areas between and around runways without architecture or overhead utility wires) these works necessarily would have had to be at ground level forms. He termed this "aerial art," intended to be viewed from planes as they arrived and took off.

Over the next year Smithson produced a number of ideas for low-lying works of or atop earth. *Wandering Earth Mounds and Gravel Paths* (1967) shows an all-over design of irregularly meandering, outlined, amoeba-like forms covering the surface except for the runways and terminal building.[2] His *Project for Clear Zone: Dallas Fort Worth Regional Airport* (1967)

FIGURE 9.2. Robert Smithson, *Wandering Earth Mounds and Gravel Paths,* 1967.
Blueprint with collage and pencil, 15½ × 11 inches (39.4 × 28 cm). Courtesy Marian
Goodman Gallery. Copyright Holt/Smithson Foundation / Licensed by Artists Rights Society, New York.

is a simple squared, counterclockwise spiral drawn on graph paper, with
the title *Asphalt Spiral* above his signature. A group of proposal drawings
are based on a series of graduated squares that sequentially increased in
size, extending the incremental format of stepped units in his solo show
at Dwan.

Frustrated by not being able to bring them to fruition outdoors in
raw earth when TAMS did not get the airport commission, he productively
synthesized his attachment to crystalline forms, entropic processes, and
dialectical permeability of systems into a new form of gallery sculpture.
Three years later in his distillation of his career to a map-like drawing, *Surd
View for an Afternoon* (1970), Smithson positioned his works around a cen-
ter identified by an arrow pointing to it marked "Air Terminal," indicating
the catalyzing impact of his involvement with TAMS.

An untitled, undated, and probably impromptu sketch of a few lines
shows a progression of five rectangular pavements along a runway's
clear zone.[3] It also roughly indicates the locations of three other works by

sculptors whom Smithson brought into the project to join him in propos-
ing aerial works: Carl Andre, Sol LeWitt, and Robert Morris. It may have
accompanied an undated proposal by Smithson for TAMS and the Dwan
Gallery to jointly fund the construction of the four sculptors' proposals on
land, and the documentation of those works in a proposed four-person ex-
hibition at the Dwan Gallery in September 1967. He probably promoted this
project to TAMS as a prototype of the airport proposals and one that would
bring attention to the firm for its support of progressive forms of sculpture.
He noted: "A blowup of a map showing the runway layout and clear zones
will be on display in the gallery along with 4 models of the artists' propos-
als. A gallery announcement will also be printed showing maps and artists'
proposals."[4]

Although they are for works to be sited directly on the undeveloped
ground, none of Smithson's initial plans engage meaningfully with the
earth considered either directly as soil or as synecdoche for greater nature.
The works' relation to the earth is solely by proximity: being low to the
ground and parallel to it, horizontal in orientation. He does not discuss
them in terms of a material or spiritual connection to the earth. Rather,
he was stimulated by a consciousness of scale—the monumentality empha-
sized in the large abstract sculpture exhibited in *Primary Structures* (1966)
and *American Sculpture of the Sixties* (1967) at the Los Angeles County Mu-
seum of Art.

Likewise, the types of terrain Smithson was drawn to were not the be-
nign countryside of the counterculture's pastoral "back to nature" fantasy,
but were either neutral and level, as a graded clear zone between runways,
or fringe landscapes displaying disorder or degradation. Nancy Holt re-
called: "Bob knew the Pine Barrens well. We had been there individually
when we were young, and we had gone down and reexplored it ourselves
prior to going with anyone else."[5] Andre's recollections of a trip in April
1967 with Smithson, Holt, Morris, and Dwan gives a sense of its explor-
atory nature: "Our goal was the Pine Barrens. I saw on a geodetic map a
six-pronged abandoned airfield deep in the boondocks & Virginia very
skillfully & bravely drove us to it on an almost non-existent dirt road. That
image later figured prominently in Bob's work."[6]

The artistic worth of such an excursion along unpaved roads had been
affirmed in *Artforum* that past December in a statement by the established
sculptor and architect Tony Smith. Speaking about an illicit nocturnal
drive on the unfinished New Jersey Turnpike, Smith noted:

> The road and much of the landscape were artificial, and yet it
> couldn't be called a work of art. On the other hand, it did something
> for me that art had never done. . . . I thought to myself, it ought to be

clear that's the end of art. Most painting looks pretty pictorial after that. There is no way you can frame it, you just have to experience it. Later I discovered some abandoned airstrips in Europe—abandoned works, Surrealist landscapes, something that had nothing to do with any function, created worlds without tradition. Artificial landscape without cultural precedent began to dawn on me.[7]

The last phrase—"artificial landscape without cultural precedent"—provides a virtual definition for the type of aesthetic experience Smithson and his fellow artists were conjuring for around airport runways, encouraging their experimentation.

In heading for the wilderness area known as the Pine Barrens, these artists, spouse, and dealer went to one in which the eponymous growth was an aberration: not the tall firs customarily associated with a forest, but pine trees that at their maturity are dwarfs. These stunted trees display the appeal for Smithson of distorted forms, or as he put it, "sites that had been in some way disrupted or pulverized," not in urban places but in vast, austere, uninhabitable deserts.[8] This was an aspect that later in 1967 would be emphasized by John McPhee in one of the *New Yorker*'s then-characteristically protracted serialized essays:

> In parts of northern New Jersey, there are as many as forty thousand people per square mile. In the central area of the Pine Barrens—the forest land that is still so undeveloped that it can be called wilderness—there are only fifteen people per square mile. . . In one section of well over a hundred thousand acres there are only twenty-one people.[9]

Within a week of the visit recounted by Andre, Holt composed and typed letters sent on Dwan's letterhead and bearing her signature to six town clerks around the Pine Barrens, seeking to purchase parcels of land.[10] Dwan's largess would make her the mother of earthworks.[11]

Another impetus to Smithson's venturing to actual outdoor sites was *Artforum* editor Phil Leider's request for an article for the June 1967 issue featuring "American Sculpture of the Sixties" on view at the Los Angeles County Museum of Art."[12] The issue served as a farewell bow to California (five years earlier *Artforum* had been founded in San Francisco) before the editorial staff decamped to Manhattan, where the magazine is based to this day. But it was already largely written by and about New Yorkers, publishing in that issue, besides Smithson, Morris's "Notes on Sculpture, Part Three," LeWitt's "Paragraphs on Conceptual Art," Michael Fried's "Art and

Objecthood," and articles on Mark di Suvero (bicoastal), Claes Oldenburg, George Segal, and David Smith.

Stimulated by the TAMS project to consider expansive outdoor sites for art but without territory on which to dig, Smithson turned to avenues open to him, exhibiting at the Dwan Gallery and writing for *Artforum*. That issue's focus on sculpture was a perfect vehicle for his announcement of a new environmental format, actualizing Smith's "artificial landscapes without cultural precedent." He wrote in the authorial voice of a reticent, scientifically inclined vanguard artist. His title underscored the exploratory nature of these endeavors by casting it as research: "Towards the Development of an Air Terminal Site." The text's combination of abstract thinking and prosaic data includes a fragmentary description of the TAMS project, scientistic commentary, and numerical lists pertaining to "the meaning of an air terminal" in response to accelerating speeds of flight and to "aero surveying." As with his prior texts, Smithson dropped the most penetrating thesis into the middle of the text. In a description of soil sampling of the terminal site, he declared:

> The "boring," like other "earth works," is becoming more and more important to artists. Pavements, holes, trenches, mounds, heaps, paths, ditches, roads, terraces, etc., all have an esthetic potential.[13]

But contrary to the subliminal import of his earlier insertions of Latin prayer excerpts, commonly overlooked as obscure and anomalous, his blunt assertion of the latest artistic trend midst abstruse language made his declaration conspicuous. Upturning dismissals of Minimal sculpture's reductive shapes and unadorned surfaces, he made "boring" not a denigration but an enticing operation. Disregarding the cessation that month of his consultancy with TAMS or the TAMS/Dwan exhibition project, stalled for lack of land, he confidently promoted a new form of art to come, of earth and directly on it, as if already successful.

Six months later, his essay "Monuments of Passaic" exemplifies both his customary inversion of antinomies—monumentality, high and heroic, becomes an ironic attribute of suburbia, low and mundane—and his practice of metaphorizing the personal in observations of the social. Titled as a witty recursion of his initial *Artforum* essay on new sculptures' radical simplification, "Entropy and the New Monuments," here he satirically describes functional infrastructures—aging bridges, pipes spewing effluent, a generic parking lot—as suburbia's distinguishing constructions. Illustrated with his own snapshots, "Passaic" appears to be a sardonic travelogue to a place that could have been called Prosaic.

The very eccentricity of this topic in the solemn *Artforum* displays Smithson's burgeoning professional confidence in singularizing himself. In it he's a sculptor, analyst of art, and a storyteller as well. We see this in his narration of travels both physical (to New Jersey quarries, to Passaic, in the future to the Yucatán and Central Park) and metaphysical (allusions to the "dark night of the soul," union with God) and their merging in his jog to the center of *Spiral Jetty*. Each of these journeys is recounted in a combination of diaristic reportage and autobiographical fantasia, fusing discovery and invention to tell tales.

Smithson's excursion to Passaic was not impromptu; in the notebook he carried with him he had already written a draft essay titled "A Guide to the Monuments of Passaic, New Jersey" identifying five topologies of monuments. And the date Smithson gave for his embarkation from Manhattan for Passaic, Saturday, September 30, 1967, is provocative, because it converges three elements too auspicious to be coincidental. First, and the most directly motivating factor, that date was the day before the opening of New York City's inventive act of temporarily placing modern sculpture outdoors in public parks citywide for the exhibition *Sculpture in Environment*, which demonstrated its prominence. Historically in New York City, artists had set up displays of their paintings around Washington Square in Greenwich Village. As Smithson was not making works of the scale and material appropriate for an outdoor urban site, subject to varied weather and human interaction, he was not included in *Sculpture in Environment*. So, he inserted himself into the dialogue by indirect reference: "Maybe an 'outdoor sculpture show' would pep that place up."[14]

Second, on the bus ride he noted that that day's *New York Times* illustrated Hudson River school painter Samuel F. B. Morse's *Allegorical Landscape* (1835–36). That is, Morse depicted a material thing or place as standing for an indirect, other meaning—which was exactly Smithson's procedure in his own article regarding the landscape of Passaic, as well as so many other disguised statements.

Third and most propitiously, the date is the feast day of Saint Jerome, the fourth-century scholar, translator of the Bible into Latin, and Doctor of the Roman Catholic Church, commonly portrayed in his hermitage bent over a book. Among the fourteen books in his library of the writings by or about Catholic saints, Smithson's copy of *The Satirical Letters of Saint Jerome* was published the year of his high school graduation. His copy of Thomas Merton's *The Wisdom of the Desert: Sayings from the Desert Fathers of the Fourth Century* was published in 1960, and Jerome is discussed in Hans Lietzmann's *The Era of the Church Fathers*, volume 4 of *A History of the Early Church* (1961). That year Smithson wrote in an incantation, "And so / Saint Jerome / Returned to the desert," precisely his own destination,

a town he would describe to Paul Cummings as a "stifling suburban atmosphere where there was just nothing," where his Passaic tour's "last stop [was a] sand box or model desert."[15] This convergence of significances on September 30 is too perfect to be accidental, so it is unfortunate that the date of his jaunt cannot be confirmed; the only section missing from his calendar of appointments from 1966 through 1973 donated to the Archives of American Art is the second half of 1967.

In a characteristic arabesque of dysphoria, Smithson observed of Passaic's downtown: "That zero panorama seemed to contain *ruins in reverse*, that is—all the new construction that would eventually be built. This is the opposite of the 'romantic ruin' because the buildings don't *fall* into ruin *after* they are built but rather *rise* into ruin before they are built."[16] It critiques the absence of monumentality of the "slurb," but it also applies to his own biography: *he* was one who rose from—had been born into—an extant state of ruin that existed before he had been "built."

He construed "Passaic center" as "no center—it was instead a typical abyss or an ordinary void" and declared, "I am convinced that the future is lost somewhere in the dumps of the non-historical past; it is in yesterday's newspapers, in the *jejune* advertisements of science-fiction movies, in the false mirror of our rejected dreams."[17] Unacknowledged by Smithson, Passaic is where he was born and lived the first year or so of his life. It was *his* past he seeks clues to, in the dumps of his nonhistorical past, in the prehistory he often refers to, in his own rejected dreams. Holt recalled how his parents had disapproved of his dedication to being a fine artist rather than a commercial one with a salaried income, and recounted, obviously anguished on her late husband's behalf:

> He didn't have support, nobody understood in his family or nobody knew about art or cared about his art. In fact, I was thinking the other day how horrible—after we got married, when his parents moved, they threw out all of his early art, photographs, and letters. They didn't even ask him! He was furious. I'd never seen him so angry.[18]

He described in his oral history for the Archives of American Art his interest in "just working my way out from underneath the heaps of European history to find my own origins," enacting an observation by psychologist Erik Erikson, "The question of origin often looms large in individuals who are driven to be original."[19]

Smithson again addressed his origins in his final faux monument, a playground "sand box or a model desert" with two analogies. He first used it to model the decrease in organization characteristic of the state of entropy,

extending his association with it initiated in his previous "Monuments" article. He explained that if the sand box were divided down the middle between areas of black and white sand, a child running in circles within it would mix them into grayness. Reversing direction would not restore it to discrete halves but would further decrease the distinction between them, intensifying the loss of order.[20] This time, the sandbox model is appropriate, literally so; physicist Lee Smolin explained that modern "thermodynamics . . . apply to physics in a box. The context for the laws of thermodynamics is an isolated system, which exchanges neither energy nor material with its surroundings."[21] The sand's disarray was limited to its box, following it, the whole playground did not descend into chaos.

But then his entropy metaphor turned darker. Smithson believed entropy demonstrated the "irreversibility of eternity," which for him, of course, referred to death.[22] He demonstrated that ultimate manifestation of entropy when at the end of his journey what had begun so matter-of-factly turned mournful. With figures of speech such as "Time turns metaphors into things, and stacks them up in cold rooms," he called up cadavers in a morgue and piled locutions of loss: "Under the dead light of the Passaic afternoon the dessert became a map of infinite disintegration and forgetfulness."[23] He continued, "Every grain of sand was a dead metaphor that equaled timelessness. . . . This sand box somehow doubled as an open grave—a grave that children cheerfully play in."[24] The loose mounds of sand in a box, conventionally thought of as a blank site where children scoop out and mold fantasies—a hole, a mountain, a castle—was for Smithson a grave associated with childhood death.

He had given readers a premonition of that association when, just as the bus turned off the highway into the town where his family had lived approximately between his years of two and nine, Rutherford, he quoted the startling first sentence of the science fiction novel *Earthworks*. He had ostensibly purchased it from a rack of cheap paperbacks at the West Side Airline Terminal (now called the Port Authority Bus Terminal) just before embarking.[25] His mention of *Earthworks* in his essay's second sentence served to reinforce for alert readers his own association with the term, as six months earlier in *Artforum* he had introduced the engineering term into the art context when announcing "The boring, like other 'earth works,' is becoming more and more important to artists."[26]

But here, his quotation of Brian Aldiss's first sentence referred to another common usage of a hole in the ground: "The dead man drifted along in the breeze."[27] Smithson's final Passaic stop at the sandbox's granular matter links to the desiccated world in Aldiss's novel, a grim story of ecological collapse. The protagonist, Nowle Noland (he knows no land), endlessly crosses seas on a tanker gathering sand from abandoned "dumps like

the Skeleton Coast" and transporting it to remaining northern ports where it will be turned into semi-arable soil "at least to raise vegetables fit to feed beef animals."[28] The journey that began by Smithson's quoting "The dead man drifted along in the breeze'" wound—rewound—its way through his past back to an association relating to death in childhood, his childhood.

Twenty-nine years after his birth there and eleven years after leaving New Jersey straight after high school, Smithson still viewed Passaic as a place marked by a "Monument of Dislocated Directions" (the bridge), "extinct machines" (dead), and "monumental vacancies that define, without trying, the memory-traces of an abandoned set of futures." A few months later, he will reiterate the connection between family and mortality in his characterization of "The Establishment [commonly disparaged by 1960s' youth as the domain of authority figures, convention, and parents] as a state of mind—a deranged mind, that appears to be a mental City of Death."[29] Harold, too, had been born in Passaic. Apparently without trying, the memory trace of Harold's lost future defined a monumental vacancy in Passaic— that is, in Smithson.

Again, these topics were foreshadowed by Smithson's strategy of provocative epigraphs. One sounds innocuously relevant to his Passaic stroll's photographic procedure: "Today our unsophisticated cameras record in their own way our hastily assembled and painted world." It is from Vladimir Nabokov's novel *Invitation to a Beheading*, about a man estranged from others and a militant totalitarian society, his desire for escape, and his wrestling with his imminent death. Smithson quotes the end of a paragraph that begins, "'But then perhaps,' thought Cincinnatus, 'I am misinterpreting these pictures. Attributing to the epoch the characteristics of its photograph.'" Smithson is asserting not photography's realism but its potential to deceive. Cincinnatus continues: "And the world really never was . . . Just as . . . But how can these ruminations help my anguish? Oh, my anguish—what shall I do with you, with myself? How dare they conceal [the date of his execution] from me?"[30] Circulating throughout Nabokov's novel are themes familiar to Smithson's work: mortality, resistance to confining authority, things not being what they seem to be, rumination on existence.

Above his quotation of Nabokov is another epigraph, an excerpt from the science fiction story *Jesting Pilot*, by Lewis Padgett, citing not the name by which the author published the book but the birth name of one of the authors, Henry Kuttner (without mentioning Kuttner's coauthor and wife, C.L. Moore), as if exposing doubleness or asserting the dominance of the family identity. The epigraph lines—"There's no way out. . . . The whole city . . . makes me feel haywire. Then I get these flashes"—cue us to Smithson's retrospective view of Passaic. Padgett's story, located in an isolated, self-sustained city enclosed by a dome, describes a man, Bill Norman

(suggesting William or "Will" to be "Normal"), who is having disturbing flashes of "rationality" that break through his hypnotized state universal among the citizenry. Padgett's own story's teaser description above his text is "They were in the City, behind the Barrier. [Smithson had painted such imprisoned figures in his 1959 *Purgatory* and *Walls of Dis*.] They had been specially conditioned from birth. None of them had ever known normal existence." Norman exclaimed, "I know what I want. *Out!*" It calls up Smithson's "Lamentations of a Paroxysmal Artist": "The Word came unto me looking like a silly mess. Take it away! Take me away! . . . Degod me!"[31] In the Padgett story, "A Controller explains, 'The idea is to trace the problems back to their psychological roots, and then get rid of the frustration somehow.' "[32] In touring his birthplace, that is what Smithson was doing, tracing his problems back to their beginning, akin to the process of psychoanalysis. Even if disguised by disparagements, in ending at a child's grave, Smithson's "Passaic" allegory merged the literary genres of odyssey and tragedy.

In between his morgue and grave references, Smithson rhetorically wondered, "Has Passaic replaced Rome as The Eternal City?" The witticism disdains the European Old World, so characteristic of American post–World War II cockiness, intensified by the 1960s' urge for innovation. He went on to describe a progression of cities from Rome in which each is "a three-dimensional mirror that would reflect the next city into existence," just as Harold's seemingly eternal presence reflected himself into the family dynamic.[33] But also, Rome represents the disappointment of his show at the Galleria George Lester there six years earlier. By the time of this speculation it was ancient history, replaced by his prominent *Artforum* traipse through Passaic.

A few months later Smithson's second solo exhibition at the Dwan Gallery in March 1968 pushed Minimalist constriction toward a more expansive use of space. Five of the six sculptures exhibited maintained his version of the categorical Minimalist format: closed geometric forms made of rigid steel or plastic in affixed sections, sequenced by size. The title of one, *Leaning Strata*, referenced his new affiliation with geology. Although industrially fabricated like the rest, its seven vertical panels slanting toward each other and the center, as if unstable entities (planks? books? drunks?) were striving to hold each other up, counter Minimalism's stolid stability. It subtly conveys the vulnerable sentiments in his paintings and early essays. Another linking past and future projects is his seventy-three-inch-high *Gyrostasis*; the vertical arc of this steel construction suggests that the similarly triangulated but ground-level horizontal panels of the model accompanying his *Aerial Map Proposal for Dallas-Fort Worth Regional Airport* (1966)

FIGURE 9.3. Robert Smithson, *Gyrostasis,* 1968. Steel, 73 × 57 × 40 inches (185.4 × 144.8 × 101.6 cm). Collection Hirshhorn Museum and Sculpture Garden, Smithsonian Institution. Copyright Holt/Smithson Foundation / Licensed by Artists Rights Society, New York.

stood up and took on bulk. With the nonrectilinear movement of these two forms, the stolidity of Minimalist cubes became even more dynamic than his previous sequences of geometricized sculptures; they point toward his move to organic form and natural materials in earthworks.

In a statement on this work, Smithson explained, "*Gyrostasis* refers to a branch of physics that deals with rotating bodies and their tendency to maintain their equilibrium."[34] It performs what in 1961 he had described to Lester as "the invisible proportions" that forestall a "fall into the pit of despair" (undated [June 1961], #12). And seven years later, around the time

he made this sculpture, he told curator Willoughby Sharp, "For me, there's a constant state of uncertainty, and disorder, and instability."[35] As its title implies, *Gyrostasis* materialized his desired stability between feverish productivity and destabilizing desolation.

The expansive scale of the airport project had expanded Smithson's spatial perceptions beyond the idea of sculpture as a discrete gestalt—perceived at once, holistically—toward seeing things more relationally as part of the encompassing environment. That new direction is evident in the scheme of the sculpture titled on Dwan's checklist for his March 1968 show, *A Non-Site (Indoor Earthwork)*. The hyphenated "non-site" emphasizes it as something it is not, or links it dialectically to a "site." (After this work, the word appeared as nonsite, deemphasizing the dyadic aspect.) But as of that date, March 1968, no work had been identified as an outdoor earthwork—its "other," the site, from which the non-site's concentric, six-pronged shape was adapted, was the pattern of runways of the little-used wilderness airfield that he had seen during an April 1967 excursion to the Pine Barrens. *Non-Site*'s design of six rays radiating from the center is identical to that of *Cryosphere*. Again, they are attached to a platform, which this time is floor-bound and low, sixty-five and one-half inches in diameter. Each of the six triangular wedges is composed of five blue trapezoidal aluminum bins descending in height from twelve inches at the circumference toward a low hexagonal bin in the center. Each bin contained sand from its "barren" ground cover.

When Smithson exclaimed to Lester, "The way up is the way down," he was describing his new postreligious paintings of busy undergrounds (and his own dive to subterfuge, using disguised symbolism) (September 22, 1961, #15). With his nonsite Smithson found another means to represent something unseen by others, not below sight but an imperceptible distant site on the ground with a corollary nonsite in the gallery. The configuration would springboard him into recognition as a highly conceptual sculptor.

Photographs, drawings, and descriptive texts accompanied early nonsite works. On the Dwan Gallery wall adjacent to these bins, a photostated map, shaped as a hexagon to mimic the bins' configuration, bore below its title this typed text:

> 31 sub-divisions based on a hexagonal "airfield" in the Woodmansie Quadrangle—New Jersey (Topographic) map. Each sub-division of the Nonsite contains sand from the site shown on the map. Tours between the nonsite and the site are possible. The red dot on the map is the place where the sand was collected.[36]

By bringing Pine Barrens sand into Dwan's Fifty-Seventh Street gallery and placing it in bins mimicking the shape of a local airfield, this "indoor earthwork" linked center and periphery and extended the sense of environment—previously implied within white box galleries by Morris's arrays of cubes or Andre's punctured carpets of bricks—to far from midtown Manhattan. This participated in the sculptural direction since the mid-1960s that was transforming the discrete, bounded object of art into an expansive space, initially interior, to be experienced by the viewer/participant's bodily movement through it. By pointing to a place outdoors and distant, not just the art object but the art world itself was being opened up in regard to materials and locales where art can be experienced, and soon thereafter, where it was made. Earthworks signaled a shift away from the artist's studio as the place where creative construction happens.

Smithson's nonsite/site duality countered what he took to be the spatial isolation of what Donald Judd termed a "specific object," the title of his essay that since its 1965 publication had become a kind of manifesto for Minimalist sculpture.[37] Smithson spoke of the nonsites' "natural aspect invading the purity of the abstraction."[38] After he became well known in his own right, he could state unequivocally, "I wasn't ever a Minimal artist. I was never involved with that kind of notion, the thing in itself. I always saw these relationships."[39] He contrasted sculptors' "focus on one object" to his emphasis on "the back-and-forth thing."[40] His desire to make art on unbuilt terrains was always in tandem with plans for linking viewers to those exterior works, initially through airport live feeds from cameras placed around the sculptures between the runways and later to display photographic, cartographical and textual documentation in galleries and periodicals.

But beyond sculptors' intellectual dueling to enunciate the artistic zeitgeist, Smithson's conceptualization of contextual understanding was historical and social. The necessity of comprehending a thing not as intrinsically unique but as an element of a wider context of relations aligns with Kubler's *Shape of Time*, which itself was influenced by Structuralism's focus on shared social patterns and underlying laws of organizing logic toward making a science of the humanities. The concept also corresponds to his personal experience: identity as not only relational, and contextualized, but also composed of two aspects, the materially perceptible "Nonsite" and the distant in time and place—as if history or memory—of an instigating force, the "site."

Non-Site's industrially fabricated aluminum, unprocessed sand, and documentary photographs and text together function more as information than as artistically mediated materials offering visual pleasure and sensory stimulation. The approach to art making recapitulated recent Conceptual Art's abstemious intellectuality and signaled the way forward for earthworks' use of crude, indigenous geological matter.

But the sand's barrenness also appealed to Smithson's taste for euphemisms for death, continuing the connection he made in his "Passaic" essay when likening a sand box to a child's grave. And just as he had identified in *Lunar Parallel* (see Figure 5.3) whose horoscope it was by the sum in numerology of the letters in "Harold," the sum of the five bins in each if the six arms plus the center one, thirty-one, is again the numerological sum of the word "Harold."

In September 1968, after that extraordinary year of the violent public assassinations of Martin Luther King Jr. and Robert Kennedy, the shooting of Andy Warhol, the national student strike and general strike in France, at that beginning of the cultural season, Smithson announced his—and by extension, if he were to be a harbinger, the art world's—way forward toward its own radicality. Published a month before the opening of the Dwan Gallery's group exhibition *Earth Works*, his latest *Artforum* essay heralded "the wreck of former boundaries" in the forms of a new genre of outdoor environmental sculpture that was not "confined to 'the studio.' "[41]

"Sedimentation of the Mind: Earth Projects" interweaves an account of a visit to slate quarries in Pennsylvania with poetic evocations of mental states. For all his interest in natural science and geology, Smithson's writing has been aptly characterized as "anything but systematic, [bearing] little resemblance to the scientific and pedagogical aims of academic art research."[42] So while its description of earth projects is informative, "Sedimentation of the Mind" is more significant for his title's linked duality, reiterated in his opening claim, "The earth's surface and the figments of the mind have a way of disintegrating into discrete regions of art."[43] His statement paraphrases a similar assertion by J. G. Ballard of a unity between geology and psychology: "The system of megaliths now provided a complete substitute for those functions of his mind which gave to it its sense of the sustained rational order of time and space."[44] Smithson's correlation of geological material and mental matters tacitly presented his work in earth as not just a conceptual innovation but an emotional correlative, and one conveying his usual fatalism: "A sense of the Earth as a map undergoing disruption leads the artist to the realization that nothing is certain or formal."[45]

That linkage achieves what a few years later Smithson would describe in his oral history as, "I was trying, I guess, to develop a reflection in the physical world, so that these two things would coincide, the mental and the material would in a sense inform each other."[46] The analogies reiterate his blunt frankness to Lester six years earlier that his work's emotional expressiveness was authentically a "spiritual crisis. A crisis born out of an inner pain" (May 1, 1961, #5). By the time he wrote "Sedimentations," he

could convey the connection more suavely: "The 'pastoral'. . . is outmoded. The gardens of history are being replaced by the sites of time."[47] Idealizations of the Edenic garden have been supplanted by the realism of degraded terrains.

From the first paragraph Smithson's phantasmagorical statements addressed the duality of mind and matter in terms of the metaphysical:

> One's mind and the earth are in a constant state of erosion, mental rivers wear away abstract banks, brain waves undermine cliffs of thought, ideas decompose into stones of unknowing, and conceptual crystallizations break apart into deposits of gritty reason. Vast moving faculty occur in this geological miasma. . . . This movement seems motionless, yet it crushes the landscape of logic under glacial reveries.[48]

With these poetic meditations on existential vulnerability in the guise of reflecting on art, Smithson wrote in a more emotionally expansive tenor than he did in previous post-1965 statements. His authorial voice returned to the passion of his early "Desolation" and "Lamentations" essays—now couched in literary figures of speech sometimes baroquely extravagant. He may have been encouraged by a cult classic among French youth in the 1960s; Smithson owned the 1968 translated paperback *Morning of the Magicians*. Addressing speculative science, ufology, Nazi occultism, alchemy, and spiritual philosophy, the book advocates receptivity to the paranormal to perceive what the authors called *fantastic realism*:

> Not a fantastic leading to escapism but rather to a deeper participation in life. . . . True imagination is something other than a leap into the unreal. . . . The fantastic is not to be equated with the imaginary. But a powerful imagination working on reality will discover that the frontier between the marvelous and the actual— between the visible and the invisible Universe, if you wish—is a very fine one.

Magicians then goes on to say, "This is what Valéry meant when he said that 'the marvellous and the actual have contracted an astonishing alliance' in the modern mind."[49]

In the last section of "Sediment," Smithson again stated the personal in the guise of the universal: "For too long the artist has been estranged from his own 'time.'" It is transparently a projection of his own sense of alienation from current art, what he had lambasted as the "secular ambushes [of] iconography . . . oriented into the snares of mediocrity called OBJECTIVITY."[50]

FIGURE 9.4. The amalgam of science, history, religion, fantastic speculation, alchemy, and mystical connections in *The Morning of the Magicians* is not what one would expect from Smithson's public persona in 1968, when this Avon paperback in his library was published, or even later. But designer Mati Klarwein's depiction of the trimorph head calls up that in Smithson's Alan Gallery show in 1961 (which in Figure 3.4 he more directly identified as Hecate), displaying another connection between the Smithson of the early and late 1960s.

But he immediately shifts the source of that dissatisfaction to others, corresponding to his latent theme of artist as victim. "Critics ... by focusing on the 'art object,' deprive the artist of any existence in the world of both mind and matter," implying that in emphasizing the mental and material aspects of works of art, the artist's own distinctiveness is disregarded. "The mental process of the artist which takes place in time is disowned, so that a commodity value can be maintained by a system independent of the artist."

"Takes place in time" suggests not only the extended creative process but also contextualization in history, both social and personal. The vehemence of his declaration, "Any critic who devalues the *time* of the artist is the enemy of art and the artist," indicates the importance to him that his individuality, his process, and his experience be recognized as essential to his "existence in the world."[51]

The final sentences digress to generalize his meditation on time in cultural terms: "Floating in this temporal river are the remnants of art history, yet the 'present' cannot support the cultures of Europe, or even the archaic or primitive civilizations." It recapitulates a line in the last paragraph of Barnett Newman's influential essay "The Sublime Is Now": "We are freeing ourselves of the impediments of memory, association, nostalgia, legend, myth or what have you, that have been the devices of Western European painting."[52] But "the impediments of memory" are exactly what Smithson has *not* freed himself from. That leads to his conclusion, circling back to fuse the present with

his prehistory. In his "Entropy and the New Monuments" essay two years earlier he had literalized several sculptors' "conjunctions of time" as akin to displays in the Museum of Natural History, where "the 'cave-man' and the 'space-man' may be seen under one roof."[53] The convergence of past and future is frequent in science fiction, as in John Taine's description in *Time Stream* of the chronological flow as circular. Regarding the broader metaphysical and psychological affinities Smithson emphasized between "Earth Projects" and "Sedimentation of the Mind," a statement in *The Morning of the Magicians* stands out: "One must be capable of projecting one's intelligence far into the past and far into the future."[54] In his concluding sentence, Smithson articulated it more poetically: "The 'present' . . . must instead explore the pre-and post-historic mind; it must go into the places where remote futures meet remote pasts." In his large earthworks, he will apply that procedure.

Smithson's "Sedimentation" essay whetted appetites for *Earth Works*, opening early the next month at the Dwan Gallery, a group exhibition he and Dwan organized of pals, peers, and precedent sculptors who worked with the earth.[55] It also, he later acknowledged, strategically "created a context that gave direction to this thing [earthworks], which made it easier for people to back it."[56] By titling the show *Earth Works*, he tacitly linked this new genre of sculpture not only to Aldiss's story of ecological degradation, *Earthworks*, but as with his procedure of selecting epigraphs that covertly referenced personal conflicts, he thereby connected himself to the first line of that novel about being shadowed by a dead man. But then, like his practice of introducing a subject to enable himself to deny it, he emphasized artists' "earth projects" as "abstract geology," distancing them from contemporaneous "back to nature" New Age fantasies of a harmonic return to an imagined prelapsarian oneness with nature. In his antihumanist voice of the intellectual artist, he wrote, "Deliverance from the confines of the studio frees the artist to a degree from the snares of craft and the bondage of creativity. Such a condition exists without any appeal to 'nature.'"[57] Around the same time, he told curator and editor Willoughby Sharp, "I see no reason for viewing the landscape as something natural. It could be conceived in terms of an abstract system rather than in terms of anthropomorphic state."[58]

Nevertheless, after the immensely influential publication of Rachel Carson's *Silent Spring* in 1962 had stimulated public awareness of the vulnerability of the natural environment, the earthworkers' material was too topical for reviewers to resist making connections to the public's developing ecological consciousness. Oblivious to artists' intentions and ignoring

earthworks' rough forms and siting in wilderness, art critics presumed that this work was driven by artists' sympathies with "Mother Nature." The day after the Dwan *Earth Works* show opened, the *New York Times* headlined its description of the "back-to-the-landscape show" as "Moving Mother Earth."[59]

For Smithson, the show offered the opportunity to elaborate his nonsite strategy. *A Nonsite (Franklin, New Jersey)* (1968) enlarged one of the Pine Barrens nonsite's wedges. Here the five floor-bound trapezoidal bins form a single acute triangle without the apex bin. The beige wood containers are filled with a mixture of raw ore and limestone from five sites within the Franklin Furnace Mines, an area of northern New Jersey rich in mineral deposits.

Referring to notes Smithson made in which he originally said he intended this piece to have six graduated bins instead of five (which would have aligned this work with *Cryosphere*'s six units of six spokes, and the Pine Barrens nonsite's six spokes), art historian Robert Hobbs provides an extended description of this piece. Smithson noted how a "mercury vapor type lamp [would give] off energy capable of making mineral respond either by fluorescing or phosphorising." Hobbs comments:

> Evidently, he originally intended a highly subtle structure. The fluorescent minerals, calcite and willemite . . . together formed the potentiality of a complementary color scheme of red and green if viewed under ultraviolet light. They would, in their basic hexagonal structure, reiterate the six bins the artist had originally planned. That the inherent properties of the minerals were unable to be seen under ordinary circumstances echoed the notion of "nonsite."[60]

Accompanying the bins is a photographic aerial map of the Franklin area cut in the same segmented truncated triangular shape, plus twenty snapshots of the five sites, and a complicated text itemizing the contents and sizes of the bins, indicating the scale of the map, and stating that tours to the site were available. Here again Smithson disturbed the deadpan accounting of minutiae with an eruption of entropy: "The 5 outdoor sites are not contained by any limiting parts—therefore they are chaotic sites, regions of dispersal, places without a Room"—or maybe without room, as in his paintings' congested confinements?—"elusive order prevails, the substrata is disrupted (see snapshots of the five shots)." He concluded by explaining the absence of the structure's apex: "(the center point is at the end of a deadend street some where in Franklin not shown on map). An unexhibited aerial photo of this point is deposited in a bank-vault. This photo can be seen—a key is available."[61]

FIGURE 9.5. Robert Smithson, *A Nonsite (Franklin, N.J.)*, 1968. 12½ h × 82 w × 110 inches (31.8 × 208.9 × 279.4 cm). Courtesy Museum of Contemporary Art Chicago, Gift of Susan and Lewis Manilow. Copyright Holt/Smithson Foundation / Licensed by Artists Rights Society, New York.

Smithson's wall text accompanying this work notes that the wedges' apex or "center point" of the long, beige-painted wood bins filled with rocks "is at the end of a deadend street some where in Franklin." Dead, but not gone.

Is this the key referred to in his copy of *Meditations on the Zodiac*? "If you want to understand the center, investigate the circumference, for it contains the key."[62] (Or as he put it himself earlier that year, "The mind is always being hurled towards the outer edge into intractable trajectories that lead to vertigo.")[63] Again Smithson teases us with hints of something which 66⅔ percent or more is unavailable to sight—an unexhibited photograph,

locked in a vault—and paradoxes such as "*Quick Million* . . . named after a movie I have never seen" or a portrait titled *Self-Less*. Those containers for things invisible or withheld, sites unavailable to sight, implicitly refute Frank Stella's claim in 1966 of Minimalism's externalized impersonality: "My painting is based on the fact that only what can be seen is there. . . . What you see is what you see."[64] Stella's radical-sounding but nonsensically reductive epigram quickly became a famous slogan of the topical discouragement of questioning interiority—the artist's, the work of art's, or its viewer's.

But with *Franklin Nonsite* Smithson entices viewers with the statement that a key is available that will reveal the identity of the "center point . . . at the end of a deadend street." Is that like the inspector's set of keys in Edgar Allan Poe's "Purloined Letter" that will open any door in Paris? Smithson's key likely also pertains to the open center of his *Cryosphere* and of his Pine Barrens *Non-site*, to all those circles he painted with dark centers, and explains the mystery of his *Secret Partner*, who was *Alive in the Grave of Machines* and why his was a *Decayed House*.

Characteristically, Smithson's titles contradict physical experience while referring to metaphysical comprehension. The complementarity of site and nonsite puns on the homonym "sight" and the experience of invisibility, unavailability to sight, or blindness. But refuting what they describe, the nonsite is visible to the gallery viewer, whereas from there the site cannot be seen. Discussing the circularity of meaning invoked by the nonsites, Smithson stated,

> There's this dialectic between inner and outer, closed and open, central and peripheral. It just goes on and on, constantly permuting itself within all this endless doubling, so that you have the nonsite functioning as a mirror and the site functioning as a reflection, so that existence becomes a doubtful thing to capture, so that you're presented with a nonworld—or what I call a nonsite. . . . What fascinates me [is] the nonexistence of this very solid real material—raw matter—and the impossibility of knowing it. . . . What you're really confronted with in the nonsite is the absence of a site.[65]

That "existence becomes a doubtful thing to capture" seems to be another aspect of the *prima materia* of Smithson's work, here the dialectic where Harold's existence, the unseen site, was difficult to capture, and for which he was the nonsite/not-Harold, who was the site with whom he contained fraternal aspects and was viewed in tandem.

Without knowing the circumstances of Smithson's birth, Craig Owens recognized that "whenever Smithson invokes the notion of the center, it

is to describe its loss. The nonsite is only a vacant reflection of the site."[66] Smithson's discourse presents the site as something distant or inaccessible, but the nonsites are not vacant. On the contrary, Smithson explained, "I have developed the Non-Site, which in a physical way contains the disruption of the site."[67] Literally, the nonsite structure *holds* the distant locale's loose earthen matter, enacting *containment* of an unbounded, perhaps overwhelming, environment, as he himself suggested when referring to the site as "oceanic."[68] He extended that in a remarkably revelatory statement to interviewer Patsy Norvell: "My interest in the site was really a return to the origins of material, sort of a dematerialization of refined matter . . . a sort of rhythm between containment and suffering."[69] Again, this evokes his work as a reliquary, a keepsake of mementos associated with a revered antecedent distant in time and place.

But Smithson's containers of suffering related to material origins clearly did not contain the matters concerning him. They spilled over, the back-and-forth rhythm of his attention did not cease. Smithson explained his nonsites as "an act of recovery. I'm recovering, or bringing, or gathering. The art is made by gathering rather than by . . . I'm gathering something that is dispersed, a disintegrated substance then reintegrating it into the system."[70] This sounds like both remembering and re-membering a dismembered body, trying to make it—or himself—whole again.

The nonsite/site dyad is another manifestation of Smithson's interest not just in duos—Rome/Passaic, mirror/reflection—but in the ultimate antithesis. He acknowledged this in stating to Norvell that his "view of art springs from a dialectical position that deals with, I guess, whether or not something exists or doesn't exist. Those two areas, those two paths—the existence and the nonexistent."[71] They oscillate throughout his work.

Professional
Consummation
1969–1970

FIGURE 10.1. Detail of Robert Smithson, *Mirror Trail,* New Jersey, 1969.

10

Mirroring Absence

Why do mirrors display a conspiracy of muteness concerning their very existence?

Mythology and the iconography of Western art tell us that the mirror, particularly when gazed into by a woman, connotes self-absorption or vanity. And as both Narcissus and Snow White knew, it is a wounded self—a sense of insufficiency—that draws one to endlessly seek oneself reflected in a mirroring surface to confirm that one exists and is appealing. (Today some use selfies to show that.) But unlike those personages' relation to the mirror, and ours when brushing our teeth, Smithson's placement of the mirror in sculptures is not opposite the face at eye level. His mirrors in sculptures thwart a viewer's examination of the reflected visage. Instead, exhibited tabletop in a dark room (*The Eliminator*) or on display plinths (ziggurat stacks calling up sparkling steps to nirvana); nestled in foliage or, more commonly, floor-bound mixed with piles of rocks, gravel, sand, or snow, they are too low to see oneself in them unless one crouches or squats; reflection of a person is elusive.

Sculptures made with mirrors both precede and extend Smithson's dialectic of site and nonsite; he made many more with mirrored planes than with the geological matter with which he is most commonly associated. His early constructions, *The Eliminator* (1965) and *Enantiomorphic Chambers* (1966), have two mirrors. In the latter, two open geometric constructions along the wall initially appear identical—blue metal bands outlining

FIGURE 10.2. Robert Smithson, *Four-Sided Vortex*, 1965. Steel and four mirrors, 35½ × 28 × 28 inches (90.2 × 71.1 × 71.1 cm). Collection of Dia Art Foundation. Copyright Holt/Smithson Foundation / Licensed by Artists Rights Society, New York.

open rectangles, green planes behind them parallel to the wall, each with a mirror—but then, they don't: the mirrors face not the viewer, but being perpendicular to the wall, reflect each other, making each unit an inversion of its opposite. "Enantiomorphic" structures mirror each other, such as the shapes of left and right hands, which is also seen in the vertical symmetry of crystals. "Chamber" is an enclosed space, a room, which Smithson

associated with nullity—*Ruined Building* (1955), *My House Is a Decayed House* (1962), or graves—the numerous underground cavities such as in *Alive in the Grave of Machines* (1961), *Scorpion Palace* (1961), *Buried Angel* (1962), and *Butter Mummy* (1962). Linking the doubled structure of *Enantiomorphic* to "chamber" also calls up an echo chamber. That's another manifestation of an observation by art historian James Meyer, who did not know Smithson's early biography: "The double is one of Smithson's obsessions. It is announced in the *Enantiomorphic Chambers*, those matched mirror constructions, and developed in his non-sites, which stage dialectic relationships to actual sites."[1] But Smithson designed *Enantiomorphic Chambers* with the two mirrors angled so that when one stands between them "the chambers cancel out one's reflected image."[2] That's one way of ridding oneself of the sense of serving as a mirror.

As psychologist Otto Rank wrote in *The Double: A Psychoanalytic Study*, "The presence of the mirror is ipso facto about identity, a relation of self to self."[3] That describes Smithson's mirror discourses—visual and verbal—which circle around the issue of a corollary self, as site to nonsite. Psychoanalyst Paula Elkisch elaborated:

> Whenever we deal with the mirror phenomenon, we are dealing with something enigmatic, with a thing that has been made the screen for man's projections of the mysterious and the uncanny. . . . It seems that the fear of loss of self (or soul) together with the attempt at retrieving the lost makes the mirror so fascinating to patients.[4]

Smithson's own fascination extended to the apartment he shared with Holt, where he mirrored the ceiling, dining table, and coffee table so as to study more closely the phenomena of infinitely receding reflections.[5] It was evident to others in his myriad metaphors made with them, both verbal and physical. He refracted Passaic through numerous analogies to mirrors—"Houses mirrored themselves into colorlessness"; "false mirror of our rejected dreams"; and "false mirror of eternity"—forging links between his birthplace, mirrors, and disillusionment. The mirror also seemed to epitomize for him an icon of identity itself: "That monumental parking lot divided the city in half, turning it into a mirror and a reflection—but the mirror kept changing places with the reflection. One never knew what side of the mirror one was on."[6]

The year after he wrote that, Smithson made a parallel observation: "various agents, both fictional and real, somehow trade places with each other."[7] Both reflect confusion about boundaries of identity characteristic of one born as a surrogate: was he supposed to be the mirror, "fictional" to

his own experience but compensating for by replicating what his parents had lost, or casting reflections as his authentic self? Again, his personal experience provided a model for understanding the malleability of identity, thus philosophically, of "truth."

As Smithson's work with nonsites developed, the enclosed bins were supplanted by mirrored planes standing on the floor behind piles and spills of sand or rocks or penetrating the mounds vertically or diagonally. His shift in configuring the nonsites displayed the influence of Anton Ehrenzweig's *The Hidden Order of Art* (1967). The book's title alone must have spoken to him, as his own art was based on undisclosed systems of signification. Ehrenzweig proposed another. Ideas of the Austrian-born British lawyer turned art theorist facilitated Smithson's integration of "organic floods" that in his transition to sculptor he initially sought to dam. Countering conventional thinking, as Smithson himself was becoming known for doing, Ehrenzweig promoted the concept of entropy and other lesser orders of organization not as adverse states but felicitous "hidden orders" of creativity. Dismissing the utility of sharply focused perception, Ehrenzweig favored a less deliberate, holistic gaze. In a process of absorption by visual scanning, perception of surface details and distinctions between foreground and background lessen and a sense of order diffuses. Ehrenzweig described this as a process of scenic or compositional elements being perceptually "dedifferentiated," made less discrete in relation to the whole.

With this, Ehrenzweig redefined a fundamental duality established by Sigmund Freud of primary and secondary processes of the psyche's functioning. Freud considered the original or primary one as irrational, from the deep unconscious, and having archaic sources. He likened it to a childlike id or immature ego, with the tendency toward seeking immediate gratification of one's

FIGURE 10.3. The repetitive overall pattern on the cover of Anton Ehrenzweig's *The Hidden Order of Art*—Josef Albers's *Homage to a Square* meets Richard Anuszkiewicz's Op Art vertigo—exemplifies Ehrenzweig's merging of foreground and background in creative scanning. This is the cover of the 1971 paperback Smithson owned, although he quoted from the book in his 1968 "Sedimentation" essay.

needs and desires. (Being more primitive, it was akin to the less-ordered state of entropy.) According to Freud, primary process thinking needed to be constrained, and as one matured it was controlled by the secondary process, conscious thinking, deriving from introspection, self-monitoring, learning, and socialization. Supplanting a deliberative creative process, Ehrenzweig emphasized "the role which the unconscious plays in controlling the vast substructure of art" and argued that the primary process had a constructive role in creativity.[8]

Ehrenzweig contrasted the more focused perception of figure/ground differentiation from a "dedifferentiated" holistic environmental awareness and recognition of a dominant form or "gestalt." Regarding those two ways of looking, he argued:

> Unconscious scanning makes use of undifferentiated modes of vision that to normal awareness would seem chaotic. Hence comes the impression that the primary process merely produces chaotic fantasy material that has to be ordered and shaped by the ego's secondary processes. On the contrary, the primary process is a precision instrument for creative scanning that is far superior to discursive reason and logic.[9]

But Ehrensweig was not advocating that art be made directly from the unconscious. Rather, "It is the privilege of the artist to combine the ambiguity of dreaming with the tensions of being fully awake. He extended the two modes of looking into metaphors of "containment (trapping) and expansion (liberation)" and considered them "as the minimum content of art [that] crops up in many different forms."[10] The formulation is so perfectly applicable to Smithson's discomfort with external constraint and his grappling with that in nonsite/site constructions that it is almost prescriptive. Smithson paraphrased it: "On a topographical earth surface . . . there's a sort of rhythm between containment and scattering. It's a fundamental process that Anton Ehrenzweig has gone into."[11] Smithson likened the primary process to Ehrenzweig's "dedifferentiation . . . it involves a suspended question regarding 'limitlessness' (Freud's notion of the 'oceanic') that goes back to *Civilization and Its Discontents*."[12] In that 1930 book, Freud described the oceanic state as a sense of "limitless extension and oneness with the universe."[13] It is often likened to the imagined experience of a fetus floating inside the womb's amniotic sac, a human enclosed in a liquid sensory deprivation tank, or contemplating an expansive of sea or nocturnal cosmos.

Smithson adopted Ehrenzweig's verb when writing "when one scans the ruined sites of pre-history." He described one of his own jaunts to undeveloped terrain in his home state, a trip to slate quarries with Holt, artist

Dan Graham, and his art dealer Virginia Dwan, in terms of an Ehrenzwei-gian dichotomy: "All boundaries and distinctions lost their meaning in this ocean of slate and collapsed all notions of gestalt unity. The present fell forward and backward into a tumult of 'de-differentiation,' to use Anton Ehrenzweig's word for entropy."[14]

Talking with Dennis Wheeler, Smithson highlighted *The Hidden Order of Art*'s confluence of suspended logic, dedifferentiation, entropy, and death:

> One chapter that is particularly good is called "The Scattered and the Buried God." Buried in this sense is another word for contain-ment. There's this interaction between the scattered and the con-tained. It's the tension between those two things that essentially manifests itself in fascinating art.[15]

We saw this tension years earlier in Smithson's *Buried Angel* (1962) con-strained by scattered blocks of cryptic series of numbers and letters (Plate 15).

Smithson coupled mirrors and scattered earth for the first time for *Earth Art*, at Cornell University's Andrew Dickson White Museum in Ithaca in February 1969. This show is distinguished for being both the first museum exhibition of the new earth art or earthworks and one of the first exhibi-tions to not transport works of art to its site but to bring the artists in ahead of the opening to make transient work in and around it. For his *Cayuga Mine Salt Project*, Smithson returned to the undergrounds he had depicted so frequently from late 1961 into 1963. He placed square mirrors on the floor of a salt mine cavern, on a ground-level path between the cavern and a nearby rock quarry and photographed them. In the gallery he arranged mir-rors that were supported by low mounds of salt crystals. Separately, many interior sculptures consist of floor-bound plate mirrors with sand, gravel, coral, shells, or dirt—not mixed together—loosely piled and spilling onto gallery floors, or heaps pierced by angled mirrors. Their play with the sheen and sparkle of the silvered plates in contrast to the dusty geological matter produced his most sensual interior sculptures. One of them he remade as *Rocks and Mirror Square II* (1971; Plate 26).

In March 1969, for the major survey exhibition, *When Attitudes Become Form: Works—Concepts—Processes—Situations—Information*, at the Kuns-thalle Bern, Switzerland, he sent instructions for a mirror displacement at a Bern site, represented in the exhibition by a photograph. When the show moved to the Institute of Contemporary Art, London, he made a floor-bound

piece of eight double-faced mirrors perpendicular to and radiating from the center of a pile of chalk rock.

Also that year, exploring dedifferentiation, or more literally, disorder, on a larger scale, Smithson proposed for the Los Angeles County Museum of Art's *Art and Technology* exhibition to build and demolish a concrete building and exhibit the dispersed material on the museum grounds; it was not accepted. In large outdoor works, he poured broad spills of molten asphalt, liquid concrete, and glue down hillsides in cascades of release. On the campus of Kent State University, Ohio, in 1970, he exaggerated nonsites' piles into an avalanche of dirt atop the roof of the campus's grounds empty storage cabin until its main beam cracked and sagged; he titled it *Partially Buried Woodshed*. All these works enact radical unbinding as a reaction to experiences of what in 1969 he was still pushing against, "walls of confinement."[16]

Yet for ardent observers of Smithson's work a hidden order of *art* is insufficient: the fascinating rhythm isn't so much between sculptural containment and scattering; it is the recurrent beat between things "buried" and "lurking." In the chapter Smithson recommended to Wheeler, Ehrenzweig's interpretation of "the death instinct (Thanatos) as the principle of entropy" is another source of Smithson's comment: "The word entropy . . . is a mask for a lot of other issues . . . a mask that conceals a whole set of complete breakdowns and fractures."[17] His first design of the nonsites as narrow boxes open at the top and holding earthen matter resembles the structure of a casket. When the nonsites' structure opened up as mirrored planes bordering or piercing loose piles—the inversion emphasizing diffusion and the act of scattering—well, fragments ceremonially scattered are a deceased's ashes. Smithson's appreciation for Ehrenzweig's linkage confirms what he himself described as a focus on "a lack of continuity, a continuity, I would say, that is a worldview in terms of the entropic, that runs right through."[18] That is, entropy functioned for him as an intellectual leitmotif that, like an X-ray image, viewed everything in photographic negative.

Yet Ehrenzweig argued that entropy was essentially generative—the "scattering of focus [is] inherent in syncretistic vision."[19] In the chapter that Smithson pointed Wheeler to, Ehrenzweig's declaration that "life can only prosper by a balance between differentiation and dedifferentiation. Both instincts are needed" encouraged procedures Smithson was already engaged in, incorporating the negative and transforming it.[20]

In the September 1969 *Artforum* Smithson offered readers another chapter in his journey narrations as he had in his essays "The Crystal Land" and "Monuments of Passaic." Describing his travels the previous April with Holt and his dealer and their friend Virginia Dwan to Mexico and Guatemala, and the temporary installations of mirrors he created along the way,

his essay "Incidents of Mirror-Travel in the Yucatan" converged his interests in mirroring, remote pasts, and exploratory expeditions. His discussion took on the fantastical tone of Jorge Luis Borges, who at the beginning of his first story in *Ficciones* writes that "mirrors have something grotesque about them. . . . Mirrors and copulation are abominable, since they both multiply the numbers of man."[21] Smithson himself does things strange with mirrors, but his reflect no people to double.

His excursion's acts of mirroring took two forms. Literally, between visits to decayed pre-Columbian temples, he successively placed and photographed square tile mirrors on foliage, dirt, or sandy grounds. But also, the Yucatán destination mimicked that of a travelogue published in 1843 by John Lloyd Stephens, *Incidents of Travel in Yucatan*. One of several widely popular editions of the anthropologist's accounts of visiting Mexico, Central and South America, Stephens's description of "numerous and extensive cities, desolate and in ruins" corresponds to Smithson's affiliation with entropy.[22]

Given his fraternal authorial relation to Stephens, it is not surprising that Smithson began his Yucatán essay with an analogy of lack: "One is always crossing the horizon, yet it always remains distant. In this line where sky meets earth, objects cease to exist."[23] Again, a lament: things he yearns for and appear to reach are always out of touch. He also conveys that ungraspable by several science fiction-esque oxymorons: "immobile cyclone," "dormant earthquake," "fluttering stillness." Akin to J.G. Ballard's extravagant antinaturalism, Smithson's expansive imagination operated on an alternating current between the mournful and the fantastical.

He then began channeling Aztec gods by having Tezcatlipoca, "demiurge of the 'smoking-mirror,' " expand upon Smithson's longing for the elusive horizon by declaring, "All those guide books are of no use. . . You must travel at random, like the first Mayans; you risk getting lost in the thickets, but that is the only way to make art.' " His contrary act of initiating a text that mimics a travelogue format by repudiating the guidebook genre typifies his skepticism of orthodoxy.

He had advocated that creative process eighteen months earlier as the opening to his essay "A Museum of Language in the Vicinity of Art":

> In the illusory babels of language, an artist might advance specifically to get lost, and to intoxicate himself in dizzying syntaxes, seeking odd intersections of meaning, strange corridors of history, unexpected echoes, unknown humors, or voids of knowledge . . . but this quest is risky, full of bottomless fictions and endless architectures and counter-architectures. . . at the end, if there is an end, are perhaps only meaningless reverberations.[24]

"Language as hallucinogenic drug," Peter Schjeldahl observed after quoting that passage.[25] True, but Smithson was also channeling J. G. Ballard's vivid descriptions of bizarre sights and sounds and T. S. Eliot's line from his poem "Gerontion": "History has many cunning passages, contrived corridors."

During his travel, Smithson placed and photographed roughly a dozen twelve-inch-square mirrors in the earth at nine different spots in undeveloped natural environments, from overgrown jungles to sandy beaches along the western and southern periphery of the Yucatán Peninsula. His color slides of each of these "incidents," from which he made prints and the illustrations in "Mirror-Travel," show the mirrors' edges loosely parallel and their faces slanted upward from the ground at angles generally uniform across each grouping. Cantilevering out of small mounds of earth, sand, gravel, or underbrush, their faces reflect the sky to form bright silver or white squares of light against the terrain. Or they are pictured nestled within trees, incorporating reflections of proximate greenery or spindly branches to suggest gleaming pictures standing out against muted foliage. Clods of earth or splays of leaves or stones scatter over some of the mirrors' surfaces. The images' richly hued juxtapositions of botanical and manufactured matter, organic and geometric forms, both are basic design contrasts and recall the dynamism of painterly fields punctured by planar rectangles in the "push-pull" compositions of mid-twentieth-century expressionist painter Hans Hofmann's late abstractions.

Smithson described the locale of his first mirror displacement as a "charred site. The people in this region clear land by burning it out." Their incineration is utilitarian, but Smithson fanned imagistic flames by elaborating on "scorched earth," "burnt tree stumps," and an "ashy mass." He reinforced the infernal by his congruence between the number of his displacements and with the circles descended by Dante in *Inferno*, nine. Smithson had displayed a visual affinity with Dante a decade earlier when painting large canvases of *The Walls of Dis* (Dante's lowest levels of hell) and *Purgatory*.[26] Dante's *Divine Comedy* was itself a mystical travelogue of the poet's journey through *Inferno*, *Purgatorio*, and *Paradiso*, so Smithson's adoption of its symbolism is like a historical mystical travelogue within a modern travelogue that is to be taken as mystical. *Inferno* is about souls' chthonic assignment after death; *The Self in Psychotic Process* describes Dante's overall *Divine Comedy* as "an account of a series of visions that portray in systematic order the symbols of individuation . . . a succession of circles designating levels of the depths and heights of spiritual development."[27] This sounds like the earliest journey Smithson alludes to, the "dark night of the soul," echoing the description by Saint John of the Cross of the road to union with God (Smithson to George Lester May 1, 1961, #5).

Each of Dante's three realms—*Inferno*, *Purgatorio*, and *Paradiso*—has

nine sequential levels. Their sum is 27; the number of paragraphs in Smithson's description of his nine mirror displacements is 18; that of each mirror's square inches (twelve by twelve) is 144; and twelve mirrors multiplied by nine sites equals 108. The digits in each of those numbers—27, 18, 144, and 108—sum to nine. In Christian numerology nine symbolizes the triplication of the Holy Trinity; in Smithson's history, it was Harold's age at death.

It is significant, but not surprising given Smithson's use of numerology's covert symbolism and his own penchant for suggestive puns, that he designated his nine acts of placing a dozen mirrors not with the more transparent term "arrangements" but with one that both sounds intellectually technical and connotes substitution, "displacement." In physics, displacement refers to the space of a mass that is replaced by another. That is the term in which Michael Heizer titled several earthen *Displacements* in remote terrain in 1969 and the early 1970s. The term became associated with earthworks and could be taken as stylistic and impersonal.

But for Smithson, introspective and psychologically minded, "displacement" had additional utility. Psychoanalytically, a verbal or visual displacement is a defense mechanism with which the mind substitutes an object for another one felt to be too anxiety-provoking or its display socially unacceptable. A self-aware artist could use displacement or metaphor to avoid speaking about an issue directly while calling attention to it by substituting something that resembles it, like the erect column in Smithson's paintings *Buried Angel* (Plate 15), *Dark Sister, Death Taking Life* (Plate 23), and *Vile Flower* that evoke a phallus.

In his Yucatán article, he wondered—ostensibly about mirrors: "When does a displacement become a misplacement?" It is common for children at some point to feel alienated from their parents and fantasize that in the hospital they were accidentally switched at birth. But with Smithson's history—prehistory—he has pertinent reasons to question his ambiguous familial identity. The sentences bracketing that question, both before it ("Why do the mirrors display a conspiracy of muteness concerning their very existence?," evoking remorse of being left out of knowledge others have) and after it ("These are forbidding questions that place comprehension in a predicament"), confirm that the issue was somehow locked up, sufficient examination prohibited.[28]

As his "Yucatán" story develops, his references to mortality—direct before 1965, then disguised—return and increase in frequency, prominence, and dramatization to an operatic pathos. In the second section, the god Tezcatlipoca describes the camera as a "portable tomb." The third analogizes reflections to "fleeting instances that evade measure," as if ghosts or shades, and space as the "remains, or corpse, of time." Smithson's

FIGURE 10.4. Detail of Robert Smithson, *Yucatán Mirror Displacements (1–9)*.

Copyright Holt/Smithson Foundation / Licensed by Artists Rights Society, New York.

Its red soil is another instance of Smithson's attraction to that color and its corporeal association.

peripatetic commentary moves from the butterflies swarming over their car to the Mayan obsidian butterfly ("beautiful but with death symbols on her face") and hops between mirrors, from one in which the god Tezcatlipoca foresaw the future, and the concave ones made by the Olmecs for adornment and ritual, to a symbolic jaguar in a mirror who knows "the work of Carl Andre."

In the fourth displacement the mirrors' reflections of the sky, "the unnameable tonalities of blue—another adoption of Beckett's *Unnamable* novella title for something unrepresentable—have vanished into the camera and now rest in the cemetery of the printed page—*Ancora in Arcadia morte*. That is the Italian translation of the seventeenth-century Latin aphorism, *Et in Arcadia ego*: "Even in Arcadia [a mountainous area of rural Greece

idealized since ancient times for its Edenic beauty] is death," famous as the title of two paintings by Nicolas Poussin depicting shepherds gathered around that inscription on the ruins of a countryside tomb.

The mirrors' overlay of mortality then turns to more explicit justifications for the metaphysical orientation: "The mirror displacement cannot be expressed in rational dimensions. The distances between the twelve mirrors are shadowed disconnections." And he repeats, "Such mirror surfaces cannot be understood by reason." And "Mirrors thrive on surds, and generate incapacity. Reflections fall onto the mirrors without logic, and in so doing invalidate every rational assertion. Inexpressible limits are on the other side of the incidents, and they will never be grasped." The full condition of being a mirror is metaphysically incomprehensible.

In the fifth locale, the jungle, Smithson admits, "Writing about mirrors brings one into a groundless jungle where words buzz incessantly instead of insects."[29] Vivid descriptions of light as "paralyzed" and "particles of color infect[ing] the molten reflections" suggest disease, which shortly becomes the stark claim that "it is that very lack of 'existence' that is so deep, profound, and terrible." Flatly declarative, evoking an anguish so direct it startles, this statement appears to be a burst of personal agony again masquerading as general metaphysical philosophizing. It is not about one's own "lack of existence"—that's unimaginable—but the unnerving absence of another.

Where is that missing body? He then riffs on earth-embedded rocks' underside craters, "secret dens" that are each an "entrance to the abyss . . . dungeons . . . of 'clammy solitude,'" not unlike catacombs of the entombed. He concluded that section with an imagined dialogue between Coatlicue, Aztec earth goddess who was sacrificed at the creation of the present period, and Chronos, the Greek god associated with time. Coatlicue declares, "You don't have to have existence to exist." Again, this parallels something he read in *Morning of the Magicians*, stated less evocatively: "Modern science has shown us that behind the visible there is an extremely complicated invisible."[30] Deceased intimates live in our hearts and memories, but even without direct memories of Harold—or maybe especially because of the lack of personal experience of him—Smithson conjures his presence in his bloody Christs, astrological charts, crystal sculptures, and literary metaphors. As poet Louise Glück put it regarding the sibling who predeceased her birth, "Her death was not my experience, but her absence was."[31]

After a fanciful account of flying in a small airplane over "vertiginous foliage" and travel in dugout canoe along a swift current to the Mayan temples of Yaxchilán to place the sixth set of mirrors, the seventh displacement recounts positioning mirror panels among gnarled branches where

reflections dematerialized, "retreated from . . . perception," and "expired into the thickets."

He then interrupted his sequence of mirror arrangements to enact an existential polarity in a different form. At this stop he planted his third version of an upside-down tree. After severing a tree's boughs from its trunk, he inverted the trunk and sank it into the ground so that its roots formed a twisted sky-bound crown.[32] Smithson's arboreal inversions partake of the international sign of distress, a flag flown upside down. A few months after the Yucatán trip, for the exhibition *Prospect '69* in Dusseldorf, Smithson made *Dead Tree,* prone along the floor, its branches hung with rectangular mirrors like ornaments on a disheveled Christmas pine thrown on a curb for garbage pickup. Its title is found in "The Burial of the Dead," the first section of Eliot's *The Waste Land* (1922), which was in a book he owned, "And the dead tree gives no shelter," near references to "A heap of broken images" (as would be generated by shards of mirrors) and the crucified "Son of Man."[33]

While Smithson's characterizations of his nine displacement sites are not each analogous to the types of sinners Dante associated with each of the nine circles of *Inferno,* here there is a connection between the sunken inversion of Smithson's trees and the Wood of the Suicides Dante observed in the seventh circle of hell. Trees have historically inspired the mystical symbol of the arborvitae, "tree of life." Contradicting that symbol of vitality, the upturned orientation of Smithson's trees mimics the international nautical sign of distress, an inverted flag. In religious terms the upturned trunk parallels Saint Peter's martyrdom on a head-down crucifix (itself associated with its source material and form, a tree). Smithson had worked with that motif before, in his set of drawings *Valley of Suicides* (1962) depicting Dante's Canto XIII, those who had been "Violent Against Themselves" and who were confined to sinewy trees, their limbs branching.

The site of the mirrors' eighth displacement, the eroding landmass of the Island of Blue Waters, then inspired a geographical analogy. "The island annihilates itself in the presence of the river both in fact and mind," another connection as in his "Sedimentation of the Mind" essay between geology and psychology. Then, "The river shored up clay, loess [a type of loam and homonym for "loss"], and similar matter that shored up the slope, that shored up the mirrors. The mind shored up thoughts and memories, that shored up points of view, that shored up the swaying glances of the eyes." Again, Eliot's *Waste Land* is an inspiration; the end of part V, "What the Thunder Said," states, "These fragments I have shored against my ruins."[34] And again, obsession with absence, the mental existence without corporeal one, and logical inversions: "The memory of what is not may be better than the amnesia of what is."[35] Vivid fantasy is better than fading reality.

In the ninth and final displacement, Smithson extended his metaphysical musings on mirrors and absence to suggest that what he sought was not a reflection of himself, what one would view in a mirror, but his other half, a complementary identity. He described "two asymmetrical trails that mirror each other" as "enantiomorphic" and extended the riff on doubleness to Quetzalcoatl, the god of both wind (represented by stylized feathers) and earth (serpent and snakeskin). Smithson could easily identify with Quetzalcoatl's duality, being a visual artist and literary essayist; a vanguard artist who was covertly Catholic; an intellectual who privately read Jung, alchemy, and the occult; who was attracted to both women and men; and who felt himself to be existentially connected to an absent sibling. Characteristically, Smithson construed the salient aspect of this Aztec figure of duality not as plenitude but lack, identifying the god as "one half of an enantiomorph (*coatl* means "twin") in search of the other half. A mirror looking for its reflection but never quite finding it."[36]

Manifesting that absence, the Yucatán region's famous architectural ruins of "dead" Mayan and Aztec cultures, the ostensible reason for their travel there, do not appear in his photographs, either directly photographed or reflected in his mirror displacements. Likewise, consistent with his other deployment of mirrors as discussed here, Smithson arranged his mirrors so that they reflect the environment, or light but no persons. "That's always canceled out," he said around the time of Cornell's *Earth Art* exhibition. "No spectator can fit himself into the mirror."[37] Can there be a more direct plaint of the frustrations of one born as a replacement, who can never fit himself into being the mirror image of the idealized lost one, or fit into the mirror of the family prior to his arrival, or as he noted regarding Passaic, can't figure out what side of the mirror he is on?

At the conclusion of the ninth displacement, he reiterated the lament with the paradox that "it is the dimension of absence that remains to be found." Smithson's play with mirrors extends the antinomies recurring across his visual and literary art: up/down; the future/in reverse; remote future meeting remote past; presence/absence; time/timelessness; site/nonsite; existence/death. These oppositions are like signals of his developmental condition of living a dialectical condition that flipped between the identities of "replacement" and "self." The very frequency of Smithson's dyadic ideation demonstrates his displacement not so much of mirrors onto terrains as of personal history into art.

But the aesthetic creation was not only in the realm of the "tomb" of the printed page. Smithson's kooky act of creating a literary fantasia that begins by his ventriloquizing an Aztec god illustrates both his imaginative power and his self-confidence such that he would expose this pseudo-hallucination in the circumspect *Artforum*. In effect, he enacted that which

was advocated by the authors of *The Morning of the Magicians*: "No other aspect of the mind *dives* as deeply as the imagination."[38] The new quality in Smithson's sculpture and essays from the late 1960s was increasingly explicit fusions of intellectuality with fantastical rumination. These expressions convey an artistic self freely displaying idiosyncratic concerns and symbolic forms that a decade earlier he had expressed uneasily—and in the mid-1960s, clandestinely.

Concomitantly, Smithson's increase in expressivity was facilitated by the material and emotional loosening up characterizing late sixties' Post-Minimalism, also known at the time as Anti-Form. Smithson's crystal-like, enclosed jagged units had opened up to become bins holding matter from sites, then the nonsites themselves were breached, with rocks or sand dispersed in and around them, or they become single planes piercing loose piles. Describing the release from the rigor of Minimalism to the amorphousness of Post-Minimalism, and tacitly referring to Smithson's initial sober discourse expanding into imaginative discursions, Robert Pincus-Witten retrospectively observed, "Emblematic of the shift, Robert Smithson was turning into another kind of Robert Smithson."[39] Not knowing of the artist's pre-1964 work, the art historian and critic couldn't recognize that the concurrence of the vanguard's fracturing of Minimalism's rigidity and Smithson's growing professional confidence converged to permit a personal return of the suppressed.

With this, Smithson took a further step, to use Félix Guattari's term, "to resingularise" himself:

> Grafts of transference operate in this way, not issuing from ready-made dimensions of subjectivity crystallised into structural complexes, but in a creation which itself indicates a kind of aesthetic paradigm. One creates new modalities of subjectivity in the same way that an artist creates new forms from the palette. In such a context, the most heterogeneous components may work towards a patient's positive evolution.[40]

Without starting with the blank canvas that might be implied by Guattari, in his Yucatán essay, Smithson made use of the imprint of history—that of art and of his own birth—and with it brought into play discrepant aspects of his personality. Actualizing the hybridity of the feathered serpent, Smithson synthesized them toward a fuller integration in "new modalities of subjectivity" he will compellingly coalesce in *Spiral Jetty*.

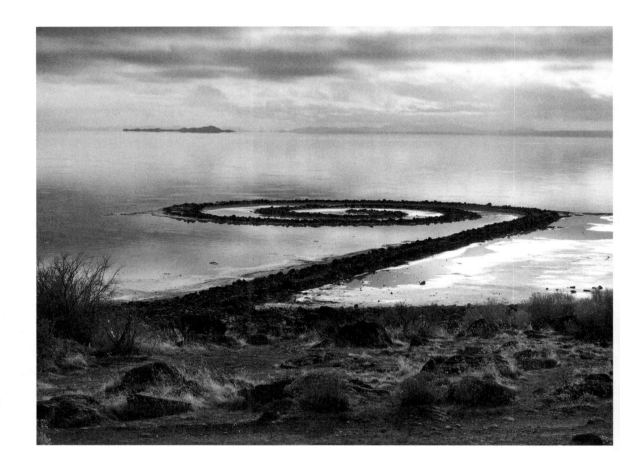

FIGURE 11.1. Robert Smithson, *Spiral Jetty,* 1970. Great Salt Lake, Utah. 1,500 ft. (457.2 m) long and 15 ft. (4.6 m) wide. Artist Patricia Leighton made this photograph in April 2008, when the water below Rozel Point was very low. Courtesy and copyright Patricia Leighton. Collection Dia Art Foundation. Artwork copyright Holt/Smithson Foundation and Dia Art Foundation / Licensed by Artists Rights Society, New York.

11

The Site of the Spiral

Thicker Than Water

From a ruptured / Blood vessel / Comes a prayer.

In its first issue of the new decade, *Vogue* magazine promoted Smithson, at thirty-two, to a place among "twenty-one wild bets for the 1970's. . . . All show talent, vitality, strength, and the drive to ride the clock." Fulfilling Meyer Levin's 1958 hunch that "[Smithson is] a good bet to come through, one day, with work of individual power" he was included along with social activist and politician Julian Bond, then thirty; author and publisher of the new age *Whole Earth Catalog,* Stewart Brand, thirty-one; director of the National Gallery of Art, J. Carter Brown, thirty-five; actress Blythe Danner, twenty-six; and singer Roberta Flack, thirty-four. The only other visual artist was Sol LeWitt, the eldest at forty-two, who since snapping up Smithson's $23.50 per month Wall Street–area loft eleven years earlier had become well regarded for his modular sculptures and wall drawings. Smithson's inclusion by the doyenne of fashion periodical dictators "at the center of artists taking art out of galleries and museums" was remarkable recognition for one who had begun doing that, at Cornell University's *Earth Art* exhibition, less than a year earlier.[1]

In *Vogue*'s description, the hint of the primal is unmistakable—the publication's "wild bets" calls up the radical early twentieth-century painters Henri Matisse and André Derain, decried as *les Fauves,* "wild beasts." The "drive to ride" evokes the pioneer bravado signaled by earthworkers' cowboy

attire of hats and boots, that is, not to "ride the clock" but to ride herd. The allusions were perfect for Smithson, who was about go west (again) in search of a raw earth and red water that he could subdue into environmental art. As he recounted in his oral history, "The Dwan Gallery was then ready to back such a project. The Earth show had taken place [*Earth Works* at the Dwan Gallery? *Earth Art* at Cornell?] and the context was set."[2]

Four months after that issue was published, Smithson fulfilled *Vogue*'s prediction of experimental greatness by constructing *Spiral Jetty*. Materially, it is a fifteen-foot-wide, fifteen-hundred-foot-long (one-quarter mile) path built in the water of a cove of the Great Salt Lake. (Since then, in various years' long phases it been submerged or landlocked; I will analyze this work as Smithson initially constructed and intended it.) Its scale in relation to humans is monumental, although not in comparison to the huge body of water. Consisting solely of 6,650 tons of basalt rock and earth dug from below the slightly elevated hillside road behind it, it was constructed by the challenging procedure of mounding a curving earthen path in a shallow cove.[3] The funding for the initial twenty-year renewable land lease from the state of Utah and for its construction was paid by his gallerist, Virginia Dwan, who had both the will and the resources to fund acres for artists. Holt recalls: "It didn't cost a lot to make the *Spiral Jetty*. So, Virginia was handsomely [re]paid" in kind, being given sculptures by Smithson that by the time she sold or donated them had considerably appreciated.[4]

That spring he made a film about it, funded by Dwan and gallerist Douglas Chrismas. Two years later his essay "The Spiral Jetty" was published in the anthology *Arts of the Environment* (George Braziller, 1972), edited by Gyorgy Kepes, whose lead essay, "Art and Ecological Consciousness," misread Smithson's intentions for his earthwork. *Spiral Jetty* has been discussed as a triadic work consisting of sculpture, essay, and film, dislodging the earthwork from a position of primacy and exemplifying a putative postmodern artistic promiscuity in media and procedure. Smithson had a suave talent for writing and film, but repeatedly asserted that for him the materialized art object or spatial environment was primary. In his most strident manifesto, "Cultural Confinement," he declared: "Writing should generate ideas into matter, and not the other way around," implying priority for the object.[5] The film and essay on *Spiral Jetty* respond to the earthwork, whereas if they didn't exist it would still be self-sufficient, providing the richest experience for the viewer/visitor. On the other hand, the essay and film provide information—literal and fantastical —that immeasurably enhance our understanding, thus experience, of the work on-site.

· · ·

For art by an ambitious New York artist desiring notice by the urban art world, the remoteness of the location of *Spiral Jetty* was perverse—forbiddingly so for many, alluringly so for the adventurous. At the time it was about two hours' drive from Salt Lake City, the last hour of which was then over unpaved dirt roads originally made to get to the oil extraction jetty southeast of Smithson's site or adjoining ranch lands; the road was often weather rutted. The challenges of travel to remote sites were part of the thrill: prove your devotion to experimental art by getting there! The necessity of committed intrepidness to see *Spiral Jetty* was eventually eased by Box Elder County's paving and road maintenance. Parking lots and toilet facilities will be built, a necessity demonstrated during the Covid-19 pandemic when *Spiral Jetty* advocates became alarmed at the surge in visitors, which topped out one day at seven hundred cars.[6]

Just as a spiral can be viewed as either centripetal or centrifugal, Smithson's *Spiral Jetty* can be considered at once a condensation and an expansion of his previous work. It is most frequently analyzed in relation to Smithson's most explicit intellectual signature, entropy. The massive spiral of earth and rock is not structurally reinforced by construction materials such as concrete or lumber as subsequent Land Art would be when funded by institutions seeking to maintain the art they commissioned as well as their investment. As its surface has altered over time, the work is popularly thought of as exemplifying entropy's gradual loss of order. Craig Owens, the first historian to declare Smithson's ideas to have been immensely influential, focused on *Spiral Jetty* as a "site-specific work [that] becomes an emblem of transience, the ephemerality of all phenomena; it is the memento mori of the twentieth century."[7] Art historian Clark Lunberry elaborated on that concept at length, asserting that *Jetty*'s regular disappearance by submersion enacts "Smithson's own broad agenda, materializing his understanding of the entropic by *de*materializing its representative object."[8]

Yet over time the earthwork has actually become *more* materialized. Structurally, as Smithson explained to painter and writer Gregoire Müller, "Its mass is intact because it's almost 80 percent solid rock, so that it held its shape. Yet at the same time it was affected by the contingencies of nature."[9] As philosopher Gary Shapiro has noted, there is an obvious contradiction between Smithson's acceptance of universal entropic decay and his desire that his own unreinforced earthworks be maintained and preserved in or close to the state in which he completed them.[10] Through the ebb and flow of the lake's water level over decades—the extremes being complete submergence and absolute dehydration of the area so *Jetty* lay exposed on the salt flats—the compressed path edged with packed boulders has remained intact. With its salt frosting, its degree of complexity did not entropically decrease, but negentropically complexified. What was assumed to be enacting

FIGURE 11.2. Imagine the darker edging and doors of this derelict trailer as pink, perfect above the roseate water at Rozel Point. In the left distance, Dolphin Island is like the "special island" Bali Hai, "lost in the middle of a foggy sea," calling you to "come to me" (from the musical *South Pacific*). Photograph by Suzaan Boettger, July 1997.

Smithson's entropy in gradual erosion in actuality experienced geological accretion. Heavy rains wash away the salt covering but it returns along the edges and, after extended submersion, across its surface. But in recent years, as drought and global warming have pulled the shoreline out past the periphery of *Jetty*, it has been immersed in the salt flats, so that it is becoming an emblem manifesting climate change.

During Smithson's visits, the ruins of structures near the rim of the Great Salt Lake, passed on the way—a ramshackle pier, abandoned amphibious vehicles, and sagging domestic trailer (most now removed)—demonstrated entropy. As he described it, "two dilapidated shacks looked over a tired group of oil rigs . . . and seeps of heavy black oil . . . A great pleasure arose from seeing all those incoherent structures. This site gave evidence of a succession of man-made systems mired in abandoned hopes."[11] His characterization continued an attraction to ruins evident early on, in his *Untitled (Ruined Building)*, drawn when he was seventeen; in his pictures of Christ's and angels' ruined bodies, incantations such as "To the Man of Sorrow" ("May your Blood / Redeem the Ruin / Of those planning ruins,

/ Of those building ruins"), and drawing of dinosaurs, an extinct or "ruined" species. As a developed artist he identified with entropy's dissolution of order, referred to the more customary form of ruins, architectural, in the weather-beaten local bridge and pipes in his tour of Passaic. He addressed cultural ruins in his Yucatán visits to decimated civilizations, and even found analogies in the verbal: "Out of [Michelangelo's "quagmire of confounded passion"] comes . . . a ruined joke."[12]

Another source of collateral satisfaction may have been the contrast of those rusted ruins to their material, structural, and social inverse, the two polished nineteenth-century train engines facing each other on a single track at the nearby Golden Spike National Historic Site. Dramatizing the joining in 1869 of the Union and Central Pacific Railroads to establish the United States' first transcontinental railroad, the engines can be seen as representing what art historian Robert Hobbs aptly described as "the no longer valid [industrial/social] optimism of the recent past."[13]

FIGURE 11.3. Robert Smithson, *Untitled*, 1955. Mixed media, 16⅞ × 11¼ inches (42.9 × 28.6 cm). Copyright Holt/ Smithson Foundation / Licensed by Artists Rights Society, New York.

Smithson's affinity for the degraded started early.

Smithson sited all three of his major earthworks, *Jetty* and the two subsequent ones in the Netherlands and Texas, in bodies of shallow water. He noted to Gregoire Müller about such environmental work: "There's something about water that quickens my motivations."[14] As intentions were not something openly discussed, he did not elaborate. But we do know from Smithson's essay on the jetty that it wasn't the water that brought him to the Great Salt Lake—there are lakes everywhere and good-size saline ones in California, Nevada, and New Mexico—but the hue of the cove below its Rozel Point.

Smithson began his "Spiral Jetty" essay by recounting how his work at the edge of Mono Lake in California (so saline that Mark Twain called it the "Dead Sea of the West") drew his attention to salt lakes in southern Bolivia, where "the pink flamingos that live around the salars match the color of the water." He quoted from the book *The Useless Land*—that is,

nonarable soil—whose authors describe the water of Bolivia's Laguna Colorada as "pink over almost its entire surface and the tint is that of a pale cherry changing with the hour of the day and the observer's position."[15]

Bolivia's pink lake was impractically distant, and the marine life in Mono Lake does not generate roseate water. Through a sequence of contacts Smithson found tinted water in the northern shore of Utah's Great Salt Lake. He recounted: "Well you can't believe how red the water is. It is like Chianti, or the ranger referred to it as tomato soup. That is in the late summer. In the winter it goes sort of a brown rusty color."[16] The water's hue is so strange that one wants to call it unnatural, but it is precisely because red microscopic algae and bacteria microbes thrive in the saline water that it is roseate. Annually, that is intensified by the additional red of molting brine shrimp. Scholar of *Spiral Jetty* Hikmet Sidney Loe provides a clear scientific explanation for the color:

> The north arm of the Great Salt Lake, the location of Rozel Point, contains a higher level of salt than the southern half, creating a rather harsh environment in which few organisms can live. Of these, red algae and bacteria are able to thrive. The brine shrimp are a brilliant red color, and during the fall molting season deposit their shells in the lake. While the shrimp contribute to the lake's red color, the bacteria provide almost a constant source of color, ranging from blood red to rust orange and purple pink. The bacteria live on the remains of the brine flies and shrimp in close proximity to the algae. It is the bacteria that give the lake its constant red color.[17]

The lake has no source of water in an underground stream; it derives solely from snow runoff and rain. When these are insufficient, the water becomes intensely salinated. Additionally, south of *Jetty*, the Lucin Cutoff railroad line across the lake (originally a trestle; replaced by a rock-and-dirt causeway) thwarts easy flow between the north and south parts of the lake, intensifying the darker color of the northern half. When there is water in the cove below Rozel Point (rare in recent years), a direct experience of Rozel Point presents an astonishing spectacle of an inlet so ruddy that this earthwork cannot be spatially perceived as a graphic swirl contrasting to a neutral field, but rather must be seen as an environmental totality of rocky coil within a very prominent milieu that varies across the day and year from lavender to crimson.

Dwan called the water's hue at Rozel Point "lurid" and said Smithson accentuated the color in his *Jetty* film by using "a red filter to increase the sense of . . . a hellish other world."[18] The otherworldly color was also familiar in his paintings: *Eye of Blood* (1960), *Vile Flower* (1961), and *King Kong*

the Monster (1962) have red backgrounds; *Dies Irae* (1961) has arcing black bands on a roseate field, foreshadowing *Spiral Jetty*'s black basalt spiral in the rosy sea. Smithson described how Australian Aborigines "use blood in their pigments. . . . That was a basic source for them. . . . The film-maker Jean Renoir said that you can't have art without a little blood, and there might be a certain truth to that."[19] A science fiction novel he owned, *The Other Side of the Mountain* (1968), by Michel Bernanos, tells of two men who find they have stumbled onto another side of reality, a world permeated with red beneath a crimson sky, foreshadowing Smithson's *Spiral Jetty* site during red sunsets.[20]

Intensely saline water is thicker than regular water; so is blood, and that is what had not been seen since *The Eliminator* (1964) and burst forth again. Although many have noted the ruddiness of the water where *Spiral Jetty* is situated, few have ventured to describe its appeal to Smithson. Michael Kimmelman made a logical association: "Smithson admired the science fiction of J. G. Ballard," the *New York Times* critic wrote when *Jetty* reemerged from submersion in 2002. "The red water vaguely evokes a Martian sea."[21] In writing his "Crystal Land," Smithson had mirrored Ballard's *Crystal World*. And in his unpublished essay "Artist as Site-Seer" (1966), he described "The Waiting Grounds," one of the few Ballard stories set on another planet, although he wrote no Martian narrative. A more striking demonstration that Ballard and Smithson could be considered blood brothers is their attraction to bodies of red water. Ballard's hallucinatory descriptions in *The Drowned World*, which Smithson owned, include: "At times the circle of water was spectral and vibrant, at others slack and murky, the shore apparently formed of shale, like the dull metallic skin of a reptile. Yet again the soft beaches would glow invitingly with a glossy carmine sheen."[22] And Ballard set nine stories in a posh resort that he took for the title of the collection, *Vermilion Sands* (1951). That describes the color of *Jetty*'s terrain when the water level recedes and its shallow lakebed is an expanse of white whose seepage tints it variegated red.

But it is not necessary to speculate about Smithson's associations to the red water he sought, as the epigraph he placed above his own words in his "Spiral Jetty" essay prominently insinuates a connection he then made explicit. I will defer to art historian Thomas Crow for his pungent concision: "A quotation from the English neo-Catholic apologist G. K. Chesterton [conveying the zeal of a convert from High Church Anglicanism] projects a deliriously mystical vision of blood's color": "Red is the most joyful and dreadful thing in the physical universe; it is the fiercest note, it is the highest light, it is the place where the walls of this world of ours wear thinnest and something beyond burns through."[23] As noted earlier, Chesterton's following sentence, not quoted by Smithson, intensifies the intrigue: "For it

marks the sacredness of red in nature, that it is secret even when it is ubiquitous, like blood in the human body, which is omnipresent, yet invisible. As long as blood lives it is hidden; it is only dead blood that we see."[24]

Smithson's own hematological effusions in his essay contradict that. Even though his association of blood was with death by leukemia, fixation on it in his consciousness was alive. In his essay, first, he made a primitivist connection between the Salt Lake's water and blood: "Chemically speaking, our blood is analogous in composition to the primordial seas." Then he related his own fantasy:

> On the slopes of Rozel Point I closed my eyes, and the sun burned crimson through the lids. I opened them and the Great Salt Lake was bleeding scarlet streaks. My sight was saturated by the color of red algae circulating in the heart of the lake, pumping into ruby currents, no they were veins and arteries sucking up the obscure sediments. My eyes became combustion chambers churning orbs of blood blazing by the light of the sun. . . . Swirling within the incandescence of solar energy were sprays of blood. My movie would end in sunstroke . . . I had the red heaves, while the sun vomited its corpuscular radiations. . . . Surely, the storm clouds massing would turn into a rain of blood.[25]

With his own vermilion vision, Smithson circled back to his numerous renderings of Christ's Passion and *Flayed Angels* painted profusely bloody. He also implicitly linked Rozel Point with his incantation lines: "With the Red fever / In the Red night / Small portions of martyrs / Rained Red / Upon our sleep."[26] Crow has been one of the few to recognize this connection, noting: "In both *Feet of Christ* and *Man of Sorrow* [*The Forsaken* hands (Plate 5) and many other of Smithson's images of Christ] one finds pinwheel forms like spiral nebulae radiating from the point where the flesh is pierced, standing in place of both wound and blood."[27]

When in his essay on *Jetty* Smithson jumped from "blood is analogous in composition to the primordial seas" to, in the next sentence, "a floating eye adrift in an antediluvian ocean," he evoked his painting, *Eye of Blood* (1960, Plate 2).[28] White chunks—streaked, dotted, and washed with red—encircle a crimson-and-black core. Atop them, thinly painted concentric lines evoke spiraling tension wires holding the blocks in place. Those colors and spiral precede *Spiral Jetty* by a decade.

But also, the painting's configuration of circular density and below it a row of white vertical rectangles calls up a large round stained glass window above columns on the facade of Gothic-period churches, illustrating Smithson's declaration to Lester: "The spirit of my art is being drawn from

a Pre-Renaissance mood" (April 7, 1961, #4). A cathedral's radiant disk shining into the nave so frequently venerates the era's second major religious icon, the Virgin, that it is often referred to, for both its tondo shape and subject matter, as a "rose window." That is the primary flower symbolizing the Virgin; its red color reflects her son's blood, and its thorns stand for the tortuous spiky crown worn during his Passion. Smithson wrote in an incantation, "The Red storm / Brings roses."[29] As he did in his "drunk on blood" insertion into his "Iconography of Desolation," the eye-blood-Virgin-crucifixion nexus connects the maternal image to blood.

But this painting's title, *Eye of Blood*, directs attention to other linkages Smithson made between blood and eyes: incantation lines "Blood mingled with tears" and "Here is the eye that cracks into rivers of blood"; his pointedly titled bloody *Blind Angel* painting (1961), and his "Spiral Jetty" essay's declaration, "My eyes became combustion chambers churning orbs of blood."[30] They call up ocular hemorrhage, a symptom of myeloid leukemia that suggests Harold may have suffered either ocular

FIGURE 11.4. Robert Smithson, *Blind Angel*, 1961. Gouache and ink/paper, 17 7/16 × 15 7/8 inches (54.6 × 40.3 cm). Photograph by Paul Hester. Courtesy Menil Collection, Houston. Copyright Holt/Smithson Foundation / Licensed by Artists Rights Society, New York.

The sinister black halo and eye mask evoke the satanic more than the sacred, an identity further muddled by this figure's delicate lips, bra, and pointy fingers contrasting to virile shoulders and compact hips. The clipped-wing angel in drag, unlike Smithson's *Flayed Angels* in Figure 2.4, is not bloody but signals that reference in the leukemic tattoo of the encircled nucleus: another instance of "confounded passions."

hemorrhage from myeloid leukemia or meningeal leukemia, tumors that grow around the brain, impairing nerve function and causing blindness. According to Dr. Freireich, the specialist in childhood leukemia, the optic nerve at the base of the brain is one of the first to go.[31]

But rather than horizontally ocular like a human eye, the "eye" in *Eye of Blood* is more circular. And its large black dot is like all those within circles in other Smithson paintings—the pupil as the nucleus in the white blood cell that goes rogue to produce hemorrhagic leukemia. The disease is inscribed in Smithson's corresponding incantation "To the Eye of Blood."

Its words "In the tempest of hail, / We seek / In the destroying storm / We seek" suggests a blizzard of aberrant white blood cells ravaging the healthy red blood cells to become leukemia's pussy corpuscles.[32]

Smithson associated the eye with blood again when describing the Rozel Point site, where his eyes were "saturated by the color of red algae . . . ruby currents [and] orbs of blood." And that linkage of eye plus blood prompted his "thought [while at the site] of Jackson Pollock's *Eyes in the Heat*." All these connections suggest that Smithson had a characteristic artistic eye *for* blood—his creative process after being fraternally bloodstained.

Artist Peter Halley was the first to recognize Smithson's "obsession with blood, and with the color red" and perceptively link the early paintings' figures "covered with rivulets of blood . . . to the theme of blood [that] would return with a vengeance ten years later in *The Spiral Jetty* and in Smithson's essay of the same name."[33] To understand Smithson's connection of red and blood more substantially we must consider it in relation to two other hues prominent at *Spiral Jetty*.

Tar seeps near Rozel Point are black. And as at Bolivia's Laguna Colorada, the cliffs along the shore are black basalt. To form the jetty, the construction crew extracted boulders of that volcanic rock. Black is another main color of Smithson's constructed environment, prominent when originally built and later visible as the jetty's geological and earthen matter after heavy rains wash away salt encrustation.

Smithson's attraction to the site's third major color, white, is illustrated by his compressed quotation of a line from a short story by Malcolm Lowry that he scrawled above a drawing of an early form of the jetty (*Spiral Island with Curved Jetty*, 1970): "Strange islands, barren as icebergs and nearly as white (off California coast)." As with his Chesterton epigraph and those above other essays, the ensuing unquoted lines give a relevant punch. After Lowry's word "white" is "Rocks! The lower California coast, giant pinnacles, images of barrenness and desolation, on which the heart is thrown and impaled eternally."[34] This poignant lament echoes Smithson's attraction to the Pine Barrens and his own essay's exploration of desolation. The source is Lowry's book *Hear Us O Lord from Heaven Thy Dwelling Place*, which Smithson owned. Its title is the first line on the score of "Fishermen's Hymn" on its frontispiece, which sounds like incantation pleas by Smithson such as "God the Father of paradise / Mercy."[35]

Just as important as the jetty's bleached hue is how it is generated. Initially, the saltwater lapping at the edges of the path produced a white fringe, creating a dramatic image of a curving path of soil and black basalt boulders, white icing along the edges, and red water between the curves and

surrounding the path. But more often, the water table has risen irregularly, sometimes for years. When the spiral's immersions subside, the encrusted path glistens white, sometimes beaching atop a white expanse seeping red.

That accretion of white is a process central to Smithson's design. In his application to the state of Utah for a twenty-year renewable land lease, he provided an artistic rationale indicating the importance of the interaction between the cove's color and its salinity:

> The purpose of placing the rock on the mud flat area will be to induce salt crystals on the rock and gravel as incrustations that will develop over a period of time. These will contrast with the red color of the water. Its purpose is purely aesthetic.[36]

This succinct pitch made the project comprehensible to the director of the Division of State Lands. Despite the visual appeal of the white-encrusted black whorl against red water, however, it would be a mistake to take Smithson at his administrative word that his aim was "purely aesthetic." "Purity" was a concept foreign to his advocacy of meaning as syncretic, deriving from back-and-forth interactions between object and environment. His official explanation so contradicts his characteristic attitude that it appears that for the purposes of this application he performed artistic formalism. His writings and interviews disparage a narrow focus and the primacy of aesthetics. "Critics . . . by focusing on the 'art object,' deprive the artist of any existence in the world of both mind and matter."[37] In the "Jetty" essay itself, he disdained "logical purity" and noted that "ambiguities are admitted rather than rejected, contradictions are increased rather than decreased. . . . Purity is put in jeopardy."[38] Rather, the white derives from the opposite of purification, a continuous process of accretion of salt atop black basalt, the two situated in red water.

Associations to those three colors go a long way back, both in Smithson's work and in Western belief systems. In a 1961 letter planning his Rome exhibition, Smithson informed Lester that of his eight proposed illustrations for the brochure, "All of the paintings consist of three colors: red, white, and black" (May 1, 1961, #5). The color scheme of others on the accompanying list of works for his show, such as the three versions of *Man of Sorrow* and *Eye of Blood*, are also that triad. In the incantation "To the Flayed Angels" that he wanted published in the exhibition brochure they become trinitarian. "In the name of the Father, Son and Holy Ghost.

In the colors of the White, Red and Black.
Action against Passion.
Passion against Action.

> This is the Divine Agony, the Blood Drenched
> Glory and the Wound of Infinite Joy.
> Let the color White turn into
> Bread and Flesh.
> Let the color Red turn into
> Wine and Blood.
> Let the Flesh and Blood atone
For the emptiness.[39]

As he implies, the association of roseate water with blood mimics the sacrament of the Eucharist during the Mass when the wine becomes the blood of Christ.

Further in the remote past, the mutations of *Spiral Jetty*'s colors mimic the alchemical process. Carl Jung wrote: "One might be tempted to explain the symbolism of alchemical transformation as a parody of the Mass were it not pagan in origin and much older than the latter." Jung explained the goal of alchemy:

> Four stages are distinguished . . . characterized by the original colors mentioned in Heraclitus: *melanosis* or *nigredo* (blackening), *leukosis* (whitening), *xanthosis* (yellowing), and *iosis* (reddening). . . . About the fifteenth or sixteenth century, the colors were reduced to three, and the *xanthosis*, otherwise called the *cintrinitas*, gradually fell into disuse or was seldom mentioned.[40]

The alchemist's ideal sequence is from the *nigredo*, black, which in medieval alchemical symbolism represents germination, a preliminary stage of development, darkness as an absence of light, and something inferior, to elevation as the *albedo*, the fullness and luminosity of white, and then which is "raised to its highest intensity," to the *rubedo*, the brilliance of a hue signifying passion, fire, blood, activity, intensity itself. *Jetty* manifests that sequence when the black spiral becomes encrusted with white salt, and then is covered with Rozel Point's red water.

Smithson displayed his knowledge of the quaternity of *prima materia* when he associated his artistic process with it, stating that he liked working with "water, land, air, and fire (solar light) as a whole interconnected phenomenon."[41] All are present at the sites of his three monumental earthworks. Likewise, he adopted the ancient "Doctrine of the Four Humours" to differentiate artists he admired: "(Barthes = sanguine . . . Ballard = phlegmatic . . . Smith = choleric . . . Borges = melancholic)."[42]

In *The Golden Bough: A Study of Magic and Religion*, James George Frazer associates the colors with three disciplines of knowledge: "the black thread

of magic, the red thread of religion, and the white thread of science."[43] It is difficult to disentangle the three in early practices. Magic could apply to all the coloristic transformations of *Jetty*. Religious metaphors are evident in Smithson's connections of the red water to blood, which he linked in paintings and incantations to Christ, as well as alchemy's analogy of color transformations with spiritual purification.

It is the scientific aspect of *Jetty* that has been taken as the most prominent of Smithson's sources, evident in statements—"Each cubic salt crystal echoes the *Spiral Jetty* in terms of the crystal's molecular lattice. Growth in a crystal advances around a dislocation point, in the manner of a screw"—that emphasize an identity as a polymath autodidact and interest in natural science.[44] But personally, his association with the crystal was underscored by the planet associated with his astrological sun sign Capricorn, Saturn, which is "largely concerned with the crystallisations of the Mineral Kingdom."[45]

Turning the lens around to a biographical perspective reveals a more significant presence of science evident in *Spiral Jetty*, because it is specific to the artist. That is, the earthen path's accretion of and coverage by white salt execute on a macroscopic level the leukemic transformation of a diseased bloodstream. Following submersion in saline water, the geological *leukosis* or whitening of the jetty corresponds to the dominance of white blood cells in leukemia. Siddhartha Mukherjee described the clinical appearance of this disease: "At the autopsy, pathologists had likely not even needed a microscope to distinguish the thick milky layer of white cells floating above the red."[46] That applies to the white blocks above red in Smithson's *Eye of Blood*. And in *Spiral Jetty*'s cycling between submerged encrustation of salt crystals and, when lake water recedes, their dissolution by rain, it enacts a relentless alternation between leukemic onslaught and remission.

Spiral Jetty recapitulates Smithson's numerous references to blood in his painted imagery; his corresponding incantations; and his 1962 drawings of Dante's Valley of Suicides (persons who died by their own hand were thence confined within trees; Dante wrote "from that trunk there came words and blood," spurting "together").[47] And onto the 1965 pulsing red *Eliminator*, to the 1969 Yucatán (where "Through the windshield the road stabbed the horizon, causing it to bleed a sunny incandescence. One couldn't help feeling that this was a ride on a knife covered with solar blood") and onto Rozel Point.[48] All reinforce his sensitivity to—or eye *for*—blood.

Smithson was productively stained by a family crisis, his "voice" rising "from the whirlpool of Blood." Recognizing this source of his imagination exposes this fluid's vitality to a creative process he recognized, writing, "From a ruptured / Blood vessel / Comes a prayer."[49] His run along the spiral became a devotional transformation.

FIGURE 12.1. Still from Robert Smithson, *Spiral Jetty,* 1970. 16 mm film, color, sound, duration 35 minutes. Copyright Holt/Smithson Foundation / Licensed by Artists Rights Society, New York. Distributed by Electronic Arts Intermix, New York.

Smithson running, photographed through a red filter.

12

Inside the Spiral

Following the spiral steps we return to our origins.

The spiral, an archaic cross-cultural symbol, calls up the experience of passage—forward, inward, upward, or downward. These potential associations apply to Smithson's *Spiral Jetty*. But his act of running on it leftward in his film intensifies the direction of all of his journeys—as F. Scott Fitzgerald recognized at the end of *The Great Gatsby*, a book Smithson owned—"to be borne back ceaselessly into the past." As much as it is an environmental sculpture, *Spiral Jetty* served Smithson as a site for enacting transformation. This was akin to the goal of alchemy: to refine mineral elements and transmute the self.

Regarding the shape, Smithson asserted that "in the end I would let the site determine what I would build," and in his essay published two years later, he described the moment of discovery:

> As I looked at the site, it reverberated out to the horizons only to suggest an immobile cyclone while flickering light made the entire landscape appear to quake. A dormant earthquake spread into the fluttering stillness, into a spinning sensation without movement. This site was a rotary that enclosed itself in an immense roundness. From that gyrating space emerged the possibility of the Spiral Jetty.

He then immediately extended his declaration of a direct experiential response by denying any predetermined intellectual sources: "No ideas, no concepts, no systems, no structures, no abstractions could hold themselves together in the actuality of that evidence."[1]

His statement of the site's visceral impact corresponds to the period's emphasis on experiential immediacy—raucous multimedia music concerts with hallucinogenic light shows at packed dance halls, which in the art world had manifested earlier as Happenings and as interior sculptural arrays encouraging movement and immersion in the gallery environment. But Smithson's unequivocality about his creative process, intended to urge confidence in the utterance, prompts skepticism. Not only is any creator's assertion of independence from sources naive, but particularly so for this inventor of site/nonsite constructions who in his speech so frequently emphasized the contextual and the dialectical.

Undisclosed in his account that geographical phenomena sparked the epiphany producing his spiral is acknowledgment of two aspects affecting its final form. One, the shape of the jetty he had initially constructed was not a spiral. The present straight long roadway ended in a single wide leftward arc about half the circumference of a circle that at its end curled backward to form a small disk of an island. The shape could be likened to a flipped question mark or a shepherd's crook with a leftward arc ending in a decorative knob. It can be discerned in Gianfranco Gorgoni's widely reproduced photograph of Smithson and Richard Serra standing together at Rozel Point, the knob ending the initial arc clearly visible in the drawing Smithson holds. Inside the cover of the large album *Gianfranco Gorgoni: Land Art Photographs*, which accompanied a 2021 exhibition at the Nevada Museum of Art, the front endpaper illustrates four rows of Gorgoni's contact sheet of his aerial photographs of the first state of *Jetty*, a prominent exposure of its little-known first form.

The early form of *Spiral Jetty* was not acknowledged until 2005 in foreman Bob Phillips's account of the construction process. He noted that about a week after he thought the initial form he had built per Smithson's specifications was complete, Smithson called him back to alter it. Philips was apparently unaware that in the intervening days, Richard Serra had visited the site at Smithson's invitation to give him his view of it (thereby demonstrating their trusting comradery).[2] A 2:55-minute silent film, probably by Holt, screened in 2021 and 2022 by the Holt/Smithson Foundation on the internet and social media, shows Smithson and Serra thrashing through lake water in high wader boots, Smithson handing stakes to the more muscular Serra to hammer into the water to reconfigure it into a spiral.

But in Smithson's own film *Spiral Jetty*, he is shown solo in the water punching stakes into the lakebed—an image evoking autonomous

masculinity. Smithson and Holt did not reveal Serra's participation in the formation of *Jetty*, and to an art historian who does not want to be identified, she repeatedly denied Serra's involvement. Serra did not publicly divulge his contribution in creating the spiral until after both were dead, describing tersely—"I helped him lay out *Spiral Jetty*"—in a publication, albeit in passing and without explanation.[3]

Art historian Kathleen Merrill Campagnolo discussed the process in regard to the photographic documentation of *Jetty*'s construction. She notes that "although there are numerous drawings and sketches related to *Spiral Jetty*, the artist appears to have destroyed all that showed the first design," and that "ironically, rarely seen photographs [by Gorgoni, now published in the previously mentioned Nevada Museum of Art book] . . . contradict Smithson's carefully constructed narrative . . . lay[ing] bare his calculated manipulation of the way *Spiral Jetty* entered cultural discourse." That is true, but his act of self-advantageous self-representation is not uncommon. Also telling is this art historian's expectation of an artist's impartial representation of "the way [his/her work of art] enters cultural discourse," a presumption that has conventionally led to scholars' and critics' unskeptical acceptance of this and every other artist's words, facilitating such deceptions.[4]

Secondly, while *Spiral Jetty* was boldly innovative as a genre or type of art as an earthwork, when Smithson designed it in April 1970 the scrolling curve was familiar in his repertoire. It appears in *Eye of Blood* (1960) and *Untitled (Crucifixion)* (1961) (Plates 2 and 12) and one of his proto earthworks, a flat, triangulated spiral to be made of concrete and placed low and parallel to the ground for an "Aerial Art" project (unbuilt); its 1967 flat tabletop maquette was made of mirrors. That led to his 1968 construction of a steel, three-dimensional, standing triangulated spiral, *Gyrostasis*, which the first state of *Jetty* broadly resembles. Indeed, he retrospectively described the latter as "a crystallized fragment of a gyroscopic rotation, or as an abstract three dimensional map that points to the SPIRAL JETTY, 1970, in the Great Salt Lake, Utah."[5]

A map is a drawing of the configuration of a mass of land and water. But a map also serves as an on-the-ground guide for travel. Much has been made of Smithson's mapping procedures as conceptual art. A map could just as well be understood as endlessly seeking to know the lay of the land and a route through it. Smithson's conjunction of "maps" and "spirals" is generative, as both imply movement from one place to another: essentially, travel. In contrast to a circle, made of a line that returns to the starting point and as an unbroken unity suggests containment and wholeness, a spiral starts at one end and continuously arcs toward the other. Understanding Smithson's repetitions and returns to the spiral format benefits by adopting

his own procedure of psychological metaphors, such as his description of Michael Heizer's "dry lakes" as "mental maps." Equally relevant is the rest of his sentence, both perceptive of Heizer's melancholic "Depressions" and even more a projection of his own: "that contain the vacancy of Thanatos."[6] The map becomes an existential emblem.

Smithson's written and filmic accounts of *Jetty*'s creation omit his false start and its stylistic refinement. Nevertheless, his ecstatic association of his discovery of the cove below Rozel Point with a "rotary that enclosed itself in an immense roundness" still applies.[7] Using his scientist voice, Smithson emphasized structural connections between the scales of spirals found in nature, which range from the macrocosmic (nebulae) to microcosmic (spirochete bacteria). He also connected it to local legend. Until the 1870s, when geologists proved otherwise, the Native American belief prevailed that the lake must be connected to the Pacific by a subterranean channel, at the head of which a huge whirlpool threatened the safety of lake craft. But that, like the proximity of the Golden Spike National Historic Site which he recounts passing on his way to the Great Salt Lake, functions to provide anecdotal local color.

More significantly, as an ancient symbol the spiral incorporates the distant past. Its earliest appearance may be in Paleolithic rock engravings. On boulders at the entrance to grave mounds at Newgrange, Ireland (third or fourth millennium BCE), or the first-century BCE torana lintels at the Great Stupa, Sanchi, India, the spiral suggests passage after death. The use of a spiral calls up both archaicism in general and the whorl shape's specific meanings around issues of mortal and spiritual transition.

Viewed from the circumference, a spiral appears to contract to the center, a place of envelopment and of ending. But it is also a point of beginning: looking outward from that inner spot promises expansion to a greater realm. Identification of a spiral mandala as a map of a soul's journey—or in alchemical terms, a primary symbol of the individuation process, the "Great Work" of self-realization—adds another episode to what Smithson called his "expeditionary art"—his journeys through the dark night of the soul, to rock quarries, the Pine Barrens, Atlantic City, Passaic, and the Yucatán.[8] His combinations of journalistic guide and allusive rumination are increasingly allegorical; his discourse on *Spiral Jetty*, previously examined here regarding its hues, must also be considered within the symbolic implications of its shape and his performative interaction with it.

As his essay on *Spiral Jetty* was commissioned for an academic anthology on *Arts of the Environment*, the film, which he initiated and independently wrote, directed, and appears in, is more directly determined and

personally revealing. The first-person narration in his own voice prompts the viewer to receive the film as autobiographical, akin to his "Monuments of Passaic" and "Yucatan" accounts.

The film opens with a stock closeup made through a telescope of the sun bubbling with solar flares. The clip is documentary, but the astronomical realism is just the veneer of this account. He would have known, and it was reinforced in his copy of *The Sun in Art* (1962), that the sun is a universal symbol of divinity in pagan and Christian cultures, and as such is widely represented in religious, fine, and folk art. His bubbling sun also relates to a line from J. G. Ballard's *Drowned World*: "The image of the archaic sun burned against his mind, illuminating the fleeting shadows that darted fitfully through its profoundest deeps."[9] And the sun on fire corresponds to the cover illustration of John Taine's *Three Science Fiction Novels*. Within it, in *The Time Stream*, a character explains: "We perceived that the disc was not a perfect circle, but an irregular spiral rent and torn into streamers of what appeared to be a compact, dazzling fire."[10]

But while viewing that bubbling disk, his soundtrack of the rasp of an artificial respirator alternating billowing and sucking calls up a struggle to breathe and a threat to living. This antithesis of the sun's benefaction was tangentially elaborated a year later by Smithson's three references to poet Paul Valéry's line "Sun, sun! Brilliant Error!" Like the unquoted sentence of his Chesterton epigraph to his "Spiral Jetty" essay that puts a darker spin on it, the next line in Valéry's poem, which Smithson divulged in an interview but not in any *Spiral Jetty* material, is "You sun who masks death."[11] That has been Smithson's own procedure throughout his work: to disguise his obsession about mortality. Associated with sun imagery is light, warmth, and life itself. In its bright roundness and wholeness, Jung noted, "The classical symbol for the unity and divinity of the self [is] the sun."[12] So by juxtaposing the bubbling sun and wheezing respirator, Smithson sets the film in motion by representing

**THE TIME STREAM
THE GREATEST ADVENTURE
THE PURPLE SAPPHIRE**
Three Science Fiction Novels
BY JOHN TAINE (ERIC TEMPLE BELL)

FIGURE 12.2. The bright-yellow spiral on the cover of John Taine's *Three Science Fiction Novels* (1964) illustrates his explanation in *The Time Stream* that stars' "packed density made up the deceptive appearance of a solid impenetrable flame. It was, in fact, a vast spiral nebula of innumerable suns." The description applies to Smithson's own hidden multiplicity.

light, warmth, and the self as debilitated, an opposition between life and death.

In the film, we're then in a moving automobile, looking through the windshield at the dusty unpaved road before us, low grassy terrain on both sides, as if setting out on an expedition. Then, pages torn from an atlas randomly fall across a rocky hillside while Smithson states, "The earth's history seems at times like a story recorded in a book each page of which is torn into small pieces. Many of the pages and some of the pieces of each page are missing." Unknown pasts. A clock ticks the passing time. Can these lost pieces be re-membered, gathered together to give a sense of wholeness? The following view out the moving car's rear window looks to the past, the dust stirred by its churning wheels obscuring the passed.

After panning over a map of the lake, we're driving forward again. Then we jump to an interior close-up of a horizontal stack of five books on a mirrored tabletop. Their spines identify the titles. From the top they are *The Lost World*, *Mazes & Labyrinths*, *The Realm of the Nebulae*, *Sedimentation*, and *The Day of the Dinosaur*. Presumably they are displayed as sources of his creation of *Jetty*; all except *Mazes & Labyrinths* appear on the list of his library contents. His placement of the 1912 novel by Arthur Conan Doyle at the summit could be due to its small size, but such pragmatic rationale is insufficient. Rather, taking these titles as clues and their sequence as significant, we see that he has favored science fiction's poetic/fantastical imagination, *The Lost World*, over descriptive nonfiction *Mazes & Labyrinths* and then science's data-driven investigation *The Realm of the Nebulae*. At base, below *Sedimentation* is *The Day of the Dinosaur*. It addresses the distant reign of the big extinct being he has often depicted as an insignia of "prehistory" in general and as a surrogate for the dead being that dominates his personal prehistory.

Of the five books, he chooses to state aloud only the title of the topmost, *The Lost World*. Sure enough, enacting his highlight, in the stack's tabletop reflection that *World* is missing. It is another play with site and nonsite but inverted: the book/site is seen, the reflection/nonsite is not. This play with presence yet absence in the mirror illustrates his Yucatán declaration: "You don't have to have existence to exist."[13] Extending the circularity, *The Lost World*'s frontispiece quatrain (unseen in the film) is also relevant to Smithson's life: "I have wrought my simple plan / If I give one hour of joy / To the boy who's half a man, / Or the man who's half a boy."[14] Or the man obsessed with a boy? So, it is ironic that Doyle's novel is actually about *finding* a world thought to be lost. In it an English journalist reports a scientific expedition's discovery in South America of living, swarming pterodactyls, and bands of prehuman ape-men. Tacitly, the story addresses a fantasy of everyone who has ever lost something dear—that is, everyone:

the desire to learn of its whereabouts and recover it.

In the film, we are next in New York's American Museum of Natural History, where when he was seven Smithson's father began to take him to see the dinosaur skeletons. Also at that age, he constructed paper dinosaurs and drew a mural-size dinosaur for the hallway of his elementary school. Around the age of ten, he and his parents visited the site of dinosaur tracks near South Hadley, Massachusetts; at fourteen, he planned a family trip to a dinosaur park in Rapid City, South Dakota. In his solo show at the Artists' Gallery in 1959 he displayed paintings titled *Blue Dinosaur* and *White Dinosaur*, in an *Untitled* 1962 drawing formerly titled *Violet Ice* he drew a stegosaurus (having triangular plates perpendicular along the spine), and in 1963 a cartouche drawing shows dinosaurs fighting (Figure 5.10). The source of the stegosaurus image was likely a painting of stegosaurs by George Geselschap for the

FIGURE 12.3. Robert Smithson at site of dinosaur tracks near South Hadley, Massachusetts, around 1948, at age ten. His stiff pose and slight grimace are similar to those in Figure 1.9. Photographer unknown. Courtesy Holt/Smithson Foundation and Nancy Holt Estate Records, Archives of American Art, Smithsonian Institution.

American Museum of Natural History (Figure 12.5). The mural, located behind a display case of fossils, which as a child Smithson had collected, was on view from 1935 to 1960, thus known from his childhood visits.

Even at the age of thirty-two, dinosaurs haunt his film on *Spiral Jetty*. In his oral history, he made dinosaurs' enduring presence emphatic by declaring, "The whole thing—the dinosaurs made a tremendous impression on me. I think this initial impact is still in my psyche." Reflecting on the connection between his early visits to the natural history museum and his return to it in the film, he noted, "So in a funny way I guess there is not that much difference between what I am now and my childhood."

And of his film, he said, "the prehistoric motif runs throughout."[15] For him prehistory was the domain of dinosaurs. In his "Sedimentation" essay, he wrote, "The tools of technology become a part of the Earth's geology as they sink back into their original state. Machines like dinosaurs must return to dust or rust."[16] He analogized that idea in the film by interspersing

FIGURE 12.4. Robert Smithson, *Blue Dinosaur,* 1959. Dimensions, medium, and whereabouts unknown. Copyright Holt/Smithson Foundation / Licensed by Artists Rights Society, New York.

The Artists' Gallery must have considered this work particularly enticing, as the checklist notes that it was placed in the gallery's window.

a section of a grunting bulldozer piling earth to form the jetty with a detail of the lower-right area of Geselschap's mural for the AMNH. As it had been removed from view, he must have photographed a reproduction of the painting in the Reader's Digest book *Our Amazing World of Nature: Its Marvels and Mysteries,* published in 1969. In his film, its five-second insertion is easily missed; when perceived, it appears as if it were a transient flashback. The time of its appearance gives us a clue to its significance. Beginning at 12 minutes 55 seconds, the sum of those digits (1 + 2 + 5 + 5) is 31, the same as the sum of the digits associated with the letters in Harold's name.

In his essay Smithson describes a previous dinosaur sequence as being "filmed through a red filter," which "dissolves the floor, ceiling, and walls into halations of infinite redness. . . . The bones, the glass cases, the armatures brought forth a blood-drenched atmosphere. . . . Glassy reflections

FIGURE 12.5. George Geselschap, *Dinosaurs That Lived Together,* circa 1935. Mesozoic landscape, mural panel, Hall of Early Dinosaurs. Courtesy the American Museum of Natural History Library.

flashed into dissolutions like powdered blood" (Plate 27). Enhancing that weirdly florid atmosphere in which the camera pans across indistinct forms of towering dark creatures is an otherworldly mechanical percussion, as if a reverberating spring and hollow metal tube were repetitiously rapping in a vault, low and foreboding.[17]

Then over this evocation of a horror movie, while the camera pans across the radiantly carmine-but-dim view of the *Gorgosaurus* (dinosaur) skeletons, Smithson intones:

> Nothing has ever changed since I have been here. But I dare not infer from this that nothing ever will change. Let us try and see where these considerations lead. I have been here, ever since I began to be, my appearances elsewhere having been put in by other parties. All has proceeded, all this time, in the utmost calm, the most perfect order, apart from one or two manifestations, the meaning of which escapes me. No, it is not that their meaning escapes me, my own escapes me just as much. Here all things, no, I shall not say it, being unable to. I owe existence to no one, these faint fires are not of those that illuminate or burn. Going nowhere, coming from nowhere.

As he does not attribute these lines to their source, the novella *The Un-namable*, by Samuel Beckett, Smithson's voicing of this first-person statement implies that it, like his other descriptions of building *Jetty*, is autobiographical.[18] Beckett's bleakness was a perfect model for the direction of Smithson's own inclinations as well as his determination; the famous last words of *The Unnnamable* are "I can't go on, I'll go on." Throughout his film Smithson adopts this unstructured (plotless and lacking paragraphs and periods) story's format of collaged fragments of existential musings.

At the time, Smithson's reading of Beckett could be taken as impersonal commentary on existence. But after his death, when in the chronology of the catalogue for the show of his drawings at the New York Cultural Center in 1974, Holt identified him as having been born following his brother's death, the biographical context makes Beckett's lines uncannily relevant to Smithson's life. "My appearances elsewhere having been put in by other parties" suggests a double for himself, or a predecessor, Harold, who held a spot until vacating it and Smithson came. His own "[meaning] escapes me" evokes the ghost whose identity cannot be grasped, and the replacement's conflict of identity between what was and what he is. For anyone else, the assertion "I owe my existence to no one" would be fatuous—literally, we each owe our existence to our parents and other caregivers, even if as adults, we try to be captain of our own ship. But for a person with Smithson's early life history, declaring "I owe my existence to no one" is at once a boast of autonomy and patently false. Chronologically and logically, he owes his conception to his predecessor's halted existence: "Survivor guilt is a common response in replacement children. Their life, they feel, is owed to the death of another."[19]

So "I owe my existence to no one" is another one of his assertions seemingly inserted to enable him to deny it: that *Quick Millions* was not named after the film with the ending relevant to his family; that his *Bio-Icons* show demonstrates that he left religion and went into science and that this striving artist "just wants to be completely uninvolved"; in "Passaic" he imagined that "a pipe was secretly sodomizing some hidden technological orifice," but he "will not draw such a crass anthropomorphic conclusion" of "'homosexual tendencies.'" Contrary to infants not conceived in response to a predecessor's absence, "coming from nowhere" is exactly *not* his situation, and neither, for this ambitious artist, is the idea that he was "going nowhere." Both emphasize the randomness of all those atlas pages fluttering down the hillside rather than the deliberateness of both Smithson's birth and his career trajectory.

While the film's low light renders the beasts shadowy and indistinct, their identification is aided by the red hue. It corresponds to Beckett's description of "unnamable's" eyes, which "from the tears that fall unceasingly

. . . must be as red as live coals." And that returns us to Harold's explosive leukemia, which from this and other references by Smithson appears to have manifested in ocular hemorrhaging.

For Smithson, his deceased brother and dinosaurs shared attributes: both were presences looming from "prehistory," geological and his own. Harold was a figure prior to his own life history, who, having been his parents' first child and with them more than nine years, was large in family memory and importance, and thus was a fearsome competitor to a nominally "only" child. Both dinosaurs and Harold were dead, yet the number of Smithson's visual and verbal allusions to the extinct beast and other coded references to his "secret partner" suggests that for him neither was at all gone. In the future, he would repeatedly configure his maps in terms of representing a connection to the past, stating about his *Spiral Jetty*, "I needed a map that would show the prehistoric world as coextensive with the world I existed in."[20] The world he lived in, metaphysically and psychologically, which included the prehistoric dinosaurs—and Harold—was a past not past, as his titling of another no longer extant painting in his 1959 show attests, *Living Extinction* (1959).

Harold is thus Smithson's unnameable, and in two ways: socially, someone who because of constraints in both Smithson's family and professional realms could not be named, and emotionally: the idea that something is "unnamable" suggests not the lack of a name but the inability to name it, something so traumatic that words fail, being unfathomable to oneself and unrepresentable to others, except in coded images.

The film returns to the vehicle rapidly traveling forward, then we are looking at a map of the Paleozoic to Jurassic geological period of geologists' hypothetical continent Gondwanaland and the fictional Atlantis, then a present-day survey map of the ten acres Smithson leased, while he reads its survey location. On the map, adjacent to Rozel Point, he wrote "The Spiral Jetty" and described it as the "point of beginning," suggesting embarkation.

Then he switches to the voice of a documentarian. Over a close-up of roseate water he soberly states, "North of the Lucin Cutoff, the water is red or pink color, due to algae, in the brine." We see the rear of male legs, his, sheathed in tall black rubber boots striding through the water and hear him describing his actions in a jarringly passive voice: "A string was extended from [a] central stake in order to get the arcs in the spiral."

While several close-up views of lapping reddish water alternate with loud grunting of earthmoving trucks unloading basalt rock brought from the shore's hillside, Smithson describes the geological composition of Rozel Point. He locates his description as being "from the center of the Spiral

Jetty," and in his "Spiral Jetty" essay and his film he calls out twenty points of orientation on a 360-degree circle, chanting the identical words "mud, salt crystals, rocks, water" for each point, as if reciting a meditative mantra, turning the square implied by north, south, east, west into a circle. (Meanwhile, the helicopter enacts that rotation by circling the completed jetty.) The repetitive pattern, as in a ritualistic prayer, is inescapable; it reprises his naming of the four cardinal directions (in Christianity they refer to the four end points of Jesus's cross) in his incantation "From Purgatory," along with "We cry / tears of mud." In turn, that may have been inspired by John Weir Perry's model of chanting distinct qualities for each of the four cardinal directions in his *The Self in Psychotic Process* chapter titled "The Symbolism of Rebirth."[21]

The camera then goes under shallow lake water to show an enlarged view of bulbous white salt crystals. Smithson describes, "The crystal steps will actually wind itself into a spiral during growth, at the steady state the spiral will appear to rotate. The right-and-left-handed dislocations give rise to clockwise and anti-clockwise spirals." The respirator wheezes again; the doubled but enantiomorphic form is unsurprisingly linked with illness.

Next, we view Smithson from the helicopter close above him in an overall roseate scene calling up the red atmosphere of Geselschap's painting of dinosaurs in the American Museum of Natural History and, of course, their referent, blood. The artist, personifying complementarity in black pants and white shirt, begins to sprint along the curve of the jetty in what he accurately calls "erratic steps." He shifts from describing the material to evoking the metaphysical. "I took my chances on a perilous path, along which my steps zigzagged, resembling a spiral lightning bolt."[22] His declaration echoes Jung's commentary: "The way to the goal seems chaotic and interminable at first, and only gradually do the signs increase that it is leading anywhere. The way is not straight but appears to go round in circles. More accurate knowledge has proved it to go in spirals."[23]

Seen from distance and height, the spiral appears to be as graphic and two-dimensional as a mandala, akin to the flat designs on Tibetan Thangka scrolls intended to focus contemplative thought. Smithson's interaction, jogging the length of the coiling pathway to the center, alters its identity. On the ground, standing atop the spiral, it becomes an experiential labyrinth that one must make one's way along toward the end point at the center. Originally, a labyrinth was a place of confinement and mortal challenge; the mythological archetype was on Minoan Crete where Theseus overcame the ferocious Minotaur (a hybrid bull and man) imprisoned at its center. As scholar of spirals Jill Purce notes, the Cretan labyrinth was "an

initiatory hero test, an overcoming of death at the center, and a subsequent return or rebirth into life, a regeneration on a higher winding."[24] In medieval Europe, spiritual pilgrims journeyed to church labyrinths such as at San Vitale in Ravenna to trace the convolutions, sometimes on their knees, as a meditative practice intended to reach a center symbolic of heavenly purity and union with the divine, to be reborn into a state of grace.

Ballard referred to traditional religious labyrinths in his 1959 story "The Voices of Time" (set in a research site near dry salt lakebeds and cited by Smithson in his "Artist as Site-Seer"). In "Voices," one scientist cuts a maze-like ideogram in the floor of an empty swimming pool. Another constructs a huge concrete labyrinth formed of a circle overlaid with a cruciform, a quadrated circle like that which Smithson pictured behind Christ's head in his *Man of Sorrow (The Passionate)*. Used in prehistoric and historical religious communities, sacrifice symbolism is as old as the spiral. In Ballard's story, the labyrinth's center is a place of corporeal death and spiritual uplift.

Elevation toward an ultimate empyrean is contradicted in Smithson's spiral by its counterclockwise orientation from the shore. Clockwise on an analog disk and the sequence of reading alphabetical letters and sentences in English and the Romance languages progress from left to right; following the apparent direction of the sun signifying the natural and growth. Transiting in the opposite direction traditionally implies subverting planetary movement toward impairment, irrationality, or regression. The Latin for "left" is *sinister*, portending an inauspicious act. That perversity may be implied by the counterclockwise direction of the spiral nebula on the cover of Taine's *Three Science Fiction Novels* containing *The Time Stream* (see Figure 12.2). Its reverse of the customary clockwise naturalness also aligns with Wylie Sypher's "Entropy is evolution in reverse," quoted by Smithson in his "Entropy" essay. *Spiral Jetty*'s counterclockwise direction corresponds to that of Smithson's journey to and through Passaic, where the chronology was backward, rewinding time from that day's newspaper through the place where he was born and lived his first years to end at a sandbox-as-grave connoting his prehistory.

In 1967 Smithson reprinted an observation by Beckett that evinced their mutual obsession with the presence of the past: "The individual is the seat of a constant process of decantation, decantation from the vessel containing the fluid of future time, sluggish, pale and monochrome, to the vessel containing the fluid of past time, agitated and multi-colored by the phenomena of its hours."[25] So it is no surprise that in his *Jetty* essay Smithson attributed to his backward-turning spiral a Beckettesque enigma: "The surd takes over and leads one into a world that cannot be expressed by number or rationality. Ambiguities are admitted rather than rejected, contradictions are increased rather than decreased—the *alogos* undermines the *logos*."[26]

His backward spiral's association with entropy and inductive rather than deductive logic also aligns with Anton Ehrenzweig's positive adoption of these toward creative "dedefinition," the experience of the loss of the discreteness of entities. Smithson had described this in his "Sedimentation" essay under the heading "Primary Envelopment": "At the low levels of consciousness the artist experiences undifferentiated or unbounded methods of procedure that break with the focused limits of rational technique."[27] He exemplified this in his "Spiral Jetty" statement: "My dialectics of site and nonsite whirled into an indeterminate state, where solid and liquid lost themselves in each other."[28] He described his plunge along his own mortal coil as "Following the spiral steps we return to our origins. . . . I was slipping out of myself again, dissolving into a unicellular beginning, trying to locate the nucleus at the end of the spiral."[29] It is the mystical "oceanic" consciousness. In *The Drowned World*, Ballard likens the lagoon to a womb and the protagonist desires to go south toward the "unattainable shores of the amniotic paradise."[30]

Drawn to the vortex that is the spiral's endpoint, the backward pull is also downward. Ballard had also united the two:

The light drummed against his brain, bathing the submerged levels below his consciousness, carrying him downwards into warm pellucid depths where the nominal realities of time and space ceased to exist. Guided by his dreams, he was moving backwards through the emergent past, through a succession of ever stranger landscapes, centred upon the lagoon, each of which . . . seemed to represent one of his own spinal levels.[31]

Smithson told Dennis Wheeler, "The viewpoint goes out like an inverse spiral. It's not a spiral that's going up."[32] Virginia Dwan recognized this when describing the *Jetty* as "very primal, almost a kind of Luciferian sort of art. There's something underworld about this particular spiral."[33] This accords with Jung's description that during the Catholic Mass a priest's counterclockwise movement of the thurible or censer over the wine and host "corresponds psychologically to a circumambulation downwards, in the direction of the unconscious, while the clockwise movement goes in the direction of consciousness."[34] The leftward *Spiral Jetty* thus implies not just what Smithson declared in his Yucatán essay ("the Future travels *backwards*") but also the descent he had exclaimed to George Lester: "The way up is the way down!" (September 22, 1961, #15).[35] He was cycling back to a past as deliberately submerged as the deepwater brachiopods standing in for him in his *Self-Less Portrait* (Plate 20).

The long pathway of *Spiral Jetty*, which remained from his first design of the earthwork, can then be seen as a cosmic umbilical cord curving back to a womb with the ancient omphalos, or navel, a still point in the turning world or an atemporal beginning. The salinity of the Great Salt Lake is an intensification of that of the ocean from which vertebrates evolved. Mixed with associations of water as the milieu of evolutionary beginnings, with the amniotic fluid of birth, and with spiritual baptism, the aqueous milieu of his labyrinth suggests a site of birth.

Yet that site's intimations of fertility also imply fatality: the high saline content thwarts gestation, leading to its designation as America's Dead Sea, and the water-as-blood. This relates Smithson's spiral to those engraved on ancient tombs. Purce notes that the spiral

> implies a death and re-entry into the womb of the earth, necessary before the spirit can be reborn in the land of the dead. . . . Such a descent into the underworld is the theme of most initiation rituals, and is comparable to the passage through the wilderness, or the "dark night of the soul" which is experienced by mystics on their path. It is furthermore nearly always symbolized by the spiral.[36]

Smithson was of course not a stranger to the dark night of the soul, and he had also prefigured his *Spiral Jetty*'s allusions in his incantation lines, "By the Dead Sea / We Weep / By the Dead Sea / We Weep," and "Blood mingled with tears," salty, as is the *Spiral*'s locale.[37]

He wrote in his "Spiral Jetty" essay, "Was I but a shadow in a plastic bubble hovering in a place outside mind and body?" Indeed, that is his existential question—was he more than his brother's shadow? Then, just as in his Passaic tour he had associated his quotidian birthplace with death, called up by the sandbox/grave, he punningly declared of the spiral's almost barren site, "*Et in Utah ego.*"[38] Literally, the Latin translates to "I too am in Utah." With it he again localized, as he had in his Yucatán essay, the phrase adopted by Nicolas Poussin for the title of two paintings, *Et in Arcadia Ego*. That is, even in Arcadia, the realm that to the ancients represented harmony and beauty, death is present, symbolized in the Poussins by the stone tomb around which shepherds gather. And Smithson? His use of italics not only indicates the foreign language; it also suggests his personal speaking of that assertion as if he were fully present. In yet another play with doubles, he echoes the canonical original and makes his own elegiac reference to the presence of death *in Utah* and in his consciousness and called up by his *Spiral Jetty*'s backward and downward turns.

In the film, upon his reaching the center endpoint, the helicopter closes

in directly above him as he stands with his back to us for a few moments, a position of reflection that almost folds the aerial distance into intimacy. Smithson's admission, "I took my chances on a perilous path," toward a center point associated with his origins is akin to Mircea Eliade's description in *The Myth of the Eternal Return*:

> The center, then, is pre-eminently the zone of the sacred, the zone of absolute reality. Similarly, all the other symbols of absolute reality (trees of life and immortality, Fountain of Youth, etc.) are also situated at a center. The road leading to the center is a "difficult road" [like] wanderings in labyrinths. . . . The road is arduous, fraught with perils, because it is, in fact, a rite of . . . passage. . . . Attaining the center is equivalent to a consecration, an initiation; yesterday's profane and illusory existence gives place to a new, to a life that is real, enduring, and effective.[39]

Smithson's traversing of the spiral was not a stroll as visitors do now, but a propulsive jog. The symbolism of his run on the spiral was recognized early on by art historian/critic Joseph Masheck, who in 1974 wrote, "The spiralling inward towards the contemplative stillness of the lonely innermost enclosure is quite suggestive, in psychological terms, of the Jungian conception of the *circumambulatio*—a compulsive spiralling in to one's undiscovered self."[40] But as his own comments make clear, Smithson was aware of his symbolic performative act. He had already imagined it. Responding a few years earlier to George Kubler's idea of art history as a chain of "jeweled links" of "prime objects," he had written, "To understand this 'chain' would be like trying to retrace the pattern of ones footsteps from the day of ones birth to the present."[41] That is exactly what he was doing, first back to his "unicellular beginning" and then back "to the present."

As the helicopter and camera pull back for a wider view of the entire spiral, the overall landscape tinted by use of a filter a vivid rose pink, he remains there a few seconds and then turns back and starts walking, more slowly, along the spiral toward the shore. He characterized it as "A road that goes forward and backward between things and places that are elsewhere."[42] The two directions suggest a journey both prospective and retrospective, recalling T. S. Eliot's conclusion to *Four Quartets*, a book he owned: "We shall not cease from exploration / And the end of all our exploring / Will be to arrive where we started / And know the place for the first time." Smithson had strong reasons to run his spiral as a symbolic regression to his "point of origin," to rewrite his beginning and erase his own origin's scar. Lucy Lippard recognized the autobiographical aspect, describing Smithson as

having "associated the shape of *Spiral Jetty* with his own 'life line,' when at the end of his film, he ran the spiral from its beginning to its end, or its center, re-enacting, perhaps unconsciously, ancient initiation rites by entering the spiral labyrinth (or womb) in order to be reborn"—free of the burden of his life's entwinement with a preceding death.[43]

At the conclusion, the helicopter starts at the hillside behind and swoops down to the spiral in the setting sun, seeing it from aerial and askew angles, almost dizzying, then up and around in daytime with the sun's brilliant light obscuring the jetty's shape. Smithson reads from Taine's *The Time Stream*:

> Gazing intently at the gigantic sun, we at last deciphered the riddle of its unfamiliar aspect. It was not a single flaming star, but millions upon millions of them, all clustering thickly, together like bees in a swarm, their packed density made up the deceptive appearance of a solid impenetrable flame. It was in fact, a vast spiral nebula of innumerable suns.[44]

Returning to the radiant disk of the sun as symbolizing the self, its constituency of myriad suns suggests that Smithson has accepted his complex identity as akin to Walt Whitman's "I am large, I contain multitudes." Then he states, "He leads us to the steps of the jail's main entrance, pivots and again locks his gaze into the sun. 'Spirals,' he whispers. 'Spirals coming away . . . circles curling out of the sun.'" The enigmatic statement sounds like it could be another quote from Taine's *Time Stream;* the sentiment may derive from that story. But the source of the quotation, not cited, is from *Rolling Stone*'s June 1970 investigative piece on the Manson Family's murders of five people in director Roman Polanski's Beverly Hills, California, home.[45] With it, Smithson again displays his literary eclecticism and his connection to morbidity.

In late afternoon light, with the dark coil contrasting with the shimmering violet lake, Smithson reads haltingly from a medical dictionary:

> Sunstroke—This term is usually restricted to the condition resulting from exposure to intense sunlight. In mild cases, it may consist only of a headache and a sense of lassitude, persisting for a few hours. In more severe cases, there may be intense headache, aversion to light, vomiting, and delirium. The skin is dry, the pulse is rapid, and there is a moderate rise in temperature. Recovery may be slow in severe cases, and for a long period subsequently, there may be loss of memory and inability to concentrate.[46]

Is this the malaise of excessive exposure to examination of the multitudes within the self that the sun metaphysically represents? The final shots in the late afternoon, circling around, catching the sun's glare, receding, have the emotional and visual tonality of an elegiac departure.

The film then cuts to a studio interior; the camera closes in on a large photograph of *Jetty* on the wall above a projector on an editing table. It's another form of return, to the interior of a room, presumably in Manhattan, the East Coast, where we see a big black-and-white photograph of *Spiral Jetty* with a bluish tint evoking sadness. The implied distance between his creation in Utah and this interior echoes the final words of his account of his prior journey: "Yucatan is elsewhere." The editing reels literally frame the *Jetty*, serving as a reminder that what we have just watched was consciously constructed as a partially fictionalized representation of what he experienced. The intrusion of mechanical tools of filmmaking into filmic storytelling disrupts the "willing suspension of disbelief" required for emotional identification and receptivity to imagined narratives. Instead, it suggests reasoned meta-analysis of a medium. Smithson recognized the cost of that intrusion of deliberate consciousness: "The disjunction operating between reality and film drives one into a sense of cosmic rupture."[47] It is a familiar maneuver distracting from recognition of his spiral's metaphysical resonance.

Commensurate with its concluding focus on mediated images, the first time *Spiral Jetty* was exhibited was in the form of eight of the documentary photographs Dwan had commissioned from photographer Gianfranco Gorgoni. They were displayed in *Information*, the Museum of Modern Art's July–September 1970 survey of conceptual and site-specific art.[48] MoMA curator Kynaston McShine's March 1970 invitation to participate—leaving open the work Smithson would show—had arrived during Smithson's process of securing a lease to Rozel Point. Demonstrating the amorphous stylistic designations of then-current art, Smithson's massive environmental construction made from unreinforced earth was shown alongside the much more dematerialized and antisensual forms of Conceptual Art, many consisting of diagrams and/or typewritten statements.

Even so, with its very physical boldness and compelling beauty, *Spiral Jetty* itself immediately captured imaginations, encouraging mental curving into, or a participant walking on, the coil of an ancient mystical symbol redolent across time and space of the experience of corporeal and spiritual passage. It is popular as an art pilgrimage site, yet most people who experience *Spiral Jetty* do so not phenomenologically in its environment but as viewers of photographs. So, for the majority of viewers, this site of symbolic

enactment along the spiral functions, in the same way studying a mandala does, as a visual stimulation of immobile reverie. In either experience, *Spiral Jetty* fulfills a characteristic of major works of art, being both timely—epitomizing artistic values of its historical period—and being out-of-time, as philosopher Arthur Danto put it thirty-five years later, having "the timeless air of some ancient monument left behind by a vanished civilization."[49]

Smithson acknowledged that aim of transcending time:

> Time is always there gnawing at us and corroding all our best intentions and all our most beautiful thoughts about where we think we're at. It's always there, like a plague creeping in, but occasionally we try to touch on some timeless moment and I suppose that's what art's about to a degree, lifting oneself out of that continuum.[50]

As if into a time stream.

Mesmerizing aerial views of the great spiral have been chosen for the covers of many books, not only about Smithson but also luring readers to texts from the expected—H. W. Janson's college standard, *History of Art* (2001)—to the novel, for example, Karl Ove Knausgaard's *My Struggle*, book 5, *Some Rain Must Fall* (2016).[51] From the mid-1980s to the mid-1990s, the alt-rockers from Hoboken in Smithson's native New Jersey released albums internationally as the group Spiral Jetty. The image is now being merchandised in photographic plaques, hand-painted purses, as a printable internet board game, and as the name of an India pale ale from Epic Brewing Company in Salt Lake City. Economist David Galenson has ranked *Jetty* as the third most frequently illustrated work of art in art history survey textbooks.[52]

Spiral Jetty's immense appeal to art and nonart audiences alike fulfills an aspect described in a book he owned that he surely consulted in relation to his film's opening close-up, *The Sun in Art*:

> The symbols behind which alchemists concealed their knowledge from the initiated were first rooted in language, but among the Arabs, and later in the West, they also entered the visual sphere of art.... In order to transmit their secret knowledge, astrologists and alchemists did not so much use reasoned explanations as a pictorial presentation calculated to appeal to the subconscious.[53]

That Smithson did not divulge the biographical sources in his *Spiral Jetty* earthwork, film, and essay continued his and his time's ethos of personal nondisclosure. Doing so also epitomizes the description by Chesterton (immediately following his sentences that Smithson quoted as an

epigraph) of being "secret even when it is ubiquitous."[54] At the same time, in his "Spiral Jetty" essay he continued his practice of dropping clues regarding his autobiographical intention:

> We have found a strange footprint on the shores of the unknown. We have devised profound theories, one after another, to account for its origin. At last, we have succeeded in constructing the creature that made the footprint. And lo! It is our own.[55]

Smithson's run on his spiral can be likened to the aim quoted by literary critic Paul John Eakin: "The final object of every autobiographical quest . . . 'is the impossible search for one's birth; one returns to the past in an attempt to penetrate the mystery of one's origins.' "[56] In "trying to locate the nucleus at the end of the spiral," Smithson's centrifugal propulsion aimed as did alchemists to symbolically construct a (transmuted) creature. From that "unicellular beginning," his centripetal momentum then delivered him to the "shores of the unknown" and outward.

Expansion
and Returns
1971–1973

FIGURE 13.1. In the mystical ouroboros symbol, widely illustrated in alchemical and occult texts, a dragon (alternatively, a snake) bites its own tail, or as here, two bite each other's tails, to form a circle. This drawing originally appeared in Abraham Eleazar's *Uraltes chymisches Werk* [Ancient chemical work] (Leipzig, 1760). Robert Smithson likely saw it reproduced in his copy of Carl Jung, *Psychology and Alchemy*. Courtesy Wellcome Library, London.

13
Reclamations

Ecology to me has replaced . . .
I mean that's the official religion right now.

n 1971, after seven years developing a reputation as a sar-
donic intellect producing ratiocinated art forms, provoc-
ative essays, fervent debates with bar buddies, and that
awesome spiral in Utah's wilderness, Smithson turned
again along the arc of his self-representation. With *Spiral Jetty* he had at
once created the most magisterial exemplar of the new sculptural format of
environmental sculpture and through its symbolic shape and with his ritu-
alistic interaction with it, had wrestled with his private netherworld. Hav-
ing coiled inward to reach the spiral's compressed center point as if it were
the *fons et origo* and his private nadir, from there his direction of return to a
public presence constituted release and expansion.

The way forward opened for him with an invitation to make a work
abroad as part of the sculpture exhibition *Sonsbeek '71*. In contrast to his
independent explorations in New Jersey, the Yucatán, and Utah, in the
Netherlands he participated in a tradition that since 1949 had triennially
displayed sculpture in Sonsbeek Park's eighteenth-century villa and formal
gardens outside the center of Arnhem. Director Wim Beeren, formerly head
of the Stedelijk Museum in Amsterdam, conceived of his first version of
Sonsbeek as an investigation of "space and spatial relationships." Recent
sculpture, conceptual art, film, and video were shown in tents centered
at the park and large-scale works dispersed nationwide. Beeren's subtitle,

"Beyond Lawn and Border" (and law and order?), indicated the unbridled formats to be experienced by intrepid visitors. Among the large number of international artists, the only other earthen environmental-scale work commissioned from an American was Robert Morris's large circular *Observatory*, aligned with solstice and equinox sunrises and sunsets.[1]

In the heather and peat region of northeastern Holland, through Beeren's connection to Sjouke Zijlstra, the director of a local theater and arts center at Emmerschans, Smithson found a site. Zijlstra negotiated an offer of space at a commercial quarry owned by the local De Boer family that prepared sand for use in stabilizing roads prior to their development as streets or highways.[2] Akin to the abandoned trailer, weathered vehicles, and disused drilling rig that for Smithson were collateral benefits of the *Spiral Jetty* site, here he found appealing antipastoral elements of geological industry: large extraction and dredging equipment and huge mounds of sand adjacent to the deep green water of the artificial lake created by pulverizing sand.

On site, Smithson sketched prospective sculptures: one with a meander of five turns; a circular jetty encompassing water with eight arms projecting from the perimeter halfway toward the center, implying a central vacant disk; curving ramps made of stacked cubes of peat; an incomplete circle of terraced sod; and an elevated spiral atop a cliff with a concrete rundown. In consultation with the private owners of the quarry and the exhibition administrators, he settled on two masses, somewhat complementary in structure: at a far edge of the small lake produced by their factory processes, *Broken Circle*, made of flat earth and a canal and bay of water, and above it, low *Spiral Hill*.

Broken Circle resembles a flat disk that has been bisected at a horizontal diameter roughly parallel to the shoreline. From the hill, the lower half is a semicircle of sandy earth shaped from a peninsula extending into the lake. Its bottom edge from about a point equivalent on an analog clock face of three o'clock to about seven o'clock is a water-filled canal.

The upper half of the disk mirrors the lower but is in complementary materials: water bound to the top by a curving jetty identical to the canal in thickness and curvature extending in an arc as if opposite to it on a clock-face from nine o'clock to about one o'clock. Together the two arcs, one of water, one of earth, form the circumference of a circle, partially enclosing it. Drawings show that as he had at *Spiral Jetty*, Smithson designated both the jetty and the canal to be edged with boulders, big ones at entrance and end points, and along the new shoreline, smaller stones, but "heavy enough so that children cannot pick them up" (written on *Broken Circle Showing Rip-Rap Shoring*, 1971) to maintain the shape against erosion. Instead, a

year after its completion the edges were bolstered by the characteristically Dutch procedure of wood timbers.

Smithson told interviewer Gregoire Müller that "lurking in my mind" before arriving in the Netherlands was his intention to work "with a circular piece."[3] Was the circle ever so distant from his consciousness that it actually "lurked" in the background? *Eye of Blood* (1960) consists of nested circles; many of his subsequent paintings and painted collages include virtual hailstorms of encircled dots or collaged automobile wheels. The gestalts of *Gyrostasis, Cryosphere, Spiral Jetty, Broken Circle, Spiral Hill*, and his future *Amarillo Ramp* are all circular.

The circle, deriving from observation of sun, moon, and planets, signifies continuity, wholeness, and an ultimate oneness. As I previously noted about his circular *Cryosphere*, to alchemists, "the opus was often called *circulare* (circular) or else *rota* (the wheel)."[4] A circle, as perfect form, could symbolize the Work or the developed Self. Reflecting Smithson's early history, it probably signified for him both continuity of time and the wholeness—rather than being one part of a duality—that he sought existentially.

Broken Circle's design bears remarkable similarity to illustrations in books he owned. The most direct correlation is to an outline drawing on the cover of Nathan Scott Jr.'s *The Broken Center: Studies in the Theological Horizon of Modern Literature*. Both drawing and earthwork consist of two arced forms inverted above and below a horizontal diameter. Scott's *Broken Center* and Smithson's *Broken Circle* are mirrored semicircles amounting to geometricized versions of Zen Buddhism's taijitu symbol. That is, a black-and-white disk of curving forms consisting of a bulbous lobe and a tail, oriented as inversions of each other and entwined. The play of dualities, familiar in Smithson's cartouche sexualities, invoked in his use of mirrors, and central to his site/nonsite complementarities, is also materialized in *Broken Circle* by the contrast of earthen and lake surfaces and of its flat swirl contrasting to *Spiral Hill*'s conical protrusion.

That is the reason he objected to the huge megalithic boulder, part of the moraine deposited by a glacier, that became the de facto nucleus of the *Broken Circle* disk. Smithson didn't like how it would draw viewers' attention from the periphery to the center and suggest a stabilizing centered mass. He wanted to have what he called the "dark spot of exasperation, a geological gangrene on the sandy expanse" removed, but it was too heavy to be budged from the pliable surface.[5]

More specifically, both the yin/yang complementarity of positive and negative shapes and even more the tensile compression of *Broken Circle*'s upper and lower arcs, like those on *Broken Center*, suggest propulsion toward closure. British essayist and psychotherapist Eric Rhode identified

FIGURE 13.2. Robert Smithson, *Broken Circle,* 1971, Emmen, the Netherlands. Photograph made in 1971 by Robert Smithson. Copyright Holt/Smithson Foundation / Licensed by Artists Rights Society, New York.

this as Smithson's "uroboric broken circle."[6] That is, the momentum is akin to that illustrated in historical, particularly alchemical, texts of a circle created by a reptile energetically clasping its tail in its mouth, an ancient symbol seen in many preindustrial cultures. Variations in the symbol show dragons, lizards, or serpents forming a circle by eating each other's tails. In Babylon, the ouroboros was known as the Heavenly Serpent; in early Egypt serpents enclosed the sun disk; the Phoenicians brought it to the Greeks, who gave it its name, *ouroboros* (alternately, uroboros), literally, a reptile devouring its tail. It is pictured in Giotto's frescoes for the Arena Chapel in Padua, Italy, and in Navajo sand paintings. The diversity demonstrates independent origins rather than deriving from one source.

An early depiction of the ouroboros by Smithson is in the painting *Serpent of Blood* (1962). He read about the ouroboros *The Time Stream* by John Taine, who described it as a "The Tail Devourer . . . a snake bent round in the form of a perfect circle, the tail in the mouth, embracing the motto the whole is one."[7] With that, Taine conveyed the concept of what his

characters experience, time as a stream that is cyclical. In 1968 Smithson described it as "a dinosaur ([etymologically, a] 'terrible lizard')—a lizard with its tail in its mouth."[8] (He was invested in being considered a polymath, but that did not extend to signaling the depth of his engagement with the occult by using its esoteric terminology such as the symbol's name: ouroboros.) By that time he had quoted Taine twice (and did so again in his *Spiral Jetty* film).

Likely Smithson—and perhaps Taine—also knew of the ouroboros from *Psychology and Alchemy*, where it is illustrated five times. Jung explains:

> The dragon is probably the oldest pictorial symbol in alchemy of which we have documentary evidence. It appears as . . . the tail-eater, in the *Codex Marcianus*, which dates from the tenth or eleventh century, together with the legend: . . . the One, the All. . . . Time and again the alchemists reiterate that the *opus* [the Work] proceeds from the one and leads back to the one, that it is a sort of circle like a dragon biting its own tail.[9]

Broken Circle's form resembles Jung's illustration of two dragons or serpents forming a circle (see Figure 13.1). The contrast of the upper as winged and crowned, more volatile, and the lower as neither, less mobile, is a motif that can be traced to the earliest alchemical illustrations. They connect the royal and the common, also thought of as the social strata of the divine and the earthly. In the four corners are geometric symbols for the elements. From top left, the downward-pointing triangle, water; an upward-pointing triangle with a line through it, air; a downward-pointing triangle with a line through it, earth; and an upward-pointing triangle, fire. Near them, in the upper two corners are words for "spirit" and "soul"; in the bottom two are German and Latin words for "body," what the circularity of the ouroboros unites and the work of the alchemist aims to do.[10]

In the context of his design's symbolism of a propulsive circularity, the unyielding boulder that his *Broken Circle* was constructed around becomes

FIGURE 13.3. In addition to the similarity of Smithson's title *Broken Circle* and Nathan A. Scott Jr.'s *The Broken Center* (1966), Smithson's propulsive circular design also resembles the cover, especially when the latter is horizontally flipped, as here. The book's subtitle is *Studies in the Theological Horizon of Modern Literature*.

FIGURE 13.4. Robert Smithson, *The Serpent of Blood,* 1962. Copyright Holt/Smithson Foundation / Licensed by Artists Rights Society, New York.

On the reverse of this large painting (88 × 83 inches) Smithson wrote what he must have intended as its full title, "The Serpent of Blood astonished by the Unicorn and the Arch fiend on the dragon throne, 1962." The winged and horned creature has the open jaw and protruding tongue familiar in early 1960s' heads by Smithson, such as in Figure 12.4 and akin to Figure 7.4 and Plate 6. He sits on a throne created by a coiled dragon ouroboros.

like an omphalos, a large stone that in Greek antiquity signified the navel of the earth or a still point in a turning world.

The ouroboros image of the self-propagating being and continuity could serve as an insignia of Smithson's own professional self-construction. After shedding his skin as a vulnerable painter and emerging as a tough sculptor he accrued substantial recognition. Jung explained:

> In the age-old image of the uroboros lies the thought of devouring oneself and turning oneself into a circulatory process, for it was

clear to the more astute alchemists that the prima materia of the art was man himself. The uroboros is a dramatic symbol for this integration and assimilation of the opposite, i.e., of the shadow.[11]

This speaks to Smithson himself, who as an artist was attempting a union of opposites, as he recognized. He addressed them in an interview in terms of "confront[ing] the area of death, or the swinging back and forth between life and death." That seemed to be his temperament's rhythm. But he also strived for resolution between his position as a forward-thinking sculptor who in his large earthworks was manifesting ancient spiritual and metaphysical symbols. He continued: "All of [my sculptural works] internally have that aspect, they all are involved with the unification of the duplicity, the dual aspect is reconciled within the pieces, and reflects a greater scale of dialectic."[12]

Yet another affinity between Smithson and Scott, then a scholar of literature and Christian theology at the University of Chicago, is their reference to brokenness in their works' titles, *Broken Circle* and *Broken Center*. Regarding the latter, Scott laments the loss of a

> genuine community and unitary tradition [which cohesively bound] "the greatest writers of the first half of the twentieth century . . . a high, tense world of strenuous and difficult metaphysics, moral doctrine, political ideology, and religious feeling" . . . despite [their] multifariousness of creative technique and fundamental point of view. . . . What has most fundamentally given [the artist's] life the aspect of crisis has been that recession of faith, and that erosion of the religious terrain.[13]

Scott's elegy for a Christian literature echoes that of Hans Sedlmayr's for contemporary art in *The Lost Center*, paraphrased by Smithson in letters to George Lester. *Broken Center*'s publication date, 1966 (and the year of Smithson's copy), indicates that Smithson had to have acquired it no earlier than two years after he began making abstract sculpture and a few years after his putative "real breakthrough of [overcoming] this lurking pagan religious anthropomorphism."[14] If interests such as *Studies in the Theological Horizon of Modern Literature* were truly behind him, it wouldn't be continually in front of him in the books he acquired. His sculpture's echo of the book cover demonstrates that even as he continued to work through his family's broken circle his affiliation with religion was unbroken.

At the same time, while Scott's address of brokenness relates to Smithson's engagement with loss, Smithson shifted its reference. The book cover's design of two nonaligned semicircles enclosed by sweeping arcs

illustrates the title, *Broken Center*. But the complementary canals partially edging the solid and liquid semicircles of *Broken Circle*'s disk together form a circumference that is incomplete in two places. Smithson's broken *circle* suggests something else entirely: a continuation ruptured. If a closed circle can evoke an endless continuity associated with recurrence or immortality, then *Broken Circle*'s gaps preventing closure suggest blockage of that everlasting continuity—that is, mortality. And that returns us to Smithson's origin, out of a broken *family* circle.

Theo Tegelaers, who worked on the 2011 film *On Breaking Ground: Broken Circle/Spiral Hill*, has commented, "[Smithson's two earthworks at Emmen] keep each other in balance, equal and opposite. . . . In the movie treatments, we find the figure eight as a sign indicating infinity." Smithson wanted the airborne camera to circle counterclockwise around *Spiral Hill* then continue as if making a figure eight clockwise around the larger diameter *Broken Circle*, forming two adjacent circles. "Here, too," Tegelaers notes, "Smithson expresses the idea of continuity. One space coming through another, vanishing into and being taken up in a great continuity."[15]

Tegelaers's perception uncannily applies to both Smithson's sculptural form and his relationship with Harold. The painted number eight in his *Self-Less Portrait*, and eight elements in other works call up Harold, as *H* is the eighth letter of the alphabet. The number's form itself—two mirrored (inverted top to bottom) teardrop shapes—symbolizes both infinity and doubleness. Smithson's "space"—his being and identity, as Tegelaers puts it—"came through another," and across Smithson's work Harold was "taken up in a great continuity."

On the bluff above *Broken Circle*, *Spiral Hill* winds upward for several turns (drawings indicate six levels; the construction has fewer). Made from red/brown loam taken from the terrain edging the lake, the mound was constructed with dark brown peat, followed by two to three inches of soil, and then seeded with a low ground cover to protect against the form's erosion. Its spiraling path was initially covered with contrasting white sand that was soon dispersed by the wind. Its conical shape recalls a famous art historical precedent, Pieter Bruegel's *Tower of Babel* (1563), but without the latter's scale and architecture.

Spiral Hill resembles even more the pointed hill with the suggestion of a spiraling path in the famous seventeenth-century book *Atalanta Fugiens*, by German physician, alchemist, epigrammatist, and composer Michael Maier, with engravings by Matthäus Merian. Emblem 12 was one of fifty "developed from Graeco-Egyptian legends and the common dicta of Medieval alchemists."[16] It pictures Mount Helicon in Greece, believed by ancient

FIGURE 13.5. Matthäus Merian's engraving of Emblem 12 in Michael Maier's *Atalanta Fugiens* [*Atalanta Fleeing*], published 1617 in Oppenheim (present-day Germany).
Courtesy Lloyd Library, Cincinnati, Ohio.

Greeks and Romans to be a site of poetic inspiration and the home of the Muses, and depicts the ancient Roman god Saturn flying above the pinnacle. Coincidentally, Merian's illustration also shows a large boulder. To avoid the prophecy that one of his children would supersede him as the god of agriculture, renewal, and plenty, Saturn had consumed each of his children. Upon Jupiter's birth, Saturn's wife presented Saturn with a wrapped stone in lieu of the infant; Merian shows Saturn vomiting the rock-as-Jupiter. Smithson previously referred to that myth, the inspiration for Francisco Goya's *Saturn Devouring His Son*, akin to Smithson's own 1959 paintings of a beast chomping on an arm.

The affinities between Merian's road spiraling up a pointed hill and Smithson's *Spiral Hill* could be coincidental, or Smithson's interest in alchemy may have drawn him to know of *Atalanta Fugiens* from books on alchemy. He may have viewed the seventeenth-century copy of the manuscript that has been in the collection of the New York Public Library since its founding. In any case, considering the shapes of *Broken Circle* and *Spiral Hill* as having mystical implications connects the latter, further elevated by being built on above the pond, to sacred mountains throughout

preindustrial cultures that connote a site of communion with higher powers and spiritual transcendence. Smithson's *Mirrored Ziggurat* (Figure 7.5) is another representation of such a mountain.

In his sketched-out film on *Broken Circle/Spiral Hill*, Smithson's one-page script of a text "to be spoken in English with Dutch accent," while not to be read by him, was written to be spoken in the chanting rhythm of his earliest artistic language, repetitive incantation: "Glacial memories—melting masses—heap upon heap—innocuous, amorphous heaps—the cycle vanishes into water and earth—swivelling—turning treads—turning wheels . . . inwards and downwards into isolation—starts and stops—on all sides the quarry . . . slipping—pushing through the sand—a vague memory."[17] *Quicksand* again.

While *Broken Circle/Spiral Hill*'s forms and related drawings manifest personal issues, professionally, they functioned for Smithson as his first project in the genre of public art. Dutch citizens had already initiated discussion with quarry management for access to the lake for picnics and frolicking on weekends. Smithson's works made it even more attractive as a destination, fulfilling his goal of holistic interaction, and he gifted it to the people of the Netherlands. In the draft of a statement for Sonsbeek Unlimited, a Netherlands nonprofit organization formed to fund the purchase and maintenance of sculptures installed around the country for Sonsbeek, he wrote that as a result of Sonsbeek, "Art began to shed its independence from the social whole . . . [and instead became] a dialectical exposition of internal relations (the art world) and external relations (society as a working process) interacting in a manifold way."[18]

That public engagement, bolstering his recognition in Europe as well as more widely opening creative and professional possibilities in the public realm, gave Smithson affirmations he needed. A few months earlier, in April 1971, Virginia Dwan had written him, "confirming rumors" that she was closing her gallery as of June.[19] The ongoing political conflicts regarding access to oil, the imminent U.S. withdrawal from Vietnam, and the developing economic recession thwarted sales and discouraged Dwan's devotion to her money-draining gallery. With that closing Smithson lost not only a generous art dealer, collector, and patron, but strong day-to-day support by a female senior in age and socially well connected. In some respects, Dwan had functioned as his third maternal figure, after his mother, Susan, and aunt Julia, a female nurturer who listened to his grand ideas, presented their materialization on the prominent Fifty-Seventh Street commercial boulevard of galleries, publicized them, and, even more, funded their actualization.

Smithson's last solo show at Dwan in November 1970 consisted of the

photographs she had commissioned Gianfranco Gorgoni to produce of *Spiral Jetty*, some shown less than two months earlier at the Museum of Modern Art's *Information* exhibition, and Smithson's film of it. Gorgoni's prints then represented Smithson's work at the Whitney Annual in December.[20] Smithson was included in group shows in museums and nonprofit exhibition halls both in the United States and abroad and participated in all the major international exhibitions in the early 1970s, but nominally, represented by repetitions of familiar types of gallery sculptures or photographic representations of known earthworks, rather than creatively. Even in prominent venues such as the *70th American Exhibition* at the Art Institute of Chicago in the summer of 1972 he was represented by photographs of the 1971 *Sonsbeek* pieces, for which he was awarded a $1,000 prize. Meanwhile, seemingly for something to sell, he repeated himself in works such as *Spiral with Concrete Rundown* (1971; Baltimore Museum of Art), a drawing of two works already completed, and had fabricated portable and salable assemblages such as *Rocks and Mirror Square II* (1971; Plate 26; he made the first for the 1969 Cornell *Earth Art* show), sensually appealing juxtapositions of dusty geological fragments strewn around shiny mirrors, which went to museums seeking a Smithson.

Meanwhile, Holt was becoming a sculptor of outdoor works, facilitated by two artists residencies in 1972. At the University of Montana, she produced the first of her *Locators*, two one-inch diameter pipes welded into a T, into which viewers looked to focus a perspective onto land, and at Narragansett Beach while an artist-in-residence at the University of Rhode Island, *Views through a Sand Dune*, a nine-inch diameter concrete pipe completely penetrating a dune to get a glimpse of the ocean.

As for Smithson, he had either lost interest in or inspiration for making gallery-scale sculpture. In May 1971, he responded to an offer from György Kepes, the director of MIT's Center for Advanced Visual Studies, of a short-term fellowship as artist-in-residence. The prospect was appealing, but he sought to expand its parameters, while addressing the university's educational mission, by

> realiz[ing] a work through the fellowship. . . . Do you think MIT would be interested in backing an expedition that would involve the building of a large scale project? . . . [It] would deal with practical problems as well as theory. . . . Scientists often have study stations in remote areas. . . . Working on something is the best way to learn.

Kepes replied on May 25, 1971: "To my greatest regret the Center's and MIT's finances are not to the scale that could afford such an enterprise. . . . Perhaps

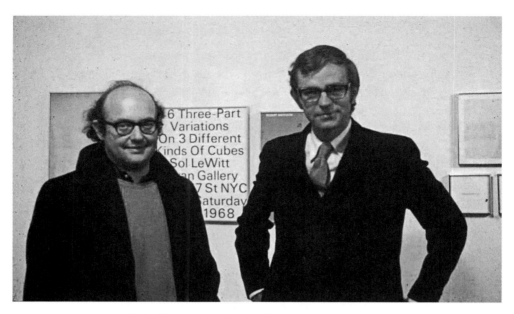

FIGURE 13.6. Sol LeWitt and John Weber, director of the Virginia Dwan Gallery first in Los Angeles and then from 1968 at its 57th Street location, Manhattan, at the reception for the opening of LeWitt's solo show there in February 1968. Courtesy Estate of John Weber.

as a cooperative enterprise between different educational institutions and museums one would be able to marshal enough funds to make the enterprise feasible."[21] It would be up to Smithson to round up the supporters.

Dwan's mild-mannered self-made gallery director John Weber succeeded her under the name of his eponymous gallery. Weber took over the lease she had committed to in the developing district downtown among artists' live/work lofts, SoHo (south of Houston Street, north of Canal Street). With his fourth floor space in the first tall building in that area exclusively containing galleries, at 420 West Broadway, Weber's venture was nestled within an upper echelon coterie with Andre Emmerich on the top, fifth floor; Sonnabend on the third floor; her former husband Leo Castelli on the second; and Hague Art Deliveries on the ground floor. Weber represented Smithson and several other sculptors who had been associated with Dwan. They had cordial relations and Weber continued providing Smithson a monthly stipend against sales, but unlike the independently wealthy Dwan, was in no position to offer grubstakes for earthworks.

At the end of the summer, 1971, Smithson drafted an undated letter to the Dutch curator Enno Develing:

> As Jennifer Licht [then a curator at the Museum of Modern Art] says, "art is less and less about objects you can place in a museum."

Yet, the ruling classes are still intent on turning their Picassos into capital. Museums of Modern Art are more and more banks for the super-rich. . . . Art that turns away from physical production to abstract consumption, strikes me as reactionary. . . . Of course, there are artists who support this reactionary condition by making abstract paintings and sculpture that can be converted into an exchange currency by the ruling powers.[22]

That text appears not to have been sent, as on September 6, 1971, he wrote a similar, more formalized letter to Develing without the commentary on art world politics.

The next year, 1972, Smithson broadcast those charges in the fifth international summer exhibition in Kassel, Germany, *Documenta 5*. In lieu of a work of art or photographic documentation of one, he chose to be represented by a brief declaration of independence he titled "Cultural Confinement"—testimonially *signed*. His *Sonsbeek* experience continued to flow outward, as it is the obvious source of his statement "When a finished work of twentieth century sculpture is placed in an eighteenth century garden, it is absorbed by the ideal representation of the past, thus reinforcing political and social values that are no longer with us."[23] But Beeren had already settled that conflict by expanding *Sonsbeek* to nonart settings around his country and inviting artists to create what and where and they pleased. Smithson had easily avoided "absorption" by Sonsbeek Park's sculptural and social traditions.

Regarding *Documenta*, Smithson explained, "I refused to do anything . . . because Documenta was a step backwards compared to Sonsbeek. Curatorially it was just a kind of collection of objects, as many objects as they could get and it was also an attempt to make art seem like something worthless to me, I mean as not a necessity."[24] So he used the occasion of its exhibition program, not only tolerant but prominent, to complain to *Documenta*'s international audience about "Cultural Confinement," paradoxically in a dematerialized "document." In his opening blast, he defined it as

when a curator imposes his own limits on an art exhibition rather than asking an artist to set his limits. . . . Some artists imagine they've got a hold on this apparatus, which in fact has got a hold of them. . . . Museums, like asylums and jails, have wards and cells— in other words, neutral rooms called "galleries."

These analogies are harsh; they construe artists as captives, patients, or victims. Previously when channeling Ehrenzweig, he had contrasted "containment" and "scattering," associating the former with mortality and

describing the latter as "vitalistic." Here he intensifies the sense of constriction by drawing upon the associations of "confinement" to a detention. But in idiomatic parlance, "confinement" is too mild a word for the experience of imprisonment (unless it is solitary)—it could describe a benign physical restriction such as a house arrest. Rather, in historical idiomatic usage "confinement" designates a woman's medically prescribed seclusion in bed, "lying-in" for a final period of pregnancy for the safety of herself and her fetus. More topically, "confinement" evokes quarantine due to a contagion or a general restriction of activity to promote healing. All of these are states of physical vulnerability.

Smithson's use of "confinement," then, calls up illness, reinforcing the allusion by likening the discussion of the exhibition of art to "a kind of esthetic convalescence. [Works of art] are looked upon as so many inanimate invalids, waiting for critics to pronounce them curable or incurable."[25] If the latter, they would become like in his second Yucatán displacement space, the "remains, or corpse, of time," then they would go to the morgue he evoked at the conclusion of his "Passaic" journey, when "time turns metaphors into *things*, and stacks them up in cold rooms."

He continued in "Cultural Confinement": "The function of the warden-curator is to separate art from the rest of society. Next comes integration. Once the work of art is totally neutralized, ineffective, abstracted, safe, and politically lobotomized it is ready to be consumed by society."[26] Just twenty-seven years after the end of World War II, the allusion to tyrannical prejudice against those deemed socially undesirable is inescapable. The likening of that to actual powers of aesthetic or professional "separation" by critics and curators is paranoid exaggeration—or hyperbole for sensationalist effect. These quasi-Marxist censures of the ruling class fashionably corresponded to political radicals in both the art world and the counterculture but not to any political or economic criticism Smithson had previously uttered. His "Iconography of Desolation" had even criticized faux radicality, a "mundane mania for the neo found-object chock full of 'banal' mystery."[27]

Smithson's previous complaints had chafed against personal constriction and the Establishment. Now he turned it against art world professionals. Yet the darkness of his diatribe against what he construed as art world discriminatory practices suggests that its sources were other than a drive for artistic and spatial/environmental autonomy. His family's trauma, "pronounced"—as Smithson projected onto curators—from the outset as "incurable," and ensuing conflicts over parental expectations, both sensitized him to being controlled by authority figures and stimulated his formulation of resistance in terms of illness and hospitalization. His description in "Cultural Confinement" of parks and gardens as "re-creations of the lost paradise or Eden," repeats his linkage in "The Iconography of Desolation"

of "yearning for Innocence"—blissful childhood—to "some impossible paradise."[28] *His* childhood had been in no sense a walk in the park. Inevitably, by the end of the essay, his thoughts plummeted to the mournful gravity of his emotional baseline: "The museum and parks are graveyards above the ground—congealed [as blood does on a wound] memories of the past that act as a pretext for reality."[29]

Again, Smithson's productive convergence of personal history and timely public issues led him to formulate positions that touched the art world's nerve. Years later his former *Artforum* editor Philip Leider observed regarding Smithson's writing, "This mingling of the aspirations of the 'extra-individual' community with those of the 'private personality' is what gives to the writings of artists their special preciousness, and insures the enduring value of these essays."[30] The changing status of works of art and exhibition practices proved to be art world pay dirt. Smithson's strident censure of constraining contexts profoundly captured the artistic zeitgeist ambivalently frustrated by the commercial expansion over the course of the 1960s of the market for contemporary art as well as the burgeoning museum exhibitions conceptualizing the concatenation of new styles. "Cultural Confinement" spoke for radical anti-commodity protectionism of art, considered as a sphere apart from commerce, where "artists. . . fight for the spoiled ideals of lost situations."[31]

These are familiar conflicts and tropes, unresolved despite his tussling with them throughout his verbal and visual creations. But the specific timing of his "Cultural Confinement" outburst, after the closing of Dwan's gallery, is significant. Earlier, in his early 1960s private "Iconography of Desolation," he had kept his denunciations—and his desolation—to himself. In a 1967 conversation with Allan Kaprow, he remarked mildly, "The categories of 'good art' and 'bad art' belong to a commodity value system."[32] The same year, his complaint "When the painting is valued over and against the picture you can be sure philistines have taken over art" was in a piece either written for private consumption or that never found a publisher.[33] Post-Dwan, he was both more economically vulnerable and need not fear offending the powerful dealer-cum-affluent patron whose hand had in more ways than one fed him. (Weber needed Smithson's stature more than vice versa.) So the bluntness of his "Cultural Confinement" condemnations also suggests an urge to retain a place in the limelight.

"Cultural Confinement" became Smithson's most influential and still regularly quoted rallying cry for artistic independence. It spoke to those who, through the Art Workers' Coalition, advocated for more control over museums' display of their work, in part by parroting AWC's attitudes such as that artists "end up supporting a cultural prison that is out of their control." Smithson's statements have been recognized by art historian Alexander

Jon Creighton as "words [that] very nearly express similar thoughts stated by Lucy Lippard in her 1970 article titled 'The Art Worker's Coalition' . . . where with regard to the relationship between artists institutions she exclaims, 'It's how you give and withhold your art that is political."[34] And an oft-quoted objection to institutional control from years earlier is Carl Andre's remark, "Art is what we do. Culture is what is done to us."[35]

Smithson's adoption of this position vis-à-vis the art world tacitly compensated for his lack of statements about non–art world political and social conflict. When 100,000 people marched against the war in New York City on April 15, 1967, Smithson, Holt, Morris, Andre, and Dwan were not among them, because that was the weekend, as marked on Smithson's and Holt's datebook, they chose to make an excursion to the Pine Barrens. Weber, Smithson's art dealer, recalled Smithson as "intensely political," implying he was actively engaged, even though "there were some artists who had a very acute political sense but they might have kept this out of their artwork and writings. . . . He talked about the [Vietnam] war. He didn't like it. He would speak about it at Max's all the time."[36]

There is no evidence in his writings or interviews of engagement with non–art world governmental politics except his invited statement, previously noted, for the Museum of Modern Art in 1970, in which he remarked on the ineffectuality of such involvement. Nor is his name among the list of sixty-eight artists and art professionals who gave testimonials at the School of Visual Arts on museum reform the day the Art Workers' Coalition was founded, April 10, 1969. In her account of the AWC, published the following year, Lippard expressed frustration at Smithson's apolitical stance in regard to artists' involvement with anti–Vietnam War protests. She grouped him with two men with whom he was close, Richard Serra and Philip Leider, as representative of "the AWC's notorious sightseers, now perennial," who are

> good talkers and would be able to convince a lot of people—as long as they play with themselves at the bar, telling everyone how absurd or mismanaged the AWC is, instead of saying the same things in the public arena, they will be the bane and to some extent the downfall of the Coalition.[37]

Nevertheless, the art world appreciated Smithson's application of the anti-Establishment zeitgeist to its own realm.

Peter Schjeldahl observed, "There is something ad hoc and self-serving about these railings at the world of museums and galleries and 'portable' art that [Smithson], with his Earthworks, had managed to escape."[38] Actually, he didn't seek to escape the gallery system. Why would he, as he had had a compliant dealer who put no constraints on him during his major

years as a sculptor and, more than that, was willing to fund trips and the creation, two thousand miles away, of a gigantic earthwork, and another gallerist on the West Coast, Douglas Chrismas, who funded the film about it? Other artists—Michael Heizer, Walter De Maria, Robert Morris, Dennis Oppenheim—made those spectacular works in western deserts, northern icebound rivers, and Dutch fields exotic to the East Coast art establishment precisely to attract gallery representation. Moreover, as Dan Graham recognized, artists' desire to remove themselves from galleries was an illusion: "Everybody was getting around the gallery system—but they were also in the gallery system. That was the dilemma of the time."[39]

Smithson's commentary to interviewer Bruce Kurtz in April 1972, made between the time that he had written "Cultural Confinement" and its publication, was much more characteristically circumspect, even defensive:

> I'm not really discontent. I'm just interested in exploring the apparatus I'm being threaded through . . . and to me that's a legitimate interest. . . . I think that actually [it] is an investigation of some kind of space control that's shot through with all kinds of social, economic, political implications. . . . I don't really see this as, you know, a complaint or anything.[40]

His statements show an early interest in what became known as "institutional critique."

Less acknowledged in "Cultural Confinement" is Smithson's scorn for "occult notions of 'concept' [which] are in retreat from the physical world. Heaps of private information reduce art to hermeticism and 'fatuous metaphysics.' . . . Writing should generate ideas into matter, and not the other way around." "A lot of the so-called conceptual art is nothing but atrophy."[41] Smithson made his loathing for its disembodied dematerialization clear by contrasting it to his way of working. Speaking to Dennis Wheeler, he described "the trap that Conceptual Art would get into. The cerebral isn't touching rock bottom; it's just a sort of pure essence that is up here somewhere. So it's going back into a kind of pseudophilosophical situation. I'm really not interested in philosophy. I'm interested completely in art."[42] That made his antinomy starkly clear: vaporous theorizing vs. plunging to depths. The terms in which he rejects conceptual art divert attention from his own hermetic allusions to his personal history—"the lost paradise or Eden . . . artists . . . challenge, compete, and fight for the spoiled ideals of lost situations"—and preoccupation with metaphysics or the metaphysical (words used six times in the 844-word essay). Contradicting his inclina-

tions, in *The Spiritual in Art: Abstract Painting, 1890–1985*, an exceptionally beautiful catalogue for an encompassing 1985 exhibition in which he would have been included had his engagement with religion and the occult not been suppressed, his sole mention is an aside referring to him as the more generic "conceptual artist."[43]

Differentiating in "Cultural Confinement" his own way of working, Smithson declared, "I am for an art that takes into account the direct effect of the elements as they exist day to day apart from representation." His phrasing transparently mimics without acknowledgment Claes Oldenburg's 1961 "Ode to Possibilities" mantra written for the catalogue of the influential Martha Jackson Gallery exhibition *Environments, Situations, Spaces* that Smithson must have seen. Oldenburg famously declares seventy-eight times "I am for an art . . . ," beginning with "I am for an art that is political-erotical-mystical, that does something other than sit on its ass in a museum," an early articulation of artists' desires in the 1960s for environmental expansion. Smithson elaborates his own aim as "I am talking about a dialectic of nature that interacts with the physical contradictions inherent in natural forces as they are—nature as both sunny and stormy." Elaborating, he characteristically prefers not "ideal gardens of the past," or "their modern counterparts—national and large urban parks," but "the more infernal regions—slag heaps, strip mines, and polluted rivers."[44] Those "infernal regions" were exactly the "rock bottom" places he had depicted a decade or more earlier: *Purgatory, Walls of Dis*, and *Valley of Suicides*, as well as despoiled sites captured in *Dead Wood, Black Grass*, and *Petrified Wood*.

Ever the contrarian, during this nascent phase of public environmentalist engagement, Smithson had led the way among masculinist earthworkers in denigrating affiliation with nature as retardataire romanticism. As nature has been traditionally coded as female, they strenuously differentiated their fields of action from the stereotype associating affiliation with earth as tender receptivity. In 1968, Smithson wrote, "Deliverance from the confines of the studio frees the artist to a degree from the snares of craft and the bondage of creativity. Such a condition exists without any appeal to 'nature.' "[45] And they did not want to be linked with what they construed as the regressive anti-intellectualism implied by the counterculture's back-to-nature fantasies. On a 1969 panel discussion at the opening of *Earth Art* at Cornell University, he stated, "I think we all see the landscape as coextensive with the gallery. I don't think we're dealing with matter in terms of a back to nature movement. For me the world is a museum."[46]

Yet the increasing public concern that led up to the 1970 establishment of Earth Day, and even more, the cessation of Dwan's largesse, put pressure

on Smithson to shift direction for his own economic if not professional sustainability. The environmentalist spark of the 1962 publication of Rachel Carson's *Silent Spring*, fanned by the validation of being excerpted in three issues of the *New Yorker*, had by the mid-1960s spread to the founding of several activist environmental advocacy groups. Extending the work of the legacy conservationist Sierra Club nonprofit, organizations such as the Environmental Defense Fund (1967), Friends of the Earth (1969), and the Natural Resources Defense Council (1970) became more proactively protectionist and instigated lobbying practices that strongly contributed to the establishment in 1970 of the federal Environmental Protection Agency. The public at large was beginning to appreciate all things natural. The unbuilt landscape itself had easy appeal as a respite—albeit one ecologically besieged by extractive industries—from the political tumult of the Vietnam War and the social one of antiestablishment radicality.

Environmentalism was becoming so mainstream that Smithson complained, "Ecology to me has replaced . . . I mean that's the official religion right now."[47] A few months earlier, speaking to journalist Calvin Tomkins, he elaborated:

> The ecology thing has a kind of religious, ethical undertone to it.
> It's like the official religion now, but I think a lot of it is based on
> a kind of late-nineteenth-century, puritanical view of nature . . .
> a tendency to put man outside nature, so that whatever he does is
> fundamentally unnatural. . . . A lot of people have the sentimental
> idea that nature is all good they forget about earthquakes and ty-
> phoons and things like that.[48]

Smithson will never forget the potential for encountering disastrous natural phenomena such as quicksand. Nevertheless, to obtain support for land projects, his professional ambition and articulation of his persona needed to at least appear to convert to the current "religion." He wasn't making sculpture that would be materially stable as urban art in outdoor public places, a type that in any case was commissioned after lengthy competitive procedures subject to several levels of bureaucratic approval and increasingly awarded to artists who found ways to refer to local history.

The push to pivot away from his "don't tread on me" stance of "Cultural Confinement" came in mid-1972. Ohio State University's invitation to participate in their April 1973 conference on new approaches to art education exposed a path in a new direction: to make earth sculpture in a strip-mining region. It brought his attention to mining companies in need of land restoration after their extractions had depleted the earth, seemingly the perfect complement to his own need for parcels of land and commissions

funding his work on them. Those ravaged sites fit his preference for terrain others would consider suboptimal. He wrote that year what could have been Smithson's personal, even autobiographical, motto: "Each landscape, no matter how calm and lovely, conceals a substrata of disaster."[49] In working with abandoned mine sites, the destruction wasn't even hidden.

He thereby collected texts on the importance of mining to the U.S. economy and periodical clippings about mining and reclamation legislation, educating himself about the mining industry, its activities and needs. He read pragmatic guides such as Time-Life Books' *Lawns and Ground Covers* (1971). He had learned that the Hanna Coal Company planned to transform its 1,000-acre depleted strip mine site in southeastern Ohio into a recreation area. In his proposal to its president, Ralph Hatch, Smithson rebranded himself as a sculptor experienced at land reclamation who could facilitate an upgrade not only of a mine's terrain but also of its reputation:

> I am well-aware of the negative publicity that strip mining has received. . . . Even if reclamation is done it lacks the visual impact of actual operational mining. . . . A restored woodland is just not visually interesting to the press. An Earth Sculpture, on the other hand, would provide a focus that would have positive visual value, and call attention to the surrounding reclamation process.

He concluded the shrewd pitch with an uncharacteristically idealistic assertion that would become his new profession's mantra: "Earth art can become a visual resource that mediates between ecology and industry."[50]

In July 1972, seeking endorsement of this project from the American Mining Congress, Smithson sent a long letter to its president, Allen Overton Jr., exaggerating his *Sonsbeek* earthworks. He described them as two distinct projects commissioned by the Dutch government instead of a museum's temporary exhibition (even if partially funded by the state), and he identified the sand-mining quarry as "slated for reclamation as a recreation site." There was no "future reclamation plan" ever announced by the De Boer family, who owned the quarry; by *Sonsbeek* (which was funded by state grants); or by the Dutch government, which presumably would have purchased the quarry or sought its donation from the owners for that purpose.

Even so, Smithson's *Sonsbeek* experience provided a useful preparation for what he offered: "I am developing an art consciousness for today free from nostalgia and rooted in the processes of actual production and reclamation." His confident assertions would have appealed to a CEO receptive to being environmentally current, while proposing a corporate commission of an unfamiliar type and application of art:

Our new ecological awareness indicates that industrial production can no longer remain blind to the visual landscape. Earth art could become a visual resource that mediates between ecology and industry. Current land reclamation projects lack sufficient imagination to catch the public eye. . . . Many ecologists tend to see the landscape through 19th century eyes, while many industrialists see nothing but profits. . . . A dialogue between earth art and mining operations could lead to a whole new consciousness.[51]

Smithson's idealism suggests that he was unaware of the *corporate* confinements he would encounter when negotiating a sculptural commission under its aegis. Or he had decided to put that aside and pretend the business leaders of the Hanna Coal Company and the American Mining Congress were both pragmatic and receptive to new ideas. Fifteen days after the date of Smithson's letter, the Mining Congress's director of communications replied on Overton's behalf as an administrative functionary. The company leaders tacitly admitted a failure of imagination: "We don't see how this can be put to effective use by the mining industry at this time."[52]

Undeterred, three months later Smithson sent Hanna a terse description of the project's equipment needs, stating that he would work with the Ohio Reclamation Association on selecting botanical ground covers and that his fee would be $20,000, including lectures he would give and other public relations activities. His proposal drawing *Lake Edge Crescents—Egypt Valley, Ohio (Hanna Coal Reclamation Project)* reduced the design of his *Broken Circle*, with a flat triangular plane at the bottom of a pit, adjacent to a lake, and a thin jetty projecting from it in a wide arc. The ground would be planted with the hardy perennial crown vetch, a legume vine considered aggressive, which blossoms in lavender (a hue seen in several of Smithson's post-Christ paintings as well as the water around *Spiral Jetty*). That ground cover, which is difficult to walk through and uncomfortable to lie on, made it ambiguous how this reclaimed site would function—as a sculpture to be viewed, or a place with some areas of lawn for play and a rest, or both? In any case, the aggressive specificity of Smithson's letter prompted Hanna to just as definitively decline, citing budgetary constraints, and noting it could possibly make land available if financing were to be obtained elsewhere.[53]

Support came via the art world from financier and sometime art collector Timothy Collins, who had met Smithson on a Whitney Museum patrons' tour of his home and studio. Collins became an advocate, urging Smithson to contact some of his corporate connections and providing a cover letter. Between December 8, 1972, and June 13, 1973, Smithson and Holt sent out thirty-eight "kits," a prospectus for sculptural renovation of

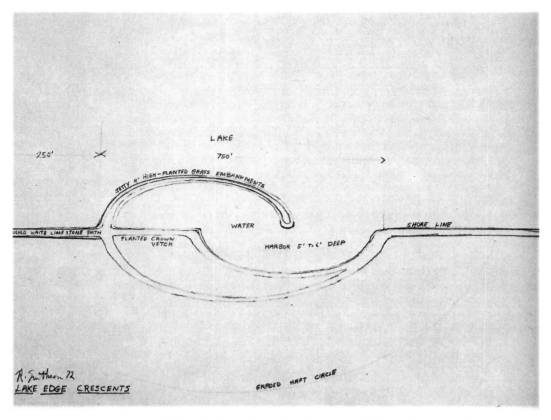

Inside the image, the following handwritten labels appear:

LAKE
250' ✕ 750' ＞
JETTY 4' HIGH—PLANTED GRASS EMBANKMENTS
WATER SHORE LINE
DASHED WHITE LIME STONE PATH
PLANTED CROWN VETCH HARBOR 5' T. 6' DEEP
R. Smithson 72
LAKE EDGE CRESCENTS GRADED HALF CIRCLE

FIGURE 13.7. Robert Smithson, *Lake Edge Crescents,* 1972. 19 × 24 inches (48.3 × 61 cm).

This design also resembles the cover of Nathan Scott's *Broken Center* (Figure 13.3).

closed mines and other sites of extraction, to mining, mineral, metals, and petroleum companies with documentation of Smithson's previous work, writings, and copies of reviews. Among the first batch of recipients, Charles Melbye, president of Minerals Engineering Company (of which Collins was a major shareholder), very shortly replied to Smithson on December 20, 1972, with the information that "since our operations are presently strictly exploratory, we are not at the stage at which your services would be beneficial. However, we will certainly keep in mind the various possibilities."[54] In May 1973, Peabody Coal responded more representatively: "After serious discussions with our Engineering Department, we have concluded that we have no interest in Earth Art as a part of public relations in mining reclamation."[55]

Smithson has been hailed as an early reclamation artist, yet his understanding of what that entails needs to be understood in both personal and historical context and differentiated from the current process. Speaking with critic Kenneth Baker in 1971, Smithson conceived of his position as "[wanting] my work to be part of the world rather than to withdraw from it

into some kind of abstract idea."[56] Since he saw the world as unstable, subject to chance, and a place of entropic degradation, that's what he wanted to present. He would counter what he considered to be the naive romance of nature characteristic of the pastoral idiom, an idealization he disparaged as "a yearning for the unspoiled paradise garden" by

> confer[ring] a different kind of value through a different kind of cultivation. I think it is possible to cultivate waste, spoil banks, or the cuts in the strip mining areas. It's a matter of developing a different kind of relationship between the industrial process and the ecological controls.[57]

In Smithson's ecological "religion," his concept of reclamation would bring a second life to the terrain in a kind of terrestrial resurrection, but signs of the land's crucifixion—raw excavations—would remain. As Andre later observed, Smithson "reveled in the wreck and chaos of our deteriorating capitalist system and loved the scars and acid tarns of dead strip mines and looted mineral veins."[58] So when Smithson promoted himself as a veteran reclamation artist, he referred to visual and structural alterations to transform an environmentally degraded site into earth art. This was neither restoring an earthen environment to its pre-excavation ecological naturalness nor upgrading it into a felicitous terrain for softball and picnics.

Reclamation of any terrain's ecological system is a substantial collaborative process of restoration. Smithson's proposed consultation with the Ohio Reclamation Association on botanical ground covers was minimal. Despite his prior engagement with natural science, he did not integrate collaboration with a chemist for neutralization treatment of the poisoned terrain and tailing ponds, or with a geologist, environmentalist, landscape designer, or designer of family recreational areas. That interdisciplinary and collaborative artistic practice had not yet begun.

Perhaps those scientific and social collaborations toward recultivation would have occurred had he received commissions. But Smithson's conception of reclamation appears to pertain primarily to material restructuring, aesthetic remediation, and revitalizing symbols rather than ecological restoration or public engagement. Ironically, as he did not divulge the symbolic associations and personal associations to him of his designs of circles, semicircles, and energetic curves, they were viewed as the "abstract ideas" he disdained. Lippard's insight that his *Spiral Hill* and *Broken Circle* earthworks functioned "in a sense of reclamations" not just of "neglected land" but "of neglected symbols" will apply even more resonantly to his final design in earth.[59]

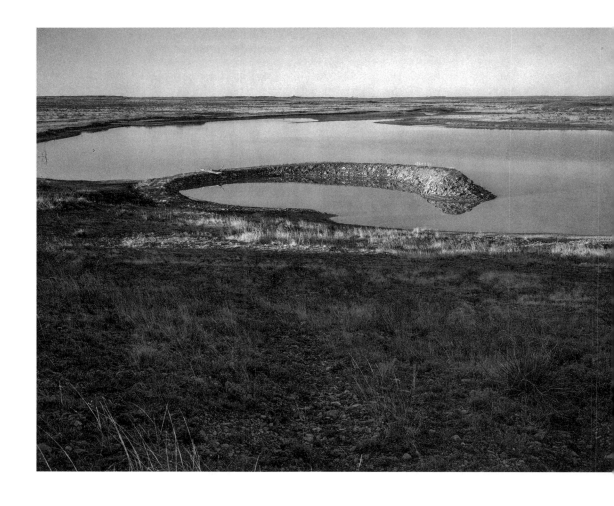

FIGURE 14.1. Robert Smithson, *Amarillo Ramp,* 1973. Tecovas Lake, Amarillo, Texas. Diameter: 140 ft. (42.7 m). Height: Ground level to 15 ft. (4.6 m). Photograph courtesy and copyright Wyatt McSpadden. *Amarillo Ramp* copyright Holt/Smithson Foundation / Licensed by Artists Rights Society, New York.

In *Amarillo Ramp on a Winter Afternoon* (1976), Wyatt McSpadden, now a well-known photographer based in Austin, conveyed the monumental serpentine grandeur of Smithson's earthwork.

14

Closing the Circle

It seems that no matter how far out you go,
you are always thrown back on your point of origin.

After my visit to Rome, and when I return every body in New York art circles will know about the George Lester Gallery and Robert Smithson. I don't have to appeal to the art world here; they will follow" (May 17, 1961, #7). Smithson's expansive prediction to Lester had come true, at least for himself. Galleria George Lester closed by the mid-1960s when the Lester family repatriated to Connecticut. By the summer of 1972, Smithson became an influential presence in both exhibitions and periodicals.

Following his 1967 "Air Terminal" declaration, "The 'boring,' like other 'earth works' is becoming more and more important to artists. Pavements, holes, trenches, mounds, heaps, paths ditches, roads, terraces, etc., all have an esthetic potential," Alice Aycock, Walter De Maria, Agnes Denes, Michael Heizer, Nancy Holt, Mary Miss, Claes Oldenburg, Dennis Oppenheim, Michelle Stuart, and many others made their first works on undeveloped earthen terrain. His *Spiral Jetty*'s merging of the stylistically progressive, the materially primitive, and the symbolically primal in a work of alluring strangeness was making him a stellar art world figure. The works in the Netherlands extended that recognition in Europe. The Archives of American Art sought him for an oral history. The armor of prestige allowed him to brashly propound his skepticism about artists' "Cultural Confinement" in relation to institutions, contributing to their professional consciousness.

But even then, as a critic of his own field he had it both ways: articulating popular anti-institutional invective yet publishing it in the substantial catalogue of the institutionalized *Documenta* and, at the exhibition's close, reprinting it in the October 1971 *Artforum*, megaphone of so many influential art critics disdained by him as ready to pronounce "invalid" art as "curable" or not.

Smithson had gone far from his point of origin in Passaic, but what the turn ahead on his personal spiral would bring was unknown. He was sought for potential teaching and a sculptural commission at University of California Irvine, but neither it nor his interdisciplinary proposal to György Kepes at MIT came through. He and Holt purchased a small island off the coast of Maine and visited it and Maine quarries. But none of the sites seemed quite right, and there was the problem of funding construction, especially at a place not easily accessible. He was in the midst of a second professional hiatus, like the twenty-eight months following his second Castellane show in November 1962. Reflecting in his oral history interview in July 1972, he remarked, "Well I haven't really worked on a major piece since the *Broken Circle*, that's a little more than a year ago now and I've just been trying to in a sense find a way out of the current art world context into another context."[1]

At that point he had not exhibited new sculpture since his February 1969 solo show at Dwan of nonsites, forty-one months, and his last solo show documenting an earthwork, *Spiral Jetty*, been on view two and a half years earlier at Douglas Chrismas's Ace galleries in Los Angeles and Vancouver in November and December 1970.

In late 1972 Smithson was awarded a Guggenheim Fellowship for 1973. His three-paragraph proposal was clever: the amount of the award would not fund traveling to a distant locale and moving earth, but it could cover costs associated with his photographic documentation of such a project. He described it as sculptural revitalization of damaged terrain, "a 1,000 acre tract in the Hanna Coal Mines [southern Ohio] which is slated for a recreation area after it is reclaimed." His book of photographs recording that project would enable him, he wrote in his application, "to continue my dialogue with the mining industry in terms of concrete problems and specific sites slated for reclamation." His accompanying drawing *Lake Edge Crescents*, "a combination of two interlocking curves (a jetty and harbor)" consists of an arc ending downward at the horizontal center of a lower semicircular bay that points upward.[2] A variation of his submissions to several mining companies, all are akin to the yin/yang complementarities of *Broken Circle*. In late November 1972, however, the president of Hanna Coal Mining had declined to commission Smithson's proposal, and the company had no proposal of its own for transforming a former mine into a recreation

site. The Guggenheim Foundation funded documentation of a project that would not be made.

Sometime in the first half of 1973 Smithson drew, atop a map of the mammoth Bingham Copper Mining Pit in Utah, four narrow, counter-clockwise, arcing jetties over the circular pond of water and chemical run-off at its nadir. The concentric terracing that seared the three-mile-wide strip-mined hole would be left largely intact, so the remediation would not be ecological but sculptural. As the ravished bowl would not encourage exploration, hiking, picnicking, or recreation, Smithson's preference for environments evincing entropic degradation conflicted with corporate aspirations to transform wasted sites into recreational areas that could become popular with the public.

Another of Smithson's proposal drawings is *Tailing Terraces with 4 Ponds* (1973). It would consist of four stepped, semicircular berms around a half circle, between which would be four channels of tailings (toxic slurry residue from the refinement of ore). The sum of the terraces and ponds is Smithson's frequent symbolic number, nine.

His contribution to the Whitney Museum's spring 1973 Biennial (the first, supplanting the Whitney Annual survey of the vanguard) was photographs of *Spiral Hill* and *Broken Circle*, made two years earlier. His creation and exhibition of new work was stalling. The way forward turned out to be the direction of his *Spiral Jetty* and *Spiral Hill*, counterclockwise, a return to formats he had mastered and with which he had become known: imaginative essays and mystical forms in earth.

Waiting for responses to his appeals to mining companies, Smithson turned to a medium more receptive to his talents: writing. Fortuitously, the Whitney Museum's autumn exhibition *Frederick Law Olmsted's New York* provided the incentive for him to discuss the historical landscape architect's designs in earth; in February 1973, *Artforum* gave him the platform. In "Frederick Law Olmsted and the Dialectical Landscape," Smithson turned away from his prior preference for the crystalline over the organic. Rather, he argued that in contrast to classical European formal (geometricized) garden design, Olmsted's program integrated naturalistic material roughness, unruly asymmetry, and sudden openings onto vistas of lakes and meadows as found in the wild. Punningly literalizing the Marxist idea of "dialectical materialism," Smithson described that as a synthesis of the historical concepts of the "beautiful" and the "sublime" in the "picturesque," appealing for its delight in irregular and culturally low terrestrial variations. "Nature for the dialectician is *indifferent* to any formal ideal."[3] In Olmsted he recognized his own recent Ehrenzweig-like preference for free form rather

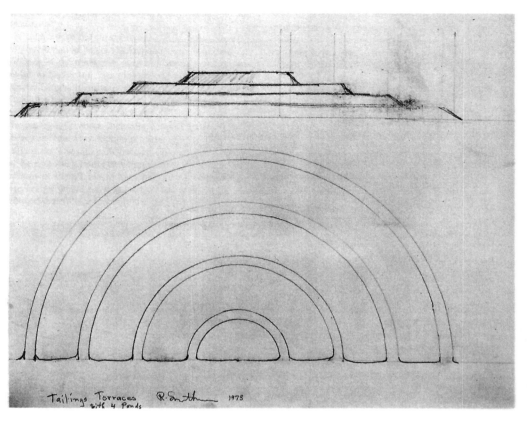

FIGURE 14.2. Robert Smithson, *Tailing Terraces with 4 Ponds,* 1973. Pencil and charcoal, 19 × 24 inches (48.3 × 61 cm). Copyright Holt/Smithson Foundation / Licensed by Artists Rights Society, New York.

than structural containment and acclaimed the nineteenth-century park designer as the "first 'earthwork artist.'"

Smithson argued his view of Olmsted in an uncharacteristically subdued voice, denatured, lacking the vitality of his customary idiosyncratic allusions and fantastical asides. One of the few eruptions of his more typical metaphysical musings is "Nature, like a person, is not one-sided." Was he chafing against the limitations of the character he had devised for himself, the literate, rationated, darkly skeptical sculptor? How many sides of himself had he disclosed, and how many had he disguised? Here, he emphasized intellectual sobriety, the better to persuade that "back in the 1850s," Olmsted, "the sylvan artist," remade the "manmade wasteland" of central Manhattan "in terms of earth sculpture." He went on to illustrate Central Park as a "dialectical landscape . . . the democratic dialectic between the sylvan and the industrial" by narrating yet another journey, a peregrination through the park.

In positing Olmsted as his precedent, Smithson continued a pattern of behavior in which he positioned himself as chronologically—and, initially,

professionally—junior to another male. That was characteristic of his friendships with Alan Brilliant, two years older, Peter Hutchinson, eight years older, and with the decade-older Donald Judd and Sol LeWitt. Some were senior in age approximately the number of years that Harold was to him. These could have been simply instances of compatriot male bonding, particularly by one who had grown up an only child feeling like a misfit in his native milieu. Yet the pattern of older surrogate brothers-of-a-sort is notable. Richard Serra, exactly ten months younger than Smithson, felt Judd "became like an older brother for me, he was very supportive." Judd's fraternal relation to Smithson was expressed in older-sibling rivalry; for example, he disparaged Smithson's writing as "sophomoric."[4] Also, through regular quotations Smithson linked himself to elder male authors: T. S. Eliot's wry malaise; Samuel Beckett's bleakness; J. G. Ballard's crystallinity and melancholy; Wylie Sypher's entropic losses; John Taine's circularity of time; John Lloyd Stephens's pioneering Yucatán exploration; G. K. Chesterton's obsession with blood; and Olmsted's naturalistic earth moving.

Toward the end of the Olmsted essay existential mourning creeps in: "A consciousness of mud and the realms of sedimentation is necessary in order to understand the landscape as it exists."[5] Like his statement "One must learn to see the mud through the grid, and create a new sense of scale," it could be taken as geography.[6] More likely, his references to "consciousness" and "learning to see" suggest the association of geology and psychology featured in his "Sedimentation" essay: "The earth's surface and the figments of the mind have a way of disintegrating into discrete regions of art."[7] But with the concluding assertion that Olmsted "sets an example which throws a whole new light on the nature of American art," he—or his *Artforum* editor—retreated to impersonal academese.

A month after the Olmsted article established his historical and public-spirited affiliation, Smithson's interview by Moira Roth as research for her dissertation topic, Marcel Duchamp, displays Smithson's acceptance of a mainstream attitude of art's relation to commerce. Speaking of the Dadaists, he remarked, "They think that everything is corrupted by commercialism and industry and bourgeois attitudes. I think it's time that we realize that there is no point in trying to transcend those realms."[8] His attitude has not been recognized by interpreters of earthworks and land art who think since it is difficult to sell, it must be against the commodification of art.

Many have wanted to see Smithson's environmental art practice as more professionally transgressive of the mercantile system of distribution of works of art by art dealers and collectors than his history shows, whereas his statement reiterates his view of the previous year: "There's a fantasy that

somehow the curator is disconnected [from commodification pressures], in some ivory tower, while all these terrible dealers are running around. I don't really see that, I mean that's just a reality. Paintings are bought and sold."[9] And talking with Lippard a couple of months after conversing about Duchamp, he again spoke of galleries with benign detachment: "As the art world multiples itself in a rather unnecessary way, as more and more galleries open up without the necessity for those galleries, to use a rather Kublerian term, aesthetic fatigue sets in."[10]

Roth's interview also indicates that religion was on Smithson's mind. Just as in the previous year, 1972, he griped separately to Paul Cummings and to Calvin Tomkins that ecology had become society's "official religion," he told Roth, "The Dadaists, they're setting up their own religion." In his familiar strategy, he sought to shape his public persona by interjecting an issue tangential to the subject, but with which he privately struggled, then critiquing it to forestall the reader's association of him with it. (Of course, if he hadn't introduced the subject, no one would have linked him to it, so he actually cued the reader to his interest in that which he ostensibly scorned.) He continued his remarks about Dadaists (my emphases):

> This whole notion of trying to form a cult that transcends all this strikes me as a kind of *religion-in-drag*. . . . I am just bored with it, frankly. I think it's a desperate attempt. And then they try to transcend their own movements and all this sort of thing. So there's this kind of *latent spiritualism* at work in just about all of modernism. . . . There's this guilt even about being an artist. At the bottom I see Duchamp as a kind of *priest* of a certain sort, who's turning urinals into *baptismal fonts*.[11]

His figures of speech bring up an intriguing mix of things hidden: spiritualism, dormant ("latent") or hiding its identity in the guise of art ("in drag"). He construes that Duchamp, who at times staged a female persona by having the artist Man Ray photograph him dressed as a woman, also merged the functions of two bowls, a urinal (for men's liquid waste) and a baptismal font (for bestowing purification and admission to Christianity). It is a projection of his conflict between a man's sexual release and devotion to the Church, which seems to have been ongoing.

Then he introduced a third covert interest from which he wanted to distance himself, recounting that in a brief meeting with Duchamp he had inquired of him, " 'I see you are into alchemy,' and he said, 'Yes, I am.' " Smithson made no reference to his own interest; he had already professed to Roth his identification with rationality: "I am just not interested in the occult. . . . Those kinds of systems are just dream worlds, it seems to me. They are

fictions at best and at worst, they are uninteresting."[12] Was he seeking an affirmation of his own inclinations? At that point he had retained twenty-three books on the occult and nine directly on mysticism, nine of the total published in 1964 or after. Speaking generally about his creative process, Smithson had told Wheeler, "So what I did was, I abstracted this situation in terms of my own experience."[13] That is as true for his experience that "lurked" around his artistic personas as it was for the obvious conditions.

Whatever he didn't have going on sculpturally, Smithson did have his influence as a wordslinger at saloons. Jack Thibeau, poet and actor, reminisced:

> I first met [Smithson] one spring night in 1973 at Max's Kansas City. The introduction was by Philip Glass, the composer, a mutual friend. . . . Our conversation took form in an imaginative series of sometimes brilliant, sometimes hilarious, sometimes oceanically serious non-sequiturs. He seemed to know almost everything about anything. . . . We were joined by [actor] Rip Torn and Ruth Kligman, who was at the time writing her memoirs about her love affair with Jackson Pollock. . . . One night he was in a booth with Joan Jonas, the performance artist, and Richard Serra, Robert Morris, and Carl Andre, the group someone once jokingly referred to as "the sculpture mafia."[14]

In mid-April, Smithson's father died of cancer. Serra recalled that although in conversations Smithson hadn't brought up his parents, at his father's death he was profoundly overcome with grief.[15] Smithson's numerous inclusions in his paintings and drawings of signs of his father's automobile-related employment suggest either a closeness with him or a desire for that, perhaps along with an acknowledgment from his father that despite his parents' objections it had not been a mistake for him to become an artist.

His final bar tab at Max's, dated June 24, 1973, lists debits for sixteen days since the beginning of the month, some days with multiple charges. On one of those, poet Louis Asekoff spent an evening with Smithson and Serra at Max's; they discussed republishing Smithson and Bochner's "In the Domain of the Great Bear" (*Art Voices*, Fall 1966) in the magazine *Fiction*, where Asekoff was an editor. Asekoff recalled: "Smithson was going through a dark, despairing mood, had many conflicts about himself; he seemed bitter, self-corrosive."[16]

Just before Smithson was leaving for the west to examine mining sites and potentially negotiate with companies, Thibeau saw him again. "He seemed a little depressed, a mood I had not seen him in before." Smithson

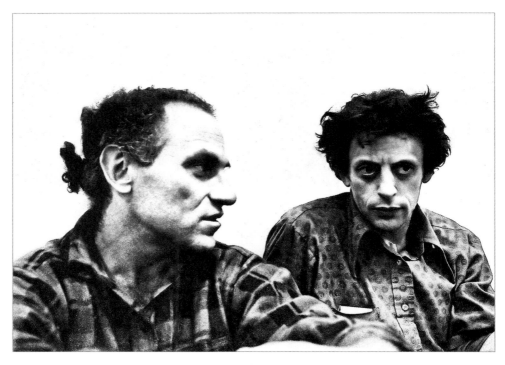

FIGURE 14.3. Richard Landry made this photograph of Richard Serra and Philip Glass during a rehearsal for Glass and Robert Wilson's *Einstein on the Beach*, 1975.
Courtesy and copyright Richard Landry.

told Thibeau that earlier that morning he had been looking at a reproduction image of Théodore Géricault's *Raft of the Medusa* (1819). "Smithson compared the painting to the New York art scene: adrift, lost at sea, wondering what to do next." Given his situation, that interpretation could just as well have applied to his feeling unmoored. "All predictions tend to be wrong," he told an interviewer that spring. "I mean planning and chance almost seem to be the same thing."[17]

On June 28, Smithson and Holt flew to Albuquerque, New Mexico, where a six-week summer session of the Whitney Museum's Independent Study Program was being held. David Diao, artist and teacher there, had asked friends, many known from Max's, who were traveling that summer to pass through and give talks. Among them were Tricia Brown, Ree Morton, Keith Sonnier, and Jackie Windsor.[18] Smithson made the visit, gave a talk on his work, and proceeded to drive with Holt to a mining site at Creede in south-central Colorado.

Written accounts of this period of Smithson's career, based on information provided by Holt, state that he had received a "promise of funding" for *Tailing Pond in* Creede, Colorado (Hobbs), or had been "commissioned

by the Minerals Engineering Company based in Denver" and as of 1973 had "work[ed] on the project for two years" (Tsai).[19] Evidence of that commitment is not among his papers in the Archives of American Art; the 1972–73 annual report for Minerals Engineering discusses Creede properties and plans for developing them without mentioning a proposed Creede project or Smithson.[20]

For Tony Shafrazi, a sculptor, conceptual artist, and later prominent art dealer, his own lectures at CalArts in Los Angeles, in San Diego, and then with the Whitney Museum program in Albuquerque were stopovers before proceeding to Texas to visit a potential patron.

Shafrazi's destination was the ranch about twenty miles northwest of Amarillo, Texas, owned by Wendy and Stanley Marsh 3 (who as one of his eccentricities indicated he was the third Stanley Marsh by appending "3" to his name rather than "III"). Shafrazi had met the Marshes the previous summer in Iran; he had shown the couple around Tehran and Isfahan for several days and was invited to visit them in Texas.

Just four hours east of Albuquerque on the Texas Panhandle, Amarillo had been a railhead for cattle drives before becoming a hub for petroleum extraction. A third-generation cattle rancher, land baron of oil and gas properties, mogul of television broadcasting stations, and graduate of the Wharton School of Business at the University of Pennsylvania

FIGURE 14.4. Vintage postcard of Amarillo, no date. From the collections of Ray Franks Publishing Route 66 Nostalgia Series; designed and printed by John Hinde Curteich, distributed by A-Town Merchants, Amarillo, Texas.

in Philadelphia, Marsh had assets that spanned the city's history. He married Wendy Bush O'Brien after her graduation from the University of Texas law school; she had grown up on the ranch next door in a family wealthier than his. (At Smith College her classmate was Lucy Lippard.) According to Shafrazi, Stanley and Wendy "were considered the A in Amarillo." Shafrazi recalled:

> I had hoped to give my lecture in Albuquerque and then go to Amarillo and spend the whole summer—maybe a month and a half or two months—there, then in September, come back to New York. I would do some artwork there, some texts, and I thought Stanley might buy something, whatever there was to buy; I was making written texts of purely abstract thoughts.

Shafrazi knew Smithson as a good friend with whom he had shared many discussions at Max's Kansas City. He recalled:

> Smithson and I bonded well together. He was five years older, very well read on all subjects, including cinema and literature, extremely articulate and a fantastic writer. He always had worn western-style clothing, black cowboy shirt, jeans, and slightly pointed boots. Even though he wore glasses, there was always something grungy, skinny, a hard rock-and-roll look to him. More important than his appearance, his sensibility—who he was—differed enormously from all other artists.[21]

Smithson had heard from Diao that Shafrazi was headed for the expansive ranch of a wealthy Texan and sometime art patron. From Colorado, he called Shafrazi and urged him to wait for them to arrive so that they could join his trip to Amarillo. Shafrazi was ready to leave Albuquerque but waited. He had misgivings: "I remember feeling a little awkward. I was a guest, and to show up with two people? But since I loved them (Robert and Nancy) very much I said, 'OK, we'll go together,' and they had a car, and we drove all the way to Amarillo, Texas, excited on a great road trip in the dry heat."

A large sculpture by John Chamberlain of crushed automobile body parts stood outside the Marshes' sprawling ranch house, a gift from the artist after they had hosted him and supported Chamberlain's construction of sculptures to be sent east for a solo show at the Castelli Gallery in Manhattan. Llamas and occasionally other exotic animals whose natural habitat was distant wilds grazed the small fields. Marsh identified with the impulsive desires of the boastful Toad in Walt Disney's film version of Kenneth

Grahame's children's story *The Wind in the Willows* and had named his home Toad Hall. Shafrazi recalled him as a "very surreal, extremely humorous, eccentric and wild character, and a very generous one" (Plate 28).

Marsh was unaware that Smithson and Holt would appear on their doorstep as house guests and knew nothing of their positions in the art world. But as they accompanied Shafrazi, himself a generous if new friend, the Marshes welcomed them all.[22] Marsh was captivated by the dark, intense Smithson. They were the same age, thirty-five, although Marsh didn't know and probably neither did Smithson that they were born at opposite ends of the same month, same year, Smithson on January second and Marsh on the thirty-first, 1938. As for Shafrazi, "Robert dominated the conversation. Before I knew it we were in the car looking and commenting on the land." Marsh was intrigued, but "I was never going to pay for it. Bob had his Guggenheim Fellowship [money]." Smithson had mentioned it and implied that it would cover the construction costs.

They drove around his property for about three days, scanning the mesquite- and cactus-dotted prairie, before Smithson settled on a site in the shallow Tecovas Lake, an artificial irrigation reservoir. Shafrazi recalls:

> Robert was always making a most lucid commentary as we were driving, noticing things left and right, as if he had just arrived in Paradise and was fascinated. He was beyond himself with this lake which had a bed and was surrounded by soft, Indian red clay; he was talking as if he had been taking hallucinogens, but I never saw him take drugs. I hadn't seen him so excited.

Marsh has been quoted as "unwaveringly declar[ing]," in an unpublished and undated memoir, "'The project was conceived of and fully conceptualized within [the] ten days' that Smithson was in West Texas."[23] The belief that an artist's work would spring forth on-site without developing from prior art and life experience, as Smithson had claimed about his epiphany of the spiral at Rozel Point, is contradicted by the *Ramp* design's similarity to both *Broken Circle* and the many drawings he produced for the restoration of mining sites. Among those Smithson made for the lake site was one akin to *Broken Circle,* with a thicker bottom half, but in a semicircle, and a curving arc above it that increased like a ramp in its height and stopped short of penetrating that lower bay. Another has a straight arm or path like *Spiral Jetty*'s that then became an almost complete circular jetty that arced around, thicker toward the end. What became *Amarillo Ramp* is something of a synthesis of the two, a curved ramp that begins at ground level and slants upward, its shape forming almost a complete circle.

Initially Smithson and Shafrazi, then with Holt, put posts in the lake to set out and mark the artwork's form and perimeters as had been done when designing *Spiral Jetty*. But the hill along one side is of insufficient rise from which to view the earthwork from a higher elevation. Marsh hired a plane. (He would tell me, "The airport is just twenty minutes from Toad Hall. In the Texas plains, chartering a plane is as easy and common as it is in New York to take a taxi.") He and Wendy joined Smithson and Shafrazi on the flight to see the work's form from the air. Holt did not go up; she was not feeling well. They circled the site, descending to get a good view.

"The problem," Shafrazi recalled, "was that the windows were above the wings, making it difficult to look down":

> So, we had to tilt the plane to see the ground. It felt like we were spiraling into a hole, the future *Amarillo Ramp* was rising out of it. He told me he had enjoyed running on the *Spiral Jetty* (which would produce vertigo) and he enjoyed circling over the lake at an angle, almost as if he were falling down. He would giggle and cackle and was very animated. He was getting a major high from the look of the lake, the color of the water. As he had done with the *Spiral Jetty*, he could see colors. He was seeing a lot more than I did. I might be daring, or very adventurous, I am a very physical guy, but it was absolutely terrifying, tilted completely sideways while you were looking down. He was going on about blood red, incredible coloration.
>
> Robert's world, unlike ours, was all about parallels, analogies, metaphors. Signs of things. It was a hot day, and we were going around in thick air, in a small, hot plane, in entropic motion. Sitting next to me, Robert was laughing. I was sickly afraid. Seeing my fear, he was courting it. There was something despicably horrible about being in that flight with Robert.

Later at a cowboy bar, Shafrazi was emphatic about not going up in the plane again and over the next few days tried to dissuade Smithson from doing so. They stayed up late talking, with Smithson drawing:

> Every time I pointed out the danger—that word isn't strong enough— he would make light of it, and assert that it was about that, it was about that feeling. He was drawn to that it, like running on the rim of a volcano, and looking in, tiptoeing to the edge. I certainly felt that we were very close to [being] on the verge of falling in, and a few hours beforehand, had the most terrifying nightmare of my life with the most memorable words—"FEEL AND FALL."

Holt had not gone up to view the work in progress:

> I had just spent, like, about five or six days with an unknown ill-
> ness that I had never had before or again. I just lost energy. I just
> laid around for about five days. . . . We were in the guesthouse, and
> they had a waterbed, and the water was always colder than my
> skin. I couldn't move or do anything.

After recovering, Holt recalled:

> I had had enough energy to help Bob stake out his work—which was
> very unusual. I mean, I didn't help him with his work. A lot of peo-
> ple think I might have, but I did a lot of photography because it was
> fun. But I didn't actually ever help him do work. But I did stake out
> the *Amarillo Ramp* and we worked together very closely, very har-
> moniously—it was beautiful. It was like two people who were hav-
> ing this great communal experience. It was out of time and place.

She continued:

> And then, the next morning, the plane was scheduled. And nor-
> mally, as I helped stake it out, I would have got up to see what it
> looked like. But fortunately, Stanley had asked me to come up with
> an idea for his land. [When he had no intention of funding Smith-
> son's?] And I said, "You know, I think I'm going to go and buy some
> cardboard tubes that they use to pour concrete." I wanted to find a
> place where they had these. Actually, it was the idea for *Sun Tun-
> nels*—it was just starting to come to me. [Bob] said, "Well, are you
> coming up in the plane?" I said, "No. Stanley had expressed inter-
> est in my doing a work there."

Holt drove into town to get cardboard Sonotubes with which she would
start to design what became her Land Art construction, *Sun Tunnels* (1973–
76), in western Utah. She reflected:

> The night before he died, Bob said to me, "You know, if I die, you'll
> be OK." . . . Perhaps he knew that he had just a certain amount of
> time to do what he had to do. . . . But anyway, he had predicted. . . .
> And the night before, he had picked up this flat, sandstone rock,
> and he did one of his rock drawings, and he wrote on the back of it
> "To Tony from Bob," just like his farewell gift. So he sort of knew.
> I think he did know.[24]

FIGURE 14.5. The elegiac cover of *Avalanche* journal (Summer/Fall 1973), with a photograph by Nancy Holt. It contains an article on *Amarillo Ramp* by editor Liza Bear and Holt, preceded by an interview with Richard Serra and an illustration of his *Spin Out '72–'73 for Bob Smithson*. The publisher was Willoughby Sharp, who had curated the *Earth Art* exhibition at Cornell University in February 1969 and interviewed Smithson, Michael Heizer, and Dennis Oppenheim for the first issue of *Avalanche* (Fall 1970).
Courtesy Willoughby Sharp.

When Smithson flew again to view the status of the work and photograph it, the plane, according to the *Amarillo Daily News*, "crashed into an embankment on the lake, skidding about 200 yards, the plane broken by the impact of the crash."[25] All three aboard—Smithson, thirty-five; the pilot, Gale Ray Rogers, twenty-six; and the photographer and ranch employee, Richard Curtin, twenty-three—were killed. The date was July 20, 1973.

Rogers was certified as an airline transportation pilot with 3,465 flying hours, 550 in that type of twin-engine, four-seat Beechcraft E55 Baron plane. The National Transportation Safety Board report states that the plane stalled due to the pilot's failure to obtain or maintain flying speed,

that the plane's flaps were in the wrong position, and posits that the pilot's attention to the operation of the plane had been diverted. Although quite experienced, the pilot may have been deferential to requests from the Amarillo mogul's guest, as would a Marsh's ranch employee, to lower and tip the plane so the ground could be viewed over the wings.

Shortly after receiving news of his death, Carl Andre, Sol LeWitt, and Richard Serra wrote a two-paragraph statement. Lauding their peer and good friend as an "American visionary artist . . . well known as the founder of Earthworks," they stated, "his most profound contribution was his constant challenge to what he termed the 'cultural confinement' of art," an assessment that has been sustained by artists' quotations of it. "In articles . . . he offered an example of rigorous individual expression which could never be imitated and could only inspire."[26]

Later that year in a letter to *Artforum* editor John Coplans, Dennis Wheeler, Smithson's interviewer-become-friend in Vancouver, bemoaned his death and conjectured, "Gawdamn him, that fucking risk he so loved."[27] That corresponds to a perception by his early friend and mentor Alan Brilliant: "Bob was a strange mixture of almost old-fashioned courtesy to others and absolutely uncompromising recklessness within himself."[28]

At the closed casket visitation at Frank E. Campbell Funeral Chapel on Madison Avenue, eighty friends and members of the New York art world signed the guest registry: many of the artists he knew from his art world presence, dealers, curators, and critics such as Kim Levin and Rosalind Krauss, who would keep him alive in their writing, and artists Michelle Stuart and Gordon Matta-Clark (who as a student at Cornell University at the time of the 1969 *Earth Art* show had met Smithson).

Just as Irving Sandler recalled that "Bob rejected Catholicism but never seemed to get it out of his system," Brilliant remembered, "Bob was a crazy Christian during all the time I knew him," and "Bob liked to pretend he put things behind himself, like worship, belief, religion. I don't think so." Corresponding to those assessments, Holt chose for the funeral Saint Jean Baptiste, the grand uptown Neo-Baroque church where a decade earlier she had been baptized and they had married; he had maintained contact with their officiating priest. Robert Pincus-Witten recorded in his journal that it was attended by "an extraordinary density of art world figures."[29] Although services had been said in English since 1965, Smithson's High Requiem Mass with communion was sung in Latin, the language of the church Smithson had grown up with and of prayers he had inserted in early essays and drawings. Most likely no one but Holt recognized the significance of the image on the memento prayer card she chose: a close-up view of a crucifixion that

rose out of a chalice held by the hands and robed arms of a priest, as if to catch blood dripping from the cross. She knew her husband.

Smithson's Catholicism was reiterated in the eulogy by Philip Leider, his *Artforum* editor, champion, and good friend whom Holt had asked to speak. Three months earlier Smithson had chosen sections from T. S. Eliot's poem *Ash Wednesday* to be read at his father's funeral. That title's holy day was particularly meaningful to Smithson as it begins the Christian observance of Lent, itself the theme of his first exhibition at the Castellane Gallery. Holt had Leider read the second and third of three stanzas of Part II of Eliot's poem. Written during the period of Eliot's conversion to the Anglican Church, *Ash Wednesday* declares Eliot's devotion to God. As Leider commented, "Bob himself knew that longing."[30]

The first lines of the section of *Ash Wednesday* are telling: "Lady of silences / Calm and distressed." Eliot describes the Virgin in her persona as chief mourner, as Smithson named Maria Dolorosa and Maria Desolata in his "Iconography of Desolation." Read at his father's funeral, the line "Grace to the Mother" would have been consoling to his grieving mother. To Smithson, Eliot's phrase "Lady of silences" corresponds to his numerous implications that the family's loss of Harold had been insufficiently spoken about, by his parents and thereafter by himself, a person of silences about intimate concerns. Eliot's "The single Rose / Is now the Garden / Where all loves end" speaks of the singularity of the crucified Christ (the rose's redness signifying blood and the thorns of his mock crown) having become a site of fertility to which the faithful are drawn. The selection ends with "This is the land. We have our inheritance." At the sudden end of his career, Smithson's most distinctive legacy in the visual arts was his inventive sculpturing of land, although equally if not more influential would be his statements written and spoken.

After the interment at Hillside Cemetery in New Jersey, Micky Ruskin, owner of Max's, invited the regulars to gather at the bar. Coplans, who served as a pall bearer, recalled of himself and LeWitt, "We sat together a long time, reluctant to speak, comforting each other with our mutual loss, trying to postpone the certainty of what we both knew and felt, then and now, that the center would not hold. Funerals are supposed to be endings. In this case, it was an ending to more than Smithson's life. The American art world was never to be the same."[31] In a condolence letter on *Artforum* stationery, Pincus-Witten elaborated on a similar theme: "A terrible loss for American Art is marked by Robert's passing—the important evolution of which Robert was a polestar and keystone may have been broken irrevocably. . . . What he achieved will denote high watershed of our culture—and we are grateful for what already exists."[32]

Years later, the curator and critic Dan Cameron retrospectively observed

that subsequent artists' verbalizings have "the sense of half-evangelical proselytizing, half-deadpan absurdity which is clearly Smithson's greatest legacy to contemporary aesthetics." For his art world peers, Smithson was a social and intellectual magnet, as LeWitt stated about his role at Max's, and again by Serra: "People say his writing was the most important contribution other than his earthworks—maybe—but he was just as important as a person on the scene who challenged people. He was a catalyst for all of us."[33]

When Holt and Shafrazi had flown back to New York with Smithson's body, Virginia Dwan hosted a gathering of art world friends for a buffet dinner at her Dakota apartment: Serra, LeWitt, Claes Oldenburg, Lawrence Weiner, and others. Shafrazi announced that he would return to Texas to complete Smithson's piece. Serra, Smithson's closest buddy, immediately declared that he would join them, or—accounts differ—Holt asked him to come because he had worked on transforming *Spiral Jetty* from its first stage (if so that rationale must have been in a private exchange as she did not want Serra's participation in creating the spiral known). Within two weeks Holt, Serra, and Shafrazi were in Amarillo, guests of the Marshes.

The tragedy of the plane crash had changed Marsh's perspective on paying for the earthwork's construction:

> I funded it out of a sense of obligation. I didn't know whether I wanted to fund it or not. But Robert Smithson had died here. No one had ever died on my ranch. I felt really bad, and felt it was certainly a way to make amends to the world. . . .
>
> It was expensive for me. It cost a lot a money to move the earth and rocks, cut the dam, so the dirt would dry out, so the trucks wouldn't sink.

According to both Holt and Shafrazi, Smithson's design was for the arcing ramp to begin in the water, then traverse part of the shore and an ascending ramp to go back into the water.[34] But Smithson had experienced that the silt of Tecovas Lake was so soft the stakes were unstable. The three New Yorkers realized they would have to drain the lake to see, plan, and construct the sculpture. Pumping the water out would have taken too long, so they cut the dike, emptied the lake, and allowed the earth to dry out. To build the ramp, they brought in red shale from a local quarry. As construction began, on the second day the driver of the construction company hired to help build the ramp overturned the truck, almost destroying the beginnings of the ramp. Shafrazi jumped in and drove the rusty dump truck himself for

FIGURE 14.6. Stanley Marsh, Tony Shafrazi, and Robert Smithson at the Marshes' ranch, July 1973. Photograph by Nancy Holt. Courtesy Holt/Smithson Foundation and Nancy Holt Estate Records, Archives of American Art, Smithsonian Institution. Copyright Holt/Smithson Foundation / Licensed by Artists Rights Society, New York.

the remainder of the project. With Shafrazi and Holt, Serra served as manager; together they completed it in about thirty days.

They didn't refill the lake but within a few years it temporarily filled and then emptied again. Not only were both of Smithson's prior earthworks situated in water but the contrast of liquidity and solidity was fundamental to the design of the earthen masses. So the construction on dry land of what Smithson had identified on drawings as *Amarillo Ramp* radically changed his conception. The benefit of doing so is that the exposed earth emphasizes both its redness, which Smithson favored, and the ramp's upward sweep and increasing breadth along it.

The curving embankment, 150 feet in diameter and almost 400 feet in length, rises in elevation from ground level at the end nearest the grassy shore to a height originally twelve feet within the dry lake, soon covered with low foliage; the highest end, originally ten feet across, has eroded due to shifting earth. Along its length both sides slope to the ground and are edged with boulders. J. G. Ballard surmised, "The *Amarillo Ramp* I take to be both jetty and runway, a proto-labyrinth that Smithson hoped would launch him from the cramping limits of time and space into a richer and more complex realm."[35]

The form of that arcing path also resembles a historical symbol regarding time and existence. *Amarillo Ramp*'s entire length is flat on top, but of

its two ends, one is high and broad and the other low and narrow, evoking a reptile's raised head and low tail (Plate 29). Smithson's drawings for it suggest a snake with a broad head and a tubular length tapering to a narrow point. That aspect was recognized by Joseph Masheck: "Those [drawings] showing the [*Amarillo*] ramp as a swelling ring sustain comparison with Dürer's *Hieroglyphics of Horapollo*, of the serpent devouring its own tail (the *uroboros*) as an emblem of the universe."[36] Also discussing *Amarillo Ramp* as ouroboric, art historian Edward Shanken condensed the symbolism: "The uroboros archetype consists of a snake biting its tail, symbolizing self-reflexivity, cyclicality and/or primordial unity." And he went on to state, "Although Smithson publicly disavowed mysticism, his earthworks repeatedly employed symbols laden with mystical significance."[37]

As noted regarding *Broken Circle*, Smithson was aware of the ouroboros symbol and had painted an image of it (Figure 13.4). Jung describes the ouroboros as "the dragon that devours, fertilizes, begets, and slays itself and brings itself to life again," and as the "prima materia of the alchemical process," as it encompasses life, death, and regeneration.[38] One of the most frequently illustrated, thus famous, historical images of the ouroboros, engraved by Matthäus Merian, accompanies Michael Maier's *Atalanta Fugiens* verse for Epigram 14, which ends, "It eats itself, vomits, dies, and is born" (Plate 30).[39]

Smithson's repeated use of the uroboros motif indicates its meaningfulness to him; he displays strong affiliation with its association with reptiles and its circularity. His copy of *Saturn the Reaper* (Saturn is the planet associated with his own astrological sun sign, Capricorn) describes "the resemblance of the symbol of Saturn to a serpent, and in many instances it has been suggestive of the serpentine power which every man possesses."[40] The poem by Paul Valéry containing the line that inspired his *Spiral Jetty* film's opening image of solar flares, "Sun, sun! Brilliant Error! You sun who masks death," is titled "Sketch of a Serpent"; the protagonist speaks as a viper.[41]

Among reptiles, snakes and lizards have the length and flexibility to bite their own tails and form a circle. More significant is the symbolism of the circle they form. As noted, in his *Time Stream*, Taine gave the meaning of the "Tail Devourer" as "THE WHOLE IS ONE," "a symbol for the whole of time, past, present, and future."[42] The experience of the continuity of time "as flowing in a circle" speaks of Smithson's reading about, picturing of, and sculpting circular structures with mystical implications. Smithson fused Taine's and George Kubler's ideas when writing in his 1967 "Ultramoderne" essay, "The 'shape of time,' when it comes to the Ultramoderne, is circular and unending—a circle of circles that is made of 'linear incalculables' and 'interior distances.' All the arduous efforts of all the monumental ages are contained in the ultra-instants, the atemporal moments, or the

cosmic seconds." His statement "The Ultraist does not reject the archaic multi-cycles of the infinite" also poetically extrapolates from Mircea Eliade's discussion of preindustrial cultures' beliefs in cyclicality in *Cosmos and History: The Myth of the Eternal Return* (1959; in his library).[43]

Jung related the circle to one's overall work or goal: "The *opus* [the Work or Art, or process toward alchemy's transformative goal] was often called *circulare* (circular) or else *rota* (the wheel)."[44] To all these references, philosopher Gary Shapiro added another: "It was Nietzsche, of course, who announced the thought of eternal recurrence and who was being fervently read and reinterpreted in the 1960s by European philosophers seeking a counterbalance to modernity and especially to Hegelian conceptions of time and history."[45] (Smithson owned *The Philosophy of Nietzsche*, 1927.) These references to the continuity of time as flowing in a circle speak of Smithson's reading about, picturing of, and sculpting circular structures, even if with mystical implications in the background or deliberately covert.

Like his jetty's spiral, *Amarillo Ramp*'s circularity can be seen as another manifestation of Smithson's personal lifeline. Its materialization of a coil, its ends nearing closure, and his repeated use of circles in his paintings and sculpture, illustrate the circularity evoked by his self-reflexive remark, "It seems that no matter how far out you go, you are always thrown back on your point of origin."[46] That "point of origin," his birth's entwinement of life and death, seems like an *axis mundi*, the Buddhist axle of the world, a still point of unchanging truth around which circled Smithson's strong consciousness of a "dialectical position which deals with . . . whether or not something exists or doesn't exist."[47] Paraphrasing Eliot's recognition in his "East Coker," "In my beginning is my end," but without its sense of equanimity, Smithson laments that no matter how much distance in time or self-aware consciousness one achieves, the past has inescapable proprietary force.

Likewise, when he declares, "The future is always going backwards," he is virtually describing an ouroboric cycle, the future as a line arcing around to its point of origin. Continuing, his reiteration "Our future tends to be prehistoric" may be taken as a literary conundrum but one that masks his psychological acuity in his frequent allusions to the impact of the past—one's history and one's parents' history—on one.[48] He described his artistic impetus as "a kind of tendency toward a primordial consciousness, a kind of tendency toward the prehistoric after digging through the histories."[49] In regularly proclaiming the power of the past, he made clear that for him it was not actually past.

Ouroboric cyclicality can be observed in Smithson's death. His innovations as an earthworks artist began with his imagining of "aerial art" for the Texas airport and ended during aero surveying in that state. Conceived

following his predecessor's brutal death, he went far in terms of accomplishment. Yet like Icarus's flight too close to the sun, plunging him into the sea, when Smithson flew too close to the earth he was "thrown back" to something like his "point of origin," his mortal coil closed in a final mirroring of his brother in a premature and violently bloody death.

The *Amarillo Ramp*'s ouroboric shape is akin to his trajectory along *Spiral Jetty*: backward to his origin and then forward and outward. Despite setbacks, Smithson had plans to move his sculptural work into new social and rehabilitative realms. He was unable to see those intentions through, but his posthumous artistic reputation continues to ascend and expand.

Addressing the original function of such images and symbols, the philosopher Jürgen Habermas described them as having been "both the control of affects and the creation of meanings."[50] In these acts of sublimating his conflicts, Smithson created work in which his suffering was generative on a scale both physically and socially expansive. As he had predicted of his work to George Lester a dozen years earlier, "Avenues that people never thought existed will be opened; avenues Forgotten will be revised" (undated [June 1961], #13). He revived the forgotten mystical symbols of the spiral and ouroboros, revising them in the new genre of sculpture, of earth.

In his three large earthworks, Smithson's elision of the explicit biographical references in his paintings erupted in elaborate sculptural metaphors. In adopting the age-old symbol of the spiral for his *Spiral Jetty* and *Spiral Hill* and the ouroboros for his *Broken Circle* and *Amarillo Ramp*, he countered Honoré Daumier's nineteenth-century epigram of modern art, "One must be of one's own time." Instead, it is another correspondence to Hans Sedlmayr's statement, "Art is, of course, only incidentally the expression of the time, in its essence it is extra-temporal, it is the manifestation of the timeless, of the eternal." That is exactly what Smithson's procedure was in his three major earthen environments: designed "to reveal," as Sedlmayr put it, "the realm of the supra-sensual by means of pictorial symbols of a special kind," ones at once ancient and cross-cultural. They materialized issues that were his—but not his alone.[51] Almost a decade after his death John Russell, the British American senior art critic of the *New York Times*, began a notice of Robert Hobbs's survey of Smithson's sculpture then at the Whitney Museum with the statement, "With every year that passes we miss Robert Smithson more."[52] Today, the daily stream of Google Alerts of references on the internet to "Robert Smithson" does not abate; artists of all ages claim his influence on their work. In effect, he reversed the course of his early life history: born a successor, he became an original, engendering followers of his own.

· · ·

This book is about agency where it has not been seen. Reading his visual and verbal creations in relation to his biography shows that Smithson, the ironic intellect, produced work that at the same time functioned as expressions of personal conflicts, often conveyed through ancient symbols' condensation of affect. While it was not socially acceptable at the time—and would have contradicted his cerebral persona—for him to directly and publicly acknowledge the personal impetus of his work, he implied as much. In his extensive conversations with Wheeler, he said, "I'm taking a certain set of perceptions that have been translated into these codes . . . and then translating them in terms of my own psychic perceptions, so that they don't come out as myth [timeless, unchanging] but as fiction [his own story, as he invents it, but won't go as far as identifying it as autobiography]." He continued about his creative process, "I'm not trying to make believe I'm a mind. It's not through the eyes of the mind, it's through the eyes of Bob Smithson." That was evident in his early work and described in confidences to Lester. Following the acclaim and confidence he gained from the reception of *Spiral Jetty*, he stated more directly to Kenneth Baker his creativity's characterological sources: "It's my temperament that follows these rather hazardous paths."[53] This claim of the affinities between his own "psychic perceptions" and his work confirms the wellspring of personal experience beyond that of the consciously cognitive driving his expressivity.

Copious evidence indicates Smithson's awareness of the biographical sources of art. Among them, he could not have narrowly focused on Christ's Passion of all the biblical incidents in his life, and depicted it so bloodily; inserted all those Latin quotations of liturgy about the slain son, Maria Desolata, Maria Dolorosa, Good Friday, and a medieval hymn about inebriation from the blood of the Madonna's son; inserted the photograph of a drugstore into his painting titled *My House Is a Decayed House*; painted Harold's astrological sun sign; mathematically configured Harold's natal horoscope; copied astrological data from *The Message from the Stars* on a young man who died from hemorrhage, as did Harold, into a drawing; and chosen the mystical symbols of the spiral and the ouroboros, to signify backward turning and desire for closure and rebirth, unintentionally. Just as Eliot wrote in *Four Quartets*, "Every poem an epitaph," it could be said that every work of art by Smithson functioned for him as an elegy. But as modern ones, they provide, in the words of literary scholar Jahan Ramazani, "not so much solace as fractured speech, not so much answers as memorable puzzlings."[54] Still, there is striving for relief: his references indicate the grip of early experience. His barely disguised repetitions function as re-petitions, attempts to console himself and requests for consoling awareness by others.

In that way, these actions cannot be construed as programmatic statements. Jean-Paul Sartre's description of subjectivity is apt:

We will never recognize and understand what human inventiveness is if we assume it to be pure *praxis*, grounded in clear consciousness. Elements of ignorance are necessary to permit inventiveness. So we can say that subjectivity has two characteristics that are essential and contradictory. Through [repetitive being and inventive being] human beings repeat themselves indefinitely, although they never stop innovating and, by this very fact, inventing themselves, since what they have invented reacts on themselves.[55]

Smithson's motivation in making art and statements alluding to his family's crisis was undoubtedly a mixture of the urge to end the haunting by his biographical prehistory and his subsequent conflicts regarding his own identity, and the simultaneous desire *not* to let go of the familiar issue, as its presence offered the possibility of understanding, resolution, and release.

Yet while Smithson was absolutely distinctive as a creator, rather than seeing him solely as singular, this study also shows that aspects of his life experience can be thought of as an intensification of common existential conditions and quandaries. One, how to "get ahead," to be successful in relation to a peer group, which may require, as it did for Smithson, changes in both the medium by which he represented himself and his professional self-presentation. More fundamental is vulnerability to the desolations, big and small, of things going. The imprint of early trauma and his career's convolutions show the necessity of approaching misfortune with resiliency.

Yet Smithson's fate gave him exceptional sensitivities to loss that he turned to his creative benefit. In effect, he enacted Robert Pogue Harrison's recognition that "coping does not consist merely in effecting a separation with the dead and 'getting on with one's life,' as we are so fond of saying in America, but in complying with the ultimate obligation of all, namely the acknowledgment of death as the very condition and ground of life. This is a lesson that only the death of others can teach."[56] Smithson learned that early on, and his works and words powerfully convey it to us. His description of Passaic's "monumental vacancies that define . . . memory-traces of an abandoned set of futures" speaks to the momentous voids beneath our own memory-traces of those once monumental in our lives. The resonance of his allusions demonstrates that it was his very attunement to absence—expressed through talent, ambition, productivity, pluck, and lucky timing—that enabled Smithson to create the fullness of art, thereby becoming significant, an art world monument, from Passaic.

Gratitudes

How can anyone believe that a given work is an object
independent of the psyche and personal history of the
critic studying it, with regards to which he enjoys a sort
of extraterritorial status?

—Roland Barthes, Criticism as Language
*Quoted by Robert Smithson in "A Museum
of Language in the Vicinity of Art"*

Once upon a time, running out of my wooden Victorian house in Oakland, California, I stopped at the sidewalk to yank open the door of the barrel-vaulted tin mailbox on a wood post (countryside on upper College Avenue). Curled inside was the just published large-format paperback *The Writings of Robert Smithson*, edited by Nancy Holt and designed by Sol LeWitt, Gianfranco Gorgoni's close-up photograph of Smithson's famously pock-marked face spanning the front. Ordered weeks earlier, it was delivered the day before its official publication. Later, I inscribed inside that cover in turquoise ink: "This book arrived in the mail on my birthday, 1979, as I was on my way to deliver my first lecture—on earthworks." While I had prepared by reading Smithson's texts published in periodicals, the collection's appearance on the day of my lecture seemed nothing less than serendipitous. Receiving this significant compilation as I departed to speak on the genre of art with which Smithson is so strongly associated confirmed my sense of being bonded with him and initiated a series of "coincidences" benefiting my research.

My destination that day at the other end of College Avenue was a large hall at the University of California, Berkeley, where Professor Peter Selz taught "Modern Sculpture." As one of his cadres of graduate student section leaders, I had been assigned to lecture to the large class on a subject of my choice. I remember flipping through books in search of a topic and being

stopped—as so many continue to be—by Gorgoni's radiant photograph displaying the beauty, grandeur, and enigma of *Spiral Jetty*. I wanted to know *what that was*, and *what was it doing there*, closer to me on the West Coast than to the dominant art scene in the east. My lecture that afternoon described interior and exterior "environmental" art and its historical sources and political context. That background aided my first published essay on Smithson, "Earthworks and Earthwords," a full-page review of the *Writings* in *Artweek*, March 29, 1980. Years later, after relocating to Brooklyn to be near all the artists and critics I needed to interview, it was the seed of my doctoral dissertation and after a few more years my first book, *Earthworks: Art and the Landscape of the Sixties*, published by the University of California Press in 2002.

The first time I visited Nancy Holt to introduce myself as a graduate student researching the history of earthworks, on February 16, 1993, she said to me, "Now, you have to remember that Bob had a brother who died two years before he was born." She considered that family loss to be crucial to understanding her late husband and included it in his exhibition catalogues' chronologies of his life and work, and in our conversations Holt reflected on it. A few years later a friend, artist-become-psychologist Scott Newkirk, alerted me to the relevant circumstance known as the "replacement child." His significant recognition led me to extensive research making evident that Smithson's visual and verbal creations were in part latent autobiography.

In the decades I have been working toward this book now in your hands, and to which the past eight years have been increasingly committed, contributions by many enabled me to formulate and produce it. First to be thankful for is the endlessly fascinating work by Robert Smithson. Then Nancy Holt, informative both in what she described and what I learned she withheld. Interviews over the past three decades with those who knew Smithson, some becoming comrades in research, contributed immeasurably to my understanding and my life. Lorraine Harner, a classmate of both Smithson and Holt beginning in elementary school, Holt's traveling companion in Europe, and Smithson's friend while she attended Barnard, and a psychologist, generously filled in early history and helped with characterizations. Alan Brilliant's recollections of years of closeness with Smithson have been absolutely illuminating. Likewise, Kathryn MacDonald, also a friend from Smithson's period as a painter, shared memories and vintage documentation, as did their friends Eli Levin and Charles Haseloff. Willoughby Sharp boomed vivid descriptions of the time and the players, gave me a copy of *Avalanche* memorializing Smithson, and shared his audiotaped conversation with him, found in his closet when searching for material for my dissertation. (I transcribed it and published much of it in

Art in America.) Tony Shafrazi's dynamic description of bringing Smithson and Holt to Amarillo and the ensuing events provides the first full account of those days of exploration, tragedy, and creative response. Insightful accounts of Smithson by Carl Andre, Lewis Asekoff, David Bourdon, Richard Castellane, Douglas Chrismas, David Diao, Dan Graham, Ira Joel Haber, Peter Hutchinson, Howard Junker, Les Levine, Brian O'Doherty, Richard Serra, and John Weber considerably contributed to this narrative. I am grateful to them all.

A writer needs readers, and I appreciate your engagement with this book and your telling your friends and colleagues about it. And every writer needs an editor. I recall with joy acquisitions editor Pieter Martin's initial email expressing appreciation for not just for my analysis but also my manner of articulating it. Astute suggestions by enthusiastic peer reviewers, editorial assistant Anne Carter's good cheer and attention to detail, copyeditor Mary Byers's acumen and sensitivity, the University of Minnesota Press's talented staff, and the book design by Wilsted & Taylor Publishing Services (in Oakland!) made this book into the best possible presentation of my work. I am grateful that the College Art Association honored this book with support to the Press from the Millard Meiss Publication Fund.

I am thankful for the many copyright holders who granted permission to reproduce images. Lisa Le Feuvre, as executive director of the Holt/Smithson Foundation an avid advocate of those artists, is revitalizing scholarship on them by encouraging diverse perspectives and, with William T. Carson, the foundation's program manager, responsively providing information. Emily Oppenheimer of the Jack Robinson Archives made Robinson's stunning portrait available for this book's cover, its darkness aptly conveying Smithson's. The many agencies, museums, and galleries recognized in illustration captions were facilitated by endearingly gracious staff, especially Andrea Mihalovic of the Artists Rights Society.

It is thrilling to share with readers the photographs of mesmerizing images of Smithson's earthworks I discovered by Bryan Brumly, Steve Durtschi, Patricia Leighton, and Wyatt McSpadden. Barbara Schwartz snapped Smithson at her party on the same terrace of the Park Avenue penthouse where decades later during graduate school I worked as the administrator of Barbara and Eugene Schwartz's art collection. For other illustrations, Daniel Root, Gregory Alders, Traian Stanescu, and John Candell contributed their photographic and digital imaging skills.

Fate also fortunately brought me to be the first full-time art historian at Bergen Community College, in Paramus, New Jersey, the proximity allowing me to maintain my New York City residency and engagement with that art world but also to be near where the Smithson, Duke, and Holt families lived and were educated, and where some of them are buried. Bergen college

administration supported my research through two sabbaticals, invitations to give faculty lectures, release time, and other means. Collegial faculty, including Robert Dill, Matt King, Fred Morton, Mark Wiener, and particularly the ebullient academic vice president and professor of chemistry Gary Porter, answered mathematical and scientific questions arising from decrypting Smithson's works.

Responsive audiences at the College Art Association, American Culture Association, Association of Art Historians, Association of Scholars of Christianity in the History of Art, Boston Psychoanalytic Society and Institute, Department of Art History of New York University, Frick Collection Art Reference Library Center for Collecting, Pollock–Krasner House and Study Center, Kent State University, New York Studio School, Newberry Library, Storm King Art Center, and Western Washington University allowed me to explore ideas in this book.

Archivists and librarians are sources of a scholar's lifeblood. It would be too much to recount all the good deeds performed for me, but let me say that they demonstrate that some librarians and archivists are saints. Marisa Bourgeoin and Jennifer Snyder of the Archives of American Art have been particularly helpful, both on my visits and during the pandemic when the Archives were inaccessible to scholars. Before and during that, many people went out of their way to facilitate my research: Kathy Grimshaw, of the Passaic Public Library; David Marks, director of the Sidney Silverman Library at Bergen Community College, and Inter-Library Loan librarians Yumi Pak and Christine Locarno; librarians of the Art and Architecture Division, New York Public Library, especially during the remote-only pandemic period, Vincenzo Rutigliano; Robert Schnell of Queens Public Library Inter-Library Loans and Christie Robbins at my local Jackson Heights branch; Matthew Von Unwerth, director of the Abraham A. Brill Library of the New York Psychoanalytic Society; librarians of the Kristine Mann Library at the C. G. Jung Institute of New York; Tara Hart and Michael Beiser of the Whitney Museum Library's Research Resources; Lisa G. Dunn, head of special collections of the Arthur Lakes Library, Colorado School of Mines; Jennifer Allison, Harvard Law School Library; Erin Campbell and Betsy Kruthoffer of the Lloyd Library, Cincinnati; Eileen Gatti of Goddard College's Eliot D. Pratt Library and College Archives; Abigail Dansiger of The Brooklyn Museum; Stephanie Cassidy of the Art Students League; Ira Galtman, Corporate Archivist, American Express; and Debra Willet of Hofstra University Library Special Collections.

By sharing their scholarly expertise, members of the Consortium of Art and Architectural Historians were instrumental in my identification of Smithson's esoteric visual references: Nicholas Campion, Martha

Dunkelman, Claire Fanger, Cynthia Fowler, Martha Hollander, Kaelin Jewell, Julia Miller, Rachel Miller, Robin O'Bryan, Kathy O'Dell, Kate Ogden, Irinia Oryshkevich, Pamela A. Patton, Debra Pincus, Shannon Pritchard, Patricia Simons, Greg M. Thomas, Jaime Vidaurrazaga, M. E. Warlick, Sarah S. Wilkins, and Kimberly Elman Zarecor.

Members of the American Cryptogram Association solved an enigma in a Smithson drawing, and in community discussions, members of the Authors Guild offered useful information and guidance regarding procedural dilemmas.

Robert Hobbs's *Robert Smithson: Sculpture* (1981) remains the most informative resource for detailed descriptions of that phase of Smithson's work, just as Jack Flam's *Robert Smithson: The Collected Writings* is a crucial compilation. My work also benefited from insights on Smithson's art by scholars Thomas Crow, Jason Goldman, Caroline A. Jones, Hikmet Sidney Loe, Timothy Martin, Joseph Masheck, Julian Myers-Szupinska, Alexander Nagel, James Nisbet, Serge Paul, Jennifer L. Roberts, Florence Rubenfeld, Gary Shapiro, Eugenie Tsai, and many others whose work I cite. Art historians Jonathan D. Katz and David Getsy generously advised on current conceptualizations of sexual identity.

In developing my interpretations, publications of scholars outside the field of the history of art provided information and insights. Some of these I discovered through Michael Ann Holly's insightful book about writing art history, *The Melancholy Art.* They are cited in the text, but I especially want to call readers' attention to the eloquent inspiration of Gabriele Schwab, on replacement children; Robert Pogue Harrison, for his *Dominion of the Dead* and other books; Rahan Ramazani's *Poetry of Mourning: The Modern Elegy from Hardy to Heaney*; and Richard Stamelman's *Lost beyond Telling: Representations of Death and Absence in Modern French Poetry.* Known only to me through their publications, several of these generously responded to my inquiries about issues prompted by their texts, participating in the great community of scholars and refining my thinking.

Literary scholar and member of the Boston Psychoanalytic Society and Institute Murray Schwartz, who chaired its jury that awarded me the 2020 Julius Silberger Award for interdisciplinary cultural criticism and published my essay in *American Imago,* for which he is editor, has through these activities been stimulating and affirming. Other scholars, authors, artists, or specialists in their fields who have been very helpful as sources of information are Larry Bell, David Bindman, Diane Brown, Virginia Budny, Judi Den Herder, Debbie Dunlap, David Evans, Mimi Gross, Peter Halley, Reinhold Heller, Eleanor Joyner, Lewis Kachur, Paul Kaplan, Maggie Leak, Edwin Lopez, Brice Marden, Joan Marter, Rick McGrath. W. J. T. Mitchell, Leslie

Parke, Anne Pasternak, Mary Peacock, Beth Petriello, Andy "The Nipper" Reid, Jon Revett, Jessica Skwire Routhier, Teri Slotkin, Lee Sorensen, Will Shortz, Judith Stein, Whitney Tassie, Nelvin Vos, and Robin Winters.

Gail Levin, initially my dissertation adviser and thereafter a colleague and warm friend, has continued to counsel and model as a productive art historian and biographer. Also among a supportive coven of sister art historians and dear friends are Ann Albritton, Iris Amizlev, Virginia Budny, Martha Hollander, Anne Swartz, Sue Taylor, and Diane Tepfer. Some read parts of my text and commented usefully, as did writer Ray X. Welch, artist Steven Siegel, and art historian James Housefield. And Martha's Generation Z son Adam Bumas proposed the inspired title *Inside the Spiral*.

In addition to those mentioned, several friends have sustained me through these years, remembering to inquire about the unfolding research and status of the manuscript. I couldn't have done it without their enthusiasm and encouragement.

This book is dedicated to my beloved husband, light of my life, David Dorfman.

Notes

Prologue and Background

1. Robert Smithson, "The Spiral Jetty," in *Robert Smithson: The Collected Writings*, ed. Jack Flam (Berkeley: University of California Press, 1996), 148. Originally published in György Kepes, ed., *Arts of the Environment* (1967). In recent years, drought, climate change, and other environmental factors have pulled the water's edge out beyond the black rock coil of *Spiral Jetty*, beaching it atop salt flats. This study will discuss the site as the state it was when Smithson encountered and worked with it.

2. G. K. Chesterton, "The Red Town," in *Alarms and Discursions* (New York: Dodd, Mead, 1911), 82.

3. Oral history interview with Robert Smithson, July 14–19, 1972, Archives of American Art, Smithsonian Institution. Hereafter Oral history interview, AAA. https://www.aaa.si.edu/collections/interviews/oral-history-interview-robert-smithson-12013#transcript. No publicly available direct transcription of this interview exists. When his statement is identical or close enough to the edited version published in Flam, *Robert Smithson*, I will refer to that version for the reader's convenience. When I quote words from this interview not there, I will refer to the transcription posted on the Archives' website, which prior to its finalization had been edited by Nancy Holt but not as much as the version she published in 1979 and again in Flam (1996). The online version includes a third side of the audiotaped interview discovered after its publication in Flam.

4. Robert Smithson, "Incidents of Mirror-Travel in the Yucatan," in Flam, *Robert Smithson*, 120. Originally published in *Artforum*, September 1969.

5. Smithson, "Spiral Jetty," in Flam, *Robert Smithson*, 152.

6. Smithson, "Spiral Jetty," 148.

7. Jean Clay, "La peinture est fini," *Robho* (Paris) 1, June 1967; published in English translation as "Painting—a Thing of the Past," *Studio International* 174, no. 891 (July/Aug. 1967).

8. Peter Halley, "Smithson's Crudity," review of new edition of Robert Smithson's *Collected Writings*, *Art + Text* 56 (Feb.–Apr. 1997): 25.

9. Smithson, "Gyrostasis," in Flam, *Robert Smithson*, 136. Published in *Hirshhorn Museum and Sculpture Garden Catalogue*, 1972.

10. Quoted in John Perreault, "Field Notes for a Dark Vision," *Village Voice*, May 9, 1974, 38.

11. Robert Smithson, draft of "A Museum of Language in the Vicinity of Art," Robert Smithson and Nancy Holt Papers, Archives of American Art, Smithsonian Institution, reel 3834, frame 429.

12. Craig Owens, "Earthwords," in *Beyond Recognition: Representation, Power, and Culture* (Berkeley: University of California Press, 1992), 42. This idea was elaborated

in Owens's "Allegorical Impulse: Toward a Theory of Postmodernism" in the same volume.

13. Smithson, "What Really Spoils Michelangelo's Sculpture" (1966–67), in Flam, *Robert Smithson*, 348, 347. Robert Smithson, "Art Through the Camera's Eye" (ca. 1971), in Flam, *Robert Smithson*, 375. Both unpublished in his lifetime.

14. Smithson, "Response to a Questionnaire from Irving Sandler" (1966), in Flam, *Robert Smithson*, 329. Unpublished in his lifetime.

15. Smithson, "Cultural Confinement," in Flam, *Robert Smithson*, 154. Originally published in the catalogue for *Documenta 5* and reprinted in *Artforum*, Oct. 1972.

16. Smithson, "Language to Be Looked At and/or Things to Be Read," in Flam, *Robert Smithson*, 61. This was a Dwan Gallery press release, June 1967.

17. Smithson, "The Eliminator" (1964), in Flam, *Robert Smithson*, 327. Unpublished in his lifetime. Smithson, "Incidents of Mirror-Travel," 119.

18. Lawrence Alloway, "Robert Smithson's Development," *Topics in American Art since 1945* (New York: W.W. Norton, 1975), 225. Originally published in *Artforum*, November 1972. Alloway quotes Smithson's "A Sedimentation of the Mind: Earth Projects," in Flam, *Robert Smithson*, 106. Originally published in *Artforum*, Sept. 1968.

19. Gene Youngblood, "Art, Entertainment, Entropy," in *Expanded Cinema* (New York: E. P. Dutton, 1970), 59. This was in Smithson's library.

20. Alison Sky, "Entropy Made Visible," in Flam, *Robert Smithson*, 304. The interview took place in late spring 1973; it was originally published in *On Site*, no. 4 (1973).

21. C. G. Jung, *The Collected Works of C. G. Jung*, ed. Herbert Read, Michael Fordham, and Gerhard Adler, vol. 12, *Psychology and Alchemy* (New York: Pantheon Books, 1953), 19, 243–44.

22. Sky, "Entropy," 309.

23. Perreault, "Field Notes," 38.

24. "An Interview with Christophe Cherix and Valerie Mavridorakis," in Mel Bochner, *Solar System & Rest Rooms: Writings and Interviews, 1965–2007* (Cambridge, Mass.: MIT Press, 2008), 188.

25. Richard Serra and Hal Foster, *Conversations about Sculpture* (New Haven, Conn.: Yale University Press, 2018), 63.

26. My interview with Tony Shafrazi, June 5, 2000, and with Les Levine, June 22, 1999.

27. Smithson to György Kepes, July 3, 1969, in Flam, *Robert Smithson*, 369. Unpublished in his lifetime.

28. Douglas Davis, "Last Flight," *Newsweek*, Aug. 6, 1973, 52.

29. Valentin Tatransky, "Themes with Meaning: The Writings of Robert Smithson," *Arts* 52, no. 9 (May 1978): 143.

30. Peter Halley, introduction, *Robert Smithson: The Early Work, 1959–1962* (New York: Diane Brown Gallery, 1985), n.p.

31. J. G. Ballard, "Robert Smithson as Cargo Cultist," in *Robert Smithson: A Collection of Writings on Robert Smithson on the Occasion of the Installation of "Dead Tree" at Pierogi 2000*, ed. Brian Conley and Joe Amrhein (New York: Pierogi, 1997), 31. My emphasis.

32. The complete list of venues of these two exhibitions is identified in *Robert Smithson: Early Works* (Berlin: Akira Ikeda Gallery, 2014), 110.

33. Meyer Levin and Eli Levin, "A Nightmare World," *Philadelphia Inquirer*, Apr. 2, 1961, 63. The chronologies in the New York Cultural Center and the Cornell exhibition catalogues list the exhibition reviewed by the Levins at the Alan Gallery, Manhattan, March 1961, the only one they identify of three group exhibitions Smithson participated in between 1957 and 1962. Their chronologies list two of Smithson's five solo shows held in those years.

34. As Harold Rosenberg observed about the position of the "artist's widow," she "controls the entirety of her dead husband's unsold production," giving her economic

power, but also "she is the official source of the artist's life story, as well as of his private interpretation of that story." Harold Rosenberg, "The Art Establishment," *Esquire* 62 (Jan. 1, 1965), 114. Frederick Ted Castle, "Occurrences/New York," *Art Monthly* (London) 85 (Apr. 1, 1985), 21. Grace Glueck, "Art: Robert Smithson, Pre-minimal Paintings," *New York Times*, Feb. 1, 1985, 70.

35. Castle, "Occurrences," 21.

36. Castle, "Occurrences," 21. Most of the show of forty paintings on Brown's checklist traveled to the Marlene Eleini Gallery, London, in the spring of 1988 and to the Kunstmuseum Luzern in the fall. The latter's checklist consisted of the forty words on the Brown checklist (of which twelve were noted as "not on view," perhaps because they had been disbursed to their buyers), plus seven additional paintings on canvas or paper. Those exhibitions of Smithson's paintings were possible because they were not under the control of the Smithson estate; its catalogues give no evidence of having obtained copyright permission from the estate to illustrate them. Brown recalled that Holt had been "opposed to making his early paintings public at the time." Interview by Takuma Kaniwa, Sept. 13, 2013, cited in Kazuhiro Yamamoto, "Robert Smithson—Painting as Meta-site: A Study of His Early Painting Blocks, Produced between 1959 and 1962 from an After-Pollock and Post-Einstein Perspective," in Akira Ikeda Gallery, *Robert Smithson: Early Works*, 26 and 42n5.

Among major museums in the United States, few are in public collections, some of them misdated or mistitled; many were gifts initiated by the donors.

37. The best illustrated survey of Smithson's work is *Robert Smithson: Retrospective Works 1955–1973*, which originated at the Museet for Samtidskunst, Oslo, in 1999 and subsequently traveled to Moderna Museet, Stockholm, and the Arken Museum for Moderne Kunst Ishøj. In preparing the show, curator Per Bj Boym consulted with me and purchased from the estate the encoded *Self-Less Portrait* (Plate 20), discussed in pages to come.

38. Anna C. Chave, "Minimalism and Biography," *Art Bulletin* 82, no. 1 (Mar. 2000): 149, 150.

39. Charles G. Salas, "Introduction: The Essential Myth?," in *The Life & the Work: Art and Biography*, ed. Charles G. Salas (Los Angeles: Getty Research Institute, 2007), 7, 12. Salas quoted Rosalind Krauss, *Passages in Modern Sculpture* (New York: Viking Press, 1977), 266.

40. Rosalind Krauss, "Sculpture in the Expanded Field," *October* 8 (Spring 1979): 30–44.

41. Rosalind Krauss, introduction and "In the Name of Picasso," in *The Originality of the Avant-Garde and Other Modernist Myths* (Cambridge, Mass.: MIT Press, 1985), 3, 39, 25, 28.

42. Richard Stamelman, *Lost Beyond Telling: Representations of Death and Absence in Modern French Poetry* (Ithaca, N.Y.: Cornell University Press, 1990), 31.

43. Eve Meltzer, "The Expanded Field and Other More Fragile States of Mind," in *Systems We Have Loved: Conceptual Art, Affect, and the Antihumanist Turn* (Chicago: University of Chicago Press, 2013), 120, 136. One of those elisions Meltzer found was that a mound in Krauss's exemplary work, Mary Miss's *Perimeters/Pavilions/Decoys*, suggests that "something buried or otherwise obscured lies beneath the very concept of the expanded field itself." Meltzer, *Systems We Have Loved*, 132.

44. Robert Smithson, "Art Through the Camera's Eye," (ca. 1971), in Flam, *Robert Smithson*, 375, and "Incidents of Mirror-Travel," in Flam, *Robert Smithson*, 125.

45. Robert Smithson, "A Sedimentation of the Mind: Earth Projects," in Flam, *Robert Smithson*, 111.

46. Robert Smithson, "Art and Dialectics," in Flam, *Robert Smithson*, 370, possibly 1971, previously unpublished.

47. Interview with Robert Smithson for the Archives of American Art, in Flam, *Robert Smithson*, 295.

48. Jennifer L. Roberts, *Mirror-Travels: Robert Smithson and History* (New Haven, Conn.: Yale University Press, 2004), 139, 1.

49. Michael Ann Holly, *The Melancholy Art* (Princeton, N.J.: Princeton University Press, 2013), xv.

50. Oral history interview with Mel Bochner, 1994 May, Archives of American Art, Smithsonian Institution, 30.

51. Robert Smithson, undated and untitled sheet, Robert Smithson and Nancy Holt Papers, Archives of American Art, Smithsonian Institution, box B3, no. 68.

52. Smithson, "Sedimentation," in Flam, *Robert Smithson*, 110.

53. Lucy Lippard, "Out of the Past," *Artforum* 46, no. 6 (Feb. 2008): 238.

54. Smithson, "Spoils," in Flam, *Robert Smithson*, 346.

55. Oral history interview, AAA.

56. Thomas Crow, *No Idols: The Missing Theology of Art* (Sydney: Power Publications, 2017), 102.

57. Guido Piovene, "Art and Subjectivity," response to Jean-Paul Sartre, *What Is Subjectivity?* (London: Verso, 2016), 72. This is regarding a 1961 lecture by Sartre.

58. Félix Guattari, *Chaosmosis: An Ethico-Aesthetic Paradigm*, trans. Paul Bains and Julian Pefanis (Bloomington: Indiana University Press, 1995), 1.

59. Yamamoto, "Robert Smithson—Painting as Meta-site," 26.

60. Heinrich Wölfflin, *Principles of Art History*, trans. M. D. Hottinger (1915; repr., New York: Dover, 1950), 1. Robert Smithson, "From the City," Robert Smithson and Nancy Holt Papers, Archives of American Art, Smithsonian Institution, reel 3834, frame 221; Simone Weil, *Gravity and Grace*, trans. Emma Crawford and Mario von der Ruhr (London: Routledge, 2002), 117.

1. Man of Sorrow

1. Peter Hutchinson, "Science Fiction and Art," in *Dissolving Clouds: The Writings of Peter Hutchinson* (Provincetown, Mass.: Provincetown Arts Press, 1994), 34.

2. My interview with Willoughby Sharp, Apr. 28, 1995.

3. Oral history interview by Scott Gutterman with Nancy Holt, July 6, 1992, Archives of American Art, Smithsonian Institution.

4. Florence Rubenfeld, "Robert Smithson: A Monograph" (master's thesis, Goddard College, 1975), 4.

5. Robert Smithson file, Art Students League, undated.

6. Interview with Robert Smithson for the Archives of American Art, in *Robert Smithson: The Collected Writings*, ed. Jack Flam (Berkeley: University of California Press, 1996), 271.

7. Gavin Butt, *Between You and Me: Queer Disclosures in the New York Art World, 1948–1963* (Durham, N.C.: Duke University Press, 2005), 66.

8. "St. Jerome to Augustine, 402." The quotation is from Anne Fremantle, *A Treasury of Early Christianity* (New York: Viking Press, 1953), 102. Jerome is also discussed in these books owned by Smithson: Hans Lietzmann, *A History of the Early Church*, vol. 4, *The Era of the Church Fathers* (1961), and Thomas Merton, *The Wisdom of the Desert: Sayings from the Desert Fathers of the Fourth Century* (1960).

9. Journal of Eli Levin, Dec. 29, 1956, 79. Provided to me by Levin.

10. Alan Brilliant, "Hanging Out with Bob Smithson: A Letter Answering Suzaan Boettger," undated; I received it September 25, 1999. Brilliant became a poet; founder and director of Unicorn Press, 1966–2016; and proprietor of Glenwood Coffee and Books, Greensboro, N.C.

11. Serge Paul, "Robert Smithson: Birth of an Artist," *Linea: Studio Notes from the Art Students League of New York*, Dec. 21, 2021, accessed Jan. 8, 2022, https://asllinea.org/robert-smithson-art-students-league.

12. Meyer Levin, "Youths Show Promise in Art Exhibit," *Syracuse Post-Standard*, Sept. 5, 1956, 4. Meyer's columns were syndicated, appearing in local newspapers throughout New York, New Jersey, Pennsylvania, and elsewhere.

13. Robert Smithson to Kathryn MacDonald, undated; the preceding and following pages are lost.

14. My conversation with Charles Haseloff, Aug. 23, 2021.

15. On June 26, 1964, his Selective Service classification was 4-A, "completed service or sole surviving son," and on July 17, 1964, that was changed to 5-A, "over the age of liability for military service." Smithson's military records were destroyed in the July 1973 fire at the National Personnel Records Center.

16. "Charles Smithson," *Public Inspector*, Feb. 1905, 25, Robert Smithson and Nancy Holt Papers, Archives of American Art, Smithsonian Institution, reel 3732, frame 480.

17. Alan Brilliant, *Robert Smithson* (Greensboro, N.C.: Unicorn Press, 2013), 34. Brilliant wrote "Sean Wilentz" but later realized, as he stated to me, that it was Sean's brother and co-owner, Theodore "Ted" Wilentz, who attended. Brilliant's second and last show was an exhibition of Arshile Gorky's watercolors lent by Chaim and Renee Gross (Mimi Gross's parents) in Jan. 1958. The gallery venture ended then with Brilliant's move downtown to live in the Washington Place (Square) apartment of his girlfriend/future wife, novelist Teo Savory.

18. Brilliant, "Hanging Out with Bob Smithson," 3. After Smithson became an employee of his bookstore, Wilentz purchased his art and with his wife, Joan, gave four pieces to the Hirshhorn, one of which is illustrated in Plate 12.

19. Meyer Levin, "How Can You Spot an Artist-to-Be?," *Birmingham News*, Feb. 2, 1958, 74.

20. Oral history interview, AAA, in Flam, *Robert Smithson*, 273.

21. Anonymous mission statement of the Artists' Gallery (1936–62), located at 851 Lexington at Sixty-Fifth Street. Smithson exhibited in *New Talent*, the Artists' Gallery group show (May 17–June 5, 1958); *Robert Smithson*, Artists' Gallery (Oct. 17–Nov. 5, 1959); and *New Painting 1960* (dates not stated). Archives of American Art, Smithsonian Institution, Artists' Gallery, D313, frame 175 and following. Direct evidence of his participation in the 1958 group show does not exist; the second page of the show's alphabetical listing is not among the papers of the Artists' Gallery in the Archives of American Art. A description accompanying Smithson's 1959 solo show states that he had previously participated in a group show there; he was not in its 1957 group show of new artists.

22. Sol LeWitt, "Statement," in *Robert Smithson: A Collection of Writings on Robert Smithson on the Occasion of the Installation of "Dead Tree" at Pierogi 2000*, ed. Brian Conley and Joe Amrhein (New York: Pierogi, 1997), 33. LeWitt recalled the year as 1958, but Smithson left his Montgomery Street loft in 1959.

23. Robert Smithson to Nancy Holt, undated and not microfilmed, Robert Smithson and Nancy Holt Papers, Archives of American Art, Smithsonian Institution.

24. Margaret Breuning, "Robert Smithson Shocks the Bourgeois," *Arts Magazine* 34, no. 1 (Oct. 1959): 53.

25. Irving Sandler, "New Names This Month," *Art News* 58, no. 7 (Oct. 1959): 18.

26. The downward triangle may evoke the identically oriented Nazi pink triangle designating homosexuals, but it was not known in the United States, from publications in English, until the early 1970s.

27. Oral history interview, AAA, in Flam, *Robert Smithson*, 275.

28. My conversation with Robert Lester, George's son, May 30, 2017.

29. Smithson to Holt, undated, Robert Smithson and Nancy Holt Papers, Archives of American Art, Smithsonian Institution.

30. Smithson to George Lester, undated (March 1961); Dec. 4, 1960; June 1961. Robert Smithson letters to George B. Lester, Archives of American Art, Smithsonian Institution, reel 5438. All of Smithson's letters to Lester are from this source; several are undated. Hereafter throughout these chapters, they will be referred to by date, if given, and by the number I assigned each letter in my estimated chronological sequence.

31. Hans Sedlmayr, *Art in Crisis: The Lost Center*, trans. Brian Battershaw (London: Hollis & Carter, 1957), 218.

32. Sedlmayr, *Crisis*, 261.

33. Sedlmayr, *Crisis*, 262, 253.

34. The MoMA show, fourth in a series of open national exhibitions organized by its Junior Council, exhibited seventy-four paintings by as many artists as *Recent Painting U.S.A.: The Figure*, May 23–Aug. 26, 1962.

35. John Weir Perry, *The Self in Psychotic Process: Its Symbolization in Schizophrenia* (Berkeley: University of California Press, 1953), 86.

36. Smithson owned the Douay, Roman Catholic, Bible, a translation of the Latin Vulgate published by the Catholic Truth Society, 1956; all biblical quotations in this text are taken from that version.

37. My conversation with Dan Graham, Sept. 24, 2020.

38. Robert Burton, *The Anatomy of Melancholy*, ed. Floyd Dell (New York: Tudor, 1955), 148–49.

39. My conversation with Raymond Saroff, June 6, 2017.

40. It also shows what may have been either another version, lost, of his large *Man of Sorrow (The Passionate)*, with Christ's head within a quadrated circle and displaying the wounds in his palms, or more likely as in this series Smithson repeated images, the lost *Man of Sorrow (The Doubted)*.

41. Sedlmayr, *Crisis*, 117.

42. Sedlmayr, *Crisis*, 213.

43. Clement Greenberg, *Art and Culture: Critical Essays* (Boston: Beacon Press, 1961), 135. The book was in Smithson's library.

44. Smithson may have seen many examples of religious art in a special two-issue edition of *Life* magazine published at Christmas 1955, during his senior year of high school. This photography-driven newsweekly cost thirty-five cents; its inexpensiveness and mix of news and popular culture made it ubiquitous in family living rooms. Most of its vast readership did not live close to museums with historical paintings, and at the time periodicals and books were infrequently illustrated in color. In comparison, this issue's feature article had lavish color reproductions. The selection of works of art to be illustrated was by the National Council of Churches' (a Protestant group) Commission on Art, which since 1954 had been led by Museum of Modern Art founder and then director of collections Alfred Barr, an observant Presbyterian son, grandson, and nephew of ministers. For consultation on the feature's subjects Barr invited the eminent art historians Perry T. Rathole, George Heard Hamilton, and Charles Rufus Morey, as well as the Protestant theologian Paul Tillich. They selected the paintings for the theme "The Life of Christ as Seen by Great Artists"; all the major incidents from the Bible were represented. Commission on Art, National Council of Churches [Alfred Barr, Perry T. Rathole, George Heard Hamilton, Charles Rufus Morey, and Paul Tillich], "The Life of Christ as Seen by Great Artists," *Life* 39, no. 26, and 40, no. 1 (Dec. 26, 1955): 18–34.

45. Paul Tillich, "A Prefatory Note," and Peter Selz, introduction, *New Images of Man* (New York: Museum of Modern Art, 1949), 10, 11–15.

46. Sally M. Promey, "The 'Return' of Religion in the Scholarship of American Art," *Art Bulletin* 85, no. 9 (Sept. 2003): 587.

47. David Morgan, "Warner Sallman and the Visual Culture of American Protestantism,"

in *Icons of American Protestantism: The Art of Warner Sallman*, ed. David Morgan (New Haven, Conn.: Yale University Press, 1996), 42–43.

48. Oral history interview, AAA, in Flam, *Robert Smithson*, 282, 286.

49. Correspondence from Kathryn MacDonald to me, June 24, 2020. Similarly, a few years later sculptor Dan Flavin, who was known for his configurations of fluorescent bulbs and who had attended a Roman Catholic seminary high school, wrote of his youth, "In time, I grew curiously fond of the solemn high funeral mass which was so consummately rich in incense, music, chant, vestments, processionals and candlelight." Dan Flavin, ". . . In Daylight or Cool White: An Autobiographical Sketch," *Artforum* 4, no. 4 (Dec. 1965): 21. Flavin titled his early 1960s painted constructions with electric bulbs *Icons*.

50. Eli Levin, undated (1958), diary entry.

51. Nathanael West, *Miss Lonelyhearts* (New York: Avon, 1959), 4, 5.

52. Barnett Newman, "The Sublime Is Now," *Tiger's Eye* 6 (1948): 53.

53. Greenberg, *Art and Culture*, 5–6.

54. Sedlmayr, *Crisis*, 195, 217.

55. Clifton Wolters, trans. and ed., *The Cloud of Unknowing* (Baltimore: Penguin, 1961), xii. Susan Sontag referred to this book in her essay "The Aesthetics of Silence," published in *Aspen* journal in 1967 and reprinted in her *Styles of Radical Will* (1969), as discussed here in chapter 7.

56. Smithson is referring to the *Walls of Dis* shown in his 1959 Artists' Gallery exhibition, described on the gallery's checklist as a triptych. Lester owned a single-panel *Walls of Dis*, which is not the same composition as the central panel of the triptych. Smithson may have painted it after Sandler singled out the earlier in *Artnews*, as quoted above. That suggests that the single-panel *Dis* should be dated later, probably 1961, when Smithson made so many canvases from which Lester could select works to show.

57. Sedlmayr, *Crisis*, 138.

58. Dorothy C. Miller, ed., foreword and acknowledgments, *Sixteen Americans* (New York: Museum of Modern Art, 1959), 6. It was on view from Dec. 16, 1959, to Feb. 14, 1960.

59. Carl Andre, "Frank Stella," in *Sixteen Americans*, 76.

60. John of the Cross, *Ascent of Mount Carmel*, trans. E. Allison Peers (Garden City, N.Y.: Image Books, 1958), 13.

61. Wolters, *Cloud*, 12.

62. "Religion and the Intellectuals," *Partisan Review* 17, no. 3 (Apr. 1950): 5.

63. Oral history interview, AAA, in Flam, *Robert Smithson*, 282.

64. All except De Niro's paintings are illustrated in Jane Dillenberger and John Dillenberger, *Perceptions of the Spirit in Twentieth-Century American Art* (Indianapolis: Indianapolis Museum of Art), 1977. Most such mid-twentieth-century linkages of art and religion concerned historical images, as in *Arts* magazine's "The Sacred Art of Europe," which was about a fall 1956 Brooklyn Museum exhibition from its collection (which Smithson didn't see as he was away at military service). "The Sacred Art of Europe," *Arts*, Oct. 1956, 48–49. The Brooklyn Museum also had an exhibition titled *Religious Painting: 15th–19th Century*, Oct. 2–Nov. 13, 1956.

65. Barr's and Rubin's shared interest in the intersection of modern art and religion is provocative. In 1967, Barr retired and Rubin joined the staff of the Museum of Modern Art, succeeding him as an influential curator.

66. Grégoire Müller, *The New Avant-Garde: Issues for the Arts of the Seventies* (New York: Praeger, 1972), 5.

67. Robert S. Ellwood, *The 60s Spiritual Awakening: American Religion Moving from Modern to Postmodern* (New Brunswick, N.J.: Rutgers University Press, 1994), 65.

68. My conversation with Elizabeth Lester, George's second wife, June 13, 2021.

69. Robert Smithson and Nancy Holt Papers, Archives of American Art, Smithsonian Institution, box 2, folder 27.

70. Robert Smithson, letters to George B. Lester, 1960–63, Archives of American Art, Smithsonian Institution, reel 5438, frame 1234, December 4, 1960 (#1) and undated (#3). At the bottom of the first letter, Lester wrote, "In letter of January 22 I accepted his offer of $650 for 18 paintings excluding *Walls of Dis*."

71. *Robert Smithson: The Early Work, 1959–1962*, Diane Brown Gallery, Jan. 19–Feb. 23, 1985.

72. Confirmation is predicated on baptism and First Communion ceremonies. Smithson's were January 23, 1938, and May 19, 1945, respectively, at St. Mary's Church, Rutherford. These records were cited to me by church administrators. We cannot know if Smithson served as what was then termed an "altar boy" assisting the priest during Mass; records of their service were not kept.

2. Brother's Keeper

1. Sally Hickson, "Grünewald, Isenheim Altarpiece," in *Smarthistory*, Aug. 9, 2015, accessed July 17, 2019, https://smarthistory.org/grunewald-isenheim-altarpiece.

2. Florence Rubenfeld, "Robert Smithson: A Monograph" (master's thesis, Goddard College, 1975), 2.

3. Siddhartha Mukherjee, *The Emperor of All Maladies: A Biography of Cancer* (New York: Scribner, 2010), 3.

4. Isaac Asimov, *The Bloodstream: River of Life* (New York: Collier, 1961), 188, 190.

5. Malcolm Gladwell, "The Treatment: Why Is It So Difficult to Develop Drugs for Cancer?" *New Yorker*, May 17, 2010, 70.

6. Todd Ackerman, "Legendary Oncologist Returns to the Limelight: MD Anderson Doctor Recalls Curing of Childhood Leukemia in New Documentary," March 27, 2015. My emphasis. Accessed March 21, 2016, http://www.houstonchronicle.com/news/health/article/Legendary-oncologist-returns-to-the-limelight-6164234.php.

7. Information not otherwise cited is from my conversations with Dr. Freireich on Nov. 9 and 20, 2017.

8. Emil J. Freireich, "History of Acute Leukemia," in *Neoplastic Diseases of the Blood*, 5th ed., ed. Peter H. Wiernik, John M. Goldman, Janice P. Dutcher, and Robert A. Kyle (New York: Springer, 2013), 171. The first medications targeting leukemia would be devised and administered by the pediatric pathologist Sidney Farber in 1949.

9. Malcolm Gladwell, "Emil 'Jay' Freireich: 'How Jay Did It, I Don't Know,'" in *David and Goliath: Underdogs, Misfits, and the Art of Battling Giants* (Boston: Little, Brown, 2013), 145.

10. Interview with Robert Smithson for the Archives of American Art, in *Robert Smithson: The Collected Writings*, ed. Jack Flam (Berkeley: University of California Press, 1996), 288.

11. C. G. Jung, *Psyche & Symbol: A Selection from the Writings of C. G. Jung*, ed. Violet S. de Laszlo, trans. Cary Baynes and F. C. R. Hull (Garden City, N.Y.: Doubleday, 1958), 168. Jung followed that statement with "The terrors of death on the cross are an indispensable condition for transformation."

12. Robert Smithson, "To the Flayed Angels," Robert Smithson and Nancy Holt Papers, Archives of American Art, Smithsonian Institution, reel 3834, frame 238. "Grant us peace" is from the Roman Catholic Agnus Dei recitation "Lamb of God, you take away the sins of the world, grant us peace."

13. Robert Smithson, "To the Stigmata" and "To the Unknown Martyr," Robert Smithson and Nancy Holt Papers, Archives of American Art, Smithsonian Institution, reel 3438, frames 242 and 195.

14. James George Frazer, *The Golden Bough* (New York: Macmillan, 1960), 60.

15. E. M. Butler, preface to *Ritual Magic* (New York: Noonday Press, 1959), n.p.

16. Smithson, "Martyr."

17. A.G. Hamman, *Early Christian Prayers*, trans. Walter Mitchell (Chicago: Regnery, 1961), 62–63.

18. Robert Pogue Harrison, "The Voice of Grief," in *The Dominion of the Dead* (Chicago: University of Chicago Press, 2003), 57, 65.

19. Melanie Klein, "Mourning and Its Relation to Manic-Depressive States," in *Love, Guilt and Reparation, & Other Works, 1921–1945* (New York: Delacorte Press/Seymour Lawrence, 1975), 360.

20. Caroline A. Jones was the first to identify Smithson as a "replacement child," in an endnote, without discussion of its ramifications. *Machine in the Studio: Constructing the Postwar American Artist* (Chicago: University of Chicago Press, 1996), 450n77.

21. Brooke Jarvis, "Good Years," review of *Extra Life: A Short History of Living Longer*, by Steven Johnson, *New Yorker*, May 17, 2021, 60.

22. Albert C. Cain and Barbara S. Cain, "On Replacing a Child," *Journal of American Academy of Child Psychiatry* 3 (1964): 443–55.

23. Gabriele Schwab, "Replacement Children: The Transgenerational Transmission of Traumatic Loss," in *Haunting Legacies: Violent Histories and Transgenerational Trauma* (New York: Columbia University Press, 2010), 124. In recent decades adults conceived following a sibling's death have written autobiographical accounts; see, e.g., Philippe Grimbert, *Secret*, trans. Polly McLean (London: Portobello Books, 2007); Barbara Jaffe, *When Will I Be Good Enough? A Replacement Child's Journey to Healing* (Virginia: Lisa Hagan Books, 2016); and Judy L. Mandel, *Replacement Child: A Memoir* (Berkeley, Calif.: Seal Press, 2009).

24. Pregnancies average forty weeks. The span between the first anniversary of Harold's death and Smithson's birth was forty-one weeks and three days.

25. Leon Anisfeld and Arnold D. Richards, "The Replacement Child: Variations on a Theme in History and Psychoanalysis," *Psychoanalytic Study of the Child* 55 (2000): 316. They referred to S. Fraiberg, E. Adelson, and V. Shapiro, "Ghosts in the Nursery: A Psychoanalytic Approach to the Problem of Impaired Infant-Mother Relationship," *Journal of American Academy of Child Psychiatry* 14 (1975): 387–421.

26. Letter to Wilhelmina van Gogh written ca. August 27, 1888, in Arles. Vincent van Gogh, *The Complete Letters of Vincent van Gogh*, trans. Mrs. Johanna van Gogh-Bonger, ed. Robert Harrison (New York: Bulfinch, 1991), number W08. Viewed August 3, 2008, http://webexhibits.org/vangogh/letter/18/W08.htm.

27. Salvador Dalí, *The Secret Life of Salvador Dalí*, trans. Haakon M. Chevalier (New York: Dial Press, 1961), 2.

28. Robert Smithson, "To the Dead Angel," Robert Smithson and Nancy Holt Papers, Archives of American Art, Smithsonian Institution, reel 3834, frame 188.

29. My interview with Nancy Holt, January 22, 1996. Indeed, in a newspaper report announcing Irving's parents' golden wedding celebration, Harold was mentioned as his and Susan's deceased son (1926–36). "Neighborhood News," *Herald-News*, Passaic, New Jersey, November 1, 1954, 12.

30. Diana Spencer, "In Her Own Words," in Andrew Morton, *Diana: Her True Story, in Her Own Words* (New York: Simon and Schuster, 1997), 24.

31. Gertrude Stein, *Everybody's Autobiography* (New York: Random House, 1937), 134. Gertrude Stein, *The Geographical History of America, or The Relation of Human Nature to the Human Mind* (New York: Vintage, 1973), 53. Random House first published the latter in 1936. Interview by Paul Toner with Robert Smithson (1970), in Flam, *Robert Smithson*, 239. Previously unpublished.

32. Catherine M. Sanders, "Risk Factors in Bereavement Outcome," *Journal of Social Issues* 44, no. 3 (1988): 104.

33. There is no death record for Alexander Duke. Chronologies for Smithson's exhibitions at the New York Cultural Center (1974) and Cornell University (1981), provided

by Nancy Holt, identify Susan's age at her parents' deaths, giving hers as thirteen at her mother's death. The New Jersey Death Index shows Mary Miller Duke's death as occurring in October 1925, when Susan was seventeen.

34. Sarah Shankar, Lizette Nolte, and David Trickey, "Continuing Bonds with the Living: Bereaved Parents' Narratives of Their Emotional Relationship with Their Children." *Bereavement Care,* online journal, accessed November 29, 2017, http://www.tandfonline.com/doi/full/10.1080/02682621.2017.1386400.

35. Schwab, "Replacement," 125.

36. My conversations with Kathryn MacDonald, July 3, 2021, and Nancy Holt, Feb. 16, 1993. Email from Alan Brilliant, October 10, 1999.

37. Cain and Cain, "On Replacing," 444.

38. My interview with Carl Andre, July 26, 1995.

39. Smithson, "Flayed."

40. Schwab, "Replacement," 2.

41. Tammy Clewell, "'Mourning Beyond Melancholia': Freud's Psychoanalysis of Loss," *Journal of American Psychoanalytic Association* 52, no. 1 (2004): 53.

42. Schwab, "Replacement," 126. Schwab quotes James Herzog, "World Beyond Metaphor: Thoughts on the Transmission of Trauma," in *Generations of the Holocaust,* ed. Martin S. Bergmann and Milton E. Jacovy (New York: Basic Books, 1982), 103–19.

43. Oral history interview, AAA, in Flam, *Robert Smithson,* 287.

44. Jahan Ramazani, *Poetry of Mourning: The Modern Elegy from Hardy to Heaney* (Chicago: University of Chicago Press, 1994), ix, xi.

45. Robert Smithson, "Iconography of Desolation," in Flam, *Robert Smithson,* 323. Unpublished in his lifetime.

46. Again, Jennifer L. Roberts's insights about Smithson's relation to the idea of history are relevant. "The essential claim of this [Roberts's] book is that Smithson's confrontation with history was marked by acute ambivalence. . . . At each point that Smithson invites history into his work, he seems to do so in order to neutralize its effects." That also illuminates Smithson's relation to his *personal* history, particularly with the conflicted memory of Harold displayed in the grisly crucifixions and *Flayed Angels.* Jennifer L. Roberts, *Mirror-Travels: Robert Smithson and History* (New Haven, Conn.: Yale University Press, 2004), 9.

47. Ramazani, *Poetry of Mourning,* 29.

48. John Bowbly, *A Secure Base: Parent–Child Attachment and Healthy Human Development* (New York: Basic Books, 1988), 32.

3. Drunk on Blood

1. Oral history interview with Robert Smithson, July 14–19, 1972, Archives of American Art, Smithsonian Institution. Hereafter Oral history interview, AAA. https://www.aaa.si.edu/collections/interviews/oral-history-interview-robert-smithson-12013#transcript.

2. Wylie Sypher, *Loss of the Self in Modern Literature and Art* (New York: Vintage, 1964), 148. At his death Smithson owned nine books by Samuel Beckett and eight books of literary criticism about Beckett's work, in addition to Sypher's discussion.

3. Alexander Alberro and Patricia Norvell, eds., "Robert Smithson June 20, 1969," in *Recording Conceptual Art: Early Interviews with Barry, Huebler, Kaltenbach, LeWitt, Morris, Oppenheim, Siegelaub, Smithson, Weiner by Patricia Norvell* (Berkeley: University of California Press, 2001), 133.

4. Robert Smithson, "The Iconography of Desolation," in *Robert Smithson: The Collected Writings,* ed. Jack Flam (Berkeley: University of California Press, 1996), 322.

5. Interview with Robert Smithson for the Archives of American Art, in Flam, *Robert Smithson,* 278.

6. Oral history interview, AAA.

7. "Allwood Folk Home from South: Smithsons Complete Motor Trip," *Herald-News,* Passaic, New Jersey, July 24, 1953, 15. Two years earlier the newspaper reported that Smithson, then thirteen, had returned from Camp Aheka, Surprise Lake, Towaco. *Herald-News,* Passaic, New Jersey, Aug. 15, 1951, 8.

8. Florence Rubenfeld, "Robert Smithson: A Monograph" (master's thesis, Goddard College, 1975), 3.

9. Calvin Tomkins, "Onward and Upward with the Arts: Maybe a Quantum Leap," *New Yorker,* Feb. 5, 1972, 53.

10. Oral history interview, AAA, in Flam, *Robert Smithson,* 270.

11. Cecily Legg and Ivan Sherick, "The Replacement Child—a Developmental Tragedy: Some Preliminary Comments," *Child Psychiatry and Human Development* 7, no. 2 (Winter 1976): 115.

12. Oral history interview, AAA.

13. Jay Martin, *The Education of John Dewey: A Biography* (New York: Columbia University Press, 2002), 6.

14. Robert Smithson, "From the Holocaust," Robert Smithson and Nancy Holt Papers, Archives of American Art, Smithsonian Institution, reel 3834, frame 226. The title "From the Holocaust" uses the word *holocaust* to signify a sacrifice completely consumed by fire: a burnt offering, prior to its strong association with the Jewish Holocaust. *On cai me on* is an alternate spelling of the classical and philosophical Greek *on kai me on,* referring to the ontological/metaphysical issue "being and not being." This explication of *on kai me on* is by Michael Hendry, accessed Nov. 2, 2018, http://curculio.org/?p=942.

15. Oral history interview, AAA, in Flam, *Robert Smithson,* 270.

16. Oral history interview, AAA, in Flam, *Robert Smithson,* 271.

17. Rubenfeld, "Robert Smithson," 2. Rubenfeld continued, quoting Holt: "Interesting, the family did not object to Bob's going to art school; they simply assumed that, of course, he intended to be a commercial artist." Yet his father's judgmental voice seems to be one that Smithson both rebelled against and echoed. Carl Andre, with whom Smithson had a strong rapport, recalled, "He was never harder on another than on himself." Carl Andre, "Robert Smithson: He Always Reminded Us of the Questions We Ought to Have Asked Ourselves," *Arts* 52, no. 9 (May 1978): 102. It was not acknowledged that the questions Andre answered in this piece were posed by Rubenfeld and part of her thesis material.

18. My interview with Nancy Holt, January 22, 1996.

19. Leon Anisfeld and Arnold D. Richards, "The Replacement Child: Variations on a Theme in History and Psychoanalysis," *Psychoanalytic Study of the Child* 55 (2000): 310.

20. Yuzu Productions, *Becoming Cary Grant,* 2017.

21. Howard B. Levine, "Toward a Psychoanalytic Understanding of Children of Survivors of the Holocaust," *Psychoanalytic Quarterly* 51 (1982): 72, 75.

22. Robert Smithson to Nancy Holt, July 24, 1961, Robert Smithson and Nancy Holt Papers, Archives of American Art/Smithsonian Institution, reel 3832, frame 744.

23. Robert Smithson and Nancy Holt Papers, Archives of American Art, not microfilmed.

24. Jung connects that to an account by Arisleus, an early Christian alchemist; Smithson's 1962 drawing *Ascribed to Arisleus* directly quotes Jung's page. C. G. Jung, *The Collected Works of C. G. Jung,* ed. Herbert Read, Michael Fordham, and Gerhard Adler, vol. 12, *Psychology and Alchemy* (New York: Pantheon, 1953), 313. Related, the motif of frontal male submerged in undulating lines, perhaps with a decorated uniform and helmet yet rigid (with fear?) is the sole subject of Smithson's painting *Dull Space Rises* (1961).

25. Albert C. Cain and Barbara S. Cain, "On Replacing a Child," *Journal of American Academy of Child Psychiatry* 3 (1964): 449; Legg and Sherick, "The Replacement Child," 117.

26. Rose George, *Nine Pints: A Journey through the Money, Medicine, and Mysteries of Blood* (New York: Henry Holt, 2018), 290n12.

27. Isaac Asimov, *The Bloodstream: River of Life* (New York: Collier, 1961), 188. In Smithson's book collection.

28. Richard A. Kaye, "Losing His Religion: Saint Sebastian as Contemporary Gay Martyr," in *Outlooks: Lesbian and Gay Sexualities and Visual Cultures*, ed. Peter Horne and Reina Lewis (London and New York: Routledge, 1996), 86–105.

29. Adolphe Napoleon Didron, *Christian Iconography, or The History of Christian Art in the Middle Ages*, vol. 2 (London: Bell, 1891), 169, Figure 208. On page 438, the source is given as a fresco, Francis da Volterra, Campo Santo, Pisa. Also, the composition of Smithson's *Archangel and the Dragon* (1960) is similar to Figure 223 in that book, page 185, from a psalter in the Bibliothèque nationale, Paris.

30. Richard Hays, "New Names This Month," *Art News* 60, no. 2 (Apr. 1961): 20.

31. Meyer Levin and Eli Levin, "A Nightmare World," *Philadelphia Inquirer*, Apr. 2, 1961, 63.

32. Kathryn MacDonald to me, June 25, 2021. In a telephone conversation with me on October 17, 2021, Eli Levin told me that he traveled weekly from Boston University, where he was a student, to Manhattan to view exhibitions for the columns he wrote as substitutes for his father's during the latter's absence when visiting Israel. In correspondence dated October 26, 2021, Eli stated that he did not write the column on Smithson but that Meyer did, "probably at Bob's request." It is not credible that his father, a sophisticated author, would have believed it appropriate to damn Smithson with this column's conservative attitudes; ignored the other three artists to focus on one whose work he detested; knew of and disparaged Smithson's parents' home; felt this text to be professionally appropriate to publish; and, if he was the sole author, would have appended his son's name to his byline.

33. Levin, May 26, 1956, journal page 153. Journal entry provided by Eli Levin.

34. Robert Smithson, "To the Mockery," Robert Smithson and Nancy Holt Papers, Archives of American Art, Smithsonian Institution, reel 3834, frame 217.

35. Thomas Crow, *No Idols: The Missing Theology of Art* (Sydney: Power Publications, 2017), 89.

36. Hans Sedlmayr, *Art in Crisis: The Lost Center*, trans. Brian Battershaw (London: Hollis & Carter, 1957), 122.

37. Smithson, "Desolation," in Flam, *Robert Smithson*, 320.

38. "Since all human opinions have created nothing but economic blindness, Maria Desolata has drained away her own Conception." Smithson, "Desolation," in Flam, *Robert Smithson*, 323. The ambiguous syntax could refer to the loss of the sacredness of her own biologically normal but spiritually pure "Immaculate Conception" and birth, without the stain of Original Sin, by Harold's hemorrhagic draining. But it could also mean that she has alienated (emotionally "drained") the present son she conceived: himself.

39. Smithson, "Desolation," in Flam, *Robert Smithson*, 326. Smithson could also have been associating himself with the poem's brash homoeroticism. (Openly gay) poet John Giorno said of Ginsberg, "When he wrote *Howl* [1956], he was the voice of the moment, mirroring what everyone felt—the moment in a larger sense." John Giorno, interview by Winston Leyland, *Gay Sunshine* 24 (Spring 1975): 3. Ginsberg had attended Smithson's Artists' Gallery post-opening party in 1959. Oral history interview by Scott Gutterman with Nancy Holt, July 6, 1992, Archives of American Art, Smithsonian Institution.

40. The wolf fantasy probably originated before Alice Neel's characterization of Smithson, when she painted his portrait, dated 1962 (Plate 16), as "wolf boy." Patricia Hills, *Alice Neel* (New York: Harry N. Abrams, 1983), 112.
41. Smithson, "Desolation," in Flam, *Robert Smithson*, 326.
42. J.S. Kestenberg, "Psychoanalytic Contributions to the Problem of Children of Survivors from Nazi Persecution," *Israel Annals of Psychiatry and Related Disciplines* 10 (1972): 311–25.
43. Martin S. Bergmann and Milton E. Jucovy, "Prelude," in Bergmann and Jucovy, eds., *Generations of the Holocaust* (New York: Columbia University Press, 1982), 19.
44. Louise Glück, "Death and Absence," in *Proofs & Theories: Essays on Poetry* (Hopewell, N.J.: Ecco Press, 1994), 127.
45. Vamik D. Volkan and Gabriele Ast, *Siblings in the Unconscious and Psychopathology* (Madison, Conn.: International Universities Press, 1997), 89.
46. Anisfeld and Richards, "Replacement Child," 310.
47. Smithson, "Ultramoderne," in Flam, *Robert Smithson*, 63. Originally published in *Arts Magazine*, Sept.–Oct. 1967.
48. Gabriele Schwab, "Replacement Children: The Transgenerational Transmission of Traumatic Loss," in *Haunting Legacies: Violent Histories and Transgenerational Trauma* (New York: Columbia University Press, 2010), 123–24.
49. Robert Smithson, "The Spiral Jetty," in Flam, *Robert Smithson*, 147.
50. Smithson, "Ultramoderne," in Flam, *Robert Smithson*, 63; interview by Paul Toner with Robert Smithson, in Flam, *Robert Smithson*, 239.
51. Robert Smithson, "Language to Be Looked At and/or Things to Be Read," in Flam, *Robert Smithson*, 61.
52. Richard Stamelman, *Lost beyond Telling: Representations of Death and Absence in Modern French Poetry* (Ithaca, N.Y.: Cornell University Press, 1990), 10.

4. Burying the Angel

1. C.G. Jung, *The Collected Works of C.G. Jung*, ed. Herbert Read, Michael Fordham, and Gerhard Adler, vol. 12, *Psychology and Alchemy* (New York: Pantheon Books, 1953), 313. In Smithson's library.
2. Jung, *Alchemy*, 280.
3. Andrea Sabbadini reports that during World War II, a nun comforting a Catholic mother who had lost her child exclaimed, "Anyway, when children die they become angels!" Sabbadini, "The Replacement Child," *Contemporary Psychoanalysis* 24, no. 4 (1988): 533. A 2012 memorial for the children and teachers killed at Connecticut's Sandy Hook Elementary School represented each as an angel.
4. Robert Smithson to Nancy Holt, Aug. 1, 1961, Robert Smithson and Nancy Holt Papers, Archives of American Art, Smithsonian Institution, reel 3832, frame 754. Lucky Strike was a popular legacy brand of cigarettes.
5. Robert Smithson, "From a Dream," Robert Smithson and Nancy Holt Papers, Archives of American Art, Smithsonian Institution, reel 3834, frame 200.
6. Robert Smithson, "To the Dead Angel," Robert Smithson and Nancy Holt Papers, Archives of American Art, Smithsonian Institution, reel 3834, frame 188.
7. Interview with Robert Smithson for the Archives of American Art, in *Robert Smithson: The Collected Writings*, ed. Jack Flam (Berkeley: University of California Press, 1996), 271.
8. Oral history interview, AAA, in Flam, *Robert Smithson*, 272.
9. Robert Smithson and Nancy Holt Papers, Archives of American Art, Smithsonian Institution, box 1.
10. My conversation with Judi Den Herder, chair of the Clifton High School class of 1956's ongoing Reunion Committee, Aug. 2, 2016.

11. My interview with Nancy Holt, Jan. 22, 1996. Her repeated association with suicide suggests the intensity of Smithson's feelings and his potential mood.

12. Analyzing a similar family situation, it was noted, "Like many replacement children she did poorly in school. It is truly impossible to compete with an idealized dead sibling." Elva Orlow Poznanski, "The 'Replacement Child': A Saga of Unresolved Parental Guilt," *Journal of Pediatrics* 81, no. 6 (1972): 1192.

13. Smithson, first version of answers to questions posed by Irving Sandler and Barbara Rose on the artistic situation in the 1960s, dated June 15, 1966, Robert Smithson and Nancy Holt Papers, Archives of American Art, Smithsonian Institution, reel 3832, frame 1084.

14. Wylie Sypher, *Loss of the Self in Modern Literature and Art* (New York: Vintage, 1964), 5. Smithson owned this book.

15. Kenneth Baker, "Talking with Robert Smithson," in *Robert Smithson: Spiral Jetty*, ed. Lynne Cooke and Karen Kelly (Berkeley: University of California Press; New York: Dia Art Foundation, 2005), 156.

16. Bruce Kurtz, "Conversation with Robert Smithson," in Flam, *Robert Smithson*, 262.

17. Robert Smithson, "The Establishment," in Flam, *Robert Smithson*, 99. Originally published in Metro, June 1968.

18. Smithson, "Establishment," 97.

19. Smithson, "Art and Dialectics," in Flam, *Robert Smithson*, 371.

20. Robert Smithson and Nancy Holt Papers, Archives of American Art, Smithsonian Institution.

21. Eli Levin, *Disturbing Art Lessons* (Santa Fe: Sunstone Press, 2012), 38.

22. Robert Smithson and Nancy Holt Papers, Archives of American Art, Smithsonian Institution, reel 3832, frame 742.

23. As of October 4, 1960, the autumn after her graduation from Tufts, Holt's Clifton High School academic record lists her "Occupation since leaving" as Lederle Laboratories, New York.

24. These and the following comments by Lorraine Harner are from my conversation with her on August 1, 2017, and many ensuing communications. Artist Dan Graham concurs about the nature of Holt's attraction to Smithson. My conversation with Graham, Sept. 24, 2020.

25. My conversation with Nancy Holt, Feb. 2, 1993.

26. Oral history interview by Scott Gutterman with Nancy Holt, July 6, 1992, Archives of American Art, Smithsonian Institution, 5.

27. He is mistaken. The Hesse sculpture illustrated in his essay "Quasi-Infinities and the Waning of Space" (*Arts*, Nov. 1966) is *Laocoön*, 1965, a bound vertical frame enclosing draped ropes referencing the Hellenistic sculpture of that name illustrated adjacent, depicting a father and two sons enwrapped by snakes, another connection to his concern with confinement. Lucy Lippard, "Out of the Past," *Artforum* 46, no. 6 (Feb. 2008): 238.

28. John Weir Perry, *The Self in Psychotic Process: Its Symbolization in Schizophrenia* (Berkeley: University of California Press, 1953), 122. It is highly unlikely that the bookmark was subsequently placed there by another scholar, as customarily sought out are the volumes Smithson referred to in his own writing, and he did not mention this one with its provocative title.

29. Lippard, "Out," 245, 242, 248.

30. Oral history with Holt, 7, 8. The senior Holts subsequently bought a home in Delaware; Holt inherited it along with her parents' other assets and sold it.

31. My conversation with Richard Serra, June 20, 2000.

32. Robert Smithson, "Iconography of Desolation," in Flam, *Robert Smithson*, 320, 321, 323.

33. Smithson, "Desolation," in Flam, *Robert Smithson*, 321.

34. Harold Rosenberg, "The American Action Painters," *The Tradition of the New* (Chicago: University of Chicago Press, 1959), 25–27.

35. Smithson, "Desolation," in Flam, *Robert Smithson*, 322.

36. The last may have been unknown to Smithson, as it was unmentioned in an essay by T.S. Eliot that may have encouraged him to cite Carroll. Elizabeth Sewell, "Lewis Carroll and T.S. Eliot as Nonsense Poets," in *T. S. Eliot: A Collection of Critical Essays*, ed. Hugh Kenner (Englewood Cliffs, N.J.: Prentice-Hall, 1962), 65–72. In Smithson's book collection.

37. Smithson, "Desolation," in Flam, *Robert Smithson*, 323, 321.

38. My interview with Howard Junker, Aug. 8, 1994.

39. Margot Wittkower and Rudolf Wittkower, *Born under Saturn: The Character and Conduct of Artists; A Documented History from Antiquity to the French Revolution* (New York: W.W. Norton, 1963), 102–3.

40. Smithson, "Desolation," in Flam, *Robert Smithson*, 320.

41. My interview with Nancy Holt, Jan. 22, 1996.

42. In his letter of May 1, 1961, he listed twenty-four paintings, twenty-two of which were dated 1961 (the others were dated 1959 and 1960); on May 17, he listed thirty-four paintings, of which thirty-one were dated 1961. Only three of the pre-1961 paintings were on both lists. So between the beginning of the year and May 17, he painted at least fifty.

43. Alan Brilliant, "Hanging Out with Bob Smithson: A Letter Answering Suzaan Boettger," 5. Undated; I received it Sept. 25, 1999.

44. Amy Newman, *Challenging Art: Artforum 1962–1974* (New York: Soho Press, 2000), 280.

45. "Earth," Symposium at White Museum, Cornell University, in Flam, *Robert Smithson*, 187.

46. Robert Smithson, "The Lamentations of the Paroxysmal Artist," in Flam, *Robert Smithson*, 319.

47. Four years later, among the thirty quotations, comments, and illustrations encircling central blocks of text of his essay "Quasi-Infinities and the Waning of Space," the struggle seemed still latent. The snippet from John Cage that he quoted echoed his own sentiments: "the pleasure / nowhere. / let him go to sleep." Smithson, "Quasi-Infinities," in Flam, *Robert Smithson*, 35. Smithson attributes Cage's text to his *Silence* (Cambridge, Mass.: MIT Press, 1966). Discussing the linkage of two other quotations in the visual, but not thematic, margins of that text, Pamela M. Lee astutely identified it as "metaphor—the way one figure of speech is employed to describe another figure of speech, which in turn hooks up to another figure of speech." Pamela M. Lee, *Chronophobia: On Time in the Art of the 1960s* (Cambridge, Mass.: MIT Press, 2004), 233. Smithson was the master of such disguised metaphors.

48. Richard Hinton, ed., *Arsenal for Skeptics* (New York: Barnes, 1961), v, 126. When the book was first published in 1934, Knopf insisted that the well-known literary critic Charles Angoff publish the potentially inflammatory text under this pseudonym.

49. Carl Andre, "Robert Smithson: He Always Reminded Us of the Questions We Ought to Have Asked Ourselves," *Arts* 52, no. 9 (May 1978): 102.

50. Patricia Hills, *Alice Neel* (New York: Harry N. Abrams, 1983), 112: Alan Brilliant, *Robert Smithson* (Greensboro, N.C.: Unicorn Press, 2013), 16.

51. Correspondence from Richard Castellane to me, Apr. 22, 2020.

52. No checklist exists; the exhibition may have included new paintings that Smithson identified in a letter to Lester of Dec. 26, 1961, as *Stricken Nature, The Dark Sister, No One to Bury, The Bad-lands, Chalice,* and *Lenten-archway.* Around this time he also made a series of drawings called "Shrovetide," another term for Lent, that would be

published in the *Minnesota Review*. Robert Smithson, "Drawings for Shrovetide," *Minnesota Review* 3, no. 2 (Winter 1963): 126–33.

53. Another version of the following discussion was commissioned and published as "Haunted: Robert Smithson's My House Is a Decayed House, 1962," commissioned by the Holt-Smithson Foundation for their website. Accessed Feb. 23, 2021https:// holtsmithsonfoundation.org/haunted-robert-smithsons-my-house-decayed-house-1962.

54. Smithson, "From the Broken Ark," Robert Smithson and Nancy Holt Papers, Archives of American Art, Smithsonian Institution, reel 3834, frame 230.

55. Initially in Eliot's manuscript it was "Gerousia," the name of the Council of the Elders at Sparta.

56. In the Czech language a *drogérie* is a purveyor of over-the-counter health aids and toiletries; the word for a prescription-dispensing pharmacy is *lékárna* (*lékař* is the word for doctor). But Americans perceiving "drogérie" as meaning drugstore would expect to get both over-the-counter health aids and prescriptions there. Czech architecture scholar Kimberly E. Zarecor provided this distinction and connected me with David Muhlena, library director, Skala Bartizal Library, National Czech and Slovak Museum and Library, Cedar Rapids, Iowa, who identified the photograph.

57. Karel Plicka and Emanuel Poche, *Walks through Prague: A Photographic Guide* (Prague: Panorama, 1984), 118. This photograph was published in several books of Plicka's photographs of Prague, including *City of Baroque and Gothic* (London: Lincolns-Prager, 1946), 148.

58. Robert Smithson, "To the Eye of Blood," in Flam, *Robert Smithson*, 318.

59. Oral history interview, AAA, in Flam, *Robert Smithson*, 278.

60. George Williamson, *A Reader's Guide to T. S. Eliot: A Poem-by-Poem Analysis* (New York: Noonday, 1957), 112.

61. Williamson, *Reader's Guide*, 113. Indeed, in his essay "A Museum of Language in the Vicinity of Art," Smithson will adapt Eliot's " 'History has many . . . contrived corridors' " as "strange corridors of history"; in Flam, *Robert Smithson*, 78.

62. Dante Alighieri, *The Inferno*, trans. John Ciardi (New York: New American Library, 1954), 119–20.

63. On June 7, the day before their wedding, Holt wrote a check to the church for $200. They hired a professional photographer but perhaps did not order a print as the Holt/ Smithson Foundation only has one, which is stamped PROOF. Holt's inheritance, including from the sale of her parents' home on March 29, 1963, for $30,000 (that would be $273,335.29 in 2022, but home prices have increased dramatically more than inflation rates) contributed considerably to their household finances. Robert Smithson and Nancy Holt Papers, Archives of American Art, Smithsonian Institution.

64. Thomas J. Shelley, *Greenwich Village Catholics: St. Joseph's Church and the Evolution of an Urban Faith Community, 1829–2002* (Washington, D.C.: Catholic University of America Press, 2003).

65. Information provided by Jean Baptiste Roman Catholic Church, Aug. 23, 2017.

66. Oral history interview, AAA, in Flam, *Robert Smithson*, 290.

67. Charlie Bongiorno to Bob and Nancy, July 29, 1964. Robert Smithson and Nancy Holt Papers, Archives of American Art, Smithsonian Institution, roll 3832, frame 810. Bongiorno's father, Charles Bongiorno (senior), died in Clifton, New Jersey, on Oct. 8, 1962. Bongiorno died in Boynton Beach, Florida, on Sept. 12, 2011. The statement on Genet was from Holt to Caroline A. Jones, June 3, 1995, as noted in Caroline A. Jones, *Machine in the Studio: Constructing the Postwar American Artist* (Chicago: University of Chicago Press, 1996), 450n77.

68. In her interviews with me and others Holt did not mention either a retrospective or contemporaneous practice of religion, although later in life she was involved with

Buddhism. Alena Williams, author of the 2010 *Sightlines* exhibition catalogue and curator of the exhibition surveying Holt's art, and Holt's friend DeeDee Halleck, both confirmed that Holt did not discuss a relation with Roman Catholicism. The fact that at Smithson's Latin mass funeral, arranged by Holt, she did not take Communion (critic and art historian Joseph Masheck was the only one among a large number of mourners to do so), suggests the transience of her affiliation with Catholicism. Robert Pincus-Witten, "Naked Lunches," *October* 3, no. 102 (Spring 1977): 115.

69. Bradford R. Collins, interview with John Giorno, June 13, 1997, as quoted in Collins, "Dick Tracy and the Case of Warhol's Closet: A Psychoanalytic Detective Story," *American Art* 15, no. 3 (Autumn 2001): 71. That combination of suppression of religious practices, prejudice against such, and common incredulity that an advanced artist could be a theist led to assessments such as "Smithson's dalliance with religion," a delicious descriptor of delimitation as if Smithson had had a fling—a tryst— with Jesus. Jennifer L. Roberts. *Mirror-Travels: Robert Smithson and History* (New Haven, Conn.: Yale University Press, 2004), 35. Rather, his actions, book collection, and confirming statements by friends make clear that Smithson was monogamous with Catholicism from his baptism when he was just twenty-one days old to his Requiem Mass at thirty-five and a half years. Smithson's affiliation with Catholicism has been endorsed by art historian Thomas Crow in "Cosmic Exile: Prophetic Turns in the Life and Art of Robert Smithson," in *Robert Smithson*, ed. Eugenie Tsai (Los Angeles: Museum of Contemporary Art; Berkeley: University of California Press, 2004), 32–56, and Crow's *No Idols: The Missing Theology of Art* (Sydney: Power Publications, 2017), 85–105.

70. John Perreault, "Art: Field Notes for a Dark Visions," *Village Voice*, May 9, 1974, 38. Howard Junker, "Jackson Pollock/Robert Smithson: The Myth/The Mythologist," *Arts Magazine* 52, no. 9 (May 1978): 131. My interview with Serra, June 20, 2000. Correspondences to me from Joseph Masheck, Nov. 3, 2021. Correspondence from Father Hebert is in the Robert Smithson and Nancy Holt Papers, Archives of American Art, Smithsonian Institution. His papers went to the Congregation of the Blessed Sacrament in Ohio; they do not contain correspondence from Smithson.

71. Clifton Wolters, ed., *The Cloud of Unknowing* (Baltimore: Penguin, 1961), 12.

5. Secret Partner

1. Calvin Tomkins, "Onward and Upward with the Arts, Maybe a Quantum Leap," *New Yorker*, Feb. 5, 1972, 53. Tomkins didn't identify—didn't ask Smithson?—what the threats were from which that private enclave sustained him.

2. Richard Cavendish, *The Black Arts* (New York: Putnam, 1967), 182.

3. I read this interview, dated Dec. 4, 1973, and conducted in Oldenburg's Broome Street studio, at the Archives of American Art in 1999. It was subsequently withdrawn from the Archives by Oldenburg and his wife, Coosje van Bruggen, according to the Archives, during a process, described by the Oldenburg studio, of managing his history and controlling his critical reception.

4. Eugenie Tsai, *Robert Smithson Unearthed: Drawings Collages, Writings* (New York: Columbia University Press, 1991), 42–43n55. But Holt subsequently recounted that he seemed to have been high on peyote the day in 1959 when they met for the first time in years. She noted that peyote was legal and commonly sold on street corners. As they didn't live together until sometime in the first half of 1963, it would seem that she could only say for sure that "Bob and I never did it [took peyote] more than a few times." Oral history interview by Scott Gutterman with Nancy Holt, July 6, 1992, Archives of American Art, Smithsonian Institution.

5. Allen Young, "No Longer the Court Jesters," in *Lavender Culture*, ed. Karla Jay and Allen Young (New York: New York University Press, 1994), 41. (Originally published 1979.) The blue and pink associations are twentieth-century phenomena. David K.

Johnson, *The Lavender Scare: The Cold War Persecution of Gays and Lesbians in the Federal Government* (Chicago: University of Chicago Press, 2004), 18. Johnson's source might be the *Washington-Times Herald*, July 27, 1950, 2; his grouped endnotes are almost impossible to disambiguate.

6. Robert Smithson to Nancy Holt, July 24, 1961, in Robert Smithson and Nancy Holt Papers, Archives of American Art, Smithsonian Institution, reel 3832, frame 744. Robert Smithson, "The Spiral Jetty," in *Robert Smithson: The Collected Writings*, ed. Jack Flam (Berkeley: University of California Press, 1996), 145.

7. J.G. Ballard, "Time, Memory and Inner Space," in *A User's Guide to the Millennium* (New York: Picador, 1996), 200.

8. Customarily in horoscopes the rising sign is marked as if at the position of nine on an analog clock; Smithson turned the sheet to put it at the position of twelve.

9. If you are a fan of puzzles or esoterica, or want more evidence that this is Harold's natal chart, read on: More directly, one could attempt to make meaning of those numbers 9 3 4 5 by applying two approaches to numerology's symbolic system. One is to successively sum the digits: 9 + 3 + 4 +5 = 21, and then sum those, 2 + 1 = 3. Three commonly symbolizes a resolution of a conflict posed by dualism, relevant to the Robert/Harold duality but not particularly pertinent to Pisces, the segment in which the numbers appear.

 Another procedure is to use a standard numerology chart to attribute a letter to each number: Since there are twenty-six letters in the alphabet but only nine single-digit numbers, in the numerological chart, each number represents two or three letters. Considering various permutations of these—read straight across or in scrambled sequence—one possibility of the nine three four five is to choose the letters for those numbers, I C M E. Reading the letters as "I see me" suggests that Smithson sees himself in that Pisces section of Harold's chart.

 According to *Saturn the Reaper*, a volume Smithson owned, "Many students of Astrology have remarked on the resemblance of the symbol of Saturn [the planet that rules Smithson's Capricorn sun sign] to a serpent," which is also associated with Scorpio, Harold's sign. Author Alan Leo describes Saturn as associated with the "God of Justice, whose mission it is to chastise and purify the souls of men through pain and suffering"—another parallel between Smithson and his own identification with Christological sacrifice. Alan Leo, *Saturn the Reaper* (London: Modern Astrology Office, 1916), 105, iii.

 And indeed, Saturn is in that section, Pisces, in Harold's natal horoscope. Pisces, and Harold's sun sign, Scorpio, and Smithson's rising sign, Cancer, are the three signs grouped with the element of water, which may be a reason that Smithson would later repeatedly note that his three major earthworks were designed in water.

10. Likewise, in the drawing (not the gouache painting) of *Untitled (Christ in Limbo)*, 1963, the company identified on the gasoline pump, "Esso," and in the collage *New York, New Jersey*, 1967, the source of the map, Esso, may be a reference to Harold, as like the sum of the letters in his name according to numerology, the sum of its letters in Esso is four.

11. C.G. Jung, *The Collected Works of C. G. Jung*, ed. Herbert Read, Michael Fordham, and Gerhard Adler, vol. 12, *Psychology and Alchemy* (New York: Pantheon Books, 1953), 297. Smithson owned this book.

12. C.E. Cirlot, *A Dictionary of Symbols* (New York: Philosophical Library, 1971), 234. Additionally, the author points out that in ancient numbers rendered by stacks of dots, the tetractys, the triangular number made up of four rows of four, three, two, and one dots, equaling ten, is related to the symbol of four.

13. Smithson and Holt had separate accounts at First National City Bank, the predecessor to Citibank.

14. Valerie Confuoco and Eleanor Joyner of the American Cryptogram Association helped out; the latter found the connection to *Message of the Stars* in five minutes.

15. Walter Herdeg, *The Sun in Art* (Zurich: Graphis Press, 1962) 40.

16. Max Heindel and Augusta Foss Heindel, *The Message of the Stars* (Oceanside, Calif.: Rosicrucian Fellowship, 1963), 463. This text is identical to the 1922 edition; a copy of Smithson's 1947 edition could not be accessed.

17. Heindel and Heindel, *Message,* 472.

18. "It was in the time of Hippocrates, around 400 BC, that a word for cancer first appeared in the medical literature: *karinos,* from the Greek word for 'crab.' The tumor, with its clutch of swollen blood vessels around it, reminded Hippocrates of a crab dug in the sand with its legs spread in a circle." Siddhartha Mukherjee, *The Emperor of All Maladies: A Biography of Cancer* (New York: Scribner, 2010), 47.

19. Fred McDarrah, "Harmless Horrors," *Village Voice,* Nov. 1, 1962, 17.

20. Explanations of these scientific labels were provided by Professor Mark Siddall, a parasitologist, and facilitated by Dean of the Public Understanding of Science Scott A. Schaefer, both of the American Museum of Natural History, New York City, June 2017.

21. Robert Smithson, "The Iconography of Desolation," in Flam, *Robert Smithson,* 323.

22. James George Frazer, *The Golden Bough: A Study in Magic and Religion* (New York: Macmillan, 1960), 734–35.

23. McDarrah, "Harmless," 17. Smithson's use of "nausea" recalls Jean-Paul Sartre's *Nausea,* first translated into English in 1949; the translation in Smithson's library is dated 1964.

24. C.G. Jung, *Psyche & Symbol: A Selection from the Writings of C.G. Jung,* ed. Violet S. de Lazslo, trans. Cary Baynes and F.C.R. Hull (Garden City, N.Y.: Doubleday, 1958), 4.

25. Robert Smithson, *From a Dream,* Robert Smithson and Nancy Holt Papers, Archives of American Art, Smithsonian Institution, reel 3834, frame 200. Jung's "Introduction to Basic Concepts of Alchemy" followed a section on dream symbolism. "Alchemy perished in its own obscurity. Its method of explanation—'*obscurum per obscurius, ignotum per ignotius*' (the obscure by the more obscure, the unknown by the more unknown)—was incompatible with the spirit of enlightenment and particularly with the dawning of the science of chemistry towards the end of the century." Jung, *Alchemy,* 217.

26. Avigdor W.G. Posèq, "On the Orientation of Heads on Renaissance Medals," *Source: Notes in the History of Art* 24, no. 3 (Spring 2005): 24.

27. "Introduction to the Brachiopoda," accessed July 21, 2016, http://www.ucmp .berkeley.edu/brachiopoda/brachiopoda.html.

28. Albert C. Cain and Barbara S. Cain, "On Replacing a Child." *Journal of American Academy of Child Psychiatry* 3 (1964): 451.

29. Alan Leo, *Saturn the Reaper* (London: Modern Astrology Office, 1916), viii.

30. Communication from Gary Porter to the author, July 11, 2017.

31. Jung, *Alchemy,* 233–34.

32. Interview with Robert Smithson for the Archives of American Art, in Flam, *Robert Smithson,* 289. In November 1966, he used this format of a center rectangular block surrounded by figures in his "Quasi-Infinities and the Waning of Space," published in *Arts* (1966).

33. J.G. Ballard, *The Crystal World* (New York: Farrar, Straus and Giroux, 1966), 148.

34. "'Hard Candy' was published in the January 1965 issue of *Mars,* page 8. [The page number is actually 12.] Published bimonthly [by Kris Studio, Chicago] the issue would have become available in late 1964." Jason Goldman, "Marginal Drawings: Robert Smithson, the Cartouche Series, and the Fragmentary Archive," in "Open

Secrets: Publicity, Privacy, and U.S. Artistic Practice in the Sixties" (PhD diss., University of Southern California, 2011), 124, 174n1.

35. Carl Andre, "Robert Smithson: He Always Reminded Us of the Questions We Ought to Have Asked Ourselves," *Arts* 52, no. 9 (May 1978): 102.

36. Goldman, "Marginal Drawings," 128.

37. Eugenie Tsai, "Interview with Dan Graham October 27, 1988," in *Robert Smithson: Zeichnungen aus dem Nachlass—Drawings from the Estate* (Münster: Westfälisches Landesmuseum für Kunst und Kulturgeschichte, 1989), 18.

38. Jung, *Alchemy*, 281–82.

39. Robert Smithson, "Abstract Mannerism" (1966–67), in Flam, *Robert Smithson*, 339. Unpublished in his lifetime. Michel Leiris, *Manhood: A Journey from Childhood into the Fierce Order of Virility* (1963); in Smithson's collection. The bibliography lists his collection of those books.

40. Douglas Chrismas to me, Nov. 5, 2019.

41. My consultation with Porter, Nov. 10, 2017.

42. Jean de Berg, *The Image*, trans. Patsy Southgate (New York: Grove Press, 1966), 127. The novel also spoke to the appeal to Smithson of doubles and mirrors. The author's name is the pen name of the French actress, photographer, and writer Catherine Robbe-Grillet, wife of the avant-garde writer and filmmaker Alain Robbe-Grillet. In her novel the two female protagonists are doubles or stand-ins for each other. Claire is Anne's S & M Master, presenting her to the male narrator for their pleasure, but she is also a stand-in for Claire, the narrator's lover. At the conclusion their identities converge.

43. In the frank conversation Smithson, Holt, and Lippard had about Eva Hesse, Smithson seems to identify with Hesse's aim to "subvert the more geometric aspects of things" as he "was preoccupied at that time with a kind of counter to the prevailing Minimal situation myself." So it is notable that he attributed to her work "bondage fantasies," and reiterated that twice, which are much more latent in her sculpture than they are explicit in his drawings. Her *Laokoön* was a cage, his *Creeping Jesus* (Plate 13) shows Jesus bound by black straps, and *Untitled* (Plate 21) shows a male squeezed by a thick serpent. Lucy Lippard, "Out of the Past," *Artforum* 46, no. 6 (Feb. 2008): 237–41.

44. Howard Junker, "Jackson Pollock/Robert Smithson: The Myth/the Mythologist," *Arts* 52, no. 9 (May 1978): 130, and email from Junker to me, Dec. 7, 2017. My conversation with Douglas Chrismas, May 16, 2019.

45. My conversations with Nancy Holt, Nov. 3, 1998; Jan. 22, 1996. All that can be said for sure about Holt's knowledge of her husband's nocturnal engagements is that her account to me is what she wanted known for the art historical record.

46. Dan Graham interviewed by Sabine Breitweiser for the Museum of Modern Art Oral History Program, Nov. 1, 2011, 4, 7, 44. Graham also identified Smithson as gay in Donatien Grau, "Dan Graham," *Flash Art*, Nov. 12, 2014, retrieved Feb. 1, 2015, https://flash---art.com/article/dan-graham. In my conversation with him on Sept. 24, 2020, Graham indicated that his belief about Smithson's sexual orientation was based on circumstantial conjecture. He also noted, "What put me off about Bob was his blatant ambition. I wasn't ambitious." This was stated by the person who began as the director of a short-lived gallery and became an internationally respected artist.

47. Vicki L. Eaklor, *Queer America: A People's GLBT History of the United States* (New York: New Press, 2008), 78, 88, 87.

48. Robert C. Doty, "Growth of Overt Homosexuality in City Provokes Wide Concern," *New York Times*, Dec. 17, 1963, 1, 33. This timely discussion includes the statement that "the old idea, assiduously propagated by homosexuals, that homosexuality is

an inborn incurable disease has been exploded by modern psychiatry, in the opinion of many experts. It can be both prevented and cured" (33). It was brought to my attention in Jason Goldman's dissertation, "Open Secrets."

49. Charles Kaiser, *The Gay Metropolis, 1940–1996* (Boston: Houghton Mifflin, 1997), 143.

50. My conversation in 2018 with an artist whose name I am not at liberty to divulge. He maintains his closeted identity today, although if I—with only a professional relation to him—know of his sexual orientation, not very successfully. This is like "John Cage never did quite come out of the closet. Nonetheless, nearly everybody in the art world who knew him [or, I would add, who knew of him] knew of his life-long relationship with Merce Cunningham." Jonathan D. Katz, "John Cage's Queer Silence; or, How to Avoid Making Matters Worse," in *Writings through John Cage's Music, Poetry, and Art*, ed. David W. Bernstein and Christopher Hatch (Chicago: University of Chicago Press, 2001), 41. Art world exceptions to homosexual self-closeting included Robert Indiana, Robert Rauschenberg, Paul Thek, and Andy Warhol.

51. John Giorno, "Vitamin G," *Culture Hero* 1, no. 5 (Mar.? 1970): 14. The creator and publisher of *Culture Hero* (1969–1970) was media artist Les Levine.

52. David Getsy, "Dan Flavin's Dedications," in *Abstract Bodies: Sixties Sculpture in the Expanded Field of Gender* (New Haven, Conn.: Yale University Press, 2015), 218, 217.

53. Robert Smithson, "Can Man Survive?" (1969), in Flam, *Robert Smithson*, 367, 368. Unpublished in his lifetime. Bruce Kurtz, "Conversation with Robert Smithson on April 22, 1972," *Fox 2*, 1975, 76. In the collections of Smithson's writings Holt edited and published in 1979 and reprinted in Flam, she deleted the paragraph regarding "swish" and the following concluding five.

54. Interview, in Flam, *Robert Smithson*, 285.

55. Robert Smithson, "A Tour of the Monuments of Passaic," in Flam, *Robert Smithson*, 71. Originally published in *Artforum*, December 1967, as "The Monuments of Passaic," to which it will generally be referred here.

56. Friar Ludovico Maria Sinistrari, *Peccatum mutum / The Secret Sin* (Paris: Collection "Le Ballet de Muses," 1958), 29, 31, 93. Emphasis in the original.

57. Smithson, "Frederick Law Olmsted and the Dialectical Landscape," in Flam, *Robert Smithson*, 169. Smithson quoted John Rechy, *The City of Night* (New York: Grove Press, 1963); in his library.

58. Bradford R. Collins notes: "A study of gay men conducted in 1996 revealed that 'an overwhelming majority (about 70%) reported some . . . level of internalized homophobia." Bradford R. Collins, "Dick Tracy and the Case of Warhol's Closet: A Psychoanalytic Detective Story," *American Art* 15, no. 3 (Autumn, 2001): 79n32. See Ilan H. Meyer and Laura Dean, "Internalized Homophobia, Intimacy, and Sexual Behavior among Gay and Bisexual Men," *Stigma and Sexual Orientation: Understanding Prejudice Against Lesbians, Gay Men, and Bisexuals*, ed. Gregory M. Herek (London: Sage, 1998), 169. One wonders if Smithson's repeated slams to Lester and in his "Iconography of Desolation" against Jasper Johns, an artist known (without his acknowledgment) to be gay, were other instances of that.

59. Tsai, "Graham," 14.

60. Bradford R. Collins, "The Metaphysical Nosejob: The Remaking of Warhola, 1960–1968," *Arts Magazine* 62, no. 6 (Feb. 1988): 47 (p. 48 illustrates Warhol's cupids, another affinity with Smithson); last quotation: Collins, "Dick Tracy," 72.

61. Robert Smithson, "What Really Spoils Michelangelo's Sculpture" (1966–67), in Flam, *Robert Smithson*, 348, 347.

62. Richard Stamelman, *Lost beyond Telling: Representations of Death and Absence in Modern French Poetry* (Ithaca, N.Y.: Cornell University Press, 1990), 4, 16.

63. Smithson, "Desolation," in Flam, *Robert Smithson*, 326.

64. Jung, *Alchemy*, 233.

6. A Better Entrance

1. J. G. Ballard, *The Drowned World* (New York: Liveright, 2012), 25.
2. Alexander Alberro, "Robert Smithson June 20, 1969," in *Recording Conceptual Art: Early Interviews with Barry, Huebler, Kaltenbach, LeWitt, Morris, Oppenheim, Siegelaub, Smithson, and Weiner by Patricia Norvell*, ed. Alexander Alberro and Patricia Norvell (Berkeley: University of California Press, 2001), 133.
3. G. R. Swenson, "What Is Pop Art? Answers from 8 Painters, Part I," *Art News* 62, no. 7 (Nov. 1963): 27, 25.
4. Howard Junker, "Post Mortem on Pop Culture," *Harper's Bazaar* 99, no. 3056 (July 1966): 9, 134.
5. Dick Aarons, "An Illuminating Exhibit: 'Pop Art' at Penn Has a Neon Glow," *Philadelphia Daily News*, Mar. 19, 1967.
6. Martin Gardner, "Mirrors," in *The Ambidextrous Universe* (New York: Basic Books, 1964), 4.
7. Interview with Robert Smithson for the Archives of American Art, in *Robert Smithson: The Collected Writings*, ed. Jack Flam (Berkeley: University of California Press, 1996), 284. His oral history was taken six months after the Museum of Modern Art's big survey of Barnett Newman's work closed (Oct. 21, 1971–Jan. 10, 1972).
8. Barnett Newman, "The Sublime Is Now," *Tiger's Eye* 6 (1948): 53.
9. My interview with Nancy Holt, January 22, 1996.
10. Lucient Goldmann, *A Study of Tragic Vision in the Pensées of Pascal and the Tragedies of Racine*, trans. Philip Thody (London: Routledge & Kegan Paul, 1964), 33.
11. George Kubler, *The Shape of Time* (New Haven, Conn.: Yale University Press, 1962), 8, 6.
12. Kubler, *Shape of Time*, 7.
13. Smithson. "Ultramoderne," in Flam, *Robert Smithson*, 65. Smithson doesn't give a citation for Kubler. He quotes page 40.
14. Kubler, *Shape of Time*, 65.
15. Kubler, *Shape of Time*, 41, 6.
16. Charles Baudelaire, "Why Sculpture Is Tiresome," in *Baudelaire: Art in Paris 1845–1862*, trans. and ed. Jonathan Mayne (London and New York: Phaidon, 1970), 111. As quoted in Suzaan Boettger, *Earthworks: Art and the Landscape of the Sixties* (Berkeley: University of California Press, 2002), 32. My text edited and condensed.
17. Graham's first sentence, Eugenie Tsai, "Interview with Dan Graham October 27, 1988," in *Robert Smithson: Zeichnungen aus dem Nachlass—Drawings from the Estate* (Münster: Westfälisches Landesmuseum für Kunst und Kulturgeschichte, 1989), 9. His next two sentences are from my conversation with Graham, Sept. 24, 2020.
18. Recalled by artist Ira Joel Haber, in my interview, Mar. 13, 2020, and Douglas Chrismas, my interview, May 16, 2019, both of whom observed Holt at different times in a white nurse's uniform and stockings.
19. Dennis Wheeler, "Four Conversations between Dennis Wheeler and Robert Smithson," in Flam, *Robert Smithson*, 210.
20. Rose Vickers, "The Artist in Earnest: Robert Smithson," *Mousse Magazine*, viewed Aug. 28, 2020, http://moussemagazine.it/robert-smithson-rose-vickers-2020.
21. Nigel Dennis, *Cards of Identity* (New York: Meridian Books, 1960), 100.
22. Dennis, *Cards*, 88.
23. My conversation with Kathryn MacDonald, July 3, 2021.
24. Wheeler, "Four," in Flam, *Robert Smithson*, 211. Smithson's use of the present tense "are" suggests either that the paintings in some sense continued to exist or that the word was erroneously transcribed from the text. Smithson's elimination of early work demonstrates a collateral benefit of purchasing art—to get it out of the hands of creators who later may want to expunge their past.

25. Richard Meyer, *Outlaw Representation: Censorship and Homosexuality in Twentieth-Century American Art* (Boston: Beacon Press, 2002),14.

26. Harold Rosenberg, "The Art Establishment," *Esquire*, Jan. 1, 1965, 43, 45.

27. My conversation with Brian O'Doherty, Apr. 1, 1997, and materials from Ira Galtman, corporate archivist, American Express, Jan. 1, 1997. *Art '65* was on view Apr. 21–Oct. 17, 1965. Brian O'Doherty, "Less Known and Unknown Painters," in *Art '65* (New York: American Express, 1965), 5.

28. A July 1, 1964, letter from MoMA curator William Seitz rejected him for inclusion in the Museum of Modern Art's winter–spring 1965 exhibition, *The Responsive Eye*. Robert Smithson and Nancy Holt Papers, Archives of American Art, Smithsonian Institution.

29. Undated press release from American Express and feature article on the American Express Pavilion at the World's Fair, which per a memo from American Express's Public Relations department dated Nov. 20, 1964, appeared in a trade magazine (unidentified) in the United States. These materials are in the archives of American Express.

30. Robert Smithson, "Quick Millions," in Flam, *Robert Smithson*, 3. Originally published in Brian O'Doherty, "Less Known and Unknown Painters."

31. My interview with Brian O'Doherty, Apr. 1, 1997, and with Richard Serra, June 20, 2000.

32. From 1961 to 1970, Irving Smithson was employed by the Toomey Mortgage Company in Hackensack, retiring as a vice president.

33. Smithson, "Quick Millions," in Flam, *Robert Smithson*, 3.

34. Smithson, "Quick Millions," 3. With these overlapping references to mortality, the wing-like symmetry of *Quick Millions'* plastic parallelograms could refer to a dove as the Holy Spirit, a soul posthumously rising to heaven.

35. Smithson, "Quick Millions," 3.

36. Warhol stated that in Swenson, "What Is Pop Art?," 26. Bradford R. Colins, "The Metaphysical Nosejob: The Remaking of Warhola 1960–1968," *Arts Magazine* 62, no. 6 (Feb. 1988): 51.

37. Robert Smithson, "Incidents of Mirror-Travel in the Yucatan," in Flam, *Robert Smithson*, 132.

38. Interview, in Flam, *Robert Smithson*, 284. *Plastics*, John Daniels Gallery, New York, Mar. 16–Apr. 3, 1965.

39. Ken Kelman, "Thanatos in Chrome," *Film Culture*, Fall–Winter 1963, 7. Smithson quoted Kelman in "Entropy and the New Monuments," *Artforum*, June 1967.

40. Tsai, "Interview with Graham," in *Robert Smithson: Zeichnungen*, 12.

41. And according to Dan Graham, "Judd . . . hated [Smithson's] essay." Tsai, "Interview with Graham," 14. About two years later, after an art critic wrote that Smithson was the spokesperson for the Minimalists (evidence of Smithson's authority as a speaker), Judd's public retort was a one-sentence letter to the editor: "Smithson is not my spokesman." *Arts Magazine* 41, no. 4 (Feb. 1967): 8. Nevertheless, Smithson's datebook records meeting with Judd on three Sundays over the course of 1972.

42. Robert Smithson, "Donald Judd," in Flam, *Robert Smithson*, 5.

43. Charles William Bunn, *Crystals: Their Role in Nature and Science* (New York: Academic Press, 1964), 4–5, 9. A couple of years later, Smithson will apply that distinction again. Heralding the post–World War I machine age aesthetic of decorative linearity on the facades of 1930s apartment buildings along Central Park West, he imagined a contrast between the "organic (Modernist) and crystalline (Ultraist)." Smithson, "Ultramoderne," in Flam, *Robert Smithson*, 63. Visually, that polarity of organic as Modernist and crystalline as Ultraist applies to 1940s' and '50s' biomorphic (lima bean–like) abstraction, but not for the Modernist styles Cubism and its

offshoots Orphism, Suprematism, Constructivism, and De Stijl—all angular and planar and exemplifying "Ultraism."

44. Donald Judd, "Specific Objects," *Arts Yearbook 8* (1965): 74–82.

45. Robert Smithson, undated and untitled sheet, Robert Smithson and Nancy Holt Papers, Archives of American Art, Smithsonian Institution, box B3, #68.

46. C.G. Jung, *Psyche & Symbol: A Selection from the Writings of C. G. Jung,* ed. Violet S. de Laszlo, trans. Cary Baynes and F.C.R. Hull (Garden City, NY: Doubleday Anchor, 1959), 6, 8.

47. Likewise, "Smithson describes a decentering effect in Judd's art that could double as a statement of the program that he was following in his own work at the time." Gary Shapiro, *Earthwards: Robert Smithson and Art After Babel* (Berkeley: University of California Press, 1995), 59.

48. Robert Smithson, "The Crystal Land," in Flam, *Robert Smithson,* 8–9. Originally published in *Harper's Bazaar,* May 1966.

49. Oral history interview with John Weber, 2006, Archives of American Art, Smithsonian Institution, 17.

50. Smithson, "Crystal Land," in Flam, *Robert Smithson,* 9. Robert Smithson, "The Spiral Jetty," in Flam, *Robert Smithson,* 146.

51. Smithson, "Crystal Land," 7.

52. Haim Finkelstein, " 'Deserts of Vast Eternity': J. G. Ballard and Robert Smithson," *Foundation* 39 (Spring 1987): 55. I elaborate on their connection in Suzaan Boettger, "Shadows of Kindred Spirits: Robert Smithson and Science Fiction," in *Deep Ends: A Ballardian Anthology 2021,* ed. Rick McGrath (Powell River, B.C.: Terminal Press, 2021), 169–75.

53. J.G. Ballard, "The Illuminated Man," in *The Complete Stories of J. G. Ballard* (New York: W.W. Norton, 2009), 609–10. Quotations from it not specifically cited are from this source, 605–27. "The Illuminated Man" appeared in the popular and widely distributed magazine *Fantasy and Science Fiction* in May 1964. It was then in a Ballard collection, *Terminal Beach,* published in London, 1964. It is the first version of the story that was almost immediately rewritten as "Equinox" and published in *New Worlds* in May/June and July/Aug. 1964, and then as the novel *The Crystal World* in 1966. This chronology was provided by Rick McGrath, Ballard scholar, http://www.jgballard.ca/terminal_collection/1964_65.html. The U.S. edition of *Terminal Beach,* which Smithson owned, does not include "The Illuminated Man." He could have read it in the magazine.

54. Robert Smithson, "The Artist as Site-seer; or, A Dintorphic Essay," in Flam, *Robert Smithson,* 341. Not published in his lifetime.

55. J.G. Ballard, "Terminal Beach," in *Terminal Beach* (New York: Berkley, 1964), 147.

56. Smithson, "Site-seer," in Flam, *Robert Smithson,* 340, 341.

57. J.G. Ballard, *The Crystal World* (New York: Farrar, Straus and Giroux, 1966), 77.

58. Ballard, "Illuminated Man," 624–25.

59. Oral history interview, AAA, in Flam, *Robert Smithson,* 283.

60. Ballard, *Crystal World,* 190.

61. Ballard, "Illuminated Man," 610.

62. Ballard. "Terminal Beach," 146, 145.

63. Ballard, "Terminal Beach," 158.

64. Ballard, *Crystal World,* 3, 60. Robert Smithson, "The Earth, Subject to Cataclysms, Is a Cruel Master," interview with Gregoire Müller, in Flam, *Robert Smithson,* 257. This interview was originally published in *Arts Magazine,* Sept. 1971.

7. Locked Within

1. My interview with Brian O'Doherty, Apr. 1, 1997. All quotations by O'Doherty not otherwise cited are from this source. Other panelists were John Hightower,

executive director of the New York State Council on the Arts, and Yale philosophy professor Paul Weiss. From 1972 on, O'Doherty would differentiate his artist self from other professional roles by exhibiting under the name Patrick Ireland.

2. My conversation with Lorraine Harner, Aug. 1, 2017.

3. Patricia Hills, *Alice Neel* (New York: Harry N. Abrams, 1983), 112.

4. Indicated in an annotation to his short story. Peter Hutchinson, "The Art Dictator," in *Dissolving Clouds: The Writings of Peter Hutchinson* (Provincetown, Mass.: Provincetown Arts Press, 1994), 19. Originally published in *Tracks Magazine*, 1975.

5. Eugenie Tsai, "Interview with Dan Graham Oct. 27, 1988," in *Robert Smithson: Zeichnungen aus dem Nachlass—Drawings from the Estate* (Münster: Westfälisches Landesmuseum für Kunst und Kulturgeschichte, 1989), 12.

6. Interview with Robert Smithson for the Archives of American Art, in *Robert Smithson: The Collected Writings*, ed. Jack Flam (Berkeley: University of California Press, 1996), 290.

7. My conversation with Ernest Schwiebert, former architect with TAMS, Mar. 15, 1998.

8. Correspondence from Smithson to German art historian Rolf-Dieter Herrmann, dated July 31, 1970, as quoted in the latter's "In Search of a Cosmological Dimension: Robert Smithson's Dallas-Fort Worth Airport Project," *Arts* 52, no. 9 (May 1978): 110.

9. Irving Sandler, *A Sweeper-Up after Artists: A Memoir* (New York: Thames & Hudson, 2003), 293.

10. Oral history interview, AAA, in Flam, *Robert Smithson*, 272.

11. My conversation with Judi Den Herder, Aug. 2, 2016.

12. Interview, in Flam, *Robert Smithson*, 272.

13. Robert Smithson, "Entropy and the New Monuments," "A Cinematic Atopia," and "The Shape of the Future and Memory," all in Flam, *Robert Smithson*, 11, 140, and 332–33. "Atopia" was published in *Artforum*, Sept. 1972; "Shape" was unpublished in his lifetime.

14. Edwin Honig, *Dark Conceit: The Making of Allegory* (New York: Oxford University Press, 1966), 130.

15. My conversation with Brice Marden, Dec. 24, 2020.

16. Oral history interview with Chuck Close, Archives of American Art, Smithsonian Institution, 35–36.

17. Bruce Kurtz, "Last Call at Max's," *Artforum* 19, no. 8 (Apr. 1981): 28.

18. Yvonne Sewall Ruskin, *High on Rebellion: Inside the Underground at Max's Kansas City* (New York: Thunder's Mouth Press, 1998), 58.

19. My interview with Richard Serra, June 20, 2000.

20. Peter Schjeldahl, "A Nose for the Abyss: Monuments of a Metaphysical Dandy," *Village Voice Literary Supplement*, June 1982, 7. In this review of the reissued *The Writings of Robert Smithson* (1979), Schjeldahl continued, "So his writings, when I finally encountered them in book form, were a big, retroactive shock."

21. Mel Bochner, "Secrets of the Domes," in *Solar System & Rest Rooms: Writings and Interviews, 1965–2007* (Cambridge, Mass.: MIT Press, 2008), 199.

22. Virginia Dwan, "Reflections on Robert Smithson," *Art Journal* 42, no. 3 (Fall 1982): 233.

23. Eva Hesse, whose work was posthumously interpreted as painfully autobiographical, restricted her revelatory comments to close friends and her diaries, which after her death were made available to researchers.

24. Jorge Luis Borges, "The Garden of the Forking Paths," in *Ficciones* (New York: Grove Press, 1962), 99. Smithson owned a copy of this edition, six other books by Borges, and four about Borges's writing.

25. Robert Smithson, "From the Walls of Dis," in Flam, *Robert Smithson*, 316.

26. Kenneth Baker, "Talking with Robert Smithson" (1971), in *Robert Smithson: Spiral Jetty*, ed. Lynn Cooke and Karen Kelly (Berkeley: University of California Press, 2005), 156. Neurologically, to be "locked in" is a condition in which a person is aware but cannot move or communicate verbally due to complete paralysis of nearly all of the body's voluntary muscles except for the eyes.

27. Eli Levin, *Disturbing Art Lessons* (Santa Fe: Sunstone Press, 2012), 38. My conversation with MacDonald, July 3, 2021. It is remarkable that Holt learned of the Smithson family's first son not from Smithson but from her mother-in-law. My conversation with Nancy Holt, Feb. 16, 1993.

28. Smithson, "Shape," in Flam, *Robert Smithson*, 332.

29. Harold Rosenberg, "The American Action Painters," in *The Tradition of the New* (Chicago: University of Chicago Press, 1959). This essay was originally published in December 1952 in *Art News*.

30. John Cage, *Silence* (Middletown, Conn.: Wesleyan University Press, 1961), 10–11. Cage's withholding of memory, imagination, and emotional sources of his art was not simply an intellectual maneuver. Art historian Jonathan Katz has insightfully analyzed Cage's transition from a composer of his expressive *Amores* (1943) and *A Valentine Out of Season* (1944) to his abstract and impersonal *4'33"* (1952), and Cage's adoption of personal nondisclosure (*Silence*), in relation to Cage's divorce from his wife and his "embracing his [personal and professional] relationship with [choreographer] Merce Cunningham and, concomitantly, his identity as a socially marginal gay man. . . . During these experiences he was coming to the conclusion that communication in art, the hallmark of an expressive musicality, was not possible. . . . It was in not talking about—and hence not reifying—one's troubles that healing began." Jonathan D. Katz, "John Cage's Queer Silence; or How to Avoid Making Matters Worse," in *Writings through John Cage's Music, Poetry, and Art*, ed. David W. Bernstein and Christopher Hatch (Chicago: University of Chicago Press, 2001), 45.

31. Leonard P. Meyer, "The End of the Renaissance? Notes on the Radical Empiricism of the Avant-Garde," *Hudson Review* 16, no. 2 (Summer 1963): 186, 177, 181.

32. From a 1965 interview, in David Sylvester, *Interviews with American Artists* (New Haven, Conn.: Yale University Press, 2001), 152. Johns's evasion of the personal is particularly disingenuous for an artist whose early work has been shown, despite his maneuvers in dodging self-disclosure, to have strong biographical sources relating to his sexual orientation.

33. "Conceptual Art and the Reception of Duchamp," roundtable discussion, *October* 70 (Autumn 1994): 140.

34. Smithson, "Outline for Yale Symposium," in Flam, *Robert Smithson*, 361. Previously unpublished; in Flam erroneously dated 1968. Wylie Sypher, "The Romantic Self," in *Loss of the Self in Modern Literature and Art* (New York: Vintage, 1962), 14, 77.

35. Smithson, "Outline," in Flam, *Robert Smithson*, 361.

36. Ludwig Wittgenstein, *Tractatus Logico-Philosophicus*, trans. D.F. Pears and B.F. McGuinness (London: Routledge & Kegan Paul; New York: Humanities Press, 1961), 149. Smithson owned G.E.M. Anscombe, *An Introduction to Wittgenstein's Tractatus*, 2d ed. (New York: Harper & Row, 1965).

37. For good measure, in his *Object and Idea: An Art Critic's Journal*, also published in 1967, O'Doherty doubled the rejection by not mentioning their history together. When Dan Graham edited the Fall 1970/Winter 1971 issue of *Aspen*, Smithson published in it "Strata: A Geophotographic Fiction."

38. Sontag, "The Aesthetics of Silence," in *Styles of Radical Will* (New York: Dell, 1969), 30, 32, 3, 4, 6.

39. Roland Barthes, "The Death of the Author," in *Image, Music, Text*, trans. Stephen Heath (New York: Hill and Wang, 1977), 143.

40. Grégoire Müller, *The New Avant-garde: Issues for the Arts of the Seventies* (New York: Praeger, 1972), 6, 7.

41. Robert Pincus-Witten, "The Seventies," in *Eye to Eye: Twenty Years of Art Criticism* (Ann Arbor, Mich.: UMI Research Press, 1984), 123, 124. Originally published in *A View of a Decade* (Chicago: Museum of Contemporary Art, 1977).

42. Baker, "Talking," 153.

43. Oral history interview, AAA, in Flam, *Robert Smithson*, 283.

44. Baker, "Talking," 151.

45. Lucy Lippard, "Breaking Circles: The Politics of Prehistory," in *Robert Smithson: Sculpture*, by Robert Hobbs (Ithaca, N.Y.: Cornell University Press, 1981), 31.

46. Interview, in Flam, *Robert Smithson*, 283.

47. Robert Smithson, "Iconography of Desolation," in Flam, *Robert Smithson*, 321.

48. Irving Sandler, "New Names This Month," *Art News* 58, no. 7 (Oct. 1959): 18.

49. Oral history interview, AAA, in Flam, *Robert Smithson*, 283.

50. Oral history interview, AAA, in Flam, *Robert Smithson*, 283.

51. E. M. Butler, *Ritual Magic* (New York: Noonday, 1959), 267.

52. Beredene Jocelyn, "Introduction: The Divinity of the Zodiac and the Magnitude of Man," in *Meditations on the Signs of the Zodiac*, by John Jocelyn (New York: Rudolf Steiner Publications, 1970), 20. Steiner was a Theosophist and this text displays strong correspondences to Theosophy's ecumenical advocacy of the development of one's spiritual consciousness. This text, dated 1965, is identical in the 1966 edition in Smithson's library.

53. Oral history interview, AAA, in Flam, *Robert Smithson*, 285.

54. Oral history interview, AAA, in Flam, *Robert Smithson*, 286.

55. Robert Smithson, "To Lent," Robert Smithson and Nancy Holt Papers, Archives of American Art, Smithsonian Institution, reel 3834, frame 194.

56. Oral history interview with Robert Smithson, July 14–19, 1972, Archives of American Art, Smithsonian Institution. Hereafter Oral history interview, AAA. https://www.aaa.si.edu/collections/interviews/oral-history-interview-robert-smithson-12013#transcript. Holt deleted her interjection from the published versions and also put together other responses.

57. Wylie Sypher, *Loss of the Self in Modern Literature and Art* (New York: Vintage, 1964), 14.

58. Oral history interview, AAA, in Flam, *Robert Smithson*, 284, 289.

59. Oral history interview, AAA.

60. Oral history interview, AAA, in Flam, *Robert Smithson*, 283.

61. Oral history interview, AAA.

62. Oral history interview, AAA, in Flam, *Robert Smithson*, 286.

63. Additional inconsistencies between his life chronology and his account of them are as follows (page numbers are in Flam, *Robert Smithson*, or the Archives of American Art transcript):

He replied to Cummings's inquiry about when he started writing by answering "1965–66," whereas he wrote his incantations and "Desolation" essay no later than 1962 and "Lamentations" verse no later than 1963 (272). He later said the first thing he wrote was in 1966 for *Harper's Bazaar*, eliminating his essay for Judd from his chronology (AAA, 19); neither publication is mentioned in the Flam version.

He suggested to Cummings that he had a single show at the Artists' Gallery; he was in three there (273).

"I was the youngest artist to even show there. And I felt—well, you know, if I can show at age nineteen . . ." The exhibition Smithson had at nineteen was at Brilliant's apartment (273).

He said he first went to Europe in 1959, but it was 1961; that he was there three months whereas dates in his correspondence indicate that it was less than two (AAA, 19).

When asked when he and Holt had met, he turned to her to provide their story. On the audiotape, her response is inaudible; in her edited version (282), he stated the date outright, 1959, a decade after they were photographed as a couple (Figure 4.3).

He recalled meeting his gallerist/patron Virginia Dwan five months earlier than it occurred and by a different means (290).

He stated that he worked for Tippetts-Abbett-McCarthy-Stratton, which led him to devising earthworks, in 1964; it was 1966–67 (290).

He dated his construction of the neon-mirrored *Eliminator* to 1963 (AAA, 29); Holt changed it to 1964 (291).

64. Smithson, "Some Void Thoughts on Museums," in Flam, *Robert Smithson*, 41. Originally published in *Arts*, Feb. 1967.

65. Thomas Crow noted, "It is fascinating (and appalling) to read his official interviewer for the AAA in 1972, Cummings, interrupt Smithson and put 'acceptable' words into his mouth just at the point where he is attempting to explain the complexities of his religious thinking around the time of his Roman trip and in general." Thomas Crow, "Cosmic Exile: Prophetic Turns in the Life and Art of Robert Smithson," in *Robert Smithson*, ed. Eugenie Tsai (Los Angeles: Museum of Contemporary Art; Berkeley: University of California Press, 2004), 50n79.

66. Lucy Lippard, "Out of the Past," *Artforum* 46, no. 6 (Feb. 2008): 246, 238.

67. Smithson, "Entropy," in Flam, *Robert Smithson*, 19.

68. Jung, *Alchemy*, 277.

69. Sandler, *Sweeper-Up*, 293.

70. Smithson, "A Museum of Language in the Vicinity of Art," in Flam, *Robert Smithson*, 79–80. Published in *Art International*, Mar. 1968. Voltaire's famous precedent was "We have words so as to hide our thoughts." But Smithson was more likely condensing Roland Barthes's assertion that "if there is such a thing as a critical proof, it lies not in the ability to *discover* the work under consideration but, on the contrary, to *cover* it as completely as possible with one's own language." Barthes, "Criticism as Language," *Times* (London) *Literary Supplement*, Sept. 27, 1963; in *The Critical Moment: Literary Criticism in the 1960s* (New York: McGraw-Hill, 1964). In Smithson's book collection.

8. Transmuted

1. This number is the sum of those texts reproduced in *Robert Smithson: The Collected Writings*, ed. Jack Flam (Berkeley: University of California Press, 1996). Miscellaneous unpublished others, completed or in draft, in his papers in the Archives of American Art add to that number.

2. Robert Martin Adams, *Nil: Episodes in the Literary Conquest of Void during the Nineteenth Century* (New York: Oxford University Press, 1966), 132, 134, 41.

3. Robert Smithson, "The Artist as Site-Seer; or, A Dintorphic Essay," in Flam, *Robert Smithson*, 345n62; see also 342. Unpublished in his lifetime.

4. Adams, *Nil*, 42–47. Robert Smithson, "A Museum of Language in the Vicinity of Art," in Flam, *Robert Smithson*, 90.

5. Susan Sontag, "Against Interpretation," in *Against Interpretation and Other Essays* (New York: Dell, 1969), 20. Originally published in *Evergreen Review*, 1964, a magazine Smithson read.

6. Donald Judd, "Specific Objects," *Arts Yearbook* 8 (1965): 74

7. Judd, "Specific Objects," 79.
8. Michel Foucault's *Discipline and Punish: The Birth of the Prison*, which discusses the panopticon, would not be published until 1975; in English translation in 1977.
9. Robert Smithson, "The Cryosphere," in Flam, *Robert Smithson*, 38. Originally published in the catalogue *Primary Structures*, 1966.
10. C. G. Jung, *The Collected Works of C. G. Jung*, ed. Herbert Read, Michael Fordham, and Gerhard Adler, vol. 12, *Psychology and Alchemy* (New York: Pantheon Books, 1953), 233–34.
11. Interview with Robert Smithson for the Archives of American Art, in Flam, *Robert Smithson*, 286.
12. E. M. Butler, *Ritual Magic* (New York: Noonday Press, 1949), 258, 263.
13. Charles William Bunn, *Crystals: Their Role in Nature and Science* (New York: Academic Press, 1964), 76, 98. Smithson owned this book.
14. Bruno Munari, *The Discovery of the Circle* (New York: George Wittenborn, 1966), 5.
15. "Four Conversations Between Dennis Wheeler and Robert Smithson," in Flam, *Robert Smithson*, 222.
16. Jung, *Alchemy*, 157, 281, 370.
17. Jung, *Alchemy*, 223.
18. Alan Leo, *Saturn the Reaper* (London: Modern Astrology Office, 1916), viii. Smithson owned this book.
19. Mel Bochner, "Primary Structures," *Arts* 40, no. 8 (June 1966): 32. Smithson owned a copy of the source of Robbe-Grillet's anti-humanist statements, *For a New Novel*, trans. Richard Howard (New York: Grove Press, 1965).
20. Robert Smithson, "The Pathetic Fallacy in Esthetics," in Flam, *Robert Smithson*, 337–38. Previously unpublished, editorially given the date of 1966–67, but Judd's "Specific Objects" appeared in December 1965 and Robbe-Grillet's *For a New Novel* in 1965, and these ideas correspond to Smithson's thinking in 1966.
21. Bochner, "Primary," 34.
22. Peter Schjeldahl, "Robert Smithson: He Made Fantasies as Real as Mountains," *New York Times*, Aug. 12, 1973, 127.
23. Eugenie Tsai, "Interview with Dan Graham October 27, 1988," in *Robert Smithson: Zeichnungen aus dem Nachlass—Drawings from the Estate* (Münster: Westfälisches Landesmuseum für Kunst und Kulturgeschichte, 1989), 12.
24. Philip Leider to Robert Smithson, Mar. 26, 1966, Robert Smithson and Nancy Holt Papers, Archives of American Art, Smithsonian Institution, reel 3832, frame 859.
25. John Taine (Eric Temple Bell), *The Time Stream, The Greatest Adventure, and The Purple Sapphire: Three Science Fiction Novels* (New York: Dover, 1964), 5, 31, 36, 106, 91, 51.
26. Robert Smithson, "Entropy and the New Monuments," in Flam, *Robert Smithson*. This essay was originally published in *Artforum*, June 1966.
27. Phil Leider, "Robert Smithson: The Essays," *Arts Magazine*, May 1978, 96.
28. Smithson, "Entropy," in Flam, *Robert Smithson*, 11.
29. Richard Schlegel, "Time and Thermodynamics," in *The Voices of Time: A Cooperative Survey of Man's Views of Time as Expressed by the Sciences and by the Humanities*, ed. J. T. Fraser (New York: Braziller, 1966), 504.
30. Wylie Sypher, *Loss of the Self in Modern Literature and Art* (New York: Vintage, 1962), 74. Being a scholar of literature, Sypher probably learned of entropy from Thomas Pynchon. Years later, Pynchon recalled that his story "Entropy," written in 1958 or 1959 and frequently anthologized, had been inspired by the conjunction of his reading *The Education of Henry Adams* and Norbert Wiener's *The Human Use of Human Beings*. "Given my undergraduate mood [previously described as "somber glee at any idea of mass destruction or decline"], Adams's sense of power out of control,

coupled with Wiener's spectacle of universal heat-death and mathematical still-ness, seemed just the ticket." Thomas Pynchon, *Slow Learner: Early Stories* (Boston: Little, Brown, 1984), 13.

31. Sypher, *Loss*, 73.
32. Lee Smolin, *Time Reborn: From the Crisis in Physics to the Future of the Universe* (New York: Houghton Mifflin Harcourt, 2013), 195, 219.
33. Sypher, *Loss*, 75.
34. Smolin, *Time Reborn*, 193, 194.
35. Gene Youngblood, "Art, Entertainment, Entropy," in *Expanded Cinema* (New York: E. P. Dutton, 1970), 63. Smithson owned this book.
36. Lucy R. Lippard, "Intersections," in *Flyktpunkter/Vanishing Points*, ed. Olle Granath and Margareta Helleberg (Stockholm: Moderna Museet, 1984), 11.
37. Smithson, "Entropy," in Flam, *Robert Smithson*, 11.
38. As quoted by John Perreault, "Nonsites in the News," *New York* 2, no. 8 (Feb. 24, 1969): 44. Perreault knew this because he and his life partner at the time, Ira Joel Haber, socialized over dinners with Smithson and Holt. His article recounts an excursion with them to New Jersey to collect geological matter for nonsites.
39. Robert Smithson, "Letter to Gyorgy Kepes," in Flam, *Robert Smithson*, 369.
40. Robert Smithson, "The Artist and Politics: A Symposium," in Flam, *Robert Smithson*, 134. This was originally published in *Artforum*, Sept. 1970; Smithson's title was "Art and the Political Whirlpool or the Politics of Disgust." Whirlpool tacitly echoed the form of his *Spiral Jetty*, represented that month in eight photographs in the MoMA exhibition *Information*.
41. My interview with Nancy Holt, Jan. 22, 1996.
42. Dale McConathy, "Robert Smithson and Anti-Modernism: The Rupture of the Past and Present," *Artscanada*, no. 240/241 (Mar./Apr. 1981): 24.
43. Suzaan Boettger, "Degrees of Disorder." Edited transcript of, and introduction to, Robert Smithson's Nov. 1968 discussion with Willoughby Sharp, *Art in America* 86, no. 12 (Dec. 1998): 79.
44. Oral history interview, AAA, in Flam, *Robert Smithson*, 293.
45. Letter from LeWitt to Dwan, dated Mar. 1966, in Robert Smithson and Nancy Holt Papers, Archives of American Art, reel 3832, frame 80. Irrespective of whether Smithson knew of LeWitt's letter, as the artists were friends it is quite likely that he knew of LeWitt's efforts on his behalf, if not even having initiated it. Six years later, when asked how he got involved with the Dwan Gallery, Smithson replied that Dwan asked him to join the gallery after he had worked with Reinhardt and Morris organizing the *10* show. This is highly unlikely, as his first solo show at Dwan with several fabricated sculptures opened exactly a month after *10* closed, and is contradicted by Dwan's own account. Smithson apparently preferred to be known as having been referred by an artist of Reinhardt's stature. Oral history interview, AAA, in Flam, *Robert Smithson*, 290.
46. Oral history interview with Virginia Dwan, Archives of American Art, Smithsonian Institution, reel 5, frame 14.
47. Virginia Dwan, "Reflections on Robert Smithson," *Art Journal* 42, no. 3 (Fall 1982): 233.
48. Smithson recalled that in future years, he, "together with Sol LeWitt, thought up the language shows at the Dwan Gallery." Interview, in Flam, *Robert Smithson*, 294. These June exhibitions (*Language to Be Looked At and/or Things to Be Read*, *Language II*, and *Language III*) concluded the 1967, 1968, and 1969 seasons. The second and third versions of Smithson's and LeWitt's summer curating became among the few instances that a few women artists (including Rosemarie Castoro, Hanne Darboven, Lila Katzen, Christine Kozlov, and Adrian Piper) exhibited at the Dwan Gallery. Holt's chronology in *Sightlines* (2010) states that she participated in the 1969

show; the list for it in *Virginia Dwan, New York, Les Années 60–70* (1991) does not mention her.

49. The exhibition *10* was on view Oct. 4–29 and included work by Carl Andre, Jo Baer, Dan Flavin, Donald Judd, Sol LeWitt, Agnes Martin, Robert Morris, Ad Reinhardt, Smithson, and Michael Steiner.

50. Oral history interview, AAA, in Flam, *Robert Smithson*, 292.

51. Kasimir Malevich, "The Non-Objective World," in *Theories of Modern Art: A Source Book by Artists and Critics*, ed. Herschel B. Chipp (Berkeley: University of California Press, 1968), 341.

52. Alexander Alberro, "Robert Smithson June 20, 1969," in *Recording Conceptual Art: Early Interviews with Barry, Huebler, Kaltenbach, LeWitt, Morris, Oppenheim, Siegelaub, Smithson, and Weiner by Patricia Norvell*, ed. Alexander Alberro and Patricia Norvell (Berkeley: University of California Press, 2001), 132.

53. *Robert Smithson*, Nov. 29–Jan. 5, 1967.

54. Caroline A. Jones, *Machine in the Studio: Constructing the Postwar American Artist* (Chicago: University of Chicago Press, 1996), 310.

55. Dwan Gallery announcement of solo show *Robert Smithson*.

56. Oral history interview, AAA, in Flam, *Robert Smithson*, 287.

57. "Contemporary American Sculpture and Prints" was on view at the Whitney from Dec. 16, 1966, until Feb. 5, 1967. *Alogon #1* was accessioned into the Whitney's collection in 1967. In 1977 collectors Kimiko and John Powers gave *Plunge* to the Denver Art Museum. In 1994 Virginia Dwan gave *Alogon #2* to the Museum of Modern Art, and the next year she gave *Terminal* to the Des Moines Art Center. In 1986 Barbaralee Diamonstein-Spielvogel gave *Mirrored Ziggurat* to the Metropolitan Museum of Art.

9. From the Ground, Upward

1. "Earth," Symposium at White Museum, Cornell University, in *Robert Smithson: The Collected Writings*, ed. Jack Flam (Berkeley: University of California Press, 1996), 177.

2. This work is sometimes identified with a pre-title *Runway Layout Ultimate Plan*, but those words are printed on the architects' layout Smithson drew on and does not mean the work is his own "ultimate plan."

3. Robert Smithson and Nancy Holt Papers, Archives of American Art, Smithsonian Institution, reel 3834, frame 912. This sketch is undated. It is illustrated in the frontispiece to Suzaan Boettger, *Earthworks: Art and the Landscape of the Sixties* (Berkeley: University of California Press, 2002).

4. Robert Smithson and Nancy Holt Papers, Archives of American Art, Smithsonian Institution, reel 3834, frames 912–15. His drawing *Airport Site Map*, showing the four artists' maquettes on pedestals and on floor-level panels, illustrated the potential gallery installation of such a show.

5. My conversation with Nancy Holt, Nov. 3, 1998.

6. In the conversation with Holt on Nov. 3, 1998, she noted that Andre's recollection was incorrect; she had driven as she knew the way. Andre continued: "My only contribution was to draw his attention to it. That evening, in Atlantic City, we were turned away from the pre-casino resort hotels & wound up in a motel built over a strip-tease bar. We had drinks with the strippers. The next day on the drive back to New York, we stopped off in Egypt (New Jersey) at a colonial-era coach staging inn." Correspondence from Andre to author, July 24, 1996. Andre did not identify the reason they were turned away; presumably because their attire or appearance was deemed unsuitable for a "resort hotel." Dan Graham, Michael Heizer, Howard Junker, Sol LeWitt, Robert Morris, and Dale McConathy went on other New Jersey trips.

7. Samuel Wagstaff Jr., "Talking with Tony Smith," in *Minimal Art*, ed. Gregory

Battcock (New York: E. P. Dutton, 1968), 386. This article was originally published in *Artforum*, December 1966.

8. Liza Bear and Willoughby Sharp, "Discussions with Heizer, Oppenheim, Smithson," in Flam, *Robert Smithson*, 244. This collage of separate interviews made to appear as a group discussion was originally published in *Avalanche* 1, Fall 1970.

9. John McPhee, "The Pine Barrens—I," *New Yorker* 43, no. 40 (Nov. 24, 1967): 67.

10. Robert Smithson and Nancy Holt Papers, Archives of American Art, Smithsonian Institution, reel 3832, frame 967, shows a carbon copy of a letter sent under Dwan's name on Apr. 21, 1967, to the town clerks of Tuckerton, New Gretna, Parkertown, Brookville, Cedar Run, and Jenkins. Dwan attributed these to having been prepared by Holt. Charles Stuckey, interview with Virginia Dwan, Archives of American Art, Smithsonian Institution, 1984, reel 7, frame 27.

11. As I noted in Suzaan Boettger, "Behind the Earth Movers: Virginia Dwan," *Art in America* 92, no. 4 (Apr. 2004): 55–62.

12. Writing to Smithson on Jan. 6, 1967, Leider left the subject matter open (stating that the fee paid would be $150) and requested, "I would regard it as a great help if you could let me know the names of a few of your colleagues who you feel might have something to contribute." Robert Smithson and Nancy Holt Papers, Archives of American Art, Smithsonian Institution, reel 3832, frame 947.

13. Robert Smithson, "Towards the Development of an Air Terminal Site," in Flam, *Robert Smithson*, 56. Originally published in *Artforum*, June 1967.

14. Smithson, "A Tour of the Monuments of Passaic," in Flam, *Robert Smithson*, 72. Ann Reynolds reports that a draft of this essay, between sketches of mirror pieces from 1966 and 1967, is among the unfilmed Smithson Papers at the Archives of American Art; Ann Reynolds, *Robert Smithson: Learning from New Jersey and Elsewhere* (Cambridge, Mass.: MIT Press, 2003), 101, 263n69.

15. Interview with Robert Smithson for the Archives of American Art, in Flam, *Robert Smithson*, 271. "Monuments," in Flam, *Robert Smithson*, 74. See also "From the Temptations," Robert Smithson and Nancy Holt Papers, Archives of American Art, Smithsonian Institution, reel 3834, frame 209.

16. "Monuments," in Flam, *Robert Smithson*, 72. The line adapts his previous "Vladimir Nabokov's observation that, 'The future is but the obsolete in reverse'" and "Wylie Sypher's insight that 'Entropy is evolution in reverse,'" published in his 1966 *Artforum* essay, "Entropy and the New Monument," reprinted in Flam, *Robert Smithson*, 11, 15.

17. Flam, *Robert Smithson*, xxi; Smithson, "Monuments," in Flam, *Robert Smithson*, 74. He had probably seen the perceptual vacancy of René Magritte's *False Mirror* (1929)—an enlarged iris as blue sky with clouds—in the collection of the Museum of Modern Art.

18. My interview with Nancy Holt, Jan. 22, 1996. That explains the sparsity of work by Smithson extant from high school classes and those at the Art Students League and Brooklyn Museum School.

19. Oral history interview, AAA, in Flam, *Robert Smithson*, 286. Erik H. Erikson, "'Identity Crisis' in Autobiographical Perspective," in *Life History and the Historical Moment* (New York: W. W. Norton, 1975), 27.

20. This analogy could have been inspired by, but counters, one by novelist John Taine regarding "the film of time; run that film backward from the present, and you will see the past restored with all its events in the reverse order. Or if you run it forward from any given epoch, the past will live once more before your eyes precisely as it was." John Taine (Eric Temple Bell), *The Time Stream, The Greatest Adventure, and The Purple Sapphire: Three Science-Fiction Novels* (New York: Dover, 1964), 10.

21. Lee Smolin, *Time Reborn: From the Crisis in Physics to the Future of the Universe* (New York: Houghton Mifflin Harcourt, 2013), 195.

22. Smithson, "Monuments," in Flam, *Robert Smithson*, 74.

23. Smithson, "Monuments," 74, 72.

24. Smithson, "Monuments," 74.

25. I discuss his purchase at greater length in Suzaan Boettger, "Digging into Aldiss's *Earthworks* and Smithson's 'Earthworks,'" *Art Journal OPEN*, College Art Association, accessed June 7, 2018, http://artjournal.collegeart.org/?p=9939.

26. Robert Smithson, "Towards the Development of an Air Terminal Site," in Flam, *Robert Smithson*, 56.

27. Smithson, "Monuments," in Flam, *Robert Smithson*, 69. Unknown to Smithson, Aldiss was also a replacement child; the first sentence of his *Earthworks* evokes the enduring presence of the phantom sibling who continued to "drift along." Aldiss described being "constantly compared with an idolized older sister whom his mother said had died when she was six months old but who, he later learned, had been stillborn." Exaggerating the length of her first child's life, Aldiss's mother had aggrandized her loss and in her mind kept the daughter alive longer. Sam Roberts, "Brian Aldiss, Prolific Author of Sci-Fi and More, Dies at 92," *New York Times*, Aug. 27, 2017, 26.

28. Brian Aldiss, *Earthworks* (New York: Signet, 1967), 12, 1.

29. Robert Smithson, "The Establishment," in Flam, *Robert Smithson*, 97.

30. Vladimir Nabokov, *Invitation to a Beheading* (New York: Capricorn Books, 1965), 51. Smithson owned this edition.

31. Robert Smithson, "Lamentations of a Paroxysmal Artist," in Flam, *Robert Smithson*, 319.

32. Lewis Padgett, "Jesting Pilot," in *Skeleton Keys: Tales from "The Edge of the Chair,"* ed. Joan Kahn (New York: Dell, 1967). 246, 258, 251–52. The magazine *Edge of the Chair* published suspense.

33. Smithson, "Monuments," in Flam, *Robert Smithson*, 74.

34. Robert Smithson, "Gyrostasis," in Flam, *Robert Smithson*, 136.

35. Suzaan Boettger, "Degrees of Disorder," edited transcript of, and introduction to, Robert Smithson's November 1968 discussion with Willoughby Sharp, *Art in America* 86, no. 12 (Dec. 1998): 76

36. Robert Hobbs, *Robert Smithson: Sculpture* (Ithaca, N.Y.: Cornell University Press, 1981), 102. When earthworks subsequently became identified as constructions that were by definition outdoors, the designation "indoor" was redundant and "earthwork" inappropriate. It was retitled *A Nonsite, Pine Barrens, New Jersey* to indicate the geographical source of its geological contents as did later nonsites (and in this case drew upon the cachet of McPhee's article, which had brought popular interest to the forlorn region).

37. Donald Judd, "Specific Objects," *Arts Yearbook* 8 (1965): 78.

38. Kenneth Baker, "Talking with Robert Smithson" (1971), in *Robert Smithson: Spiral Jetty*, ed. Lynne Cooke and Karen Kelly (Berkeley: University of California Press, 2005), 149.

39. Oral history interview with Robert Smithson, July 14–19, 1972, Archives of American Art, Smithsonian Institution. Hereafter Oral history interview, AAA. https://www.aaa.si.edu/collections/interviews/oral-history-interview-robert-smithson-12013#transcript.

40. "Earth," in Flam, *Robert Smithson*, 178.

41. Robert Smithson, "A Sedimentation of the Mind: Earth Projects," in Flam, *Robert Smithson*, 110, 102.

42. Edward A. Shanken, "Broken Circle&/Spiral Hill?: Smithson's Spirals, Pataphysics, Syzygy and Survival," *Technoetic Arts: A Journal of Speculative Research* 11, no. 1 (2013): 4–5.

43. Smithson, "Sedimentation," 100.

44. Smithson, "The Artist as Site-Seer; or, A Dintorphic Essay," in Flam, *Robert Smithson*, 340. Smithson quoted from J. G. Ballard, "Terminal Beach," in *Terminal Beach* (New York: Berkley, 1964), 150.

45. Smithson, "Sedimentation," in Flam, *Robert Smithson*, 110.

46. Oral history interview, AAA.

47. Smithson, "Sedimentation," in Flam, *Robert Smithson*, 105.

48. Smithson, "Sedimentation," 100.

49. Louis Pauwels and Jacques Bergier, *The Morning of the Magicians*, trans. Rollo Myers (New York: Avon, 1968), xxvi, xxvii.

50. Smithson, "Desolation," in Flam, *Robert Smithson*, 320–21.

51. Smithson, "Sedimentation," 111, 112.

52. Smithson, "Sedimentation," 113. Barnett Newman, "The Sublime Is Now," *Tiger's Eye* 6 (1948): 53.

53. Smithson, "Entropy," in Flam, *Robert Smithson*, 15.

54. Pauwels and Bergier, *Magicians*, xxiii. Smithson, "Sedimentation," in Flam, *Robert Smithson*, 113.

55. *Earth Works*, Dwan Gallery, Oct. 5–30, 1968. Carl Andre, Herbert Bayer, Walter De Maria, Michael Heizer, Stephen Kaltenbach, Sol LeWitt, Robert Morris, Claes Oldenburg, Dennis Oppenheim, and Robert Smithson. That influential exhibition is the centerpiece of Suzaan Boettger, *Earthworks*.

56. Oral history interview, AAA.

57. Smithson, "Sedimentation," in Flam, *Robert Smithson*, 107.

58. Boettger, "Degrees," 79.

59. Grace Glueck, "Moving Mother Earth," *New York Times*, Oct. 6, 1968, D38.

60. Hobbs, *Robert Smithson*, 108. The Franklin source of the minerals was significant to Smithson biographically as one of the minerals, smithsonite, is named for Charles Smithson, whose bequest was the impetus to the founding of the Smithsonian Institution and whose name suggests that he may have been Smithson's ancestor.

61. See Hobbs, *Smithson*, 106.

62. John Jocelyn, *Meditations on the Signs of the Zodiac* (San Antonio: Naylor, 1966), 14.

63. Robert Smithson. "A Museum of Language in the Vicinity of Art," in Flam, *Robert Smithson*, 94.

64. Bruce Glaser, "Questions to Stella and Judd," in Battcock, *Minimal Art*, 158. This edited version of a discussion originally broadcast on the FM radio station WBAI was first published in *Art News*, Sept. 1966.

65. Alexander Alberro, "Robert Smithson June 20, 1969," in *Recording Conceptual Art: Early Interviews with Barry, Huebler, Kaltenbach, LeWitt, Morris, Oppenheim, Siegelaub, Smithson, and Weiner by Patricia Norvell*, ed. Alexander Alberro and Patricia Norvell (Berkeley: University of California Press, 2001), 126.

66. Craig Owens, "Earthwords," in *Beyond Recognition, Representation, Power, and Culture* (Berkeley: University of California Press, 1992), 41.

67. Smithson, "Sedimentation," in Flam, *Robert Smithson*, 111.

68. Smithson, "Sedimentation," 111.

69. Quoted in Lucy Lippard, "Breaking Circles: The Politics of Prehistory," in Hobbs, *Robert Smithson*, 32.

70. Robert Smithson, discussion with Willoughby Sharp, Nov. 1968. Transcribed by Suzaan Boettger, unpublished.

71. Alberro, "Robert Smithson," in Alberro and Norvell, *Recording Conceptual Art*, 124.

10. Mirroring Absence

1. James Meyer, "The Logic of the Double," *Artforum* 46, no. 6 (Feb. 2009): 257.

2. Smithson, "Interpolation of the Enantiomorphic Chambers," in *Robert Smithson: The Collected Writings*, ed. Jack Flam (Berkeley: University of California Press, 1996), 39. Originally published in *Art in Process*, Finch College, New York, 1966.

3. Otto Rank, *The Double: A Psychoanalytic Study*, trans. and ed. Harry Tucker Jr. (Chapel Hill: University of North Carolina Press, 1971), xiv. First published 1925.

4. Paula Elkisch, "The Psychological Significance of the Mirror," *Journal of American Psychoanalytic Association* 5, no. 2 (1957): 238, 243.

5. Florence Rubenfeld, "Robert Smithson: A Monograph" (MA thesis, Goddard College, 1975), 19.

6. Robert Smithson, "A Tour of the Monuments of Passaic, New Jersey," in Flam, *Robert Smithson*, 74, 73.

7. Robert Smithson, "A Sedimentation of the Mind: Earth Projects," in Flam, *Robert Smithson*, 100.

8. Anton Ehrenzweig, *The Hidden Order of Art* (Berkeley: University of California Press, 1967), 31.

9. Ehrenzweig, *Hidden Order*, 5.

10. Ehrenzweig, *Hidden Order*, 12, 173.

11. William C. Lipke, ed., "Fragments of a Conversation," in Flam, *Robert Smithson*, 189. Smithson is quoting Ehrenzweig, *Hidden Order*: "Projection (expulsion, scattering, casting-out) and containment (burial alive, trapping) are two poles in the creative rhythm of the ego" (216).

12. Smithson, "Sedimentation," in Flam, *Robert Smithson*, 103.

13. Sigmund Freud, *Civilization and Its Discontents* (London: Hogarth Press, 1949), 14.

14. Smithson, "Sedimentation," 110.

15. Dennis Wheeler, "Four Conversations between Dennis Wheeler and Robert Smithson," in Flam, *Robert Smithson*, 199.

16. "Earth," symposium at White Museum, Cornell University, Feb. 1969, in Flam, *Robert Smithson*, 182.

17. As quoted by John Perreault, "Nonsites in the News," *New York* 2, no. 8 (Feb. 24, 1969): 44.

18. Oral history interview with Robert Smithson, July 14–19, 1972, Archives of American Art, Smithsonian Institution, https://www.aaa.si.edu/collections/interviews/oral-history-interview-robert-smithson-12013#transcript.

19. Ehrenzweig, *Hidden Order*, 11.

20. Ehrenzweig, *Hidden Order*, 221, 219.

21. Jorge Luis Borges, "Tlön, Uqbar, Orbis Tertius," in *Ficciones* (New York: Grove Press, 1962), 17.

22. John Lloyd Stephens, *Incidents of Travel in Yucatan* (New York: Harper & Brothers, 1843), 9. My discussion is adapted from Suzaan Boettger, "In the Yucatán: Mirroring Presence and Absence," in *Robert Smithson* (Los Angeles: Museum of Contemporary Art; Berkeley: University of California Press, 2004), 201–5.

23. Robert Smithson, "Incidents of Mirror-Travel in the Yucatan," in Flam, *Robert Smithson*, 119.

24. Robert Smithson, "A Museum of Language in the Vicinity of Art," in Flam, *Robert Smithson*, 78.

25. Peter Schjeldahl, "A Nose for the Abyss: Monuments of a Metaphysical Dandy," *Village Voice Literary Supplement*, June 1982, 8.

26. Smithson owned *The Inferno* (Penguin, 1949) as well as a *Portable Dante* (Viking Press, 1947).

27. John Weir Perry, *The Self in Psychotic Process: Its Symbolization in Schizophrenia* (Berkeley: University of California Press, 1953), 126.

28. Smithson, "Yucatan," in Flam, *Robert Smithson*, 124. Given that an act of "displacement" is neither an esoteric psychoanalytic term nor uncommon in poetic imagery, the fact that Smithson was never questioned about his usage indicates the extent to which the art and criticism of his time resisted examining psychological allusions. Likewise, no one questioned in print Heizer's evocative titling of trenches in the desert as *Nine Nevada Depressions* in relation to his sensibility, made the

summer before he received attention for his participation in the Dwan *Earth Works* exhibition.

29. Smithson, "Yucatan," 124.

30. Louis Pauwels and Jacques Bergier, *The Morning of the Magicians*, trans. Rollo Myers (New York: Avon, 1968), xxvi.

31. Louise Glück, "Death and Absence," in *Proofs & Theories: Essays on Poetry* (Hopewell, N.J.: Ecco Press, 1994), 127.

32. Earlier in April he had made the first *Upside-Down Tree* when working with students as a visiting artist at the State University of New York at Alfred. He had picked up an uprooted deciduous tree, cut off its leafless boughs, and planted this beheaded trunk upside down in a muddy field. Also in April 1969, he made another *Upside-Down Tree* on the beach while visiting Robert Rauschenberg at Captiva Island, Florida.

33. T. S. Eliot, *The Waste Land*, in *The Complete Poems and Plays, 1909–1950* (New York: Harcourt, Brace & World, 1962), 30.

34. Eliot, *Waste Land*, 46.

35. Smithson, "Yucatan," in Flam, *Robert Smithson*, 131.

36. Smithson, "Yucatan," 131.

37. Wheeler, "Four Conversations," 224.

38. Pauwels and Bergier, *Morning*, xxvi.

39. Robert Pincus-Witten, "The Seventies," in *Eye to Eye: Twenty Years of Art Criticism* (Ann Arbor, Mich.: UMI Press, 1984), 124.

40. Félix Guattari, *Chaosmosis: An Ethico-aesthetic Paradigm*, trans. Paul Bains and Julian Pefanis (Bloomington: Indiana University Press, 1995), 7.

11. The Site of the Spiral

1. "A 10-Year Gamble on Winning Strength: Bets for the 70's," *Vogue*, January 1, 1970, 147, 148. The project the article describes in the past tense of covering a Vancouver Island with broken glass did not occur, having been denied by the government because of environmentalists' concerns for avian inhabitants.

2. Oral history interview with Robert Smithson, July 14–19, 1972, Archives of American Art, Smithsonian Institution. Hereafter Oral history interview, AAA. https://www.aaa.si.edu/collections/interviews/oral-history-interview-robert-smithson-12013#transcript.

3. Contractor Bob Phillips describes the construction process in *Robert Smithson: Spiral Jetty*, ed. Lynne Cooke and Karen Kelly (Berkeley: University of California Press, 2005), and Hikmet Sidney Loe provides data and descriptions in her aptly named *The Spiral Jetty Encyclo* (Salt Lake City: University of Utah Press, 2017).

4. My interview with Nancy Holt, Jan. 22, 1996.

5. Robert Smithson, "Cultural Confinement," in *Robert Smithson: The Collected Writings*, ed. Jack Flam (Berkeley: University of California Press, 1996), 155.

6. Gabriella Angeleti, "Surge in Visitors to Spiral Jetty through the Pandemic Leads to Plans for More Amenities and Ecological Awareness," viewed May 27, 2021, https://www.theartnewspaper.com/news/spiral-jetty-receives-spike-in-visitors-amid-pandemic.

7. Craig Owens, "Allegorical Impulse: Toward a Theory of Postmodernism," in *Beyond Recognition: Representation, Power, and Culture* (Berkeley: University of California Press, 1992), 56.

8. Clark Lunberry, "Quiet Catastrophe: Robert Smithson's *Spiral Jetty*, Vanished," *Discourse* 24, no. 2 (Spring 2002): 96.

9. Gregoire Müller, ". . .The Earth, Subject to Cataclysms, Is a Cruel Master," in Flam, *Robert Smithson*, 253.

10. "There is a clear tension between Smithson's pursuit of entropy (or its close kin, an open-ended materialist dialectics) and the will to own, preserve, and sign what he

has made." Gary Shapiro, *Earthworks: Robert Smithson and Art after Babel* (Berkeley: University of California Press, 1995), 197.

11. "Robert Smithson, "The Spiral Jetty," in Flam, *Robert Smithson*, 146.

12. Smithson, "What Really Spoils Michelangelo's Sculpture," in Flam, *Robert Smithson*, 348.

13. Robert Hobbs, *Robert Smithson: Sculpture* (Ithaca, N.Y.: Cornell University Press, 1981), 195. Jennifer Roberts discusses the relation of the Golden Spike site and *Spiral Jetty* in her *Mirror-Travels: Robert Smithson and History* (New Haven, Conn.: Yale University Press, 2004).

14. Müller, ". . .The Earth," in Flam, *Robert Smithson*, 261.

15. Smithson, "Spiral Jetty," in Flam, *Robert Smithson*,143. The source of his undocumented quotation is John Aarons and Claudio Vita-Finzi, "The Pink and the Putrid," in *The Useless Land: A Winter in the Atacama Desert* (London: Robert Hale, 1960), 132.

16. Oral history interview, AAA.

17. Hikmet Sidney Loe, "Robert Smithson's *Spiral Jetty*," in *Great Salt Lake: An Overview of Change*, ed. J. Wallace Gwynn (Salt Lake City: Utah Geological Survey, 2002), 566. Loe cites F. J. Post, "Life in the Great Salt Lake," *Utah Science* 35 (1975), 45.

18. Dwan's remark is in Charles Stuckey, interview with Virginia Dwan, Archives of American Art, Smithsonian Institution, June 6, 1984, tape 9, 36.

19. Kenneth Baker, "Talking with Robert Smithson," in Cooke and Kelly, *Robert Smithson*, 158.

20. Michel Bernanos, *The Other Side of the Mountain*, trans. Elaine P. Halperin (Boston: Houghton Mifflin, 1968).

21. Michael Kimmelman, "Out of the Deep," *New York Times Sunday Magazine*, Oct. 30, 2002, 42.

22. J.G. Ballard, *The Drowned World* (New York: Liveright, 2012). Smithson's copy was published in 1962.

23. Thomas Crow, "Cosmic Exile: Prophetic Turns in the Life and Art of Robert Smithson," in *Robert Smithson*, ed. Eugenie Tsai (Los Angeles: Museum of Contemporary Art; Berkeley: University of California Press, 2004), 39.

24. The epigraph is attributed to G. K. Chesterton without citation; it is from Chesterton's essay "The Red Town," in *Alarms and Discursions* (New York: Dodd, Mead, 1911), 81–82.

25. Smithson, "Spiral Jetty," in Flam, *Robert Smithson*, 148.

26. Robert Smithson, "To the Unknown Martyr," Robert Smithson and Nancy Holt Papers, Archives of American Art, Smithsonian Institution, reel 3834, frame 195.

27. Crow, "Cosmic Exile," 37.

28. Smithson, "Spiral Jetty," in Flam, *Robert Smithson*, 148.

29. Smithson, "Unknown Martyr," reel 3834, frame 195.

30. Robert Smithson, "To the Flayed Angels" and "From the Broken Ark," Robert Smithson and Nancy Holt Papers, Archives of American Art, Smithsonian Institution, reel 3834, frames 238 and 230.

31. My conversations with Dr. Emil Freireich on Nov. 9 and 20, 2017.

32. Robert Smithson, "To the Eye of Blood," in Flam, *Robert Smithson*, 318. Unpublished in his lifetime.

33. Peter Halley, introduction to *Robert Smithson: The Early Work, 1959–1962* (New York: Diane Brown Gallery, 1985), n.p.

34. Malcolm Lowry, "Through the Panama," in *Hear Us O Lord from Heaven Thy Dwelling Place* (New York: Capricorn Books, 1969), 35. The elision is Lowry's. Lowry is quoted again (from his pertinently titled novel *Dark as the Grave Wherein My Friend Is Laid*) for the title of Smithson's 1971 interview with Gregoire Müller, ". . . The Earth," in Flam, *Robert Smithson*.

35. Smithson, "From a Dream," Robert Smithson and Nancy Holt Papers, Archives of American Art, Smithsonian Institution, reel 3834, frame 200.

36. Copy of letter from Smithson to Division of State Lands, March 10, 1970, Robert Smithson and Nancy Holt Papers, Archives of American Art, Smithsonian Institution, reel 3833, frame 90.

37. Robert Smithson, "A Sedimentation of the Mind: Earth Projects," in Flam, *Robert Smithson*, 111.

38. Smithson, "The Spiral Jetty," in Flam, 147.

39. Smithson, "Flayed," Robert Smithson and Nancy Holt Papers, Archives of American Art, Smithsonian Institution, reel 3834, frame 238.

40. C. G. Jung, *The Collected Works of C. G. Jung*, ed. Herbert Read, Michael Fordham, and Gerhard Adler, vol. 12, *Psychology and Alchemy* (New York: Pantheon Books, 1953), 218.

41. Müller, ". . . The Earth," in Flam, *Robert Smithson*, 260.

42. Robert Smithson, "The Artist as Site-Seer; or, A Dintorphic Essay" (1966–67), in Flam, *Robert Smithson*, 343n2. The "Smith" he's referring to is most likely his stylistic peer sculptor Tony Smith rather than David Smith, established as a dynamic sculptor and not in Smithson's circle.

43. James George Frazer, *The Golden Bough* (New York: Macmillan, 1960), 713. Smithson owned this book.

44. Smithson, "Spiral Jetty," in Flam, *Robert Smithson*, 147.

45. Alan Leo, *Saturn the Reaper* (London: Modern Astrology Office, 1916), viii.

46. Siddhartha Mukherjee, *The Emperor of All Maladies: A Biography of Cancer* (New York: Scribner, 2010), 4.

47. John Ciardi, trans., *The Inferno* (New York: New American Library, 1954), 119–20.

48. Robert Smithson, "Incidents of Mirror-Travel in the Yucatan," in Flam, *Robert Smithson*, 110.

49. Smithson, "Flayed" and "From the City," Robert Smithson and Nancy Holt Papers, Archives of American Art, Smithsonian Institution, frames 238 and 221.

12. Inside the Spiral

1. "Robert Smithson, "The Spiral Jetty," in *Robert Smithson: The Collected Writings*, ed. Jack Flam (Berkeley: University of California Press, 1996), 145, 146. Parts of this chapter were incorporated in, and elaborated on, in my publications "Brother's Keeper: Robert Smithson's Anti-Elegiac Pictures," *American Imago* 78, no. 4 (Winter 2021): 559–93, https://muse.jhu.edu/article/845180, and "Living Extinction: Robert Smithson's Dinosaurs," *Burlington Contemporary*, Nov. 2021, https://contemporary.burlington.org.uk/journal/journal/living-extinction-robert-smithsons-dinosaurs.

2. Bob Phillips, "Building the Jetty," in *Robert Smithson: Spiral Jetty*, ed. Lynne Cooke and Karen Kelly (Berkeley: University of California Press; New York: Dia Art Foundation, 2005), 185–98. Three accounts differ as to how Serra and Smithson commenced the second formation of *Spiral Jetty*.

- Serra told me (June 20, 2000) that he had been in Los Angeles, having stopped over on the way to Japan, when Smithson called him and asked him to come to Utah to advise him on his construction.
- Gorgoni told art historian Kathleen Merrill Campagnolo (Mar. 2004) that at Smithson's request, he and Serra flew from New York City to Salt Lake City to work with Smithson on the second state.
- Gorgoni told William L. Fox (May 16, 2017) of the Nevada Museum of Art and essayist in Gorgoni's *Land Art Photographs* that Smithson and Serra picked him up in Manhattan in a taxi and they flew together to Salt Lake City. Serra, the only person alive who may know for sure, did not respond to my

request for comment on these discrepancies. No matter how Serra got there, film documentation shows that he worked with Smithson to stake out the spiral.

3. Richard Serra and Hal Foster, *Conversations about Sculpture* (New Haven, Conn.: Yale University Press, 2018), 62.

4. Smithson, "Art Through the Camera's Eye," in Flam, *Robert Smithson*, 371. Kathleen Merrill Campagnolo, "Spiral Jetty Through the Camera's Eye," *Archives of American Art Journal* 47, no. 1/2 (2008): 22, 21.

5. Robert Smithson, "Gyrostasis," in Flam, *Robert Smithson*, 136.

6. Robert Smithson, "A Sedimentation of the Mind: Earth Projects," in Flam, *Robert Smithson*, 109–10.

7. Smithson, "Spiral Jetty," in Flam, *Robert Smithson*, 146.

8. Achille Bonito Oliva, "Robert Smithson Has been Interviewed in Rome by Achille Bonito Oliva, in October," *Domus* 481 (Dec. 12, 1969): 43.

9. J. G. Ballard, *The Drowned World* (New York: Liveright, 2012), 41.

10. John Taine (Eric Temple Bell), *The Time Stream, The Greatest Adventure, and The Purple Sapphire: Three Science Fiction Novels* (New York: Dover, 1964), 16. Smithson quoted from that story for his "Entropy and the New Monuments" epigraph and will do so again later in his *Jetty* film.

11. Smithson draws attention to the line in his interview with Gregoire Müller, ". . .The Earth, Subject to Cataclysms, Is a Cruel Master," in Flam, *Robert Smithson*, 258, and in "Art Through the Camera's Eye," in Flam, 373. Kenneth Baker, "Talking with Robert Smithson," in Cooke and Kelly, *Robert Smithson*, 159–60. The line is from Valéry's poem "Silhouette [or Sketch] of a Serpent." Continuing with Baker, Smithson remarked that "the sun just hangs in the sky completely indifferent to our moral [in the audio recording, he might have actually said 'mortal,' as that would relate more closely to Valéry's statement of the sun masking death] problems. . . . We suppose it to be the giver of life. That's how the spiritual film makers see it [another mistaken transcription? It is traditionally seen that way but who are these filmmakers?], unity and all that crap. To me it is a portent of entropy. That's why in my film the sun gives off the sound of a hospital respirator." But what is the reason for using that sound later in the film when discussing enantiomorphic crystal formations? Because it refers to his family enantiomorphic link? Smithson's diversionary comment distracted Baker from looking beyond the by then clichéd association of his interviewee with entropy to question his reasoning, here of how a fiery sun could be an omen of degradation. (Smithson could not be referring to the then unrecognized concept of global warming, which in any case has caused an increase of volatility in the biosphere rather than an entropic loss of energy.)

12. C. G. Jung, *The Collected Works of C. G. Jung*, ed. Herbert Read, Michael Fordham, and Gerhard Adler, vol. 12, *Psychology and Alchemy* (New York: Pantheon Books, 1953), 80.

13. Robert Smithson, "Incidents of Mirror-Travel in the Yucatan," in Flam, *Robert Smithson*, 126.

14. Arthur Conan Doyle, *The Lost World* (New York: Medallion Books, 1965), n.p.

15. Interview with Robert Smithson for the Archives of American Art, Smithsonian Institution, in Flam, *Robert Smithson*, 279, 271.

16. Smithson, "Sedimentation," in Flam, *Robert Smithson*, 104.

17. Smithson, "Spiral Jetty," in Flam, *Robert Smithson*, 152. The percussive sound is so unfathomable that I had to consult the musician, composer, and audio producer Peter Fedak, who provided me with its description.

18. In the penultimate sentence of his "Spiral Jetty" essay published two years after the film was completed, Smithson states in passive voice, "From the soundtrack . . .

the words of 'The Unnameable are heard," as if to disown association with his own sensibility. He may have learned of *The Unnamable* from Wylie Sypher's discussion of it in *Loss of the Self*, but by its publication year, 1962, five of the seventeen other books by or about Beckett that he possessed at the time of his death had been published.

19. Gabriele Schwab, "Replacement Children: The Transgenerational Transmission of Traumatic Loss," in *Haunting Legacies: Violent Histories and Transgenerational Trauma* (New York: Columbia University Press, 2010), 126.

20. Smithson, "Spiral Jetty," in Flam, *Robert Smithson*, 151.

21. John Weir Perry, *The Self in Psychotic Process* (Berkeley: University of California Press, 1953), 129. In Smithson's library.

22. Smithson, "Spiral Jetty," in Flam, *Robert Smithson*, 148, 147.

23. Jung, *Alchemy*, 28.

24. Jill Purce, *The Mystic Spiral: Journey of the Soul* (New York: Avon Books, 1974). 29. In 1971 Smithson and Purce corresponded; she sought a photograph of his *Gryostasis* for her article in the *Structuralist* and received it from him but didn't use it there or in her book. Per her email to me, Mar. 29, 2019, she cannot find his letters to her.

25. Smithson, 'Quasi-Infinites and the Waning of Space," in Flam, *Robert Smithson*, 37, originally published in *Arts*, Nov. 1966. Smithson attributes Beckett's writing to his book *Proust*.

26. Smithson, "Spiral Jetty," in Flam, *Robert Smithson*, 147.

27. Smithson, "Sedimentation," in Flam, *Robert Smithson*, 102.

28. Smithson, "Spiral Jetty," in Flam, *Robert Smithson*, 146.

29. Smithson, "Spiral Jetty," 146, 149.

30. J. G. Ballard, *The Drowned World* (New York: Berkley Medallion, 1962), 70.

31. Ballard, *Drowned*, 100.

32. Wheeler, "Four Conversations," in Flam, *Robert Smithson*, 200.

33. Court Mann, "The Strange History of Utah's 'Spiral Jetty,' Which Just Turned 50," *Deseret News*, Apr. 7, 2020. Viewed Apr. 10, 2020, https://www.deseret.com/entertainment/2020/4/7/21207816/spiral-jetty-50-robert-smithson-nancy-holt-anniversary-dia-umfa-great-salt-lake-landmarks-utah.

34. C. G. Jung, *Psyche & Symbol: A Selection from the Writings of C. G. Jung*, ed. Violet S. de Laszlo, trans. Cary Baynes and F. C. R. Hull (Garden City, N.Y.: Doubleday, 1958), 158.

35. Smithson, "Incidents," in Flam, *Robert Smithson*, 133.

36. Purce, *Mystic Spiral*, 29–30. Smithson's work is not represented in Purce's publications.

37. Robert Smithson, "*To the Mockery*" and "*From the Broken Ark,*" Robert Smithson and Nancy Holt Papers, Archives of American Art, Smithsonian Institution, reel 3834, frames 217 and 230.

38. Smithson, "Spiral Jetty," in Flam, *Robert Smithson*, 149.

39. Mircea Eliade, *Cosmos and History, or The Myth of the Eternal Return* (New York: Harper Torchbooks, 1959), 18. Smithson owned this book.

40. Joseph Masheck, "Smithson's Earth: Notes and Retrievals," in *Robert Smithson: Drawings* (New York: New York Cultural Center in association with Fairleigh Dickinson University, 1974), 26. Masheck cannily quotes Jung's *Psychology and Alchemy*, 207, without knowing that Smithson closely attended to it.

41. Smithson, "Ultramoderne," in Flam, *Robert Smithson*, 65.

42. Smithson, "Spiral Jetty," in Flam, *Robert Smithson*, 152.

43. Lucy R. Lippard, "Art Outdoors, in and out of the Public Domain," *Studio International* 193, no. 986 (Mar./Apr. 1977): 87.

44. John Taine (Eric Temple Bell), *The Time Stream*, in *The Time Stream, The Greatest Adventure, and The Purple Sapphire: Three Science Fiction Novels* (New York: Dover, 1964), 17.

45. David Felton and David Dalton, "Flashback: Charles Manson; The Incredible Story of the Most Dangerous Man Alive," *Rolling Stone*, Nov. 21, 2017. Viewed Aug. 2, 2019, https://au.rollingstone.com/culture/culture-news/flashback-charles-manson-the -incredible-story-of-the-most-dangerous-man-alive-2156.

46. From William A. R. Thomson, *Black's Medical Dictionary*, year not given (1965?), Robert Smithson and Nancy Holt Papers, Archives of American Art, Smithsonian Institution, reel 3835, frame 955.

47. Smithson, "Spiral Jetty," in Flam, *Robert Smithson*, 152.

48. *Information* was presented at the Museum of Modern Art, July 2–Sept. 20, 1970.

49. Arthur C. Danto, "The American Sublime: Robert Smithson's Epic Earthwork, Spiral Jetty Tends to Render Critics Speechless," *Nation*, Sept. 1, 2005. Accessed Aug. 7, 2015, http://www.thenation.com/article/american-sublime.

50. Baker, "Talking," 155.

51. Among the books in English that illustrate *Spiral Jetty* on its jacket or cover are, in chronological order, Jack Burnham, *Great Western Salt Works* (New York: Braziller, 1974); *Robert Smithson: Drawings* (1974); Robert Hobbs, *Robert Smithson: Sculpture* (Ithaca, N.Y.: Cornell University Press, 1981); Gary Shapiro, *Earthwards: Robert Smithson and Art After Babel* (Berkeley: University of California Press, 1995); Jeffrey Kastner and Brian Wallis, *Land and Environmental Art: The Definitive Survey of Land Art and Contemporary Environmental Art* (London: Phaidon, 1996); Jack Flam, ed., *Robert Smithson* (1996); *Robert Smithson Retrospective: Works 1955–1973* (Oslo: National Museum of Contemporary Art, 1999); H. W. Janson and Anthony F. Janson, *History of Art*, 6th ed. (Upper Saddle River, N.J.: Prentice Hall, 2001); Ron Graziani, *Robert Smithson and the American Landscape* (Cambridge: Cambridge University Press, 2004); Jennifer L. Roberts, *Mirror-Travels: Robert Smithson and History* (New Haven, Conn.: Yale University Press, 2004); Lynne Cooke and Karen Kelly, eds., *Robert Smithson* (2005); Margaret Iversen, *Beyond Pleasure: Freud, Lacan, Barthes* (University Park: Pennsylvania State University Press, 2007); Sylvan Barnet, *A Short Guide to Writing about Art*, 9th ed. (Upper Saddle River, N.J.: Prentice Hall, 2007); Adrian Locke, *Art & Place: Site-Specific Art of the Americas* (London: Phaidon, 2013); Karl Ove Knausgaard, *My Struggle*, book 5, *Some Rain Must Fall* (Brooklyn: Archipelago, 2016); and Hikmet Sidney Loe, *The Spiral Jetty Encyclo* (Salt Lake City: University of Utah Press, 2017).

52. Galenson was discussed in Patricia Cohen, "A Textbook Example of Ranking Artworks," *New York Times*, Aug. 4, 2008, E5. His book is David W. Galenson, *Conceptual Revolutions in Twentieth-Century Art* (Cambridge: Cambridge University Press, 2009).

53. Walter Herdeg, *The Sun in Art: Sun Symbolism, from the Past to the Present, in Pagan and Christian Art, Popular Art, Fine Art and Applied Art* (Zurich: Graphics Press, 1962), 42.

54. G. K. Chesterton, "The Red Town," in *Alarms and Discursions* (New York: Dodd, Mead, 1911), 82.

55. Smithson, "Spiral Jetty," in Flam, *Robert Smithson*, 148. Smithson quoted A. S. Eddington in Tobias Dantzig, *Number: The Language of Science* (New York: Doubleday Anchor, 1954), 232.

56. Paul John Eakin, *Fictions in Autobiography: Studies in the Art of Self-Invention* (Princeton, N.J.: Princeton University Press, 1985), 37–38. Eakin quotes Philippe Lejeune, *Le pact autobiographique* (Paris: Seuil, 1975), 201.

13. Reclamations

1. Dennis Oppenheim was represented by documentation of prior work. Michael Heizer withdrew before making a work for it in Limburg (he had also withdrawn from Cornell's *Earth Art* show, in solidarity with Walter De Maria's withdrawal

from that show; both withdrew again from the Museum of Contemporary Art, Los Angeles, exhibition *Ends of the Earth: Land Art to 1974).*

2. This information is from my conversations with Sjouke and Cornelia Zijlstra in Emmen, Aug. 1999; other details are in Suzaan Boettger, *Earthworks: Art and the Landscape of the Sixties* (Berkeley: University of California Press, 2002). To Gregoire Müller and in his oral history, Smithson erroneously described Zijlstra as a geographer.

3. Gregoire Müller, ". . . The Earth, Subject to Cataclysms, Is a Cruel Master," in *Robert Smithson: The Collected Writings*, ed. Jack Flam (Berkeley: University of California Press, 1996), 253.

4. C. G. Jung, *The Collected Works of C. G. Jung*, ed. Herbert Read, Michael Fordham, and Gerhard Adler, vol. 12, *Psychology and Alchemy* (New York: Pantheon, 1953), 281.

5. Müller, ". . . The Earth," 258.

6. Eric Rhode, "Art and Pilgrimage," in *On Revelations* (London: Apex One, 2014), 145.

7. John Taine (Eric Temple Bell), *The Time Stream, The Greatest Adventure,* and *The Purple Sapphire: Three Science Fiction Novels* (New York: Dover, 1964), 33. Smithson quoted Taine as his epigraph in "Entropy and the New Monuments," *Artforum*, June 1966, and in "Ultramoderne," *Arts*, Sept./Oct. 1967.

8. Smithson, "A Museum of Language in the Vicinity of Art," in Flam, *Robert Smithson*, 87.

9. Jung, *Alchemy*, 281. Illustrations of the uroboros are on page 45, Figure 6; page 53, Figure 13; page 99, Figures 46 and 47; and page 281, Figure 147.

10. This decoding was aided by art historians Martha Hollander and M. E. Warlick, two among many members of the Consortium of Art and Architectural Historians who were helpful in interpreting symbols.

11. C. G. Jung, *The Collected Works of C. G. Jung*, ed. Herbert Read, Michael Fordham, and Gerhard Adler, vol. 14, *Mysterium Coniunctionis: An Inquiry into the Separation and Synthesis of Psychic Opposites in Alchemy* (New York: Pantheon, 1963), 365.

12. Paul Toner, "Interview with Robert Smithson," in Flam, *Robert Smithson*, 239.

13. Nathan A. Scott Jr., *The Broken Center: Studies in the Theological Horizon of Modern Literature* (New Haven, Conn.: Yale University Press, 1966), 1–2, 15. Scott quotes Richard Chase, who said T. S. Eliot "made his way back to a classical tradition of religious faith and found in Christian history the deepest inspiration for the work of his last thirty-five years." Chase, *The Democratic Vista: A Dialogue on Life and Letters in Contemporary America* (Garden City, N.Y.: Doubleday, 1958), 16.

14. Interview with Robert Smithson for the Archives of American Art, Smithsonian Institution, in Flam, *Robert Smithson*, 283.

15. Theo Tegelaers, "On Breaking Ground: Broken Circle/Spiral Hill," in *Robert Smithson: The Invention of the Landscape*, ed. Eva Schmidt (Cologne: Snoeck, 2012), 60. This account makes clear that the film was not Smithson's vision that was produced, but Holt's view forty years later; thus it is not analyzed here.

16. C. G. Jung, *The Collected Works of C. G. Jung*, ed. Herbert Read, Michael Fordham, and Gerhard Adler, vol. 12, *Psychology and Alchemy* (New York: Pantheon Books, 1953), 357.

17. Robert Smithson, "Broken Circle Emmen Holland (Script)," Robert Smithson and Nancy Holt Papers, Archives of American Art, Smithsonian Institution, reel 3834, frame 346.

18. Robert Smithson, "Sonsbeek Unlimited—Art as an Ongoing Development," Robert Smithson and Nancy Holt Papers, Archives of American Art, Smithsonian Institution, reel 3834, frames 875, 877.

19. Robert Smithson and Nancy Holt Papers, Archives of American Art, Smithsonian Institution, reel 2822, frame 306. Dwan did continue to act as Smithson's patron at least once, later in the year giving the Department of Architecture at the University of Utah $20,000 ($138,000 today) with which to pay him monthly stipends during

1972 as a visiting professor. Contrary to the position's customary practice of regular presence and engagement with students, Smithson apparently visited only once, to recount his visit to Hotel Palenque in the Yucatán. He was described as having narrated thirty-one photographs in forty-two minutes "in the manner of a family vacation slide show" and "accompanied by a glass of Scotch" (transgressive both to a school setting and the prohibitionist values of the predominately Mormon state of Utah), presented "meandering observations . . . [that] ranged from the illuminating, to the humorous, to the boring, simultaneously straddling understanding and complete nonsense." Annie Burbidge Ream, "Smithson Is Elsewhere: Robert Smithson at the University of Utah," accessed Nov. 15, 2021, https://umfa.utah.edu/smithson-is-elsewhere.

20. *Information* was presented at the Museum of Modern Art, July 2–Sept. 20, 1970. Smithson's solo show at the Dwan Gallery, New York, ran from Oct. 31 through Nov. 25, 1970. The Whitney Museum Annual was on view Dec. 12, 1970–Feb. 7, 1971. Gorgoni was not identified as the photographer, suggesting a status as commissioned works for hire.

21. Correspondence between Robert Smithson and György Kepes, Robert Smithson and Nancy Holt Papers, Archives of American Art, Smithsonian Institution, reel 3833, frames 322–23.

22. Smithson to Enno Develing, undated (Aug. 1971), Robert Smithson and Nancy Holt Papers, Archives of American Art, Smithsonian Institution, reel 3833, frame 366.

23. Smithson, "Cultural Confinement," in Flam, *Robert Smithson*, 154–56.

24. Oral history interview with Robert Smithson, July 14–19, 1972, Archives of American Art, Smithsonian Institution. Hereafter Oral history interview, AAA. https://www.aaa.si.edu/collections/interviews/oral-history-interview-robert-smithson-12013#transcript.

25. Smithson, "Confinement," in Flam, *Robert Smithson*, 154.

26. Smithson, "Confinement," 155.

27. Robert Smithson, "Iconography of Desolation," in Flam, *Robert Smithson*, 321.

28. Smithson, "Confinement," 155, and Smithson, "Desolation," 322.

29. Smithson, "Confinement," 156.

30. Philip Leider, "Robert Smithson: The Essays," *Arts* 52, no. 9 (May 1976): 97. The essay was later reprinted as the introduction to *The Writings of Robert Smithson*, ed. Nancy Holt (New York: New York University Press, 1979).

31. Smithson, "Confinement," 155.

32. "What Is a Museum? A Dialogue between Allan Kaprow and Robert Smithson," in Flam, *Robert Smithson*, 50. This article was originally published in *Arts Yearbook*, 1967. Six years earlier, Smithson had written to Lester, "The Happenings are simply 'The Black Mass' for the retarted and should be stopped." Undated (June 1961, #12).

33. Smithson, "From Ivan the Terrible to Roger Corman or Paradoxes of Conduct in Mannerism as Reflected in the Cinema," in Flam, *Robert Smithson*, 352.

34. Alexander Jon Creighton, "Robert Smithson in Space: Science Fiction in the Gallery and Beyond" (master's thesis, University of Colorado Boulder, 2014), 7, accessed July 1, 2018, https://scholar.colorado.edu/arth_gradetds/1.

35. Barbara Rose and Irving Sandler, eds., "Sensibility of the Sixties," *Art in America* 55, no. 1 (Jan./Feb. 1967): 49. Smithson was aware of this article as he had a statement in it.

36. John Weber, Joe Amrhein, and Brian Conley, "Conversation with John Weber," in *Robert Smithson: A Collection of Writings on Robert Smithson on the Occasion of the Installation of "Dead Tree" at Pierogi 2000*, ed. Brian Conley and Joe Amrhein (New York: Pierogi, 1997), 11, 14.

37. Lucy Lippard, "The Art Workers' Coalition: Not a History," *Studio International* 55, no. 2 (Nov. 1970): 72. When reprinted, Lippard removed the sexual allusions. In her essay "Breaking Circles: The Politics of Prehistory," Lippard notes that Smithson

"infrequently and inactively attended [meetings of the Art Workers' Coalition]. . . . He watched the AWC as a detached bystander, too aware of our powerlessness to join in, and amused by the spectacle of all of us 'idealists' scrapping with each other." In Robert Hobbs, *Robert Smithson: Sculpture* (Ithaca, N.Y.: Cornell University Press, 1981), 36.

38. Peter Schjeldahl, "Robert Smithson: He Made Fantasies as Real as Mountains," *New York Times*, Aug. 12, 1973, 127.

39. Eugenie Tsai, "Interview with Dan Graham October 27, 1988," in *Robert Smithson: Zeichnungen aus dem Nachlass—Drawings from the Estate* (Münster: Westfälisches Landesmuseum für Kunst und Kulturgeschichte, 1989), 16.

40. Bruce Kurtz, "Conversation with Robert Smithson," in Flam, *Robert Smithson*, 72.

41. Smithson, "Confinement," 155. Smithson stated the last quote to Calvin Tomkins in "Onward and Upward with the Arts, Maybe a Quantum Leap," *New Yorker*, Feb. 5, 1972, 54.

42. Dennis Wheeler, "Four Conversations Between Dennis Wheeler and Robert Smithson," in Flam, *Robert Smithson*, 209.

43. John F. Moffitt, "Marcel Duchamp: Alchemist of the Avant-Garde," in *The Spiritual in Art: Abstract Painting, 1890–1985* (Los Angeles: Los Angeles County Museum of Art; New York: Abbeville Press, 1986), 269.

44. Smithson, "Confinement," 155.

45. Smithson, "A Sedimentation of the Mind: Earth Projects," in Flam, *Robert Smithson*, 107.

46. Liza Bear and Willoughby Sharp, "Discussions with Heizer, Oppenheim, Smithson," *Avalanche* 1, Fall 1970; in Flam, *Robert Smithson*, 246.

47. Oral history interview with Robert Smithson, AAA, Smithsonian Institution, 44.

48. Tomkins, "Onward," 53.

49. Robert Smithson, "Art Through the Camera's Eye," in Flam, *Robert Smithson*, 375.

50. Robert Smithson to Ralph D. Hatch, June 10, 1972, Robert Smithson and Nancy Holt Papers, Archives of American Art, Smithsonian Institution, reel 3835, frame 1210.

51. Robert Smithson to Allen Overton, July 13, 1972, Robert Smithson and Nancy Holt Papers, Archives of American Art, Smithsonian Institution, reel 3833, frame 537.

52. Gene Wortsman to Robert Smithson, July 28, 1972, Robert Smithson and Nancy Holt Papers, Archives of American Art, Smithsonian Institution, reel 3835, frame 1215.

53. Robert Smithson to Ralph D. Hatch, October 4, 1972; Hatch to Smithson, November 20, 1972, Robert Smithson and Nancy Holt Papers, Archives of American Art, Smithsonian Institution, reel 3835, ca. 1250.

54. Charles E. Melbye to Robert Smithson, Dec. 20, 1972, Robert Smithson and Nancy Holt Papers, Archives of American Art, Smithsonian Institution, reel 3835, frame 1225.

55. William G. Stockton to Robert Smithson, Robert Smithson and Nancy Holt Papers, Archives of American Art, Smithsonian Institution, reel 3935, frame 1259. The list of thirty-eight recipients of the kits is in reel 3835, frame 1222.

56. Kenneth Baker, "Talking with Robert Smithson," in *Robert Smithson: Spiral Jetty*, ed. Lynne Cooke and Karen Kelly (Berkeley: University of California Press, 2005), 151.

57. Moira Roth, "An Interview with Robert Smithson," ed. and annotated by Naomi Sawelson-Gorse, in *Robert Smithson*, ed. Eugenie Tsai (Los Angeles: Museum of Contemporary Art; Berkeley: University of California Press, 2004), 94. The version published in *Artforum*, Oct. 1973, and reproduced in Flam is considerably condensed.

58. Carl Andre, "Robert Smithson: He Always Reminded Us of the Questions We Ought to Have Asked Ourselves," *Arts* 52, no. 9 (May 1978): 102.

59. Lucy R. Lippard, *Overlay: Contemporary Art and the Art of Prehistory* (New York: Pantheon Books, 1983), 32.

14. Closing the Circle

1. Oral history interview with Robert Smithson, July 14–19, 1972, Archives of American Art, Smithsonian Institution. Hereafter Oral history interview, AAA. https://www.aaa.si.edu/collections/interviews/oral-history-interview-robert-smithson-12013#transcript.

2. Robert Smithson, Guggenheim Fellowship application, 1972, n.p., Holt/Smithson Foundation.

3. Robert Smithson, "Frederick Law Olmsted and the Dialectical Landscape," in *Robert Smithson: The Collected Writings*, ed. Jack Flam (Berkeley: University of California Press, 1996), 160.

4. Richard Serra and Hal Foster, *Conversations about Sculpture* (New Haven, Conn.: Yale University Press, 2018), 48. Donald Judd, "A Long Discussion not about Master-Pieces but Why There Are So Few of Them, Part II," *Art in America* 72 (Oct. 1984): 11.

5. Smithson, "Frederick Law Olmsted," in Flam, *Robert Smithson*, 170.

6. Robert Smithson, undated and untitled sheet, Robert Smithson and Nancy Holt Papers, Archives of American Art, Smithsonian Institution, box B3, no. 68.

7. Robert Smithson, "A Sedimentation of the Mind: Earth Projects," in Flam, *Robert Smithson*, 100.

8. Moira Roth, "An Interview with Robert Smithson," ed. and annotated by Naomi Sawelson-Gorse, in *Robert Smithson*, ed. Eugenie Tsai (Los Angeles: Museum of Contemporary Art; Berkeley: University of California Press, 2004), 85.

9. Bruce Kurtz, "Conversation with Robert Smithson on April 22, 1972," in *Robert Smithson: The Collected Writings*, ed. Jack Flam (Berkeley: University of California Press, 1996), 262.

10. Lucy Lippard, "Out of the Past," *Artforum* 46, no. 6 (Feb. 2008): 249.

11. Roth, "Interview," 85–86.

12. Roth, "Interview," 91, 89. In the interview, Smithson recanted the affiliation with a machine he had made eight years earlier in his *Quick Millions* statement: "All kinds of engineering fascinates me, I'm for the automated artist." To Roth, he asserted, "Andy Warhol saying that he wants to be a machine is this linear and Cartesian attitude developed on a simple level. And I just don't find it very productive. It leads to a kind of Cartesian abyss" (85).

13. "Four Conversations between Dennis Wheeler and Robert Smithson," in Flam, *Robert Smithson*, 211.

14. Jack Thibeau, "The Man Who Cast the Land," *Rolling Stone*, Aug. 14, 1974, 58, and Jack Thibeau, untitled and undated manuscript, Robert Smithson and Nancy Holt Papers, Archives of American Art, Smithsonian Institution, reel 3835, frame 150.

15. My interview with Richard Serra, June 20, 2000.

16. My conversation with Louis Asekoff, Dec. 23, 1996. The *Fiction* editorial staff decided not to publish a text already in print.

17. Jack Thibeau, untitled and undated manuscript, Robert Smithson and Nancy Holt Papers, Archives of American Art, Smithsonian Institution, reel 3835, frame 150. Alison Sky, "Entropy Made Visible," in Flam, *Robert Smithson*, 304.

18. My interview with David Diao, July 31, 2018.

19. Robert Hobbs, *Robert Smithson: Sculpture* (Ithaca, N.Y.: Cornell University Press, 1981), 219. Eugenie Tsai, "Robert Smithson: Plotting a Line from Passaic, New Jersey, to Amarillo, Texas," in Tsai, *Robert Smithson*, 30.

20. Lisa G. Dunn, head of special collections, Colorado School of Mines Library, examined the physically restricted reports and provided this information in an email to me, Oct. 25, 2019.

21. My interview with Tony Shafrazi, June 5, 2000. All Shafrazi quotations are from this source.

22. My interview with Stanley Marsh 3, July 3, 2003. All quotations by Marsh not otherwise cited are from this source.

23. Amy Von Lintel and Jonathan Revett, "Completing Smithson's Trilogy," *Robert Smithson in Texas* (New York: Estate of Robert Smithson and James Cohan Gallery, 2013), 23. Stanley Marsh 3, "My Dear Files," unpublished and undated memoir, 14. The concept of Smithson's three earthworks being an intentional triology is from Marsh's attribution to a comment Smithson made to him. No other person who spoke with Smithson has identified the trio of earthworks as such. Neither the memoir nor Marsh's assertions about Smithson are mentioned in any of numerous articles on Marsh's activities as a patron of art such as Sandy Sheehy, "Stanley Marsh 3: Cristo of the Cap Rock," *Texas Big Rich: Exploits, Eccentricities, and Fabulous Fortunes Won and Lost* (New York: William Morrow, 1990). When I interviewed Marsh at his ranch on July 3, 2003, his memoir did not exist.

24. Holt's recollections in this chapter are from my interview with her, Jan. 22, 1996.

25. Steve LaPrade and Ben Keck, "Plane Crash Takes Three Lives," *Amarillo Daily News*, July 21, 1973, 1.

26. Robert Smithson and Nancy Holt Papers, Archives of American Art, Smithsonian Institution, reel 3832, frame 603. This sheet is unsigned. Each artist writing it confirmed to me his participation. Smithson's passing also inspired a "Robert Smithson Scholarship Fund" at the Brooklyn Museum's School of Art, where he had studied. It seems to have run 1978–81; its source of funding is unknown. As Holt did not include this when providing catalogue information about Smithson, the Estate was probably not the funder.

27. Dennis Wheeler to John Coplans, Oct.15, 1973, Robert Smithson and Nancy Holt Papers, Archives of American Art, Smithsonian Institution, reel 3833, frames 0760–73.

28. Alan Brilliant, email to me, Oct. 10, 1999.

29. Alan Brilliant, "Hanging Out with Bob Smithson: A Letter Answering Suzaan Boettger," undated, received Sept. 25, 1999; Alan Brilliant, *Robert Smithson* (Greensboro, N.C.: Unicorn Press, 2013), 82. Irving Sandler, *A Sweeper-Up after Artists: A Memoir* (New York: Thames & Hudson, 2003), 293; Robert Pincus-Witten, "Naked Lunches," *October* 3, no. 102 (Spring 1977): 115.

30. His eulogy text was published as Philip Leider, "For Robert Smithson," *Art in America* 61, no. 6 (Nov./Dec. 1973): 81. The place of the funeral was mistakenly written as St. John's, a homophone of the French St. Jean, and the date given was that of the mortuary viewing, not the funeral Mass the following day.

31. John Coplans, "A Postscript," Robert Smithson and Nancy Holt Papers, Archives of American Art, Smithsonian Institution, reel 3833, frame 819. The text that it was to follow is unstated. Other pall bearers were Lawrence Alloway, Mel Bochner, Robert Fiore (editor of the *Spiral Jetty* film and a friend), Leider, and Serra.

32. Robert Pincus-Witten, Condolence to Nancy Holt, Robert Smithson and Nancy Holt Papers, Archives of American Art, Smithsonian Institution, reel 3833, frame 800.

33. Dan Cameron, "Incidents of Robert Smithson: Posthumous Dimensions of a Premature Pre-Modern," *Flash Art* 23, no. 155 (Nov./Dec. 1990): 107. Serra and Foster, *Conversations about Sculpture*, 63.

34. As Nancy Holt described in Jan Butterfield, "Robert Smithson 1938–1973," *Arts* 48, no. 1 (Sept.–Oct. 1973): 57.

35. J.G. Ballard, "Robert Smithson as Cargo Cultist," in *Robert Smithson: A Collection of Writings on Robert Smithson on the Occasion of the Installation of "Dead Tree" at Pierogi 2000*, ed. Brian Conley and Joe Amrhein (New York: Pierogi, 1997), 31

36. Joseph Masheck, "Smithson's Earth: Notes and Retrievals," in *Robert Smithson:*

Drawings (New York: New York Cultural Center in association with Fairleigh Dickinson University, 1974), 28.

37. Edward A. Shanken, "Broken Circle&/Spiral Hill? Smithson's Spirals, Pataphysics, Syzygy and Survival," *Technoetic Arts: A Journal of Speculative Research* 11, no. 1 (2013): 9, 11.

38. C. G. Jung, *The Collected Works of C. G. Jung*, ed. Herbert Read, Michael Fordham, and Gerhard Adler, vol. 12, *Psychology and Alchemy* (New York: Pantheon, 1953), 357.

39. Michael Maier, *Atalanta Fugiens: An Edition of the Fugues, Emblems and Epigrams*, trans. Joscelyn Godwin (Grand Rapids, Mich.: Phanes Press, 1989), 9, 133. It is an excerpt from Michael Maier, *Atalanta fugiens* (Oppenheim: Hieronymous Galler, 1617).

40. Alan Leo, *Saturn the Reaper* (London: Modern Astrology Office, 1916), 105.

41. In a telling coincidence, several of his buddies separately—they could not have known of each other's descriptions—associated him similarly. Eli Levin recounts how the National Portrait Gallery of the Smithsonian Institution "bought two portraits that I drew . . . of Smithson's reptilian head, in 1955." Dale McConathy claimed that from the time Smithson had his childhood naturalist museum of specimens, "his familiar had been a snake, many snakes, and forever after he saw himself as reptilian, cold, earthbound." Dan Graham characterized his "amoral position" as "amphibious"; Serra associated his appearance with the reptilian, and Shafrazi recounted that on their dizzying flight Smithson "would give these reptilian beady-eyed giggles." Smithson's extremely pock-marked skin, scars from adolescent acne that were frequently mentioned when recalling him, was undoubtedly a visual source of that association. Eli Levin, *Disturbing Art Lessons* (Santa Fe: Sunstone Press, 2012), 39. Dale McConathy, "Keeping Time: Some Notes on Reinhardt, Smithson and Simonds," *Artscanada* 32, no. 98–99 (June 1975): 52. Eugenie Tsai, "Interview with Dan Graham October 27, 1988," in *Robert Smithson: Zeichnungen aus dem Nachlass; Drawings from the Estate* (Münster: Westfälisches Landesmuseum für Kunst und Kulturgeschichte, 1989), 14; Tony Shafrazi quoted in Anthony Haden-Guest, *True Colors: The Real Life of the Art World* (New York: Atlantic Monthly Press; 1966), 4. My interview with Richard Serra, June 20, 2000.

42. John Taine (Eric Temple Bell), *The Time Stream, The Greatest Adventure, and The Purple Sapphire: Three Science Fiction Novels* (New York: Dover, 1964), 36.

43. Robert Smithson, "Ultramoderne," in Flam, *Robert Smithson*, 63, 65.

44. Jung, *Alchemy*, 281.

45. Gary Shapiro, *Earthwards: Robert Smithson and Art after Babel* (Berkeley: University of California Press, 1995), 28. Smithson owned Friedrich Nietzsche, *The Philosophy of Nietzsche* (New York: Modern Library, 1927).

46. "Robert Smithson, June 20, 1969," in *Recording Conceptual Art: Early Interviews with Barry, Huebler, Kaltenbach, LeWitt, Morris, Oppenheim, Siegelaub, Smithson, and Weiner by Patricia Norvell*, ed. Alexander Alberro and Patricia Norvell (Berkeley: University of California Press, 2001), 126.

47. "Robert Smithson, June 20, 1969," 124.

48. "Robert Smithson, June 20, 1969," 133.

49. Oral history interview, AAA.

50. Jürgen Habermas, "The Liberating Power of Symbols: Ernst Cassirer's Humanistic Legacy and the Warburg Library," in *The Liberating Power of Symbols* (Cambridge, Mass.: MIT Press, 2001), 9.

51. Hans Sedlmayr, "Chaos Unleashed," in *Art in Crisis: The Lost Center*, trans. Brian Battershaw (London: Hollis & Carter, 1957), 217, 223.

52. John Russell, "Critics' Choices," *New York Times*, Feb. 14, 1982, 464. Like Mrs.

Jackson Pollock—that is, Lee Krasner—following her husband's premature death in a violent accident—Holt's productivity and career flourished.

53. Dennis Wheeler, "Four Conversations Between Dennis Wheeler and Robert Smithson," in Flam, *Robert Smithson*, 213. Kenneth Baker, "Talking with Robert Smithson" [no specific date 1971], in *Robert Smithson: Spiral Jetty*, ed. Lynne Cooke and Karen Kelly (Berkeley: University of California Press, 2005), 151.

54. Rahan Ramazani, *Poetry of Mourning: The Modern Elegy from Hardy to Heaney* (Chicago: University of Chicago Press, 1994), ix.

55. Jean-Paul Sartre, "Marxism and Subjectivity: Jean-Paul Sartre's Rome Lecture" (1961), in *What Is Subjectivity?* (London: Verso, 2016), 26.

56. Robert Pogue Harrison, *The Dominion of the Dead* (Chicago: University of Chicago Press, 2003), ix, 70.

Robert Smithson's Library

1. Shortly after Smithson's death, Valentin Tatransky compiled a categorized list of his books at Nancy Holt's request and included magazines and records. It was published in *Robert Smithson*, ed. Eugenie Tsai (Berkeley: University of California Press; Los Angeles: Museum of Contemporary Art, 2004). Lori Cavagnaro and Ann Reynolds designated the book's genres or subjects slightly differently and published the list of books in Ann Reynolds, *Robert Smithson: Learning from New Jersey and Elsewhere* (Cambridge, Mass.: MIT Press, 2003). The catalogues do not include every book Smithson mentioned and quoted. Many of those not listed are science fiction, such as Brian Aldiss's *Earthworks*; J.G. Ballard's stories "Billenium," "The Overloaded Man," and "The Waiting Grounds," and novels *The Drowned World* and *The Wind from Nowhere*; and the story collection containing Henry Kuttner's "Jesting Pilot." If he owned any of these, they must have been discarded or lent.

2. When conservative Roman Catholic critic Roger Kimball offered "reflections on Hans Sedlmayr's remarkable—and largely forgotten—work," he described it as "In an important sense . . . not an exercise in art history at all. It *uses* art, not to make an aesthetic case but in order to illustrate a moral diagnosis." Roger Kimball, "Art in Crisis," *New Criterion*, Dec. 2005. Accessed Aug. 24, 2017, https://www.newcriterion.com/issues/2005/12/ldquoart-in-crisisrdquo.

3. Alexander Alberro, "The Catalogue of Robert Smithson's Library," in Tsai, *Robert Smithson*, 246.

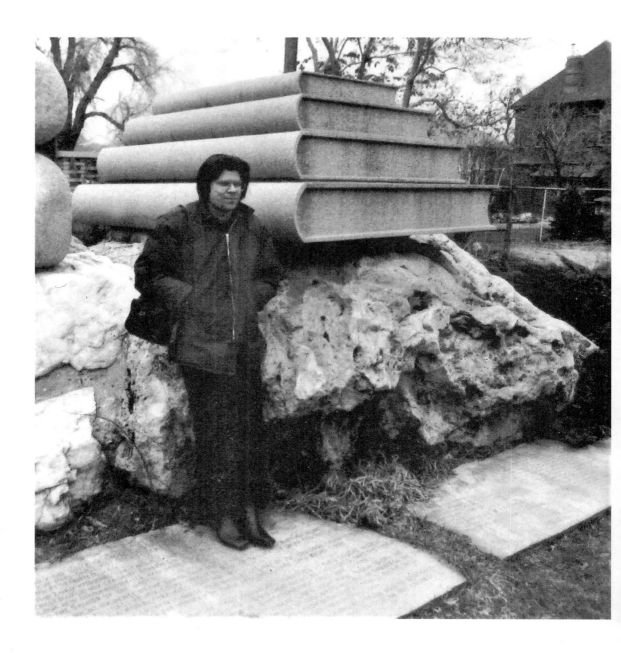

FIGURE B.1. In another connection between books and Christianity in relation to Smithson, he stands at the Monument to the Priesthood at Gilgal Gardens, Salt Lake City, a private display of mid-twentieth-century carving by Thomas Battersby Child Jr. (1888–1963). The four cast-stone books represent the standard scriptures used by the Church of Jesus Christ of Latter-day Saints: the Bible, the Book of Mormon, the Doctrine and Covenants, and the Pearl of Great Price, a compilation of historical revelations. Photographed by Nancy Holt, 1970. Courtesy Holt/Smithson Foundation and Nancy Holt Estate Records, Archives of American Art, Smithsonian Institution. Copyright Holt/Smithson Foundation / Licensed by Artists Rights Society, New York.

Robert Smithson's Library

A Selective Bibliography

Subject Areas:

Alchemy, Astrology, Cryptology, Numerology, and the Occult

Christianity or Christian Orientation

Mysticism

On Jesus and Saints

Religions Other than Christianity

Saints' Writings

Science Fiction and Its Literary Criticism

Sexuality, Sexual Identity, and Love

The following lists of books in Robert Smithson's library highlight his interests in selected areas as demonstrated by his acquisition and retaining of numerous books in those subjects. The two available catalogues of his entire library as of his death group the publications in basic broad categories, for example, mixing astrology, alchemy, mythology, and Atlantis with religion.[1] To understand Smithson more intimately, I found it necessary to make a more fine-grained catalogue and to cross-list books that are nominally one subject but have a prominent subtext, most frequently astrology, literature, or art viewed through Christianity. Some pertaining to religion do not discuss theology in any substantial way, such as art historian Émile Mâle's *Religious Art from the Twelfth to the Eighteenth Century* (1958). Others, such as Hans Sedlmayr's *The Lost Center* (1958) and Nathan A. Scott Jr.'s *Broken Circle* (1966), are Christian exhortations masquerading as art history or literary criticism.[2]

To facilitate knowledge of when it would have been possible for him to have been engaged with a book, these lists are sequenced within each category chronologically by publication year.

These groupings are based on my own direct reading of each book.

Among the more than eleven hundred volumes Smithson owned at the time of his death, a little over one hundred can be designated as either written by religious practitioners (early Christian saints, monks) or famous theologians or scholars of religion, or are nominally about other subjects but whose subject matter has strong religious orientations. Generally Christian, they suggest that he embraced the Catholic intellectual tradition. Of the books pertaining to religion, the majority were published in 1961 or earlier, when he was painting the crucifixions and writing George Lester about his beliefs, indicating the potential extent of his reading on religious topics that spring.

Likewise, nominally "psychology," *The Mind and Heart of Love: Lion and Unicorn; A Study in Eros and Agape* (1960) is actually—as indicated by author M. C. D'Arcy's credentials, "S.J." (Society of Jesus; D'Arcy was a Jesuit priest)—a theological analysis of types of Christian love. Carl Jung's *Psyche & Symbol* has chapters titled "Christ, a Symbol of the Self," "Transformation Symbolism in the Mass," and "Psychological Commentary on the Tibetan Book of the Dead." More than half of Jung's *Psychology and Alchemy* analyzes parallels to and distinctions from Christianity.

A big contingent within literature, not separately listed here, is authors whose writing manifests their Catholicism. Some, like Mary McCarthy (four books) and Flannery O'Connor (one), were raised Catholic; W. H. Auden (two books, plus an introduction to Charles Williams, *The Descent of the Dove: A History of the Holy Spirit in the Church*, 1956) grew up Anglo-Catholic. Another groups' zealous identification with Catholicism was likely expressing their religious conversions: to Anglo-Catholicism, for example, T. S. Eliot (seven books by; six about), and to Roman Catholicism: G. K. Chesterton (four); Thomas Merton (three); Evelyn Waugh (three); Graham Greene (two); and philosopher Jacques Maritain (one). Smithson also owned five books by the Anglo-Catholic poet and novelist Evelyn Underhill, formerly an agnostic, who was known for her histories and advocacy of Christian mysticism.

Another strong (under)current of his book collection is the downbeat: the titles of forty-four volumes refer to negative experiences (e.g., Søren Kierkegaard, *The Concept of Dread*, 1967), social, architectural, or geological decay (e.g., Morse Peckham, *Man's Rage for Chaos: Biology, Behavior, and the Arts*, 1967), and thirteen of those have "death" or "dead" in their titles, as in Georges Bataille, *Death and Sensuality: A Study of Eroticism and the Taboo* (1969); Louis-Ferdinand Céline, *Death on the Installment Plan* (1966); and Susan Sontag, *Death Kit* (1967).

A glance at the numerous titles Smithson collected in the area of sexuality, sexual identity, and love suggests the conflicts he wrestled with about intimacy and expression of a sexual self.

We cannot know when Smithson read a particular book he owned, or even if he read it, unless he cited it or wrote in it. But as scholar Alexander Alberro has asserted, "Discerning the idiosyncratic structure of Smithson's collection is presently more relevant than determining which texts the artist carefully read (or read at all!) . . . since the particular items he chose to gather together provide a glimpse of his cultural landscape."[3] Indeed, considering the lay of the land of his library—the number of volumes he acquired in particular subject areas—reveals the topography of his *personal* landscape.

Alchemy, Astrology, Cryptology, Numerology, and the Occult

Seward, A. F. *The Zodiac and Its Mysteries: A Study of Planetary Influences upon the Physical, Mental, and Moral Nature of Mankind.* Chicago: Seward, 1915.

Leo, Alan. *Saturn the Reaper.* [London]: Modern Astrology Office, 1916.

Sampson, Walter H. *The Zodiac: A Life Epitome, Being A Comparison of the Zodiacal Elements with Life-Principles: Cosmic, Anthropologic and Psychologic.* London: Blackfriars Press, 1928.

Davidson, D., and H. Aldersmith. *The Great Pyramid: Its Divine Message.* 5th ed. London: Williams and Norgate, 1932.

Eisler, Robert. *The Royal Art of Astrology.* London: Herbert Joseph, 1946.

Heindel, Max, and Augusta Heindel. *The Message of the Stars.* 11th ed. London: Fowler, 1947.

I Ching: or, Book of Changes. Translated by Cary F. Baynes from the Richard Wilhelm translation. Princeton, N.J.: Princeton University Press, 1950.

Jung, C. G. *Psychology and Alchemy.* Vol. 12 of *The Collected Works of C. G. Jung.* Edited by Herbert Read, Michael Fordham, and Gerhard Adler. New York: Pantheon Books, 1953.

Gardner, Gerald B. *Witchcraft Today.* New York: Citadel Press, 1955.

Róheim, Géza. *Magic and Schizophrenia.* Bloomington: Indiana University Press, 1955.

Leschnitzer, Adolf. *The Magic Background of Modern Anti-Semitism: An Analysis of the German Jewish Relationship.* New York: International Universities Press, 1956.

Jung, C. G. *Psyche & Symbol: A Selection from the Writings of C. G. Jung.* Edited by Violet S. de Laszlo. Translated by Cary Baynes and F. C. R. Hull. Garden City, N.Y.: Doubleday, 1958.

Butler, E. M. *Ritual Magic.* New York: Noonday, 1959.

Frazer, James George. *The Golden Bough: A Study in Magic and Religion.* New York: Macmillan, 1960.

Murray, Margaret. *The God of the Witches.* Garden City, N.Y.: Anchor Books, 1960.

Herdeg, Walter. *The Sun in Art: Sun Symbolism, from the Past to the Present, in Pagan and Christian Art, Popular Art, Fine Art and Applied Art.* Zurich: Graphics Press, 1962.

Jung, C. G., ed. *Man and His Symbols.* New York: Dell, 1964.

MacNeice, Louis. *Astrology.* Garden City, N.Y.: Doubleday, 1964.

Malinowski, Bronislaw. *The Language of Magic and Gardening.* Vol. 2 of Coral Gardens and Their Magic. Bloomington: Indiana University Press, 1965.

Jocelyn, John. *Meditations on the Signs of the Zodiac.* San Antonio: Naylor, 1966.

Cavendish, Richard. *The Black Arts.* New York: Putnam, 1967.

Pauwels, Louis, and Jacques Bergier. *The Morning of the Magicians.* Translated by Rollo May. New York: Avon, 1968.

Gleadow, Rupert. *The Origin of the Zodiac.* New York: Atheneum, 1969.

Christianity or Christian Orientation

The Holy Bible, Containing the Old and New Testaments. Teacher's ed. Oxford: Oxford University Press, n.d.

Didron, Adolphe Napoleon. *Christian Iconography, or The History of Christian Art in the Middle Ages.* Vol. 2. London: Bell, 1891.

Chesterton, G. K. *The Everlasting Man.* Garden City, N.Y.: Image Books, 1925.

Underhill, Evelyn. *Worship.* New York: Harper, 1936.

Eckhart. *Meister Eckhart: A Modern Translation.* Translated by Raymond Bernard Blakney. New York: Harper & Row, 1941.

Heindel, Max, and Augusta Heindel. *The Message of the Stars.* 11th ed. London: Fowler, 1947.

Maritain, Jacques. *Existence and the Existent.* Garden City, N.Y.: Image Books, 1948.

Vogt, Von Ogden. *Art and Religion.* Boston: Beacon Press, 1948.

Eliot, T. S. *Christianity and Culture: The Idea of a Christian Society and Notes towards the Definition of Culture.* New York: Harcourt, Brace, 1949.

Fremantle, Anne, ed. *A Treasury of Early Christianity.* New York: New American Library, 1953.

Halverson, Marvin. *Great Religious Paintings.* New York: Abrams, 1954.

White, T. H., ed. and trans. *The Book of Beasts, Being a Translation from a Latin Bestiary of the Twelfth Century.* New York: Putnam, 1954.

Bede. *A History of the English Church and People.* Harmondsworth, UK: Penguin, 1955.

Thomas à Kempis. *The Imitation of Christ.* Garden City, N.Y.: Image Books, 1955.

White, Andrew D. *A History of the Warfare of Science with Theology in Christendom.* New York: Braziller, 1955.

The Holy Bible, Douay Version. Translated from the Latin Vulgate. London: Catholic Truth Society, 1956.

Kierkegaard, Søren. *Attack upon "Christendom," 1854–1855.* Translated by Walter Lowrie. Boston: Beacon Press, 1956.

Williams, Charles. *The Descent of the Dove: A History of the Holy Spirit in the Church.* Introduction by W. H. Auden. New York: Meridian Books, 1956.

Harnack, Adolf von. *Outlines of the History of Dogma.* Translated by Edwin Knox Mitchell. Boston: Beacon Press, 1957.

Chesterton, G. K. *The Amazing Adventures of Father Brown.* New York: Dell, 1958.

John of the Cross. *Ascent of Mount Carmel.* Garden City, N.Y.: Image Books, 1958.

Mâle, Émile. *Religious Art from the Twelfth to the Eighteenth Century.* New York: Noonday, 1958.

Sedlmayr, Hans. *Art in Crisis, the Lost Center.* Translated by Brian Battershaw. Chicago: Henry Regnery, 1958.

Sinistrari, Ludovico Maria. *Peccatum Mutum: The Secret Sin, Sodomy.* Paris: Le Ballet de Muses, 1958.

Böhme, Jakob. *Personal Christianity: The Doctrines of Jacob Böhme.* New York: Ungar, 1960.

D'Arcy, M. C. *The Mind and Heart of Love: Lion and Unicorn, a Study in Eros and Agape.* Cleveland: World, 1960.

Hales, Edward Elton Young. *The Catholic Church in the Modern World.* Garden City, N.Y.: Doubleday, 1960.

Ignatius. *The Spiritual Exercises of Saint Ignatius.* Westminster, Md.: Newman Press, 1960.

Newman, John Henry. *An Essay on the Development of Christian Doctrine.* Garden City, N.Y.: Image Books, 1960.

Unamuno, Miguel de. *The Agony of Christianity.* Translated by Kurt F. Reinhardt. New York: Ungar, 1960.

Visser 't Hooft, W. A. *Rembrandt and the Gospel.* New York: Meridian Books, 1960.

Adams, Henry. *Mont-Saint-Michel and Chartres.* New York: New American Library, 1961.

Bunyan, John. *God's Knotty Log: Selected Writings.* Cleveland: World, 1961.

Chautard, J. B. *The Soul of the Apostolate.* Garden City, NY: Image Books, 1961.

Chesterton, G. K. *The Catholic Church and Conversion.* New York: Macmillan, 1961.

Hinton, Richard W. [Angoff, Charles], ed. *Arsenal for Skeptics.* New York: Barnes, 1961.

Hamman, A. G. *Early Christian Prayers.* Translated by Walter Mitchell. Chicago: Regnery, 1961.

Lietzmann, Hans. *The Era of the Church Fathers.* Vol. 4 of *A History of the Early Church.* Cleveland: World, 1961.

———. *From Constantine to Julian.* Vol. 3 of *A History of the Early Church.* Cleveland: World, 1961.

Rubin, William. *Modern Sacred Art and the Church of Assy.* New York: Columbia University Press, 1961.

Tawney, R. H. *Religion and the Rise of Capitalism, A Historical Study.* New York: New American Library, 1961.

Wolters, Clifton, ed. *The Cloud of Unknowing.* Baltimore: Penguin, 1961.

Bernanos, Georges. *The Diary of a Country Priest.* Garden City, NY: Image Books, 1962.

McCarthy, Mary. *Memories of a Catholic Girlhood.* New York: Berkley, 1963.

Rahner, Hugo. *Greek Myths and Christian Mystery.* New York: Harper & Row, 1963.

Simon, Louis de Rouvroy. *The Age of Magnificence: The Memoirs of the Duc de Saint-Simon.* Translated by Ted Morgan. New York: Capricorn, 1963.

Underhill, Evelyn. *The Mystics of the Church.* New York: Schocken Books, 1964.

Abbott, Walter M. *The Documents of Vatican II.* New York: American Press, 1966.

Ghyka, Matila. *The Geometry of Art and Life.* New York: Sheed & Ward, 1966.

Jocelyn, John. *Meditations on the Signs of the Zodiac.* San Antonio: Naylor, 1966.

Scott, Nathan A. *The Broken Center: Studies in the Theological Horizon of Modern Literature.* New Haven, Conn.: Yale University Press, 1966.

Wenzel, Siegfried. *The Sin of Sloth: Acedia in Medieval Thought and Literature.* Chapel Hill: University of North Carolina Press, 1967.

Diderot, Denis. *The Nun.* Translated by Eileen B. Hennessy. Los Angeles: Holloway House, 1968.

Everson, William. *The Residual Years, Poems 1934–1948.* The Precatholic Poetry of Brother Antonius. New York: New Directions, 1968.

Hughes, Robert. *Heaven and Hell in Western Art.* New York: Stein & Day, 1968.

Tennant, Frederick. *The Sources of the Doctrines of the Fall and Original Sin.* New York: Schocken Books, 1968.

Thielicke, Helmut. *Nihilism: Its Origin and Nature, with a Christian Answer.* Translated by John W. Doberstein. New York: Schocken Books, 1969.

Mysticism

Underhill, Evelyn. *Practical Mysticism.* New York: Dutton, 1943.

Pond, Kathleen, ed. *Spirit of the Spanish Mystics: An Anthology of Spanish Religious Prose from the Fifteenth to the Seventeenth Century.* New York: Kennedy, 1958.

Reinhold, H. A., ed. *The Soul Afire: Revelations of the Mystics.* New York: Meridian Books, 1960.

Underhill, Evelyn. *The Essentials of Mysticism and Other Essays.* New York: Dutton, 1960.

Cohn, Norman. *The Pursuit of the Millennium: Revolutionary Millenarians and Mystical Anarchists of the Middle Ages.* New York: Harper, 1961.

Underhill, Evelyn. *Mysticism: A Study in the Nature and Development of Man's Spiritual Consciousness.* New York: Dutton, 1961.

———. *The Mystics of the Church.* New York: Schocken Books, 1964.

Merton, Thomas. *Mystics and Zen Masters.* New York: Farrar, Straus & Giroux, 1967.

Katsaros, Thomas, and Nathaniel Kaplan. *The Western Mystical Tradition: An Intellectual History of Western Civilization.* New Haven, Conn.: College and University Press, 1969.

On Jesus and Saints

Bettenson, Henry, ed. *Early Christian Fathers: A Selection from the Writings of the Fathers from Saint Clement of Rome to Saint Athanasius.* London: Oxford University Press, 1956.

Chesterton, G. K. *Saint Francis of Assisi.* Garden City, N.Y.: Doubleday, 1957.

Teresa of Avila. *The Life of Saint Teresa.* Harmondsworth, UK: Penguin, 1957.

Brown, Raphael. *The Little Flowers of Saint Francis.* Garden City, N.Y.: Image Books, 1958.

Steinmann, Jean. *Saint John the Baptist and the Desert Tradition.* Translated by Michael Boyes. New York: Harper, 1958.

Grant, Robert M. *The Secret Sayings of Jesus: The Gnostic Gospel of Thomas.* Garden City, N.Y.: Doubleday, 1960.

Merton, Thomas, ed. *The Wisdom of the Desert: Sayings from the Desert Fathers of the Fourth Century.* New York: New Directions, 1960.

Farrer, Austin. *A Rebirth of Images: The Making of Saint John's Apocalypse.* Boston: Beacon Press, 1963.

Religions Other Than Christianity

Davidson, D., and H. Aldersmith. *The Great Pyramid: Its Divine Message.* 5th ed. London: Williams and Norgate, 1932.

The Song of God: Bhagavad-Gita. Translated by Swami Prabhavananda and Christopher Isherwood. Introduction by Aldous Huxley. New York: New American Library, 1944.

I Ching: or, Book of Changes. Translated into English by Cary F. Baynes from the Richard Wilhelm translation. Princeton, N.J.: Princeton University Press, 1950.

Kerényi, Karl. *The Gods of the Greeks.* New York: Book Collectors Society, 1950.

Leschnitzer, Adolf. *The Magic Background of Modern Anti-Semitism: An Analysis of the German Jewish Relationship.* New York: International Universities Press, 1956.

Eliade, Mircea. *Myths, Dreams, and Mysteries: The Encounter between Contemporary Faiths and Archaic Realities.* Translated by Philip Mairet. New York: Harper & Row, 1957.

Harrison, Jane. *Prolegomena to the Study of Greek Religion.* New York: Meridian Books, 1957.

Wind, Edgar. *Pagan Mysteries in the Renaissance.* New Haven, Conn.: Yale University Press, 1958.

Butler, E. M. *Ritual Magic.* New York: Noonday, 1959.

Cumont, Franz. *After Life in Roman Paganism.* New York: Dover, 1959.

Eliade, Mircea. *Cosmos and History: The Myth of the Eternal Return.* New York: Harper, 1959.

Freud, Sigmund. *Moses and Monotheism.* New York: Vintage, 1959.

Vatsyayana. *Kama Sutra: A Complete and Unexpurgated Version of This Celebrated Hindu Treatise on Love.* Paris: Éditions de la Fontaine d'Or, 1959.

Book of the Dead: An English Translation of the Chapters, Hymns, etc., of the Theban Recension. Edited and translated by E. A. Wallis Buge. London: Routledge & Kegan Paul, 1960.

Dawson, Christopher. *Progress and Religion.* Garden City, N.Y.: Doubleday, 1960.

Frazer, James George. *The Golden Bough: A Study in Magic and Religion.* New York: Macmillan, 1960.

Murray, Margaret. *The God of the Witches*. Garden City, N.Y.: Anchor Books, 1960.
Zimmer, Heinrich. *The King and the Corpse: Tales of the Soul's Conquest of Evil*.
New York: Meridian Books, 1960.
Gaer, Joseph. *The Legend of the Wandering Jew*. New York: New American Library, 1961.
Campbell, Joseph. *The Masks of God: Oriental Mythology*. New York: Viking Press, 1962.
Rahner, Hugo. *Greek Myths and Christian Mystery*. New York: Harper & Row, 1963.
Eliade, Mircea. *Mephistopheles and the Androgyne: Studies in Religious Myth and Symbol*.
Translated by J. M. Cohen. New York: Sheed & Ward, 1965.
Graves, Robert, and Raphael Patai. *Hebrew Myths: The Book of Genesis*. New York:
McGraw-Hill, 1966.
Burland, C. A. *The Gods of Mexico*. London: Eyre & Spottiswoode, 1967.
Cavendish, Richard. *The Black Arts*. New York: Putnam, 1967.
Merton, Thomas. *Mystics and Zen Masters*. New York: Farrar, Straus & Giroux, 1967.
Pauwels, Louis, and Jacques Bergier. *The Morning of the Magicians*. Translated by Rollo
Myers. New York: Avon, 1968.
Zohar: The Book of Splendor. Edited by Gershom G. Scholem. New York: Schocken
Books, 1968.
Black Elk. *Black Elk Speaks: Being the Life Story of a Holy Man of the Oglala Sioux*.
New York: Pocket Books, 1972.
Suzuki, Shunryu. *Zen Mind, Beginner's Mind*. New York: Weatherhill, 1973.

Saints' Writings

Jerome, Saint. *The Satirical Letters of Saint Jerome*. Translated by Paul Carroll. Chicago:
Gateway Editions, 1956.
Augustine, Saint. *City of God*. Garden City, N.Y.: Image Books, 1958.
John of the Cross. *Ascent of Mount Carmel*. Garden City, NY: Image Books, 1958.
Aquinas, Thomas. *The Pocket Aquinas: Selections from the Writings of Saint Thomas*.
New York: Washington Square Press, 1960.
Augustine, Saint. *The Confessions of St. Augustine*. Translated by Edward B. Pusey.
New York: Washington Square Press, 1960.
Ignatius, Saint. *The Spiritual Exercises of Saint Ignatius*. Westminster, Md.: Newman
Press, 1960.
Augustine, Saint. *Selected Writings*. Edited by Roger Hazelton. Cleveland: Meridian
Books, 1962.

Science Fiction and Its Literary Criticism

Van Vogt, A. E. *The Players of Null-A*. New York: Berkley, 1948.
Vance, Jack. *The Dying Earth*. New York: Lancer Books, 1950.
Wolfe, Bernard. *Limbo*. New York: Ace, 1952.
Clement, Hal. *Cycle of Fire*. New York: Ballantine Books, 1957.
Wells, H. G. *The Time Machine*. New York: Berkley, 1960.
Ballard, J. G. *The Voices of Time and Other Stories*. New York: Berkley, 1962.
Wells, H. G. *The Invisible Man and The War of the Worlds*. New York: Washington Square
Press, 1962.
Burgess, Anthony. *A Clockwork Orange*. New York: Norton, 1963.
Knight, Damon. *Beyond the Barrier*. New York: MacFadden Books, 1963.
Moskowitz, Sam. *Explorers of the Infinite: Shapers of Science Fiction*. Cleveland: World,
1963.
Ballard, J. G. *Terminal Beach*. New York: Berkley, 1964.
Bell, Eric Temple (John Taine). *The Time Stream, The Greatest Adventure, and The Purple
Sapphire: Three Science Fiction Novels*. New York: Dover, 1964.
Burgess, Anthony. *The Wanting Seed*. New York: Ballantine Books, 1964.

Clarke, Arthur C. *Profiles of the Future: An Inquiry into the Limits of the Possible.*
　　New York: Bantam Books, 1964.
Vance, Jack. *The Killing Machine.* New York: Berkley, 1964.
Wells, H. G. *The Island of Doctor Moreau.* New York: Berkley, 1964.
Binder, Eando. *Anton York, Immortal.* New York: Belmont Books, 1965.
Doyle, Arthur Conan. *The Lost World.* New York: Medallion Books, 1965.
Knight, Damon, ed. *Thirteen French Science-Fiction Stories.* New York: Bantam Books,
　　1965.
Laumer, Keith. *The Other Side of Time.* New York: Berkley, 1965.
Tales of the Incredible. New York: Ballantine Books, 1965.
Aldiss, Brian W. *Cryptozoic!* New York: Avon, 1967.
Joseph, M. K. *The Hole in the Zero.* New York: Avon, 1967.
Knight, Damon, ed. *Cities of Wonder.* New York: MacFadden-Bartell, 1967.
Scholes, Robert. *The Fabulators.* New York: Oxford University Press, 1967.
Verne, Jules. *From Earth to the Moon.* New York: Airmont, 1967.
Wells, H. G. *The First Men in the Moon.* New York: Berkley, 1967.
Ballard, J. G. *The Drought.* Harmondsworth, UK: Penguin, 1968.
Calvino, ltalo. *Cosmicomics.* New York: Collier Books, 1968.
Le Clezio, J. M. G. *Fever.* Translated by Daphne Woodward. New York: Atheneum, 1968.
———. *The Flood.* Translated by Peter Green. New York: Atheneum, 1968.
Zamiatin, Evgenii lvanovich. *The Dragon: Fifteen Stories.* Edited and translated by
　　Mirra Ginsburg. New York: Vintage, 1968.
Eiseley, Loren C. *The Unexpected Universe.* New York: Harcourt, Brace & World, 1969.
Dunsany, Edward John Moreton Drax Plunkett. *At the Edge of the World.* New York:
　　Ballantine Books, 1970.
Eiseley, Loren. *The Invisible Pyramid.* New York: Scribner, 1970.
Clareson, Thomas D., ed. *SF: The Other Side of Realism.* Bowling Green, Ohio: Bowling
　　Green University Popular Press, 1971.
Clement, Hal. *Star Light.* New York: Ballantine Books, 1971.
Smith, Clark Ashton. *Hyperborea.* New York: Ballantine Books, 1971.

Sexuality, Sexual Identity, and Love

Winwar, Frances. *Oscar Wilde and the Yellow 'Nineties.* New York: Harper, 1940.
Bloch, Iwan. *Marquis de Sade: His Life and Works.* N.p.: Brittany Press, 1948.
Stekel, Wilhelm. *Auto-erotism: A Psychiatric Study of Onanism and Neurosis.* New York:
　　Grove Press, 1950.
Sinistrari, Ludovico Maria. *Peccatum Mutum: The Secret Sin.* Paris: Le Ballet de Muses,
　　1958.
Vatsyayana. *Kama Sutra: A Complete and Unexpurgated Version of This Celebrated Hindu
　　Treatise on Love.* Paris: Editions de la Fontaine d'Or, 1959.
D'Arcy, M. C. *The Mind and Heart of Love: Lion and Unicorn, a Study in Eros and Agape.*
　　Cleveland: World, 1960.
Reik, Theodor. *Psychology of Sex Relations.* New York: Grove Press, 1961.
Rechy, John. *City of Night.* New York: Grove Press, 1963.
Leiris, Michel. *Manhood: A Journey from Childhood into the Fierce Order of Virility.*
　　Translated by Richard Howard. New York: Grossman, 1963.
Ruitenbeek, Hendrik, ed. *The Problem of Homosexuality in Modern Society.* New York:
　　Dutton, 1963.
Sartre, Jean-Paul. *Saint Genet: Actor and Martyr.* Translated by Bernard Frechtman.
　　New York: Braziller, 1963.
Southern, Terry, and Mason Hoffenberg. *Candy: A Novel.* New York: Putnam, 1964.
Girodias, Maurice. *The Olympia Reader.* New York: Ballantine Books, 1965.

Eliade, Mircea. *Mephistopheles and the Androgyne: Studies in Religious Myth and Symbol.* Translated by J. M. Cohen. New York: Sheed & Ward, 1965.

Berg, Jean de. *The Image.* Translated by Patsy Southgate. New York: Grove Press, 1966.

Bowen, Elizabeth. *The Demon Lover and Other Stories.* Harmondsworth, UK: Penguin, 1966.

Girodias, Maurice, ed. *The Best of Olympia: Etc etc short-lived and Much Lamented Olympia Magazine.* London: New English Library, 1966.

Sade, Marquis de. *Justine, Philosophy in the Bedroom, and Other Writings.* Introduction by Jean Paulhan and Maurice Blanchet. New York: Grove Press, 1966.

Ayres, Joan. *Lady Susan's Cruel Lover.* Covina, Calif.: Collectors, 1967.

Reage, Pauline. *The Story of O.* New York: Grove Press, 1967.

Rechy, John. *Numbers.* New York: Grove Press, 1967.

Vidal, Gore. *Myra Breckinridge.* New York: Bantam Books, 1968.

Bataille, Georges. *Death and Sensuality: A Study of Eroticism and the Taboo.* New York: Ballantine Books, 1969.

Vidal, Gore. *Sex, Death and Money.* New York: Bantam Books, 1969.

Millett, Kate. *Sexual Politics.* Garden City, N.Y.: Doubleday, 1970.

Harding, M. Esther. *Woman's Mysteries: Ancient and Modern; A Psychological Interpretation of the Feminine Principle as Portrayed in Myth, Story and Dreams.* New York: Putnam, 1971.

Reage, Pauline. *Return to the Chateau, Preceded by A Girl in Love.* New York: Grove Press, 1971.

Index

Page numbers in **bold** refer to illustrations.

SUZAAN BOETTGER is professor emerita of the history of art at Bergen Community College and author of *Earthworks: Art and the Landscape of the Sixties.*